THE LAST ROMANTICS
The Romantic Tradition in British Art
BURNE-JONES TO STANLEY SPENCER

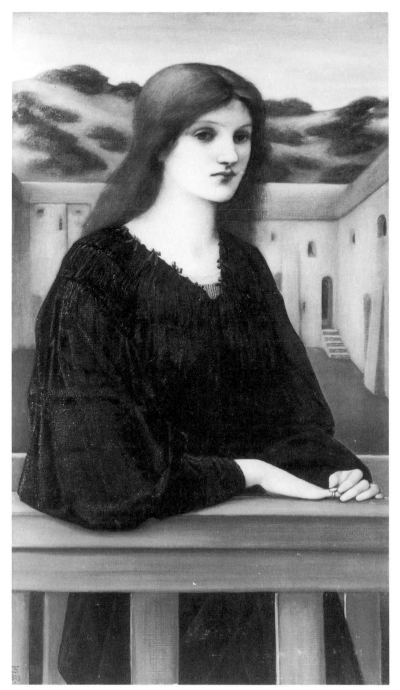

Edward Burne-Jones *Vespertina Quies* **1893.** Cat. 4

THE LAST ROMANTICS

The Romantic Tradition in British Art

BURNE-JONES TO STANLEY SPENCER

Edited by John Christian
with essays by MaryAnne Stevens,
J G P Delaney, Lindsay Errington, Benedict Read,
Alan Powers and David Fraser Jenkins

Lund Humphries · London
in association with
Barbican Art Gallery

Copyright © 1989 Barbican Art Gallery,
Corporation of the City of London

First edition 1989
Published by
Lund Humphries Publishers Ltd
16 Pembridge Road, London W11
in association with
Barbican Art Gallery, London

British Library Cataloguing in Publication Data

The Last Romantics: the Romantic Tradition in
British Art, Burne-Jones to Stanley Spencer.
1. British visual art. Romanticism, 1880–1950 –
Catalogues, indexes
I. Christian, John II. Barbican Art Gallery
709'.41

ISBN 0 85331 552 3

This is the catalogue of the exhibition
THE LAST ROMANTICS
THE ROMANTIC TRADITION IN BRITISH ART
BURNE-JONES TO STANLEY SPENCER
held at Barbican Art Gallery, London
9 February to 9 April 1989

Exhibition selected by John Christian, with
the assistance of Benedict Read (Sculpture)
Exhibition organised by Jane Alison,
Barbican Art Gallery

Designed by Ashted Dastor Associates
Made and printed in Great Britain
by BAS Printers Limited, Over Wallop,
Stockbridge, Hampshire

Cover: E R Hughes *Night with her Train of Stars* c1912 Cat. 49

Frontispiece: Edward Burne-Jones *Vespertina Quies* 1893 Cat. 4

CONTENTS

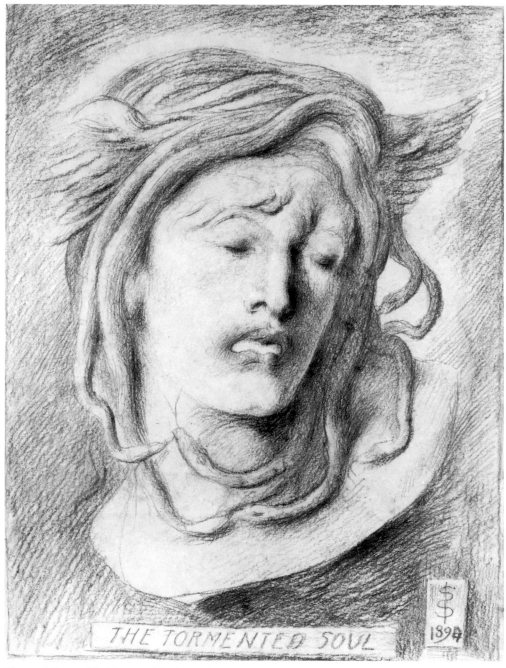

THE TORMENTED SOUL

Simeon Solomon *The Tormented Soul* **1894.** Cat. 24

FOREWORD

Since the time of its opening in 1982, Barbican Art Gallery has made one of its programming aims the reassessment of certain, overlooked movements or figures in nineteenth- and twentieth-century British art. In nearly seven years this direction has brought some notable successes and *The Last Romantics*, we hope, will add to these.

This exhibition looks at a strain of British painting that has long been unfashionable. Today we see these 'last romantics' carrying on their work beyond a fifty-year span, from the second generation of Pre-Raphaelites, led by Burne-Jones and Waterhouse, to the Slade School dominated symbolists, headed by Augustus John and later Stanley Spencer. Not only have the artists of this romantic inclination been out of fashion for many years, their work has been critically derided and ignored by modernist-orientated critics, since the time when Wyndham Lewis had the strength of mind to express his admiration for Burne-Jones's *Perseus Cycle* in *The Listener* in 1948. For years, the narrative sentimentality with which Victorian high art had addressed its audience seemed alien to the perception of a contemporary world, its slick techniques too clean and delineated for the brash, assertive modern artist. Now, with a current of interest in the narrative being present among many younger artists today, it is timely to reassess the work of two generations of neglected British artists, whose abundant outpourings, full of religious and mythic quests, anguished lovers and tormented souls have suffered the critical ravages of time.

Yet the reason for preparing this exhibition does not come purely from a desire for critical reappraisal. To generalise, the British public has long remained enthusiastic about narrative art, whenever museum curators have had the courage to display it, and this same audience has been sceptical throughout this century about embracing modernist work. It was challenging recently to find the Tate Gallery referring to Waterhouse's *The Lady of Shalott* as the most popular picture in the British collection at Millbank. In an age of supposedly hardened cultural sophistication, it is revealing to discover that such a tale of unrequited love, in a painting, engenders still this strong human response.

Indeed, the idea to carry out this reassessment of *The Last Romantics* was born out of the Tate Gallery's hugely popular *Pre-Raphaelites* exhibition in 1984. In this display, the final room was devoted to Burne-Jones and hinted at a mass of work that for many reasons could not be included in that exhibition. Yet the strong air of expectation that encouraged one on leaving that room to look for pictures by Waterhouse, Draper et al., elsewhere in the building, suggested another exhibition somewhere, waiting to be realised. From that time, John Christian has worked devotedly on the exhibition's preparation with the Barbican staff. But for programming difficulties, *The Last Romantics* should have been shown in advance of our *Paradise Lost* exhibition, its natural successor. Jane Alison, having worked on the earlier show, has provided a valuable link between the two studies.

Any exhibition, though, relies on many components to make it happen. Barbican Art Gallery would like to express its gratitude therefore to the many lenders who have generously contributed their works to this display and also to thank the other contributors whose work and enthusiasm has made *The Last Romantics* into the major reassessment that it is.

John Hoole
Curator, Barbican Art Gallery

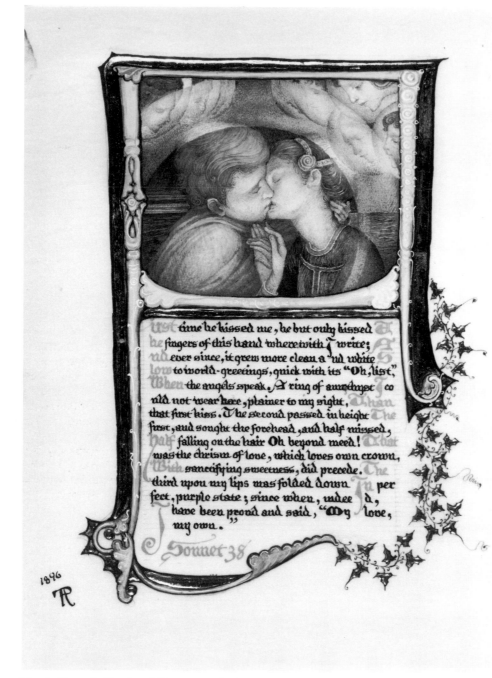

Phoebe Traquair *Illuminated Manuscript, Elizabeth Barrett Browning's 'Sonnets from the Portuguese' No 38.* Cat. 382

EDITOR'S PREFACE

An exhibition of this kind cannot be researched without help, and this I have more than received. The first task was to find exhibits, and here I am conscious of many kindnesses: from private collectors who made me welcome, shared their enthusiasms with me, and introduced me to 'new' artists; art dealers who held things for us and put us in touch with owners; and museum officials who gave me their time and made me free of those fascinating arcana, their reserve collections. Many things were found in regional museums, located initially with the help of Dr Catherine Gordon's researches at the Courtauld Institute; but I also owe a special debt of gratitude to the staff of the British Museum and V&A printrooms, who allowed me to plough through mountains of solander boxes in search of the 'right' images.

One lender, alas, cannot be thanked. George Warner Allen, who died last July, was to have lent one of his pictures, and I always thought of him (though I may have been wrong) as our only living artist. I am glad we were able to discuss the exhibition, in which he looked forward to appear in the company of his hero, Ricketts.

I could not have embarked on so large a project without the help of other specialists. The six scholars who have contributed essays to the catalogue – Lindsay Errington, MaryAnne Stevens, Paul Delaney, David Fraser Jenkins, Alan Powers and Benedict Read – have not only enriched the treatment of the subject by discussing important aspects in detail but have guided my own steps in areas where I often needed guidance. Benedict Read has been wholly responsible for selecting and cataloguing the sculpture section, while Paul Delaney helped to select the books and drafted biographical notes on Ricketts, Shannon, Glyn Philpot and Warner Allen.

There are also many others – collectors, scholars in museums and the trade, free-lance art historians and members of artists' families – whom I have pestered shamelessly for information. I hope that all these – and those to whom Benedict Read feels a similar sense of obligation – are included in the list of acknowledgements at the end of the catalogue, and offer my apologies to any who have, inadvertently, been omitted.

I am grateful to John Hoole, Curator of the Barbican Art Gallery, for inviting me to undertake the project. Jane Alison has shouldered the heavy burden of administration, ably assisted by other members of the Barbican staff. Claire Bald and Stephanie Bennet have typed the long and complex manuscript of the catalogue.

Completing the catalogue, with so many artists and so many images demanding detailed comment, has indeed proved arduous for all concerned. Where I should have been without Charlotte Burri, my kind, long-suffering and wonderfully efficient editor, I do not know. When time was running perilously short, Becky Sykes and Jane Alison both gave valuable assistance by writing or drafting material for the last four sections. Ashted Dastor has, in very difficult circumstances, produced a stylish design, and BAS Printers have performed miracles in 'turning round' copy at incredible speed. John Taylor has watched over us all with a mixture of benign reassurance and firmness which has seen us through many a crisis.

Last of all I should like to thank my family, who have coped for months with the fall-out of this operation. The 'last romantics' are like many people: delightful to know, perhaps even objects of worship – but not always easy to live with.

John Christian

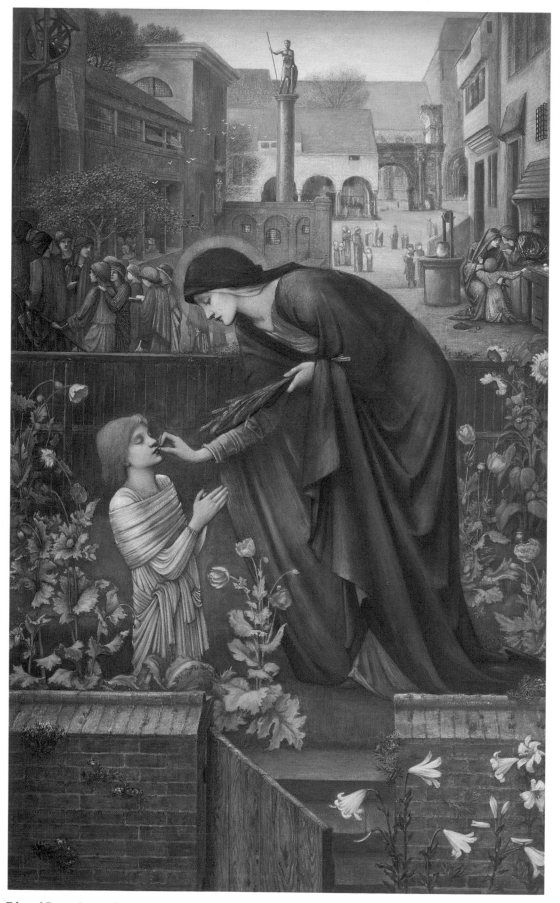

Edward Burne-Jones *The Prioress's Tale* 1865–98. Cat. 9

INTRODUCTION

John Christian

'The genius of our greatest painters . . .', wrote Herbert Read, 'was always romantic',[1] and no one could claim that in recent years this 'genius' has lacked honours. Gainsborough, Constable, Turner, Blake – all have been the subject of major exhibitions. As for the Pre-Raphaelites, their triumphant return to popularity after half a century of eclipse is one of the most remarkable features of contemporary art-historical taste. Since the great revelation of their collective talents staged by the Tate Gallery in 1984, we have moved on, seeing the so-called Neo-Romantics of the 1940s and 1950s celebrated in the exhibition *A Paradise Lost* at the Barbican two years ago. But perhaps in our enthusiasm for the romantic tradition we have moved a little too fast; between the decline of Pre-Raphaelitism in the late nineteenth century and the rise of Neo-Romanticism shortly before the Second World War there is still an important part of the tradition which is comparatively unexplored. 'Comparatively', because it has long been of interest to certain collectors and dealers, while books and exhibitions have been devoted to individual artists. However, until the present exhibition no attempt has been made to survey the field as a whole.

The reasons are partly historical – a point to which we must return – and partly implicit in the nature of the field itself. Whereas Pre-Raphaelitism and Neo-Romanticism are fairly coherent phenomena, definable in terms of time, ideals, style and social connections, we are dealing here with a period of some fifty years and a bewildering galaxy of artistic groupings. We cannot call our subject a movement; and it has never really acquired a name, 'Post-Pre-Raphaelite' and 'Traditionalist' being little more than clumsy, inadequate catch-phrases. While certain artists are central to the story, others swim in and out, including some whose focus of activity falls well outside our orbit. Indeed there were times in organising the exhibition when it almost seemed to be a question of which artists active during the period did *not* have claims for inclusion. Clearly certain guidelines had to be established, and it may be well to explain these here.

At an early stage there were plans to include a number of 'father-figures', artists who taught the more 'central' characters, acted as mentors, or could even be seen as part of the same development. Rossetti, Burne-Jones, Leighton, G F Watts, Legros, Gustave Moreau and Puvis de Chavannes – all these and more would have qualified. It soon became apparent that, fruitful though it might have been to provide this historical background, it was altogether too ambitious if we were to meet our other commitments. Yet one 'father-figure' – Burne-Jones – was clearly in a class of his own. Not only was he the crucial link with the immediate past, being the last of the great Pre-Raphaelites and a vital source of inspiration for a large proportion of our artists; he also embodied everything we meant by the word 'romantic', both in its general sense of 'poetic', the sense implied by Yeats in the passage which gives the exhibition its title:

> *We were the last romantics – chose for theme*
> *Traditional sanctity and loveliness*[2]

and in the more specific sense of spiritual descent, however remote, from the Romantic Movement. For Burne-Jones was nothing if not a child of Romanticism, whether we think of his profound debt to

Rossetti and Ruskin or the lesser parts played in his imaginative development by Blake, Keats, Byron, Scott, and the German Romantic writers.

Burne-Jones, then, was our starting point, and the first task was to show him in relation to his more immediate followers, using the term fairly loosely to embrace artists of comparable aim within his circle and those linked to him by ties of style (BURNE-JONES AND HIS FOLLOWERS). The group eventually came to include two early associates, J R Spencer Stanhope and Simeon Solomon; three artists – Fairfax Murray, T M Rooke and J M Strudwick – who were employed as his studio assistants; two of the followers – Walter Crane and Robert Bateman – he acquired by exhibiting at the Old Water-Colour Society in the 1860s; an associate of this group, E R Hughes; the two women whose names leap to mind in this context, Marie Stillman and Evelyn De Morgan; and such miscellaneous adherents as Louis Davis, W Graham Robertson, Aubrey Beardsley, E R Frampton and John Riley Wilmer. It may not be strictly logical that Burne-Jones is mainly represented by works of the 1890s, while his followers' paintings are often considerably earlier. We should remember, however, that at the end of his career Burne-Jones consciously returned to some of his earliest pictorial values. Thus a picture by Crane (Cat. 33) or Bateman (Cat. 25) which is indebted to his *Merciful Knight* (Birmingham) of 1863 may have an underlying relationship with a late Burne-Jones (Cat. 5–6) in which the master himself re-invokes the spirit of that seminal early work.

THE BIRMINGHAM GROUP was an outpost of Burne-Jones influence that demanded separate treatment, not only on numerical grounds but because of the artists' strong corporate identity, defined by their close association with the Birmingham School of Art, their commitment to the Arts and Crafts, and their preference for tempera as a medium. They were indebted to the Pre-Raphaelites generally, but their relationship with Burne-Jones, himself a Birmingham man, had a special, symbolic, significance. Remembering the lack of artistic stimulus offered by Birmingham when he was growing up there in the 1840s, he was quick to respond when, in the 1880s, his help was sought in shaping the cultural institutions created or developed at this period by the town's Liberal, Nonconformist, Ruskin-inspired elite. He accepted the Presidency of the Birmingham Society of Artists, gave informal lessons and advised on casts at the Art School, and provided spectacular examples of his own style in *The Star of Bethlehem*, the colossal watercolour he painted for the new Art Gallery (1888–91), and the four great windows he designed for the Cathedral (1885–97). All this had a profound impact on the Birmingham Group, two of whom, Arthur Gaskin and J E Southall, forged stronger links by visiting him in London. His influence is still discernible in the work of their most interesting follower, Maxwell Armfield.

Everyone remembers the Pre-Raphaelites' rather puerile joke about Sir 'Sloshua' Reynolds, but in fact they had connections with the Royal Academy right from the time when Hunt, Millais and Rossetti met as RA students and Hunt and Millais had their most innovative early works hung on the Academy's walls. The group of followers, headed by Robert Bateman, whom Burne-Jones acquired in the 1860s, were mainly RA trained; so was T M Rooke, who became his assistant

Walter Crane *The White Knight* **1870.** Cat. 33

in 1869. In the 1870s we find Academicians like Leighton, Poynter and Watts exhibiting at the stronghold of Aestheticism, the Grosvenor Gallery; while the young Frank Dicksee, who had a lineal connection with Burne-Jones through Henry Holiday, created in his famous picture *Harmony* (1877; Tate Gallery) the perfect fusion of academic and late Pre-Raphaelite values. The climax came in the 1880s, when Leighton persuaded a reluctant Burne-Jones to become an ARA; when Burne-Jones's follower J M Strudwick had a picture bought for the Chantrey Bequest; and when J W Waterhouse, hitherto known mainly for classical subjects in the Alma Tadema style, switched to Burne-Jonesian themes and types, giving them a new dimension by expressing them in the bold 'square brush' technique that he shared with his Newlyn friends and derived from Bastien-Lepage.

Clearly the exhibition had to embrace those artists who, in one form or another, continued the late Pre-Raphaelite tradition from an academic standpoint, whether they were academics by temperament, had been RA students or received comparable training abroad, or simply identified with the Royal Academy by exhibiting there on a regular basis (THE EARLY ACADEMIC TRADITION). Waterhouse and Dicksee marked the starting point, closely followed by Arthur Hacker, Maurice Greiffenhagen, and H J Draper. While none of these had quite Waterhouse's lyricism or Dicksee's feeling for the lush costume piece, they were only a few years younger, shared a broadly similar approach, and belonged to the same St John's Wood circle. Others of the same generation were the American E A Abbey, an artist one might be tempted to describe as the Alma Tadema of the Middle Ages if it were not for his command of psychology and

powerful sense of design, and that most difficult of figures to categorise, T C Gotch, a Newlyn symbolist dedicated to expressing the sacramentality of childhood. After a glance at Marianne Stokes and Elizabeth Stanhope Forbes – both, like Gotch, recipients of a foreign academic training who were subsequently associated with Newlyn – the focus then moves to a younger generation: Byam Shaw, his friend Eleanor Fortescue-Brickdale, and Frank Cadogan Cowper, all born in the 1870s. Unlike the Birmingham Group, their contemporaries, who still saw Pre-Raphaelitism as a living tradition, these artists tended to regard it as a phenomenon ripe for revival, going back to the early work of Rossetti and Millais and reinterpreting it in a more academic spirit. Inevitably with such antecedents, their work is hard and particular, a world apart from that of another contemporary, Charles Sims, the symbolist of frivolity, the master of sun-bathed forms and lost-and-found outline. Different again are the slightly older George Spencer Watson and four artists born a decade later: Harry Morley, the constructor of bold mythological figure groups, modernistic Signorellis; Dorothy Hawksley, distilling her refined style from the early Italians and Japanese prints; Russell Flint and Wynne Apperley, both of whom, when they put their minds to it, could be more than facile technicians of somewhat prurient sensibility; and that rebarbative yet compelling 'Pre-Raphaelite' of the suburbs, Noel Laura Nisbet.

Other areas that suggested themselves are discussed more fully in the ensuing essays. SCULPTURE clearly had to be included; not only was it an obvious source of exciting images but, as Benedict Read points out, had close connections with contemporary painting, Burne-Jones once again demonstrating his extraordinary power to inspire.[3]

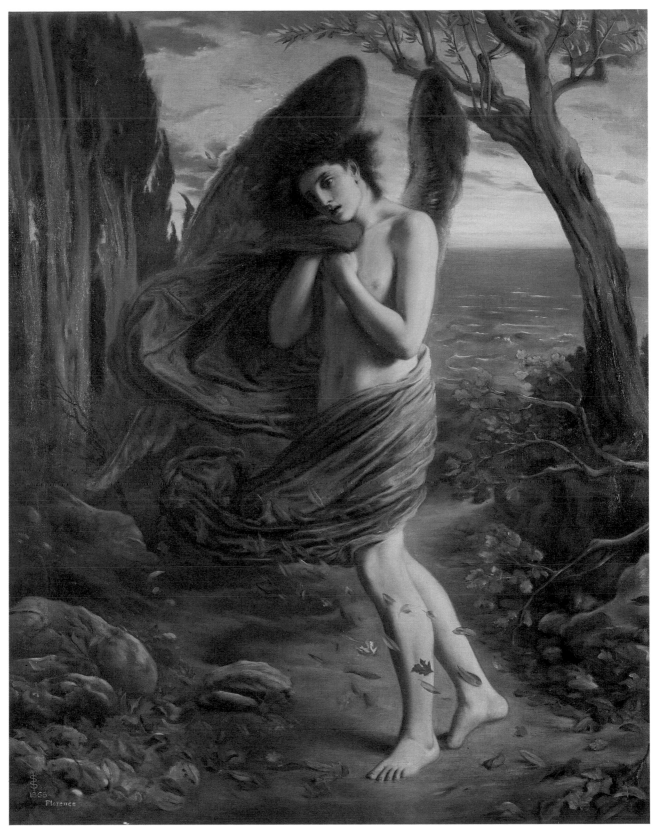

Simeon Solomon *Love in Autumn* **1866.** Cat. 20

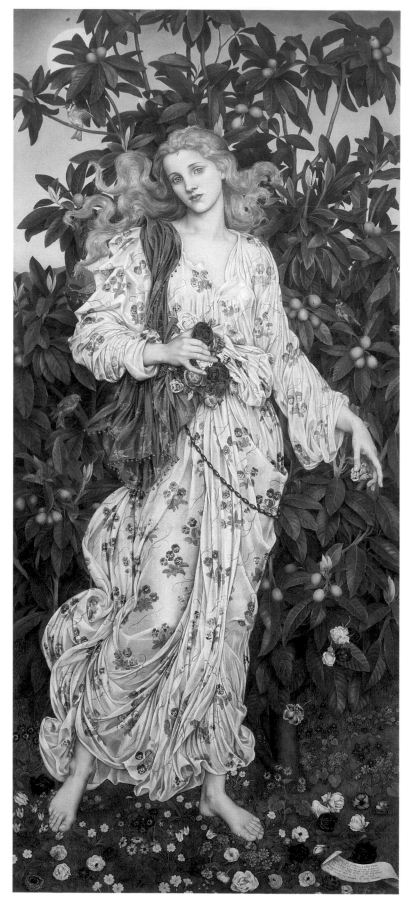

Evelyn De Morgan *Flora* **1894.** Cat 50

Indeed since most of our sculptors were Royal Academicians, the transfer of late Pre-Raphaelite values to the academic arena is seen here in its most telling form. It is scarcely accidental that a number of pieces in the show have themes – as varied as Sigurd, St George, Perseus, Guinevere and Peter Pan – that are also represented pictorially. Others bridge the gap in a different way, being by artists who were principally painters.

From the outset it was clear that Ricketts and Shannon would have a major role to play (RICKETTS, SHANNON AND THEIR CIRCLE). While yielding to none in their respect for Rossetti and Burne-Jones, they brought to the romantic tradition a welcome European element, both being ardent admirers of Puvis de Chavannes, whom they visited as students, and Ricketts betraying the influence not only of Gustave Moreau but of Chassériau and Delacroix. Their famous aesthetic partnership has attracted a good deal of attention in recent years, but the emphasis has tended to be on everything except their painting: Ricketts's brilliant personality, the Vale Press, Ricketts's designs for jewellery and the stage, Shannon's lithographs, their collecting. The exhibition, while embracing a number of their multifarious activities, was an opportunity to look primarily at their painting, and to see whether, as their admirers contend, their lyrical vision transcends the faults of drawing and technique from which their work undoubtedly suffers. At the same time Ricketts's personal magnetism could be turned to good account, providing one (if not the only) means of introducing a number of artists who came within his orbit and shared his artistic ideals: William Strang, Laurence Housman, Thomas Sturge Moore, Robert Anning Bell, Frederick Cayley Robinson, Edmund Dulac, Glyn Philpot and others. Like 'followers' and 'academic', the word 'circle' is deliberately used here in an expansive sense. It includes at least one figure whom Ricketts would probably have called an 'enemy', his rival stage-designer Gordon Craig; two artists admired and patronised by his friend Gordon Bottomley – Clinton Balmer (who owed much stylistically to Shannon) and James Guthrie; and Guthrie's friend Reginald Hallward. Also squeezed in is William Shackleton, another enricher of the romantic tradition since he is probably the only artist in the exhibition to be profoundly influenced by Turner. Indeed Shackleton, like Gotch, is a truly independent spirit, hard to place in any context. He fits well enough here, however, partly because he evidently knew Ricketts's friend Cecil French, who sat to him for his portrait and owned some of his imaginative paintings; partly because he shared Ricketts and Shannon's love of the Old Masters and admiration for G F Watts.

THE CELTIC DIMENSION was another theme that clearly needed pursuing. After all, here was the very stuff of native romance, which English artists, for all their devotion to the *Morte d'Arthur*, had hardly begun to explore. Even Burne-Jones, though of Welsh descent and a youthful reader of 'Ossian', had stopped short at Malory. At the same time there were numerous links with England: William Sharp's friendship with Rossetti; the influence of Ruskin and Morris on Patrick Geddes; Ruskin lending Phoebe Traquair illuminated manuscripts to study; the presence of John Gray and André Raffalovich in Edinburgh (Cat. 286); Duncans and Traquairs in Gordon Bottomley's collection; Greiffenhagen, Anning Bell and Cayley Robinson all teaching in Glasgow; Yeats and Hugh Lane buzzing between London and Dublin. The 'star' of this section is undoubtedly John Duncan – intentionally, since he not only fits the bill so perfectly but is so little known in England. But if Edinburgh steals the limelight, the better-known Glasgow School is well represented, while Ireland can boast a magnificent Orpen and characteristic examples of George Russell and Harry Clarke.

Then there was the tantalising notion that while many artists preserved the outward forms of Pre-Raphaelitism, the soul of the movement had passed to the brilliant pre-Great War generation of Slade School students (SLADE SCHOOL SYMBOLISTS). As Gordon Bottomley told Paul Nash, 'you for a long time and Stanley Spencer for a minute were the only true heirs of the Pre-Raphaelites'.[4] A related idea was expressed by Robin Ironside in 1940, when he wrote that 'nothing could be more mistaken than to regard the art of [Burne-Jones] as an exotic backwater', and that if it had not been eclipsed by New English Art Club Impressionism, it 'might well have brought forth a progressive symbolism which would have rendered the compelling influences of modern French painting less disconcerting'.[5] Clearly a challenge existed to explore these arguments and see whether in fact there had been some confluence of the native romantic tradition and the strong element of symbolism contained in Post-Impressionism; and this is taken up in David Fraser Jenkins' essay and the corresponding selection of pictures, which embraces not only the familiar names – John, Spencer, Nash, Gertler, Roberts, Bomberg, etc – but the Roman Catholic artist Mark Symons, another of the exhibition's incorrigible eccentrics. A further section (ROME SCHOLARS, MURALISTS AND OTHERS) is devoted to artists who, drawing on both the Slade and academic traditions, continued to paint imaginative figure subjects into the 1920s and beyond. This begins with a backward glance at Mary Sargant Florence, who, though born as early as 1857, seems to find her rightful place in this context. The emphasis, however, is on the British School in Rome, particularly its star pupil, Tom Monnington. There are also works by the versatile Leon Underwood; a group of imaginative painters, headed by Charles Mahoney, who were encouraged by Sir William Rothenstein in the 1830s (see Alan Powers' essay); and the isolated figure of George Warner Allen who died only last year, painting religious and mythological subjects to the end.

The late Victorian and Edwardian period was a golden age in British book illustration, stimulated, at least in part, by the foundation of the Kelmscott Press in 1891, brought to a close by the restrictions of the First World War. Many of our artists, from Burne-Jones onwards, contributed; indeed illustration was often the medium of their most interesting flights of fancy, offering them (in addition to income) a scale more manageable than an easel painting and a ready outlet for the imaginative faculty in decreasing demand elsewhere (the last refuge of the 'last romantics'?). Obviously this important area of activity had to be included, and the books of those illustrators who were also painters have usually been considered as part of their work as a whole. But there were a number of artists who were primarily or exclusively illustrators – some like E J Sullivan, Paul Woodroffe or Florence Harrison, who treated a variety of subjects; others, including H J Ford, Arthur Rackham and Cicely Mary Barker, who continued an honourable nineteenth-century tradition and specialised in fairy themes. All these have been included in a final section (IN FAIRYLAND), together with J D Batten, an artist whose true place (like that of Mary Sargant Florence) would have been a section devoted to tempera and fresco painters, but who fits in here because of his stylistic relationship with Ford and the fact that he himself was a prolific illustrator of fairy tales. There are also a few minor figures whom it was frankly difficult to place elsewhere – the little-known Cyril Goldie, the still more obscure Oswald Couldry, and the positively anonymous author of the charming *Vanity* (Cat. 501). While this fairy tailpiece may provide a little light relief after the sonorities of earlier sections, it is not without symbolic importance. It suggests that subject-matter may be as fruitful an approach to the 'last romantics' as stylistic trends; and by embracing some real obscurities it serves as a timely reminder of how much remains to be learnt about this field of British art.

* * *

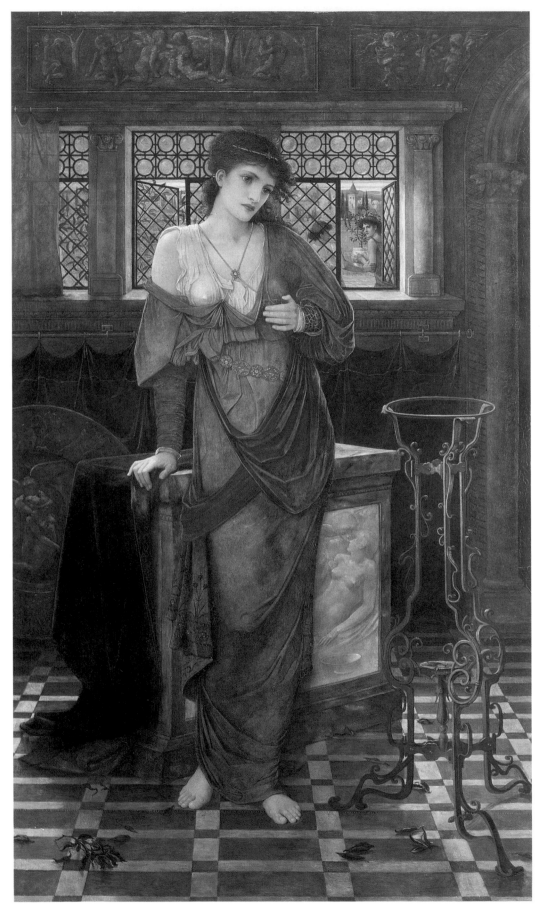

J M Strudwick *Isabella* **1879.** Cat. 44

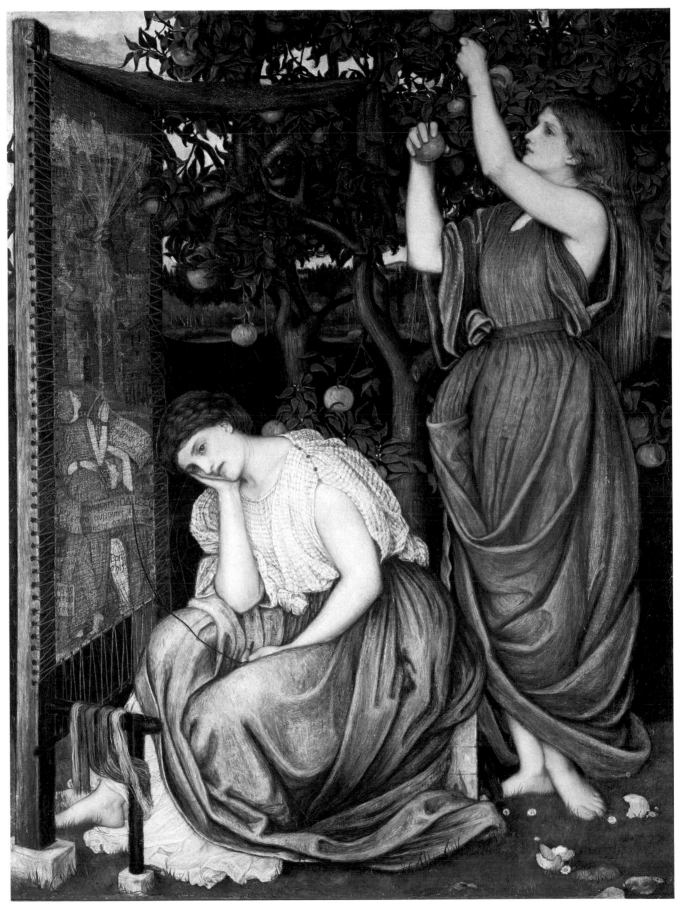

J R Spencer Stanhope *Penelope* **1864.** Cat. 1

Here, then, was the show's basic outline, hopefully imposing some sort of order on an all too refractory theme. Yet with so many artists involved, a sense of confusion could still easily have resulted. To avoid this, it seemed wise to keep to the path indicated by Burne-Jones and confine ourselves mainly to imaginative figure subjects – religious, historical, literary, or of an artist's own invention – treated in a lyrical or poetic form. There are virtually no portraits (Shannon's likeness of Lillah McCarthy in medieval dress, Cat. 255, is an exception; his studies of mice, Cat. 261, were another irresistible anomaly), while landscapes have only been included if sufficiently literary in approach. The 'pure' landscapes of John Duncan and Harry Morley failed to qualify, but moodier, more 'inhabited' examples, by Bateman, Payne, E R Frampton, Guthrie, Goldie or Nash, were welcomed. It was tempting to add F L Griggs and his followers, including the young Graham Sutherland, with their dependence on Samuel Palmer. After all, we were including artists (Laurence Housman and Vernon Hill, for instance) who were inspired by Palmer's master, Blake. Yet somehow this seemed wrong, an encroachment on ground that the Neo-Romantics were to make peculiarly their own.[6] Paul Nash, though also a forerunner of the Neo-Romantics, was in a different category: his early debt to the Pre-Raphaelites made him definitely 'our' property.

There were other arbitrary decisions, vaguely related to the Burne-Jones model. While medieval, classical, oriental and even modern dress were acceptable, if treated in a sufficiently imaginative way, it seemed wiser to avoid the eighteenth-century revival (although a Tiepolesque Anning Bell, Cat. 241, did slip in). This is the reason for the omission of Conder. Quite why modern dress passed muster when it was never introduced by Burne-Jones, it is hard to say. Perhaps it has something to do with the practice of the early Italians, to whom so many of our artists, including Burne-Jones, looked back. Certainly Harry Morley, Stanley Spencer, Charles Mahoney and others all used it in precisely the Italian manner.

The reader will have guessed that to achieve our sense of homogeneity, many artists have had to be extensively 'edited'. Beardsley, for instance, appears as the illustrator of the *Morte d'Arthur*, not of *The Rape of the Lock* (more eighteenth century), still less as the *enfant terrible* of *The Yellow Book*. Glyn Philpot features as the painter of lyrical subject pictures dating from the period when he was influenced by Ricketts and Shannon, not as the fashionable portrait painter or the anxious seeker after a more 'modern' style. Indeed several artists lost their flourishing portrait practices, including Dicksee, Hacker, Draper, Shannon and Sims, although the most extreme cases were McEvoy and Orpen, whose portraiture was totally disregarded in favour of rare excursions into imaginative subject-matter. Similarly, though in quite different fields, Clausen scrapes in with his murals but is ignored as a follower of Bastien-Lepage and Millet; Elizabeth Stanhope Forbes figures not as a Newlyn *plein-airiste* but as an unconventional illustrator of Arthurian themes; Heath Robinson is admitted for his *Midsummer Night's Dream* and Rabelais designs, not as a caricaturist and inventor of preposterous gadgets; while Russell Flint appears as the illustrator of Theocritus, Malory and Keats, not as the relentless purveyor of tasteful titillation. Even within the field of subject painting some discretion has been used. Arthur Hacker, an artist who made a virtue of varying his style, is represented by two of his more 'Pre-Raphaelite' works, an Arthurian theme and a Giorgionesque figure group, while his thorough-going essays in the French academic manner have been avoided.

Certain omissions make positive points about the exhibition. Why, for instance, did Brangwyn not fit in (he was not without advocates)? Perhaps because his particular brand of romance was essentially public – the romance of industry, imperialism, adventure on the high seas – whereas the artists in the exhibition, even the most rhetorical, were concerned with exploring a private world of their own. The point is neatly illustrated if we compare his British Empire panels, commissioned for the House of Lords in 1926, with John Duncan's treatment of a comparable theme, *Ivory, Apes and Peacocks* (Cat. 395). While the Duncan demanded inclusion, the Brangwyns (assuming such huge works were borrowable) would have struck a discordant note, and disrupted the dream-like surface of the show.

There could also have been more 'fantastic' illustrators – Sidney Sime, Austin Spare, Alan Odle, Willy Pogány, Kay Nielsen, and others. It cannot be claimed that everything included is, in Coleridge's famous analysis, the product of Imagination rather than Fancy, although this distinction must have been familiar to many of our artists, if only from Ruskin's adaptation of it in *Modern Painters*.[7] But there is a certain imaginative restraint, a refusal to opt for mere visual conceits. In fact it needed little to achieve this emphasis, which is typically English. Pogány was Hungarian by birth and Nielsen Danish. The artist included who comes nearest to them is the Irishman Harry Clarke, and even the Scot John Duncan could be very weird at times.[8] On the other hand, Burne-Jones, presumably thinking of Coleridge, once criticised Hoffmann for being 'fantastic, not imaginative'. He also refused to exhibit at the Salon de la Rose + Croix, which took its tone from its organiser, the exotic 'Sâr' Péladan, and represented European Symbolism at its most self-indulgent. Later we find Ricketts (surprisingly, perhaps, in view of his admiration for Moreau) constantly expressing his hatred of '"individualism" and the lack of discipline, subordination, sense of proportion, which goes with it'.[9] George Warner Allen, to whom Ricketts was a hero, even objected to the title of the exhibition, arguing that for him the word 'romantic' had 'connotations of egotism, self-expression of hardly existent personalities, etc.'[10]

Most significant of all was the decision to steer clear of the Arts and Crafts – stained glass, metalwork, needlework and so on – even though many of the artists, notably the Birmingham Group, were deeply involved (Anning Bell's painted reliefs and Phoebe Traquair's illuminated books were border-line cases that just got in). Although this was a practical decision, to prevent the exhibition growing out of hand, in retrospect it put the emphasis firmly on visual imagination, on the question of how an artist represents a religious, mythological or literary theme in an age when the time-honoured iconographies are losing their currency and many doubt the validity of treating such themes at all. The answers provide the drama of the exhibition, for if the field of expression is deliberately restricted, the approach is endlessly varied. A subject that Burne-Jones imbues with poetic intensity will be made more decorative by Strudwick, more prosaic by Crane, more theatrical by Dicksee, or simply sent up by Beardsley. Where Sims finds significance in spring and sunlight, Harry Clarke offers us a closed, alchemical world of jewelled monstrosities. Southall sees Salome in terms of Edgbaston, Spencer insists that the Bible is enacted in Cookham. Armfield and Cadogan Cowper play games with art-historical reference, Bomberg's response to Michelangelo is to strip a subject to its barest formal essentials. Eric Robertson's celebration of a saucy sexuality stands at the opposite extreme to the 'Children's Corner' piety of Margaret Tarrant or Cicely Mary Barker.

* * *

So much for the diversity of the subject. It is not hard to think of other artists who might have been included, and some will quarrel with the choice of those who are. Ultimately, however, a show of this kind has to be an exercise in subjectivity, and is perhaps none the worse for that.

It remains to say something of the changes of taste which are also reflected in the timing of the exhibition. The Pre-Raphaelite revival

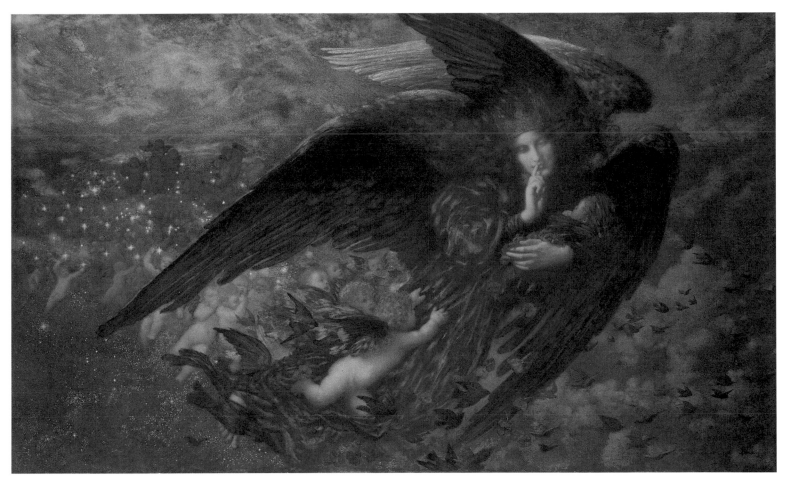

E R Hughes *Night with her Train of Stars* c1912. Cat. 49

may date back some twenty years, but these later ramifications, though often the subject of specialist interest, still have an air of being 'new', uncharted territory. Ironically, the only artists we feel we 'know' (with the possible exception of Burne-Jones, and even he could not have been included until recently) are the 'Slade School symbolists', considered revolutionary in their day but long since enshrined in the canonical view of the development of modern British art. One orthodoxy has replaced another, and it is with the older orthodoxy that this introduction is now primarily concerned.

It is important not to confuse the eclipse of the 'last romantics' with the fact that literary subject painting was never a majority taste in England. Oscar Wilde, lecturing in America in 1882, felt obliged to defend the Pre-Raphaelites' lack of popularity with a characteristic witticism: 'To know nothing about their great men is one of the necessary elements of English education'. Nonetheless, Burne-Jones lived to see his reputation, at its height in the 1880s, decline. When late paintings like Love Leading the Pilgrim (Tate Gallery), exhibited in 1897, failed to sell, he would tell T M Rooke philosophically that 'I must be prepared for public weariness about me . . . I've had a good innings'. He was also correct in identifying the chief threat to his position as the advent of Impressionism – 'a blow I shall never get over'.[11] In 1904 George Moore, the self-appointed prophet of Impressionism in England, described him as 'the worst artist that ever lived, whether you regard him as a colourist, a draughtsman, a painter or a designer'.[12]

Theoretically, as Robin Ironside has reminded us, Roger Fry's Post-Impressionist exhibitions of 1910 and 1912 could have brought about a rapprochement, a pooling of the symbolist elements in Burne-Jones and Post-Impressionism. But quite apart from the fact that Burne-Jones was rapidly going out of fashion – partly due to Impressionism, partly as a result of the inevitable reaction to such a characteristic and influential phenomenon, the Post-Impressionist emphasis would probably have had to be on Gauguin (see MaryAnne Stevens' essay, and under the puritanical auspices of Fry, who believed that a work of art's highest spiritual benefit was conveyed through 'the contemplation of form', it was unequivocally on Cézanne. (Significantly, Charles Ricketts, though he had little use for Cézanne or Van Gogh, found 'flashes of real lyrical feeling' in Gauguin;[13] nor should we forget the influence of Gauguin on Strang and, probably, E R Frampton; see Cat. 64.) At all events by 1914 Sickert was writing that 'the Burne-Jones attitude is almost intolerable to the present generation',[14] and this is confirmed by Vanessa Bell who, on reading Lady Burne-Jones's life of her husband in 1916, wrote to Fry as follows: 'How perfectly awful and how provincial those Victorians were, . . . B J himself simply deteriorated into a machine I think. He went on with his incredibly sentimental owl in an ivy bush view of himself and his holy mission completely ignorant of the whole of French art of this time, impressionists and all . . . I see the only hope for the English is to get outside their island pretty often.'[15] She cannot have read the book very carefully since Burne-Jones's relationship with Puvis de Chavannes, the popularity of his work in Paris, and his hope that 'a splendid school of painting [would] yet . . . come out of France', are all discussed. Presumably none of this counted in view of his misgivings about Impressionism, which are also recorded.

Dying in 1898, Burne-Jones was not seriously affected by the reaction against what Sickert called his 'attitude'. But most of the 'last romantics' were still in mid-career, or indeed scarcely launched. We see the reaction reflected particularly in the work of academic painters, many of whom turned increasingly to portraiture as the fashion for subject pictures declined. There is more than a hint of critical *ennui* in press comment on Waterhouse's painting *The Danaïdes* (Aberdeen), exhibited in 1906, *The Times* dismissing it as 'a decorative bit of

mythology' and the *Athenaeum* complaining that the figures had 'the fretful weariness of Kentish Town housewives oppressed by eternal cleaning'. Byam Shaw saw his early masterpiece *Love of the Conqueror* (private collection), sold off the easel in 1899 for £1,000 and subsequently reproduced in a popular engraving, knocked down for 42 guineas when his dealers, Dowdeswell's, went into liquidation eighteen years later; and it is probably significant that subject pictures by Dicksee and Greiffenhagen included in this exhibition were still on the artists' hands when they died. Charles Ricketts would have sympathised. 'Our career has been a constant bluff . . .', he wrote of himself and Shannon in 1905, 'we have against us the growing public indifference to art, and the hostility of the artistic world, which tends, as always, to a different current of effort, ie "the smart rendering of chance things in Nature"'.[16] In 1915 he had the humiliating experience of hearing that 'some youngster genius . . . who does decoration of sorts in the new style', had spoken of him and Shannon as 'those back-numbers, those effete Victorians with their rarefied airs and aesthetic sense, who lean heavily on the Old Masters'.[17] Perhaps the 'genius' was a pupil at the Slade under Tonks, who once said of Ricketts's work, 'Of course some people may think it very nice, but it is just NOT painting'.[18]

Believing as he did that style should be based on an intelligent study of the art of the past, Ricketts was upset by the incident, which in any case came at a particularly unfortunate time. Reading a new novel by Anatole France in March 1914, he had detected in it 'a sense of fear which is, I believe, fairly widespread among thinking men, who dread some sort of decivilising change, latent about us, which expresses itself especially in uncouth sabotage, Suffragette[s][19] and post-Impressionism, Cubist and Futurist tendencies'.[20] The outbreak of war later that year confirmed his worst forebodings, and he felt 'old beyond belief, a survivor from the romantic epoch which welcomed all Art manifestations and discovered "that approximate eternity" which we can compass by familiarity with the past'.[21] Indeed the war, with its appalling loss of life and wilful destruction of his beloved works of art, dealt him a psychological blow from which he never fully recovered. He used to say that he 'died during the war'. To Yeats he wrote in 1922: 'these many years of fear, anxiety, fatigue and disillusion have had a wearying effect. I know I am a quite useless survival from another age, and because the future has no use for me I look at it like a sheep in a railway truck.'[22]

Ricketts is a prime example of what might be called 'last romantics' syndrome', an acute sense of alienation induced by the march of modernism, and of fighting a rearguard action on behalf of an older, richer, hopelessly doomed culture. This is what makes Yeats's couplet so relevant (even if in fact there is never a 'last' romantic). Variations on the theme are not hard to find.[23] J M Strudwick seems to have stopped painting years before his death, probably because of discouragement, and Graham Robertson certainly abandoned his brushes about 1920, seeing no place for his art in 'this new and beauty-hating' post-war world. Never (as he was the first to admit) a powerful artistic personality, he was happy to find other outlets for his versatile talents in the theatre, but this did not prevent him constantly lamenting the changed artistic climate. On the death of his friend and heroine Sarah Bernhardt in 1923, he wrote: 'This passing of almost the last Great Romantic Figure of the past century seems to emphasise the death of Art and Beauty and to reveal the full dreariness of the ugly desert stretched around us'.[24] His tone was still the same in the 1940s. 'I have lived for long, happy years . . . in a lovely land of art and literature where men strove earnestly and, I think, nobly to create and perpetuate beauty. Now that land has been invaded and overrun by a rabble rout, who have profaned its innermost sanctuaries and polluted them with ugliness and obscenity . . . I am sorry that I ever

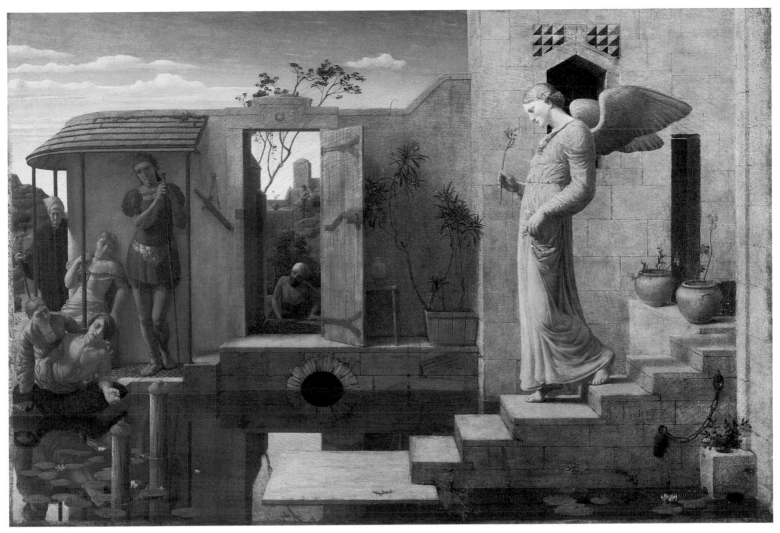

Robert Bateman *The Pool of Bethesda* **1876–7.** Cat. 26

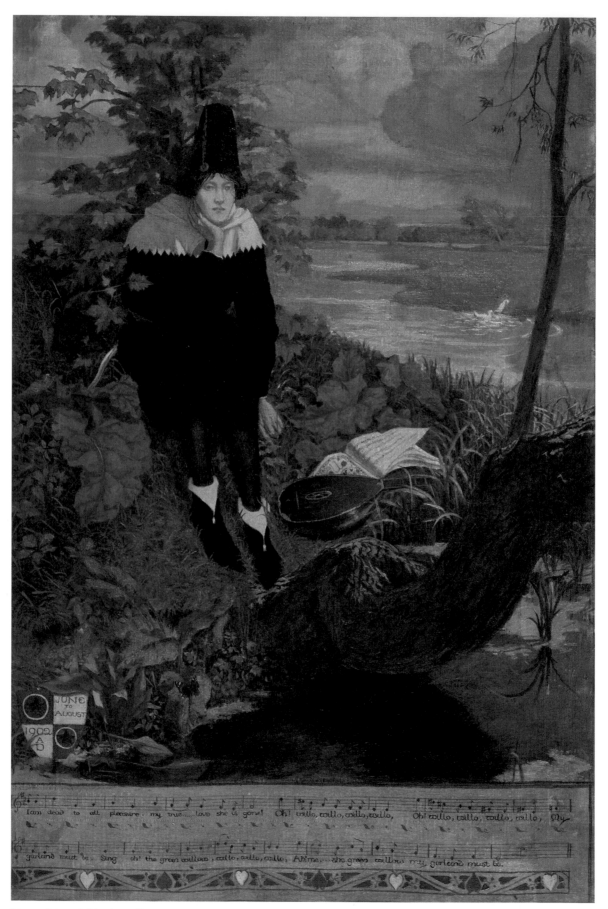

Maxwell Armfield *Oh! Willo! Willo! Willo!* **1902.** Cat. 103

tried to be a painter and bitterly ashamed of my late profession.'[25]

The circumstances of Frank Dicksee, who ended his career as PRA after many professional triumphs, could hardly be a greater contrast; yet he died bewildered and disillusioned, tired of fighting battles with modernists and widely dismissed as irrelevant. Different again was the case of Harry Morley, whose painting *Apollo and Marsyas* (Cat. 171) was bought for the Chantrey Bequest the year Dicksee became President. An artist who temperamentally needed the support of tradition, he was forced to look back to Reynolds, Vasari and even Cennino Cennini in search of a context for his literary figure subjects. The rather older John Duncan, though never without followers, was similarly cut off from the main art currents in Edinburgh; while Cecil French, friend and patron of many 'last romantics', refused to leave his collection to the Tate Gallery because of its modernist sympathies. Among a younger generation, Charles Mahoney was so haunted by a conviction that his work was unappreciated and a fear that he would lose his teaching post at the Royal College of Art, that he felt unable to complete his series of murals in Campion Hall, Oxford (Cat. 479–81). As for George Warner Allen, he suffered a lifelong sense of isolation. Interestingly enough, for him as for Ricketts, war and the condition of art were closely related. He would often recall how, as a student at the Byam Shaw school in the late 1930s, vividly aware of the rise of the Nazis and his head 'full of the glories of the Raphael Stanze', he 'burst forth with a lament for the coming horrors, the declining civilisation and the lack of opportunities for artists', and received the sage advice from his master F E Jackson, 'I know, Allen, I know, but just keep the place warm'. This remark, he wrote shortly before his death, became 'the lode stone of my work'.[26]

But we must be careful; such attitudes, though characteristic, were by no means universal. Not everyone voiced the anguish and hysteria we find in Ricketts and Robertson – two highly articulate characters whose utterances happen to have been preserved. William Shackleton, exhibiting pictures at his native Bradford in 1918, explained that his aim was 'to penetrate below the surface of things to the meaning of life; through the interpretation of facts or the evocation of images to approach to the eternal verities and mysteries'. One could hardly be more romantic than this, yet Shackleton was careful to add that 'these opinions are my own, and other artists and critics may have different ones'.[27]

We have also seen that attitudes to 'modern' art were complex, with Ricketts finding virtue in Gauguin, and Gordon Bottomley, who knew both Ricketts and Robertson well and passionately admired Ricketts as an artist, encouraging Spencer and Nash. Bottomley also found himself 'sometimes attracted' by the Post-Impressionists, 'liked' Roger Fry 'very much', thought Nevinson's work 'noble', and discerned 'an original feeling for beauty' in that of William Roberts.[28] His fellow poet Laurence Binyon plotted a similar course; though again very close to Ricketts, it was he, as David Fraser Jenkins observes, who provided the intellectual basis for a decorative style practised briefly by several Slade-trained artists. (Ricketts's 'youngster genius' doing 'decoration in the new style' could well be in the exhibition.) Others who bridged the gap were Harry Morley, who admitted that his monumental style owed something to Cézanne and Clive Bell's Cézanne-inspired concept of 'significant form';[29] Mark Symons, whose combination of formal distortion with naturalistic detail reflected his ability to appreciate both the Pre-Raphaelites and Picasso; and Charles Sims, whom Paul Nash described in 1920 as 'the only Academician . . . who has interest and sympathy with modern work outside Burlington House'.[30] Indeed this 'sympathy' was to explode in Sims' own late paintings, rather as Glyn Philpot was to reach an accommodation with modernism in the 1930s. There must have been others who were ready to look at 'modern work', and even

perhaps subconsciously felt its influence. In old age, Dorothy Hawksley, while yielding to none in her admiration for Piero della Francesca and 'Mike' (as she called the painter of the Sistine Chapel), would calmly discuss the merits of Max Ernst or Munch.

Worst of all would be to think of the 'last romantics' as a set of helpless victims, unable to make their way in a hostile world. Perhaps there is no real danger of this, having mentioned Sir Frank Dicksee, and seen that he was only one of the large contingent of Royal Academicians included in the exhibition. Leighton may have failed to hold Burne-Jones, who resigned in 1893, but younger adherents of the Pre-Raphaelite tradition, if not, like Dicksee and Waterhouse, already within the Academy, were soon joining in force. The most graphic example is the migration of founder or early members of the New English Art Club, launched in direct opposition to the Academy in 1886. Hacker, Anning Bell, Shannon, Greiffenhagen, Strang, Sims and Cayley Robinson all became RAs or ARAs between 1894 and 1921. So did another NEAC founder who is just included here, George Clausen, while T C Gotch is said to have missed being elected ARA by a single vote. Since most of these artists had received academic training, either in London or Paris, the Academy was their spiritual home; but economics were important too. Shannon was 'delirious with his dread of ridicule' when in 1905 Clausen suggested putting him up for membership, but Ricketts pointed out that 'the future is uncertain'[31] and Shannon became an Associate six years later. In due course Ricketts was to follow him, and indeed played a large part in Academy affairs. In all, the exhibition includes two Presidents – Dicksee and Monnington – forty-two RAs and ARAs, and artists who between them were responsible for some seventy Chantrey purchases. Most of these artists were Academicians, but there are some important exceptions, including Bayes, Draper, Gotch, Reynolds-Stephens, Rooke, Sargant Florence, Strudwick and Toft. Of course many more exhibited at the Academy without any official recognition – even such a wayward character as Mark Symons.

The Academy, however, was by no means the only venue for the 'last romantics'. Many followed Burne-Jones and supported the Grosvenor and New Galleries. E R Hughes was Vice-President of the Royal Water-Colour Society; Strang was President and Shannon Vice-President of the International Society; Gotch's links with Australia caused him to be Vice-President of the Royal British Colonial Society for fifteen years. Duncan showed regularly at the Royal Scottish Academy, becoming an Academician in 1923; E R Frampton identified closely with the Royal Institute of Oil Painters; William Shackleton, the Geres, Maxwell Armfield and others were loyal to the New English Art Club. Many forged links with commercial galleries in London – Dowdeswell's, Dunthorne's, Baillie's, Van Wisselingh's, the Carfax, the Cotswold, the Leicester, the Fine Art Society, and Barbizon House. Many sent to the big provincial exhibitions – Liverpool, Birmingham, Bradford, etc, often finding that their work was bought for the local Art Galleries; paintings in the exhibition by Eleanor Fortescue-Brickdale, Dorothy Hawksley and Annie French all adhere to this pattern. Others, again following Burne-Jones, established international reputations, both by exhibiting abroad and by the publication of their work in the *Studio* and other journals. While Crane and Anning Bell are probably the outstanding examples, they are far from unique. Hughes was represented at the first Venice Biennale in 1895; Shannon and Draper won medals respectively at the Munich Exhibition of 1897 and the Paris Exhibition of 1900; Waterhouse was similarly honoured in Paris and Brussels, exhibited in Chicago and St Louis, and had four important early pictures bought for public collections in Australia.

We have already touched on certain areas of professional success: artists who had flourishing portrait practices; Ricketts's distinguished

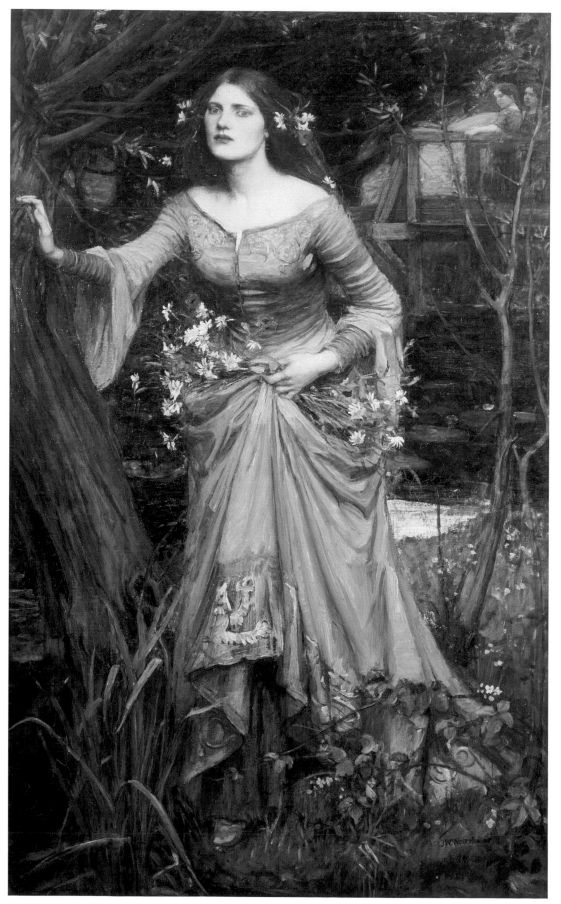

J W Waterhouse *Ophelia* 1910. Cat. 113

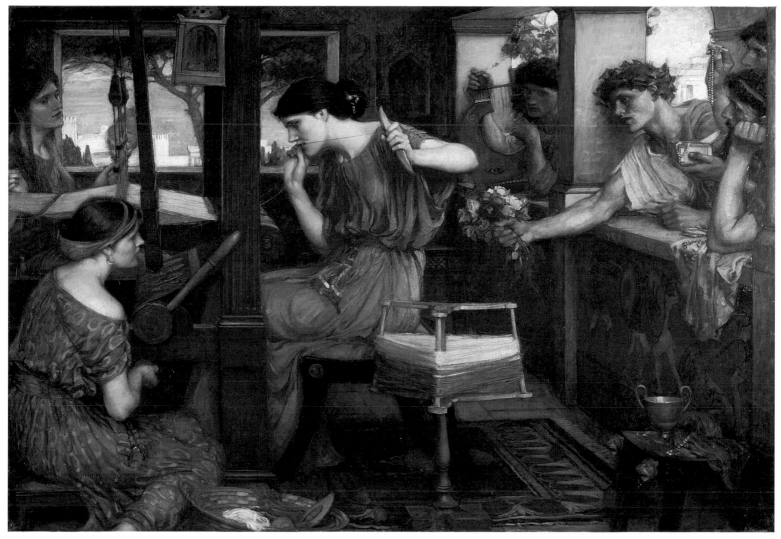

J W Waterhouse *Penelope and her Suitors* **1912.** Cat. 114

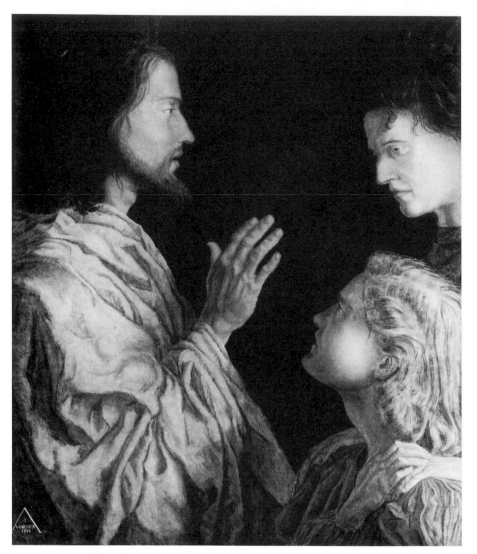

George Warner Allen *Christ with Martha and Mary* **1949.** Cat. 485

career as a designer for the stage; and the many who found niches in the world of book illustration. These would often establish a close working relationship with a particular publisher: C M Gere with St John Hornby, Batten with David Nutt, Dulac with Hodder and Stoughton, Margaret Tarrant with the Medici Society, to name but four. Other artists received prestigious public commissions. Byam Shaw, Henry Payne and Frank Cadogan Cowper contributed to the murals in the East Corridor of the Palace of Westminster (1908–10); Clausen, Sims, Philpot, Forbes, Monnington and Colin Gill were all involved with those in St Stephen's Hall (1927). Anning Bell's many public works included the mosaic tympanum over the entrance to Westminster Cathedral, and the number of official commissions given to sculptors is almost beyond count. In Edinburgh Robert Burns, John Duncan and Phoebe Traquair all carried out murals, while J E Southall, S H Meteyard, Kate Bunce and others were similarly employed in and around Birmingham. Many had the support of rich private patrons. Strudwick was collected by two Liverpool ship-owners, William Imrie (Cat. 47) and George Holt (Cat. 45), Southall by his fellow Quakers, the Cadburys. Payne worked for years on Lord Beauchamp's chapel at Madresfield (Cat. 99); Cayley Robinson's Middlesex Hospital murals were paid for by Sir Edmund Davis, who also supported Ricketts, Shannon and others (see Paul Delaney's

essay). Lord Northcliffe, Lord Blanesbrough (Cat. 232), Sir Hugh Lane and Judge Evans were all active in this area of patronage, not to mention the Wolverhampton brewer, Laurence Hodson (Cat. 218). One of Phoebe Traquair's finest illuminated manuscripts was commissioned by Lord Carmichael of Stirling (Cat. 384).

In other ways too the 'last romantics' tasted the fruits of success. Some were popular and influential teachers – Crane at Manchester, Waterhouse at St John's Wood, Greiffenhagen at Glasgow, Anning Bell at Liverpool, Glasgow and South Kensington. Byam Shaw had his own art school; several were involved with the British School in Rome. Many were prominent in the Arts and Crafts Exhibition Society or luminaries of the Society of Painters in Tempera. No fewer than thirteen of our somewhat arbitrary selection – Crane, George Frampton, Holroyd, Strang, Pomeroy, Clausen, Rackham, Anning Bell, Bayes, Ernest Jackson, Sullivan, Morley and Garbe – were Masters of the Art Workers' Guild. Others again, art historians as much as artists, shone in the world of museums. Holroyd was the first Keeper of the Tate, then Director of the National Gallery, and wrote a monograph on Michelangelo; Ricketts was offered the National Gallery Directorship, advised the National Gallery of Canada, sat on several art committees, and wrote books on the Prado and Titian. Fairfax Murray was a highly respected dealer in works of art.

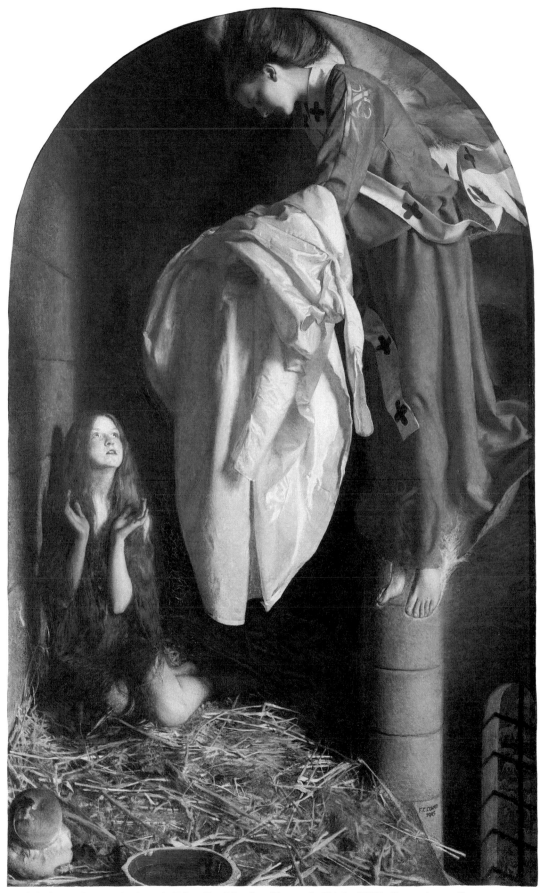

Frank Cadogan Cowper *St Agnes in Prison Receiving from Heaven the Shining White Garment* 1905. Cat. 159

Ultimately, no doubt, it is all a matter of perspective. If some of the 'last romantics' saw themselves as last-ditch defenders of a dying culture, to the prophets of the new dispensation they were part of an all too well-entrenched establishment. Indeed it was precisely because they were so well established that they had to be attacked so hard. To us, with the luxury of hindsight, they seem above all exponents of a flourishing alternative culture, respected by those not concerned with artistic fashion, valued for their ability to paint a mural, design a war memorial, conceive a dramatic stage set or illustrate a children's book, but not carrying much weight with the *cognoscenti* or likely to find their way into the history books. This is the underlying picture which emerges from Roger Fry's account of addressing the Art Workers' Guild in 1917: 'I gave them a terrific sermon about their attitude to art . . . and their desire to make everything moral and what not. They were as meek as lambs . . . But of course they are so fundamentally stupid that I don't suppose it's much good.'[32] Another non-meeting of minds took place when Fry visited Birmingham a few months later. 'Stayed with Southall, a little slightly disgruntled and dyspeptic Quaker artist who does incredible tempera sham Quattrocento modern sentimental things with a terrible kind of meticulous skill, but who was goodness itself and so generously open-minded.'[33]

Needless to say, the Royal Academy bore the brunt of avant-garde hostility, always simmering but never stronger than in the 1920s and 1930s, when a series of celebrated clashes gave it a special force. The hapless Dicksee, who was President at the time of particular friction over the administration of the Chantrey Bequest, and was still exhibiting pictures like *The End of the Quest* (Cat. 121) as late as 1921, acquired an almost symbolic significance as everybody's bogeyman. Early in 1933 the Academy held an exhibition to commemorate recently deceased members, with groups of works by Dicksee, Greiffenhagen, Ricketts, Orpen, Sims, George Frampton, Pomeroy and Mackennal. *The Times* made it the subject of a leading article but felt obliged to explain Dicksee to its readers as a period piece and point out that at least the show had the virtue of being intensely English; it also anticipated 'titterings in Bloomsbury'. In fact the exhibition was poorly attended, as several correspondents, including Clausen and J W Mackail, complained. Among the visitors, however, was the young George Warner Allen, who was much inspired.

Another sign of the times was the Burne-Jones centenary exhibition, held the same year at the Tate Gallery. That it took place at all is significant, and despite dire predictions from surviving members of the artist's family and circle, it was adequately, if a little patronisingly, reviewed, and well attended. Yet for J B Manson, the Director, and his assistant, H S Ede, it was a duty rather than a pleasure. Old Mrs Gaskell, Burne-Jones's last Egeria, wrote to Ede: 'I wonder has it made you like him any better? or do you still think Sickert's magenta lady on the wall close by the art to worship?'[34] Sickert's 'magenta lady', the then recently-acquired full-length portrait of Gwen Ffrangcon-Davies, also figures in Graham Robertson's account of visiting the exhibition. Though not an altogether reliable witness (he had advised against holding the show on the grounds that it was bound to be misunderstood), his description of seeing Manson 'marshal' two visitors up to the Sickert with the words 'Now here *is* something fine', has the ring of truth.[35]

More research needs to be done on this area of taste, with its fascinating overlaps of starkly contrasting values. Also highly relevant are the Ricketts and Shannon studio sales (1933, 1938) and those of their patron, Sir Edmund Davis (1939, 1942), at which their work fetched pitifully low prices. Several items in the studio seem to have been given to the servants, as if even this were better than nothing (Cat. 290).

Perhaps most telling of all is to see how the 'last romantics' fare in books of the period. R H Wilenski's *The Modern Movement in Art* (1927) gives them the full Fry treatment. When Cézanne is the hero for returning to 'classical architectural formal art', and Gauguin has 'confused the issue' by not breaking completely with 'the romantic heresy of the nineteenth century', it stands to reason that Burne-Jones should be condemned for his 'ragout of pseudo-romantic subjects and . . . degenerate Pre-Raphaelite technique' and his followers dismissed as 'still more addled in mind'. Not everyone was so contemptuous. A less polemical book, Charles Johnson's *English Painting* (1932), has words of praise for Burne-Jones, Cayley Robinson and Strang; Eric Underwood in his *Short History of English Painting* (1933) even calls Waterhouse 'a painter of great imaginative power'. But with C H Collins Baker's *British Painting* (1933) we are back in Wilenski-land. Burne-Jones is a 'mediocre artist', 'a weakling aesthete' indulging 'girlish dreams'; his followers – 'a small chaste school' – are relegated to a single footnote; while their academic contemporaries are petulantly summed up as a group 'on whom, so far as I am responsible, oblivion shall settle undisturbed'.

The emergence of Neo-Romanticism brought a more enlightened attitude, of which Robin Ironside's *Horizon* article on 'Burne-Jones and Gustave Moreau', already quoted, is the shining example. Here at last was a critic prepared to acknowledge that it was useless to approach Burne-Jones 'with the notion that "formal relationships", "pattern", "structure", etc., have any absolute value' in his work. Even Ironside, however, is hard on Burne-Jones's followers, among whom he includes Solomon, Beardsley and Ricketts ('their talent . . ., though occasionally exquisite, was minor'[36]), while John Piper in his *British Romantic Artists* (1942) jumps from the Pre-Raphaelites to the Neo-Romantics with the comment that the intervening period shows 'Pre-Raphaelite parentage . . . very little'. Anthony Bertram's *A Century of British Painting* (1951) at least discusses the subject at length, but he is deeply unhappy about the Burne-Jones phenomenon ('the Medieval Revivalists knocked the guts out of the Middle Ages'), embarrassed by Ricketts and Shannon ('I can never focus them'), and turns with 'relief' from Dicksee. As for Sir John Rothenstein's lavishly illustrated *British Art since 1900* (1962), after being told that 'the decades that followed the dissolution of the pre-raphaelite [sic] Brotherhood in the 'fifties were . . . the bleakest in the whole history of English art', we can hardly expect reproductions of Southalls, Duncans, Cayley Robinsons, Shackletons or Philpots. In fact almost the only artists featured who reappear in our exhibition are those in the Slade School section; the exceptions are Eric Gill, Leon Underwood, and Sir William Rothenstein's protégé, Charles Mahoney.

To be fair, the Pre-Raphaelite/Symbolist revival had not taken place when Rothenstein was writing. It is reflected in Richard Shone's survey of the same period, *The Century of Change. British Painting since 1900*, published in 1977; but old ideas die hard, as we saw in the exhibition *British Art in the Twentieth Century* at the Royal Academy in 1987. Here again, with the single exception of Eric Gill, there was no overlap with our exhibition other than in the Slade area. True, this was an exploration of British art 'within the context of the Modern Movement'; but as several reviewers pointed out, even if 'modernism' is a valid concept (which is questionable), it is no longer possible to define it in these terms.

In 1933 Roger Fry visited the Burne-Jones centenary exhibition and wrote: 'I want to write on him. We can look at him now quite dispassionately and I've always maintained he had some qualities'.[37] More than half a century on, and 'dispassion' is still needed. After all, if Fry found Southall 'terrible', we now know that Picasso (who had been inspired by Burne-Jones in the 1890s) tried to buy pictures by Southall, no doubt recognising a fundamental affinity in the way

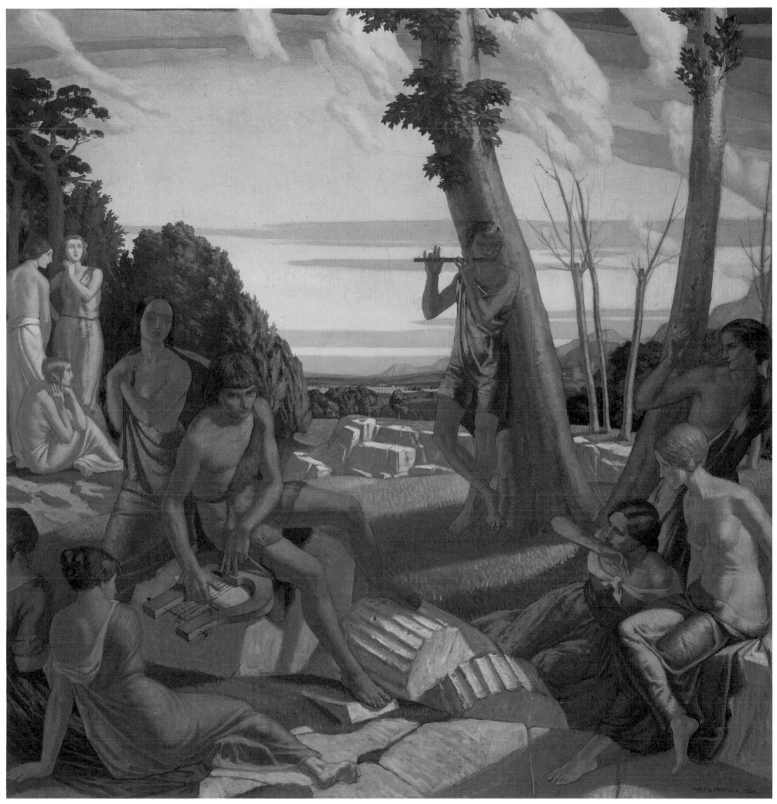

Harry Morley *Apollo and Marsyas* **1924.** Cat. 171

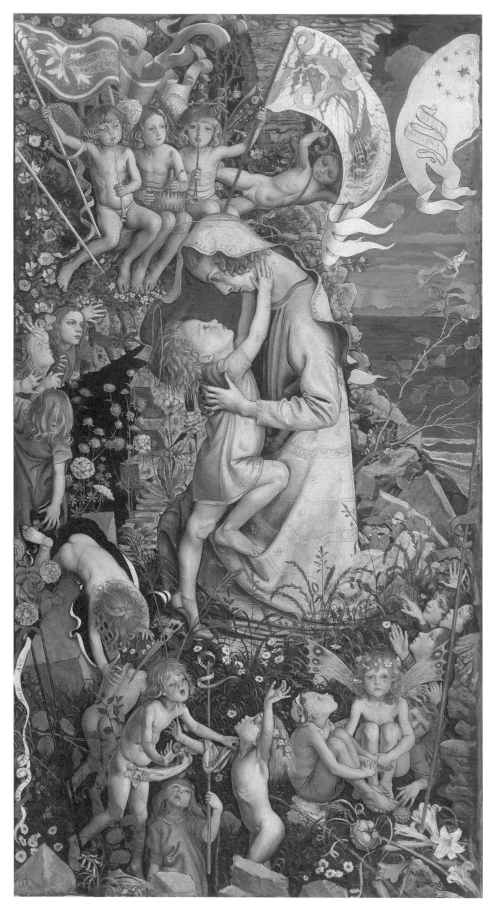

Mark Symons *Ave Maria* 1929. Cat. 441

both artists, irrespective of style, were seeking to create an autonomous visual world.[38] There are many new perspectives of this kind to consider. We have already seen that while Fry was stressing Cézanne, Ricketts and his circle were looking, if not to Gauguin, then certainly to his mentor, Puvis de Chavannes. Barriers break down still further when we remember Harry Morley's respect for Cézanne and the influence of Puvis and Maurice Denis on Bloomsbury figure subjects; indeed the whole debate about whether British art should be insular or European is seen to be irrelevant once we accept that Burne-Jones and his followers belonged to the European symbolist tradition. We might also ask ourselves whether there is not more in common than we think between, say, Anning Bell's debt to the early Italians and Stanley Spencer's or Bomberg's; or why Wilson Steer looms so large in accounts of modern British painting while William Shackleton is virtually forgotten. Steer may indeed be the better, certainly the more accessible, artist; yet Shackleton's debt to Turner is at least theoretically as interesting as Steer's to Turner and Constable; perhaps in a sense more interesting since, like Turner, he admits a symbolist dimension.[39] Nor should we be afraid to use our eyes. There are surely significant relationships between Southall, Mark Symons, Noel Laura Nisbet and Stanley Spencer, just as Winifred Knights' *The Deluge* (Cat. 466), with its strange contrapuntal rhythms, seems to stand somewhere between Burne-Jones and Vorticism. Perhaps this is hardly surprising when we remember that one of the few to praise Burne-Jones in the 1940s was Wyndham Lewis.[40]

An exhibition of this kind is bound to ask more questions than it answers. Even the term 'last romantics' can only be one of convenience, albeit embodying an important element of truth. The following essays treat certain aspects from a specialist point of view, but it in no way diminishes their value to say that we are dealing with a subject so large, nebulous and often shrouded in mystery that the exhibition must be something of an interim report. The very nature of that subject is still open to argument, and many areas need to be focused in the light of further research. The exhibition will have served its purpose if it stimulates debate, opens our eyes to some neglected artists, and strikes a blow for a more subtle, imaginative approach to twentieth-century British art.

Notes

1 Herbert Read, *Contemporary British Art* 1951, p39

2 'Coole Park and Ballylee, 1931' in *The Winding Stair and Other Poems* 1933

3 The respect was not unilateral; he once told Lady Lewis that he regarded sculpture as a 'higher' form of art than painting and that he had 'often' thought of becoming a sculptor himself: 'if ever my eyes grow dim . . . I will give up painting and take to sculpture' (unpublished note by Lady Lewis; private collection).

4 Claude Colleer Abbott and Anthony Bertram (eds), *Poet and Painter. Being the Correspondence between Gordon Bottomley and Paul Nash 1910–1946* 1955, p265

5 Robin Ironside, 'Burne-Jones and Gustave Moreau' *Horizon* June 1940, pp407, 424

6 Perhaps the artist most to be regretted is the etcher Joseph Webb (1908–62). While he has affinities with Griggs, there is a human dimension to some of his prints, notably *Shepherd's Haven*, which almost puts him within our range.

7 William Shackleton certainly knew of it. 'Nearly every quality in Art', he wrote, 'has its inferior counterpart, often mistaken for the greater, ie:– Imagination – Fancy', etc (cat. of Bradford Spring Exh. 1918).

8 See *The Fomors* and *The Play Garden* at Dundee

9 Cecil Lewis (ed), *Self Portrait. Taken from the Letters and Journals of Charles Ricketts, RA* 1939, p265

10 Letter to the author, 9 April 1988

11 Unpublished section of Rooke's notes of conversation in Burne-Jones's studio (V&A)

12 D S MacColl, *The Life, Work and Setting up of Philip Wilson Steer* 1945, p68

13 Cecil Lewis, op cit, p340

14 Osbert Sitwell (ed), *A Free House! . . . the Writings of Walter Richard Sickert* 1947, p280

15 Frances Spalding, *Vanessa Bell* 1983, pp152–3

16 Cecil Lewis, op cit, pp129–30

17 Ibid, p249

18 Joseph Hone, *The Life of Henry Tonks* 1939, p245

19 Not mere male chauvinism; a few weeks later he was to hear of a Suffragette attack on Bellini's *Agony in the Garden* in the National Gallery.

20 Cecil Lewis, op cit, pp189–90

21 Ibid, p223

22 Ibid, p343

23 One of the most dramatic would be the suicide of the classical painter J W Godward (1861–1922), which has been attributed to changes in artistic taste rendering his style obsolete. There seems, however, to be no proof of this.

24 Kerrison Preston (ed), *Letters from Graham Robertson* 1953, p104

25 Ibid, p488

26 Letter to the author, 9 April 1988

27 Cat. of Bradford Spring Exh. 1918

28 C C Abbott and A Bertram, op cit, pp29, 75, 101, 115

29 See Part I of his six-part article on 'Figure Paintings in Oils. Theory and Practice' *The Artist* September 1936–February 1937

30 C C Abbott and A Bertram, op cit, p122. Another interesting example is provided by Walter Crane, who mistrusted Impressionism but wrote of Post-Impressionism that it seemed to indicate 'a return to sanity and a desire to restore the art of painting as an art of design' (*William Morris to Whistler* 1911, p235)

31 Cecil Lewis, op cit, p127

32 Denys Sutton (ed), *Letters of Roger Fry* 1972 II, p406–7

33 Ibid, p413

34 Letter dated 21 August 1933 (Tate Gallery archive)

35 Kerrison Preston, op cit, p292

36 The word 'minor' applied to Ricketts greatly upset Gordon Bottomley; see Kerrison Preston, op cit, p451

37 D Sutton, op cit, p679

38 The link between Southall and Picasso was first established by Charlotte Gere; see her Introd. to the Fine Art Society's *Earthly Paradise* exh. cat. 1969, p2.

39 It is perhaps worth noting that Steer and Shackleton had consecutive exhibitions at Barbizon House in 1927.

40 See Walter Michel and C J Fox (eds), *Wyndham Lewis on Art. Collected Writings 1913–1956* 1969, pp429–30

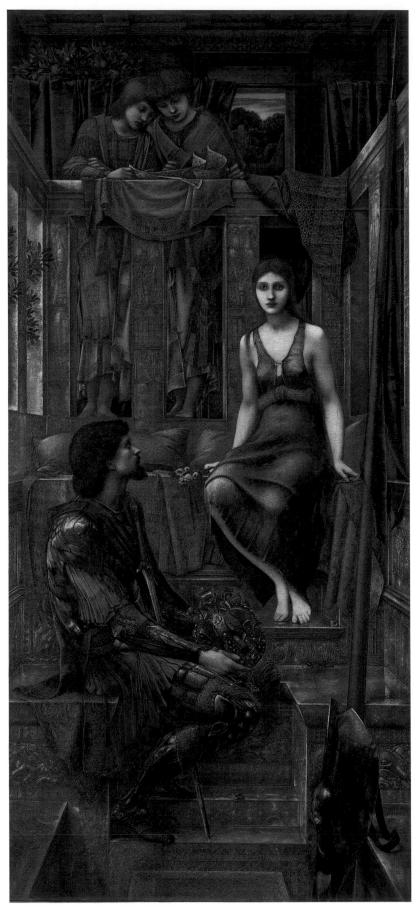

Fig. 1 Edward Burne-Jones *King Cophetua and the Beggar Maid* 1884. Tate Gallery, London

TOWARDS A DEFINITION
OF SYMBOLISM

MaryAnne Stevens

In 1888, Jules Christophe, the French writer and critic, attempted to define Symbolism as formulated in the circle of the Café Gambrinus in Paris in the mid-1880s:

'It was here that Symbolism was born, out of a disgust with all that was vulgar, all that made use of external and outmoded Naturalist formulae; Symbolism, the seeker of souls, of delicate subtleties of meaning, of emotional states, of fugitive, frequently sorrowful and significant images; an art therefore which is esoteric, unavoidably aristocratic, a bit 'fumiste' [obscurantist], if you wish, where one finds a desire for some form of mystification which takes revenge upon universal stupidity, an art which finds its roots in both science and the dream, the evocator of patterns, that is to say, of every formal concept which exists within the senses and outside objective matter, an art which is spiritual, and phyrric, nihilistic, religious and atheistic, even Wagnerian.'[1]

Christophe's recourse to vague, often contradictory terms in order to describe one of the major cultural movements in the second half of the nineteenth century is indicative of Symbolism's essential ambiguity: it involved all art forms – music, drama, literature and the visual arts, and it was capable of a variety of interpretations. Furthermore, while its two capital cities were Paris and Brussels, both its precursors and its latterday disciples guaranteed it an international position.

Christophe's reference to Symbolism's disgust for naturalism was shared by all adherents to the movement. By the third quarter of the nineteenth century, industrialisation had swept across Europe, bearing in its wake both the benefits and the drawbacks of the modern age. Materialism shaped the ambitions of society; Positivism, elaborated by Auguste Comte, Hippolyte Taine and, with certain significant differences, Karl Marx, dominated the schools of philosophy. In literature, the naturalist novels of Zola appeared to have reached a dead end. In painting, Impressionism, naturalism and social realism were seen to be no more than the visual records of now discredited external reality.

The Symbolists expressed their revulsion to this world in several ways: political, para-scientific, philosophical and artistic. The political response represented a negation of social responsibilities, either through retreat into a private world or through adherence to anarchy. The former solution was advocated by Huysmans in his novel, *A Rebours* (1884), in which the hero, des Esseintes, immures himself in a suburban villa surrounded by liqueur mouth-organs, tanks stocked with exotic fish, and a library almost exclusively filled with texts by early Christian sages. Painters also adopted this solution; Fernand Khnopff retreated behind the walls of his memory-laden house in medieval Bruges, while Gauguin sought refuge in the South Seas. Even Burne-Jones's world of Arthurian legends and Tennysonian fairy tales can be comfortably contained within this response. Anarchy demanded a more public position. Paul Claudel, as a young disciple of the Symbolist poet Mallarmé, recalled that it 'provided me with an almost instinctive gesture, similar to that of a drowning man who struggles for air, of throwing bombs indiscriminately without any forethought or pre-selected target'.[2] Such random gestures were also advocated by the American Symbolist poet resident in Paris and Brussels, Stuart Merril, and by the Belgian artist James Ensor, who was associated with the anarchist circle around Rousseau in Brussels in the early 1880s. Anarchy also provided the framework for Henry James's novel, *The Princess Casamassima*, published in 1886.

If the contemporary world was in part unacceptable because of its adherence to Positivism and the rule of science, then disgust could also be shown through a predilection for para-science, notably spiritualism, alchemy and satanism. Spiritualism and an interest in psychic phenomena appear to have aroused more interest in northern Europe than in Belgium and France. The Society of Psychical Research was founded in London in 1882, and Ibsen, Strindberg and Munch referred to the psychic world in plays such as *Ghosts* and *Dreamplay*, and in paintings such as *The Scream*. Satanism and its traditional close ally, alchemy, were apparently more prevalent in France. Both play central roles in Huysmans' novel, *Là-Bas* (1891). When discussing alchemy, Huysmans records that, at the end of the nineteenth century, there were as many as forty alchemical furnaces in France, and perhaps even more in Hanover and Bavaria. The phenomenon of satanism is represented by the figure of the defrocked Abbé Docre and his obscene black masses conducted behind the walls of quiet, unassuming Parisian suburban houses, holding enthralled a society desparately in search of a spiritual experience which Positivism had so peremptorily denied it.

For the Symbolists, a reinstatement of the spiritual and the supernatural necessarily implied replacing Positivism with a metaphysical system based more or less closely on the German Idealist philosophies of Hegel and Schopenhauer; also influential was the theory of 'Correspondences', developed at the end of the eighteenth century by the Swedish mystic, Swedenborg, and made available, at least to the French, through Baudelaire's poem, 'Correspondences', published in *Les Fleurs du Mal* (1857). All three philosphers took as their premise the belief that all objects in this world are relative, since they are perceived by the senses and thus constrained by the laws of causality, time and space. Absolute ideas of truths exist in the world beyond and are perceived by the mind. Objects in the relative world, however, can act as 'representatives' of these absolute truths or ideas. Those people able to comprehend these relationships between relative objects and absolute ideas were those endowed with genius – the artist, the poet, the composer.

The implications of this aesthetic programme for the Symbolists were three-fold. They necessarily cast aside all subject matter specifically drawn from the external world of relative objects. Hence, Impressionism, naturalism and social realism were ousted in favour of subjects derived from the world of ideas, a position aptly summarised by Charles Morice: 'Since our life is such a terrible affair . . . unable to provide us with the perfect realisation of our dreams of happiness, art will have to deck herself out in the widow's weeds of joy which life refuses to give us and which can still be created in the imagination.'[3] Furthermore, since the artist was elevated to the status of 'seer', the creative process became the subject-matter of a work of art and hence the measure of its aesthetic quality. Finally, given the need to protect the discreet position of the artist as mediator, the Symbolists viewed the official art of the Salon as commercial and

Fig. 2 Fernand Khnopff *Listening to Schumann* 1883. Musées Royaux des Beaux-Arts, Brussels

hence debased, and sought to propagate an art which was accessible only to an elite. Mallarmé, for example, during his association with Paul Marguerite's Théatre des Valvins, founded in 1880, evolved 'le drame', an ideal dramatic work which was to be read as a monologue by the poet to an audience numbering between eight and twenty-four people. De Wyzéwa, the poet, critic and ardent Wagnerian, translated this élitist position into Symbolist doctrine in 1886 when he declared that 'the aesthetic value of a work of art is always in direct inverse proportion to the number of people who can understand it'.[4] It is therefore not surprising to find Gauguin and Redon evolving their own hermetically-sealed symbolic systems, nor to read critics attributing the success of the Symbolist avant-garde theatre, the Théatre de l'Œuvre, founded by Lugné Poë in 1893, to the fact that it drew its support from the intellectual élite of Paris rather than from the populace at large.

The Symbolists' philosophical and artistic reaction against naturalism can in large measure be summarised by the nature of their interest in the ideas and works of Richard Wagner.[5] This interest, which gained momentum during the second half of the nineteenth century and claimed such adherents as Debussy, Gauguin, and Munch, was expressed in two different ways. The theoretical appeal of Wagner, enshrined in 'Wagnerism', can be traced back to the writer who was so influential in shaping many of the Symbolists' ideas, Charles Baudelaire. In 1861, Baudelaire wrote an impassioned defence of

Fig. 3 Puvis de Chavannes *The Beheading of St John the Baptist* **c1868. The National Gallery, London**

Wagner's ill-fated production of *Tannhäuser*,[6] booed off the stage of the Paris Opéra after only two performances. He declared Wagner's music-dramas to presage the music of the future, praising it for having overturned the traditional belief that music is superior to all other art forms. The equality between music and painting was celebrated in works such as Khnoppf's *Listening to Schumann* (Fig. 2) and in essays such as de Wyzéwa's on Wagnerian painting published in May 1886.[7] In this article, de Wyzéwa argued that painting, if equivalent to music, could partake of the latter's non-mimetic properties. Thus, the new art of the future need no longer be concerned with representation but should be governed first and foremost by its formal properties of line and colours. It was this emphasis upon the liberation of painting from literal representation which was given full expression in the work of Paul Gauguin and Emile Bernard in the summer of 1888.

The themes of Wagner's music-dramas also attracted the Symbolists. Mallarmé, in common with many other Symbolist writers and artists, was eager to stress Wagner's use of specific legends to express universal truths.[8] Thus, his music-dramas became a rich source of non-natural symbolist subjects, to be drawn upon by artists such as Delville in Belgium, Fantin-Latour, Redon and Jacques-Emile Blanche in France, and Watts in England. Even Wagner's essay on Beethoven,

published in 1870, provided ample source material: in France, where it was known through de Wyzéwa's translation, it was regarded as a model for the application of Schopenhauer's ideas to art,[9] while in Vienna it inspired Klinger's polychromatic sculpture of Beethoven and Klimt's Beethoven frieze.

The distinction between the theoretical and thematic appeals of Wagner's works permits a separation of the Symbolist movement into two broad camps. On the one hand there were those artists who, in close association with the literary avant-garde, accepted that the subject-matter of Symbolism demanded the creation of a new visual vocabulary. On the other, there were those who, while accepting the new subject-matter, persisted in cloaking it in traditional visual forms. The former artists looked, in part, to Puvis de Chavannes, while the latter took Gustave Moreau as their mentor.

Both Gustave Moreau and Puvis de Chavannes belonged to the generation which preceded the Symbolists and so provided links with late Romanticism. Gustave Moreau's painting demonstrated a subtle blend of classical mythology and decadent themes, most notably seen in his Salome series. Puvis de Chavannes, although advocating an overtly public art for his large-scale mural decorations in which 'every clearly defined idea can be translated into a specific plastic thought', none the less determined to convey these ideas in formal terms which

Fig. 4 Gustave Moreau *L'Apparition* **1876. Musée du Louvre, Paris**

stressed the two-dimensionality of the surfaces upon which the decorations were placed (Fig. 3). Both artists shunned the encroachment of demands for naturalist or contemporary themes and both adopted techniques which stressed the timeless, artificial properties of their arts.

It was both Moreau's subject-matter as well as his elaborate technique, derived in part from late *quattrocento* painting as well as from Ingres and Delacroix, which appealed to those Symbolists less brave in confronting the formal demands of the new aesthetic programme. Moreau had drawn his subjects from Baudelaire, Flaubert and Mallarmé, and had also given personal interpretations to the more highly-charged classical myths. It was these sources which were adopted by the 'negative' Symbolists such as Khnoppf, Schwabe, Delville and Henri Martin.

While Moreau's and Puvis de Chavannes' work were primarily accessible in Paris, both artists also exhibited in London. At the opening exhibition of the Grosvenor Gallery in 1877, Gustave Moreau's *L'Apparition* (Fig. 4) was hung beside works by Burne-Jones and Watts. A natural affinity of style and subject-matter was perceived between Moreau and Burne-Jones, and may in no small way have fuelled the enthusiasm for the English artist's work in Paris over the succeeding decade and a half.[10] Burne-Jones also provided a crucial link between the Pre-Raphaelites and Puvis de Chavannes. When in 1889 Burne-Jones exhibited *King Cophetua and the Beggar Maid* (Fig. 1) at the Exposition Universelle in Paris, Puvis de Chavannes was sufficiently impressed to attempt to obtain a medal for the work. Although his efforts produced no more than a 'Légion d'honneur' for the artist, Burne-Jones was moved to record that 'I have not for many a day had such comfort and pleasure in matters that affect my work as the sympathy that had been shown me in France . . . It has touched me very deeply.'[11] Puvis de Chavannes' support then led to Burne-Jones

promising to collaborate with the Salon du Champs de Mars, established in Paris in 1891, to which he sent works in 1892, 1893, 1895 and 1896. It was also almost certainly due to Burne-Jones's success at the Exposition Universelle that Sâr Péladan invited him to exhibit at his Idealist Salon de la Rose + Croix – an invitation which Burne-Jones declined, and that an exhibition of photographs of works by both Burne-Jones and Rossetti was held in Brussels in 1891.

In 1890 Arthur Symons published an article introducing the Symbolist artist, Odilon Redon, to the readers of *The Studio* as the French Blake.[12] In many ways Redon acts as a bridge between the more traditional and the consciously innovative groups within the Symbolist pictorial movement. Redon drew much of his subject-matter from the same literary sources as Gustave Moreau and his followers. Yet his own highly personal vision created images which prevented him from being too closely associated with these artists. Indeed, by juggling scales of juxtaposed objects, by setting imaginary objects beside those drawn from nature and from his childhood memories of the desolate Landes outside Bordeaux, and by evolving captions that bore no apparent relationship to the images which they accompanied, Redon sought to create an art which reflected the 'ambiguity of the indeterminate'.[13] In seeking to penetrate the nature of this ambiguity, Redon invited the spectator to enter the creative process.

Redon's art is often seen as the pictorial equivalent of the poetry of Mallarmé, and in this respect it links him to those artists who confronted the new subject of Symbolism, the Idea, and sought to forge a new visual vocabulary through which to give it expression. In January 1885 Paul Gauguin had expressed a concern to give form to the supernatural world which can only be perceived through the emotions. At this stage, however, he had no more than a vague understanding that this world should be conveyed through the use of symbolic line and colour.[14] Indeed, Gauguin had to wait another three

Fig. 5 Paul Gaugin *The Vision after the Sermon* **1888. National Gallery of Scotland, Edinburgh**

years before the new literary and visual programme was fully formulated.

On 18 September 1886 Jean Moréas issued a manifesto for literary Symbolism. He emphasised the decay of all past literary forms and the need to create a new school of literature the aim of which was 'to clothe the Idea with sensual form'.[15] This manifesto caused shock waves through Parisian literary circles, and ten days later Gustave Kahn sprang to Moréas' defence with his article 'La Réponse des Symbolistes'. With extreme clarity, he called for the rejection of subject-matter which was 'quotidien, near-at-hand, contemporaneous' in favour of an art which 'objectifies the subjective (i.e. the exterioration of the Idea)'.[16] Like Moréas, he also called for a new formal vocabulary to achieve this end. It is more than coincidence that Emile Bernard and Louis Anquetin, two artists closely associated with the literary circle around Moréas and Kahn, should choose, in the autumn of 1886, to reject the art of the Impressionists and the Neo-Impressionists and declare that they too were now searching to create an art in which 'Ideas dominate the technique of painting'.[17]

That Ideas should dictate a painting's form became the principle underlying Bernard's and Anquetin's artistic evolution during the two following years. Moving from the depiction of overtly artificial subject-matter, they evolved the style known as 'cloisonnisme', a decorative manner derived from Puvis de Chavannes, early van Gogh, Japanese prints and the flattened images and blocks of colour found in stained-glass windows.[18] From 'cloisonnisme' they moved to a fully developed 'Synthetist' or 'Pictorial Symbolist' style best characterised in Bernard's *Pardon at Pont Aven* (1888; private collection, St Germain-en-Laye). Painted in Brittany in the summer of 1888, it was this picture which finally provided Gauguin with the formal means which he had been seeking three years earlier. He could now turn his back upon nature and produce *The Vision after the Sermon* (Fig. 5). Both these paintings fulfil the 'pictorial Symbolist' programme which was to be elaborated by the critic Albert Aurier in 1891. In his article, 'Paul Gauguin – le Symbolisme en peinture', Aurier claimed that pictorial Symbolism was ideist, symbolist, synthetic, subject-oriented and hence decorative.[19] And indeed both Gauguin's and Bernard's paintings distort nature so as to suggest the Idea – religion and primitivism in *Pardon at Pont Aven* and the relationship between reality, imagination and the creative process in *The Vision after the*

Sermon. Both paintings express their respective ideas through symbolic forms. Both synthesise nature by simplifying the forms in order to enhance the subject of the painting, the Idea, and detract the spectator's eye from individual details. Both paintings, moreover, started from the Idea and then sought the forms appropriate to its translation. Hence both paintings are decorative in the sense that they are first and foremost non-representational.

Symbolism was a short-lived movement. For many of its adherents the very contradictions summarised by Jules Christophe in his definition of 1888 posed an almost insurmountable problem, centred on the definition of the subject of Symbolism itself – the Idea. While this demanded the right of an absolute, it denied all possibility of physical description because it was necessarily abstract. It insisted on concrete expression through symbols, yet rejected any notion of being represented in such conventional terms as beauty. By 1900 many Symbolists could no longer encompass such contradictions; they either turned their back on the whole issue and accepted nature as the subject-matter of their art, or they redefined the Idea as the more concrete Ideal which could be embodied in traditional terms.

Yet Symbolism did make an important contribution to the history of art. For the first time it posed the possibility that excellence in a work of art need not depend upon the degree to which the image approximated to objects drawn from the external world or from the classical tradition. Rather it stemmed from the artist's ability to convey the meaning of the work through the creative process itself.

Notes

1 Jules Christophe, *La Cravache parisienne* 16 June 1888
2 Paul Claudel, *Mémoires improvisées* Paris 1954
3 C Morice, *La Littérature de toute à l'heure* Paris 1889
4 Th de Wyzéwa, 'La Littérature wagnerienne' *La Revue wagnerienne* June 1886
5 For Wagnerism in France see G D Turbow, 'Art and Politics: Wagnerism in France' in D C Large and W Weber (eds), *Wagnerism in European Culture and Politics* Ithaca and London 1984
6 Charles Baudelaire, 'Richard Wagner et "Tannhäuser" à Paris' *La Revue européenne* April 1861
7 Th de Wyzéwa, 'La Peinture wagnerienne', *La Revue wagnerienne* May 1886
8 Stéphane Mallarmé, 'Richard Wagner: Rêverie d'un poète français' *La Revue wagnerienne* January 1886
9 Richard Wagner, 'Beethoven' (transl Th de Wyzéwa) *La Revue wagnerienne* May–August 1885
10 For a detailed study of Burne-Jones's relations with France, see J Lethève, 'La Connaissance des peintres préraphaélites anglais en France (1855–1900)' *Gazette des Beaux-Arts* 1959, 6ème période, LIII, no.1084–5, pp315–28
11 G Burne-Jones, *Memorials of Edward Burne-Jones*, London 1904, II, p202
12 A Symons, 'A French Blake: Odilon Redon', *Art Review*, July 1890
13 O Redon, *Lettres d'Odilon Redon, 1878–1916* Paris 1923, pp31–2
14 Paul Gauguin, Letter to E Schuffenecker, January 1885 in V Merlhès (ed), *Correspondance de Paul Gauguin* Paris 1984, no.65
15 Jean Moréas, 'Manifeste du symbolisme' *Le Figaro* 18 September 1886
16 G Kahn, 'La Réponse des symbolistes' *L'Evénement* 28 September 1886
17 Émile Bernard, 'Louis Anquetin, peintre-artiste' *Mercure de France* November 1932, p594
18 For a detailed study of the evolution of Cloisonnisme, see B Welsh-Ocharov, *Vincent van Gogh and the Birth of Cloisonnisme* Toronto and Amsterdam 1981–2
19 A Aurier, 'Le Symbolisme en peinture – Paul Gauguin' *Mercure de France* March 1891, pp260–63

Charles Ricketts *Bacchus in India* c1913. Cat. 288

RICKETTS, SHANNON
AND THEIR CIRCLE

J G P Delaney

In the early days at the Vale, Chelsea, Ricketts and Shannon 'knew few people, and prided themselves on going nowhere; their few intimates came to see them, usually on Friday evenings'.[1] Before that, at art school, Shannon had had lots of friends until Ricketts quarrelled with them. Their isolation had grown out of a high-minded commitment to their artistic ideals as well as to their dislike of the growing influence of Impressionism among their contemporaries. What they sought in their own work was the imaginative and romantic vision of such artists as Puvis de Chavannes, whom they had visited in 1887 and regarded as the greatest French artist of the nineteenth century.

They had a small coterie of friends who shared their ideals – the artist Reginald Savage, the poet and wood-engraver Thomas Sturge Moore, the poet John Gray and, a little later, the art historian Charles Holmes. These all contributed either to the *Dial*, an occasional periodical published by Ricketts and Shannon between 1889 and 1896, or to the fifty or so publications of the Vale Press, which Ricketts founded in 1894 and closed in 1903. The Press's office, which also sold the earliest books of Lucien Pissarro's Eragny Press, was situated in Warwick Street, Piccadilly; it was painted green, 'the colour of hope', and had a sign painted by Shannon (Aberdeen Art Gallery) and a small room for exhibitions. The designs of Arthur Boyd Houghton, the engraved illustrations of Millais, and woodcuts of the fifteenth and early sixteenth centuries were all the subject of exhibitions as part of Ricketts's programme to educate the public in the importance of woodcuts and to revive interest in the illustrators of the 1860s. The shop also sold prints by Ricketts, Shannon, Sturge Moore, Rothenstein, Pissarro and Alphonse Legros. Among the many callers at the shop were Jane Morris, the wife of William Morris, Max Beerbohm and Whistler, who had wanted Ricketts and Shannon to act as his agents. Knowing how touchy Whistler could be, they wisely declined.

Ricketts's partner in the Vale Press was Llewellyn Hacon, a well-to-do barrister who had been introduced to him by Rothenstein. Though he was mainly a sleeping partner, he did read through proofs and show a general if distant interest in the running of the Press. After he married 'Ryllis', a beautiful model (with the sort of past one might expect), he took over the house in the Vale when Ricketts and Shannon left and entertained his many artist friends there. 'Ryllis' had sat to Shannon, as Delia in *Tibullus in the House of Delia* (Nottingham), and to Rothenstein; indeed it was a pastel of her by the latter that had first captivated Hacon. Shannon also did a fine portrait of her in a splendid gown (National Gallery of Ireland, Dublin), as well as a lithograph of Hacon. His beautiful poetic lithographic portraits indeed show many of their friends in the 1890s: Beerbohm, Savage, Gray, Sturge Moore, Legros, Pissarro and their cultured and intelligent dealer Van Wisselingh, whose Dutch Gallery exhibited much of their early work.

Legros represented a link with an earlier generation of French writers and artists that fascinated Ricketts. He had known Baudelaire (who had praised his work), met Rossetti and his associates, and 'spoke of Ingres, Delacroix and Millet as if they were yet living, and of Manet and Rodin as if they were still promising young men'.[2] (Similar friendships with older men like Fairfax Murray supplied a link with

many stories about Rossetti, and Shannon had often visited Madox Brown and Watts.) Though he had lived in England since 1863, and had been Slade Professor of Fine Art in London since 1876, the Frenchman spoke no English. Moreover, when he came to visit them, it was for the day, and Ricketts, who spoke fluent French, would take him out to galleries and exhibitions, so as to permit Shannon at least to carry on with his work. Ricketts and Shannon both thought highly of Legros as an artist, and were involved in a plan to honour him with a dinner and purchase one of his paintings for the national collection. This was partly because they thought, according to Sturge Moore, that 'he is much bullied at home by his wife and children because he no longer makes money and this will make them think more of him.'[3] Their influence also helped to revive interest in his prints and drawings, and Ricketts wrote an article on him (*Saturday Review* 17 April 1897) and the preface to a catalogue of his prints (1923). Legros in turn admired Shannon's work, especially his portrait of Sturge Moore, which had won a gold medal at Munich. The portraits he did of Ricketts (silverpoint, 1896) and Shannon (pencil, 1897) are superb drawings and excellent likenesses (Figs 6, 7).

As might be expected, there was a great deal of mutual portraiture in such a circle of artists. Rothenstein did many portraits of Ricketts and Shannon, jointly, singly, and in different media, and Beerbohm was responsible for a number of caricatures. So was Edmund Dulac, a later friend, while Francis Dodd and Laura Anning Bell made drawings of Ricketts. Even Ricketts did some portraits, though these were never really in his line. Three of the jewels he designed contained likenesses of the recipient: those for Mrs Hacon, Mrs J R Green and Edith Cooper. Mrs Green, who lived in Kensington Square, was a London hostess with a strong interest in Ireland and many notable friends. At her table Ricketts met the explorer Mary Kingsley, who fascinated him with stories of Africa and delighted him with a West African proverb, 'Softly, softly, catchee monkey'. Much more intimate was the friendship with Edith Cooper and her aunt Katherine Bradley, who together wrote under the pseudonym of 'Michael Field'. This remarkable couple were in many ways a female version of Ricketts and Shannon, with their rather exclusive devotion to art and to one another; indeed, they went even further than the two men in writing their poems and poetic dramas together, and claiming that no one would detect the seams where their different contributions joined. When they moved to Richmond in 1899 to be near the two artists, their association became close and constant. Even before meeting Ricketts and Shannon, they had been concerned about the appearance of their books, and Selwyn Image's beautiful cover for *The Tragic Mary* (1890), shown at the Arts and Crafts Exhibition that year, prompted Ricketts and Shannon, who thought they were a man, to write them a fan letter. It is not surprising that they soon wanted Ricketts to design some of their books: he published four of their plays at the Vale Press with decorations by himself, later designed four books of their poetry, and did a series of emblems for other plays by them. Moreover, though he genuinely admired their work, he did not hesitate to prune some of the more stilted or prosaic passages. Their friendship, which became a bit too claustrophobic for the artists at times, loosened somewhat after the two men moved to Holland

Fig. 6 Alphonse Legros *Portrait of Charles Ricketts* 1896. **Fitzwilliam Museum, Cambridge**

Fig. 7 Alphonse Legros *Portrait of Charles Shannon* 1897. **Fitzwilliam Museum, Cambridge**

Park in 1902 and the two women became Roman Catholics in 1907. Edith Cooper's face often appeared (probably unconsciously) in Ricketts's early drawings and woodcuts, as did that of a later friend, Cecil Lewis, the subject of his only portrait in sculpture.

Ricketts and Shannon also had many contacts among museum officials and dealers. As the two artists were also connoisseurs and collectors, these contacts were useful, and ultimately played a large part in the disposition of their collection. Indeed Laurence Binyon, poet and expert in oriental art, was one of the few friends whom the rather touchy and restless Ricketts never tired of. Binyon was always a loyal and whole-hearted supporter of his work and earned Ricketts's devotion by never leavening his praise with the hesitations and qualifications that he found so irritating. Another museum official who was also a close friend was Sidney Cockerell, whom Ricketts described as a 'gruff diamond'.[4] His letters to Cockerell, now in the British Museum, are mainly concerned with art historical and collecting matters. When Cockerell became Director of the Fitzwilliam Museum, Cambridge, he persuaded Ricketts and Shannon to leave their collection to it. The bulk therefore went to Cambridge, although half the Japanese prints and drawings went to the British Museum, where Binyon was in charge of the Oriental Department.

Although in the early days Shannon was the better-known artist, Ricketts was the dominant influence on the group, marking it firmly with his distinctive character and his preference for imaginative over naturalistic art. Laurence Housman, Lucien Pissarro, the sculptor R F Wells (who did fine portrait busts of Ricketts and Shannon) and others came under Ricketts's influence for a time, but ultimately their ways parted. Not everyone could take his powerful personality.

Ricketts and Shannon's entry into a larger world had started with the advent of Oscar Wilde in 1888. He brought others, such as Graham Robertson and William Rothenstein, to meet the 'Valeists', and as his visits became more frequent, there was a marked improvement in dress, in the wit of the conversation, and in the breadth of the friends' social horizons. Many Nineties figures, including Lionel Johnson, Arthur Symons and Gleeson White, came to see them as their work gained in reputation and the legend of Ricketts and Shannon, two young artists who lived only for art and for each other, became known in what Ricketts called 'little London', the artistic and literary world of the capital.

Their artistic connections also grew wider, even Wilson Steer and Walter Sickert being among their outer circle of friends, regular visitors but excluded from real intimacy. This outer group spanned the artistic divisions between imaginative and naturalistic art which grew wider as the new century progressed. Still more surprising was the inclusion of D S MacColl and Roger Fry, whose later espousal respectively of the Impressionist and Post-Impressionist causes eventually put them both outside the pale in Ricketts's view. In fact, these divisions only hardened later and very heterogeneous groups of artists often exhibited together. Shannon, for instance, sent work to the New English Art Club from 1887 to 1900. Only later did he and Ricketts become so exclusive about where they chose to exhibit their work. In 1898 they were involved in the foundation of the International Society, which seemed to offer possibilites of promoting their artistic values, and although they soon resigned over the machinations of the

Fig. 8 Edmund Dulac *'The Musical Soirée': Mr and Mrs Edmund Davis at home in Venice* 1912. **British Museum**

first president, Whistler, they later rejoined and became two of its leading members. Ricketts played art politics with zest and skill, and the annual fancy-dress balls gave him an opportunity to indulge his passion for dressing up.

As Ricketts and Shannon's addresses improved – after Chelsea, then a cheap area, they moved to Richmond (1898), then to Holland Park (1902) and finally to Regent's Park (1923) – so did their social lives. Indeed Ricketts had at first feared that the move from Richmond would make them too accessible to others and to the attractions of music and entertainment. This did not seem so awful when it actually happened, and as Ricketts moved into the theatre as a designer and onto committees of the International Society and later the Royal Academy, where Shannon had preceded him, their gatherings at Lansdowne Road attracted a wider diversity of people: artists, writers, actors, musicians, critics and collectors – some famous, many (for Ricketts was not interested in celebrities as such) unknown. Distinguished foreign visitors included Bakst, Diaghilev, Nijinski, Count Kessler, and Kohitsu, a hereditary expert on Japanese art, while W B Yeats, Bernard Shaw, Lillah McCarthy, Harley Granville Barker, Mme Marchesi, Vladimir Rosing, Constant Lambert, Isadora Duncan, and the Princess of Monaco were among those who could be found at their dinner table, the 'tea-fights' they organised to show

Shannon's latest pictures, or their regular Friday evenings. 'Friday is the day', Ricketts wrote, 'we are supposed to be at home to our enemies. They drop in about 10, allured by the local whisky, and then become vacant or self-absorbed.'[5] In spite of one or two bohemian elements, this was not a bohemian world. The men wore suits, though Ricketts's was rather a shabby one. It was a highly civilised group, which rotated round art, music, and writing, which in that order formed Ricketts's own hierarchy of values.

Central to their later circle of friends were Edmund and Mary Davis (Fig. 8). Born in Australia, Davis had made a fortune from mining in South Africa and eventually settled in London. Like her husband, Mrs Davis had had artistic training; indeed, she had been taught in the 1890s by Shannon, which is how the two couples met. Unlike her husband, she persisted in her art and exhibited her paintings on silk at the New Gallery. Gradually Ricketts and Shannon became unofficial and unpaid artistic advisers in forming their collection of Old Master paintings, which was eventually one of the finest in England, with masterpieces by Rembrandt, Canaletto, Van Dyck, Reynolds, Gainsborough and many others. The Davises were also generous patrons of contemporary British artists. They commissioned Charles Conder to decorate two rooms of their house in Lansdowne Road and Frank Brangwyn to adorn their music room and bedroom;

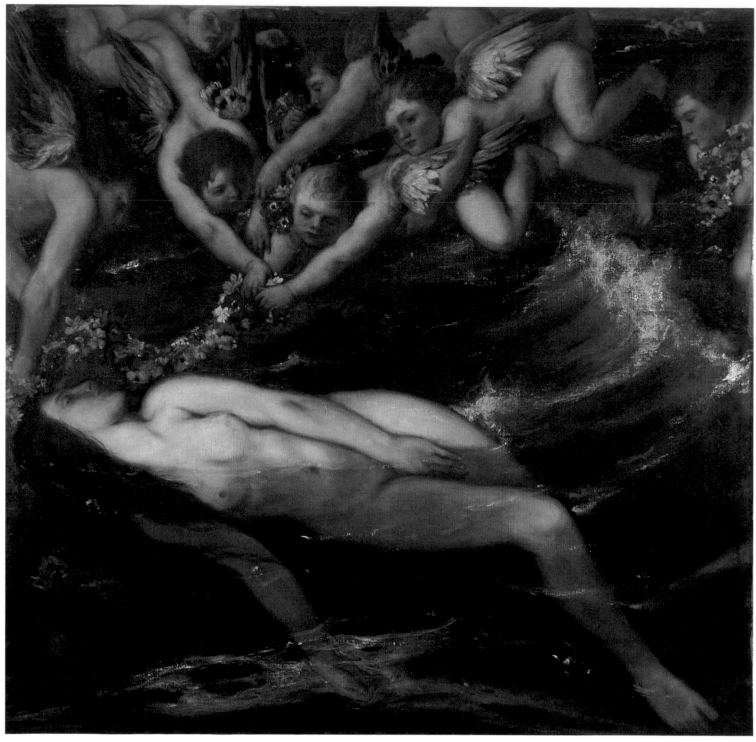

Charles Shannon *The Birth of Venus* **1923.** Cat. 259

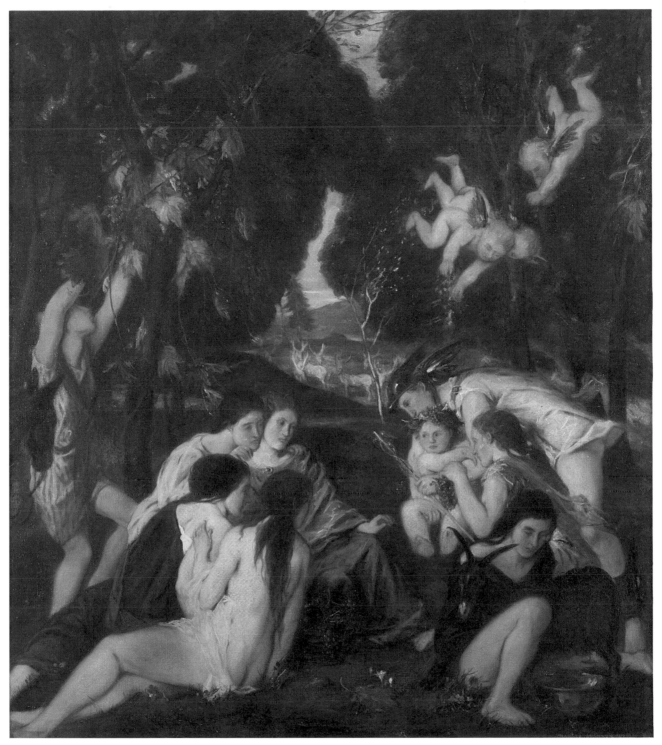

Charles Shannon *The Childhood of Bacchus* **1919–20.** Cat. 256

Charles Ricketts *Don Juan and the Commander* c1905. Cat. 286

James Pryde did up a room at their country house, Chilham Castle in Kent. Among Davis's most generous acts was to give in 1915 a collection of thirty-seven paintings by contemporary British artists to the Luxembourg in Paris (now mostly in the Musée d'Orsay), because he felt that British painting was badly represented there. A series of similar gifts was later made to the South African National Gallery. Work by Ricketts and Shannon not only formed part of these presentations but were prominent in their houses. Mrs Davis, a kind and motherly woman who was devoted to Ricketts, as he was to her, actually sold some of her jewellery to buy Shannon's portrait of him, *The Man with the Greek Vase* (Leamington Spa). It joined Shannon's splendid self-portrait *The Man in the Black Shirt* and its pendant portrait of Ricketts, *The Man in the Inverness Cape* (both National Portrait Gallery), which were also in the Davis collection, together with eight paintings and seven bronzes by Ricketts and four other paintings by Shannon.

As well as being very artistic, the Davises were intensely musical. They held soirées where their guests, sometimes in fancy dress, were entertained by Arthur Rubinstein and other famous musicians. At a dinner given by the Davises, Ricketts met Rodin, who had a profound influence on his sculpture. Charles Conder, Glyn Philpot, Vyvyan Forbes, Edmund Dulac, Robert and Laura Anning Bell and T E Lowinsky were among the many other artists who frequented their houses in London and the country.

To repay Ricketts and Shannon for their artistic advice, Davis offered them a flat in Lansdowne House, which he built at the top of Lansdowne Road in 1902. Conceived as a centre for artists, the house had six flats (now divided up), each with a two-storey studio with a good north light. Ricketts and Shannon's flat was built to their specifications and had two studios; they were granted a twenty-one year lease, for which they paid a low rent. When they left in 1923, it was taken over by Glyn Philpot and Vyvyan Forbes, who Ricketts hoped would become 'the Ricketts and Shannon of the near future'.[6] (Philpot's early work had been much influenced by Ricketts, but though they met socially on occasion, they never became close friends.) Also in Landsowne House lived James Pryde and Frederick Cayley Robinson, so that six distinguished British artists had homes there, making it worthy of the largest blue plaque in London. In 1918 the Davises offered Ricketts and Shannon the Roman-Norman Keep at Chilham Castle, where Ricketts designed a fountain and a flight of steps for the garden. This gave them a country retreat and more opportunity to entertain friends and even have people to stay. They themselves did not like going away for weekends. Ricketts told Robbie Ross to 'hint to Mrs Colefax that we never spend weekends . . . Accuse me of drug habits, etc., any picturesque detail. I cannot stand more than two hours of any company.' He also claimed that Shannon's 'refusal to WeekEnd will for ever prevent his being made a baronet'.[7] Nonetheless they were among the artists who enjoyed the Davises' hospitality at their villas in Venice and on Lake Como, even if they did not (like Dulac) take part in a Mediterranean cruise on their yacht. While art patronage was still largely in the hands of wealthy individuals (and not in that of Government committees which Ricketts would have abominated), such friendships could enrich artists' lives as well as their pockets.

Another friend and patron, though on a smaller scale than the Davises, was Henry Winslow. He lived in St John's Wood near Townshend House, which the artists bought when they left Lansdowne House. Belonging to a distinguished American family, he studied art in Paris before settling in London. He bought several paintings by Ricketts, who also designed the interior of the Winslows' house, contributing among other things a large piece of malachite and an 'Elizabethan' mirror made by himself. Nothing was ever permitted to change the Ricketts arrangement. Ricketts thought highly of Winslow and intended to leave him some of his unpublished manuscripts.

However, not all those who acquired the work of Ricketts and Shannon were wealthy. Gordon Bottomley (Fig. 9) was a poet who lived in Lancashire on a modest private income, suffering from a lung complaint that made London and travel difficult. A fervent admirer of the Pre-Raphaelites, and a considerable authority on their work, he told Ricketts 'My life falls into two parts at the dazzling moment when I first saw a Rossetti (the little "Sancta Lilias") reproduced in a picture paper in my boyhood; and ever since then I have been sure of what I wanted.'[8] The passionate imaginative vision of Rossetti and his followers had an inexhaustible appeal to Bottomley, as it had for Ricketts. Even on his small income, he was able to buy some fine Pre-Raphaelite works, but much of his collection came to him by gift or bequest. Ricketts gave him some Burne-Jones drawings as well as works by himself; other pictures came from the Davises and 'Michael Field'. In all, Bottomley owned three oils by Ricketts, as well as prints and drawings. Ricketts denied the comparison between himself and Rossetti which was made by Bottomley, Mary Davis and others, but he was always rather touched by the devotion of Bottomley who described him as his 'prince of men'.[9] This had started even before he met Ricketts, for his *Gate of Smaragdus* (1904) shows the strong influence of Ricketts and Shannon on its typography, illustrations and binding (Cat. 357). Later Ricketts designed four bindings for him. Other books by Bottomley were decorated by James Guthrie and published at his Pear Tree Press (Cat. 355), and Bottomley

Fig. 9 Paul Nash *Portrait of Gordon Bottomley* **1922. Carlisle Museum and Art Gallery**

was also a friend and patron of Paul Nash, who designed some of his plays. A prolific letter-writer, Bottomley made up for his lack of mobility by a wide correspondence, though friends such as the poet Edward Thomas came regularly to stay. Occasionally he risked a visit to London, or would stay with Graham Robertson, another close friend, in Surrey. He left his collection to the Carlisle City Art Gallery in 1948 in the hope that (in the words of his executor) 'it might add something permanently valuable to north country imaginative experience'.[10]

Most of these friends and patrons shared Ricketts's predilection for imaginative painting and for the Pre-Raphaelites. As the new century progressed, Ricketts threw himself into countering the modernist influence on various art committees. He became more and more active in organising exhibitions, a task for which his taste and intelligence made him highly suitable. His exhibition *A Century of Art 1810–1910* at the Grafton Galleries in 1911 was an act of homage to the great imaginative artists of the nineteenth century and an answer to Roger Fry's Post-Impressionist Exhibition held at the same venue the previous year. Even more ambitious was his organisation, with W G Constable at the National Gallery, of the stupendous Italian Exhibition at the Royal Academy in 1930. This was one of the finest exhibitions ever held in England, with an almost incredible range and quality of works of art, lent by the Pope, Mussolini and many galleries and private collectors. It included works from Ricketts and Shannon's own

collection and two paintings from the Canadian National Gallery which Ricketts, the Gallery's art adviser, had recommended it to buy. Over 500,000 people attended the exhibition.

Even Ricketts's energy and expertise could not stem the tide of modern art. Though he found much to admire in the work of Augustus John, Henry Lamb, Stanley Spencer and Eric Kennington, he came to realise that he was (for the moment) losing the struggle. In some of his admirations, such as that for the sculptor and draughtsman Ernest Cole, he was merely clutching at straws, and as time passed, despite friendships with younger artists and writers like Cecil Lewis, Henning Nyberg and 'Bengy' Lowinsky, he became increasingly isolated from the mainstream of art and even social life, ruefully recording that he had heard himself described as a 'back number'. In January 1929 Shannon suffered a tragic accident; falling from a ladder when hanging a picture, he damaged his brain and never fully recovered his senses. This caused Ricketts to withdraw from all but his closest friendships and throw himself into a hectic round of trips, exhibitions and theatrical productions. All this, together with the strain of Shannon's illness, exacted its toll, and he died of a heart attack on 8 October 1931. Shannon outlived him by six years; faithfully attended by his manservant Nicholls and his wife, he occupied a house at Kew which was subsequently taken over by Sydney Cockerell on his retirement from the Fitzwilliam Museum.

Notes

1 William Rothenstein, *Men and Memories* 1931 I, p174
2 Charles Ricketts (Introd), *Catalogue of the Bliss Collection of Alphonse Legros* 1923, pp[iii]–[iv]
3 Quoted in Sylvia Legge, *Affectionate Cousins: T. Sturge Moore and Marie Appia* 1980, p101
4 Unpublished letter to Robert Ross, no date
5 Unpublished letter to 'Michael Field', 26 October 1902
6 Unpublished letter to W B Yeats, 1922
7 Charles Ricketts to Robbie Ross, June 1911 in *Robert Ross: Friend of Friends* (ed Margery Ross) 1952, p215 and unpublished letter to Robbie Ross, March/April 1916
8 Cecil Lewis (ed), *Self-Portrait . . . Letters and Journals of Charles Ricketts* 1939, pp304–5
9 Unpublished letter from Gordon Bottomley to William Rothenstein, 12 January 1932
10 *Gordon Bottomley: Poet and Collector* exh. cat. Carlisle City Art Gallery 1970, cat. p1

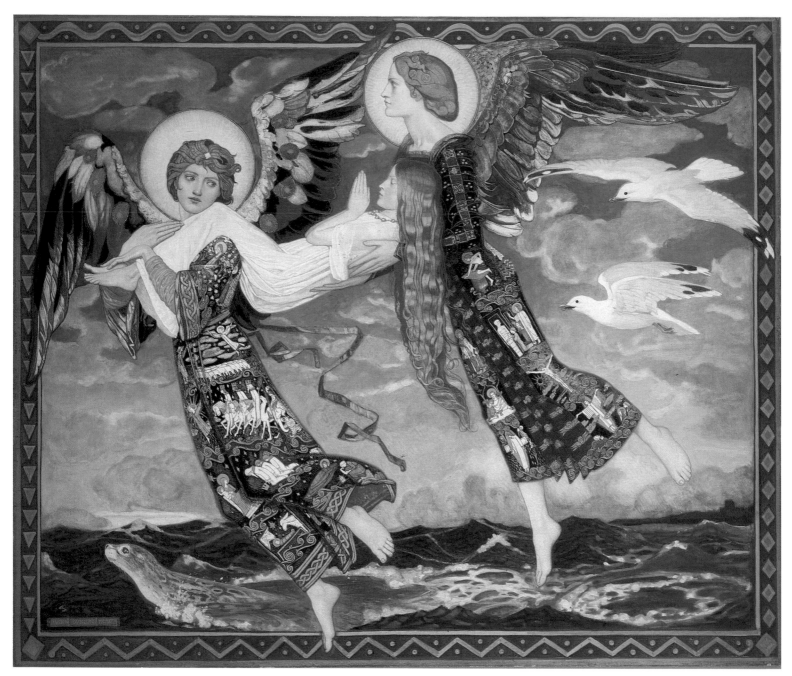

John Duncan *St Bride* **1913.** Cat. 392

CELTIC ELEMENTS IN SCOTTISH ART AT THE TURN OF THE CENTURY

Lindsay Errington

With few exceptions, the fantastic, magical and visionary found little place in nineteenth-century Scottish art, where, from Raeburn to such 'Glasgow School' artists as Guthrie, W Y Macgregor, and Paterson, the trend was towards naturalism or realism of style and factual possibility of subject. For most of the century the paintings shown at the Royal Scottish Academy were divisible into four main groups: portraits, landscapes, rural genre and scenes from Scottish history or historical novels. The bituminous brown style of chiaroscuro deriving from Wilkie gave way to the brighter colours, sharper outlines and prolixity of detail popular in the mid-nineteenth century, and this in turn was superseded by the emphatic broken handling of McTaggart or of the already-named Glasgow School painters in the 1880s, but these stylistic revolutions would undoubtedly have been defended or justified by their practitioners on naturalistic grounds. This naturalistic approach and factual, sometimes prosaic, attitude, may strike one as odd in a country possessing such a literary store of legendary, mythical and supernatural materials and such records of actual witchcraft, and in a country, furthermore, which broke into eighteenth-century European culture with Macpherson's 'translations' of Ossian's poems. The vague atmosphere of *Ossian*, so full of mist and shadowy spectres, the sense of foreboding and melancholy, which seemed to excited eighteenth-century literati the antithesis to the clarity of Homer, is hardly to be found in nineteenth-century Scottish painting before the last decade of the century, though Richard Muther made a somewhat ludicrous attempt to locate an Ossianic sensibility in Lavery's 1883–7 painting *Queen Mary after the Battle of Langside*.[1] The artistic exceptions – the dissidents in this reign of naturalism – therefore stand out in all their eccentric clarity: the morose and defiant early nineteenth-century David Scott, influenced by Blake's poetry and painting; his brother William Bell, poet, painter and friend of the Pre-Raphaelites; and the extraordinary Joseph Noel Paton, painter and minor poet, who also had contacts with Pre-Raphaelitism, and lived surrounded by a débris of armour and ancient relics. Paton, indeed, was to prove a link figure between the poetic and fantastic painting of the earlier century and that of the Celtic revivalist John Duncan in the 1890s, and an interest in the later phases of Pre-Raphaelitism underlines much of the decorative and fantastic *fin-de-siècle* painting with which we are now concerned, and which emerged, more or less simultaneously, in both Glasgow and Edinburgh.

What took place in Edinburgh in the 1890s has been condemned by the twentieth-century Scottish writer Ian Finlay, who much preferred to see an orthodox straight march of progress in easel painting advancing from Raeburn to the Glasgow School realists, and thence on to the colourists Peploe, Cadell, Fergusson and Hunter. 'Scotland', he claims 'had her escapist movement with its own peculiar significance. It centred mainly on Edinburgh, which, by the end of the century, had come to contemplating its own past glories rather than present needs. It took the form principally of decorative wall painting, and at a time when Glasgow men were producing vital easel-pictures, retired into one of its phases of arid intellectualism. ... The most significant figure in the movement ... is John Duncan. He was the painter counterpart to 'Fiona Macleod', the poet, and it is impossible properly to assess the two apart. ... While the painters of the 'greatest Celtic city in the world', only forty miles away, were searching for the same things as all the other young men in western Europe, ... Duncan buried himself in tomes of Gaelic legend and illustrated its maidens and monsters.'[2]

Finlay was able to approve an unconscious, latent Celticism which he believed underlay the swirling rhythms of Glasgow Henry's *Galloway Landscape* (Glasgow), but he carefully avoided mention of Henry and Hornel's only essay in overt Celticism, shortly to be discussed. His dislike of Art Nouveau, and his loathing for 'arty-craftiness', led him to distort and underplay what took place in the Edinburgh Arts and Crafts movement, and his preference for Glasgow encouraged him to overlook any Celticism which cropped up in that city. It is not, however, the purpose of this essay to describe or attempt to evaluate the significance of the Scottish Arts and Crafts movement, but rather to say something briefly about the Celtic renaissance – which Finlay preferred to call a 'Celtic Twilight': the subject-matter, the style, and the needs which were met by such a movement at the turn of the century.

Robert Brydall, whose *History of Art in Scotland*, published 1889, was the first attempt to compose such an account, confidently dates the origins of Scottish art to the arrival of St Columba, and, in his first chapter, deals with Celtic art, with standing stones, early symbols, illuminated manuscripts, sculptured crosses, churches and Celtic metal work. It might almost be a programme for the Scottish Arts and Crafts movement. His book had been preceded by James Drummond's *Archaeologica Scotica. Sculptured Monuments in Iona and the West Highlands*, published posthumously in 1881, and Joseph Anderson, in his Rhind lectures, *Scotland in Early Christian Times* and *Scotland in Pagan Times* (delivered in 1879 and 1882, published 1881 and 1886), broke new archaeological ground. The deceased Celts of the sixth and seventh centuries did not, however, monopolise scholarly attention. Professor Blackie, who occupied the Greek chair at Edinburgh University, was campaigning vigorously, in the 1870s, to prevent the extirpation of Gaelic as a living spoken language, and his efforts were rewarded by the foundation, in 1882, of a Celtic chair at Edinburgh University. During the same decade, the small crofting farmers of the highlands, who steadily and for over a century had been evicted from the former clan lands by a new race of commercially-minded landowners, were at last given security of tenure by the passing of the Crofters Act in 1886. The concept of Scotland as once a Celtic nation with an impressive artistic culture, and still a Celtic nation in terms of race, was, by the beginning of the 1890s, forcibly established in the public mind. Even Stevenson, far away in Samoa, beginning his unfinished Border novel of the Covenanting period, *Heather Cat*, commenced with allusions to prehistoric symbols, standing stones and 'an antiquity older perhaps than any, and still living and active – a complete Celtic nomenclature and a scarce-mingled Celtic population'.

The first visual response to this new attitude seems to have been *The Druids* (Fig. 10), the strange collaborative painting exhibited by the Glasgow School artists E A Hornel and George Henry at the Grosvenor Gallery in 1890. This painting was followed by another in 1891, *The Star in the East* (Fig. 11), which must, for reasons which will be explained, be regarded as its thematic pendant. *The Druids*

Fig. 10 George Henry and E A Hornel *The Druids: bringing in the Mistletoe* **1890. Glasgow Art Gallery and Museum**

Fig. 11 George Henry and A E Hornel *The Star in the East* **1891. Glasgow Art Gallery and Museum**

is a striking combination of Glasgow School 'square-brushstroke' naturalism, in rather brighter colours than usual, with a medley of decorative motifs which endow it with a suitable magical and pre-historic quality. Two sturdy white oxen, probably destined for sacrifice, descend a snowy slope followed by Celtic worshippers. The aging Druid wears – since nineteenth-century pictorial traditions had established this as *de rigeur* – a gold lunula balanced upside down on his head. Another lunula is carried by the foremost figure – the golden sickle by which the mistletoe has improbably been cut. He wears a sun disc embellished with a serpent which may derive from Pictish symbol stones, and other emblems of more obscure significance are scattered over his robe. It is the winter solstice, which was the moment in the calendar year deliberately adopted for the celebration of the Christian holy birth, a point made in the same year that the *Druids* was painted in the first edition of Fraser's *Golden Bough*, and emphasised by the Christian and distinctly less exciting *Star in the East* which Hornel and Henry painted in 1891. The Celtic road, however, was one which they followed no further (turning instead to Japonaiserie), and other Glasgow artists in the last decade of the century – especially the so-called 'Four', Mackintosh, MacNair and the two Macdonald sisters – tended to look more to Art Nouveau and stylistic trends on the continent, though their work has sometimes been rather loosely and inaccurately described as Celtic.

It was in Edinburgh, as Finlay stated, and under the influence of that strange figure, biologist, town-planner and visionary, Patrick Geddes, that the Celtic revival took shape. Geddes encouraged or commissioned a number of artists to undertake mural paintings in various public or semi-public buildings in Edinburgh, including the walls of his own newly-built student residences on the edge of the Castle Esplanade. He was also responsible for producing four seasonal volumes of a new publication, *The Evergreen*, in which (via contributions from painters, writers and biologists) science, mysticism, pagan-ism, Christianity, theories of evolution and promises of a Celtic renaissance mingle in surprising juxtapositions. One of Geddes' col-laborators called *The Evergreen* 'an experiment in practical anarch-ism',[3] but it is in fact more homogeneous in character than this engaging description would lead one to expect, and is strongly domin-ated by Geddes' own biological mysticism. The Celtic character was reinforced throughout by the attractive head- and tailpieces supplied by two of John Duncan's art students. Duncan himself, and Robert Burns, are the two artists who emerge as the most distinct and indi-vidual personalities connected with *The Evergreen*. Burns had studied in Paris, where he would have encountered Japanese Art in an exhibi-tion of 1898. His sources are eclectic, with little apparent Celticism, and though his *Evergreen* illustration *Natura Naturans* (Fig. 13) seems the perfect visual counterpart to Geddes' conception of evolving natural forces, Burns would appear to have held aloof from Geddes' circle, and to have gone his own way. When, late in life, he provided a series of illustrations to traditional Scots poetry (Cat. 407–9), it was to the stark and sometimes grim realism of the Border Ballads that he turned, rather than to the shadowy and dream-like images of Gaelic myth.

Phoebe Traquair, another of Geddes' protégées, did not contribute to *The Evergreen*, but produced work in a variety of techniques from enamel to embroidery, and a series of mural paintings beginning in 1884 with the modest decoration of the Mortuary at the Sick Chil-dren's Hospital (Fig. 12) and culminating in the decoration (begun 1893) of the Catholic Apostolic Church, London Street, Edinburgh. The influence of early Italian fresco painters, filtered through a sen-sibility modelled by late Pre-Raphaelitism, is evident in the figurative parts of the design, but the decorative borders contain a number of Celtic-influenced motifs. This stylistic division – which is already

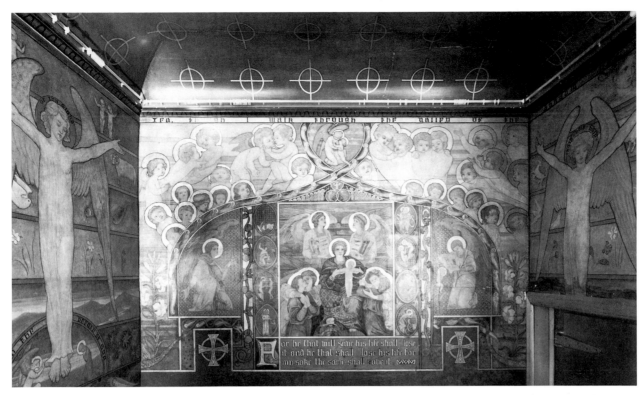

Fig. 12 Phoebe Traquair
Mortuary Chapel (north wall)
Royal Hospital for Sick
Children, Edinburgh **begun**
1884. Courtesy of the Royal
Commission on the Ancient
and Historical Monuments
of Scotland

apparent in the Hornel/Henry collaborative *Druids* – between the semi-naturalism with which the figures are treated, and the Celticism which is applied decoratively to borders, jewellery and clothes, recurs also in a number of Duncan's paintings. It was perhaps inevitable, since original early Celtic art was more decorative and abstract than figurative, but the problem of the separation of one picture into two styles was never fully resolved.

It was Duncan, rather than Burns or Traquair, and to a lesser extent, Duncan's pupil or assistant George Dutch Davidson, the short-lived Dundee artist, who made the only serious attempt to create a new Celtic art, incorporating elements of ancient but re-worked design, and ancient but re-worked myths.

Duncan's maturity as a painter did not come till the first decade of the twentieth century, when he managed to create, out of an unlikely rag bag of disparate stylistic elements, including Celtic art, photographs of the frescoes of Michelangelo, *cinquecento* Italian tempera paintings and late Pre-Raphaelitism, a strange pale, bright, arid, intricate jewelled style of his own which is the perfect counterpart to the otherworldly and magical nature of his subjects. The imaginative world of spurious Celticism which he was both exploring and making is close to that described by the Celtic poet and contributor to *The Evergreen*, Fiona MacLeod. Fiona Macleod, the visionary, dreaming poet whom no one ever met, was in fact the female alter ego of the writer William Sharp, busy critic and pot-boiling author, friend – if his private correspondence can be trusted – of Rossetti, Meredith, Browning and almost every other High Victorian writer.[4] Although none of Duncan's paintings can be described as illustrations to Fiona Macleod, both paintings and poems explore the same mental states and symbols, in parallel as it were, and are usefully examined together.

Fiona Macleod's *The Immortal Hour* was first published in America in 1907. Set to music by Rutland Boughton after the author's death, it was first performed at Glastonbury in 1914, and again, after the war, on the London stage, in several revivals during the 1920s. *The Immortal Hour* is a re-working of the ancient Irish myth of Midir and

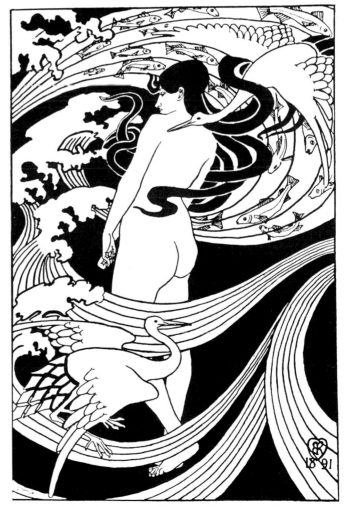

Fig. 13 Robert Burns *Natura Naturans, illustration to 'The Evergreen'* **1891**

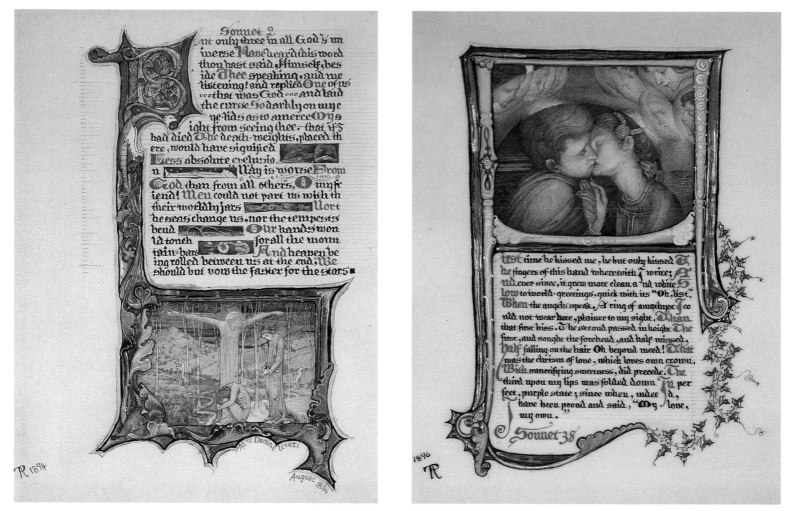

Phoebe Traquair *Illuminated manuscript from Elizabeth Barrett Browning's Sonnets from the Portuguese,* **nos 2 and 38 1894–6.** Cat. 382

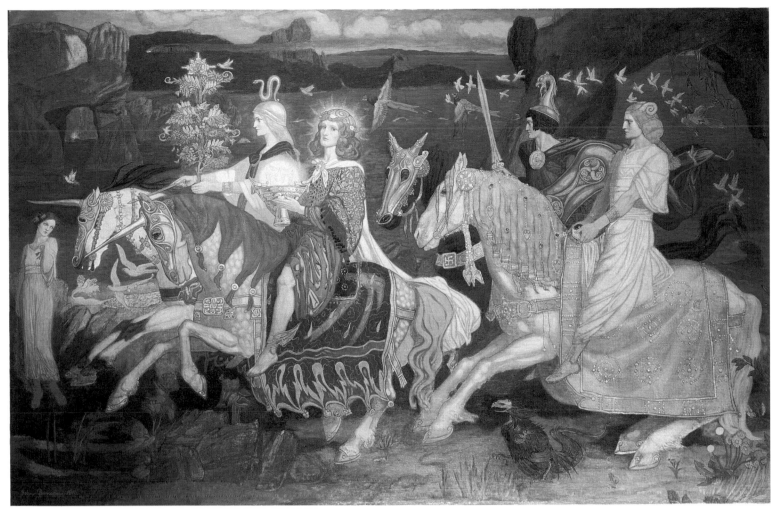

John Duncan *The Riders of the Sidhe* **1911.** Cat. 390

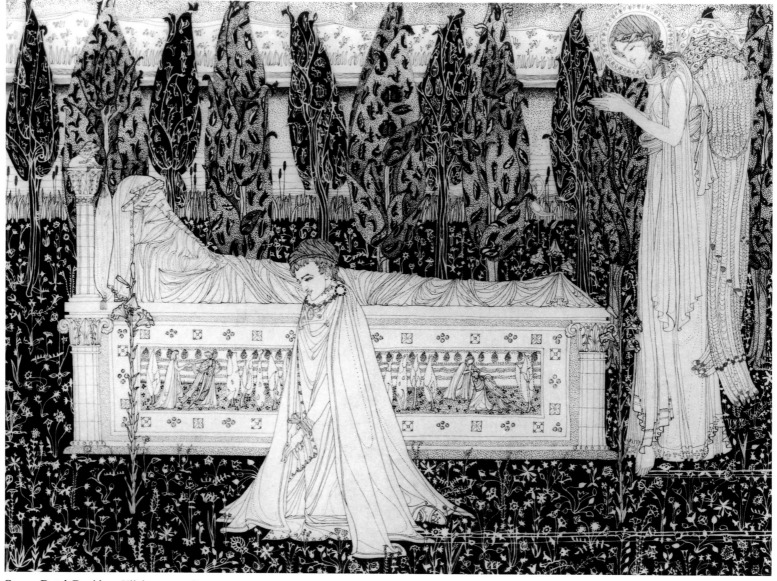

George Dutch Davidson *Ullalume* 1900. Cat. 414

Etain which, the author believed, symbolised the coming of spring. Etain, like Mary Rose in Barrie's drama, moves in and out between two worlds, that of the Sidhe (pronounced Shee) or fairy people, and that of ordinary human beings. Like the strain of music which calls Mary Rose, a song awakens Etain's memory and summons her to return from the ordinary world into the other:

> *How beautiful they are,*
> *The lordly ones,*
> *Who dwell in the hills,*
> *In the hollow hills*

In her introduction, Fiona Macleod emphasises that the Sidhe or 'Hidden People . . . were great and potent, not small and insignificant beings'. It is these Sidhe, once Celtic gods, whom Duncan depicts in his painting of 1911, *Riders of the Sidhe* (Cat. 390). His riders are shown setting out on the eve of Beltane (one of the four seasonal Celtic festivals) bearing symbols as follows: the tree of life and of knowledge, the cup of the heart of abundance and healing, the sword of the will on its active side, and the crystal of the will on its passive side. E A Taylor, writing on Duncan in *The Studio* in 1920, claims

these symbols for age-long Celtic tradition, but accounts of Celtic myth and religion signally fail to mention them, and it seems rather as though they are Duncan's own invention, betraying in their type of symbolism the still lingering influence of Patrick Geddes.

Duncan's *St Bride* of 1813 (Cat. 392) is another design which has affinities with the work of Fiona Macleod. Brigid or Bride, the Irish saint, is supposed to have been born about AD 450 of Christian parents, and to have founded a religious community of women at Kildare. Legends concerning the pre-Christian Celtic deity Brighid or Brithid came in time to be attached to the historical person, and she was known as 'Mary of the Gael' and 'The Foster Mother of Christ'. It is said that she was miraculously transported to Bethlehem on the night of Christ's birth, and wrapped the baby in her cloak. One version of this story was told by Fiona Macleod in the Autumn number of *The Evergreen*, but this account, in which Bride simply walks out of Iona into Bethlehem for a year and a day, differs from that depicted by Duncan, where angels carry her over the sea in a trance. Their copes, which are embroidered with a series of pictures showing the future life of Christ and his Crucifixion, induce the sense of conflated states of time so dear to the Celtic revival. A footnote

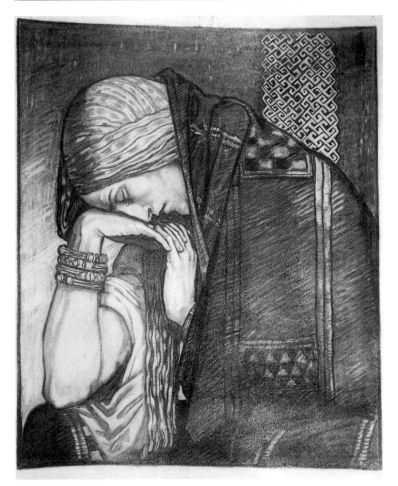

John Duncan *Deirdre of the Sorrows.* Cat. 397

by Fiona Macleod in her article 'The Gaelic Heart'[5] may indicate why Duncan wished to introduce the sea into his design.

'That earlier Brighid was goddess of poetry and music, one of the three great divinities of love, goddess of women, the keeper of prophecies and dreams, the watcher of the greater destinies, the guardian of the future. I think she was no other than a Celtic Demeter – that Demeter-Despoena born of the embrace of Poseidon, who in turn is no other than Lir, the Oceanus of the Gael. . . . It is Demeter-Brighid seeking her brother Manan, God of the Sea.' The prologue of Fiona Macleod's *The Sin-Eater and other Tales*, published 1895, is entitled 'From Iona', and its description of spring on the Sound of Iona with the seals 'putting their breasts against the running tide', the congregation of sea fowl, and the waters of the Sound which 'dance their blue bodies, and swirl their flashing white hair o' foam', reads like the programme for the seascape setting of Duncan's *St Bride*.

Other mythological Celtic figures who enter Fiona Macleod's writings, and who were also portrayed by Duncan, are Cuchulain the Irish hero, who shares many of the attributes of a solar deity (Cat. 398), Angus Og or Ogue, the Celtic god of love and youth; the Children of Lir, magically changed to swans; and Deirdre, the Celtic Helen, whose fate is described by the Irish Synge in his *Deirdre of the Sorrows* (1909), but who, a number of years earlier than that, was dealt with by Fiona Macleod in her play *The House of Usna*,[6] first performed in 1900 (Cat. 397).

Celtic revivalism was not in Scotland, as it was in Ireland, the prologue to a militant nationalism, and Fiona Macleod was only too anxious to avoid such imputations. Finlay's criticism, quoted above, is justified to the extent that the Celtic stories and symbolism employed were complex, and to most people probably obscure. Duncan's tree, cup, sword and crystal bore private meanings, and at least one of his Christian paintings, showing Jesus walking on the sea, and inscribed below: 'MY DRUID IS CHRIST', must have baffled many othodox believers. What, then, did the Scottish Celtic revivalists hope to attain? One answer is provided in the constant insistence on the functions of the Celtic pantheon as solar and natural deities, whose stories represent the recurrent cycle of seasons, of birth, growth, death and renewal, and who thus could be taken as emblems of forces perpetually at work, and perpetually evolving. Another answer seems to lie in a revulsion against the rational, factual and material side of life in favour of the intuitive, spiritual, dreaming side. It is no accident that visions and dreams play a considerable part in Celtic revival subjects. Fiona Macleod claimed that the intellectual drama of Ibsen had had its day and become outworn, and that a new 'Psychic Drama' was in preparation, whose emotional energy would move 'along the nerves of the spirit'.[7] 'In Celtic Scotland', she wrote, 'a passionate regret, a despairing love and longing, narrows yearly before a bastard utilitarianism which is almost as great a curse to our despoiled land as Calvinistic theology has been and is'.[8] Lastly, of course, the movement was – despite its differences from that in Ireland, and its refusal to lead to political action – a piece of national consciousness-raising. The Celts, however, whose spirit the revival evoked, were not seen as conquering heroes, ousting the Saxon rulers, but as a doomed people on the edge of extinction. This mood, not unlike that of the aged Ossian's reiterated lament for 'the songs of other days' in Macpherson's *Ossian* (re-issued by Patrick Geddes and colleagues, with introduction by William Sharp), perhaps justified Finlay's designation of the movement as a 'Twilight', and found its best expression in Fiona Macleod's valediction: 'A doomed and passing race. Yes, but not wholly so. The Celt has at last reached his horizon. There is no shore beyond. He knows it . . . "Even the children of Light must go down into darkness". But this apparition of a passing race is no more than the fulfilment of a glorious resurrection . . . The Celt falls, but his spirit rises in the heart and the brain of the Anglo-Celtic peoples, with whom are the destinies of the generations to come.'[9]

Notes

1 Richard Muther, *The History of Modern Painting* 3 vols 1895, III, p691
2 Ian Finlay, *Art in Scotland* Oxford 1948, p144
3 Victor Branford, in a letter of 22 October 1895, National Library of Scotland, MS 15941 f34
4 Letters to and MSS and papers of William Sharp, National Library of Scotland, MS 15941 ff105–99
5 'The Gaelic Heart' was an essay in *The Winged Destiny: Studies in the Spiritual History of the Gael* first published 1904, repr in vol. V in *The Works of Fiona Macleod*, arranged by Mrs William Sharp 1910
6 *The House of Usna* was first performed in 1900 by the Stage Society of London, at the Globe Theatre.
7 Fiona Macleod, in Foreword to first ed (published posthumously in America in 1907) of the drama, *The Immortal Hour*.
8 Fiona Macleod, in 'From Iona', Prologue to *The Sin-Eater and Other Tales*, Patrick Geddes and colleagues, Edinburgh 1895
9 Ibid

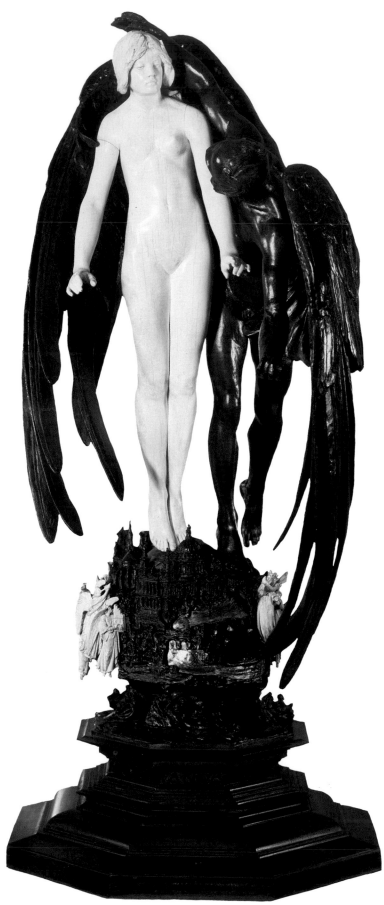

Harry Bates *Mors Janua Vitae* **1899.** Cat. 186

SAILING TO BYZANTIUM?

Benedict Read

Accounts of a recent revolution in British sculpture were well current before the nineteenth century closed. The painter Millais was cited as claiming all Europe might straightway fall into ecstasy were some of the works of British sculptors of this period dug up, partially dismembered and disguised as from Antiquity. The claims of others both then and more recently put forward a convincing case for such a major change.[1]

The two main aspects of this change were the new ways in which sculptors used their materials to give form to their subject-matter, and the type of subject-matter they chose to represent.[2] In bronze much more detailed surface modelling was the aim as opposed to the blander, more generalised surfaces achieved in the mid-nineteenth century; the adoption by Gilbert (Cat. 187) and Stirling Lee (Cat. 191) of the lost-wax method of casting bronze by the mid-1880s allowed for much greater subtlety of surface detail, whether of human musculature or material additions. The increased use of this technique led to a new variety of surface handling in bronze at both small and large scale (see Pomeroy, Cat. 189 and Toft, Cat. 202). The idea of animating the surface of the object led Gilbert to experiment further in colouring bronze surfaces, first in the allegorical supporting figures in his *Fawcett Memorial* of 1887 in Westminster Abbey, where he employed gold and silver plating as well as inset turquoises and garnets;[3] later in the *Duke of Clarence Memorial* at Windsor (1892–99/1901) he mingled and fused a wide variety of materials – bronze, marble, aluminium, ivory and brass – as well as painted colouring on the metal (Fig. 14).[4] In these same years George Frampton began to develop polychrome plaster works: *Christabel* was shown at the Paris Salon of 1889, *Mysteriarch* dates from 1892, and there followed two decades of work in polychromy and precious metals by Frampton (Cat. 193), Bates (Cat. 186), Stirling Lee (Cat. 191) and Reynolds-Stephens (Cat. 200–1). The nineteenth century had seen little like this in sculpture in Britain: John Gibson's efforts at tinting his marbles in mid-century, considered extreme at the time, are mild and experimental in comparison.[5]

At the same time as these technical adventures there arose a specialised area of subject-matter in sculpture, relating to Fate, Life, Love, Enchantment and (occasionally) Death, sometimes coupled together; subjects almost poetic rather than intrinsically sculptural, as Marion Hepworth Dixon implied in an article of 1892, referring to some isolated sculptors 'who will hold us by the cunning of some hidden meaning, some suggestive grace . . . by which we are beckoned into other and ideal worlds'.[6] Again, Gilbert seems to have set the pace with his *Enchanted Chair* of 1886 (now destroyed). The meaning of this is not self-evident – a naked sleeping woman is slumped on a throne composed of cherubs, wings and a fluttering dove at her feet – but we do need to be told that this symbolises the dreamer borne aloft by gentle sleep. And she is overshadowed by the wings of a huge bird – eagle or vulture – setting the tone of the meaning of the work as a whole, 'the terrifying force of the unconscious, the nature of dreams and the helplessness of the dreamer against those fears that rise up in us when we sleep'.[7]

The following year Gilbert showed *Post equitem sedet atra cura* ('Behind the horseman rides dark care'), but those who took up this line could be less pointedly morbid: Pegram's *Ignis Fatuus* 1889; Toft's *Fate-led* ('Fate leading, she must needs go on and on'); Allen's "*Love flies from the doubting soul*" of 1890; Reynolds-Stephens' *Love and Fate*; Allen's *Love Repulsed* of 1893; Toft's *The goblet of life* ('Filled is life's goblet to the brim!' etc) of 1894; Allen's *A Dream of Love* (Cat. 203) of 1896. Sometimes the mood veered right away, as in Onslow Ford's series of statuettes: *Folly* (1886); *Peace* (1887); *The Singer* (1889); *Applause* (1893); the critic Gosse referred to the first of these as 'this giddy creature, waving and oscillating in her foolish nudity from the top of her rock . . .'[8] and one feels that these statuettes, though typical in their detailed modelling rendered in bronze, are a world away from the more serious subjects mentioned above. Certainly they differ from Frampton's *Mysteriarch* of 1893 and *My Thoughts are My Children* of 1894 and could not be compared to Bates' *Mors Janua Vitae* ('Death the Gateway of Life') of 1899 (Cat. 186).

After 1900 the metaphysical type of subject continued in different degrees: *Prophetess of Fate* (Drury 1900); *Castles in the Air, Love's Coronet* (Reynolds-Stephens 1901 and 1902); *Spirit of Contemplation* (Toft, 1901–3, Cat. 202 – induced by life's goblet being filled to the brim? (see above)). By this time many more direct allegorical representations were featuring on public monuments – Bravery, Justice, Knowledge and so forth were ideal companions to the heroes of the time, let alone the great heroine herself, Queen Victoria, whose death in 1901 provided scope for sculptural commemoration on a grand scale throughout the country and Empire, where not already taken up by her Jubilee of 1897. There was still room though for historical commemorations fusing history, allegory, scale and colour such as Reynolds-Stephens' *A Royal Game* (Cat. 200) of 1911.

The more spiritual/allegorical area of subject-matter was not the only one singled out at this time for special treatment. The classical had always been the almost archetypal prime source for sculpture in view of the number of antique prototypes visible in the British Museum and elsewhere, and study from the Antique was *de rigeur* in academic training (see Cat. 205). But for the reuse and adaptation of classical subjects Gilbert again led the way in the 1880s with his *Perseus Arming* (exhibited 1882) and *Icarus* (exhibited 1884) in which he took over basic classical subjects and gave them additional interpretations of his own,[9] as well as transforming the images by his particular use of modelling in bronze. For Harry Bates classical mythology and literature were the staple of his subject pieces – the Aeneid, Psyche, Pandora and Endymion for example. Mackennal's *Circe* (Cat. 204) could cause a stir at the Royal Academy of 1894, while Pomeroy's *Perseus* (Cat. 189) is not just a restatement via Cellini – it was shown as 'a symbol of the subduing and resisting of Evil'.

The mythology of Christianity could also provide subjects with that extra edge to them to suit the times: when Mackennal chose the theme of Rahab from the Old Testament, to illustrate the text from the Book of Proverbs, 9.14: 'For she sitteth on a seat in the high places of the city', we are told 'this . . . realises not too subtly, so that all may understand, triumphant Vice (comprising a seated naked lady). Conscious of her power and supremacy, her expression indicating amused and contemptuous cynicism, she shamelessly offers herself for the golden rose. Her foot is set . . . on True Love, with his broken

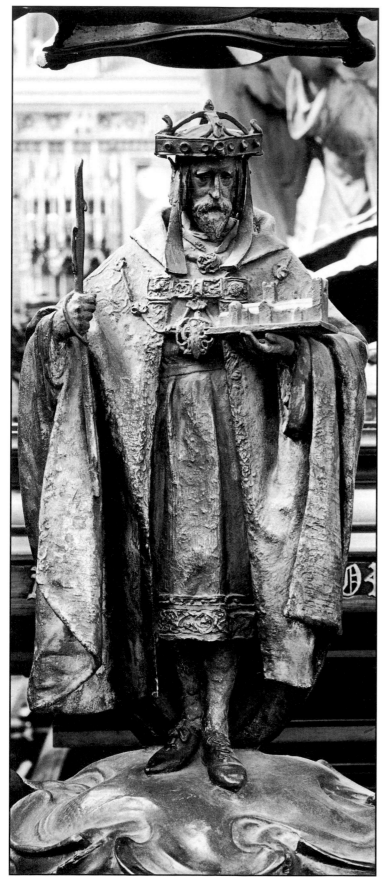

Fig. 14 Alfred Gilbert *Edward the Confessor*: detail from the Clarence Memorial, Windsor Castle, Albert Memorial Chapel 1899

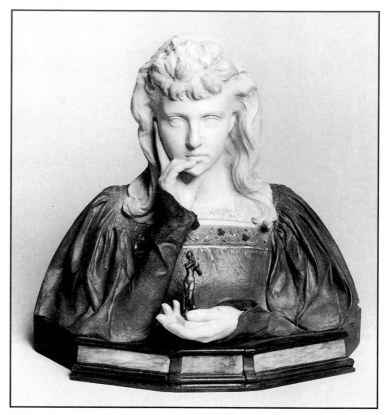

Fig. 15 Jean Dampt *Comtesse de Béarn* or *Réflexion* 1981 replica of 1897 original. Musée d'Orsay, Paris

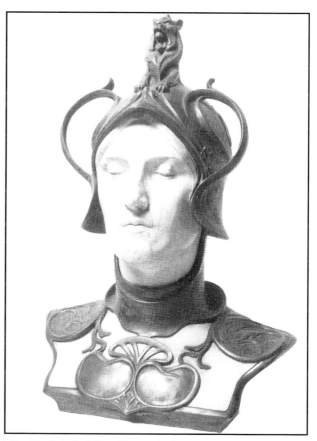

Fig. 16 Paul Dubois *La Liberté/De Vrijheid.* Musées Communaux/Stedelijke Musea, Brussels

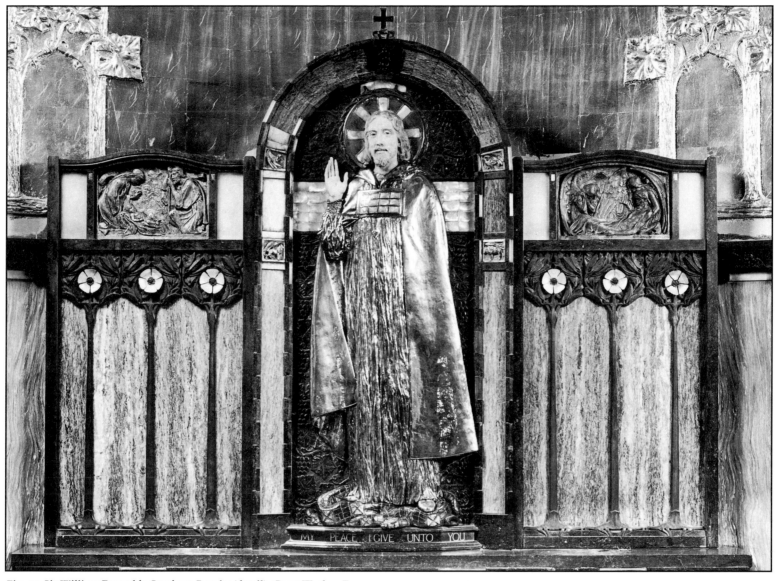

Fig. 17 Sir William Reynolds-Stephens *Reredos* **(detail). Great Warley, Essex**

wing; while the head of the Man, Sin, decorates the back of her throne'.[10] Both Frampton and Reynolds-Stephens, in reredoses for churches, represent not a conventional Christ crucified, but Christ in Glory, saying 'Feed my Sheep' (Frampton, St Mary, Edith Weston 1890); at St Mary the Virgin, Great Warley, an image of Christ inscribed 'My Peace I Give Unto You' (Fig. 17) is the focus of Reynolds-Stephens' overall decorative scheme, with layers of meaning and ramification: 'The primary object . . . in his designs has been to lead the thoughts of the worshippers onward through his decorations to the glorified and risen Christ whose form in the centre of the reredos is to be the keystone of the whole scheme. He has made free use of floral forms throughout the decoration, emblematic of progressive growth in the earthly life, but still more of glorious hope which year by year is emphasized at Eastertide, the time of floral recrudescence.'[11]

Similarly in subjects from literature: Frampton's *Peter Pan* (Cat. 196) alludes to magic and fairyland; his *Madonna of the Peach Tree* (Cat. 195) is almost certainly miraculous. Drury's *Griselda* (Cat. 190) is symbol of patience in suffering, while *Lamia* (Cat. 193) encapsulates colour, magic and ultimate deadly whiteness. Frampton

was not the only sculptor at this time to choose such a subject: Reynolds-Stephens had exhibited a relief in 1896 from Keats's 'Lamia' – 'Happy in beauty, life, and love, and everything' – we have met with the enchantress Circe in Mackennal and Drury (1894), Derwent Wood (1895) and Walker (1907) had chosen her too; the ur-snake woman Lilith – 'O bright snake, the death worm of Adam' – was sculpted by Toft (1889) and Drury (1913). The Welsh sculptor Goscombe John was able to use specific Celtic examples of magic (Cat. 198) and fairyland (Cat. 197).

A further particular literary source is worth noting. For about fifteen years following Tennyson's death in 1892, a handful of sculptors took up Tennysonian subjects which had been generally absent from sculpture before. Frampton featured ten of his heroines between 1896 and 1908; Goscombe John's *Merlin and Arthur* (Cat. 198) was shown in 1902; Hartwell exhibited '*As he rode down to Camelot*' in 1903. Reynolds-Stephens exhibited *Sir Lancelot and the nestling; the last tournament* in 1899, then *Guinevere and the nestling* – '*And after loved it tenderly etc*' in 1900; both were in bronze, ivory, mother-of-pearl and enamel. *Guinevere's Redeeming* (Cat. 201) followed in 1907. Treatment of further Nordic mythology came from Frampton (*The Children of*

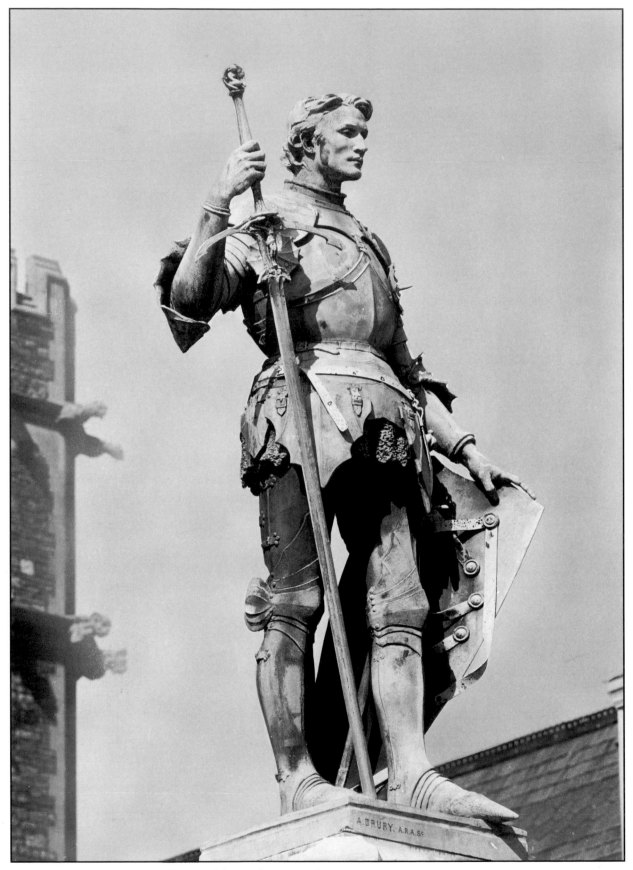

Fig. 18 Alfred Drury *Boer War Memorial*. Clifton College, Bristol

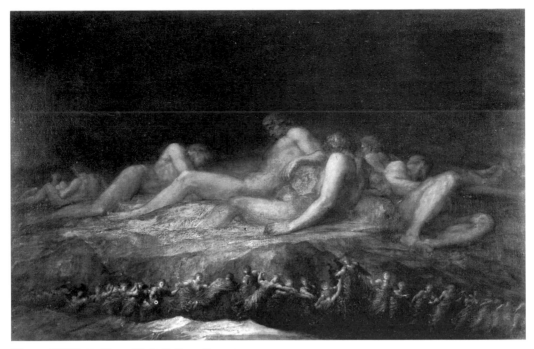

Fig. 19 G F Watts *Chaos*. Watts Gallery, Compton

the Wolf, RA 1893) and Gilbert Bayes; various Valkyrie scenes between 1894 and 1912, and, via William Morris as specific literary source, the *Sigurd* of 1909–10 (Cat. 206).

To find sources for the radical physical and imaginative changes in British sculpture described so far, one must look beyond native traditions in sculpture itself. There is little doubt that the type of finely modelled bronze statuette that Gilbert's *Perseus Arming* launched (and to which Mackennal's *Circe*, Cat. 204, Pomeroy's *Perseus*, Cat. 198, March's *Orpheus*, Cat. 211 and Stirling Lee's *The Music of the Wind*, Cat. 191, all belong) is indebted to a French type seen best in Mercié's *David Vainqueur*, as well as to Italian Renaissance work. In addition, unlike previous generations of developing sculptors who trained at home or (occasionally) went to Rome, from the 1870s many went to Paris and during the 1880s Stirling Lee, Mackennal, Drury, Bates, Pomeroy, Frampton and Goscombe John were all there for varying times and purposes of study or work experience.[12] One should be cautious as to what was cause and effect, and what simply analogy. Contemporary sources could write of a spontaneous renewal of interest in polychrome sculpture in Germany , France and England, with Paris and London showing in 1892 carefully thought-out works in coloured and tinted marble, ivory, variously hued bronze and painted terracotta – 'no one of these examples shows any sign of having been suggested by any other of them' (Figs 15, 16).[13] Nonetheless Jean Dampt was accoladed in the *Magazine of Art*: 'For many years he has been regarded by most artists, especially in England, as one of the great modern masters',[14] while Frampton we know had close contacts with advanced artistic circles in Belgium.[15] And there was a splendidly vigorous Symbolist movement current in both these countries in which sculpture featured very strongly.[16]

On the other hand, one should also remember that for sources of colour and subject-matter the sculptors needed to look no further than the home-grown Pre-Raphaelites. Lamia's origin in Keats is prefigured by Millais and Holman Hunt – the latter's *Pot of Basil* is just as morbid, with the said pot containing Isabella's lover's severed and buried head. Meanwhile Rossetti could provide in his painting and poetry an endless supply of metaphysical women, Boats of Love,

Arthurian passions and Liliths.[17] A channel of this influence was Burne-Jones with his poetic mythology and treatments of Perseus, Arthur and Merlin. One should remember too the power of the sheer physicality and colour of Burne-Jones at his best. Fernand Khnopff wrote of the 'brillante armure d'acier sombre' in *King Cophetua*, of 'la couronne de métal noir qu'éclairent les rouges des coraux et des rubis . . . les tissues précieux scintillent et luisent . . . les panneaux d'or ciselé . . . la petite armure en acier de Persée; la nef en chêne et en cuivre de la Table ronde . . . Le spectateur se sentait ravi dans une atmosphère de bonheur rêvé . . . cette ivresse de l'âme . . .".[18] Gilbert became for a time a 'humble proselyte' of Burne-Jones[19] who then, with other sources, helped to inspire the armoured figures of the Fawcett and Clarence Memorials, let alone *St George and the Dragon, Victory Leading* (Cat. 187). Reynolds-Stephens executed a *Sleeping Beauty* relief; Frampton, Bayes and Drury were to take up St Georges as supporting figures in monuments[20] or as the key figures themselves, especially in war memorials (Fig. 18).[21]

Granted one painter as inspiration for a generation of sculptors (and so demonstrating the folly of imposing an ideological impasse between these arts – Reynolds-Stephens and Drury trained and practised in both), two further figures immediately suggest themselves. Both Leighton and Watts produced individual sculptures, as well as extensively using sculptured models in their paintings; the *Studio* magazine launched its career as leading avant-garde art magazine with an article on Leighton's clay models.[22] Baldry claimed that Leighton looked at nature with a sculptor's eye – he was by instinct and habit of mind more a sculptor than a painter,[23] while Watts claimed about himself that there were few designs of his that would not be suitable for sculpture.[24] In addition, both painters had evolved their own very distinctive types of painting involving allegory to the point of imaginative metaphysics. From the later 1840s Watts attempted paintings that illustrated 'the poetry of ideas':[25] *Love and Death, Love and Life* (cf. Allen, Cat. 203), *Hope* and *Chaos* – this latter he would rather have called *Cosmos* or even *Chaos passing to Cosmos* (Fig. 19).[26] Leighton too had evolved, particularly from the later 1860s, a series of mainly classical (but sometimes biblical) subjects as vehicles of

Harry Bates *Mors Janua Vitae* (detail). Cat. 186

Fig. 20 Alfred Turner *Sir Galahad*. Victoria College, Jersey 1923

Fig. 21 Alfred Gilbert *A Dream of Joy during a Sleep of Sorrow, The Sam Wilson Chimneypiece* 1908–13.
Leeds City Art Galleries

abstract form and colour, paintings such as *Jonathan's Token to David* or *Daedalus and Icarus* (cf. Derwent Wood, Cat. 205), in which too there could be added layers of implicit emotion. Leighton's *Perseus and Andromeda*, shown in 1891, was under way just as a marble version of his sculpture *Athlete Struggling with a Python* was being prepared by Pomeroy (cf. *Perseus*, 1898, Cat. 189). In his last years Leighton was producing works like *Solitude* (RA 1890), *The Spirit of the Summit* (RA 1894), *Fatidica* (RA 1894) which in concept if not always in form coincide with sculptures like *Sibylla Fatidica* (Pegram, RA 1891), *The Spirit of Contemplation* (Cat. 202) or *The Spirit of Solitude* (Drury, RA 1913). We should not really be surprised when Gilbert uses Watts as model for *Edward the Confessor* on the Clarence Memorial (Fig. 14) or that Sculpture (Cat. 185) features equally with Painting on Brock's *Leighton Memorial* in St Paul's Cathedral, while Bates' master-work (Cat. 186) recalls Watts, Leighton and Burne-Jones.

In spite of such inspiration and the thirty years of commitment to certain ideals so far described, it would be unrealistic to expect this type of sculpture to persist against all forces of art and society, although Bayes (Cat. 206) and Pegram continued to exhibit classical and spiritual/allegorical pieces well into the 1920s and 1930s. Certain personal variants were still feasible: Ricketts blended subjects within this convention (Cat. 316) with a style based on Rodin, still fairly exceptional at this time. Alfred Gilbert, who had led for so long, had moved to a higher dimension with his commitment to Royal patronage and the Clarence Memorial in the 1890s; but his inability to complete the commission on time and his apparent flouting of royal protocol led to physical and artistic exile. On occasion though, as with the Wilson chimney-piece (Cat. 188; Fig. 21) of 1908–13, he still maintained and developed his own individual brand of personal allegory and symbolism, and he returned to England in 1928 to execute the *Queen Alexandra Memorial*, a final statement, if slightly over the top, of the symbolist ideas of the previous half-century.[27]

Other sculptors too persisted with certain modified themes. Alfred Turner reintegrated St George with Arthurian myth to form *Sir Galahad* as a war memorial (Fig. 20) and his personal vision of classicism and symbolism produced *Dreams of Youth* (Cat. 210).[28] Fauns and Pans (Cat. 208) remained valid – 'Who said, Pan is dead?' wrote

Maurice Hewlett. '. . . He is not dead, and will never die. Wherever there's a noonday hush over the Weald, wherever there's mystery in the forest, there is Pan. Every far-sighted, unblinking old shepherd up here afield with his dog knows all about him.'[29] Walker, who had joined in the classical side (*Circe* 1907; *Atalanta* 1909) also showed a Faun in 1926; he had always, though, a strong bias to the religious and his *Christ at the Whipping Post* (Cat. 199) still exemplifies the unflinching polychromatic vigour of Frampton and Reynolds-Stephens. Eric Gill's *Prospero and Ariel* (Cat. 212), though seemingly an irreproachable token of modernism in sculpture – the artist was selected via Herbert Read, no less – and so completely out of place in this context, has certain roots in what had gone before in the complexities of its ostensible and personal symbolisms. For Gill with his background in the post-Pre-Raphaelite Arts and Crafts movement, and deeply imbued with Roman Catholicism, the imaginative creation is not too far developed from Mackennal's Rahab or Bates' *Mors Janua Vitae*.

How much of a role there should be for such works, precious and refined alike in material and concept may be open to question. In 'Sailing to Byzantium' Yeats seems to describe so aptly the context:

> *Once out of nature I shall never take*
> *My bodily form from any natural thing,*
> *But such a form as Grecian goldsmiths make*
> *Of hammered gold and gold enamelling*
> *To keep a drowsy Emperor awake;*
> *Or set upon a golden bough to sing*
> *To lords and ladies of Byzantium*
> *Of what is past, or passing, or to come.*

Tennyson had warned of too exclusive a retreat into the Palace of Art (in his poem of that name). Yet one may legitimately ask whether these artefacts, in concentrating on the truth and beauty of the materials they use, in attempting to give form to ideas perhaps on the verge of the visually inexpressible, did not pave the way for a future generation to go still further; it is possible that the achievements of modern British sculpture owe something to these artists.

Notes

1 The main accounts of the sculpture of this period are: Edmund Gosse, 'The New Sculpture 1879–1894' *Art Journal* 1894, pp138–42, 199–203, 277–82, 306–11; Marion H Spielman, *British Sculpture and Sculptors of To-day* 1901; Lavinia Handley-Read Introd. to Fine Art Society exh. cat. *British Sculpture 1850–1914*, 1968, pp7–17; Susan Beattie, *The New Sculpture*, New Haven and London 1983. For a more general account see B Read, *Victorian Sculpture*, New Haven and London 1982, pp289ff.

2 It should be remembered that the average sculptor continued to earn a living by producing portrait busts and commemorative statues.

3 Richard Dorment, *Alfred Gilbert*, New Haven and London 1985, p67

4 Ibid, pp153–75

5 See in particular *The Tinted Venus* of 1851–6, Sudley Art Gallery, Liverpool

6 *Magazine of Art* 1892, p325

7 Dorment, op cit, p61

8 *Art Journal* 1894, p282

9 See Dorment, op cit, passim pp38–49

10 Spielmann, op cit, p133, ill p135

11 From a leaflet published at the time of the church's dedication in 1904, quoted by John Malton in 'Art Nouveau in Essex' in *The Anti-Rationalists* (eds N Pevsner and J Richards) London 1973, p159

12 This new relationship bore fruit at the Paris Exposition Universelle of 1900 when Allen, Bayes, Drury, Frampton and Goscombe John all won awards.

13 Claude Philips, *Magazine of Art* 1892, pp378–9

14 *Magazine of Art* 1899, p307

15 Exact dates for polychrome sculpture in Belgium are hard to determine. Destrée (O G Destrée, *The Renaissance of Sculpture in Belgium* 1895, p74) suggests ivory

was available from 1894. For Paul Dubois, see *Académie*, exh. cat. Musées Royaux des Beaux-Arts de Belgique, Brussels 1987, pp325–7. For polychromy in French nineteenth-century sculpture, see Antoinette Le Normand Romain, 'La polychromie' in *La Sculpture française au XIXe siècle* exh. cat. Grand Palais, Paris 1986, pp148–59

16 See Destrée, *Académie* and *La Sculpture française au XIXe siècle* cited in note 15

17 See T Earle Welby, *The Victorian Romantics* 1929, pp31–2: 'With Rossetti's group, and still more with its disciples, we find . . . a reliance on exotic, antique, mystical accessories . . . used with . . . confidence that their mere presence in the picture or poem will give it artistic value'. (I have deliberately omitted where indicated Welby's critical reservations.)

18 Fernand Khnopff, 'Des souvenirs à propos de Sir Edward Burne-Jones in *Académie Royale de Belgique, Annexe aux Bulletins de la Classe des Beaux-Arts*, Brussels 1919, pp36, 39

19 Isabel McAllister, *Alfred Gilbert* 1929, p147

20 See Frampton, rear of Victoria Memorial, St Helen's, Lancs (1906), Lockhart Memorial, St Giles Cathedral, Edinburgh (1908), Edward VII Memorial, Northampton (erected 1913)

21 See also Bayes' war memorial, Todmorden

22 *Studio* 1 1893, pp2–7

23 A L Baldry, *Leighton* 1908, p76

24 See *Victorian High Renaissance* exh. cat. Manchester and Minneapolis 1978–9, p83

25 Mrs Russell Barrington, *G F Watts Reminiscences* 1905, p195

26 See *Victorian High Renaissance*, op cit, p81

27 See Dorment, op cit, pp317–22

28 For further information on Alfred Turner see Nicholas Penny, *Alfred and Winifred Turner* exh. cat. Ashmolean Museum, Oxford 1988

29 Maurice Hewlett, *Letters to Sanchia* 1911 ed, p37

Fig. 22 Charles Mahoney *Fortune and the Boy* mural panel. Brockley School, Lewisham 1934–6.
Photograph courtesy of Mark Fiennes

PUBLIC PLACES AND PRIVATE FACES - NARRATIVE AND ROMANTICISM IN ENGLISH MURAL PAINTING 1900-1935

Alan Powers

'The only essential distinction between Decorative and other art is the being fitted for a fixed place; and in that place, related, either in subordination or in command, to the effects of other pieces of art.'[1] Thus John Ruskin made the claim for mural painting in his lecture 'Modern Manufacture and Design', given at Bradford in 1859. The desire to escape from the confines of the picture frame and work in relation to other arts was one often professed in the nineteenth century but only fully realised in the twentieth.

Mural painting was an integral part of the Arts and Crafts movement but its impact was greatest after 1900. Frank Brangwyn began his mural-painting career at this time, fresco technique was being reintroduced by Mary Sargant Florence, and a number of architects were deliberately making opportunities for murals in their buildings. The new movement for civic consciousness and reform, of which Patrick Geddes was a pioneer in Edinburgh in the 1880s, saw murals as part of its programme. In *Modern Mural Decoration* by A Lys Baldry (1902), the list of artists around whom 'a small band of believers can rally' included Puvis de Chavannes, G F Watts, Frederic Leighton and Burne-Jones. While the last three had struggled with varying degrees of success to paint murals during a period when there were few commissions for them, Puvis de Chavannes had benefited from a greater interest in public painting in France. The calm, classical assurance of his work did not preclude a symbolist intensity, and he managed to project his imagination onto the large spaces of public buildings in a manner which strongly impressed a number of younger English painters. The potential conflict between the private and personal imagination of the artist and the requirements of a large-scale decoration for a public space provides a theme for the study of late romantics. For many of the best English painters of the period 1900–35, mural painting was the activity towards which their training and aspirations were directed. Difficulties of patronage frequently frustrated their idealism, but the period cannot be seen as a whole without giving murals a prominent place.

A remarkable but little-known work is the Library of the Unitarian Church, Ullet Road, Liverpool, by Gerald Moira (1900). The simple vaulted ceiling is painted with *Truth uplifted by Time* (Fig. 23). Moira was appointed Professor of Mural Painting at the Royal College of Art in 1900, the subject being considered by W R Lethaby as essential to his Arts and Crafts reform of art education. Moira advocated a new and different kind of training for mural painting, believing that the discipline of pictorial design and construction would benefit all kinds of painting. As in architecture at this time, the brief *rapprochement* with Art Nouveau, apparent in the Ullet Road ceiling, transformed itself in the first decade of the new century into a search for a modern classicism.

After Leighton's death, the chief advocate of mural painting at the Royal Academy was Edwin Austin Abbey, who supervised the execution of the eight historical panels in the East Corridor of the Palace of Westminster, completed in 1910, co-ordinating the works of a group of painters, including Henry Payne, Byam Shaw and F Cadogan Cooper. Payne's *Choosing the Red and White Roses in the Old Temple Garden* (Cat. 82), a fictional incident from Shakespeare's *Henry VI Part 1*, shows how valuable the Pre-Raphaelite tradition remained

when it came to distributing light evenly through a picture, and keeping a unity of surface. The other paintings range from the brashly vulgar to the anecdotally trivial, revealing the need for specialised training for mural work.

The Arts and Crafts reform in mural painting was concerned with the materials and media of the painter rather than the subject. The revival of fresco had been abandoned after the relative failure of the first cycle of Palace of Westminster paintings, and it was left to enthusiasts like John D Batten, Christiana Herringham, Joseph Southall and Mary Sargant Florence to return to the written sources of Cennino Cennini and Vasari, and make practical experiments both in fresco and tempera. This movement is largely, but not exclusively, associated with the Birmingham School of painters, who combined interest in

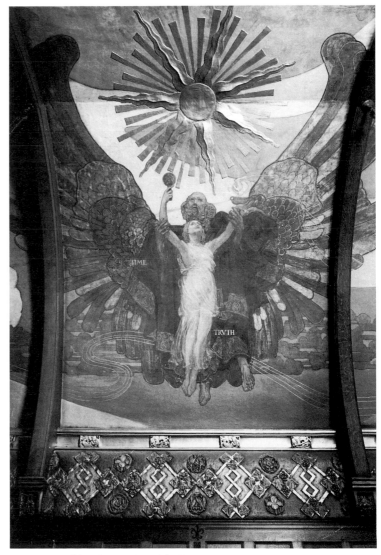

Fig. 23 Gerald Moira *Truth Uplifted by Time*. Unitarian Church, Ullet Road, Liverpool

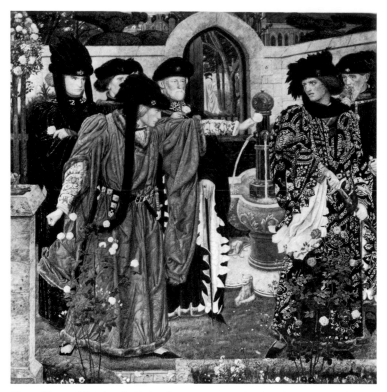

Henry Payne *Choosing the Red and White Roses in the Temple Gardens* c1910. Cat. 82

historical subjects with research into early techniques, and an interest in the social function of art. Lady Herringham's new edition of Cennini was published in 1899, and in 1901 the Society of Painters in Tempera was formed, renamed the Society of Mural Decorators and Painters in Tempera in 1912. Its three volumes of published proceedings, extending to 1935, are among the curiosities of the period, exciting admiration at the perseverance and scholarship, and also fears that the advocates of these media were regarded as cranks. The Society acknowledged the influence of the recent past and paid a reverent visit to Holman Hunt in 1907, although the artist had never in fact used tempera. Spencer Stanhope was one of the active members from the older generation, but there was no necessary association between historical romanticism and fresco and tempera, as Joseph Southall showed by his choice of subject for his only substantial *in situ* fresco, *Corporation Street, Birmingham, in March 1914* (1916) in Birmingham City Art Gallery. At the same time, Henry Payne's use of tempera for the murals in the Chapel at Madresfield Court (Cat. 99) contributes to the rich yet delicate atmosphere of late Pre-Raphaelitism.

The least-known but most original painter in the fresco revival was Mary Sargant Florence, Suffragette, colour-theorist and passionate enemy of oil-painting. Two major cycles of her frescoes survive, at Oakham School, Rutland (1903–10), and at Bourneville Junior School, Birmingham (Cat. 460). A third, *Les Aveugles*, a subject from Maeterlinck, formerly existed at her own house, Lord's Wood, near Marlow, and she was one of the painters chosen to execute panels for Chelsea Town Hall following a competition in 1911. Her work can be considered broadly as a continuation of the Burne-Jones tradition, but she replaced his classical tendencies in figure drawing and composition with something tougher and more Nordic. The Oakham frescoes illustrate the story of Gareth from Malory, 'an allegory of a boy's life at school'.[2] The psychological content of the subjects is the dominant concern, although decorative details give relief. The

colours are earthy and rich, and the execution broad, as Mary Sargant Florence believed that this was one of the advantages of the fresco medium. The Bourneville paintings are of New Testament subjects and the work was shared with Mary Creighton, a close follower of Mary Sargant Florence, although with less talent and originality. The unnatural perspectives and unconventional compositions are surprising for a painter born in 1857, and lift these works above the general level of religious mural painting at the time.

Writing of the years before 1914, Mary Sargant Florence recalled how 'groups of young artists banded themselves together with the object of beautifying the walls of public buildings in London and elsewhere'.[3] Some were deliberately anti-romantic, like the Borough Polytechnic murals in Southwark organised by Roger Fry in 1911, or the decorations for Madame Strindberg's nightclub, 'The Cave of the Calf'. Others partook of the style described in this catalogue as 'Slade School symbolism', such as the murals, all now destroyed, at Bishop Creighton House, a settlement in Fulham. William Roberts, who took part in the scheme, recalled the design by Dora Carrington 'of blacksmiths hammering on an anvil, rather reminiscent . . . of Puvis de Chavannes'.[4] A surviving panel by John Nash from the Minoru Restaurant, Judd Street, decorated in 1914 by John and Paul Nash and Rupert Lee, shows a woodland with a bright green pinetree, which might reflect the influence of Derain, or might equally be a throwback to Maeterlinck's symbolic world.

In 1914 John Nash was also involved in an interesting unexecuted scheme for church murals at Uxbridge, intended to be executed jointly with Carrington, who had some experience of fresco from working on a panel at Ashridge, Hertfordshire, during the previous two years. Carrington was going to do Jacob and Rachel, evidently with emphasis on trees, landscape and sheep, while Nash's subject was Ruth and Boaz. However, against the artists' intentions, these had to be exchanged for New Testament subjects, for, as Nash wrote to Carrington, 'the Old Testament is it appears romantic and the New more authentic'.[5] In his monograph on Nash, Sir John Rothenstein illustrates a Stanley Spencerish drawing of *Balaam and the Ass* (dated 1914), presumably connected with the Uxbridge scheme, and quotes Nash's letter enthusing about a Pre-Raphaelite exhibition at the Tate in the summer of 1913. Carrington replied, 'Oh isn't the "Hireling Shepherd" amazing! I really think they got there. Wouldn't you like to do a real picture like that?'[6]

The return to visionary rural subject-matter by John and Paul Nash just before 1914, refreshed by their combination of naïve drawing and sophisticated understanding of the avant-garde, is one of the origins of the Neo-Romanticism of the 1940s, although the focus of romantic painting in the older tradition remained the narrative content and the idealisation of the figure. In 1914 Edward Marsh was due to publish a book of 'Georgian Drawings' as a counterpart to *Georgian Poetry*, a volume which would have helped to fix the romantic style of the younger generation, and to make the connections with poets, above all Walter de la Mare whose pastoral idylls are sometimes menaced by unanswerable problems.

Among this group, Stanley Spencer was recognised even at the time as the leader. His early masterpieces like *Joachim among the Shepherds* (Cat. 453) and *Zacharias and Elizabeth* (Cat. 452) have more involvement with landscape than most of his later compositions. His vivid imagination and command of the figure made him potentially the best mural painter of his generation, and he proved his ability at Burghclere, with exceptionally sympathetic patrons. On numerous other occasions he lost commissions when his private world was deemed unsuitable for public display. Gilbert Spencer, Stanley's talented younger brother, also lapsed from the strange poetic romanticism of *The Seven Ages of Man*, a mural-scale exercise for the Slade

Mary Sargant Florence *'Suffer Little Children to Come Unto Me'* 1913. Cat. 460

monthly composition prize, 1913. His murals of *The Foundation of Balliol* at Holywell Manor, Balliol College, Oxford (1935) treat the difficult narrative subject in a jocular manner, while *The Scholar Gipsy* at the University of London Students Union (1955) is conceived in full, matter-of-fact, sunlight.

In the summer of 1912, attention was drawn to mural paintings by an exhibition at Crosby Hall, Chelsea, which offered prizes in the form of mural commissions, donated by Sir Edmund Davis, Sir Hugh Lane and others. Davis's commission was for the vestibule of the Middlesex Hospital, and was won by Donald MacLaren, although the work was actually executed by F Cayley Robinson between 1916 and 1920 (Figs 24, 25). If doubts have been expressed about the possibility of combining a romantic imagination with a public commission, here is proof that they were not incompatible. Cayley Robinson's mixture of mythology and modern life is movingly matched by his light and colouring. Here, at last, is the English Puvis, and no pale imitation. Cayley Robinson painted another fine mural as a war memorial for Heanor School, Derbyshire; and in the 1912 competition for panels for Hugh Lane's projected Gallery of Modern Art in Dublin he won a well-deserved prize for *The Coming of St Patrick to Ireland*, a vision harmonious with the poetry of 'Fiona Macleod' and Rutland Boughton's opera *The Immortal Hour*, written 1911–12.

In 1908, Lane had tried to get public commissions in Dublin for Augustus John, and when he bought 100 Cheyne Walk in 1909 he commissioned him to decorate the hall. John was the grand romantic painter that Edwardian England might have gloried in, had the conditions of patronage favoured this type of work rather than the rapid production of portraits. He accepted unquestioningly the academic hierarchy of values, but found imaginative figure subjects in the 'grand style' difficult to achieve. Lane's panels in Chelsea were never finished or installed, but they are among John's finest works, *The*

Mumpers, afterwards sold to the Detroit Institute of Arts, and *Lyric Fantasy* (Fig. 26) which remained incomplete. As Sir John Rothenstein wrote in 1945, 'it is difficult to look at this superb painting without sadness, for it represents something unique in our time, but it remains unfulfilled, not through the artist's fault but ours.'[7]

In 1916, John painted, reputedly in one week, a forty-foot long composition, *Galway*, for the Arts and Crafts Exhibition at the Royal Academy. The best of a heterogeneous collection of murals intended to inspire civic patronage of painters as part of post-war reconstruction, *Galway* confirms again what a loss John was, not only to mural painting, but to romantic painting as a whole. In 1949, he made a final attempt at a mural triptych, at the instigation of the Abbey Fund Committee, who originally had in mind a site in the Festival Hall, but it was too late, and although he persevered with the composition for some years, it was never completed.

The Rome Scholarship in Painting, established in 1912, was an attempt to embody public narrative art in the system of art training, being specifically for 'Decorative Painting'. This term was widely used at the time, and never clearly defined. It did not imply any lack of seriousness, the aim being to emulate the compositional processes of the Renaissance with a view to creating a group of painters available for national commissions and murals in public buildings. Scholarships in architecture and sculpture were established at the same time in a search for the often-discussed 'Unity of the Arts'. The scholarship was won through competition involving a figure subject, worked up from sketches, full-size cartoon and colour studies. The Faculty of Painting for the Rome School (an advisory committee rather than a teaching body) represented traditional academicism (Sir Edward Poynter and Sir William Blake Richmond), the liberal side of the Royal Academy (George Clausen and Charles Sims), and the Slade (Philip Wilson Steer and Henry Tonks). One scholar per year was chosen, and

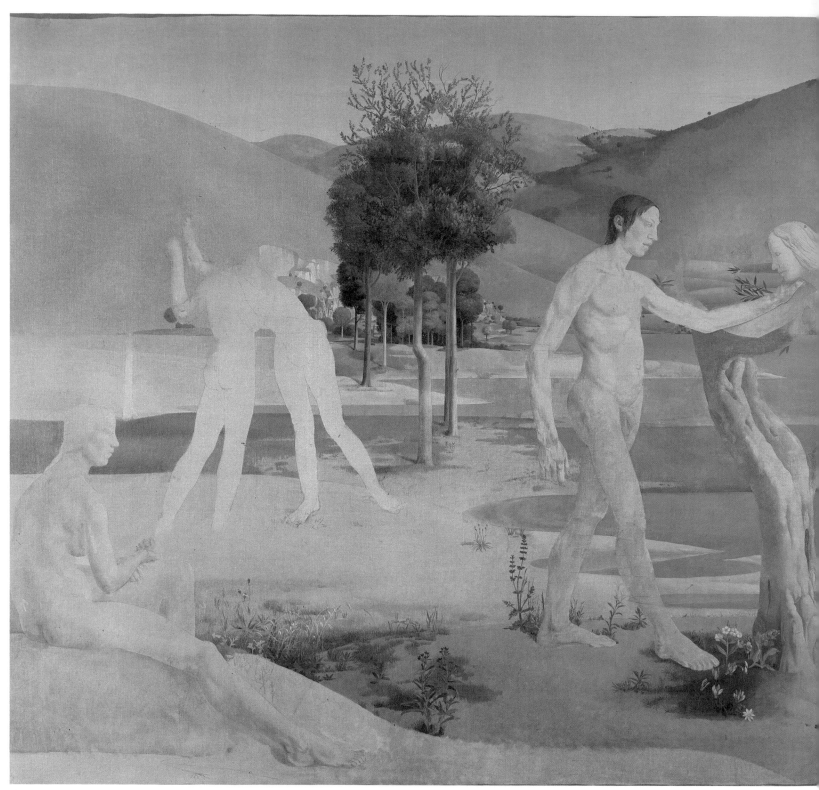

Sir Thomas Monnington *Allegory* c1924. Cat. 468

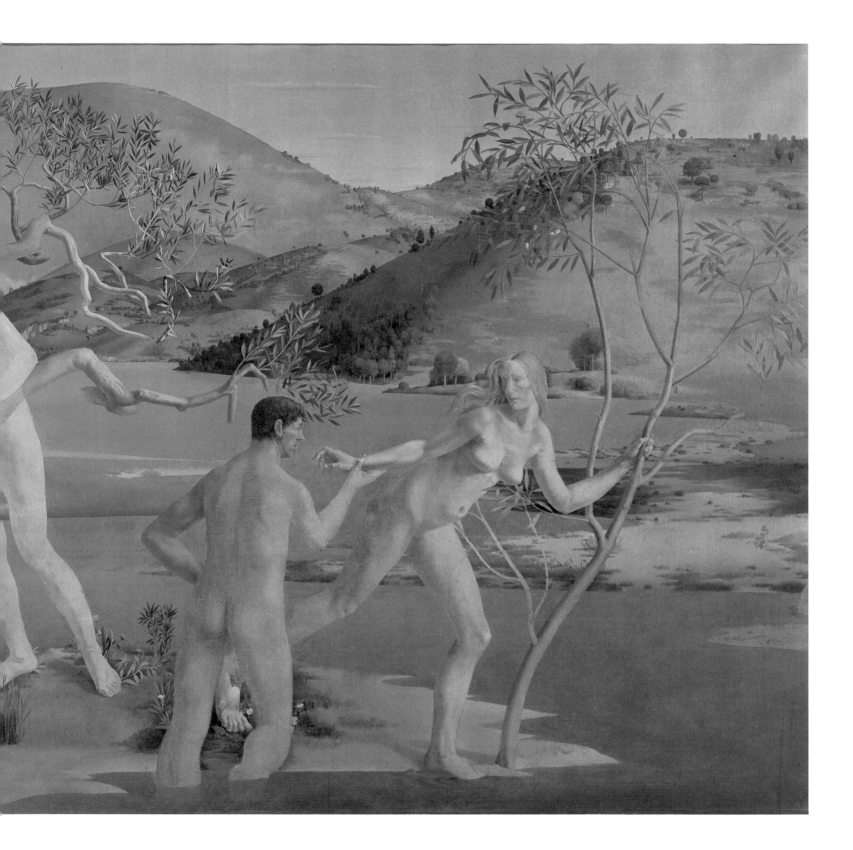

Figs 24, 25 Frederick Cayley Robinson *The Doctor*, two mural panels. Middlesex Hospital

required to make copies and work on an original composition for each year spent in Rome.

The first scholar was Colin Gill (1892–1940), whose composition, *L'Allegro* of 1919 (Cat. 462), while resembling continental neo-classical paintings of the time, has a personal quality of strangeness not found in Gill's later, more public work. His time in Rome overlapped with that of Winifred Knights, a painter whose intense imagination was at odds with the scholarship's aim of producing public art. She worked furthermore, very slowly, with meticulous craftsmanship; her prize-winning composition *The Deluge* (Cat. 466) is her most forceful work, breaking free of the influences both of the Renaissance and of Stanley Spencer to achieve an almost Vorticist flat geometry.

Tom Monnington's *Allegory* (Cat. 468) is unquestionably one of the few great romantic paintings of the 1920s. Charles Ricketts, another of the original Faculty members, normally a severe critic of candidates' work, reported back from Rome in 1924 that Monnington's drawings were 'quite notable in their sense of finish and beauty'.[8] The painting's subject is private and personal, while its unfinished state enhances its feeling of mystery. On his return to England, Monnington joined Gill and A K Lawrence, his successor in the Rome Scholarship, in the scheme to decorate St Stephen's Hall in the Palace of Westminster. Also participating were George Clausen, William Rothenstein, Glyn Philpot and Charles Sims, but apart from those of Clausen and Sims, the paintings are wooden. The same is true of Monnington's other public compositions of the time, with the exception of the small altarpiece representing the Supper at Emmaus which he painted for St Peter's, Bolton in 1931. His attempt to see the officials of the Bank of England through the eyes of Piero della Francesca,

which he was asked to do in 1932, was doomed to failure.

As one of Tonks's star pupils, Monnington embodied the hopes of a generation. His elders seem to have projected onto him their dreams of stability, conservatism and continuity in art. By the late 1930s, however, he had almost dried up as a painter, and was only later to find his way back through abstraction.

It is interesting to compare Monnington with Rex Whistler, another of Tonks's favourites. His murals, starting with the Tate Gallery Restaurant (1926), were undeniably romantic, but in the Neo-Georgian manner favoured by 'Bright Young Things'. While Monnington's work perpetuated the earnestness of the late Victorians, Whistler reacted against it. Yet in spite of the anti-romantic tendency of much art writing of the 1920s, a new generation of romantic painters, distinct from and preceding the Neo-Romantics of the 1940s, was emerging at the Royal College of Art, under the Professorship of Sir William Rothenstein. Though not himself an imaginative artist, Rothenstein still cherished the idea of a national romantic tradition picking up the threads from the Pre-Raphaelites whom he revered in spite of his cosmopolitan training. Among the many brilliant students in the post-war generation, including Edward Bawden, Eric Ravilious and Barnett Freedman, Rothenstein had a particular protégé in Charles Mahoney, whom he chose for the Concert Hall mural at Morley College, Southwark, in 1928. Unlike the stylish high jinks of Ravilious and Bawden's Refreshment Room in the same building, Mahoney's allegorical rendering of *The Pleasures of Life* (destroyed by enemy action, 1940) attempted the grand style, to general approval. It might be described as Burne-Jones done over again from nature.

Rothenstein continued his romantic counter-attack in a broadcast 'Whither Painting?' in 1931, claiming that 'the English genius early expressed itself through poetry, and English painters have usually given to their objective vision a poetical or illustrative quality'.[9] He also called for the use of young artists in the decoration of public buildings. One result of this was the scheme of murals illustrating Aesop's Fables at Brockley School, Lewisham (1934–6), under the direction of Mahoney, who painted two of the main panels (Cat. 475–7). Their visionary quality is enforced by the Pre-Raphaelite attention to detail. This was well adapted to the small awkward spandrels mostly painted by Evelyn Dunbar, whose style closely resembled Mahoney's. Two younger RCA students also contributed, one of whom, Mildred Eldridge, went on to paint in the 1950s a major, but virtually unknown mural cycle *The Dance of Life* in a hospital near Oswestry.[10]

Another result of Rothenstein's championing of romantic tendencies among his students is the collection of drawings in the City Art Gallery at Carlisle, for which he managed an annual purchase grant of £100. Apart from fine watercolours by Ravilious and Bawden, there is an Alan Sorrell drawing of 1929 done when he was a Rome Scholar and already indicating his mature romantic style, and poetic figure subjects by Edward Payne, Henry Bird, Lionel Ellis (Cat. 472) and Geoffrey Rhoades (Cat. 465). John Piper, another RCA student of this time, was perhaps too close to see the ancestry of this work, writing in *British Romantic Artists* (1942), that 'Aubrey Beardsley and *The Yellow Book* show Pre-Raphaelite parentage: subsequent English painting till today shows it very little'.[11]

At Carlisle, Rothenstein's purchases are racked alongside Gordon Bottomley's Samuel Palmers, Rossettis and early Paul Nashes, making a continuity of romantic art stretching over a hundred years. Without exception, these artists reveal their strength as much in graphic media as in large-scale painting, and it is in book illustrations of the 1930s and after that their influence should be traced. The work of Harold Jones, another of this generation of RCA students, still delights thousands of children through his Spencerish illustrations to *Lavender's Blue* (1954). It is easier for a romantic sensibility to be communicated on such a small scale, rather than in public art such as mural painting, but some fine work was created in an effort to prove that this need not be so.

Notes

1 John Ruskin, 'Modern Manufacture and Design' in *The Two Paths* 1859
2 W L Sargant, *The Book of Oakham School*, privately printed, Cambridge 1928; Mary Sargant Florence, 'Frescoes in the Old School, Oakham' in John D Batten (ed), *Papers of the Society of Mural Decorators and Painters in Tempera* II 1925, pp42–54
3 Mary Sargant Florence, 'Survey of the Society's Development' in M Sargant Florence (ed), *Papers of the Society of Mural Decorators* etc III 1936, p139
4 Quoted in Richard Cork, *Art Beyond the Gallery* 1985, p240
5 Dora Carrington to John Nash, 2 August 1913. John Nash papers, Tate Gallery Archive
6 John Rothenstein, *John Nash* 1983, p32
7 John Rothenstein, *Augustus John* 1945, p16
8 Charles Ricketts to Evelyn Shaw (Secretary, British School at Rome), 8 August 1923. Monnington file, British School at Rome Archives
9 William Rothenstein, *Whither Painting?* 1932, p15
10 See Alan Powers, 'Labour of Love' (Brockley murals) *Country Life* 30 April 1987 and 'Wards and Walls' (Murals at Robert Jones and Agnes Hunt Orthopaedic Hospital, Gobowen) *Country Life* 17 March 1988
11 John Piper, *British Romantic Artists* 1942, p42

Stanley Spencer *Zacharias and Elizabeth* **1914.** Cat. 452

SLADE SCHOOL SYMBOLISM

David Fraser Jenkins

The precise and voluptuous figure drawings made by the young Augustus John are the hallmark of the Slade School manner in the early years of this century. The finest of these, for which he has since been best known, were in fact drawn only from about ten years after he had left the School, when in 1907–8 he began a series of Ingres-like sketches of Dorelia McNeil, wearing the supposedly gypsy-style clothes she herself designed. These drawings, even though they were then exhibited and sold, were intended to be studies for 'decorations'. It is the style of these mural decorations, very few of which were completed, which is here described as 'Slade School symbolism'. A contemporary acknowledgement is found in the 'Introduction' to the exhibition catalogue *Twentieth Century Art, a Review of Modern Movements* at the Whitechapel Art Gallery in 1914, which categorised the work of 'the younger British artists'. The author (probably C Campbell Ross, the Secretary of the Gallery) sorted the most interesting work into four groups:

1 '. . . influenced by Mr Walter Sickert . . . sordid scenes in a sprightly manner . . .' (ie the Camden Town Group)
2 '. . . influence of Puvis de Chavannes, Alphonse Legros and Mr Augustus John . . . imposing decorative design . . . not merely that of a satisfying "pattern" . . .'
3 '. . . the later Impressionists . . . Cézanne . . . "designing in volumes"' (ie the Bloomsbury artists)
4 '. . . has abandoned representation . . . established a "Rebel Art Centre"' (ie the Vorticists).

This essay describes the work of the second group.

This unnamed but distinctive style can be traced through several clearly distinctive phases, first appearing in the early figure groups of Augustus John, continuing with artists who had been pupils at the Slade School from Orpen to Stanley Spencer, persisting in the underlying arrangement of figures in the Vorticist paintings of Bomberg and Nevinson, and reviving after the war with the academic competitors for the Rome Scholarship in the 1920s. Taken for granted as the manner for the most ambitious paintings in this period, it had followers also in large schemes of sculpture. It has not been acknowledged not only because it was never at the time given a name, but because it was a style used in passing by many artists. It was a middle style between the advanced and the traditional, separate from the Impressionist-realist Camden Town painters, who were committed to urban subjects and a rich technique, yet also separate from the work of those Royal Academicians who painted imaginative subjects. In origin it was an attitude towards figure composition based on the life study, in the belief that there was a certain rhetoric of the body, which, incorporated into a pictorial rhythm, was itself expressive. Hence there was little need for an elaborate exterior subject; the pose itself was enough.

This was an international style, as the successive elaborations of Post-Impressionism were cultivated co-incidentally in different countries. In 1970 the historian Mark Roskill described its origin in French painting as the final development of symbolistic art, based on the style of Puvis de Chavannes:

'As for the fourth stage, around 1900, this reflects the other side of Puvis' art: his view of civilization. A world beyond time is conjured up by the way in which the figures pose and interact with one another; and the artistic past is recollected in and through the figures' stature and physique. This past is really a whole tradition, with its roots in antiquity, the Renaissance or ancient Indian and Far Eastern art. The quintessential temper and mood of that tradition of rendering the human form are conjured up, by association, in a modern recreation. In these terms, then, there is an associative synthesis of the old and the new'.[1]

Such an art is found not only in Britain but in the national galleries in Scandinavia, America, Italy and Germany, each movement becoming independent of Paris and differing with the example of particular local artists. In each country the artists tend to have only national reputations; if known elsewhere – like Munch and Lehmbruck – they are regarded as individual eccentrics.

Between 1907 and 1915 Augustus John (Slade School 1894–8) painted a series of large, decorative paintings of groups of figures, disposed in shallow space across a wide canvas. The best known is *Lyric Fantasy* (1912 and 1914; Tate Gallery) which, since it has been abandoned, repainted and then left unfinished, is seen to best advantage in the full-size cartoon (Fig. 26). This shows a complete design without the dislocations which, even apart from the varieties of finish, make looking at the painting such a strain on the imagination; the half-seated girl omitted from the painting is present, and the portrait heads are still individual. As this shows, the key to these paintings by John, so few of which succeeded, is that there has to be a delicate balance between the hidden personal emotion of the subject – in this case his own family – and the vigorous demands of the impersonal decoration. Only when committed in both senses was it possible to complete the design without filling in, and it is not surprising that the drawing could not survive the greater illusion of colour.

John's letters reveal that it was a lonely breakthrough that he made with this style in Britain. The change in his work in 1907 was dramatic; in place of confused, Baroque compositions came clear life drawings, and instead of *fêtes galantes* a remote world of primitive emotions. John's enthusiasms indicated his release:

'I went to see Puvis's drawings in Paris. He seems to be the finest modern – while I admire immensely Rodin's later drawings – full of Greek lightness. Longings devour me to decorate a vast space with nudes and – and trees and waters. I am getting clearer about colour tho' still very ignorant, with a little more knowledge I shall at last begin . . .'[2]

The subjects painted by Puvis de Chavannes a generation earlier are echoed in John's 1907 design for a 'Death and the Maiden' (National Museum of Wales, Cardiff). His painting of this is lost, but the setting of the drawing recalls Puvis' *Pauvre Pêcheur*, with in addition the more sinuous rhythms of Rodin's individual figures. The high-minded otherworldliness of Puvis' painting was counteracted by John's more sensual drawing, and in later work probably also by the impact of his astonishing exchange of studio visits with Picasso in the early sum-

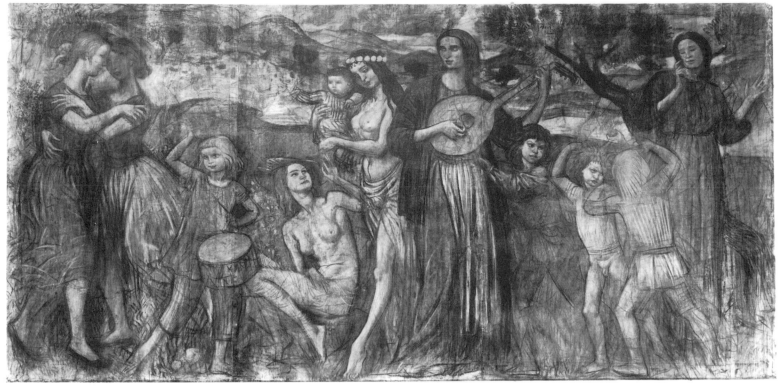

Fig. 26 Augustus John *Lyric Fantasy* **c1912. Private Collection**

mer of 1907. It is likely that he saw the *Demoiselles d'Avignon* and some Iberian-style paintings, and despite the violence of the Picasso, and his contradiction of rhythmic composition, there are echoes of these works in several large paintings by John, such as his *Peasant Boy* (National Museum of Wales, Cardiff). If these artists seen in Paris were a stimulus for his new figure style, then the groups themselves, ideal views of his family, were surely provoked, as Holroyd suggests, by the death of his wife Ida in March 1907. The following months became his enlightened access to this type of European painting, to which he remained faithful.

Neither John's originality nor his personality were admired by the two *chefs d'école* Walter Sickert and Roger Fry. In due course he was invited to exhibit both with the Camden Town Group and in Fry's Post-Impressionist exhibitions, but his support came from independent critics, the most thoughtful of whom was Laurence Binyon (1869–1943). Binyon had catalogued the British drawings in the British Museum, where he and Campbell Dodgson encouraged contemporary art and had bought three drawings by John in 1906. In 1907, at the outset of his career as critic for the *Saturday Review*, Binyon several times compared John to Rossetti as part of a continuing Pre-Raphaelite tradition. He fought for the principle that the modern artist should work within the tradition of the Old Masters, just at this unique moment when it seemed that there could be a break in the continuity of art.[3]

Binyon also praised the ugliness of John's large *Seraphita* – 'she haunts, she fascinates . . . this enigmatical conception . . .'[4] as well as *The Infant Pyramus* (bought by Hugh Lane for Johannesburg Art Gallery; Fig. 27). A preparatory drawing shows that John eliminated three figures from this when he came to the painting, which is thus disturbingly empty. The undefined expressiveness of the composition appealed to Binyon:

'Something sad and mad, something passionate or bitter . . . a gust of strangeness and disquiet, a breath of outlandish liberty and revolt

. . . poignant and alive in its own imaginative world, it possesses a spice of the strangeness of beauty . . . concerned with [life's] deep and central emotions'.[5]

John seems to have had difficulty in completing his large cartoons, sensing that a perfectly finished design could become banal, while an incomplete design was equally unsatisfactory. *The Bathers* (Cat. 432), of about the same date as *The Infant Pyramus*, is only partly put together from life studies. The design is held together by the central figures of mother and child, yet it is in these figures that John found the greatest difficulty; it is clear that he redrew them away from the model as if the beautiful drawing of the other figures was unacceptable.

William Strang (Slade School 1876–80) was a generation older than the other artists mentioned here, and although one of the first in Britain to respond to Puvis de Chavannes, he seems to have taken up a more linear symbolism only after about 1912. After beginning as a print-maker, his first paintings were similar to the Venetian-inspired work of C H Shannon (Cat. 256). His commissioned series of Adam and Eve (1899–1901) are an unusually early symbolist subject, painted richly in chiaroscuro with realistic studio nudes (see Cat. 218). Strang knew Laurence Binyon well, and perhaps encouraged his taste for such traditional painting; Philip Athill remarks the interest taken in the Adam and Eve series when it was exhibited in London in 1910. A sequence of bizarre group portraits by Strang, notably *Bal Suzette* (1913; private collection) and *The Worshippers* (1913), takes licence from the younger artists for a mixture of detail, pure colour and fantasy that resembles contemporary charades whose subjects are yet to be understood. His *Laughter* (c1914; Cat. 220) is still rather Venetian in technique, but with its comic subject of abandoned nudity and its careful posing is indebted to John. Strang's career is that of a connoisseur, adopting manners from Holbein to Stanley Spencer, but as a personal friend through his son Ian (Slade School 1902–6) of much younger artists he may have been a more valuable

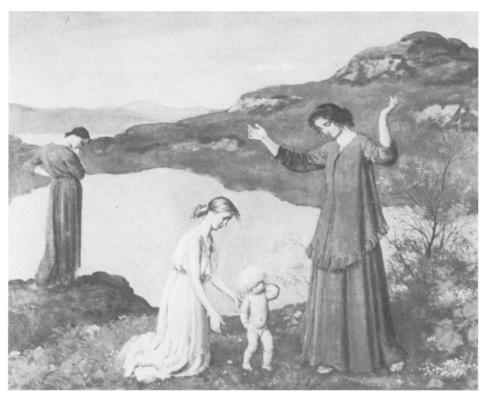

Fig. 27 Augustus John *The Infant Pyramus* 1908. Johannesburg Art Gallery

proponent of decorative painting than his own sometimes derivative work suggests.

John's personal example was at least a spur to the symbolist compositions of artists in his circle. His association with J D Innes (Slade School 1905–8) was complex, as this junior artist was in some ways a better painter, although in figure subjects Innes was certainly less inventive. His extraordinary *Fantasy – The Bathing Pool* (about 1909; National Museum of Wales, Cardiff) is a gesture for his first contact with John, pleasing for pointing so directly to the location of these subjects in a summer landscape in Eden: John Hoole has suggested that it was painted after seeing Matisse's *Joie de Vivre* in Paris, and partly as a parody of John. The compositions of Henry Lamb such as *The Lake* (private collection) are close both to John and his sources in French painting, but his compulsively straightforward imagination became an advantage in completing small symbolist paintings which were close to things he had actually seen. For this he needed a more genuinely primitive landscape, finding it first in Brittany in 1910–11, where his paintings were a balance of Gauguin and John, then in Gola Island off Donegal, which he visited in 1912 and the following year. Lamb's *Fisherfolk, Gola Island* (1913; Cat. 436) remarkably manages to elevate a Newlyn subject into a primitive mystery of the ages of man (oddly, the fishermen's wives are missing, but may have been intended to be added from an earlier study); a debt is evident to Stanley Spencer's recent painting, and possibly also to Millais' crowded *Isabella* (1848–9; Walker Art Gallery, Liverpool). In Lamb's career this symbolist approach is almost unique, and was not followed in his war paintings of 1919. His masterpiece, the large portrait of Lytton Strachey (1914; Tate Gallery), was designed before his visits to Ireland, but, as with the Gola islanders, combines sober realism and colouring with extraordinary geometry; it is a rare example of such decorative symbolism being used in a portrait of a single figure.

The most unexpected appropriation of Slade School symbolism was by William Orpen (Slade School 1897–9) for three paintings of Ireland, made just before and during the war. The style was felt suitable for Irish subjects, in themselves primitive, and it appears that Orpen made a deliberate renunciation of his superb portrait technique to portray his own country in his time. The last of these paintings, *The Holy Well* (1916; Cat. 412), has been read as an ironic complaint against the Church, as if an allegory; but Orpen's persistent sense of humour is difficult to interpret. He had rarely used life studies in his paintings, and follows John both in this and in the drama of unrestrained nudity versus the decorum of dress. It was presumably the Irish revival as well as the war in Europe that led him to take up a grand style, and to plan so elaborately. His artist friend Sean Keating, depicted standing over the well, is defiantly modern and quizzical, and the figures below seem to represent an expulsion from their paradise.

Both Orpen and Lamb were portrait painters and associates of John, and took up a symbolist style for particular works. These were not commissions, and were not repeated. However, for some British artists at the beginning of the century this style was a natural way to work, although they were not able to live from it. The unpopular reaction to this style outside the specialist art gallery was evident from the public display of Jacob Epstein's sculptural decoration on the British Medical Association building in the Strand (1908). Epstein's eighteen nude figures took up a traditional Renaissance format, but with a typically symbolist theme of birth and death, youth and age:

'In symbolism I tried to represent man and woman, in their various stages from birth to old age . . . Perhaps this was the first time in London that a decoration was not purely "decorative"; the figures had some fundamentally human meaning'.[6]

The basic offence against decorum was not, as Epstein judged, that the figures were sexually provocative, but that they were quite evidently not merely a meaningless decoration (though Epstein could

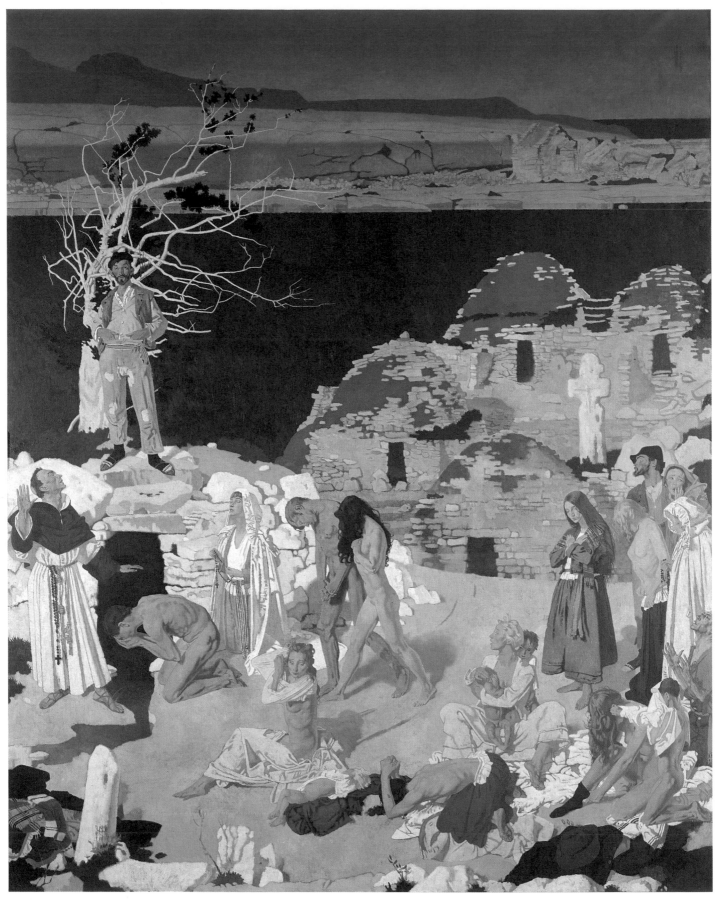

William Orpen *The Holy Well* c1913–14. Cat. 412

find no other word to describe the kind of design, even in 1940, except 'decoration'). The figures were neither realistic nor ideal, but some kind of middle genre of committed symbolism. This remained Epstein's aim for his nude figures, and was the motivation for his early sculptures with Euphemia Lamb as model, and for the new Stonehenge that he, Eric Gill and John planned to make in the open air in Sussex in 1910.

There is a symbolist motive behind some sculptures by Gill, although these are sometimes directly religious in an early Renaissance sense, as are his *Stations of the Cross* at Westminster Cathedral (1914–18). His extraordinary Eve, however, titled *A Roland for an Oliver* (1910; University Art collection, Hull), with its symmetrical pose and complex iconography, given by the inscription and also by the pairing with a *Crucifixion* (1910; Tate Gallery), has some original meaning beyond either decoration or ostensible subject. The sexual licence of Gill's sculpture is accounted for not primarily by primitive and oriental examples but by this symbolist style, whose proper subject was the allusiton to basic human responses. The group *Ecstasy* (1910–11; Tate Gallery) was thus able to stand for a general conjunction of matter and spirit, and although his own title for this work is not known, he called later prints of the same design *Divine Lovers*. Gill was soon to find a comparable doctrine of symbolism within the Roman Catholic Church.

Epstein's frustration with the term 'decoration' was paralleled in the attitude of Stanley Spencer (Slade School 1908–12) to 'composition'. Writing of his *Mending Cowls, Cookham* (1915; Tate Gallery) he denied that its composition was an exercise, but was rather a means of more intense expression:

'But I did that thing not because of the "composition" it made, some people might say, it has a "fine sense of solid composition" such people know nothing of the feeling that caused me to paint it. There are certain children in Cookham, certain corners of roads and these cowls, all give me one feeling only. I am always wanting to express that'.[7]

Spencer's art was literally learnt from the artists pre-Raphael, for he followed Giotto and the early Renaissance artists in his use of dramatic gesture. His ordering of figure groups through pose is similar to John's, who was admired at the Slade while Spencer was there and whose style may have influenced the Professor's choice of subject for the annual painting competitions. This association of symbolism, compositon and personal iconography is discussed by Andrew Causey, who mentions a description of these artists in 1914, most of whom were supported by the collector Edward Marsh, as 'neo-primitive'.[8] In place of John's linear rhythms Spencer repeated patterns and symmetrical poses, everything being painted in schematic solid shapes. His lack of interest in naturalism gave strength to subjects such as *Apple Gatherers* (1912–13; Tate Gallery), a Slade School set subject. Here the suppressed meaning dominates with some serious but completely unknown significance, centred on the unexpectedly crossed arms of the man and woman, deliberately made less clear in the paintings than in the preliminary design. Spencer's subjects were not totally imaginary, but were invariably based on Cookham, his home village in Berkshire; and he was one of the few artists then able to see as primitive an area not geographically remote. A group of large paintings of 1914–15 were the most extreme by Spencer in his symbolist style of composition, particularly *Zacharias and Elizabeth* (1914; Cat. 452) and *The Centurion's Servant* (1914; Tate Gallery). The biblical subject of the former is overstepped and diverted by the personal emotions of Spencer's home life: *The Centurion's Servant*, a self-portrait with others, is so unusual as to be frightening. Both are intensely real and yet fantastic, and impossible to comprehend except in

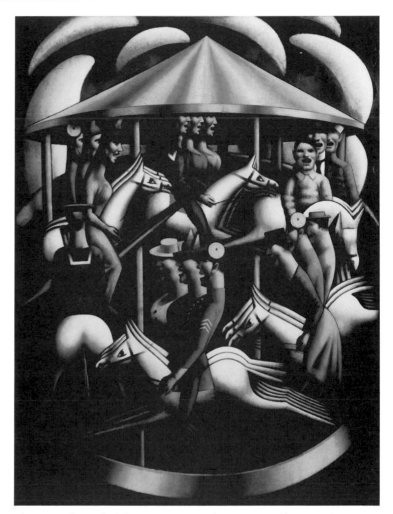

Fig. 28 Mark Gertler *The Merry-Go-Round* 1916. Tate Gallery, London

terms of abstracted symbolism.

The most extended attempt at the time to relate this style to the Pre-Raphaelite tradition was the essay of 1913 by Laurence Binyon, 'The Art of Botticelli, An Essay in Pictorial Criticism', the major part of which is sub-titled 'Botticelli's significance for modern art'. Binyon is too diffident to name his contemporaries, but is distinctly opposed to both realism and Impressionism ('it is ridiculous to place Monet on a level with Puvis de Chavannes'[9]) and in favour of an artist who is traditional and yet, like Botticelli, is

'never quite one of the modern movement, yet never quite able or willing to turn his back on it'.[10]

He repudiates the development of Roger Fry's Post-Impressionism, which he sees leading to a weakening through unnecessary loss of subject, in contrast to the attitude of Botticelli, who,

'trained to study structure and mass and relief . . . cares nothing for the representation of these for their own sake . . . his draughtsmanship [is] expressive of the emotion of the spirit within the form.'[11]

Binyon recommends 'mural painting and decoration on a large scale', and complains of the lack of 'the public virtue of magnificence'. The style should be linear, but he stresses rhythm and movement, in an advance on the usually static groups by John. The content, which should not be narrative, would be, as Botticelli's, from the 'fibre of his imaginative vision and incommunicable':

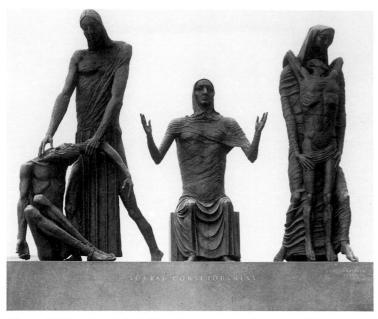

Fig. 29 William Epstein *Social Consciousness* **1951–3. Courtesy of the Fairmount Park Art Association, Philadelphia**

'The time has not yet come, but it will come, when decoration will cease to be a kind of geometry, a filling of space for the sake of filling a space, but will be an overflow of our thoughts and susceptibilities, no longer external to ourselves, no longer separated from what we express in painting or statue, but belonging to the same world of human expression'.[12]

Binyon is aware that the reaction against Impressionism has gone too far, and there are artists 'endeavouring to present in pictorial terms energies rather than appearances', and he was against innovation as an ideal, and artists who try to keep up to date.

The difference of personality between Binyon and Fry – and the former's employment at the British Museum – prevented his becoming the champion of this symbolist style as Fry had for the followers of Post-Impressionism. The painters who now seem most to fulfil his demands are David Bomberg (Slade School 1908–12) from the years 1912–13, and Mark Gertler (Slade School 1908–12) in about 1915, the times when both artists were on the brink of abstraction. Binyon recommended the prints of Pollaiuolo as studies of movement, and it is these, together with Michelagelo's *Battle of Cascina*, that are evidently behind some of Bomberg's violently active groups of figures, particularly the large unfinished painting *Island of Joy* (c1912; private collection), possibly intended to be a *Rape of the Sabines*. The painting is typical of Slade School competition subjects, and was painted as Binyon recommended with an emphasis on linear decoration and rhythmic movement. This remains true of Bomberg's later Vorticist paintings, despite their superficial appearance so far from either Botticelli or John. Whether the subjects were *Ezekiel* or *The Mud Bath*, they were compositions of figures arranged with an expressive geometry and appear distinctly 'Florentine' rather than contemporary. The intellectual apologist for Bomberg (and for Epstein), T E Hulme, was keen to emphasise, while writing of 'pure form' and 'abstraction', that these were to convey 'the ordinary everyday human emotions' as part of a conventional process 'by which *form* becomes the *porter* or *carrier* of internal emotions'.[13] The climax of this more abstract symbolist style is Gertler's *Merry-Go-Round* (Fig. 28). It is also is an adaptation of a medieval subject, the *Wheel of Fortune*, possibly known to Gertler from Burne-Jones's ver-

sions, and was prepared by detailed drawings of the heads. The description of it as geometrical and decorative, while correct so far as it goes, seems inadequate to describe its intensity of emotion and violence of movement.

Most of these artists did not follow a symbolist style after the war, turning to landscapes and portraits. Paul Nash (Slade School 1910–11) briefly used such subjects in 1914 but then rarely drew figures again, although he found in certain landscapes a substitute for symbolism. William Roberts (Slade School 1910–13; see Cat. 454) and Stanley Spencer were both faithful to figure compositions, but in styles of extreme eccentricity. In the 1920s it was the British School at Rome, through set subjects for scholarships, that maintained this tradition, promoting fresco-like decorations into the age of abstraction and Surrealism. The deliberately archaic early style of Thomas Monnington (Slade School 1918–22; Cat. 468), his wife Winifred Knights (Slade School 1915–20; Cat. 466) and Colin Gill (Slade School 1910–13; Cat. 462), beautiful but cold, was not pursued in their later work, any more than was the case with the abstract painter Merlyn Evans, who submitted Crivelli-like studies for the Rome Scholarship in 1932.

Throughout later life Augustus John tried to revive his early style of decoration, in the 1950s constantly altering figures in groups in the hope that the right pose might appear that would somehow give the painting strength. Epstein equally returned to a primitive style whenever he found a suitable commission, although this was usually only for a single figure. His last attempt at such a group is the bronze *Pan* at Bowater House, Hyde Park (1959), easiest to understand in the context of an eloquent but unspecific symbolism. More successful than this, and one of the most moving public monuments of modern art, is his *Social Consciousness* at the Philadelphia Museum (1951–3); like a *quattrocento* relief, based on life studies and figure composition, linear, with no apparent subject, it is clearly of the time when 'decoration will cease to be a kind of geometry . . . but will be an overflow of our own thoughts and susceptibilites'.[14]

Notes

1 Mark Roskill, *Van Gogh, Gauguin and the Impressionist Circle* 1970, p245
2 Augustus John to William Rothenstein 1907. Quoted in Michael Holroyd *Augustus John* I 1974, p253
3 *Saturday Review* 'Art and Archaism' 20 July 1907
4 *Saturday Review* 28 March 1908, p398
5 *Saturday Review* 6 June 1908, p720
6 Jacob Epstein, *Let there be Sculpture* 1940, p34
7 Stanley Spencer to James Wood, May 1916, Tate Gallery Archive. Quoted in Keith Bell *Stanley Spencer*, exh. cat. Royal Academy 1980, p54
8 Andrew Causey, *Stanley Spencer*, exh. cat. Royal Academy 1980, p22
9 Ibid, p30
10 Ibid, p9
11 Ibid, p34
12 Ibid, p36
13 T E Hulme, *The New Age* 9 July 1914, p231
14 See note 12

Notes

Within each section artists are listed chronologically, as are the works themselves, in the following order: paintings (including finished watercolours), drawings, prints, sculpture, books.

While the support of works in oil and tempera is specified (canvas, panel, etc), drawings and watercolours are assumed to be on paper unless otherwise indicated.

Sculptors regularly produced different versions of their works in various sizes and in different media (eg plaster, bronze, marble). In the sculpture entries, when a work is said to have been exhibited, it does not follow that it was the very same version as shown here.

Measurements are in centimetres, with inches in brackets, height before width. The measurements of prints denote the size of the plate, not the whole sheet. 'Sight' sizes are not specified.

The references at the end of the biographies only indicate major or particularly significant sources, and are in no way comprehensive. Three sources, used too often for individual mention, are gratefully acknowledged here: Simon Houfe, *Dictionary of British Book Illustrators and Caricaturists 1800–1914* (1978); Kenneth Guichard, *British Etchers 1850–1940* (1981); Brigid Peppin and Lucy Micklethwait, *Dictionary of British Book Illustrators. The Twentieth Century* (1983).

The literature cited in an abbreviated form under individual catalogue entries sometimes refers back to biographical sources; otherwise it appears in the list of abbreviations at the end of the Catalogue.

The exhibitions listed are generally only the first (RA, New Gallery, International Society, etc) and the most recent, which may have informative catalogues. However, other significant exhibitions are sometimes included.

Contents

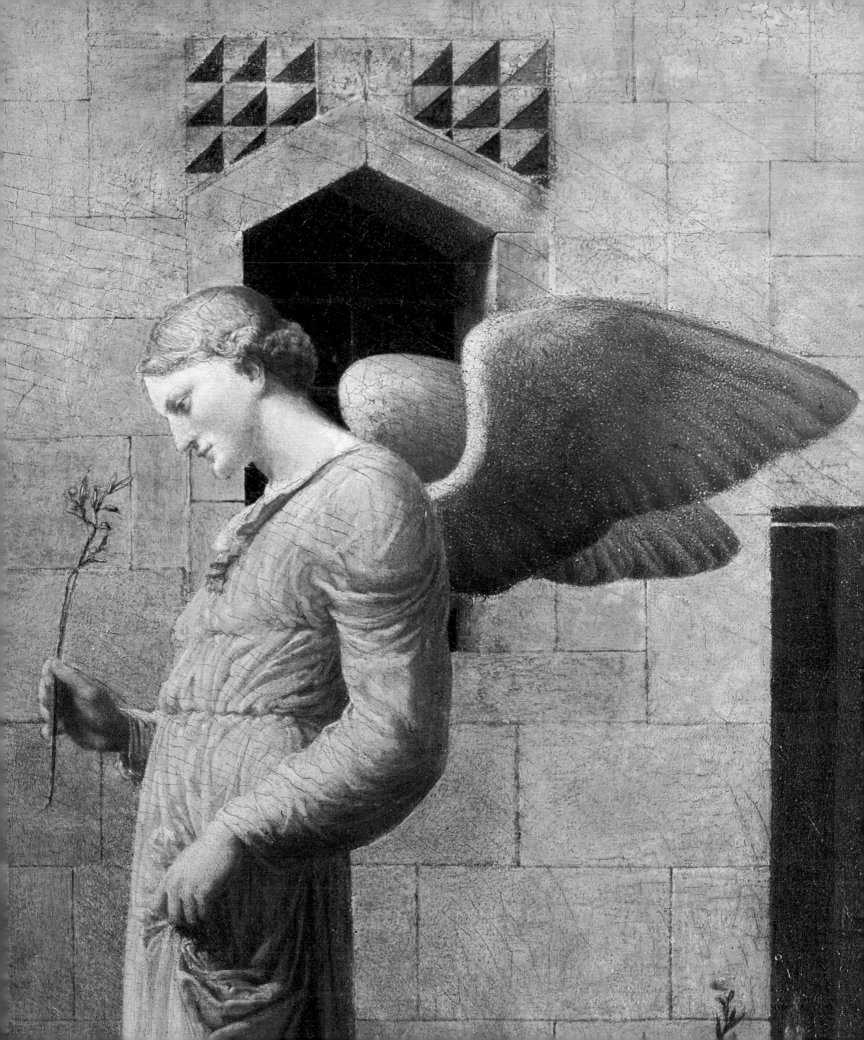

BURNE-JONES AND HIS FOLLOWERS

JOHN RODDAM SPENCER STANHOPE
1829–1908

Spencer Stanhope came from an aristocratic background; his grandfather on his mother's side was Thomas Coke, Earl of Leicester, one of the great agricultural reformers of his day. Educated at Rugby and Christ Church, Oxford, he resisted strong parental opposition to become an artist and studied under G F Watts, accompanying him on visits to Italy (1853) and Greece (1856–7). Through Watts he met D G Rossetti and Burne-Jones, helping them and others to paint the ill-fated murals in the Oxford Union in 1857. Burne-Jones, though four years his junior, was the crucial influence on his developed style.

Stanhope exhibited intermittently at the RA (1859–1902) but mainly supported the Dudley, Grosvenor and New Galleries, all important venues for the late Pre-Raphaelite school. He suffered much from ill-health and in 1880 settled at the Villa Nuti at Bellosguardo outside Florence, making it a centre for the English community and visitors, including his niece Evelyn De Morgan (Cat. 50–1). Much of his later work is in tempera and he painted murals in Marlborough College Chapel and the Anglican Church in Florence. In 1901 he helped to found the Society of Painters in Tempera. Died at Bellosguardo.

Ref: A M W Stirling, *A Painter of Dreams* 1916

1. **Penelope** 1864 *ill. p17*
Oil on canvas, 106 × 80 (41¾ × 31½)
Exh: RA 1864 (476); Japan 1987 (31)
Penelope is seen dreaming of Ulysses' return as she sits at her loom weaving the tapestry which she unpicks each night to deceive her importunate suitors (see also Cat.114). The picture dates from the early part of Stanhope's career when his work has a lyrical quality and lacks the mannerisms which characterise his later paintings. Although it shows that he was no great draughtsman, it reveals an interesting sense of colour. Burne-Jones once said of him, somewhat extravagantly, that 'his colour was beyond any the finest in Europe'; also that he had 'an extraordinary turn for landscape'.
THE TRUSTEES OF THE DE MORGAN FOUNDATION

2. **Love and the Maiden** 1877 *ill. p80*
Oil with gold paint on canvas, 138 × 202.5 (54¼ × 79¾)
Signed and dated *RSS 1877*
Exh: Grosvenor Gallery 1877 (54); *The Aesthetic Movement and the Cult of Japan*, FAS 1972 (58)
Lit: C Wood 1981, p137, repr
One of four pictures which Stanhope showed in 1877 at the first Grosvenor Gallery exhibition, another being the *Eve Tempted* now at Manchester. Like his friend Burne-Jones, who showed eight large works and leapt to fame overnight, he was clearly out to make a big impression and reap the full advantage of this epoch-making event. Not surprisingly, reviewers tended to lump him with Burne-Jones and others of his school, such as Strudwick and Walter Crane, *The Times*, for instance, describing their pictures as 'unaccountable freaks of individual eccentricity, . . . the strange and

Opposite page: Detail Cat. 26

unwholesome fruits of hopeless wanderings in the mazes of mysticism and medievalism'. *Love and the Maiden* exemplifies Stanhope's mature style, at once personal and eclectic; Botticelli's influence seems particularly prevalent in the treatment of the coastline seen through the trees. It is not clear whether the subject has a literary origin or was the artist's own invention.
PRIVATE COLLECTION

EDWARD COLEY BURNE-JONES
1833–1898

The most important artist in the later phase of the Pre-Raphaelite movement and a figure of enormous influence at home and abroad, Burne-Jones was born in Birmingham, the son of a frame-maker. In 1844 he entered the local grammar school, King Edward's, and soon, inspired by the Tractarians, planned to go into the Church. At Oxford, however, he and his friend William Morris came under the influence of Ruskin and the Pre-Raphaelites, and decided to devote themselves to art. D G Rossetti, with whom they became intimate when they settled in London in 1856, was their special hero, and had a profound impact on Burne-Jones's early work, which consists mainly of small pen and ink drawings and watercolours. In 1861 he became a partner in the firm of Morris, Marshall, Faulkner and Co., 'Fine Art Workmen', and from then on was deeply involved with the design of stained glass and many other forms of decorative art. In 1859 he paid his first visit to Italy, returning in 1862 (with Ruskin), 1871 and 1873; these visits were of great importance for his later style, in which the influence of Giorgione, Mantegna, Botticelli, Michelangelo and others may readily be discerned. In 1866, a sign of growing professionalism, he employed his first assistant, Fairfax Murray (Cat. 41–3); and in 1867, by now married with two children, he moved to The Grange, a large Georgian house in Fulham which remained his London home until his death. Meanwhile in 1864 he had been elected an Associate of the Old Water-Colour Society; there his work attracted adherents, such as Walter Crane (Cat. 32–40) and Robert Bateman (Cat. 25–6), but it also met with great hostility, both from other members and the press, and in 1870 he resigned.

For the next seven years he scarcely exhibited, relying on the support of such devoted patrons as William Graham, MP for Glasgow, and the Liverpool shipowner, F R Leyland. However, in 1877 he was invited to exhibit at the Grosvenor Gallery, opened that year as a more adventurous alternative to the Royal Academy, and the eight large paintings he showed there caused a sensation, revealing him as the 'star' of the Grosvenor, a key figure in the Aesthetic Movement, and one of the leading artists of the day. From then on he continued to show major works every year, at the Grosvenor until 1887, thereafter at is successor, the New Gallery. In 1886 he exhibited one picture at the RA during a somewhat unhappy period as an Associate (1885–93). The peaks of his later career were

the exhibition of *King Cophetua and the Beggar Maid* (Fig. 1) at the Grosvenor in 1884, and of the four *Briar Rose* paintings (Buscot Park) at Agnew's in 1890. In 1894 he accepted a baronetcy. During the 1890s he also enjoyed an international reputation, being especially fashionable in Symbolist circles in Paris, where *King Cophetua* was received with great acclaim at the Exposition Universelle of 1889 and where he continued to exhibit until 1896. At the end of his life he saw his popularity decline, and his last pictures, withdrawn and abstract, seem to be painted essentially for himself. The New Gallery mounted a retrospective exhibition in 1892–3 and a large memorial show in 1898–9.

Ref: G(eorgiana) B(urne)-J(ones), *Memorials of Edward Burne-Jones* 1904; Martin Harrison and Bill Waters, *Burne-Jones* 1973; Penelope Fitzgerald, *Edward Burne-Jones. A Biography* 1975; *Burne-Jones*, Arts Council 1975–6, exh. cat. by John Christian; *Burne-Jones*, Galleria Nazionale d'Arte Moderna, Rome 1986, exh. cat. by Maria Teresa Benedetti and Gianna Piantoni

3. **The Finding of Medusa** c1882–5
Oil on canvas, 162.5 × 150 (64 × 59)
Exh: *From Bronzino to Boy George: Treasures from Sussex Houses*, Brighton Museum 1985 (140)
This is an unfinished version of one of the well-known Perseus series, commissioned by Arthur Balfour to decorate the music room of his London house, 4 Carlton Gardens, in 1875. The series as a whole was never completed, but the magnificent gouache cartoons exist in the Southampton Art Gallery, and the 'final' oils, some finished, some not, are in the Staatsgalerie, Stuttgart.

The present painting, which shows Perseus about to slay Medusa while her Gorgon sisters crouch in terror, is particularly interesting in the context of this exhibition since it belonged to Ricketts and Shannon. A photograph shows it hanging on the walls of the keep at Chilham Castle, Kent, which they were given as a country retreat by their patron Sir Edmund Davis in 1918 (see Joseph Darracott, *The World of Charles Ricketts* 1980, p79). The two artists were great admirers of Burne-Jones, and many more of his works are with the rest of their collection in the Fitzwilliam Museum, Cambridge.
SIR GEORGE CHRISTIE

4. **Vespertina Quies** 1893 *ill. p2*
Oil on canvas, 108 × 62.2 (42½ × 24½)
Signed and dated *EBJ 1893*
Exh: New Gallery 1894 (136)
Lit: *The Reproductive Engravings after Sir Edward Coley Burne-Jones*, Julian Hartnoll 1987, p46
A figure whose mood and pose seem to owe something to the *Mona Lisa* is seen against a background imbued with the Celtic or Arthurian feeling so characteristic of Burne-Jones's work in the 1890s. F G Stephens, writing in the *Athenaeum* when the picture was exhibited in 1894, identified the setting as 'the empty courtyard of a convent' seen in a 'soft, warm, almost shadowless evening light', and described the girl's serene expression as indicative of 'that inner peace which belongs to a pure soul in harmony with itself'.

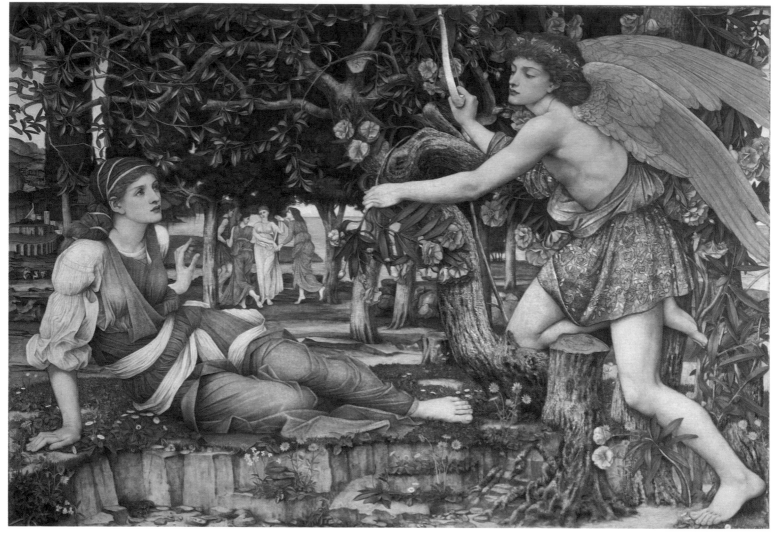

Cat. 2

The sitter was Bessie Keene, a professional model who posed for many artists of the day, as did her mother before her. 'Burne-Jones', wrote Graham Robertson, who knew her well, 'used Bessie's face much in his later work – she succeeded her mother as chief "angel" and "nymph" – and he produced one beautiful portrait of her; actually a portrait though he called the picture *Vespertina Quies*'. A devout Roman Catholic with a great sense of humour, Bessie later emigrated to America, dying in Los Angeles in about 1944.

The picture was owned by Maud Beddington, a follower of Burne-Jones whose family had known him since his boyhood in Birmingham. She bequeathed it to the Tate in 1939.

THE TRUSTEES OF THE TATE GALLERY

5. **Sir Lancelot at the Chapel of the Holy Grail** c1893 *ill. p81*
Watercolour with bodycolour, 51 × 61 (20 × 24)
This and Cat. 6 are finished studies for a set of tapestries illustrating the Quest of the Holy Grail, executed by William Morris in the early 1890s. One of the greatest achievements of the Arts and Crafts movement and the climax of Morris's attempt to revive tapestry manufacture, the set was made for Stanmore Hall, near Uxbridge in Middlesex, the home of the Australian mining magnate, W K D'Arcy. Further sets were subsequently commissioned by two remarkable

collectors, the brewer Laurence Hodson of Compton Hall, Wolverhampton, and George McCulloch, a business associate of D'Arcy's, who lived in Queen's Gate, Kensington. The tapestries are now scattered, but five, from the Hodson and McCulloch sets, are in the Birmingham City Art Gallery.

Like many artists at the end of their careers, in the 1890s Burne-Jones returned to early sources of inspiration. In particular he experienced a revived feeling for Malory's *Morte d'Arthur*. This found varied expression: the vast painting of *The Sleep of King Arthur in Avalon* (Puerto Rico), left unfinished at his death; the sets and costumes for J Comyns Carr's play *King Arthur*, staged at the Lyceum in 1895; and the Holy Grail tapestries. These were specially important, for no part of the legend moved him more deeply than the Quest of the Grail. 'Lord!', he wrote, 'how that San Graal story is ever in my mind and thoughts. . . . Was ever anything in the world beautiful as that is beautiful? If I might clear away all the work that I have begun . . . and dedicate the last days to that tale – if only I might' (*Memorials* II, p333).

In *Sir Lancelot at the Chapel* an angel appears to the knight in a dream, telling him that he will never achieve the Grail because of his adultery with Queen Guinevere. A large oil version, dated 1896, is at Southampton, and the composition looks back to Rossetti's treatment of the same theme on the walls of the Oxford Union,

painted in 1857.
PRIVATE COLLECTION

6. **Sir Gawain and Sir Uwain at the Chapel of the Holy Grail** c1893
Watercolour with bodycolour and gold paint, 51 × 61 (20 × 24)
See Cat. 5. Like Sir Lancelot, Sir Gawain and Sir Uwain failed to achieve the Grail because of their sinful condition.
PRIVATE COLLECTION

7. **The Watermill** c1895 *ill. p81*
Watercolour with bodycolour on wallpaper, laid down, 80 × 121 (31½ × 47⅝)
Lit: Angela Thirkell, *Three Houses* 1931, p60; *Fine English Drawings and Watercolours*, Phillips, 2 November 1987, sale cat., pp120–3
This painting and Cat. 8 were recently detached from the walls of North End House, Burne-Jones's much-loved country retreat at Rottingdean, a few miles east of Brighton. They were executed in the nursery for his grandchildren, Angela and Denis Mackail, born respectively in 1890 and 1892, and are described by Angela (later the novelist Angela Thirkell) in her book *Three Houses*. As she says of *The Watermill*, 'like all the backgrounds of his pictures it was of no real place and the evening light was the light of Avalon. There was no

story about it, but a child could invent an infinite number of stories for itself'. Despite the ephemeral nature of the paintings, which have no doubt suffered some nursery depredations, they are among the artist's most moving works. Operating in an intensely private context, concerned only to stimulate the imagination of his two young grandchildren, he has succeeded in expressing the very essence of his vision.
PRIVATE COLLECTION

8. A Ship on the Sea c1895
Watercolour with bodycolour on wallpaper, laid down, 57 × 112 (22½ × 44)
Lit: As for Cat. 7
See Cat. 7
PRIVATE COLLECTION

9. The Prioress's Tale 1865–98 *ill. p10*
Watercolour with bodycolour, 103.4 × 62.8 (40¾ × 24¾)
Signed and dated *EB-J 1865–98* (lower left)
Exh: New Gallery 1898 (82); Burne-Jones memorial exh., New Gallery 1898–9 (36); *Burne-Jones*, Arts Council 1975–6 (194)
Lit: See Arts Council exh. cat.
Chaucer's 'Prioress's Tale' is set in a city in Asia and tells of a widow's son who has a special devotion to the Virgin Mary. He is murdered by the Jews, but the Virgin lays a grain of corn on his tongue and he continues to sing her praises even after death. The picture is a remarkable example of Burne-Jones's tendency to rework visual ideas over many years. The design was conceived for the wardrobe he decorated as a wedding present for Morris in 1858 (Ashmolean Museum, Oxford). The present picture, highly finished in brilliant colours with an effect of early morning light, was started in 1865 (according to the inscription; 1869 according to the artist's work record) but was not completed until 1898, the year he died. In fact it was one of his last two exhibited pictures. Burne-Jones himself pointed out how the foreground flowers 'come at intervals like those in a tune', an interesting application of the Paterian principle that 'all art constantly aspires towards the condition of music'. The model for the boy was the young Edward Horner, who was killed in the First World War.

The subject occurs again among the illustrations to the Kelmscott *Chaucer* (Cat. 16), but the composition is different.
DELAWARE ART MUSEUM, SAMUEL AND MARY R BANCROFT MEMORIAL

10. The Magic Circle c1882 *ill. p81*
Watercolour with bodycolour, 35.6 × 33 (14 × 13)
Exh: *Burne-Jones*, Art Council 1975–6 (316); Japan 1987 (23)
Lit: Charles Johnson, *English Painting* 1932, p277
Apparently the drawing has no specific subject, being purely a figment of the artist's imagination. It evokes a mood of trance-like stillness, tinged by threat, that is wholly characteristic.

The date is suggested by the stylistic resemblance to the famous 'Flower Book' watercolours (British Museum) which Burne-Jones began to make in 1882 (see Cat. 19).
THE TRUSTEES OF THE TATE GALLERY

11. Study of a Girl's Head 1880s
Red, white and black chalk on terracotta paper, 38.1 × 26.7 (15 × 10½)
Exh: Berlin 1898; *Burne-Jones*, Arts Council 1975–6 (322)
This attractive drawing, in a technique that Burne-Jones often used in the 1880s and 1890s, is apparently unrelated to a picture. Together with Cat. 12, it was in the collection of the 1st Viscount Leverhulme, and both drawings were included in the Lady Lever Art Gallery

Cat. 5

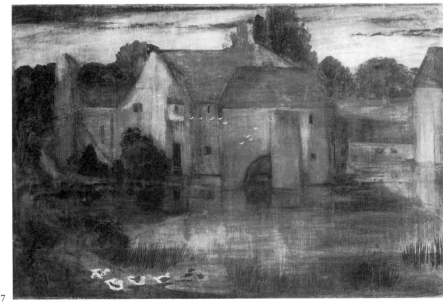

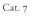

Cat. 7

Cat. 10

sale, Christie's, 6 June 1958, lot 23, realising the princely sum of 48 gns.

12. Study of a Girl's Head 1895

Pencil, 49.2 × 34.3 (19⅜ × 13½)
Inscribed *EB-J for the CAR OF LOVE no.XVI 1895* (lower right)
Exh: Berlin 1898
Lit: *Studio* 31 1904, p313, repr

A study for one of the driven lovers in the enormous unfinished painting *The Car of Love* (V&A), on which Burne-Jones was working at his death. It belongs to a group of late head studies connected with this picture which were described by Graham Robertson: 'He had got a new model, a curious type quite away from his usual face. She had very small eyes which gave her a rather sly expression, and she evidently interested him (pictorially) very much' (K Preston (ed), *Letters from Graham Robertson* 1953, p487). Such studies, widely exhibited and reproduced in Frederick Hollyer's excellent photographs, played a large part in disseminating the Burne-Jones style.

13. Jacobus da Voragine, *The Golden Legend*

Translated by William Caxton. Edited by F S Ellis
London: Kelmscott Press 1892. Large 4to. Vol.2 of three vols

William Morris's last great venture was the launching of the Kelmscott Press in 1891. Inevitably he wanted his friend Burne-Jones to produce the illustrations, and some of Burne-Jones's most original work in the 1890s was in this field. The small black and white designs proved the ideal vehicle for his last, most mannered and abstract style.

His first work for the Press was two illustrations for vols 1 and 2 of *The Golden Legend*, the English version of the popular medieval collection of saints' lives published by Caxton in 1483. The drawing for the present design is in the Ashmolean Museum, Oxford.

14. William Morris, *The Life and Death of Jason*

London: Kelmscott Press 1895. Large 4to

The fourth edition of Morris's poem, first published in 1867, the book contains two illustrations by Burne-Jones, one showing Jason with the golden fleece, the other Medea in the presence of Circe. Drawings for both are in the Pierpont Morgan Library, New York.

15. William Morris, *The Well at the World's End*

London: Kelmscott Press 1896. Large 4to

After the *Chaucer* (Cat. 16), this late prose romance by William Morris has more designs by Burne-Jones than any other Kelmscott publication. His four designs, one at the head of each book, were made as replacements for a larger series by the young Birmingham artist Arthur Gaskin which Morris, for some unspecified reason, refused to accept (see Cat. 80). This caused much delay, the book being announced in December 1892 but not appearing until June 1896.

Drawings for the designs are in the V&A and the Ashmolean Museum, Oxford.

16. *The Works of Geoffrey Chaucer*

Edited by F S Ellis
London: Kelmscott Press 1896. Folio

This famous book, the masterpiece of the Kelmscott Press and one of the triumphs of the Arts and Crafts movement, was planned as early as 1891. Originally there were to have been sixty illustrations by Burne-Jones, but this number had grown to eighty-seven by the time the book appeared in June 1896, four months before Morris's death. Chaucer had been revered by Morris and Burne-Jones ever since they had read him as undergraduates at Oxford in the 1850s, and Burne-Jones saw the task as an act of homage. 'I am putting myself wholly aside', he wrote, 'and trying to see things as he saw them; not once have I invaded his kingdom with one hostile thought' (*Memorials* II, p217). Nonetheless the designs are among the most inventive of his later works.

The finished drawings and many preliminary sketches are in the Fitzwilliam Museum, Cambridge.

17. William Morris, *Love is Enough*

London: Kelmscott Press 1897. Large 4to

When Morris's metrical romance *Love is Enough* was first published in 1873, an edition illustrated by Burne-Jones was planned. The scheme was abandoned, but the frontispiece was used as one of two illustrations when the Kelmscott Press edition appeared twenty-five years later. The other illustration, shown here, was new; two studies for it exist in the William Morris Gallery, Walthamstow.

18. William Morris, *The Story of Sigurd the Volsung*

London: Kelmscott Press 1898. Small folio

Morris's epic poem *Sigurd the Volsung*, a reworking of the Icelandic *Volsunga Saga* and the German *Nibelungenlied*, was first published in 1876. Burne-Jones was asked to provide forty illustrations for the Kelmscott Press edition, but he found the theme uncongenial and the book eventually appeared with only two designs.

For Gilbert Bayes' sculptural treatment of the subject, 1909–10, see Cat. 206.

19. *The Flower Book, Reproductions of Thirty Eight Water-Colour Designs by Edward Burne-Jones*

With a preface by Lady Burne-Jones
London: Fine Art Society 1905. 4to

Burne-Jones began these designs, now in the British Museum, in 1882, and worked on them intermittently until his death sixteen years later, often during visits to his holiday retreat at Rottingdean on the Sussex coast. No flowers actually appear; he has merely used the names of flowers as the starting point for fanciful designs, sometimes reinterpreting ideas he had already treated elsewhere. The Fine Art Society's publication of these facsimile reproductions has made the project one of his most famous works.

SIMEON SOLOMON
1840–1905

Solomon was the youngest of eight children in an orthodox Jewish family in the East End of London; his brother Abraham and sister Rebecca were also artists. After early training at Leigh's and Cary's academies, he entered the RA Schools in 1855 and there formed a sketching club with three contemporaries – Henry Holiday, Albert Moore and Marcus Stone. A lively, precocious youth, he met Rossetti and Burne-Jones about 1858, by which time he was already producing highly finished drawings and watercolours in the Pre-Raphaelite style, generally illustrative of Hebraic history and ritual; between him and Burne-Jones there was a good deal of mutual influence. He exhibited at the RA 1858–72, and was a regular contributor to the Dudley Gallery from 1865. During the 1860s he was involved in the revival of book illustration, did decorative work for William Morris and William Burges, and – fatally for someone of his temperament – became closely associated with a group of men formulating the ideals of the Aesthetic Movement, notably Swinburne and Pater. Under their influence he turned to classical themes, and between 1866 and 1870 he paid three visits to Italy, where he was much influenced by Leonardo and his school. In Rome in 1869 he wrote the prose poem *A Vision of Love Revealed in Sleep* on the platonic theme of the fulfilment of the soul through earthly love; this was published in 1871 and warmly reviewed by Swinburne and J A Symonds.

In February 1873 Solomon's career collapsed when he was arrested and convicted for homosexual offences. He never regained his position in respectable society, or apparently wished to, preferring to live the life of a vagabond and alcoholic, based (from 1884) at St Giles's Workhouse, Seven Dials. However, he continued to work, producing large numbers of watercolours and chalk drawings with symbolist themes. He died at St Giles's and is buried in the Jewish Cemetery, Willesden.

Ref: Simon Reynolds, *The Vision of Simeon Solomon* 1984; *Solomon. A Family of Painters*, Geffrye Museum, London and Birmingham 1985–6, exh. cat. by Lionel Lambourne and others

20. Love in Autumn 1866 *ill. p13*

Oil on canvas, 84 × 64 (33 × 25¼)
Signed and dated *SS 1866 Florence* (lower left)
Exh: Dudley Gallery, Winter 1872 (96), as *Autumn Love*; Geffrye Museum and Birmingham 1985–6 (53)
Lit: Bate, p64 and repr; Reynolds, *passim* and pl.1

One of Solomon's most beautiful and haunting works, *Love in Autumn* was painted during his visit to Florence to study the Old Masters in 1866. It is characteristic of this period when, like so many artists in his circle, he found himself attracted to pagan and classical themes; but its real subject is one to which he often returned, the vulnerability of love. As Simon Reynolds observes, it anticipates a passage in his prose poem *A Vision of Love Revealed in Sleep*, begun in Rome in 1869 and published two years later.

A watercolour sketch for the picture is in the same collection, and shows that Solomon originally thought of introducing a temple in the middle-distance on the right.

21. The Strawberry Flower 1892

Red chalk, 53.3 × 36.2 (21 × 14¼)
Signed and dated *SS 1892* (lower right) and inscribed with the title below

Exh: *A Century of British Drawings and Watercolours*
1872–1972, Piccadilly Gallery 1985 (47)
Cat. 21–4 are examples of the chalk drawings which
Solomon produced in large numbers during the latter
part of his career, when, ostracised by society, he was
living as a pauper in St Giles's Workhouse, Seven Dials.
The Strawberry Flower is a little unusual in focusing on
a female head and introducing a pastoral note, but even
here the sexual ambiguity which haunts his work is not
entirely absent.
THE PICCADILLY GALLERY, LONDON

22. For the Night must Pass before the Coming Day 1893 *ill. p83*
Black chalk, 34.9 × 54 (13¾ × 21¼)
Signed and dated *SIMEON SOLOMON 1893* (lower
right) and inscribed with the title below
Exh: Geffrye Museum and Birmingham 1985–6 (71)
Lit: Reynolds, p96, repr
Night, shadowed and sunk in slumber, is overtaken by
the brighter, winged figure of Day. Such vague
symbolist concepts were the stock-in-trade of
Solomon's late paintings and drawings. 'Night, Sleep,
Death and the Stars, they are the themes that I love best',
he told Julia Ellsworth Ford, his American admirer and
author of the first monograph on him, published in
New York in 1908.
CHARLES CHOLMONDELEY

23. Orestes and Hypatia 1894 *ill. p83*
Pencil, 37 × 54 (14½ × 21¼)
Signed and dated *SIMEON SOLOMON 1894* (lower
right); the left figure inscribed *ORESTES
SALVATOR* (above) *LASSATUS ALEXANDRIAE*
(lower right); the right figure inscribed *HYPATIA
MATHEMATICIAN TORN TO DEATH BY
CYRIL OF ALEXANDRIA* (above)
One of Solomon's more bizarre conceptions. Both
figures were victims of Christian fanaticism under St
Cyril of Alexandria. Orestes, governor of Egypt, was
stoned by the mob; Hypatia, a girl celebrated for her
beauty, virtue and erudition, was brutally assassinated in
AD 415. The story is told by Gibbon, and by Kingsley
in his novel *Hypatia*. No doubt it appealed to Solomon
as a symbol of the persecution that refinement and
intellect receive at the hands of the philistine. None-
theless, in view of his attraction to ritualism and the
Roman Catholic Church, it is curious to find him
treating a theme that Kingsley had used as a stick to beat
the Tractarians in the 1850s.
 Hypatia was the title given to one of Julia Margaret
Cameron's photographs of Marie Stillman (1868), and
a more academic treatment of a subject from the novel,
Arthur Hacker's *Pelagia and Philammon* (RA 1887), is in
the Walker Art Gallery, Liverpool.
THE PICCADILLY GALLERY, LONDON

24. The Tormented Soul 1894 *ill. p6*
Black chalk, 39.5 × 30 (15½ × 11¾)
Signed and dated *SS 1894* (lower right) and inscribed
with the title below
Lit: Reynolds, p94 and pl.77
There are a number of variations on the theme of the
Medusa's head among Solomon's late drawings. One
was published in *The Hobby Horse* in 1893 and Reynolds
reproduces another, op cit, pl.72.
THE PICCADILLY GALLERY, LONDON

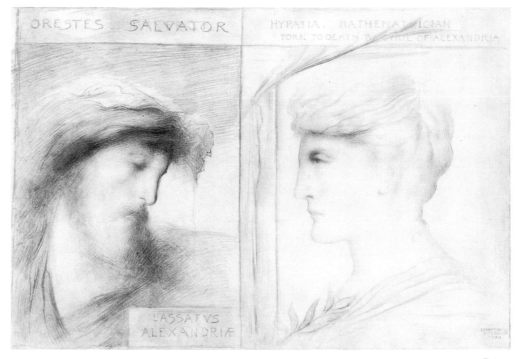

Cat. 23

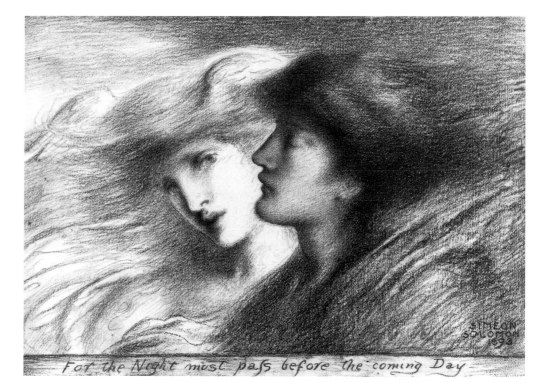

Cat. 22

Cat. 25

ROBERT BATEMAN

1842–1922

Bateman is still a comparatively mysterious figure; though clearly an artist of great talent, he is known today by only a handful of works. According to Walter Crane, he was the leader of a group of young artists who were inspired by the pictures Burne-Jones exhibited at the Old Water-Colour Society in the 1860s, and were dubbed by hostile critics the 'Poetry-without-Grammar-School'. The group also included Crane himself; Henry Ellis Wooldridge, later an eminent musicologist and Slade Professor at Oxford; Theodore Blake Wirgman, best known for his portraits of famous Victorians published in *The Graphic* in the 1880s; Edward Clifford, the painter of graceful society portraits and copies after Burne-Jones; Alfred Sacheverell Coke, who specialised in classical subjects; and the landscape painter E H Fahey.

The son of James Bateman, a distinguished horticulturalist, Bateman entered the RA Schools in 1865 and showed six works at the RA between 1871 and 1889; Crane particularly notes *The Raising of Samuel*

(1879), 'a very weird and powerful conception . . . worked out with extraordinary invention . . . in symbolic and subsidiary detail'. He also showed regularly at the Dudley and Grosvenor Galleries, and William Graham, Burne-Jones's great patron, owned examples of his work. A man of imposing appearance, Bateman married Caroline Octavia Howard, the daughter of a Dean of Lichfield, in 1883, and they lived successively at Benthall Hall, a 16th-century mansion near Much Wenlock, Shropshire, and at Nunney Delamere, Frome. He was known not only as a painter but as a sculptor, botanist, Italian scholar and philanthropist. Crane praises his paintings of flowers and observes that 'he was always experimenting . . . in methods and mediums, and produced slowly, though always with exquisite finish'. He perfected a modelling material which he called 'plasma Bentellesca' (after Benthall Hall), and in 1901 was a founder member of the Society of Painters in Tempera. A devoted husband, he died only five days after his wife in 1922.

Ref: Walter Crane, *An Artist's Reminiscences* 1907; unpublished research by Amanda Kavanagh

25.**The Dead Knight** c1870 *ill. p84*
Watercolour, 28 × 38.7 (11 × 15¼)
Lit: Christopher Newall, *Victorian Watercolours* 1987, pp103–6, pl.71
Even more than Walter Crane's *White Knight* (Cat. 33), this picture shows the influence on Bateman and his circle of the watercolours exhibited by Burne-Jones at the Old Water-Colour Society in the 1860s: works such as *The Merciful Knight* (Birmingham) and *Green Summer* (private collection) which Crane described as revealing 'a magic world of romance and pictured poetry, peopled with ghosts of "ladies dead and lovely knights", – a twilight world of dark mysterious woodlands, haunted streams, meads of deep green starred with burning flowers, veiled in a dim and mystic light' (*Reminiscences* 1907, p84). The white sky in *The Dead Knight* is particularly characteristic. In his quaint little book of reminiscences, *Broadlands as It Was* (1890), Edward Clifford, another member of this circle, praises a number of Burne-Jones's early watercolours and specifically mentions their 'weird, whitish skies'.
ROBIN DE BEAUMONT

26. The Pool of Bethesda 1876–7 *ill. p26 ; detail p78*
Oil on canvas, 50.8 × 73.6 (20 × 29)
Signed and dated *RB 1877* (on steps, lower right) and
RB 1877 me fecit (on rectangular flower pot, centre)
Exh: RA 1876 (30)
Lit: *Saturday Review* 6 May 1876, p584 ; *Academy* 6 May
1876, p441 ; *Athenaeum* 13 May 1876, p670 ; Basil
Taylor, 'A Forgotten "Pre-Raphaelite" : Robert
Bateman's "Pool of Bethesda"', *Apollo* August 1966,
Supplement ('The Paul Mellon Centre for British Art.
Notes on British Art 6'), pp3–4
The picture illustates St John's Gospel 5.2–4 :

> Now there is at Jerusalem by the sheep market a pool,
> which is called in the Hebrew tongue Bethesda,
> having five porches.
>
> In these lay a great multitude of impotent folk, of
> blind, halt, withered, waiting for the moving of the
> water.
>
> For an angel went down at a certain season into the
> pool, and troubled the water : whosoever then first
> after the troubling of the water stepped in was made
> whole of whatsoever disease he had.

Probably the most important work by Bateman
known to us today, the picture was unrecognised until
comparatively recently, appearing at Christie's in 1965
with an attribution to Richard Beavis (same initials).
The double signature and date 1877 led Basil Taylor to
wonder whether it was the picture of this title that
Bateman exhibited at the RA in 1876, or another
version. In fact the RA picture was noted in at least three
reviews (see above), and these accounts leave little doubt
that it was the present canvas. The later dates may
indicate some subsequent reworking.

All the reviews stressed the picture's debt to the Old
Masters, particularly Mantegna, the *Academy* noting that
this 'revivalism' was 'in truth more "Pre-Raphaelite"
than any of the known so called Pre-Raphaelite styles'.
Taylor also emphasised the early Italian influence,
finding echoes not only of Mantegna (in the figure of
the soldier) but of Antonello da Messina in the old man
on the left and the landscape, and of Piero della
Francesca in 'the stillness and stability of the
composition as well as its austere and exact
organisation', seen particularly in the fact that the corner
of the wall to the left of the angel cuts the length of the
canvas at the Golden Section. Such an awareness of
Piero was rare at this date, and although all the
influences can be paralleled in Burne-Jones, Taylor
rightly observed that Bateman makes a highly personal
use of them, treating a scene of suffering in terms of a
restrained geometric design and a cool, almost
monochromatic colour scheme to create a sense of
'withdrawn emotionalism' which is subtly disturbing. It
is a further sign of his originality that he chooses to
represent the moment when the angel is about to
'trouble the waters', rather than the more usual subject
of Jesus healing a man who 'had an infirmity thirty and
eight years', which follows in the Gospel text.

YALE CENTER FOR BRITISH ART, PAUL MELLON COLLECTION.

THOMAS MATTHEWS ROOKE
1842–1942
Born in Marylebone, the son of a Jermyn Street tailor,
Rooke trained at South Kensington and the RA
Schools. In 1869 he applied to work for Morris and
Co., and this led to his becoming Burne-Jones's studio
assistant. A gentle, endearing character, he was ideally
suited to the role, and, unlike others, continued to
work for Burne-Jones until the latter's death, subse-
quently completing his mosaics in the American
Church in Rome. In 1872 he married Leonora Jones,
a school mistress from the Channel Islands, and for
a time she acted as governess to Burne-Jones's
daughter, Margaret. In the 1890s he kept a remarkable
record of conversations in Burne-Jones's studio ; pass-
ages are quoted in Lady Burne-Jones's *Memorials*, and
a selection was published as *Burne-Jones Talking* in
1981.

Under Burne-Jones's influence Rooke attempted
imaginative paintings, specialising in Old Testament
subjects. He also became deeply involved in the Arts
and Crafts movement, decorating furniture, design-
ing stained glass, helping to found the Art Workers'
Guild (1884) and exhibiting with the Arts and Crafts
Exhibition Society (established 1888). However, he
also had another side to his talent, being a faithful
topographical draughtsman. In 1878 Ruskin sent him
to Venice to record the mosaics of St Mark's, and he
continued to work for Ruskin until 1893. He
exhibited at the RA (from 1876), the Grosvenor and
New Galleries, and in 1891 was elected Associate of
the RWS (member 1903). In the late 1870s he settled

at 7 Queen Anne's Gardens in Bedford Park, Norman
Shaw's new garden suburb in West London, continu-
ing to live there until his death at the age of
ninety-nine.

Ref: *Drawings and Watercolours by T M Rooke* exh.
Hartnoll & Eyre 1972, cat. by Bill Waters ; *Thomas
Matthew [sic] Rooke RWS*, exh. Martyn Gregory 1975,
cat.

27. The Dancing Girls 1882 *ill. p85*
Oil on canvas, 61 × 97 (24 × 38¼)
Signed and dated *TMR 1882* (below, right of centre)
A comparatively early work. The group of dancing
figures was probably inspired by Burne-Jones's
charming little watercolour *The King's Wedding*
(Clemens-Sels-Museum, Neuss), painted in 1870, which
Ruskin praised so highly in *The Three Colours of Pre-
Raphaelitism*, first published in 1878 (see Martin
Harrison and Bill Waters, *Burne-Jones* 1973, pl.25).
THE VISITORS OF THE ASHMOLEAN MUSEUM, OXFORD

28. Night and Morning (a pair) c1890(?)
Each watercolour with bodycolour, 25.4 × 27 (10 × 10⅝)
Rooke was not a great draughtsman and had no
compelling imagination, but his subject pictures are
often imbued with a certain homely poetry, as the
present examples show. They are in their original
frames, appropriately decorated with stars (Night) and
sun-rays (Morning) ; these were no doubt designed by
the artist himself and reflect his close involvement with
the Arts and Crafts.

PRIVATE COLLECTION, LONDON

Cat. 27

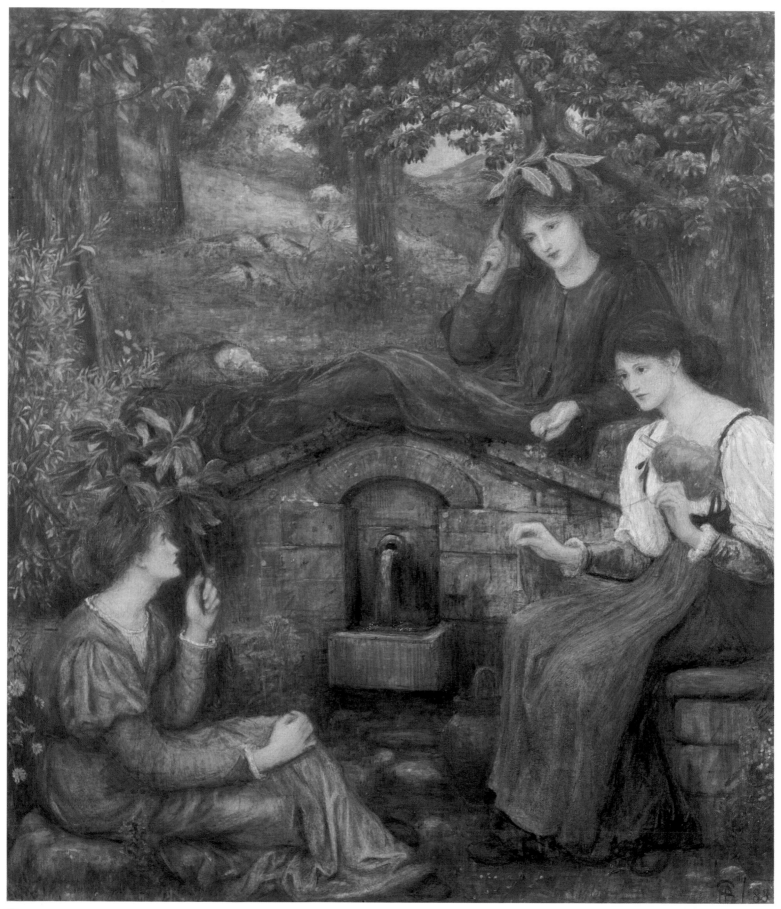

Cat. 29

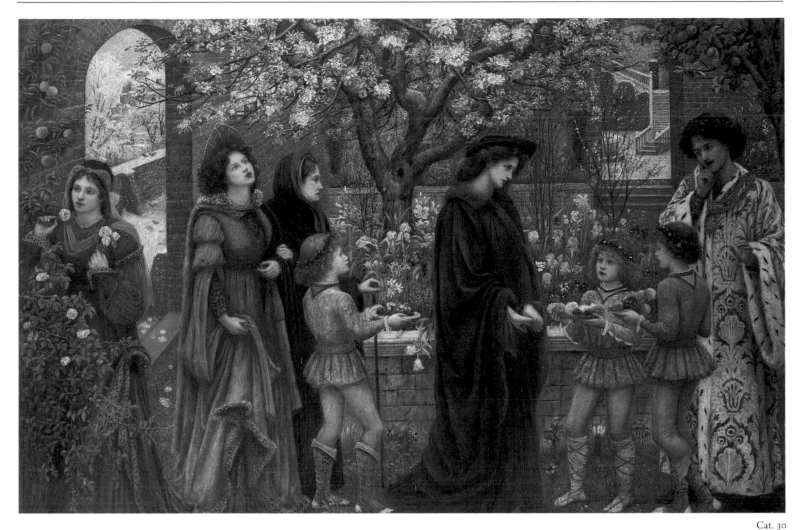

Cat. 30

MARIE STILLMAN (née Spartali)

1844–1927

Marie belonged to the Anglo-Greek community which played such a prominent role in the annals of late 19th-century English art; her father, Michael Spartali, was a wealthy merchant and acted as Greek Consul-General in London 1866–82. Renowned, like her younger sister Christine, for her beauty, she sat to many artists, notably Rossetti, Burne-Jones and the photographer Julia Margaret Cameron; but she was also talented herself, and in the later 1860s had regular instruction in art from Ford Madox Brown. She began to exhibit at the Dudley Gallery in 1867, and showed a few works at the RA in the 1870s; but from 1877 she supported the Grosvenor and New Galleries. Her work consists mainly of watercolours inspired by Dante, Boccaccio and other authors, and later tends towards landscape; although her drawing was often shaky, she had a fine sense of colour and mood. In 1871 she married the American journalist and diplomat W J Stillman, and this took her to live in Florence and Rome. However, she continued to visit England and regularly exhibited several pictures a year. On Stillman's retirement in 1898 they settled in Surrey, and after his death in 1901 she lived with her daughters in Kensington. Her looks and bearing remained striking till the end.

Ref: The Times 8 March 1927, p21; Richard Ormond,

'A Pre-Raphaelite Beauty', *Country Life* 138 30 December 1965, pp1780–1; John Christian, 'Marie Spartali. Pre-Raphaelite Beauty' *Antique Collector* March 1984, pp42–7

29. **By a Clear Well, Within a Little Field** 1883 *ill. p86*
Watercolour with bodycolour, 54 × 47 (21¼ × 18½)
Signed and dated *MS 83* (lower right)
Exh: Grosvenor Gallery 1884 (368, as *By a Dear Well, within a Little Field*)
Lit: Christian 1984, p47, fig.8
The picture illustrates Rossetti's translation of a sonnet by Boccaccio, 'Of three Girls and of their Talk', published in the Appendix to Part II of his *Early Italian Poets* (1861). It is a good example both of the artist's hesitant drawing and her gentle lyrical vision. The motif of a girl holding up a branch recurs in her picture *Madonna Pietra degli Scrovigni* (Liverpool), which was also shown at the Grosvenor Gallery in 1884 (362) and again illustrates a sonnet in Rossetti's *Early Italian Poets* (no. XII), this time by Dante. Since other pictures by Marie are inspired by this book, it was evidently a favourite source.
PRE-RAPHAELITE INC. (BY COURTESY OF JULIAN HARTNOLL)

30. **The Enchanted Garden** 1889 *ill. p87*
Watercolour with bodycolour, 77.5 × 102.8 (30½ × 40½)
Signed and dated *MS 1889* (lower left)
Exh: New Gallery 1889 (177); Japan 1985 (32)
Lit: Bate, facing p112, repr; C Wood 1981, p132, repr

Like Cat. 29, the picture is inspired by Boccaccio, this time one of the stories from the *Decameron*. Set in Udine, it tells of the love of Messer Ansaldo, a nobleman, for Madonna Dianora, the wife of a wealthy grandee. She rejects his advances, but eventually agrees to yield to him if he causes a garden to blossom in January, believing this to be impossible. He, however, with the aid of a magician, accomplishes the miracle, and proudly presents her with fruit and flowers – the subject of the picture. The story has a happy ending. Dismayed, Dianora confesses to her husband, who tells her that she must keep her contract; Ansaldo, overcome by such liberality, releases her.

One of Marie Stillman's largest and most ambitious works, the picture reflects her experience of living in Italy; the costumes of the page-boys, who might have stepped out of a fresco by Ghirlandaio or Benozzo Gozzoli, are a particularly characteristic touch. The subject was also treated in a very late work by J W Waterhouse (Lady Lever Art Gallery, Port Sunlight).
PRE-RAPHAELITE INC. (BY COURTESY OF JULIAN HARTNOLL)

31. **Beatrice** 1898
Watercolour with bodycolour, 53.3 × 36.8 (21 × 14½)
Signed and dated *MS 1898* (lower right)
Lit: Christian 1984, p46, fig.6
A rather later example than Cat.29–30, but very typical of the artist in subject and composition, both betraying the strong influence of Rossetti.
PRIVATE COLLECTION

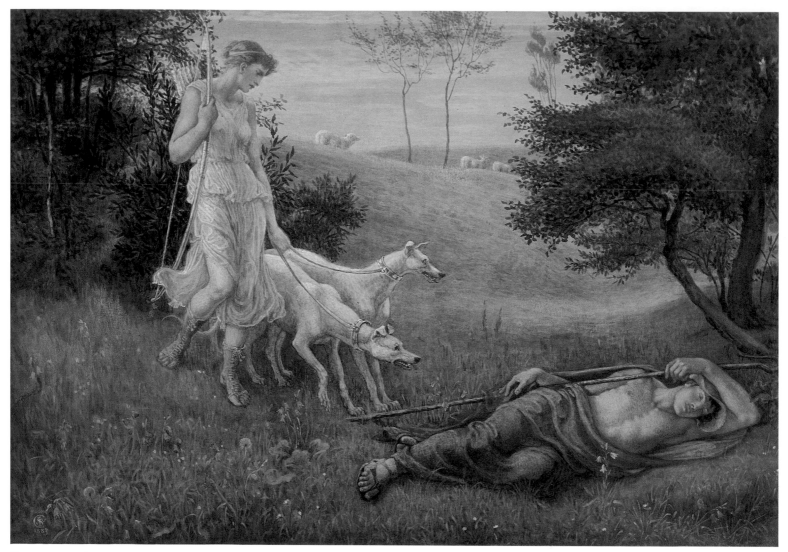

Cat. 35

WALTER CRANE

1845–1915

Crane was born in Liverpool, the son of a versatile local artist, but spent his boyhood in Devon before moving with his family to London in 1857. When his father died in 1859 he was apprenticed for three years to the wood-engraver W J Linton, after which he continued to work as an illustrator, his designs for J R Wise's *New Forest* (1862) being the outstanding product of this period. In 1863 he met Edmund Evans, the pioneer of colour printing, and two years later they began producing a long series of cheap picture books for children; these proved enormously popular and made Crane's name. Meanwhile, inspired by Burne-Jones's exhibits at the Old Water-Colour Society, he was showing paintings at the Dudley Gallery, which opened in 1865 and attracted a number of young Pre-Raphaelite followers (see note on Robert Bateman above). He met Burne-Jones and William Morris in 1871. In September that year he married and set out with his wife for an extended honeymoon in Italy, returning in 1873 and settling in Shepherd's Bush. He was to make further visits to Italy, notably in 1882–3 (see Cat. 35–6). In 1877 he was invited to exhibit at the new Grosvenor Gallery

and sent *The Renascence of Venus* (Tate), later owned by G F Watts. He continued to show pictures at the Grosvenor and New Galleries, as well as at the ROI and RWS (Associate 1888), and always maintained that painting was his first love. However, his main significance as an artist probably lies in his book illustrations, which did much to promote popular awareness of the Aesthetic Movement through their eclectic combination of classical, medieval, Renaissance, Pre-Raphaelite and oriental sources, and in his manifold contribution to the Arts and Crafts. A prolific designer of wallpapers, needlework, stained glass, ceramics and gesso decoration, he undertook important decorative schemes for George Howard, Frederic Leighton, Alexander Ionides and the American heiress, Catherine Wolfe. In 1880 he designed a tapestry for Morris, and in 1894 illustrated his prose romance *The Story of the Glittering Plain* for the Kelmscott Press.

Like Morris, Crane identified closely with the growing Socialist movement. He was also much involved with art education, being Director of Design at Manchester School of Art 1893–7 and Principal of the RCA, London, 1898–9. The lectures he gave in these capacities were published in a series of books.

He was Master of the Art Workers' Guild 1887–9, and first President of the Arts and Crafts Exhibition Society (founded 1888), holding the post till 1893 and then again 1896–1912. His influence was also strong in Europe and America, partly because his work was often featured in the *Studio*, which had a large international circulation, partly as a result of the exhibition of his work which toured the USA in 1891/2 and subsequently had a great success in Australia, Bohemia, the Netherlands and Scandinavia. In 1895 he was made an honorary member of the Munich Academy, and many of his later paintings found German buyers, who no doubt liked their elaborate symbolism. In 1900 he scored a further triumph with a large exhibition in Budapest. This was later included in the enormous show of decorative art held at Turin in 1902, and for his work on this project, in which he was assisted by Robert Anning Bell, he was made a Knight of the Order of the Crown of Italy by King Victor Emmanuel. He published his *Reminiscences* in 1907 and died in London in March 1915.

Ref: Walter Crane, *An Artist's Reminiscences* 1907; Isobel Spencer, *Walter Crane* 1975; *Walter Crane*, exh. Whitworth Art Gallery, Manchester 1989, cat. by Gregory Smith and Sarah Hyde (eds)

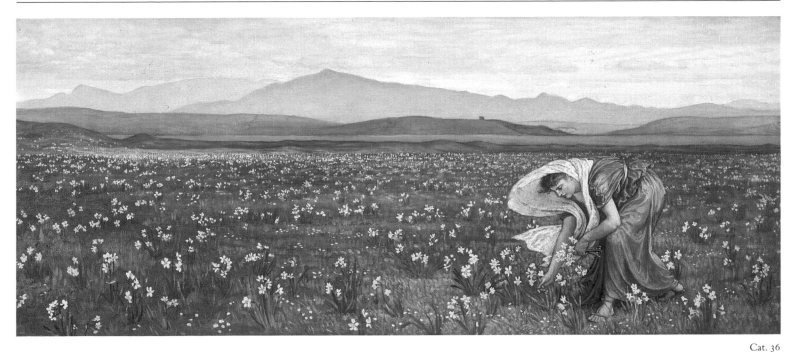

Cat. 36

32. A Winged Female Figure in a Boat on a River c1867
Watercolour with bodycolour, 24 × 52 (9½ × 20½)
A label on the back is inscribed *No.2* and gives the artist's name and address (46 Argyle Square, WC), followed by some almost indecipherable lines of verse
The picture is clearly an early work, dating from the late 1860s when Crane's vision was at its most poetic, and this is confirmed by the address on the back, where he lived from 1861 until his marriage ten years later. River landscapes figure prominently in his pictures of the period; compare, for example, *Such Sights as Youthful Poets Dream* (Dudley Gallery 1869; Sotheby's, 21 June 1988, lot 66, repr in cat.) and *Ormuzd and Ahriman* (Dudley Gallery 1870; repr Spencer, p67).

A little research might well identify the picture more precisely. The lines of verse on the back are not totally illegible, while 'No 2' suggests that the picture was exhibited.

WILLIAM WILTSHIRE

33. The White Knight 1870 *ill. p12*
Watercolour, 45.7 × 61 (18 × 24)
Signed with monogram and dated *1870* (lower right)
Exh: *Morris and Company*, FAS 1979 (193)
Lit: Mark Girouard, *The Return to Camelot* 1981, p196 and pl.XXII
A particularly beautiful example of Crane's early style, betraying the influence of the intensely romantic pictures shown by Burne-Jones at the Old Water-Colour Society in the 1860s; *The Merciful Knight* (Birmingham), exhibited in 1864, is surely especially relevant. The picture seems to have acquired its present title quite recently, and it is tempting to identify it with *The Red Cross Knight in Search of Una*, a watercolour inspired by Spenser's *Faerie Queene* which Crane exhibited at the Dudley Gallery in 1871 (320). According to Crane, the picture, which was bought by Somerset Beaumont, the brother-in-law of the popular preacher, the Rev. Stopford Brooke, showed the knight as 'a small figure on horseback wandering through a green landscape taken from one of the Derbyshire "cloughs"' (*Reminiscences*, p106). (Derbyshire was a favourite painting ground for Crane at this period.) The obvious objection to this theory is that the knight in the

picture is not accoutred as Spenser describes his hero:
> But on his brest a bloudie Crosse he bore,
> The deare remembrance of his dying Lord . . .
> Upon his shield the like was also scor'd.
Could this be artistic licence?
PRIVATE COLLECTION

34. Diana 1881 *ill. p90*
Watercolour with bodycolour, 35 × 25 (13⅜ × 9⅞)
Signed with monogram and dated *1881* (lower left)
Exh: *The Aesthetic Movement and the Cult of Japan*, FAS 1972 (8)
Lit: Christopher Newall, *Victorian Watercolours* 1987, p106 and pl.72
Although it dates from 1881, *Diana* shows Crane still thinking in terms of the 'dark mysterious woodlands', 'haunted streams' and 'weird' white skies that he and his friends had admired so much in Burne-Jones's watercolours of the 1860s (see Cat. 25). Like Cat. 103, the picture belonged to those two pioneers in the connoisseurship of Victorian and Edwardian art, Charles and Lavinia Handley-Read, to whose inspiration so much that has happened in this field of recent years is due. *The Last Romantics* is no exception.
PRIVATE COLLECTION

35. Diana and Endymion 1883 *ill. p88*
Watercolour with bodycolour, 55.3 × 78.1 (21¾ × 30¾)
Inscribed *WC* (monogram) *ROME 1883* (lower left)
Exh: Grosvenor Gallery 1883 (75, as *Diana and the Shepherd*); Japan 1987 (39)
Lit: Crane, pp243, 410; Spencer, p127
Endymion was a shepherd endowed with eternal youth. Diana, the goddess of hunting, saw him sleeping on Mount Latmos and was so struck by his beauty that she descended from heaven every night to share his bed. The subject was also treated by G F Watts (Grosvenor Gallery 1881; private collection) and by E J Poynter (1901/2; Manchester). Crane's picture, which may have been inspired by Watts's famous version, dates from the period following the death of his infant son in January 1882, when the artist and his wife temporarily left their London home and travelled in England and abroad. The design was made when they were staying at Tunbridge Wells, and Graham Robertson recalled posing there for the figure of Diana, 'holding in leash a large lean hound

which had bitten the butcher during the foregoing week and always seemed to me to be looking round for more of him' (*Time Was* 1931, pp410–1).

The picture was painted in Rome early in 1883 and exhibited at the Grosvenor Gallery that summer. No doubt because of Diana's association with the moon, Crane sent it in a silver frame, but this 'dismayed the Management so much' that he was asked to have it gilded. Since the picture retains its original frame (no doubt designed by the artist), the change is still evident, and it is clear that silver would have suited the colour scheme better. Crane also records that the picture was attacked by Harry Quilter, the art critic of the *Spectator*, who wrote that 'it was strange that an artist who had studied so long in Italy could not paint an olive tree. As it happened, the background . . . had been found on Tunbridge Wells Common, so I was able to turn the tables on him on this point.' Today *Diana and Endymion* seems one of the happier products of Crane's later career as a painter, less cluttered in design than many and with none of the rather ponderous allegorising to which he was so addicted.

DUNDEE ART GALLERIES AND MUSEUMS

36. La Primavera 1883 *ill. p89*
Oil on canvas, 38 × 91.5 (15 × 36)
Signed and dated *Walter Crane 1883* (lower left)
This attractive picture was apparently painted during Crane's stay in Rome in the early part of 1883, making it exactly contemporary with Cat. 35. He had long been attracted to the theme of springtime in Italy. 'The beauty of the Italian spring was upon us. . . .', he wrote of his honeymoon in 1871, 'I found a subject on the Pincio, a view of Rome, with almond trees in front and two figures gathering flowers on the sloping gardens, which I sent to the Dudley [1873]. Also "A Herald of Spring" [Birmingham] – a figure in a pale green robe and pink scarf coming down a Roman street in the early morning with a basket of daffodils on her arm' (*Reminiscences*, pp138–9). The theme found further expression in *The Advent of Spring*, *Winter and Spring*, and *The Earth and Spring*, all dating from the 1870s, and *La Primavera* seems to be its final treatment. The picture is very much in the 'Etruscan' style, reflecting the fact that Crane was in touch with two of the leading exponents, Giovanni Costa and Matthew Ridley

Corbet, during his 1883 visit.

La Primavera belonged to Alexander Ionides, whose house, 1 Holland Park, had one of the most famous 'aesthetic' interiors of the day. Crane designed the gesso-work decoration in the dining-room and an overmantel in the drawing-room to hold his patron's choice collection of Tanagra statuettes.

ROY MILES FINE PAINTINGS

37. **The Butterfly's Ball** c1880(?)

Watercolour with bodycolour, 24.1 × 16.8 (9½ × 6⅝)
Exh: *Fantastic Illustration* 1979 (41)
Diana Johnson in the catalogue of the *Fantastic Illustration* exhibition suggests that this drawing may be connected with William Roscoe's poem for children, *The Butterfly's Ball and the Grasshopper's Feast* (1807). In style it is a little reminiscent of 'Dicky' Doyle, particularly his well-known designs for William Allingham's *In Fairyland* (1870).

THE TRUSTEES OF THE BRITISH MUSEUM

38. **The Fountain of Youth** c1901

Watercolour with bodycolour, 38.5 × 29.5 (15⅛ × 11⅝)
A sketch for a picture exhibited by Crane at the New Gallery in 1901 (67, repr *Reminiscences*, facing p494). The Gallery made a special feature that year of works by members of the newly formed Society of Painters in Tempera, showing them in a group together. Crane submitted two paintings (the second being *The Mower*, repr *Reminiscences*, facing p462); other contributors included C M Gere, J D Batten, Arthur Gaskin, Marianne Stokes, J E Southall, Kate Bunce, Henry Ryland and Bernard Sleigh.

As Gregory Smith points out, two further studies for the picture are in the local history collection at Kensington Public Library. Burne-Jones had toyed with the idea of painting this theme in the 1870s and early 1880s; several of his studies for the project survive, including a freely-worked gouache in the Tate (3428).

THE TRUSTEES OF THE ROYAL SOCIETY OF PAINTERS IN WATER-COLOURS (FROM THE DIPLOMA COLLECTION)

39. **Edmund Spenser,** *The Faerie Queene*

Edited by T J Wise and 'displayed in a series of designs by Walter Crane'
London: George Allen 1894–7. 4to. Vols 1–2 of 3 vols
Crane records in his *Reminiscences* (pp429–30) how he was asked to undertake the illustrations by Ruskin's publisher, George Allen, who believed that Ruskin's well-known admiration for Spenser would make the book popular among his followers. Crane, who had long been interested in Spenser himself (see Cat. 33), contributed full-page illustrations to each canto, title-pages, headings and tailpieces, the entire project taking three years to complete. It was not the expected success, and indeed there is something disappointing about the book. Individual designs are arresting, but as Isobel Spencer observes, 'it must be concluded that despite his deep affection for Spenser's allegory Crane found it difficult to sustain enthusiasm and a spontaneous response' (op cit, p135).

Crane based a picture of *Britomart* (1896; repr *Reminiscences*, facing p428) on a heading in Book III, and in the Royal Albert Memorial Museum at Exeter there is a set of twelve reproductions from the book, hand-coloured by the artist as models for tableaux vivants presented by the Cambridge University Extension Guild at the Theatre Royal, Exeter, in 1904.

In 1897 a rival three-volume edition was published by J M Dent with illustrations by the Birmingham artist Louis Fairfax-Muckley; this was a sequel to the same publisher's *Morte d'Arthur* illustrated by Beardsley (Cat. 61).

THE BRITISH LIBRARY BOARD

40. **Edmund Spenser,** *The Shepheard's Calender*

'Newly adorned with twelve pictures and other devices by Walter Crane'
London: Harper 1898. 8vo
Crane was responsible for the whole design, including end-papers and a particularly charming cover (repr Spencer, p125), and the result is much more successful than *The Faerie Queene* (Cat. 39). Isobel Spencer suggests that he may have been inspired to reduce the over-busy detail of the *Faerie Queene* designs by William Morris's recent edition of *The Shepheard's Calender* (Cat. 79), which has a simple overall design and characteristically clean-cut illustrations by Arthur Gaskin. Whatever the case, it is interesting to compare Crane's shaggy, homespun style with Gaskin's more incisive treatment of the same themes.

PRIVATE COLLECTION

Cat. 34

Cat. 43

CHARLES FAIRFAX MURRAY

1849–1919

Probably from an impoverished family (his father died in the Charterhouse), Murray began his career in an engineer's office in Westminster. Somehow he became involved with the Pre-Raphaelites, and in November 1866 was taken on as Burne-Jones's first studio assistant. A skilful technician, quick to assimilate the style of others, he also worked for Rossetti and G F Watts; William Morris employed him to prepare stained-glass cartoons, paint windows, and add figures to his illuminated manuscripts; while Ruskin, who described him as a 'heaven-born copyist', sent him to Italy to record Old Master paintings. His own work, though clearly indebted to Rossetti, Burne-Jones and the 16th-century Venetians, has an unmistakable character. He excelled at portrait drawings, leaving likenesses of many of his circle, and painted numerous small figure subjects on panel for the Fleet Street firm of decorators, Collinson and Lock, which also employed T M Rooke. He exhibited at the RA (1867, 1871) but mainly supported the Grosvenor and New Galleries.

Murray's sympathy with the Old Masters, and perhaps a lack of confidence in his own powers as an artist, caused him to devote more and more time to collecting. He travelled extensively and established a family in Florence, though continuing to live mainly in England. Rightly regarded as one of the leading connoisseurs of the day he was closely involved with the dealers, Agnew's; and Burne-Jones, whose house in Fulham he was to take over as a repository for his collection, recommended him for the Directorship of the National Gallery in 1894. He published catalogues of the Duke of Portland's pictures (1894) and of portions of his own collection. His Old Master drawings were bought *en bloc* by the American collector, J Pierpont Morgan, and he made generous gifts to the National Gallery, the Birmingham City Art Gallery, the Fitzwilliam Museum and the Dulwich Picture Gallery. A short, thickset figure with badly bowed

legs, he was somewhat pugnacious in character and had a great love of music. He died at Chiswick on 25 January 1919 after a series of strokes.

Ref: *The Times* 28 January 1919, p11; A C Benson, *Memories and Friends* 1924, ch.12; W S Spanton, *An Art Student and his Teachers in the Sixties* 1927, ch.4

41. **A Pastoral** 1869–71

Watercolour with bodycolour, 29 × 34.5 (11⅜ × 13⅝)
Signed with initials and dated *1869–71*; signed and inscribed with title on the back
An early work, painted during the period when Murray was most actively employed as Burne-Jones's studio assistant. The influence of his master is obvious, as well as that of Venetian painting, which also impinged powerfully on Burne-Jones himself. The most obvious comparison is with Burne-Jones's well-known design, *Green Summer*. The original watercolour dates from 1864, and a larger oil version was made in 1868, probably with Murray's help.

Murray exhibited pictures entitled *A Pastoral* at the Grosvenor Gallery exhibitions of 1879 and 1882, but both were probably more substantial works than this.
PRIVATE COLLECTION

42. **Kings' Daughters** c1875

Oil on panel, 25.8 × 36.5 (10¼ × 14⅜)
The design is based on Rossetti's poem *My Father's Close*, a translation from the Old French published in his *Poems* of 1870. Burne-Jones had made two pen and ink drawings on the theme in the late 1850s (see *Burne-Jones*, Arts Council exh. 1975–6 (14), and *The Little Holland House Album*, Dalrymple Press 1981, pp19, 36).

The picture is probably a little later than Cat. 41, although the composition is still very Giorgionesque. In fact Venetian painting remained a constant influence on Murray's style, not only suggesting motifs but determining his characteristic oil technique of glazing colours over a low-keyed underpainting.
THE GOVERNORS OF DULWICH PICTURE GALLERY

43. **The Last Parting of Helga and Gunnlaug**

c1880–5 *ill. p91*
Oil on panel, 30.4 × 67.3 (12 × 26½)
Signed *CFM* (lower left)
Exh: *The Pre-Raphaelite Era: 1848–1914*, Wilmington 1976 (4–20); *English Pre-Raphaelite Painting*, Washington 1977 (16)
An illustration to 'The Story of Gunnlaug the Worm-Tongue and Raven the Skald', a translation from the Icelandic by Eirikr Magnússon and William Morris which appeared first in the *Fortnightly Review* in January 1869 and was reprinted as one of *Three Northern Love Stories*, all by the same translators, in 1875.

The picture was bought from the artist in 1893 by Samuel and Mary Bancroft, who formed the fine collection of Pre-Raphaelite works now at Wilmington, Delaware, with Murray's help and advice. A drawing for the painting is also in the collection.
DELAWARE ART MUSEUM, SAMUEL AND MARY R BANCROFT MEMORIAL

Cat. 47

JOHN MELHUISH STRUDWICK

1849–1937

Born in Clapham and educated there at St Saviour's Grammar School, Strudwick studied art at South Kensington and the RA. He was an unsuccessful student but received encouragement from the Scottish artist, John Pettie, whose bold, fluent brushwork he emulated for a time. He found his true direction in the early 1870s when he became an assistant first to Spencer Stanhope and then to Burne-Jones. *Songs without Words* (private collection), the picture with which he made his first and only appearance at the RA in 1876, shows his style fully formed, and it underwent little development from then on. While clearly owing much to Burne-Jones, it lacks his nervous intensity and intellectual vigour, relying for its effect on surface decoration and often evoking a mood of cloying sweetness.

Like so many of Burne-Jones's adherents, Strudwick began to exhibit at the Grosvenor Gallery in 1877, transferring to the New Gallery eleven years later. He enjoyed considerable success: *Songs without Words* was bought by Lord Southesk, a Scottish peer with antiquarian interests; *A Golden Thread* (1885) was acquired for the Chantrey Bequest; and two Liverpool shipping magnates, William Imrie and George Holt, were long-standing patrons. In April 1891 he was the subject of an article by George Bernard Shaw, then an art and music critic. According to Shaw, Strudwick told him that 'he could not draw – never could', a failing Shaw interpreted as 'a priceless gift', saving him from empty virtuosity. Shaw also recorded that the artist had 'a fine sense

of humour' – something one would hardly guess from his pictures, and that he had never visited Italy, although critics often complained that his pictures were merely pastiches of early Italian work.

Strudwick lived all his adult life in Hammersmith, not far from Burne-Jones and T M Rooke. He married a Miss Harriet Reed, and had one child, Ethel, born in 1880. (She was to become High Mistress of St Paul's Girls School in 1927.) He was still contributing to the New Gallery when it held its last exhibition in 1909, but seems to have ceased painting about this time, although he lived on until 1937. His *Times* obituary describes him as 'a beautiful old man . . . [and] a charming personality, exceedingly kind to young artists'.

Ref: G Bernard Shaw, 'J.M. Strudwick' *Art Journal* April 1891, pp97–101; *The Times* 20 July 1937, p18

44. **Isabella** 1879 *ill. p16*
Tempera with gold paint on canvas, 99 × 58.5 (39 × 23)
Exh: Grosvenor Gallery 1879 (40); Japan 1985 (30)
Lit: Bate, facing p110, repr
An illustration to Keats's poem *Isabella; or, The Pot of Basil*, which had already inspired major paintings by Millais (1848–9; Liverpool) and Holman Hunt (1866–8; Newcastle). Derived from Boccaccio, it tells how Isabella falls in love with Lorenzo, an employee of her brothers, who murder him to prevent their marriage. She exhumes his body and buries his head in a pot of basil, which she waters with her tears. The brothers discover and steal it, and she dies of a broken heart.

Strudwick shows her bereft as the brothers, having snatched the pot from its elaborate wrought-iron

pedestal, make their escape through the streets of Florence outside her window.

Unsigned, like most of Strudwick's pictures, *Isabella* is an early work, and once belonged to W Graham Robertson. Strudwick exhibited another picture with the same title at the Grosvenor Gallery in 1886.
THE TRUSTEES OF THE DE MORGAN FOUNDATION

45. **Circe and Scylla** 1886 *ill. p94*
Oil on canvas, 99.7 × 69.8 (39¼ × 27½)
Exh: Grosvenor Gallery 1886 (6)
Lit: Sudley, *Illustrated Catalogue (of the Emma Holt Bequest)* . . . 1971, p68, no.303 and pl.46
The subject is taken from Ovid's *Metamorphoses*. Scylla, a water nymph, was loved by Glaucus, a sea deity. She rejected his advances, and he turned to aid for Circe, the celebrated enchantress. Circe, however, fell in love with Glaucus herself, and to destroy Scylla, her rival, poisoned the stream where the nymph was accustomed to bathe. When Scylla entered the water she was transformed into a hideous monster, whereupon she threw herself into the sea which separates Italy from Sicily and was changed into the rock, so perilous to sailors, which bears her name.

Strudwick shows Circe pouring poison into the stream, while Scylla advances unawares to bathe. He must have known Burne-Jones's famous picture *The Wine of Circe* (private collection), exhibited in 1869, but a closer comparison is J W Waterhouse's *Circe Invidiosa* (Adelaide), shown at the RA in 1892, which treats the same incident as the Strudwick.

Circe and Scylla is among four pictures by Strudwick which were acquired in the 1890s by George Holt (1825–96), one of a number of important Liverpool collectors at this time (see Cat. 47). His pictures can still

Cat. 46

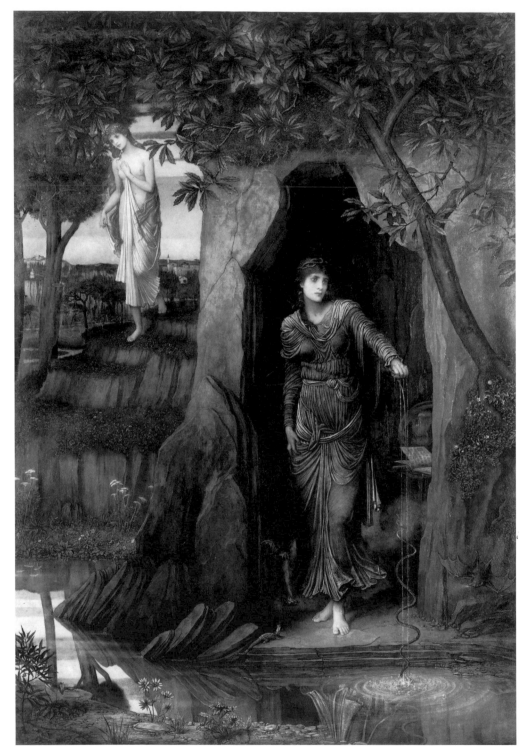

Cat. 45

other at the New Gallery in 1897. All the evidence suggests that the 1882 picture was the single standing figure reproduced in George Bernard Shaw's article, p99 (and sold Sotheby's Belgravia, 9 April 1974, lot 69), so presumably the present picture is the one shown in 1897, only four years before *Summer Hours*, which it resembles so closely in composition and style. It should, however, be added that *The Times*, in its review of the New Gallery exhibition in 1897, refers to Strudwick's contribution as 'a small "St Cecilia"'. Our picture is not particularly small.
BENNIE GRAY

47. **Passing Days** c1904 *ill. p92*

Oil on canvas, 77.5 (central arch 95.3) × 266.7 (30½ (central arch 37½) × 105)
Exh: New Gallery 1904 (104); 34th Autumn Exh. of Modern Art, Walker Art Gallery, Liverpool 1904 (1215)
One of Strudwick's most ambitious works, this is a larger and much later version of a picture he exhibited at the Grosvenor Gallery in 1878 (120). In his article on Strudwick, Bernard Shaw described the subject as follows: 'a man sits watching the periods of his life pass in procession from the future into the past. He stretches out his hands to the bygone years of his youth at the prompting of Love; but Time interposes the blade of his scythe between them; and the passing hour covers her face and weeps bitterly'. Several pictures by Strudwick are allegories of time, *A Golden Thread* (Tate Gallery), exhibited in 1885, being another good example.

The small version (private collection) has twice passed through the saleroom in recent years, and the two pictures have been much confused. There is no doubt, however, that it was the large version which belonged to the Liverpool ship-owner William Imrie (1837–1906), appearing at his posthumous sale at Christie's, 28 June 1907, lot 138 (when, to confuse matters further, it was erroneously said to have been exhibited in 1894). Imrie, who owned a total of six works by Strudwick, *Passing Days* being the latest and largest, as well as examples of Leighton, Rossetti, Burne-Jones, Spencer Stanhope, Dicksee, and Evelyn De Morgan (see Cat. 50), belonged to a group of Liverpool ship-owners and merchants who formed major collections at this period; others were T H Ismay, Imrie's partner in the White Star Line; George Holt, whose collection still exists at Sudley; and – most significant of all – F R Leyland. The links (or rivalries) between these men deserve further study. Like Imrie, Holt was a patron of Strudwick, buying four pictures by him in the 1890s (see Cat. 45). Leyland was one of the most important patrons of Rossetti and Burne-Jones; he also employed Norman Shaw to mastermind his famous 'aesthetic' interior at 49 Prince's Gate in London; and it was Shaw who later built Ismay's country-house, Dawpool, at Thurlaston in Cheshire.

After Imrie, *Passing Days* had another interesting owner in Sir Jeremiah Colman (1858–1942), head of the well-known mustard firm and a noted philanthropist.
BENNIE GRAY

be seen at his family house, Sudley, now an outstation of the Walker Art Gallery.
TRUSTEES OF THE NATIONAL MUSEUMS AND GALLERIES ON MERSEYSIDE, SUDLEY ART GALLERY

46. **St Cecilia** 1897 *ill. p93*

Oil on canvas, 91.5 × 91.5 (36 × 36)
Exh: New Gallery 1897 (78)
Like Burne-Jones, Strudwick loved to paint compositions in which a mood of wistful sadness is evoked by a group of female figures playing musical instruments, usually giving them such indeterminate titles as *Songs without Words*, *Golden Strings*, or *The Gentle Music of a Bygone Day*. *St Cecilia* is essentially a work of this kind, and in fact is very comparable to another example, *Summer Hours*, exhibited at the New Gallery in 1901 (see Japan exh. 1985, cat. no 31, repr). The subject, however, is more specific, and the picture has an unusual intensity, capturing the spirit and decorative effect that Strudwick was always seeking without the cloying sweetness and finicky detail that sometimes make him tiresome.

The artist exhibited at least two pictures entitled *St Cecilia*, one at the Grosvenor Gallery in 1882 (184), the

Cat. 48

EDWARD ROBERT HUGHES
1851–1914

Nephew of the Pre-Raphaelite painter Arthur Hughes, under whom he first studied. He then entered the RA Schools and worked with Holman Hunt, helping to complete some of his later' works (including the St Paul's version of *The Light of the World*). He was also in touch with Burne-Jones and knew George Macdonald, to whose daughter he was engaged before she died. He worked mainly in water-colour, painting literary themes of a symbolist nature and portraits; also specialised in red chalk portrait studies. Exhibited much with the RWS (Associate 1891, member 1895, Vice-President 1901–3) and at the RA (1870–1911), and his picture *Biancabella and Samaritana* was shown at the first Venice Biennale, 1895. For some years he was a popular teacher at LCC evening classes. He is recorded at several London addresses but moved to St Albans in 1913 and died there 23 April, 1914.

48. 'Oh, what's that in the hollow . . . ?' c1895
ill. p95
Watercolour with bodycolour, 63.2 × 93.3 (24⅞ × 36¾)

An illustration to Christina Rossetti's poem 'Amor Mundi', in which two lovers, pursuing the easy downhill path of wordly pleasure, encounter warning portents, including a corpse:

> 'Oh, what's that in the hollow, so pale I quake to follow?'
> 'Oh, that's a thin dead body which waits the eternal term'.

When published in the *Shilling Magazine* in 1865 the poem was accompanied by one of Frederick Sandys' most famous illustrations.

The subject is a curious choice for Hughes, whose work is generally sweet and lyrical in mood. No doubt he realised that the picture would never be 'commercial', and selected it accordingly as his Diploma work for the RWS. The dog-roses may owe something to Burne-Jones's *Briar Rose* paintings, exhibited to great acclaim in 1890.

THE TRUSTEES OF THE ROYAL SOCIETY OF PAINTERS IN WATER-COLOURS (FROM THE DIPLOMA COLLECTION)

49. **Night with her Train of Stars** 1912 *ill. p19*
Watercolour with bodycolour and gold paint, 75.5 × 124.5 (29¾ × 49)

Signed *E R HUGHES RWS* (lower left)
Exh: RWS, Summer 1912 (199); *Death, Heaven and the Victorians*, Brighton 1970 (73); *Fantastic Illustration* 1979 (121)
Lit: Jullian, p90, fig.44
The picture takes its title from W E Henley's poem 'I M Margaritae Sorori', no.35 in his *Echoes*, 1872–89:

> Night with her train of stars
> And her great gift of sleep.

It was given to Birmingham in 1915 by the E R Hughes Memorial Committee and is possibly the artist's masterpiece, although the blue tonality and soft *sfumato*, achieved by an elaborate process of stippling, are very characteristic. Diana Johnson, in her *Fantastic Illustration* catalogue, aptly describes the picture as 'a touching and sentimental Victorian allegory on death' of a type (also represented by Holman Hunt's *Triumph of the Innocents*) that many found comforting in an age of high infant mortality. It is also a very symbolist image; the poppies alone, symbol of oblivion, recall Rossetti's *Beata Beatrix* (Tate) and T C Gotch's *Death the Bride* (Kettering).
BIRMINGHAM CITY MUSEUM AND ART GALLERY

EVELYN DE MORGAN (née Pickering)
1855–1919
Born Evelyn Pickering, the eldest daughter of
Percival Pickering of Cannon Hall, Barnsley, she was
the niece on her mother's side of J R Spencer Stan-
hope. From an early age she was determined to
become an artist, and in 1873 braved parental disap-
proval to enter the Slade, which had opened two years
earlier. There she won many prizes, but in 1875 she
left to study in Rome. She was influenced by Stan-
hope, Burne-Jones, G F Watts, and the early Italian
masters, whom she continued to study when visiting
her uncle, who settled near Florence in 1880. In 1877,
when still only twenty-one, she was invited to con-
tribute to the opening exhibition at the Grosvenor
Gallery; later she transferred to the New Gallery and
showed at provincial centres, but never at the RA.
In 1887 she married the potter William De Morgan;
they settled in Chelsea but spent the winter months
in Italy for the sake of William's health. Her paintings
are relentlessly literary in theme, dauntingly com-
petent and often extremely ambitious; in her last
years she painted a number of allegories relating to
the Great War, exhibiting them in her studio to raise
money for the Red Cross. William De Morgan died
in 1917 and Evelyn two years later.

Ref: W Shaw Sparrow, 'The Art of Mrs William De
Morgan' *Studio* 19 1900, pp221–32; A M W Stirling,
William De Morgan and his Wife 1922

50. **Flora** 1894 *ill. p14*
Oil on canvas, 198 × 86 (78 × 34)
Signed and dated *E.de M. Maggio 1894* (lower right)
Exh: Glasgow and Wolverhampton (according to Mrs
Stirling, without date); Japan 1985 (33)
Lit: Sparrow, p227 and repr; Bate, facing p112, repr;
Stirling, p192, note
This is generally agreed to be Evelyn De Morgan's
masterpiece; her works are often more elaborate, but
few are so satisfactorily resolved. The picture was
painted in Florence (note the Italian form of the date),
and clearly owes much to Botticelli's *Primavera* in the
Uffizi. The figure of Flora in that painting is isolated,
given a similar dress and placed in a similar setting, with
fruit-laden branches silhouetted against the sky and a
foreground carpet of flowers.
 The picture was one of eight commissioned from the
artist by the Liverpool ship-owner William Imrie (see
Cat. 47).
THE TRUSTEES OF THE DE MORGAN FOUNDATION

51. **Medusa** c1876
Bronze, height 79 (31)
Exh: Grosvenor Gallery 1882 (according to Mrs
Stirling, but not listed in catalogue)
Lit: Sparrow, p232 and repr; Stirling, pp185–6 and repr
This over life-size bust was modelled and cast in Rome,
whence the artist had gone to study, much against her
parents' wishes, on leaving the Slade School in 1875 at
the age of twenty. It is an astonishing performance for
someone so young and says much about the character
of her work – ambitious, confident, steeped in the past,
and ultimately rather repellent.
 Evelyn De Morgan executed very few sculptures; the
only other example seems to be a terracotta bust of the
Mater Dolorosa (repr Sparrow, p230).
PRIVATE COLLECTION (BY COURTESY OF JULIAN HARTNOLL)

LOUIS B DAVIS
1860–1941
Painter, designer of stained glass and illustrator, much
influenced by Burne-Jones and Blake. Drawings by
him appear in the *English Illustrated Magazine* (ed J

Comyns Carr) 1886–92, and in 1895 he illustrated
Good Night, a collection of verses by Dollie Radford
(co-editor of William Allingham's *Diary*, 1907), pub-
lished by David Nutt. She also contributed songs to
The Goose Girl at the Well (Elkin Mathews, 1906),

Cat. 52

a 'fairy play' adapted by Davis from the brothers Grimm. His stained glass and other decorative works were popular, being commissioned, among other places, for Westminster Abbey, Gloucester Cathedral, Welbeck Abbey, All Hallows Church, Southwark, the Thistle Chapel in St Giles' Cathedral, Edinburgh (by Lorimer, 1909–11), Paisley Abbey (1907–8), Colmonell Church (1910), Dunblane Cathedral (1915), Wemyss Castle, and St Patrick's Cathedral, Dublin; he also decorated the private chapels of the Duchess of Bedford and the Marquess of Londonderry. Many of these designs were published (see British Library cat.), and his work is reproduced in the *Studio*. Davis exhibited with the Arts and Crafts Exhibition Society and was a member of the Art Workers' Guild 1891–1906. As a painter he exhibited at the New Gallery, RWS (Associate 1898) and elsewhere (not RA), his work embracing imaginative subjects, landscapes and flower studies. He is recorded living at Ewelme Cottage, Pinner, by 1897, and died there at the age of eighty-one.

Ref: *The Times* 23 October 1941, p7

52. An Angel 1897 *ill. p96*
Watercolour with bodycolour, 29.8 × 17.1 (11¾ × 6¾)
Signed with monogram and dated *1897* (lower right);
inscribed *NISI DOMINUS FRUSTRA* (In vain without God) (lower left)
Exh: *Pre-Raphaelitism*, Maas Gallery 1970 (46); *Aspects of Victorian Art*, FAS 1971 (34), repr cat. pl.32
A characteristic work of the artist, who was happiest evoking a world of child-like innocence. The conception is reminiscent of Holman Hunt's *Light of the World*, and in fact the picture is given this title in the Maas Gallery and FAS catalogues. A drawing in the British Museum (1953-9-24-9) may be a preparatory study.
CHRISTOPHER WOOD

53. The Nativity c1900
Watercolour with bodycolour, 35.5 × 26 (14 × 10¼)
Another delightful example of Davis's fairy-tale style, probably not far removed in date from Cat. 52. Both clearly depend on early Burne-Jones, the present picture being particularly reminiscent of his 'Nativity' tryptych of 1863 (private collection; repr John Christian, *The Pre-Raphaelites in Oxford* 1974, p41). This was commissioned by the Dalziel brothers, the famous wood-engravers, and is full of wilful quaintnesses inspired by early German engravings and the contemporary work of Ludwig Richter, both of which Burne-Jones was studying at the time in connection with the current movement for better book illustration.
PETER ROSE AND ALBERT GALLICHAN

54. Old Pinner, Middlesex c1905(?)
Watercolour with bodycolour, 30.5 × 55.3 (12 × 21¾)
Signed with monogram (lower left)
Evidently a view near the artist's home and a favourite type of subject (cf *Old Barns at Rickmansworth*, exh. *Aspects of Victorian Art*, FAS 1971, no.35). Davis's visionary approach to landscape is almost certainly indebted to Blake and his followers. He owned Edward Calvert's watercolour *A Primitive City*, now in the British Museum, and a number of his designs are patently Blake-inspired. *The Chariot of Fire* (BM), formerly in the collection of Cecil French, is one example; others are the illustrations to Dollie Radford's *Good Night* (1895), which are integrated with the text in a very Blake-like manner. It might be imagined that he moved from an early, Burne-Jonesian style to a later, Blakean idiom, but the dating of *Good Night* suggests that the two influences were concurrent. Clearly Davis's development needs research.
PRIVATE COLLECTION

Cat. 55

GRAHAM WALFORD ROBERTSON
1866–1948

W Graham Robertson (as he preferred to be known) was born in London, the only son of wealthy parents, and educated at Eton. He studied art under Albert Moore and at the RCA, while learning much from friendships with Burne-Jones, Walter Crane, Whistler, Arthur Melville and Sargent, who painted his portrait in 1895. He was also passionately interested in Rossetti and William Blake, an unrivalled collection of whose work he formed. Open to so many influences, it is hardly surprising that his work is varied and eclectic. His paintings include portraits, imaginative subjects and landscapes, and he was a facile illustrator, decorating books by G K Chesterton, Kenneth Grahame, Algernon Blackwood and others, as well as the numerous children's stories, books of verse and plays he wrote himself. During the late Victorian and Edwardian period he enjoyed considerable acclaim. He exhibited at the New Gallery, the NEAC, the Society of Portrait Painters and elsewhere; in 1906 he had a one-man exhibition at the Carfax Gallery, and articles on his work appeared in the *Magazine of Art* (1899), the *Studio* (1905) and *Cassell's Magazine* (1908). His other great interest from early years was the stage. He knew Wilde, Irving, Ellen Terry, Sarah Bernhardt, etc, and in 1908 his play *Pinkie and the Fairies* had a phenomenal success when produced at His Majesty's Theatre by Tree with an all-star cast. After the First World War, this interest became paramount and he virtually gave up painting. In 1888 he and his mother had acquired a house at Sandhills, near Witley in Sur-

rey, formerly owned by William and Helen Allingham, and in the 1920s he devoted much time to writing and producing pageants with local players. In 1931 he published his autobiography, *Time Was*, a characteristically witty account of his many friendships with the famous, and in the last decade of his life he became something of a guru to younger theatrical talents, including Olivier, Coward and the Lunts. Many of the pictures in his collection – which in addition to the Blakes and the Sargent portrait included works by Rossetti, Burne-Jones, Albert Moore and Whistler – were given or bequeathed to the Tate.

Ref: W Graham Robertson, *Time Was* 1931; Kerrison Preston (ed), *Letters from Graham Robertson* 1953

55. Unidentified Medieval Subject, with Female Figures Praying c1885–90 *ill. p97*
Pencil and watercolour, 29.8 × 43.1 (11¾ × 17)
Obviously a youthful and somewhat immature drawing, from what Robertson called 'my very early "romantic" period when I was completely under the spell of Rossetti' (see Cat. 56). Two more substantial essays in this 'Rossetti' style, *My Lady Greensleeves* and *The Queen of Samothrace*, are reproduced in Percy Bates' *English Pre-Raphaelite Painters* 1899. They were exhibited respectively at the New Gallery in 1889 and 1896.
PRIVATE COLLECTION

56. The Lacquer Cabinet c1920
Watercolour, 28.3 × 14 (11⅛ × 5½)
Signed *GR* (lower left) and inscribed by the artist on the back: *The Lacquer Cabinet by W Graham*

Robertson 9 Argyll Road Kensington W
Exh: Carlisle 1970 (111); Newcastle 1972 (123)
Lit: Preston, pp470, 525
This and the following exhibit, both from the collection of the poet Gordon Bottomley, who knew the artist well, seem to belong to a group of small watercolours painted about 1920 which represents Robertson's last burst of activity as a painter. In fact many were included in what he called his 'clearance sale' exhibition at Guildford in March 1921. 'My candid friends here', he wrote at the time, 'allude to [them] as "the pub signs" – there being a good deal of strong colour . . . They're very old-fashioned and quite a throwback to my very early "romantic" period when I was completely under the spell of Rossetti' (Preston, p55).

The Lacquer Cabinet, with its standing figure, strong sense of pattern, and oriental and floral accessories, perhaps owes a greater debt to Robertson's master, Albert Moore. He later referred to it as 'merely a colour study'.
CARLISLE MUSEUM AND ART GALLERY

57. **The Pilgrim** c1920
Watercolour, 18.4 × 16.5 (7¼ × 6½)
Signed *GR* (lower left)
Exh: Carlisle 1970 (110); Newcastle 1972 (124)
Lit: Preston, pp470, 525
See Cat. 56. Robertson told Kerrison Preston, who owned a number of his works, that this drawing was 'a companion to your "Sanctuary", both being illustrations to that queer little poem of Maeterlinck's that begins: *J'ai cherché trente ans, mes sœurs*'. He knew Maeterlinck, who wanted him to illustrate his play *The Blue Bird*, in the event undertaken by Cayley Robinson (Cat. 235). The three figures on the right in the watercolours are clearly based on those of the sea-maidens in Burne-Jones's painting *The Arming of Perseus* in his Perseus series. Large gouache cartoons for these paintings, now at Southampton, hung in the artist's garden studio, and were well-known to Robertson; indeed in his autobiography, *Time Was* (pp76–7), he specifically mentions the impact they made on him on his first visit to Burne-Jones.
CARLISLE MUSEUM AND ART GALLERY

58. **Moon Magic** c1920
Watercolour, 19 × 15.2 (7½ × 6)
Signed *GR* (lower left); the title inscribed by the artist on the back
In terms of colour the picture is less of a 'pub sign' than Cat. 56–7, but it must belong to the same period, being similarly signed and inscribed, and having an identical Rowley Gallery frame. The title too recalls that of a watercolour included in Robertson's Guildford exhibition of 1921: 'taken from the *Anthology of Recent Poetry* – a de la Mare verse . . . a subtle blend of an old Persian tile and a sixpenny Christamas card . . . called "The Blue Moon"' (Preston, p56). While the figure is clearly 'Pre-Raphaelite', the landscape seems to betray the influence of Samuel Palmer – not surprisingly in view of Robertson's passionate interest in Blake. It probably represents a view near his home in Surrey.
RACHEL MOSS

59. **Julia Horatia Ewing**, *Old Fashioned Fairy Tales*
Illustrated by W Graham Robertson
London: G Bell & Sons 1920. 8vo
Robertson was a prolific illustrator of books, both by himself and others (for a comprehensive list, see Preston, pp529–30). This was one of the last he undertook. 'I always loved Mrs Ewing's work', he wrote at the time, 'and am interested in the job' (Preston, p44).
THE BRITISH LIBRARY BOARD

AUBREY BEARDSLEY
1872–1898
One of the most famous figures of the 1890s, Beardsley was born at Brighton and attended the local Grammar School, where he already showed signs of precocity. On leaving, he took a job as a clerk with the Guardian Life Insurance Co. in London, meanwhile attending evening classes at the Westminster School of Art under Frederick Brown. He also received encouragement from Burne-Jones, experienced a variety of influences from the engravings of Mantegna to Whistler's Peacock Room, and in 1892 (like Ricketts and Shannon) visited Puvis de Chavannes. The same year he was introduced by the bookseller Frederick Evans to an ambitious young publisher, J M Dent, who commissioned him to illustrate Malory's *Morte d'Arthur* (Cat. 61), thus enabling him to give up his job in insurance. In 1893 his work was discussed by Joseph Pennell in the first number of the *Studio*, and in 1894 he illustrated Oscar Wilde's *Salome* and became editor of John Lane's new journal, *The Yellow Book*. These projects made his name, his sophisticated, witty and disturbing drawings seeming to capture the essence of the age. After the Wilde trial, however, he was dismissed from the staff of *The Yellow Book*, an event which aggravated his tubercular condition, diagnosed as early as 1879, and ensured that the last three years of his life were a frantic race against time. In 1896 he was a regular contributor to a new magazine, *The Savoy*, edited by Arthur Symons and published by Leonard Smithers, who also commissioned his last important sets of drawings, for Pope's *Rape of the Lock*, Aristophanes' *Lysistrata*, the 6th Satire of Juvenal, Gautier's *Mademoiselle de Maupin* and Ben Jonson's *Volpone*. Much of this period was spent abroad, in Dieppe, Paris and Brussels; he died at Menton on 16 March 1898, still only twenty-five.

Ref: Brian Reade, *Aubrey Beardsley* 1967

60. **How Queen Guenever Rode on Maying**
1893–4
Two drawings, each pen and indian ink, 20.6 × 16.8 (8⅛ × 6⅝)
Exh: *Aubrey Beardsley*, V&A 1966 (186); *Fantastic Illustration* 1979 (10); *Aubrey Beardsley*, exh. circulated in Japan by the Tokyo Shimbun 1983 (13), repr in cat.
Lit: Robert Ross, *Aubrey Beardsley* 1908, p79, no.59 (XVIII); Reade, p323, no.141 and pl.137
The drawings represent a double-page illustration to the Dent *Morte d'Arthur* (Cat. 61) (Book XIX, ch.1; Vol.II, between pp880 and 881), and are among many for this project which survive. Their combination of medieval theme and detail with a flat decorative effect inspired by Japanese prints is typical of Beardsley at this period, and characteristic of the Aesthetic Movement in general.
THE BOARD OF TRUSTEES OF THE VICTORIA AND ALBERT MUSEUM, LONDON

61. **Sir Thomas Malory**, *The Birth Life and Acts of King Arthur . . .*
'Embellished with many original designs by Aubrey Beardsley'
London: J M Dent 1893–4. 4to. Vols 1–2 of 3 vols
Beardsley's first commission, given in 1892 when he was twenty. The publisher, J M Dent, was out to produce a Kelmscott-style book using the photographic, and therefore much cheaper, line-block process; and the illustrations, for which Beardsley was paid £250, were to be 'in the manner of Burne-Jones', whom Beardsley knew. Burne-Jones's influence is certainly apparent, but so too is that of Japanese prints, while the mood of the drawings is sinister and mocking, a parody of the Burne-Jones style. No wonder Burne-Jones and Morris

were horrified when they saw the results. The book was issued in monthly instalments, and Beardsley originally intended to produce some 400 drawings, including full- and double-page illustrations, chapter openings, borders and initials; in the event the number rose to over 580 and the project occupied him a year longer than anticipated, taxing his interest to the limit. By the time it was finished he had produced the designs for Oscar Wilde's *Salome* and was deeply involved in *The Yellow Book*.
THE BRITISH LIBRARY BOARD

62. **Aubrey Beardsley**, *Under the Hill and other Essays in Prose and Verse*
London: John Lane 1904. 4to
Under the Hill was published posthumously as Beardsley's 'literary remains'. The main item, giving the book its title, is a fragment of a never-completed parody of the legend of Tannhäuser, a wry act of homage not only to his hero, Wagner, but to Swinburne and Burne-Jones, who had also treated the theme. In 1896 the fragment was published by Leonard Smithers in *The Savoy*, with illustrations in the 18th-century manner Beardsley evolved at this time. When Smithers went bankrupt in 1899, John Lane bought up his rights in the story and five years later reprinted it, together with the illustrations, three of Beardsley's poems, examples of his 'table talk', two letters written to the press in reply to criticism, and some further unpublished drawings.
THE BRITISH LIBRARY BOARD

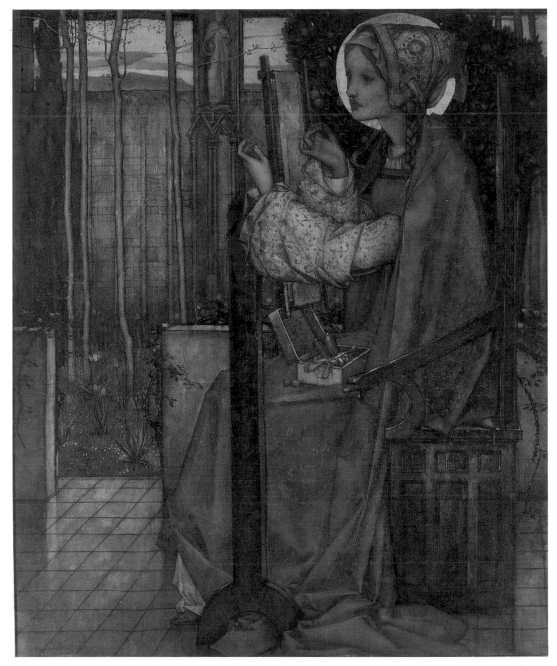

Cat. 63

EDWARD REGINALD FRAMPTON

1872–1923

The son of a stained-glass artist, Frampton was educated at Brighton Grammar School, where he was an exact contemporary of Beardsley. He then attended the Westminster School of Art and worked for seven years with his father, before spending lengthy periods studying in Italy and France. His flat schematic style clearly owes much to his involvement with stained glass, which continued as late as 1918. He also acknowledged the influence of the early Italian masters, Puvis de Chavannes and Burne-Jones, whose retrospective exhibitions at the New Gallery (1892, 1898) impressed him deeply.

With such an artistic background, it is hardly surprising that Frampton specialised in murals, carrying out schemes in churches at Hastings, Rushall, Birstall, Ranmore, Southampton and elsewhere, often as war memorials (see *Studio* 36 1906, pp346–50; 78 1919, pp61–3), as well as secular projects, as at Waddington Hall, Yorkshire. For many years his easel paintings consisted mainly of religious and symbolist themes, but latterly he turned more to landscape, still using a severely formalised style. He exhibited regularly with the Royal Institute of Oil Painters (member 1904), but also belonged to the RBA (1894), the Tempera Society (1907), and the Art Workers' Guild (1912), while showing at the RA (1895–1923), the New Gallery, the Paris Salon, etc, and holding a one-man exhibition at Baillie's Gallery in 1914. As a young man he practised as a sculptor, and for many years he was on the Higher Education Art Committee of the LCC. He married Lola, daughter of Francis Mallard Clark, a civil servant at the Admiralty, and lived in Kensington and Chelsea. His recreations included chess and sailing, and he evidently travelled widely since his landscapes include subjects in Sussex, Cumberland, the Channel Islands, Brittany and the Bernese Oberland. He died suddenly in Paris in November 1923, on his way to Austria, and is buried in the cemetery of Saint-Germain. A memorial exhibition was held at the Fine Art Society the following year.

Ref: Rudolf Dircks, 'Mr E Reginald Frampton' *Art Journal* October 1907, pp289–96; Aymer Vallance, 'The Paintings of Reginald Frampton, ROI' *Studio* 75 1918, pp67–77; *The Times* 8 November 1923, p14

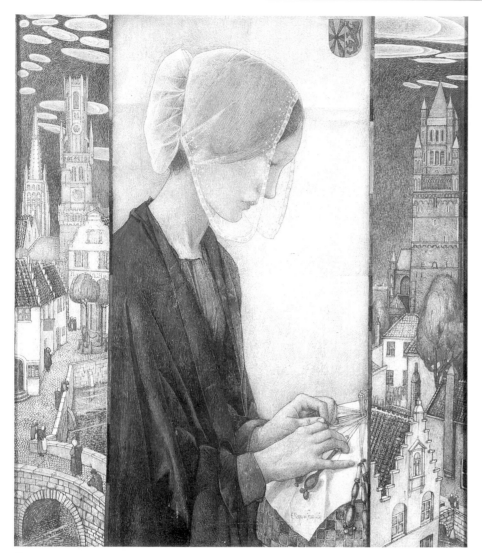

Cat. 66

evolved for his figure subjects and ultimately went back to his training as a stained-glass artist. Some have titles which underline this approach by stressing the relationship between the natural elements. Here, for instance, clouds become 'hills'; another is called *The Sympathy of Land and Sky* (Sotheby's Belgravia, 20 March 1979, lot 241). For further information, see Rudolph Dircks, 'Mr Reginald Frampton's Landscapes' *Studio 86* 1923, pp3–9. As Dircks observes, a feature common to many of these paintings is 'a patch of wild flowers' in the foreground. Here again our example is typical.

PRIVATE COLLECTION (BY COURTESY OF JULIAN HARTNOLL)

66. A Maid of Bruges 1919 ill. p100

Tempera, 53.3 × 45.1 (21 × 17¾)
Signed *E Reginald Frampton* (lower centre); the title and artist's address inscribed on a label on the back
Exh: RA 1919 (857); E R Frampton memorial exh., FAS 1924 (37)
Lit: *Royal Academy Illustrated* 1919, p100
A typical Frampton composition, similar to Cat. 64 but eight years later and considerably more abstract in style. This movement towards abstraction is found throughout his later work and was no doubt due to the influence of modernism. At the same time the picture looks back, hinting that he shared the feeling for Bruges found in many Symbolist artists and writers, Georges Rodenbach's novel *Bruges-la-Morte* (1892) being the most famous example. (For some comments on this phenomenon, see Jullian, pp143–7.) A further reflection of this feeling may perhaps be traced in Frampton's picture *The Gothic Tower* (Sotheby's, 28 November 1972, lot 45), which was surely inspired by Jan Van Eyck's *St Barbara* in the Antwerp Museum.

THE PICCADILLY GALLERY, LONDON

67. St Brandan 1911

Pencil, 17.5 × 22.2 (6⅞ × 8¾)
Signed *REGINALD FRAMPTON* (lower right) and inscribed *St Brandan June 1911* (lower left)
Exh: Probably Arts and Crafts Exh. Soc., 10th exh., Grosvenor Gallery 1912 (199 a or d); or 11th exh., RA 1916 (508)
Lit: Houfe, p309, repr
St Brandan (or more usually Brendan) was a 6th-century Irish monk who is reputed to have sailed the sea for seven years in search of a fabulous earthly paradise. Frampton's source was Matthew Arnold's poem *Saint Brandan*, which he also illustrated in a picture showing the Saint encountering Judas Iscariot on an iceberg (New Gallery 1908). The artist was a keen sailor and a number of his works have nautical themes. Other examples are *The Passage of the Holy Grail to Sarras* (New Gallery 1907; Sotheby's, 21 June 1988, lot 70); an allegorical figure of *Navigation* (New Gallery 1909); and *The Childhood of Perseus* (Royal Institute of Oil Painters 1911; repr Vallance, p75).
The drawing is probably one of three designs for book illustrations on the theme of St Brendan that Frampton exhibited with the Arts and Crafts Exhibition Society in 1912 and 1916 (see above), but no published illustrations corresponding to them are known. Indeed Frampton never seems to have had any illustrations published. The V&A has two more of his composition drawings, given with this one in 1972.

THE BOARD OF TRUSTEES OF THE VICTORIA AND ALBERT MUSEUM, LONDON

68. The Princess and the Shepherdess c1910(?)

Pen and ink and watercolour, 21.5 × 17.8 (8½ × 7)
Signed *Reginald Frampton* (lower left)
Drawings by Frampton seem to be rare; a watercolour of *St Winifred*, dated 1899, at Manchester, the three composition sketches in the V&A (see Cat. 67), and

63. St Clare, as Patron Saint of Embroidery 1905 ill. p99

Oil and gold paint on canvas, 60 × 49.5 (23⅝ × 19½)
Signed *E Reginald Frampton* (lower left)
Exh: Institute of Oil Painters 1905 (159)
A particularly sensitive example of Frampton's early religious subjects, exhibited at the Institute of Oil Painters the year after he became a member. The figure is very different from the usual images of St Clare, the austere follower of St Francis, nor is this Saint generally known as a patroness of embroidery. However, the other possibility, St Clare of Rimini (d.1346), does not seem very likely either.
BENNIE GRAY

64. A Madonna of Brittany 1911

Oil and gold paint on canvas, 51.5 × 47 (20¼ × 18½)
Exh. Royal Institute of Oil Painters 1911 (121); Japan 1987 (57)
Lit: Vallance, p77
A number of Frampton's pictures have Breton themes, the outstanding example being *Brittany, 1914* (Tate), shown at the RA in 1920, in which a French soldier and a Breton girl are seen kneeling in prayer at a wayside shrine. According to a letter from Frampton in the archives of Cartwright Hall, written when *A Madonna of Brittany* was acquired in 1913, the picture was painted

in 'a little fishing village in the extreme north-west corner of Finistère', and the seascapes to either side of the figure show sections of the local coastline on the Rade de Brest. A similar stretch of scenery, with the harbour of Camaret-sur-Mer, appears in *Brittany, 1914*.
Frampton of course was only one of many artists who were powerfully attracted to Brittany at this period, the most famous of all being Gauguin. Like Gauguin and his followers, he clearly responded to the deeply religious character of the region, while his work has a formal relationship to theirs in its flat, decorative quality and a technique which Vallance described as 'barely distinguishable from that of the . . . Pointillistes.' The fact that both Frampton and Gauguin admired Puvis de Chavannes only underlines the connection. It would be interesting to know more about his early studies in France, and if he was in contact with other artists when painting *A Madonna of Brittany*.
BRADFORD ART GALLERIES AND MUSEUMS

65. Hills of the Land and Sky: Cumberland 1917

Oil on canvas, 47 × 100.3 (18½ × 39½)
Signed *E Reginald Frampton* (lower right)
Exh: Royal Institute of Oil Painters 1917 (253)
A fine example of the landscapes that Frampton painted in the later part of his career. Though based on actual views, they are treated in the formalised style he had

Cat. 69

three studies of the nude in the Letchworth Museum, are other examples.

TOWNELEY HALL ART GALLERY AND MUSEUMS, BURNLEY BOROUGH COUNCIL

JOHN RILEY WILMER

1883–1941

The son of a Falmouth chemist, Wilmer attended the local art school before studying under Charles Napier Hemy; Henry Scott Tuke also gave him advice. His watercolour *A Dream of the Sorrowful Way*, exhibited at the RA in 1905, was hailed as 'the artistic surprise of the year' and compared to 'a design for a stained-glass window by Burne-Jones, assisted by the ghost of Albert Dürer'. He continued to show subject pictures at the RA till 1926, including the ambitious *Dream of Omar Khayyám*, 1917 (Sotheby's, 17 June 1986, lot 51). Wilmer seems to have lived all his life at Falmouth, and is buried in the local cemetery. He almost certainly knew T C Gotch (Cat. 121–4), probably through Tuke (see Cat. 70).

Ref: Falmouth Art Gallery archive

69. **Dardanians View the Monster Dead** 1906
ill. p101

Watercolour with bodycolour, 37.5 × 53.5 (14¾ × 21⅛)
Signed and dated *John Wilmer 1906* (lower left)
According to a note by the artist on the back, the picture was inspired by a passage in *The Merchant of Venice* (Act 3, Scene 2), and shows a Trojan (Dardanian) noble and his wife viewing the head of the Gorgon Medusa, slain by Perseus, in a shield held by a Libyan slave. Anyone who looked at the head itself was of course turned to stone.

An early work, painted only a year after Wilmer made his début at the RA, the picture may owe something to Burne-Jones's Perseus series (see Cat. 3), while the realistic treatment of the sea and sea-birds must be based on observation at Falmouth. The mood is harsher and the composition more dynamic than usual with Wilmer.

VICTOR ARWAS

70. **The Adoration of the Magi** 1911
Watercolour with bodycolour on board, 36.2 × 46.3 (14¼ × 18¼)

Signed and dated *J Riley Wilmer 1911* (lower left)
Exh: Probably RA 1912 (1158)
Painted five years later than Cat. 69, and more characteristic of the artist, with its gentle, introspective mood and static composition. It is probably the work of this title that was shown at the RA in 1912. The subject evidently appealed to Wilmer, who exhibited two variations in 1916 and 1918.

The picture was given to the Falmouth Art Gallery in 1923 by the wealthy South African collector, A A de Pass (1861–1952), also known for his benefactions to the Fitzwilliam Museum, Cambridge, the Royal Institution of Cornwall, and other places. De Pass lived at Cliffe House, Falmouth, and probably knew Wilmer; he was certainly a patron and close friend of another Falmouth artist, H S Tuke. For a detailed account of their circle, which also included T C Gotch and J W Waterhouse, see B D Price (ed), *Biographical Notes on Alfred Aaron de Pass*, Royal Cornwall Polytechnic Society, Falmouth 1982.

FALMOUTH ART GALLERY (FALMOUTH TOWN COUNCIL)

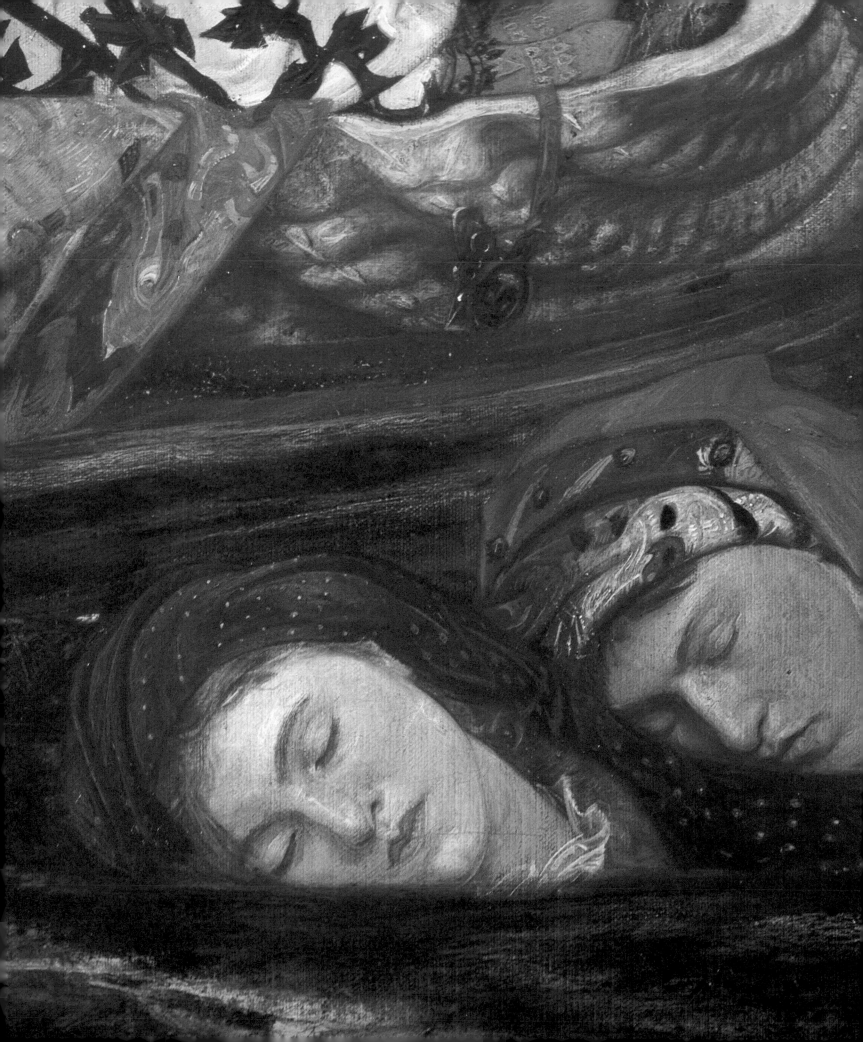

THE BIRMINGHAM GROUP

KATE ELIZABETH BUNCE

1858–1927

Her father was John Thackray Bunce (1828–99), editor of the *Birmingham Daily Post* and a leading member of the town's Liberal establishment, having much to do with the administration of the Municipal School of Art and with creating the collection of the new City Art Gallery. She studied at the School of Art under Edward R Taylor, and painted one of the murals illustrating scenes from local history which the students carried out for the Town Hall c1890. She exhibited four works at the RA (1887–1901), while supporting the RBSA (Associate 1888) and the New Gallery; in 1901, together with Crane, Southall, Gaskin, Batten and others, she was among the members of the newly-formed Society of Painters in Tempera who showed there in a group. A staunch Anglo-Catholic, she also executed decorative paintings in churches, and she illustrated one book (1895). Rossetti seems to have been the main influence of her style and choice of subject; some of her pictures have beaten metal frames made by her sister Myra.

71. **Melody** c1895–7 ill. p103
Oil on canvas, 76.3 × 51 (30 × 20⅛)
Exh: *Oil Paintings lent by the Corporation of Birmingham*, Cartwright Hall, Bradford 1910 (28); *Birmingham Art Circle Annual Exh.*, RBSA 1928 (86); *Painters in Tempera*, Kettering and Grantham 1958

This is the best of three known easel paintings by the artist, the others being *The Keepsake* (New Gallery 1901 (68); repr *By Hammer and Hand*, p77, fig.53), also in the Birmingham City Art Gallery, and *A Chance Meeting* (New Gallery 1907, no.284), which was recently on the London art market. The painting clearly owes much to Rossetti, and in fact was given to the Art Gallery in 1897 at a time when many Pre-Raphaelite paintings were entering the collection, often with the active support of Kate's father, J T Bunce, an ardent admirer of Ruskin and the Pre-Raphaelites. The sitter may have been her sister Myra, whose beaten metalwork probably finds an echo in the repoussé silver plaque inscribed 'MUSICA' at upper left.

BIRMINGHAM CITY MUSEUM AND ART GALLERY

Right: Cat. 71.
Opposite page: Detail Cat. 81.

JOSEPH EDWARD SOUTHALL

1861–1944

Southall was born in Nottingham of Quaker parents, and was taken by his mother to Birmingham when his father died the following year. In 1874 he entered the Friends' School, Bootham, where he was taught painting by Edwin Moore (brother of Albert and Henry). Four years later he joined the Birmingham firm of architects, Martin and Chamberlain, but in 1882 he left to concentrate on painting, attending the Birmingham School of Art where he met A J Gaskin, henceforth his closest friend, and other members of the Birmingham Group. About the same time he settled at 13 Charlotte Road, Edgbaston, his home for the rest of his life. In 1883 he spent eight weeks in Italy, absorbing the early masters, and on his return he began to experiment with tempera. Meanwhile, through an uncle, he had made the acquaintance of Ruskin, who commissioned him to design a museum for the Guild of St George at Bewdley (1885); this came to nothing but took him again to Italy. He also received encouragement from W B Richmond and Burne-Jones, to whom he paid visits in London (1893–7). In 1895 he began to exhibit at the RA (Cat. 72), showing there till 1942, while also supporting the New Gallery (1897–1909), the RBSA (Associate 1898, member 1902) and the Arts and Crafts Exhibition Society shows (1899–1923). In 1901, together with J D Batten, Walter Crane and others, he helped to found the Society of Painters in Tempera, and he was undoubtedly the single most important exponent of the tempera revival. Though never, like so many members of the Birmingham Group, on the staff of the local Art School, he gave lessons on tempera painting in his Edgbaston studio and lectured on the subject widely. As well as literary figure subjects, he painted genre scenes, portraits and landscapes; his wife Anna Elizabeth, a first cousin whom he married in 1903, appears in many of his pictures, and often helped to decorate their elaborate gilded frames. Southall was a leading figure among Birmingham Quakers, a Socialist and pacifist; he campaigned vigorously against the conduct of the Great War, during which he painted the fresco of *Corporation Street, Birmingham, in March 1914*, on the staircase of the Birmingham Art Gallery. In later life he joined the NEAC and RWS (1925), participated in joint exhibitions with other Birmingham and tempera painters, held a number of one-man shows (notably at the Alpine Club 1922), and, building on the success of an exhibition at the Galeries Georges Petit in Paris in 1910, established a considerable international reputation. He and his wife paid frequent visits to Italy, sometimes with Charles and Margaret Gere; also to France, Southwold and Fowey, where he found many subjects. In 1933 he was appointed Professor of Painting at the RBSA (President 1939), and in 1937 began a fresco in the Council House. It was not, however, completed; that August he underwent a major operation and never fully recovered, dying in 1944. A memorial exhibition was held at Birmingham, the RWS and Bournemouth the following year.

Ref: *Joseph Southall*, exh. Birmingham and FAS 1980, cat. by George Breeze

72. Cinderella 1893–5 *ill. p104*
Watercolour with gold paint, 54.3 × 38.4 (21⅜ × 15⅛)
Signed (monogram) and dated *JES 1893–5* (lower left)
Exh: RA 1895 (962); RBSA, Autumn 1896 (634); *Joseph Southall*, Galeries Georges Petit, Paris 1910 (11); Memorial Exh., Birmingham, RWS and Bournemouth 1945 (72); Birmingham and FAS 1980 (B1)

An illustration to Grimm's famous fairytale; Cinderella is seen seated on her mother's grave and shaking the hazel-tree which provided her with rich apparel for the ball, while in the background her family leave for the ball by coach. The picture was admired by Burne-Jones

Cat. 72

Cat. 74

when Southall took it to his studio in February 1894 – one of several visits he made in the 1890s to seek the older artist's advice; and the following year Southall showed it at the RA, his first appearance there. The style is softer than that of his later work, although the treatment of the drapery and the emphasis on decorative foreground detail is already characteristic. Similarly, the watercolour medium is handled in a manner that resembles his use of tempera. He had experimented with this as early as 1883, but only adopted it consistently from 1895.
THE TRUSTEES OF THE TATE GALLERY

73. **Bacchus and Ariadne** 1912–13
Tempera on linen, 68.7 × 99.3 (27 × 39⅛)
Signed (monogram) and dated *JES 1912–13* (lower right)
Exh: Paris Salon 1913 (1173); NEAC, Winter 1913 (3); Memorial Exh., Birmingham, RWS and Bournemouth 1945 (61); Birmingham and FAS 1980 (B10)
Lit: Arthur Finch, 'The Paintings of Joseph Southall', *Studio* 71 1917, p46, repr
Southall's tempera technique and flat decorative style give a curiously 'frozen' quality to all his work, but the effect is particularly striking here where the subject is one of passionate eroticism. There are a number of other typical features: the somewhat awkward anatomy, the striped patterns on the draperies, the 'chorus' figures at upper right, and the white rabbits lower left. The picture is in its original carved and gilded frame, designed by the artist. It was bought from Southall by William Heywood, a prominent Birmingham architect.
PRIVATE COLLECTION (BY COURTESY OF JULIAN HARTNOLL)

74. **The Daughter of Herodias** 1904–5 *ill. p105*
Pencil, indian ink and ink wash, 102 × 91 (40⅛ × 35⅞)
Signed (monogram) and dated *JES 1905* (lower left), and inscribed *CARTOON BEGUN 17.X.04* (upper right)
Exh: *A Birmingham Group* RBSA 1919 (8); *Painters in Tempera*, Kettering and Grantham 1958 (12)
This is the cartoon for an untraced tempera painting. Henry Payne, as a master at the Birmingham Art School, arranged for a group of students and Birmingham artists, including Arthur Gaskin, Mary Newill and Margaret Gere, to watch Southall at work on the picture as a (paid) demonstration of the tempera technique. It was exhibited at the New Gallery in 1906 (423), and again at Southall's successful exhbition at the Galeries Georges Petit in Paris in 1910, when it was bought by an American collector. It is reproduced in *The Pictures of 1906* ('Pall Mall Magazine' Extra) May 1906, p120.
 The two domestic cats in the lower left corner are a very characteristic touch. Southall and his wife were devoted to cats, and they appear in many of his pictures.
BIRMINGHAM CITY MUSEUM AND ART GALLERY

75. **Charles Perrault**, *The Story of Blue Beard*
'Illustrated with pictures and ornaments by Joseph Southall'
London: Lawrence and Bullen 1895. 8vo
Southall's 'pictures and ornaments' – seven full-page illustrations and numerous decorative borders – display a characteristic fusion of medieval and Renaissance elements. He was not as prolific an illustrator as other members of the Birmingham Group; this was his only complete book, although he contributed one illustration each to *The Quest*, the periodical produced by the Birmingham Guild of Handicraft 1894–6, and vol.IX of *The Yellow Book* (April 1896), in which all the illustrations were by Birmingham men (see *Joseph Southall*, exh. 1980, cat.no.A8).
PRIVATE COLLECTION

ARTHUR JOSEPH GASKIN
1862–1928

Gaskin was born in Birmingham, the son of a decorative artist, and educated at Wolverhampton Grammar School; a fellow pupil was Laurence Hodson, later to be his most important patron. In 1883 he entered the Birmingham School of Art, where he met his lifelong friend Joseph Southall and another student, Georgie Cave France, whom he married in 1894. By 1885 he was teaching at the School himself. His earliest paintings show Newlyn influence, but in the 1890s he encountered Morris and Burne-Jones and adopted a linear, Arts-and-Crafts, style. He was now deep in book illustration, among other projects supervising the two books illustrated jointly by the Birmingham Group (*A Book of Pictured Carols* 1893, and *A Book of Nursery Songs and Rhymes* 1895) and producing two splendid sets of designs for the Kelmscott Press (Cat. 79–80). Similar stylistic tendencies emerge in his paintings, which include imaginative subjects, portraits (especially of children; see *Studio* 64 1915, pp25–33 and landscapes. The portraits betray the influence of Holbein, and in 1897 he visited Italy with Southall and studied the early Italian masters. Southall also taught him the tempera technique. However, neither illustrations for private presses nor pictures painted slowly in tempera were profitable, and increasingly Gaskin, ably assisted by Georgie, turned his attention to jewellery, enamelling and metalwork, branches of the crafts with a long Birmingham tradition. In 1903 he became Head Master of the Vittoria Street School for Jewellers and Silversmiths, holding the post till 1924 and having a wide influence. He exhibited at the RA, the New Gallery (1897–1907), the RBSA (Associate 1898, member 1905), and with the Arts and Crafts Exhibition Society, and belonged to the Art Workers' Guild (1917–22) and the Royal Society of Painter-Etchers (1927). Like so many Birmingham artists, he had Socialist leanings and was strongly attracted to the Cotswolds, spending the last years of his life at Chipping Campden. A memorial exhibition was held at the Birmingham Art Gallery in 1929.

Ref: *Arthur and Georgie Gaskin*, exh. Birmingham and FAS 1982, cat. by George Breeze, Glennys Wild and Stephen Wildman

76. **The Nativity** 1925
Tempera with pencil and chalk on linen, 40.2 × 47.5 (16⅝ × 18¾)
Signed and dated *ARTHUR J GASKIN 1925* (lower right)
Exh: RBSA, Autumn 1925 (78); Gaskin Memorial Exh., Birmingham 1929 (12); Birmingham and FAS 1982 (C5); FAS, Spring 1986 (12)
A late work, though not quite as late as Cat. 77, on which Gaskin was working shortly before his death. He painted only two religious subjects, the other being an *Annunciation* which dates from 1898 and is more Anglo-Catholic in feeling (see 1982 exh., cat. pl.1). The treatment of the Christ Child seems to owe something to Ford Madox Brown's painting *Take Your Son, Sir* (Tate). Although this only entered the national collection in 1929, Gaskin would have known it from reproductions, eg that in F M Hueffer's *Life* of Brown, 1896.

The picture was bought from the artist by F L Griggs, and remained for many years in his family.
THE FINE ART SOCIETY

77. **The Twelve Brothers Turned into Swans**
1928
Tempera on panel, 35.2 × 25.1 (13⅞ × 9⅞)
Inscribed on reverse *Pure Egg Tempera, Varnished/on panel*
Exh: Gaskin Memorial Exh. Birmingham 1929 (3); *Modern English Tempera Painting*, Whitechapel 1930 (33); FAS 1969 (11); Birmingham and FAS 1982 (C6)
The last of Gaskin's rare subject pictures; he was working on it three weeks before his death and it remains unfinished. Such swan themes clearly appealed to him, having inspired some of the best designs among his illustrations to Hans Andersen's *Fairy Tales*, 1893 (see 1982 exh., cat. p22, figs 37–8). In 1899 he was working on a comparable set for Grimm's *Household Tales*, and these may well have been the starting point not only for the present picture but for *The Twelve Brothers*, a painting of 1898–9 (1982 exh., no.C2; repr cat. pl.IV). In fact our picture seems to conflate two very similar tales in Grimm: 'The Twelve Brothers' and 'The Six Swans'. In the first, twelve brothers are turned into ravens, in the second, six brothers into swans; both tell how the brothers rescue their sister from being burnt at the stake at the very moment that she enables them to re-assume their human form – in 'The Six Swans' by throwing over them magic shirts. This is the subject of Gaskin's picture. Whether he confused the two stories by mistake or because he needed twelve swans for compositional reasons is not clear.

As Stephen Wildman observes, the same subject, with the 'correct' number of six swans, had been painted by Briton Riviere in 1872 (Christie's, 18 February 1983, lot 74, repr in cat.).
JOSCELYNE V CHARLEWOOD TURNER

78. **J M Neale, *Good King Wenceslas***
'Pictured by Arthur J. Gaskin'
Birmingham: Cornish Bros 1895. Large 4to
Conceived by 1889–90, long before the book appeared, these illustrations are among Gaskin's earliest and most vigorous. They are also wholly in the Arts and Crafts tradition; the text is incorporated with the illustrations to ensure a harmonious overall design, and Gaskin personally printed the edition of 125 copies on the press of the Birmingham Guild of Handicraft. William Morris, who took a keen interest in the Birmingham School of Art, contributed an 'introduction' stating that 'the pictures done by my friend Mr Gaskin . . . have given me very much pleasure, both as achievements in themselves and as giving hopes of a turn towards the ornamental side of illustration, which is most desirable'. Finished drawings exist in a private collection, and preliminary sketches are at Birmingham.

The book has interesting connections with the Pre-Raphaelite past. J M Neale was one of the leaders of the Tractarian movement that so inspired Burne-Jones and Morris at Oxford, and it was in Cornish's bookshop that Burne-Jones discovered the *Morte d'Arthur* in 1855. For further comment and contemporary reviews, see 1982 exh., cat. pp20–3, 35–6.
THE BRITISH LIBRARY BOARD

79. **Edmund Spenser, *The Shepheardes Calender***
Illustrated by A J Gaskin. Edited by F S Ellis
London: Kelmscott Press 1896. Medium 4to
Acting on his enthusiasm for Gaskin's *Good King Wenceslas* designs (Cat. 78), Morris commissioned the artist to illustrate two books for the Kelmscott Press. *The Shepheardes Calender*, published in 1896, shortly after Morris's death, has twelve full-page designs and ornamental letters. The book was widely and favourably reviewed, and the illustrations have recently been described as Gaskin's 'best', their backgrounds 'full of a sense of movement of trees, leaves or sky, indicated by intricate linear patterns in black and white' (see 1982 exh., cat. pp23, 38–9). Characteristically clean-cut, they make an interesting contrast to Walter Crane's equally typical designs for the same book, published two years later Cat. 40).

The original drawings for the twelve full-page illustrations are in the Birmingham City Art Gallery.
THE BRITISH LIBRARY BOARD

80. **William Morris, *The Well at the World's End***
Album of seven proofs of Gaskin's unused illustrations
Lit: Birmingham and FAS exh. 1982, cat. p46 (proofs listed)
Morris's second commission (see Cat. 79) was for illustrations to his own prose romance *The Well at the World's End*. Gaskin produced a long series but they were rejected by Morris and the book appeared in 1896 with four illustrations by Burne-Jones (Cat. 15). The reason for Morris's decision has never been satisfactorily explained and is all the more curious in that Gaskin's designs are particularly rich and inventive. For a full set of reproductions, see 1982 exh., cat. pp43–8.
THE TRUSTEES OF THE BRITISH MUSEUM

Cat. 81

HENRY ARTHUR PAYNE
1868–1940

Born at King's Heath, Birmingham, Payne studied at the Birmingham School of Art under E R Taylor. He was among the students who painted murals in the Town Hall (his panel exhibited 1890), and joined the staff in 1889. His main interest was in stained glass. Having taught the subject in the 1890s, he himself underwent a course of instruction from Christopher Whall in 1901, and by 1904, though still teaching, he was running a busy independent stained-glass practice (see *Studio* 61 1914, pp128–31). Meanwhile he was involved in a number of decorative schemes with the Bromsgrove Guild, and in 1902 was commissioned to decorate the chapel at Madresfield Court (see Cat. 99), a task which occupied him for twenty years and is one of the great achievements of the Arts and Crafts movement. It also led to his painting a mural in the Palace of Westminster (Cat. 82). In 1901 he had

married Edith Gere, sister of Charles and Margaret and herself a talented artist, and in 1909 they settled at St Loe's House, Amberley, in Gloucestershire, thus consolidating the colonisation of the Cotswolds by Birmingham artists begun when the Geres had moved to Painswick a few years earlier. He continued to produce stained glass and founded the 'St Loe's Guild', while also painting portraits and landscapes. He exhibited at the RA (1899–1935), with the Arts and Crafts Exhibition Society, and elsewhere, and was a member of the Society of Painters in Tempera. Died at Amberley 4 July 1940.

Ref: *The Times* 6 July 1940, p7; *By Hammer and Hand*

81. **The Enchanted Sea** 1900 *ill. p107; detail p102*
Oil on canvas, 89 × 63.5 (35 × 25)
Signed *HAP* (lower left)
Exh: New Gallery 1900 (2); FAS 1969 (115); *Masterly Art*, Birmingham 1986–7 (no cat.); *Romantic and Symbolist Paintings and Drawings*, Charles Cholmondeley

1987 (6)
Lit: Jullian, p58, fig.25
Payne undertook only two major easel paintings in oils, *The Witch Lady*, exhibited at the RA in 1899 (84) and now lost, and the present picture. The precise subject of this is obscure, though research might clarify it. There is a certain relationship with a decorative painting of *The Vanishing of Undine*, executed by Payne about the same date for a shipping magnate's house in Liverpool under the auspices of the Bromsgrove Guild (see *By Hammer and Hand*, p75, fig.49), and Philippe Jullian comments that Payne has treated 'a favourite theme of the Symbolists, that of drowned and drowning women'. The picture is in its original frame, designed by the artist, and it is said that Maxwell Armfield posed for the heads of the floating figures at lower right.

An embroidered panel based on the composition was shown at the Arts and Crafts Exhibition Society's show of 1899 (no. 222B; repr *Studio* 18 1899, p277).
CHARLES CHOLMONDELEY

82. **Choosing the Red and White Roses in the Temple Garden** 1909–10 *ill. p64*
Watercolour with bodycolour and gold paint,
50.2 × 55.5 (19¾ × 20¼)
Exh: RBSA Centenary Retrospective 1968 (90); *British Watercolours 1760–1930 from the Birmingham Museum and Art Gallery*, Arts Council 1980–1 (65), repr in cat.
Lit: *By Hammer and Hand*, repr on cover
A highly finished *modello* for Payne's mural painting in the East Corridor of the Palace of Westminster. He was one of six artists (the others including Byam Shaw, Frank Salisbury and F Cadogan Cowper) who were commissioned in 1908 to paint scenes from English history in this area. The project was under the supervision of E A Abbey, who had completed major decorative paintings for Boston Public Library and the Royal Exchange within the past ten years, and Payne's contribution was sponsored by Lord Beauchamp, for whom he was already working at Madresfield (see Cat. 99). His subject – the supposed origin of the Wars of the Roses – was based on a scene in Shakespeare's *Henry VI, Part I* (Act II, Scene 4), in which the Earl of Somerset (seen on the right) is challenged by Richard Plantagenet, later Duke of York. It is the only non-Tudor incident included, and the one most open to historical doubt, as critics noted at the time. The theme had earlier been treated by John Pettie in a picture exhibited at the RA in 1871 (Liverpool).

Payne based the background of his design of the garden of St Loe's House, the 16th-century schoolhouse of Amberley, Gloucestershire, to which he and his family moved in 1909. The mural was in place by October 1910 and other studies for it exist, including one at Birmingham (P.175′79).
BIRMINGHAM CITY MUSEUM AND ART GALLERY

83. **The Valley of Vision** c1910(?) *ill. p108*
Watercolour, 38 × 48.2 (15 × 19)
Exh: *Masterly Art: The Birmingham Municipal School of Art 1884–1920*, Birmingham 1986–7 (no cat.)
The drawing illustrates Dante's *Purgatorio*, Cantos VII–VIII, in which the poet is shown 'a flowery valley', populated by 'many famous spirits' and watched over by two Angels, dressed in green, 'with flaming swords broken at the points'. It was a subject that Payne treated several times, basing the landscape on Minchinhampton Common, close to his home at Amberley, near Stroud, and the figures on local villagers. There is no connection with C M Gere's illustrations to the Ashendene Press *Dante* (1919), which do not include this subject.
JOHN REDMAN

84. **The Wild Ducks** 1921 *ill. p108*
Watercolour, 39.6 × 42 (15⅝ × 16½)
Signed and dated *Henry A Payne 1921* (lower left)
Exh: *First Exh. of Water Colour and Other Drawings by Cotswold Artists*, Cotswold Gallery, London 1921 (16); RA 1923 (743, renamed *Homewards*)
A beautiful example of the pastoral landscapes undertaken by Payne in later life, full of the spirit of the Cotswolds where he lived. This is evidently a second version; another, dated 1920 (private collection), was included in the *Masterly Art* exhibition held at the Birmingham Art Gallery in 1986–7 (no cat.).
CHELTENHAM ART GALLERY AND MUSEUMS

Cat. 83

Cat. 84

SIDNEY HAROLD METEYARD
1868–1947

Born at Stourbridge, Meteyard, like so many of the Birmingham Group, studied under E R Taylor at the Birmingham School of Art and subsequently (1886) joined the staff. At the School he may well have encountered Burne-Jones who was certainly the main influence on his style and choice of subject-matter. He contributed to the Town Hall murals painted by members of the Group c1890, and to two of their joint schemes of illustration, *The Quest* and *A Book of Pictured Carols* (1893). As a teacher he was responsible for enamelling, gesso, leatherwork and other crafts. He exhibited pictures at the RA (1900–1918), as well as at the New Gallery, the RBSA (Associate 1902, member 1909, eventually Secretary), and the Paris Salon. He was also a prolific designer of stained glass, carried out altarpieces in churches at Bordesley (1916) and Southport (1921), illustrated two more books (Cat. 89), illuminated rolls of honour, and executed enamel plaques, often in collaboration with his wife and former pupil, Kate Eadie. Little is known of the man himself. He seems to have lived an uneventful life, continuing to teach at the School of Art until 1933, and never, like other members of the Group, moving away from the Birmingham area. He died at Alcester on Good Friday 1947.

Ref: By Hammer and Hand

85. St George Rescues the Princess c1904
Oil on canvas, 109.3 × 111.8 (43 × 44)
Exh: RBSA 1904 (347); *Symbolists*, Piccadilly Gallery, London, and Towner Art Gallery, Eastbourne, June–October 1970 (58); Spencer A Samuels, New York, November 1970 (111)
One of Meteyard's most characteristic works in the sense that the Saint's plate armour and the scaly body of the dragon are motifs perfectly attuned to his hard metallic style. Even the drapery of the Princess looks as if it might have been cut out of sheet metal. Like Cat. 86, the subject has Pre-Raphaelite antecedents, having been treated by Rossetti and Burne-Jones. There are also numerous parallels in contemporary sculpture (see Benedict Read's essay).
PRIVATE COLLECTION

86. 'I am Half-Sick of Shadows' 1913 *ill. p110*
Oil on canvas, 76 × 114.5 (30 × 45)
Signed and dated (*S H*) *Meteyard 1913* (lower left)
Exh: RA 1913 (909)
Lit: C Wood 1981, p140, repr
An illustration to Tennyson's *Lady of Shalott*, the picture looks back to famous treatments of this theme by Holman Hunt (Hartford, Conn., and Manchester) and J W Waterhouse (Leeds). Meteyard's fellow Birmingham artist Arthur Gaskin had made a design of the subject in 1888 (*Arthur and Georgie Gaskin*, exh. Birmingham and FAS 1982, no.B28), and parallels exist in contemporary sculpture (see Benedict Read's essay). Meteyard's own version is generally regarded as his masterpiece, not least because of its sumptuous colour, to which his experience of working in stained glass and enamel must have contributed. The enamel plaques made by Meteyard and his wife Kate Eadie find a further echo in the design of the embroidery on which the Lady is working, and Kate herself was the model for the figure. The large circular mirror seems to derive from Hunt, who made this motif (which he borrowed from Van Eyck) a prominent feature of his interpretation. Meteyard, however, may also have been thinking of Burne-Jones's well-known portrait of his daughter Margaret seated in front of a convex mirror (1886; private collection).
PRIVATE COLLECTION

Cat. 89

87. Lucifer and his Angels c1910
Watercolour with bodycolour, 46 × 27 (18⅛ × 10⅝)
Signed *SM* in monogram
An illustration to the opening lines of Longfellow's *Golden Legend* (Cat. 89). Lucifer and his fellow rebel-angels try vainly to drag the cross from the spire of Strasbourg Cathedral.
PRIVATE COLLECTION

88. Barbarossa c1910
Watercolour with bodycolour, 42.5 × 25.4 (16¾ × 10)

Signed *SM* in monogram (lower right)
Exh: FAS 1969 (105)
Another of Meteyard's illustrations to Longfellow's *Golden Legend* (Cat. 89), based on the lines

Like Barbarossa, who sits in his cave,
Taciturn, sombre, sedate, and grave,
Till his beard has grown through the table of stone!

The passage seems particularly suited to his hard uncompromising style, and it is probably significant that he chose to illustrate it.
PRIVATE COLLECTION

Cat. 86

89. H W Longfellow, *The Golden Legend* ill. p109
Illustrated by S H Meteyard
London: Hodder and Stoughton 1910. 4to
This is Meteyard's most ambitious venture into the field
of book illustration, although he undertook one other
book single-handed (May Byron, *A Day with John
Milton* 1913) and collaborated with fellow Birmingham
artists on two joint projects – *The Quest* and *A Book of
Pictured Carols* – in the 1890s. Unlike most of these
artists, he was not particularly concerned to make his
illustrations an integral part of the overall design of a
book, treating them as highly finished watercolours
which remain essentially independent of the text.

Many of the twenty-five illustrations for *The Golden
Legend* survive. Two are exhibited here (Cat. 87–8), four
were included in the *Masterly Art* exhibition at
Birmingham in 1986–7 (no cat.), and the beautiful
design of *The Annunciation* which forms the frontispiece
is in a private collection in America (see *19th Century
English Art from the Collection of Harold and Nicolette
Wernick*, Smith Art Museum, Springfield, Mass. 1988,
no.29).
SIMON REYNOLDS

CHARLES MARCH GERE
1869–1957
Gere was born at Gloucester and studied at the Bir-
mingham School of Art under E R Taylor, being one
of the students who painted murals in the Town Hall
c1900 and joining the staff in 1893. In the 1890s he
contributed to *The Quest* and the two books illus-
trated by the Birmingham Group (see under Gaskin);
he also designed the frontispiece for William Morris's
News from Nowhere (Kelmscott Press 1892) and illus-
trated several publications of St John Hornby's
Ashendene Press, including a Malory (1913), a Dante
(1919), and the *Fioretti* of St Francis (1922). In fact
during his early career he was involved in a number
of the arts and crafts, designing embroidery, metal-
work and stained glass and painting the reredos in the
Chapel at Madresfield (see Cat. 99). Gradually, how-
ever, he became almost exclusively a landscape pain-
ter (see *Studio* 59 1913, pp87–95). About 1904 he and
his sister Margaret settled at Painswick, near Stroud,
and many of his subjects were found in the Cots-
wolds, although Wales and North Italy (first visited
1895) were also favourite painting grounds. After
showing early works at the New Gallery (including
two with other members of the infant Society of
Painters in Tempera in 1901), he transferred his alle-
giance to the RA (ARA 1934, RA 1939), while also

belonging to the NEAC, RWS and Art Workers'
Guild (1906–29). A memorial exhibition was held at
Gloucester in 1963.

Ref: *The Times* 6 August 1957, p8; *By Hammer and Hand*

90. The Finding of the Infant St George 1892–3
Oil on canvas, 92.5 × 151.5 (36⅜ × 59⅝)
Signed and dated *CMG 92–93*
Exh: New Gallery 1893 (251)
Exhibited in 1893, when Gere was twenty-four, and
acquired by the Walker Art Gallery, Liverpool, the
following year, this is clearly one of the artist's most
important early works; yet despite the recent interest in
the Birmingham School it had received little attention.
The subject is taken not from the legends of St George
but from Spenser's *Faerie Queene* (Book 1, Canto X
verse 66). The effect is that of a British version of the
finding of Moses.
TRUSTEES OF THE NATIONAL MUSEUMS AND GALLERIES ON
MERSEYSIDE, WALKER ART GALLERY

91. The Lady of Grey Days 1897 *ill. p111*
Watercolour with bodycolour, 47.6 × 31.7 (18¾ × 12½)
Signed (monogram) and dated 1897. Inscribed on the
back *Aurea Howard from Mother Oct 4th 1912*
Exh: Hartnoll & Eyre, October 1972, Catalogue 25 (25)
According to the inscription on the back, this charming
early work by Gere was given by Rosalind, Dowager

Cat. 91

Countess of Carlisle, to her daughter, Lady Aurea MacLeod (born 1884). Rosalind's husband George Howard, 9th Earl of Carlisle, was a great patron of the arts, commissioning numerous works not only from artists of his own generation – Burne-Jones, William Morris, Arthur Hughes, etc – but from the younger Birmingham Group and their contemporaries, including E R Hughes, Byam Shaw, Charles Holroyd, H J Ford and J D Batten (see *George Howard and his Circle*, exh. Carlisle Art Gallery 1968, and this exh., Cat. 490). Howard was also closely associated with the murals in the East Corridor of the Palace of Westminster (1908–10), a scheme to which Byam Shaw and Gere's brother-in-law Henry Payne contributed (see Cat. 82).

Howard died in 1911 and his widow probably gave the picture to her daughter when she moved from Naworth Castle to Boothby, a smaller house nearby, the following year.

PRIVATE COLLECTION, LONDON

92. **The Twelve Months** c1900
Twelve drawings, three to a sheet; pen and ink corrected with white bodycolour, each drawing 5 (2) diam.
Signed *CMG* on each sheet; each month inscribed with its name
The purpose of these attractive drawings is unknown; they do not seem to have been published.
JOHN GERE

93. **Oliver W F Lodge,** *Love in the Mist*
Painswick : printed for the author by E F Millard 1921. 8vo
The delightful illustration by Gere, which must have been executed considerably earlier than the publication of the book, is undoubtedly influenced by the engravings of Edward Calvert. Gere owned a set of Calvert's prints in the edition issued by the Carfax Gallery in 1904.

The author of the book was Oliver William Foster

Lodge, poet, not Sir Oliver Joseph Lodge, the famous scientist.
JOHN GERE

94. **St Christopher** 1908
Woodcut, 5 × 9 (2 × 3½)
Inscribed *PAINSWICK* (printed) *Christmas 1908* (lower left) and *With good wishes to Mr and Mrs Colvin from Charles M Gere* (to right of image)
A particularly sensitive design, showing something of the influence of the followers of William Blake also found in Cat. 93). Much of Gere's early and best work is in this tradition.

The print was sent as a Christmas card to Sidney Colvin, Keeper of the Department of Prints and Drawings at the British Museum 1883–1912, and a man with many contacts in the worlds of art and letters. He was knighted in 1911.
THE TRUSTEES OF THE BRITISH MUSEUM

Cat. 96

BERNARD SLEIGH
1872–1954

Born in Birmingham, Sleigh was apprenticed to a commercial process engraver while attending evening classes at the School of Art. He gave up his apprenticeship to cut Gaskin's illustrations to *Hans Andersen's Fairy Tales* (George Allen 1893) and to teach engraving at the School, holding the post till 1937. Like so many of the Birmingham Group, he was involved in the Town Hall murals in the 1890s and active in several branches of the arts and crafts, designing needlework and stained glass and helping to carry out decorative schemes commissioned from local Guilds of Handicraft and the architects Crouch and Butler. However, his main contribution was as a wood-engraver and illustrator. He was associated with the Essex House Press, cutting designs by William Strang, and cut at least one design by Ricketts. The most original of his own compositions – whether illustrations to books, by himself or others, or individual prints – are those involving fairies, in which he believed. He was clearly something of a psychological case, conducting a long correspondence with Havelock Ellis (published 1930) and leaving a manuscript autobiography, *Memoirs of a Human Peter Pan* (Birmingham Central Reference Library), which is both self-revealing and a valuable record of the activities of the Birmingham Group. He exhibited occasionally at the RA, also at the New Gallery and RBSA (member 1928). His book *Wood Engraving since Eighteen-Ninety* was published 1932.

95. **Selene, Goddess of the Moon** c1900 *ill. p112*
Watercolour with bodycolour, 30.5 × 15.5 (12 × 6⅛)
Signed *BS* in monogram
Exh: *Masterly Art*, Birmingham 1986–7 (no cat.)
An early work, obviously indebted to Burne-Jones, who painted a number of such figures – *Night*, *The Evening Star*, *Luna*, etc – in the 1860s and 1870s, all in the predominantly blue tonality that Sleigh adopts here. For a comparable image by Sleigh himself, see the figure of *Air* which he painted on the end of a choir-stall in the Unitarian Memorial Church at Liscard, Merseyside, opened in September 1899 (*By Hammer and Hand*, p72, fig.48).
GRAHAM HORTON

96. **Piers Plowman** 1904 *ill. p112*
Chiaroscuro woodcut, 20.2 × 38 (8 × 15)
Signed and dated *BERNARD SLEIGH 1904 DES & ENG* (lower right)
Sleigh made a speciality of these large chiaroscuro woodcuts; others are *The Sheepfold* 1907 (V&A: E.1637–1920) and *Elfland* 1925 (BM: 1925–3–12–21). *Piers Plowman*, however, is the most familiar, having been published in *The Artist Engraver*, no.1, 1904.

The subject is significant, Sleigh, like so many of the Birmingham Group, being a Morrisian Socialist; for other schemes and images which reflect this, see *By Hammer and Hand*, pp71, 132.
THE VISITORS OF THE ASHMOLEAN MUSEUM, OXFORD

97. **The Fairy Ring** and **The Fountain** 1922
Two chiaroscuro woodcuts, each approx. 14 × 19 (5½ × 7½)
Both signed with initial(s) in the plate, and signed and dated *Bernard Sleigh 1922* in pencil below
In addition to his large chiaroscuro woodcuts (see Cat. 96), Sleigh executed a number of smaller prints in the same technique featuring fairies in romantic landscapes. These are characteristic examples.
THE TRUSTEES OF THE BRITISH MUSEUM

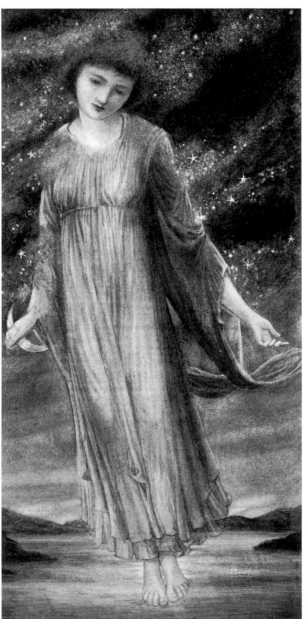

Cat. 95

98. Bernard Sleigh, *The Faerie Calendar*
With woodcuts designed by the author, engraved by
Ivy A Ellis
London: Heath Cranton 1920. 8vo
Perhaps the most striking of Sleigh's fairy books, which
also include *The Map of Fairyland* (1918) and *A Faerie
Pageant* (1924). They were not mere products of
whimsy. 'I believe in Faeries', he wrote in the Preface
to *The Faerie Calendar*, 'It is very natural and not a bit
foolish; for in these days we are quickly learning how
little we know of any other world than our own'. In
another book, *The Gates of Horn* (1926), he edited
'sundry records from the proceedings of the Society for
the Investigation of Faery Fact and Fallacy'.

Sleigh's publications are contemporary with the so-
called Cottingley mystery – photographs purporting to
represent fairies taken by Elsie Wright and Frances
Griffiths, 1917–20 – and the researches of Sir Arthur
Conan Doyle, whose book *The Coming of the Fairies*
appeared in 1922.
THE BRITISH LIBRARY BOARD

**99. (Bernard Sleigh), *The Chapel, Madresfield
Court***
London: Chiswick Press (n.d.). 8vo
Illustrated and with manuscript corrections by the
author
The decoration of the Chapel at Madresfield Court, the
seat of the Beauchamp family near Malvern, is one of
the greatest achievements not only of the Birmingham
Group but of the whole Arts and Crafts movement. It
was a wedding present from Lettice Grosvenor, sister of
the Duke of Westminster, to William, 7th Earl
Beauchamp, whom she married in 1902, and was not
completed until 1923. The chief executant was Henry
Payne who, with the assistance of students, including the
young Henry Rushbury, covered the walls with murals
and designed stained glass; but many others were
involved: W H Bidlake designed the elaborate reredos,
C M Gere painted the altarpiece and designed the
embroidered altar-frontal, the Gaskins provided the
altar cross and candlesticks. The overall effect is
sensational; when the narrator in *Brideshead Revisited* sees
the Chapel's fictional derivative, he utters just one
word: 'Golly'. See *By Hammer and Hand*, p74, Figs 50–1.

According to Sleigh's manuscript autobiography, he
too worked at Madresfield, but his booklet is
anonymous and makes no mention of any of the artists
concerned, focusing entirely on the iconographical
scheme. Also undated, it must have been published by
1924, when the copy in the British Museum was
acquired.
JOHN GERE

Cat. 100

MARGARET GERE
1878–1965
Born at Leamington Spa, Margaret was the youngest
of the Gere family; C M Gere was her half-brother,
and her sister Edith married Henry Payne. She
attended Leamington High School and in 1897
entered the Birmingham School of Art, where C M
Gere, Gaskin and Payne were among her teachers;
she was also to study at the Slade (1905). In 1900,
together with her brother and the Paynes, she paid
the first of many visits to Italy, and about 1904 she
and her brother settled at 'Stamages', the house at
Painswick where they were to live for the rest of their
lives, being joined by the Paynes at Amberley in 1909.
In early years she showed at the New Gallery (1902–7)
and the RBSA (1900–1917; Associate 1909), but later
transferred to the NEAC (1910–50; member 1925)
and showed with the Cheltenham Group of Artists
(1926–60). A one-man exhibition was held at the
Cotswold Gallery, London, in 1922, others following
at the Beaux-Arts Gallery (1929) and Cheltenham Art
Gallery (1944). Her early work, small subject pictures
in tempera or watercolour, is generally the most
interesting; after about 1915 her style became looser
and more decorative, paintings of flowers, executed
on glass, being a speciality. A remarkable 'character',
kindly but tactless, she had a wide circle of friends,
including Max Beerbohm, Alfred Munnings, Stanley
Spencer and John Betjeman. Died at Stroud, 20
September 1965, aged eighty-seven.

Ref: Margaret Gere 1878–1965, cat. of exh. at Cheltenham
Art Gallery 1984

100. Pharaoh's Dream 1911 *ill. p113*
Tempera on canvas, 31.4 × 27 (12⅜ × 10⅝)
Signed and dated *M GERE 1911* (lower right)
Exh: NEAC 1911 (52); *Oils and Water Colours by Miss
Margaret Gere*, Cotswold Gallery, London, May 1922
(26); Cheltenham 1984 (A16)
The picture dates from the period before the First
World War when the artist did her most important
work. The *Athenaeum*, reviewing the first exhibition of
the Society of Painters in Tempera, held at the Carfax
Gallery in 1905, had high praise for another picture of
this kind: 'It is for the delicacy and freshness of its fancy,
the real delight in free and appropriate invention which
it discovers, that we think it so attractive . . . Miss Gere's
is not a great or ambitious talent, but it has the
inexplicable quality of perfect sincerity and ease'. Most
of Margaret Gere's models were found among her
family and friends, but for *Pharaoh's Dream* she 'hired
two professional touring Italians from London, who
came complete with their "props"' (Cheltenham exh.
cat., p12).
CHELTENHAM ART GALLERY AND MUSEUMS

101. The Baptism 1924
Oil on panel, 25.5 × 20.4 (10 × 8)
Signed and dated *M. GERE 1924* (lower right)
Exh: Cheltenham 1984 (B4); *Masterly Art*, Birmingham
1986–7 (no cat.)
Apparently influenced by Piero della Francesca. The
artist would have known his *Baptism* in the National
Gallery, and during her visit to Italy in 1901 she had
copied his *Triumph of the Duke of Urbino* in the Uffizi
(exh. Cheltenham 1984 (A6), repr cat., p4).
R PRICE

Cat. 104

MAXWELL ARMFIELD
1881–1972

Born at Ringwood of Quaker parents, his father being a milling engineer, Armfield entered the Birmingham School of Art in 1899. There he came under the influence of Payne, Gaskin and Southall, who taught him the tempera technique he was to practice for the rest of his life, and was deeply impressed by the Pre-Raphaelite paintings in the Art Gallery. In September 1902, after visiting Italy at the suggestion of Gaskin, he went to Paris, enrolling at the Académie de la Grande Chaumière and sharing a studio with three other students – Norman Wilkinson (also from Birmingham), Keith Henderson and the sculptor Gaston Lachaise. In 1904 his painting *Faustine*, inspired by Swinburne, was bought for the Luxembourg.

Returning to London the following year, he embarked on the series of one-man exhibitions that were henceforth to mark his career, showing first at Robert Ross's Carfax Gallery (1908, 1912) subsequently the Leicester Galleries and elsewhere, as well as contributing regularly to the RA, NEAC and RWS (member 1941). In 1909 he married the writer Constance Smedley, with whom he was to work closely until her death in 1941. In 1915 they left for an intensely active and successful seven-year spell in America. Armfield was not only a painter but a prolific illustrator and versatile decorative artist, while being deeply involved in theatre, music, teaching and journalism and writing some twenty books, including poetry, accounts of foreign travel, and such textbooks as the much-acclaimed *Manual of Tempera Painting* (dedicated to Southall, 1930). He was also a tireless researcher into occult religions, and passionately interested in the formal and philosophical basis of art. Neglected for many years after the Second World War, he lived to see a revival of interest in his work before his death at the age of ninety-one in 1972.

Ref: *Homage to Maxwell Armfield*, exh. FAS 1970, cat; *Maxwell Armfield*, exh. Southampton, Birmingham and FAS 1978, cat; *DNB* (essay by Peyton Skipwith); Nicola Gordon Bowe, 'Maxwell Armfield 1881–1972: an Account of his Decorative Art', *Journal of the Decorative Arts Society* 12 (ed Barbara Morris) 1988, pp26–37

102. **Oedipus and the Sphinx** c1900(?)
Tempera on board, 33 × 24 (13 × 9½)
The picture is a copy, with colour added, of Charles Ricketts's early pen and ink drawing exhibited here (Cat. 291). It was probably taken not from the drawing itself, which remained in private collections until 1949, but from the reproduction in *The Pageant* 1896, p65. Armfield recorded that *The Savoy* and *The Pageant* were studied by students at the Birmingham School of Art when he was there, and that he met Ricketts when the artist visited his exhibition at the Carfax Gallery in 1908 and 'very kindly went round the entire exhibition giving me really worthwhile criticism'. He was subsequently invited to lunch with Ricketts and Shannon at Lansdowne House – 'a very red-letter day'. That Ricketts's drawing remained a fertile image for him is proved by his picture *The Sphinx of Meru* (1978 exh., no.56, repr in cat.), painted in 1948, which he described as 'largely inspired by Charles Ricketts'. Ricketts's Sphinx reappears in a similar pose, together with the fantastic column behind her.
PRIVATE COLLECTION

103. **Oh! Willo! Willo! Willo!** 1902 *ill. p22*
Oil on canvas, 44.5 × 28.9 (17½ × 11⅜)

Dated *June–August 1902 AD* (on shield lower left) and initialled (lower right)
Exh: FAS 1970 (11); *Victorian and Edwardian Decorative Art: The Handley-Read Collection*, RA 1972 (E122); *Paintings, Water-Colours & Drawings from the Handley-Read Collection*, FAS 1974 (4)
The conception has the same bittersweet quality as Cat. 104, and may well, like that picture, contain an element of autobiography. It is based on a ballad that was made famous by Shakespeare, who introduces it into Act 4, Scene 3 of *Othello*, where Desdemona recalls that her mother's maid Barbara died singing it after being crossed in love. The full text appears in Frank Sidgwick's *Ballads and Lyrics of Love* 1908 (see Cat. 141).

The picture has become one of Armfield's most familiar works, having been bought from the artist by the Handley-Reads (see Cat. 34), included in their memorial exhibitions, and subsequently acquired by the Tate.
THE TRUSTEES OF THE TATE GALLERY

104. **The Young Queen and the Page** 1904 *ill. p114*
Watercolour, 15.8 × 24.1 (6¼ × 9½)
The central scroll dated *mdccciv* (below) and inscribed in German with the following lines from Heine's *Book of Songs*, New Spring, no.29 (1827):

> There was a comely page,
> Blond was his hair,
> Light was his spirit.
> He carried the silken train
> Of the young Queen.
> Do you know that old saying?
> It sounds so sweet,
> It sounds so sad:
> They both had to die,
> They had loved each other too much.

Exh: *Victorian Art, Sacred and Secular*, Julian Hartnoll, Burlington Fine Art Fair, RA 1979 (38)
Painted in Paris in 1904, the picture is an allegorical self-portrait with Rene Lewis, a fellow student and close friend of the artist at the Birmingham School of Art; that their relationship was not fulfilled is reflected in the lines from Heine inscribed on the scroll. Julian Hartnoll's catalogue reproduces photographs of both sitters, that of Armfield being specially taken for the picture by his friend Norman Wilkinson, with whom he was sharing a studio at the time. The watercolour's background is based on the Italian Lakes which Armfield had visited in 1902, and its style is clearly influenced by early German and Flemish art. The crown of thorns and chalice within a heart, seen at the foot of the scroll, emphasise the meaning symbolically; Armfield actually appears wearing a crown of thorns in the related photograph.
PRIVATE COLLECTION, NEW YORK

105. **Unicorn Champêtre (Homage to Giorgione)** c1945–50
Flemish tempera (according to label on back) on board, 49.5 × 41.6 (19½ × 16⅜)
Signed with monogram (lower left)
Exh: FAS 1970 (115)
Presumably one of the 'Homage to Masters' series that Armfield painted in the late 1940s, although not included in his book of this title (1949) or the group of works from the series shown in the 1970 exhibition (nos 39–42). The figure on the left is taken from a Giorgionesque painting by Palma Vecchio in the Lansdowne Collection (see B Berenson, *Italian Pictures of the Renaissance: Venetian School* 1957 II, pl. 914).

'Flemish tempera' was the method that Armfield used from this time on. Believed to have been used in Flanders in the 15th century, it involves laying in the design in tempera monochrome on a toned ground and then adding colour with resin glazes. The picture's frame was almost certainly designed and made by the

artist himself.
PRIVATE COLLECTION

106. *Aucassion and Nicolette.* Translated from the Old French by Eugene Mason
Illustrated by Maxwell Armfield
London: J M Dent 1910. 8vo
The courtly sophistication of this famous French medieval romance is perfectly reflected in Armfield's illustrations, which betray many early influences (see Cat. 108) and are among his best. It is interesting to compare them with Paul Woodroffe's less self-conscious designs for the same book, published eight years earlier (Cat. 538).
PRIVATE COLLECTION

KEITH HENDERSON
1883–1982

Born in Scotland, the son of an artist, Henderson was educated at Marlborough and studied art at the Slade and in Paris, where he shared a studio with Maxwell Armfield and Norman Wilkinson. He and Wilkinson, a fellow pupil of Armfield's at the Birmingham School of Art who was later to make a name for himself as a stage designer (see Cat. 314), collaborated on an illustrated edition of the *Romaunt of the Rose* in 1908 (Cat. 108). After the First World War, during which he served on the Western Front, he settled in Scotland, but painted in France, Egypt, Africa and South America. He exhibited for many years at the RA, belonged to the Royal Society of Portrait Painters (1912), ROI (1934), RWS (1933), etc, and was awarded the OBE. His numerous illustrated books include works by Burns, Hardy, W H Hudson and Janet Beith, as well as those he wrote himself on a wide variety of subjects. Died in South Africa, 1982.

107. **Ydelnesse** 1907
Watercolour, 36.5 × 37 (14⅜ × 14⅝)
Signed and dated *Keith Henderson 1907* (lower right)
One of Henderson's original designs for *The Romaunt of the Rose* (Cat. 108), and a particularly good one, very 'Pre-Raphaelite' in feeling. Another is in the Hugh Lane Municipal Gallery of Modern Art, Dublin, and a third was included in the exhibition *Dream and Fantasy in English Painting 1830–1910*, Anthony d'Offay 1967 (29).
PRIVATE COLLECTION (BY COURTESY OF JULIAN HARTNOLL)

108. *The Romaunt of the Rose.* Rendered out of the French into English by Geoffrey Chaucer
Illustrated by Keith Henderson and Norman Wilkinson
London: Chatto and Windus for the Florence Press 1908. 4to
This edition of the celebrated poem begun by Guillaume de Lorris about 1237 and later completed by Jean de Meun and translated into English by Chaucer, forms a counterpart to Maxwell Armfield's *Aucassin and Nicolette*, published two years later (Cat. 106). Sharing a studio in Paris in the early 1900s, Armfield, Henderson and Wilkinson evolved a spare elegant style which ideally matched the conventions of courtly love within which these romances are conceived. Indeed stylistically there is little to choose between the groups of ten designs which Henderson and Wilkinson each contributed to their book, although Henderson's are perhaps a little more inventive.

The *Romaunt* had been a favourite of Morris and Burne-Jones, and there is a link here with the present edition since Wilkinson owned a copy of the Kelmscott *Chaucer*, containing the text with Burne-Jones's illustrations. Armfield's portrait of him, painted in Paris in 1904, not only shows him reading the book but surrounded by other items – a medieval carving, a Clouet-like portrait, a Chinese lantern, etc – which suggest the sources of the group's communal style (see *Homage to Maxwell Armfield*, exh. FAS 1970, cat. pl.5).
PRIVATE COLLECTION

THE EARLY
ACADEMIC TRADITION

JOHN WILLIAM WATERHOUSE
1849–1917

The son of a minor artist and copyist, Waterhouse was born in Rome and spent his earliest years in Italy, returning to England with his family in 1854. In 1870 he entered the RA Schools, where Dicksee, Gilbert and Stanhope Forbes were among his fellow students. He began to exhibit at the Academy in 1874 and showed there regularly until his death, while also supporting the Grosvenor and New Galleries, the Liverpool Autumn Exhibitions, etc. After tentative beginnings, he rapidly gained assurance, specialising in modern subjects painted in Italy and classical themes in the Alma Tadema vein. In 1885 he was elected ARA (RA 1895) and in 1886 his picture *The Magic Circle* (Tate) was bought for the Chantrey Bequest. Meanwhile, an international reputation was growing: pictures were acquired for Melbourne, Sydney and Adelaide; *Mariamne* (RA 1887; Forbes Magazine Collection) gained a medal at the Paris Exhibition of 1889 and was subsequently acclaimed in Chicago and Brussels.

Mariamne marks the climax of his early phase; with *The Lady of Shalott* (RA 1888; Tate) he began to attempt Pre-Raphaelite themes, often coming close to Burne-Jones in mood, facial types, and a tendency to repetition, but continuing to handle paint with the vigour he had learnt from Bastien-Lepage and shared with friends in the Newlyn School. *Hylas and the Nymphs* (RA 1896; Manchester) is often seen as the flower of this hybrid style, but Waterhouse was an artist who continued to develop and some of his late works are outstanding, as examples shown here prove. In 1883 he married Esther Kenworthy, an artist and writer, and they settled in Primrose Hill, migrating to St John's Wood, that commune of academic artists, in 1900. In later years he was a much respected figure, teaching at the St Johns Wood and RA Schools and collected by such important patrons as George McCulloch, Sir James Murray of Aberdeen and Sir Alexander Henderson (see Cat. 110, 112). In 1913 his health began to fail and he died from cancer four years later. His last picture, *The Enchanted Garden* (Port Sunlight), remains unfinished.

Ref: Anthony Hobson, *The Life and Art of J W Waterhouse RA* 1980

109. **Mariana in the South** c1897
Oil on canvas, 134.5 × 86.3 (53 × 34)
Signed *J W Waterhouse* (lower right)
Exh: *50 Years Ago*, Preston 1947 (64)
Lit: Hobson, p104, pl.88 and cat. 118
Technically a study for a picture exhibited at the New Gallery in 1897 (Hobson, cat.117, pl.71) but in effect another version, being almost as highly finished and actually somewhat larger than the final picture. There are also slight differences in the pose of the figure, foreground details, etc.

Opposite page: Detail Cat. 114

The subject is taken from Tennyson's poem of the same name, which in turn is based on Shakespeare's *Measure for Measure*. The poem had been illustrated by Rossetti in the famous Moxon edition of Tennyson's *Poems* (1857), while Millais had treated the closely related poem, 'Mariana in the Moated Grange', in a painting of 1851 (Makins collection). Waterhouse would have known both these images.

The picture belonged to Cecil French (1879–1954), one of the few keen collectors of the 'last romantics' during the period when they were out of fashion. He refused to leave his pictures to the Tate because of its modernist leanings, and as a result many other collections benefited. Because of Burne-Jones's long residence in Fulham, the borough received a large bequest of works by him and others, including the present picture.
LONDON BOROUGH OF HAMMERSMITH AND FULHAM (CECIL FRENCH BEQUEST)

110. **Nymphs Finding the Head of Orpheus** 1900
Oil on canvas, 149 × 99 (58⅝ × 39)
Signed and dated *J W Waterhouse 1900* (lower right)
Exh: RA 1901 (231); RA, Winter 1922 (15); *Late Nineteenth Century English Paintings*, Leger Galleries 1971 (12)
Lit: Hobson, pp115–6, pl.105 and cat.135; C Wood 1983, pp236–9, fig.10
One of Waterhouse's finest works, beautifully conceived and executed and with a welcome depth of meaning due to the choice of subject. According to legend, Orpheus, the famous musician, having lost Euridice by looking back as she followed him out of Hades, was torn to death by Thracian women celebrating the orgies of Bacchus; his head was thrown into the river Hebrus, where it continued to lament Euridice as it floated down to the Aegean sea. The subject had been central to French Symbolism ever since Gustave Moreau had treated it in a famous picture exhibited as the Salon of 1866 (Louvre), he, Redon and others seeing the head still singing after death as an image of the immortality of art. Waterhouse's picture is an interesting attempt to import this tradition to England, where it seems to have few parallels, although Anning Bell exhibited a version of the subject at the RWS in summer 1906. See also Cat. 332.

The picture is one of over thirty works by Waterhouse that were acquired by the wealthy financier Sir Alexander Henderson, later Lord Faringdon, and his brothers. Henderson, who also owned Burne-Jones's *Briar Rose* paintings and works by Watts, Leighton and Rossetti (all still at Buscot), was Waterhouse's most important patron during the last fifteen years of the artist's life, not only buying subject pictures but commissioning portraits of the female members of the Henderson family. In the winter of 1914–15 he took him to Algeçiras, hoping to halt the illness from which Waterhouse died two years later.
PRIVATE COLLECTION

111. **Echo and Narcissus** 1903 *ill. p118*
Oil on canvas, 109.2 × 189.2 (43 × 74½)
Signed and dated *J W Waterhouse 1903* (lower right)
Exh: RA 1903 (16); Liverpool Autumn Exh. 1903 (636)
Lit: Hobson, pp119–20, pl.113 and cat.141; C Wood 1983, p239, fig.11

Echo, one of Juno's attendants, fell in love with the beautiful youth Narcissus, but he, obsessed with his own likeness, failed to respond, and she pined away and died. The picture is almost as well-known as the famous *Hylas and the Nymphs* of 1896 (Manchester), and indeed is comparable in design and in the use of water as an important narrative and compositional element. Waterhouse often introduces water in this way (see also Cat. 110), just as many of his paintings harp on the theme of unrequited love. This is particularly well expressed here by a design which emphasises the isolation of the figures and a marvellously atmospheric landscape.

Hobson suggests that the picture represents a 'conscious reaction' against Solomon J Solomon's treatment of the same theme, shown at the RA in 1895. When exhibited itself, it met with a mixed response from the critics, the *Studio* and *Art Journal* approving, the *Athenaeum* finding faults. It was bought by the Walker Art Gallery for £800 when shown later the same year at the Liverpool Autumn Exhibition – not altogether to the liking of 'progressive' local artists.
TRUSTEES OF THE NATIONAL MUSEUMS AND GALLERIES ON MERSEYSIDE, WALKER ART GALLERY

112. **Lamia** 1905 *ill. p118*
Oil on canvas, 146 × 90.2 (57½ × 35½)
Signed *J W WATERHOUSE* (lower right)
Exh: RA 1905 (125); Liverpool Autumn Exh. 1905 (284)
Lit: Hobson, pp122–3, pl.80 and cat.148
'Mr J W Waterhouse's beautiful *Lamia*, one of his most admirable fantasies', to quote A L Baldry in the *Studio*, is a free interpretation of Keats's poem. Where Keats describes a grotesque being, half woman, half serpent,
 Striped like a zebra, freckled like a pard,
 Eyed like a peacock, and all crimson barr'd,
Waterhouse merely hints at the idea by showing his heroine shedding a snakeskin and wearing a skaly-patterned dress. He also transposes the subject from classical antiquity to the late Middle Ages. In composition and mood, *Lamia* looks back to his earlier picture inspired by Keats, *La Belle Dame sans Merci* (Darmstadt; Hobson, pl.58), exhibited at the RA in 1893; and in 1909 he would return to the theme in an entirely different design (Hobson, pl.81). It was also treated by H J Draper (RA 1909) and Sir George Frampton (Cat. 193), and Benedict Read in his essay points to other sculptural parallels. Rossetti's Lilith offers a more general comparison, as do the many hybrids in European Symbolism, Khnopff providing some of the best examples.

Like Cat. 110, the picture belonged to Sir Alexander Henderson, and like Cat. 47 was subsequently in the collection of Sir Jeremiah Colman. The present owner bought it in the 1950s when it could hardly have been more out of fashion.
PRIVATE COLLECTION

113. **Ophelia** 1910 *ill. p24*
Oil on canvas, 101.5 × 63.5 (40 × 25)
Signed *J W Waterhouse* (lower right)
Exh: RA 1910 (114); Japan 1975 (47)
Lit: Hobson, cat.176 and pl.79 (where the picture is confused with cat.109); C Wood 1981, p145, repr
The last of three renderings of the subject by Waterhouse, earlier versions dating from 1889 and 1894

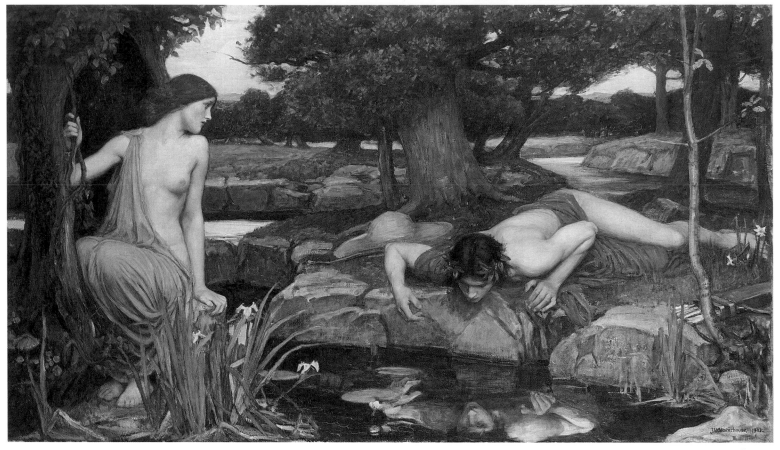

Cat. 111

(Hobson, cat.78, pl.74, and cat.109, pl.165). Ophelia, driven out of her mind by Hamlet's neglect and the murder of her father, Polonius, makes her way to the stream where she is to drown, clutching garlands of flowers. The free handling of the paint and the children seemingly in 'modern' dress at upper right underline the artist's connection with the Newlyn School.

The subject of Ophelia had been treated by many Victorian artists, most famously of course by Millais (1852; Tate) but also by Rossetti, Arthur Hughes, G F Watts and others.

PRE-RAPHAELITE INC. (BY COURTESY OF JULIAN HARTNOLL)

114. **Penelope and her Suitors** 1912 *ill. pp25, 116*
Oil on canvas, 129.8 × 188 (51⅛ × 74)
Signed and dated *J W Waterhouse 1912* (lower right)
Exh: RA 1912 (21); Japan 1985 (48)
Lit: Hobson, p128, pl.77 and cat.188; C Wood 1983, p243, fig.15

One of Waterhouse's most spectacular late works, in which all his most formative influences – the subject-matter of Alma Tadema, the sensibility of Burne-Jones, the technique of Bastien-Lepage and the Newlyn School – are triumphantly reconciled, and he emerges as a master of pictorial narrative with a powerful sense of colour and design. The subject has already been encountered in Cat. 1. Penelope works at her never-to-be-completed tapestry, besieged by the suitors whom Ulysses will one day return and destroy.

The picture was purchased from the artist for £1,400 by Aberdeen Art Gallery, whose Committee had taken an option on it when it was still at a preliminary stage. In 1927 it was to be joined by another late work, the more sombre *Danaïdes* of 1906 (Hobson, pl.118), bought at the sale of the Aberdeen collector, Sir James Murray.

ABERDEEN ART GALLERY AND MUSEUMS

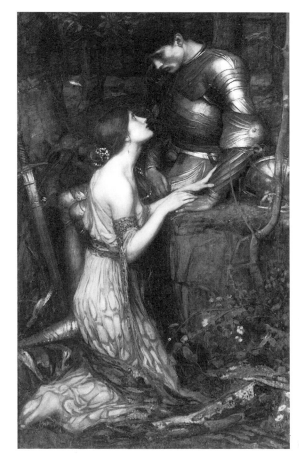

Cat. 112

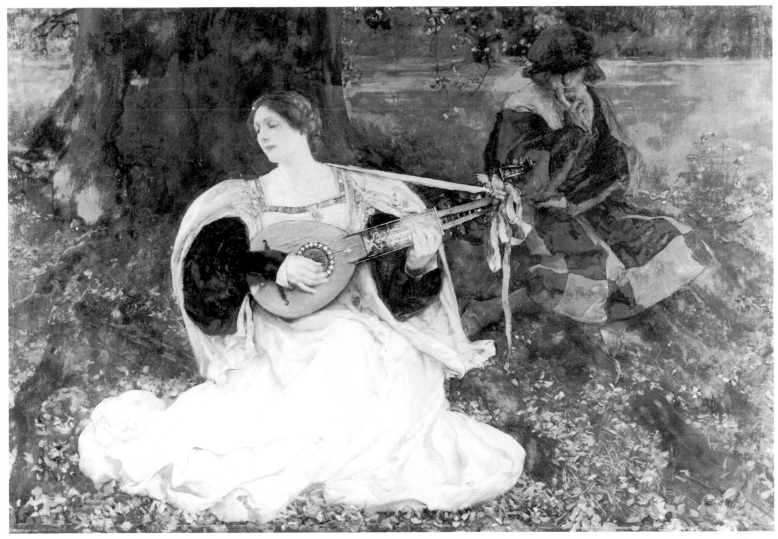

Cat. 115

EDWIN AUSTIN ABBEY
1852–1911

Born in Philadelphia, where he attended evening classes at the Academy while working as an apprentice draughtsman for a local publisher. In 1870 he began a long association with the New York publishers, Harper's, who sent him to England in 1878 to research an illustrated edition of Herrick's poems. After two years in Europe he returned briefly to America, then finally settled in England, marrying in 1890 and establishing himself at Morgan Hall, Fairford, the following year. Having made his name with his illustrations and watercolours, exhibiting at the RI 1883–7 and the RWS 1893–6, he began to paint seriously in oils in 1889 and soon conquered the RA with such dramatic historical and literary works as *Richard, Duke of York, and the Lady Anne* (Yale), the 'picture of the year' of 1896, and the magnificent *Crusaders*

Sighting Jerusalem (Yale) of 1891. Meanwhile in 1890, together with his friend John Sargent and Puvis de Chavannes, he was commissioned to paint murals in the new Public Library at Boston, exhibiting them in London in 1895 and 1901 to great acclaim. He was elected ARA in 1896 and RA two years later. Other projects of this period were the designs for Irving's (abandoned) production of *Richard II* (1898), a mural in the Royal Exchange, and the official painting of the Coronation of Edward VII (both completed 1904). The murals in the East Corridor of the Palace of Westminster were painted under his supervision 1908–10 (see Cat. 82). His last years were devoted to a massive scheme of decoration for the state capitol at Harrisburg, Pennsylvania (commissioned 1902). A relentless traveller, he exhibited internationally and was showered with honours in England, Europe and America. He suffered a physical breakdown in 1906 and was still only fifty-nine when he died.

Ref: E V Lucas, *The Life and Works of Edwin Austin Abbey, RA* 1921; *Edwin Austin Abbey*, cat. of exh. at Yale, Philadelphia and Albany 1973–4

115. **Fair is my Love** 1900 *ill. p119*
Oil on canvas, 61 × 91.5 (24 × 36)
Signed and dated *E A Abbey 1900* (lower right)
Exh: RA, Winter 1912 (Abbey memorial exh.) (319)
The picture takes its title from some (unidentified) lines of verse inscribed on the back:

Fair is my love, my dear and only jewel,
Mild are her looks, but yet her heart is cruel,
O that her heart were, as her looks are, mild,
Then should I not from comfort be exiled.

It is perhaps the best of the few easel paintings by Abbey in British public collections, others being *O Mistress Mine* (1899; Liverpool) and *A Lute Player* (1900), his somewhat disappointing RA Diploma work.

Abbey's style owes much to the Pre-Raphaelites and is remarkable for its psychological insight, sense of design and historical accuracy. Visitors to his huge purpose-built studio at Fairford were astonished to see his enormous collection of costumes and other properties, 'classified with such care, love and pride as an entomologist might display in the arrangement of his specimens' (M H Spielmann, *Magazine of Art* 1899, p196).
HARRIS MUSEUM AND ART GALLERY, PRESTON

FRANCIS BERNARD DICKSEE

1853–1928

Dicksee came from an artistic family; his father, Thomas Francis Dicksee, uncle, brother and sister were all painters and exhibited at the RA. Like many other artists of the time, they lived in Bloomsbury, where Dicksee attended the Rev. George Henslow's school. After a year working with his father, he entered the RA Schools in 1870, being taught by Millais and Leighton and proving a model student who won gold and silver medals. He also had a formative period assisting Henry Holiday with stained glass. In the 1870s and 1880s much of his creative effort was chanelled into illustration, both for magazines – *Cassell's*, the *Cornhill*, the *Graphic*, etc – and books, notably Longfellow's *Evangeline* (1882) and two editions of Shakespeare's plays (1883–92), all published by Cassell's. A number of these designs were later developed as easel paintings. He began to exhibit at the RA in 1876, and it was always his spiritual home, although he supported the Grosvenor Gallery and other institutions. His name was made with *Harmony* (Tate), exhibited in 1877; a winning combination of sentimental theme, 'aesthetic' decor and academic technique, it was hailed as the 'picture of the year' and became one of the first works bought for the Chantrey Bequest. He was elected ARA in 1881 and RA ten years later. In addition to literary and historical subjects, he specialised in scenes of social drama such as *The Crisis* (1891; Melbourne) and *The Confession* (1896; private collection). Many of his pictures were widely disseminated through engravings, and in 1900 he scored another great success with *The Two Crowns* (Tate), which again became a Chantrey purchase. However, the fashion for such costume pieces was waning, and increasingly he turned to portraiture and landscape. Never marrying, he settled in 1898 at 3 Greville Place in St John's Wood, then so popular with academic artists. In later years he received many honours, both at home and abroad. The climax of his career was his election as PRA in 1924 in succession to Sir Aston Webb. He held the post with distinction and tact, and it brought him a knighthood in 1925 and a KCVO two years later. However, the advent of the Modern Movement, of which he was an outspoken critic, had left him an isolated figure. By the time he died, his art, once so popular, was generally dismissed as outmoded and irrelevant.

Ref: E Rimbault Dibdin, 'The Art of Frank Dicksee, RA', *Christmas Art Annual* 1905, pp1–32; *DNB* (T. Borenius); Amanda Kavanagh, 'Sir Frank Dicksee (1853–1928). A Post Pre-Raphaelite', *Country Life* January 1985, pp240–2

116. **Chivalry** 1885 ill. *p120*
Oil on canvas, 183 × 136 (72 × 53½)
Exh: RA 1885 (53); *William Morris and the Middle Ages*, Whitworth Art Gallery, Manchester 1984 (122); Japan 1985 (34)
Lit: Christopher Forbes, *The Royal Academy (1837–1901) Revisited* 1975, p38, no.10; C Wood 1981, p138, repr; Amanda Kavanagh, 'Frank Dicksee and Chivalry', *Antique Collector* March 1987, Victorian Pictures Supplement, pp25–32
A dramatic and confident expression of the ideal of chivalry which, as Mark Girouard has shown in his book *The Return to Camelot* (1981), appealed so strongly to the Victorians. Contemporary critics compared the picture to Millais' *The Knight Errant* (Tate), exhibited at the RA in 1870, the year Dicksee entered the RA Schools, and painted on the same scale. They also described the handling and colouring as 'Venetian' –

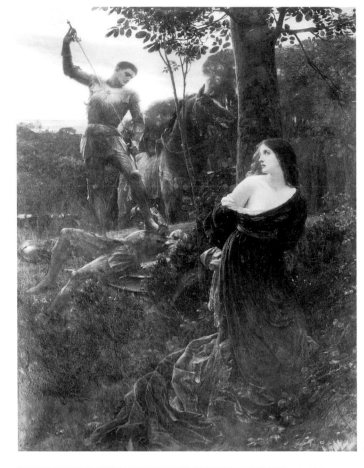

Cat. 116

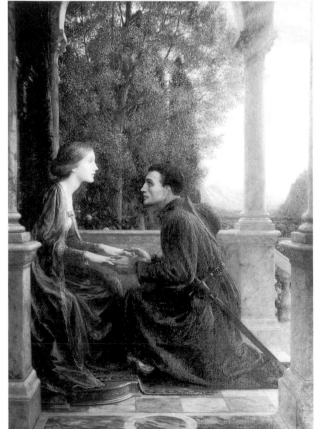

Cat. 117

justifiably, since Dicksee, who visited Italy for the first time in 1882, was a great admirer of Venetian art, telling his students at the RA to 'revel in the joyous company of Titian and Giorgione, Tintoretto and Veronese'. One might even speculate on a link with Tintoretto's *St George and the Dragon* in the National Gallery, which has distinct thematic and compositional similarities. However, it would be wrong to push this too far since Amanda Kavanagh has shown that Dicksee's design is based on an earlier illustration of his own to a 'modern' story – R D Blackmore's novel *Erema*, published in the *Cornhill* in 1877. She also suggests certain sculptural prototypes, Renaissance and modern, for the elegant poses of the figures.

The 'Venetian' palette and rich, soupy texture of the paint are characteristic features of Dicksee's style, as is the subtle yet dramatic effect of light. Such effects, which also occur in the famous *Harmony* of 1877 (Tate) and other works, may well have been encouraged by his early experience of working on stained glass with Henry Holiday.

The picture was commissioned by Sir John Aird, a rich contractor (he built the Aswan dam) and (from 1887) MP who lived at 14 Hyde Park Terrace and formed an extensive collection, mainly of works by academic painters (Leighton, Alma Tadema, Waterhouse and Marcus Stone were also represented) but including one early Rossetti. *Chivalry* hung in the living-room over the fireplace.

THE FORBES MAGAZINE COLLECTION, NEW YORK

117. The End of the Quest 1921 *ill. p120*

Oil on canvas, 144.7 × 106.7 (57 × 42)
Signed and dated *FRANK DICKSEE 1921* (lower left)
Exh: RA 1921 (158)
Lit: *Royal Academy Illustrated* 1921, p103
One of Dicksee's last subject pictures, *The End of the Quest* is thirty-six years later than Cat. 116, though it shows virtually no development in spirit or handling. It seems to take its theme from medieval notions of courtly love, the conception of the lover as a pilgrim recalling Burne-Jones's *Love Leading the Pilgrim* (exh. 1897; Tate), inspired by the *Romance of the Rose*.

The picture was shown at the RA the same year as Spencer Watson's *Story of Creation* (Cat. 137) and Shannon's *Vanity and Sanctity* (Cat. 258), but, as *The Times* observed, 'the proportion of subject pictures to landscapes and portraits grows smaller year by year'. Indeed to many *The End of the Quest* must have seemed hopelessly old-fashioned in 1921, a symbol of everything that was stuffy and reactionary about the Royal Academy. Significantly, it apparently failed to find a buyer; the artist's sister presented it to Leighton House in 1929, a year after his death.

LEIGHTON HOUSE MUSEUM, ROYAL BOROUGH OF
KENSINGTON AND CHELSEA

118. The Return from the Combat c1890 (?)

Watercolour with bodycolour, 11.8 × 25 (4⅝ × 9⅞)
It is difficult to decide whether this is a study for an unidentified illustration, a sketch for a painting, or an independent work.

THE TRUSTEES OF THE BRITISH MUSEUM

119. Study of Armour c1900

Grey/black wash and white bodycolour over black chalk on grey paper, 56 × 34.3 (22 × 13½)
Exh: Probably RA 1929 (1021)
This handsome drawing is a study for the principal figure in *The Two Crowns* (Tate), in which a knight is seen returning in triumph from battle, his glance arrested by the figure of Christ on a crucifix. Shown at the RA in 1900, it was voted the best picture in the exhibition by readers of the *Daily News*, and bought for the Chantrey Bequest for £2,000.

THE TRUSTEES OF THE BRITISH MUSEUM

HENRY JOHN STOCK

1853–1930
Born in Greek Street, Soho, Stock went blind in childhood but recovered his sight on being sent to live at Beaulieu in the New Forest. He studied at St Martin's School of Art and the RA Schools, and was encouraged by the wood-engraver W J Linton, who took him to Italy. In the 1870s he was employed to draw figures for stained glass. He exhibited at the RA 1874–1910, also at the Grosvenor, ROI, RI (member 1880), etc. Although he painted portraits (of Linton and his wife, the Chamberlain family and Lord Ronald Gower, among others), he is chiefly known for his imaginative works, those shown at the RA including illustrations to the Bible, Dante, Coleridge and Whitman, as well as two musical subjects – *Listening to Brahms* (1901) and '*In the Night*' – *Schumann* (1909) – which evoke comparison with well-known Symbolist works (see Fig. 2). As Cat. 120) shows, he was obviously influenced by Blake and G F Watts. Indeed with Blake he may well have felt some sense of identity. Blake too was born in Soho, and Stock lived latterly at Felpham in Sussex, where Blake spent the years 1800–3 under the patronage of William Hayley.

Ref: *The Times* 8 November 1930, p17

120. Elohim 1904 *ill. p121*

Watercolour over black chalk, 25.4 × 35.5 (10 × 14)
Signed and dated *H J STOCK 1904* (lower right)
Exh: RI 19(?) (2)
The picture illustrates what appear to be the main influences on Stock's artistic development. Its title is clearly borrowed from Blake, like that of two paintings called *Good and Evil Spirits Fighting for Man's Soul* which he exhibited at the RA in 1879 and 1882. At the same time it owes much to G F Watts – as presumably did *Life's Immensity* (RA 1900) and *Man and the Infinite* (RA 1908). Particularly reminiscent is Watts's late painting *The Sower of the Systems* (Watts Gallery, Compton), a symbolic representation of the origin of the cosmos, in which an almighty power is seen scattering the stars and planets. However, whether Stock could have seen this in time is debatable. Painted in 1902, the picture was displayed in the Watts Gallery when this opened on Good Friday 1904, but it was not exhibited in London until 1905 when it was included in the artist's memorial exhibition at the RA.

A label on the back indicates that *Elohim* was exhibited at the Royal Institute of Painters in Water-Colours, but gives no date. It was not shown 1904–6.
DAVID LEMON

Cat. 120

THOMAS COOPER GOTCH
1854–1931

Born at Kettering, Northamptonshire, Gotch came from a nonconformist family that had prospered in banking and the local shoemaking trade; his three brothers, an uncle and a cousin all distinguished themselves in scholarship or the arts. He was educated at Kettering Grammar School and worked for three years in his father's business before entering Heatherley's Art School in 1876. He then worked briefly in Antwerp, had a two-year spell at the Slade, and completed his studies in the atelier of J P Laurens in Paris. In 1881 he married a former colleague at the Slade, Caroline Yates, who was also studying in Paris, and in 1883 they returned to England with their daughter Phyllis. Having touched down briefly in Newlyn, the Cornish fishing village then attracting the attention of artists, they went off to Australia, holding a joint exhibition in Melbourne in March 1884. Back in England, they finally settled at Newlyn in 1887.

They were to live there for the rest of their lives, playing a prominent part in the artistic community. Gotch was a close friend of H S Tuke (another former Slade student), and like him and Stanhope Forbes, the leader of the Newlyn School, was a founder-member of the NEAC (1886). For some years he worked along traditional Newlyn lines, treating local subjects in a realistic manner owing much to Bastien-Lepage. But a latent interest in abstract ideas and a visit to Florence in 1891–2 pointed him in the direction of symbolism, and he began to produce a series of highly individual works in which themes of childhood and adolescence were seen in terms of the iconographical conventions of early Italian and Flemish art. His first venture in this style was *My Crown and Sceptre* (1892; Sydney), followed, among others, by *A Golden Dream* (1893; Preston), *The Child Enthroned* (Cat. 121), *Alleluia* (1896; Tate), *The Awakening* (1898; Bristol), *A Pageant of Children* (1899; Liverpool) and *Holy Motherhood* (1902; Newcastle). The number of public galleries that bought these pictures testifies to their popularity. Acclaimed on exhibition, they won medals in Paris, Berlin and Chicago, and were the subject of a perceptive article by A L Baldry in the *Studio* in 1898. An important show of his 'child pictures' was held at Newcastle in 1910.

Gotch exhibited at the RA 1880–1931, although he was never an Associate, and in addition to the NEAC, he belonged to the RBA (1885), where he clashed with Whistler, and the RI (1912). His Australian connections involved him closely with the Royal British Colonial Society, of which he was President 1913–28, and he was Vice-President of the Royal West of England Academy. While continuing to specialise in child subjects (less symbolical as time passed), he painted portraits and landscapes, visiting Denmark (1889) and South Africa (1913) in search of paintable scenes. He died suddenly on 1 May 1931, having come up to London for 'varnishing day' at the RA. A memorial exhibition was held at Kettering the following year.

Ref: A L Baldry, 'The Work of T C Gotch', *Studio* 8 1898, pp73–82; *The Times* 4 May 1931, p16, 9 May, p14; *Painting in Newlyn* exh. Barbican Art Gallery 1985, cat. pp75–7

121. **The Child Enthroned** 1894 *ill. p123*
Oil on canvas, 58.7 × 100.3 (62½ × 39½)
Exh: RA 1894 (540); Paris Salon 1896; *Children's Portraits and Child Pictures by T C Gotch RBC* Newcastle 1910 (8); International Exh., Rome 1911; Memorial Exh., Kettering 1932 (16); *Childhood* Sotheby's 1988 (275)
Lit: *The Times* 5 May 1894, p16; *Athenaeum* 5 May

Cat. 123

1894, p587; *Magazine of Art* 1894, p273; Baldry, pp78–9; *Great Victorian Pictures*, Arts Council exh. 1978, under cat.18; C Wood 1981, p151, repr

An early essay in what Baldry called Gotch's 'imaginative symbolism', the picture made a great impact when it was shown at the RA in 1894. *The Times* described it as 'one of the most original [works] in the whole exhibition', the *Magazine of Art* praised its 'Gothic conviction of feeling', while F G Stephens in the *Athenaeum* called it 'a remarkable and noble outcome of that mood of which Bastien-Lepage is the most popular representative . . . There is something almost Byzantine in the still sweetness and joyous serenity of the comely boy with Flemish features, about which long straight tresses of pale golden hair fall to his shoulders . . . Bright, pure, beautifully drawn, and very delicately modelled, all the parts, especially the face and hands, will please the artist'.

Stephens' assumption that the picture represented the youthful Christ was shared by critics when it was shown at the Paris Salon two years later, but in fact the sitter was the artist's daughter, Phyllis, and the painting was intended as an image of virginal womanhood, the central theme of his new symbolist programme. Stephens was nearer the mark in his references to Byzantine and Flemish art. The hieratic pose and rich brocades, not to mention the flat gold halo, all proclaim Gotch's dependence on the Old Masters, so oddly at variance with the aspirations of the other Newlyn artists among whom he was working.

One of the painting's early owners was George McCulloch, a Scottish prospector who had made a fortune in Australia and lived at 184 Queen's Gate, Kensington. His astonishing collection of well over three hundred paintings, drawings and sculptures included masterpieces by Millais, Leighton, Albert Moore and Burne-Jones.
HENRY KESWICK

122. **The Message** 1903
Oil on canvas, circular, diam. 84.5 (33¼)
Signed *T. C. Gotch* (lower centre)
Exh: RA 1903 (377); *Children's Portraits and Child Pictures by T C Gotch RBC* Newcastle 1910 (3); *Pictures . . . by T C Gotch*, Northampton 1924 (48); Memorial

Exh., Kettering 1932 (19)
Lit: *Royal Academy Pictures* 1903, p49

As so often with Gotch, it is hard to know quite how to take this picture. It might be assumed that it was simply a quirky version of the Annunciation, but in the catalogue of his exhibition at Newcastle in 1910 Gotch described the subject as 'a young girl perceives that life has for her a new and unsuspected meaning'. It is equally hard to come to terms with the formal approach, the academic handling appearing to be at odds with an element of 'early Italian' primitivism.

The poppies recall the artist's better-known painting *Death the Bride* (1895; Kettering), where they also figure prominently, with rather more symbolic purpose.
DEIRDRE MACLELLAN

123. **The Nymph** c1920(?) *ill. p122*
Watercolour, 51 × 61 (20⅛ × 24)
Signed *T C Gotch* (lower left). The frame inscribed '*Now Again She Flies Aloof*' . . . (RLS)

The picture was evidently inspired by Robert Louis Stevenson's poem *To Will. H. Low*:

This is unborn beauty: she
Now in air floats high and free,
Takes the sun and breaks the blue; –
Late with stooping pinion flew
Raking hedgerow trees, and wet
Her wing in silver streams, and set
Shining foot on temple roof:
Now again she flies aloof,
Coasting mountain clouds and kiss't
By the evening's amethyst.

Gotch was an accomplished watercolourist and *The Nymph* is a particularly fresh example of his work in this technique. Its date has not been established.
KETTERING MUSEUM AND ART GALLERY

124. **The Madonna of the Mount** 1926
Oil on canvas, 46 × 30.5 (18⅛ × 12)
Signed *T C Gotch* (lower right)
Exh: RA 1926 (482); Memorial Exh., Kettering 1932 (11)

St Michael's Mount, clearly visible from Newlyn where the artist lived, is seen in the distance.
KETTERING MUSEUM AND ART GALLERY

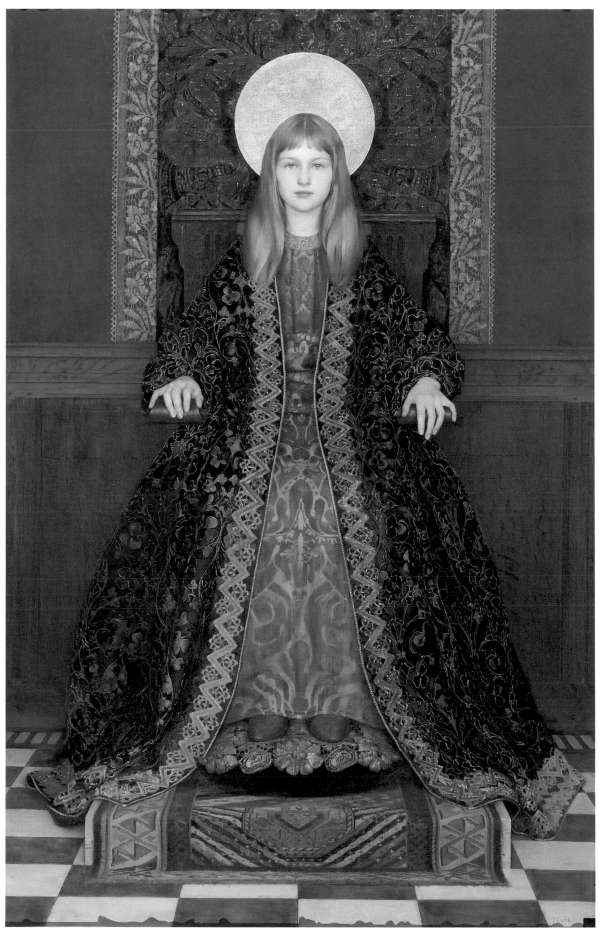

Cat. 121

MARIANNE STOKES, née PREINDLS-BERGER

1855–1927

Born at Styri, Southern Austria, she maintained that her art owed much to two early influences, an illustrated edition of Grimm's *Fairy Tales* given to her as a child and the experience of Catholic ritual. She trained at the Munich Academy and in Paris with Colin and Courtois. In 1884 she married the painter Adrian Stokes, whom she had met while painting in Brittany, and from the mid-1880s she exhibited regularly in England, at the RA (1884–1926), the New Gallery, NEAC, Liverpool Autumn Exhibitions, etc. Her early work is influenced by the French realists, especially Dagnan-Bouveret, under whom Stokes studied 1885–6, and Bastien-Lepage; *The Parting* (1884) and *Polished Pans* (1887), both at Liverpool, are good examples. However in the 1890s, stimulated by a visit to Italy in 1891, she turned to biblical subjects and themes from medieval romance, at first visualising them in terms of her academic-realist style (Cat. 125), but by c1898 adopting the tempera technique and a more 'primitive' idiom. In 1900–1 she was the subject of a group of articles, two by the Catholic writers Wilfrid and Alice Meynell. She was among the members of the newly-formed Society of Painters in Tempera who exhibited their work together at the New Gallery in 1901 (see Cat. 37); and she designed a tapestry for Morris and Co. in 1912. While based in London, she travelled widely, Hungary inspiring a number of her later subjects. Children are a recurring theme in her work, though she herself was childless.

Ref: Harriet Ford, 'The Work of Mrs Adrian Stokes', *Studio* 19 1900, pp149–56; Wilfrid Meynell, 'Mr and Mrs Adrian Stokes', *Art Journal* 1900, pp193–8; Alice Meynell, 'Mrs Adrian Stokes', *Magazine of Art* 1901, pp241–6.

125. **Angels Entertaining the Holy Child** 1893
ill. p124
Oil on canvas, 150 × 176 (59 × 69)
Signed *Marianne Stokes* (lower right)
Exh: RA 1893 (447); Liverpool Autumn Exh. 1893 (1020); *Autumn Anthology*, Pyms Gallery 1983 (7)
Lit: See Pyms Gallery cat.
A transitional work, anticipating the artist's later style in its subject-matter and the touch of naivety in the conception of the two angels, but still betraying the influence of French academic art. *The Times* noted this in its review of the 1893 RA exhibition, calling it 'a religious subject in the style that is often to be seen in the Salon'. Other critics praised the picture's 'strong colouring and uncompromising draughtsmanship', its 'vigour' and 'harmony', while F G Stephens, writing in the *Athenaeum*, admired the balance between realism and taste: 'Examining the very realistic, but not coarse, treatment and the directness of the art embodied here, we find nothing that is irreverent, crude or ungraceful'.
PYMS GALLERY, LONDON

GEORGE PERCY JACOMB-HOOD

1857–1929

The son of Robert Jacomb-Hood, director of the London, Brighton and South Coast Railway, he was educated at Tonbridge School and entered the Slade in 1875. Three years later, on Legros' recommendation, he went to study in Madrid, and he also (like Gotch) worked under J P Laurens in Paris. He exhibited at the RA (1879–1929), as well as at the Grosvenor, RBA, RE etc, and was a founder-member of the NEAC (1886). A versatile figure, active as painter, etcher, illustrator and even sculptor, he is perhaps best known for his illustrations to Oscar Wilde's *Happy Prince* and his long association with *The Graphic*. Among other missions, this sent him to cover the Delhi Durbar in 1902 and George V's state visit to India in 1911, an experience which led to portraits of Rajahs and numerous official and ceremonial paintings. A friend of Whistler, Sargent, Helleu and others, he published his reminiscences in 1925. Died at Alassio.

Ref: Morley Roberts, 'Notes on Some Pictures by G P Jacomb-Hood', *The Artist* April 1898, pp193–202; *The Times* 13 December 1929, p16, and 31 December 1929, p14 (appreciation by E F Benson)

126. **A Gentle Knight** 1880
Etching, 20 × 15.2 (7⅞ × 6)
Signed *P. Jacomb-Hood* and inscribed *A gentle Knight was pricking on the plaine* etc. *The Faery Queen Bk 1 Canto 1* (in plate below)
In addition to a number of modern subjects found in England and France, Jacomb-Hood's early etchings include three illustrations to Spenser's *Faery Queene*. The present example, based on the opening lines of the first Canto, shows the Red Cross Knight accompanied by Una leading a 'milke white lamb', with her dwarf 'lagging' in the distance. Published in *The Portfolio* in 1880, it is much more successful than the other two designs, *The Red Cross Knight and the Saracen* (Book 1, Canto 2) and *Una and the Lion* (Book 1, Canto 3; published in *The Etcher* Part XLII, December 1882).

A Gentle Knight is reproduced in Stephen Calloway, *English Prints for the Collector* 1980, p157. As Calloway observes, the composition seems to owe something to Dürer's *Knight, Death and the Devil*, although the mood is closer to G F Watts, who painted a picture on this theme.
PRIVATE COLLECTION

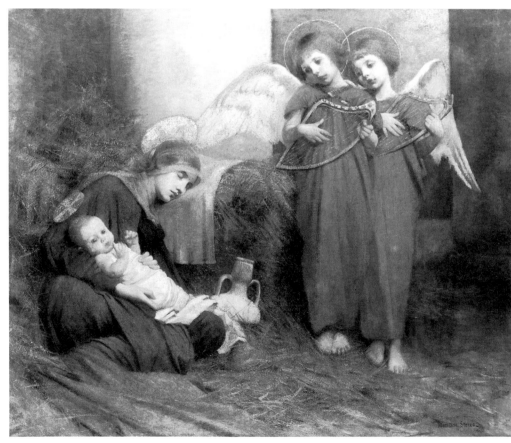

Cat. 125

ARTHUR HACKER

1858–1919

The son of Edward Hacker, a line engraver, Hacker entered the RA Schools in 1876 and continued his studies in Paris in the atelier of Léon Bonnat (1880–1). Like Stanhope Forbes, a fellow pupil, he was influenced by French realism, attracting attention with a scene of peasant life, *Her Daughter's Legacy*, shown at the RA in 1881; and in 1886, again like Forbes, he helped to found the NEAC. However, the following year he exhibited *Pelagia and Philammon* (Liverpool), the first of a series of subject pictures in a melodramatic French academic style. Based on Kingsley's *Hypatia*, it reflected his fondness for North Africa (first visited with Solomon J Solomon, c1881), as did *Vae Victis: Sack of Morocco by the Almohades* (RA 1890). Other notable examples of this manner, all shown at the RA, were *The Annunciation*, bought for the Chantrey Bequest in 1892; *The Temptation of Sir Percival*, exhibited here (Cat. 127); *The Cloister or the World* (1896; Bradford); and another North African theme, *And there was a great cry in Egypt* (1897; Christie's, 27 June 1988, lot 703). As the taste for subject pictures declined, Hacker found other outlets for his versatile and facile talent. He specialised in London street scenes with soft, misty effects, one of these, *A Wet Night at Piccadilly Circus*, being chosen as his RA Diploma work (he was elected ARA in 1894 and RA in 1910). At the same time, like so many academic painters, he developed a large portrait practice, painting among others a number of figures in the art world of the day – Sir Frank Short, E Onslow Ford, Sir William Goscombe John, Ernest Newton, M H Spielmann, C W Dyson Perrins, and Sir George Alexander (as 'Benedick'). Hacker's wife Lilian also painted, exhibiting at the RA 1909–24. He died of a heart attack at his house in the Cromwell Road, 12 November 1919.

Ref: A L Baldry, 'The Paintings of Arthur Hacker', *Studio* 56 1912, pp175–83; *DNB* (T Borenius)

127. **The Temptation of Sir Percival** 1894
Oil on canvas, 132 × 157.5 (52 × 62)
Signed and dated *Arthur Hacker 1894* (lower left)
Exh: RA 1894 (154)
Lit: *Royal Academy Pictures* 1894, p131; *The Times* 12 May 1894, p10

According to Malory's *Morte d'Arthur*, Sir Percival, one of the purest knights of the Round Table, was tempted by the devil in the form of a beautiful woman during his quest of the Holy Grail. He was on the point of succumbing to her charms when he saw how the pommel of his sword formed the shape of the Cross, and this gave him strength to resist. Hacker's painting, an ambitious work exhibited the year that he was elected ARA, represents this type of theme at its most theatrical, and clearly reflects his Parisian training. *The Times* found in it 'a certain facile merit . . . as there is in everything of Mr Hacker's, but the expression on his hero's face, as he handles the bowl the temptress has placed in his hands, suggests grotesque associations'. It is hard to decide whether in fact the picture stops short of bathos. Certainly much is done to redeem it by the vigorous brushwork and the subtle colour scheme, in which touches of purple offset the prevailing russets of the autumn landscape.
LEEDS CITY ART GALLERIES

128. **'Musicienne du Silence'** 1900 *ill. p125*
Oil on canvas, 101.5 × 127 (40 × 50)
Signed and dated *1900*
Exh: RA 1900 (309)

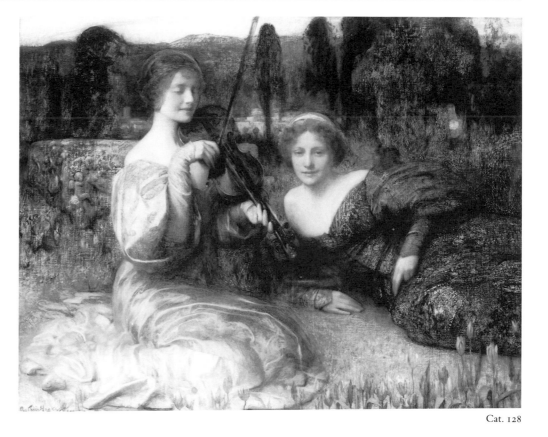

Cat. 128

Lit: *Royal Academy Pictures* 1900, p90; *Art Journal* 1900, pp175, 178

Hacker made a virtue of varying his style; as the *Art Journal* observed (1897, p170), he was 'possessed with a similar spirit to that of Mr Dicksee in endeavouring to avoid the danger of painting in a single groove'. In '*Musicienne du Silence*' he attempts a Venetian mode, finding (to quote the *Art Journal* again) 'scope for his colour-sense' and evoking 'a memory of music-haunted silence in an old-world spot'. Possibly Giorgione's *Concert Champêtre* in the Louvre had been a favourite picture when he was an art student in Paris.

The title may also go back to this period; its source is not given in the RA catalogue but it sounds like the name of a French Symbolist poem and should not be impossible to identify.
ERIC HOLDER

ELIZABETH ADELA STANHOPE FORBES, née ARMSTRONG

1859–1912

Born in Ottawa, the daughter of a government official, she enjoyed a varied artistic training in London, New York and Munich, as well as painting in Brittany and Holland. In 1883, when she was living with an uncle in Chelsea, she had pictures accepted at the RA and RI, and throughout her life she exhibited widely, both in London and the provinces. Much of her best early work was in etching, a medium which brought her into contact with Whistler and Sickert. In 1885 she settled with her mother at Newlyn, and in August 1889 she married Stanhope Forbes, the leader of the Newlyn School. This gave her a prominent position in local artistic society, and she taught in the School of Painting which she and Forbes launched in 1899. Her work, like that of so many Newlyn artists, owes much to Bastien-Lepage, but also admits a strong element of fantasy, with an emphasis on childhood themes. Forbes was right when he referred to her 'charming and beautiful pictures which combine such lovely imaginative qualities with almost unrivalled technical skill and artistic feeling'.

Ref: *Painting at Newlyn*, exh. Barbican Art Gallery 1985, cat. pp77–9

129. **Arthur and Guinevere** before 1904
Watercolour with bodycolour over charcoal, 12 × 14.6 (4¾ × 5¾)
Signed in monogram (lower right) and inscribed on the old mount *To Phyllis from her friend Elizabeth Stanhope Forbes*
Exh: Probably *Model Children and Other People* (watercolours by Mrs Stanhope Forbes), Leicester Galleries, London 1904 (between 62–84); *British Post-Impressionists and Moderns* Belgrave Gallery 1987 (7)

A study for Plate X in *King Arthur's Wood* (Cat. 131),

where the figures form part of a larger design in the shape of an inverted 'L', showing the young Gareth before Arthur and Guinevere. The model for Arthur was Elizabeth Stanhope Forbes's fellow Newlyn artist, T C Gotch, and she gave the drawing to his daughter, Phyllis (who posed for Cat. 121).

R D FRANKLIN

130. **The Black Knight** before 1904
Watercolour with bodycolour over charcoal, 47 × 31.7 (18½ × 12½)
Signed *E A Forbes* (lower left)
Exh: Probably Leicester Galleries 1904 (see Cat. 129);
Victorian Romantics, Christopher Wood Gallery 1985 (6)
Lit: See Christopher Wood Gallery cat.
Like the previous exhibit, this is an illustration to *King Arthur's Wood* (Cat. 131), although it was evidently discarded since it does not appear in the book. The artist also made a large oil version of the design.

It says much for the futility of attempting to classify an artist like Elizabeth Stanhope Forbes, especially in her Arthurian vein, that Cat. 129 and 130 have recently been included in exhibitions entitled respectively *British Post-Impressionists and Moderns* and *Victorian Romantics*.

PRIVATE COLLECTION (BY COURTESY OF JULIAN HARTNOLL)

131. **Elizabeth Stanhope Forbes,** *King Arthur's Wood*
Illustrated by the author
Bristol: Edward Everard 1904. Folio
Written for the artist's son Alec, who was born in 1893 and killed in the First World War, *King Arthur's Wood* tells the well-known Arthurian story of Sir Gareth of Orkney in the context of a modern-life fairy tale. Freely handled in combinations of charcoal, watercolour and gouache, the drawings are an interesting attempt to see a very English literary theme in terms of a technique, and even to some extent a visual vocabulary, rooted in French naturalism. A greater contrast to the contemporary illustrations of, say, the Birmingham School, could hardly be imagined. For a contemporary review, see *The Studio* 33 1905, p270.

FIONA FORBES

MAURICE GREIFFENHAGEN
1862–1931

Greiffenhagen was of Danish descent, his grandparents having emigrated to England. Born in London, he was educated at University College School, and in 1878 entered the RA Schools where he won the Armitage Prize. He exhibited at the RA from 1884 (ARA 1916; RA 1922), but also supported the NEAC (1889–92), RBA, ROI, etc. A versatile talent, able to adopt a variety of styles, he was active in early life as an illustrator, working for the *Illustrated London News* and other magazines and making dramatic designs for the novels of Rider Haggard. He also painted portraits, often in the Whistler mode (see cat. of NEAC Centenary Exh., Christie's 1986) and figure subjects; *An Idyll* (1891; Liverpool) is said to have been D H Lawrence's favourite picture. He had two works bought for the Chantrey Bequest: *Women by a Lake* (1914), a group of Rubensian female nudes, and *Dawn* (1926), which is more Symbolist in feeling. In 1906 he was appointed headmaster of the Life School at Glasgow School of Art, a post he held till 1929, visiting the School regularly but continuing to live in London. During later years, in addition to portraits, he specialised in large-scale decorative panels with historical themes; examples were commissioned for Langside Library, Glasgow (1919), exhibition pavilions in Paris, Dunedin (both 1925) and Antwerp (1930), and SS 'Empress of Britain' (1931). Their bold flat style also produced a striking poster for the LMS

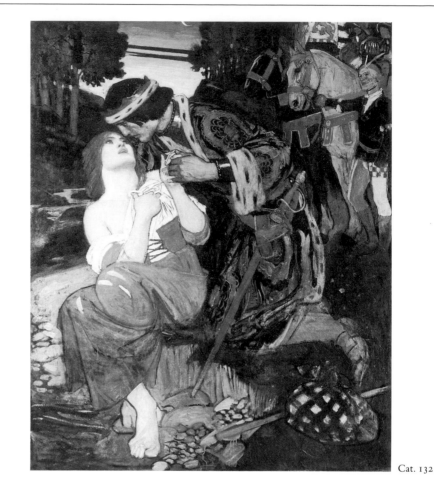

Cat. 132

Railway (Cat. 134) and is reflected in such late subject pictures as *The Message*, his RA Diploma work, and *The Offerings* (Cat. 133). Married, with two sons (the elder killed in the Great War), Greiffenhagen lived successively in the artistic enclaves of Primrose Hill and St John's Wood, in both being a neighbour of his friend J W Waterhouse. A large group of his works was shown in the exhibition held at the RA in 1933 to commemorate recently deceased members.

Ref: J Stanley Little, 'Maurice Greiffenhagen and his Work', *Studio* 9 1897, pp235–45; *The Times* 28 December 1931, p12

132. **King Cophetua and the Beggar Maid**
c1920–5 *ill. p126*
Oil on canvas, 136.5 × 90.2 (53¾ × 43)
Exh: RA, Winter 1933 (315)
The subject, taken from a traditional ballad, had inspired Burne-Jones's celebrated painting exhibited at the Grosvenor Gallery in 1884 (Fig. 1). Byam Shaw treated it in Frank Sidgwick's *Ballads and Lyrics of Love* 1908 (see Cat. 141), and H M Brock in Beverley Nichols' *Book of Old Ballads* 1934 (Cat. 539).

Greiffenhagen's version is undated, but it has features in common with his RA Diploma picture, *The Message*, which is dated 1923. The two works are almost sacred and profane treatments of the same theme, the Virgin hearing the voice of the Angel in *The Message* in the same spirit of ecstatic surrender with which the Beggar Maid receives the advances of King Cophetua, while both pictures, despite the bravura of the brushwork, look back to early Rossetti. *King Cophetua* was bought for Glasgow in 1937, no doubt to commemorate the artist's long association with the Glasgow School of Art.

GLASGOW ART GALLERY AND MUSEUM

133. **The Offerings** 1925
Oil on canvas, 110.5 × 90.2 (43½ × 35½)
Signed and dated *Maurice Greiffenhagen 1925*
Exh: RA 1925 (13); RA, Winter 1933 (312)
Lit: *Royal Academy Illustrated* 1925, p57
This slightly unconventional version of the Adoration of the Magi in one of several religious subjects painted by Greiffenhagen in the early 1920s, all with oblique titles. Others are *The Vision* (RA 1921; repr *RA Illustrated*, p73), in which the Virgin and Child are seen appearing to two fishermen, and *The Message*, ie The Annunciation, deposited as the artist's RA Diploma work in 1923.

THE ABBOT AND COMMUNITY OF AMPLEFORTH ABBEY

134. **Carlisle – The Gateway to Scotland** 1924
Oil on canvas, 76.2 × 116.8 (30 × 46)
Signed and dated *Maurice Greiffenhagen 1924* (lower left)
Lit: Percy V Bradshaw, *Art in Advertising* 1925, pp280–1, poster repr
This is the original design for Greiffenhagen's well-known poster for the London, Midland and Scottish Railway, a splendid example of 'last romanticism' turned to commercial use. The poster was the result of an advertising campaign to which a number of Royal Academicians and Associates were asked to contribute, others including Brangwyn, D Y Cameron, Clausen, Sims, Orpen, Campell Taylor, Sir Bertram Mackennal, Cayley Robinson and Augustus John. It was one of several posters by Greiffenhagen included in the commemorative exhibition of works by recently deceased members held at the Royal Academy in 1933, and *The Times* in its review (7 January, p9) considered that they gave 'the best account of him' as an imaginative artist.

THE NATIONAL RAILWAY MUSEUM, YORK

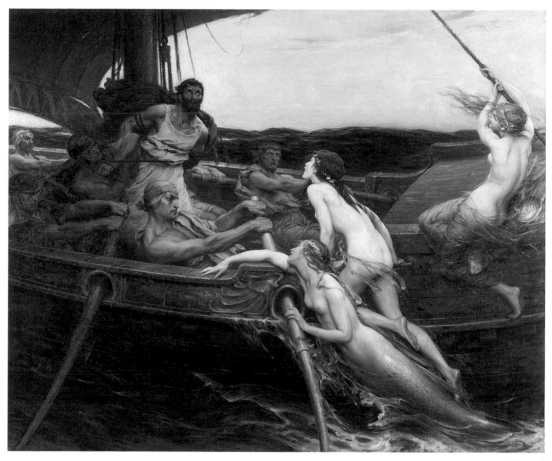

Cat. 136

HERBERT JAMES DRAPER

1864–1920

Despite the imposing nature of his work, Draper is an obscure figure. Born in London, he studied at the St John's Wood Art School before entering the RA Schools in 1884; five years later he won the gold medal and a travelling scholarship, which enabled him to pursue his studies at the Académie Julian, Paris, and in Rome. He exhibited at the RA from 1887 until his death, his subject pictures often being inspired by the English poets and having a marked tendency to marine and nautical themes; in this respect the two shown here are typical. *The Lament for Icarus* (RA 1898) was bought for the Chantrey Bequest and awarded a gold medal at the Paris International Exhibition in 1900; other works were acquired for Liverpool, Manchester, Bradford, Preston, Truro and Hull, as well as Durban and Adelaide. Like so many academic artists of this generation, he also established a flourishing portrait practice and carried out decorative projects, notably a ceiling painting for the Livery Hall of the Drapers' Company representing *Prospero Summoning Nymphs and Deities* (RA 1903; did his name help secure the commission?). As a figure draughtsman he belonged to the Leighton tradition (see *Studio* 68 1916, pp103–10), but landscape studies made in Switzerland, the Scilly Isles, etc were included in an exhibition of his drawings at the Leicester Galleries in 1913. He married Ida, daughter of Walter Williams, JP, and had one daughter. His Drapers' Company ceiling was painted in a studio at St Ives, Cornwall, but from 1896 he lived at 15 Abbey Road, St John's Wood, a neighbour of Waterhouse,

Dicksee, Greiffenhagen and others. Like Gotch, he belonged to the Royal British-Colonial Society of Artists, but curiously enough he was never an RA, or even an Associate. Moreover, *The Times* carried no obituary, only a brief notice of his death.

135. The Golden Fleece 1904

Oil on canvas, 155 × 272.5 (61 × 107¼)
Signed *Herbert Draper* (lower right)
Exh: RA 1904 (199); Japan 1987 (53)
Lit: *The Times* 30 April 1904, p12; C Wood 1983, pp215–16, fig.13

Having won the Golden Fleece from Æetes, King of Colchis, Jason set sail for Greece with the Argonauts and Æetes' daughter, Medea. The King pursued them and Medea ordered that her brother, Absyrtus, should be thrown into the sea, causing Æetes to stop and so let Jason escape. Draper's account of this subject would have been even more dramatic if he had followed the version of the story which says that Absyrtus was torn limb from limb and the pieces strewn in his father's path, but no doubt this would have been too much for his audience. William Morris had also evaded the issue in his *Life and Death of Jason* (1867), though in a different way.

The picture was exhibited at the RA in 1904 and was among what *The Times* called the 'conspicuous popular successes' of that year. The muscular figures of the Argonauts provide Draper with an ideal opportunity to display his academic knowledge of the nude.

BRADFORD ART GALLERIES AND MUSEUMS

136. Ulysses and the Sirens 1909 *ill. p127*

Oil on canvas, 177 × 213.5 (69¾ × 84)
Signed *HERBERT DRAPER* (lower left)
Exh: RA 1909 (206); Japan 1987 (54)
Lit: *Royal Academy Pictures* 1909, p132; *The Times* 1 May 1909, p12; *Athenaeum* 1 May 1909, p534; C Wood 1983, pp215–16, fig.12

The three Sirens were said to inhabit an island near Cape Pelorus in Sicily, where they lured sailors to destruction with the charm of their melodious voices. Returning from the Trojan War, Ulysses was warned of this hazard by Circe, and had his sailors' ears stopped up with wax and himself lashed to the mast in order to escape unharmed.

When exhibited at the Academy in 1909 the picture was given a prominent place but severely criticised. The *Athenaeum* dismissed it as 'merely illustrative', and *The Times* took the artist to task for not being faithful to Homer. 'Homer's sirens had nothing to do with the conventional mermaid, and did not cling to the ship; they were beings of an undescribed form who sat in a meadow and sang. Really painters ought not thus to amend the text of their authorities'. This was hardly fair since Draper had made no claim to be illustrating Homer and accounts of the sirens differ widely, some writers describing them as sea-nymphs, others as birds with women's heads. Draper has clearly chosen the version richest in sexual implication, and exploited it to the full. The picture is painted with an almost Sargentesque bravura.

The subject had been treated by J W Waterhouse in a picture shown at the RA in 1891 (Melbourne), and a smaller and later version of our picture is at Leeds.

FERENS ART GALLERY (HULL CITY MUSEUMS AND ART GALLERIES)

GEORGE SPENCER WATSON

1869–1934

The son of a surgeon, Spencer Watson was born in London and educated at Merchant Taylors' School. In 1889 he entered the RA Schools where he was a Landseer scholar and silver medallist; Byam Shaw was a fellow student and close friend. He exhibited regularly at the RA from 1891, making his name with *The Donkey Ride* (1919; Liverpool) and becoming ARA 1929 and RA 1932; he was also an active member of the Royal Society of Portrait Painters, RBA and Art Workers' Guild. Though mainly known as a portraitist, specialising in official likenesses, including several for Livery Companies (he himself was Master of the Saddlers' Company), he also painted nudes (good example at Preston), landscapes and subject pictures, and exhibited one bronze (RA 1906). The portraits are suave in style but the figure subjects, which include biblical and classical themes and illustrations to Keats and Shelley, are often bizarre; as his obituary put it, while his work in general shows 'reserve of feeling and purity of line', he could 'become rather reckless when he let himself go'. He lived in Kensington and his wife and daughter were known for their association with 'an original form of dramatic entertainment, half-play, half-masque'. A memorial exhibition was held at the FAS in June 1934, and his picture *A Lady in Black* was bought for the Chantrey Bequest the following year.

Ref: *The Times* 12 April 1934, p17, and 13 April, p16 (appreciation by Sir W Reynolds-Stephens)

137. The Story of the Creation 1921

Oil on canvas, 160 × 142.2 (63 × 56)
Signed and dated *G. Spencer Watson 1921* (lower left)
Exh: RA 1921 (207); *Works of the late George Spencer Watson RA* (Memorial Exh) FAS 1934 (35)
Lit: *Royal Academy Illustrated* 1921, p82; *The Times* 2 May 1921, p9; *Daily Telegraph* 18 May 1921
The picture illustrates Milton's *Paradise Lost* and shows the Archangel Raphael visiting Adam and Eve in Eden and revealing to them the story of their creation. 'Mr Spencer Watson[']s . . . paradise', wrote the art critic of *The Times*, 'is a delightful place; and what a background for the Russian Ballet! . . . Only the Archangel, as in Milton, is a little boring, and he seems to be boring Adam. There is in his face a look of empty enthusiasm as if he were a Hegelian expounding his abstractions to a puzzled gardener'. The picture's exotic background, a little reminiscent of Brangwyn's British Empire panels commissioned five years later, was also seen in theatrical terms by Sir Claude Phillips in a review in the *Daily Telegraph*, although he disagreed over the figures. 'The landscape is rich to excess in fantastic details, overgrown with huge plants so disquieting of aspect that they suggest rather the dangerous delights of Klingsor's magic garden than the wholesome joys of an earthly paradise. Slender, lovely Eve is too self-possessed, too condescending in her assumption of royal graciousness. A really interesting conception is that of the Archangel, who is shown as a perfectly shaped youth, entirely nude and with wings. . . . Such careful elaboration of a tender, graceful theme, if not complete acceptance, claims, at any rate, moderate admiration.'

The picture was included in Spencer Watson's memorial exhibition, together with a tempera sketch. The fact that it was for sale (at 300 gns) suggests that, like Dicksee's *End of the Quest* (Cat. 117), also shown at the RA in 1921, it failed to find a buyer in the artist's lifetime. This is yet another indication of the lack of interest in literary subject pictures at this period.

WOLVERHAMPTON ART GALLERY COLLECTION

Cat. 139

JOHN BYAM LISTON SHAW

1872–1919

Byam Shaw (as he was always known) was born in India, his father being the Registrar of the High Court at Madras. He was brought to England at the age of six and educated at home. In 1887, on his father's death, he entered the St John's Wood Art School, transferring to the RA Schools in 1890; there his fellow students included Gerald Metcalfe (see Cat. 153–4), with whom he shared a studio 1893–7, and Evelyn Pyke-Nott, whom he married 1899. From the start he showed a strong feeling for narrative, an astonishing versatility, and prodigious powers of application. He began to exhibit at the RA in 1893, showing a picture inspired by D G Rossetti, a crucial early influence. He also supported the New Gallery, the ROI, the Pastel Society and RWS (Associate 1913), while enjoying a close relationship with the dealers, Dowdeswell's, who bought and published his early masterpiece *Love the Conqueror* (1899; private collection) and held four exhibitions of his work on specific themes (subjects suggested by *Ecclesiastes* 1902; illustrations to Percy's *Reliques* 1908, etc). His most famous subject picture is probably *The Boer War* (1901; Birmingham). He also painted portraits, was a prolific illustrator, designed a tapestry (for Morris & Co. 1898) and stained glass, and executed one of the murals in the East Corridor of the Palace of Westminster (1908–10). For many years he maintained a close connection with the stage, painting Ellen Terry and Dion Boucicault and designing Beerbohm Tree's production of *Much Ado about Nothing* (1905) and a

new act drop for the London Coliseum (1914). In addition to all this he devoted much time to teaching. In 1904 he joined the staff of the Women's Department of King's College, London, and six years later he and his friend Rex Vicat Cole launched their own art school (still in existence) in Camden Street, Kensington. On the outbreak of war, he joined the United Arts Rifles, later transferring to the Special Constabulary; he also commented on the war in drawings in the press and painted one of the Canadian War Memorial pictures, entitled *The Flag*. These labours, after years of overwork, brought about a collapse, and he died in January 1919, aged only forty-six.

Ref: Rex Vicat Cole, *The Art and Life of Byam Shaw* 1932; Peyton Skipwith, 'A Pictorial Story Teller', *Connoisseur* 191 March 1976, pp189–97; *Byam Shaw*, exh. Ashmolean Museum, Oxford 1986, cat. by Gerald Taylor

138. The Queen of Hearts 1896 *ill. p129*

Oil on canvas, 91.5 × 71 (36 × 28)
Signed and dated *BYAM SHAW 96* (lower left)
Exh: ROI 1898; Japan 1985 (36); Ashmolean Museum 1986 (9)
Lit: Vicat Cole, pp66–8, repr
Cole describes this as 'one of the pictures which . . . brought [Shaw] reputation', and quotes Eleanor Fortescue-Brickdale's comment that it was 'the first picture in which he sprang suddenly out in his own extraordinarily brilliant and original style'. The model for the main figure was Evelyn Pyke-Nott, herself an artist, who was engaged to Byam Shaw at this time and married him in 1899. No doubt this personal

involvement goes far to explain the success of the picture, which is one of the artist's most appealing works. Far less attractive is the sequel, *The Queen of Spades* (1898; exh. Ashmolean 1986, cat.10, repr), a more stagey affair reminiscent of Cadogan Cowper.

Still in its original, specially designed frame, the picture obviously owes much to Rossetti's paintings of the late 1850s, which offer many parallels for the treatment of the subsidiary figures, the bright colours and flat heraldic patterns. Ruskin, who disliked these works, complained of one of them that its 'mode of colour-treatment' was 'too much like that of the Knave of Hearts', but the most relevant is probably *Regina Cordium* (Johannesburg), a portrait of the artist's wife painted in 1860 in which the heart-motif figures prominently in the background.

PRE-RAPHAELITE INC. (BY COURTESY OF JULIAN HARTNOLL)

139. **The Alchemist** c1910 or earlier *ill. p128*
Oil on canvas, 57 × 62 (22½ × 24½)
Exh: Ashmolean Museum 1986 (1)
The subject of this unfinished picture is not entirely clear; it could be Faust and Margaret. The sitter for the female figure (and previous owner of the picture) was Maud Tindal Atkinson, a pupil of the artist who often modelled for him.

JAMES BYAM SHAW, CBE, D LITT

140. **Study of Drapery** c1910 or earlier
Pencil, squared for transfer, 38 × 34.3 (15 × 13½)
Exh: Ashmolean Museum 1986 (3)
This study for the skirt of the female figure in Cat. 139 is a fine example of Byam Shaw's drawing style. The influence of Burne-Jones's early drapery studies is evident; in 1897 Byam Shaw had a reproduction of *Sidonia von Bork*, the artist's well-known watercolour of 1860 (Tate), pinned up in his studio.

JAMES BYAM SHAW, CBE, D LITT

141. **The Knight and the Shepherd's Daughter** c1908
Watercolour with bodycolour, 34.4 × 24.5 (13½ × 9⅝)
Signed *BYAM SHAW* (lower left)
Exh: *Water-Colours Illustrative of 'Percy's Reliques of Ancient English Poetry' by Byam Shaw*, Dowdeswell Galleries, May 1908 (3); Ashmolean Museum 1986 (64)
One of Byam Shaw's illustrations to Frank Sidgwick's *Ballads and Lyrics of Love* (Chatto and Windus 1908), and a good example of his highly professional approach. The story is similar to that of the better-known ballads *Childe Waters* and *Burd Helen* (see Cat. 145).

THE VISITORS OF THE ASHMOLEAN MUSEUM, OXFORD

142. *Tales from Boccaccio*
'Done into English by Joseph Jacobs. Illustrated by Byam Shaw'
London: George Allen 1899. 4to
One of Byam Shaw's earliest illustrated books and perhaps the best; the twenty black and white designs are beautifully conceived, at once formally sophisticated and psychologically acute. For two of the original drawings, see 1986 exh., cat. 33, 37, and for a review, *Studio* 18 1900, p217.

George Allen was Ruskin's publisher and had recently finished issuing *The Faery Queene* with illustrations by Walter Crane (Cat. 39). Joseph Jacobs is better known for his collections of fairy tales published by David Nutt in the early 1890s with illustrations by J D Batten.

Many English artists have been inspired by the *Decameron*. Stylistically, Waterhouse's two late paintings at Port Sunlight provide the closest parallel, but Marie Stillman's *Enchanted Garden* (Cat. 30) is in fact nearer in date.

NICHOLAS BYAM SHAW

Cat. 138

143. **John Bunyan,** *The Pilgrim's Progress*
With thirty colour plates by Byam Shaw
London and Edinburgh: T C and E C Jack 1904. 8vo
Pilgrim's Progress excercised the imagination of many 'last romantics', others who tackled it including William Strang (1895), Heath Robinson (1897), Anning Bell (1898), Reginald Savage (1899) and E J Sullivan (1902).
JAMES BYAM SHAW, CBE, D LITT

129

Cat. 146

ELEANOR FORTESCUE-BRICKDALE

1872–1945

Born at Upper Norwood, the daughter of a barrister, she studied at the Crystal Palace School of Art and the RA Schools. In 1894 her father was killed in an Alpine accident, and her family moved to London. She was to live there for the rest of her life, sharing a house with her sister Kate at 23 Elsham Road, Shepherd's Bush, and having a studio at 11 Holland Park Road, almost opposite Leighton House. Influenced by the Pre-Raphaelites and the early Italians, familiar to her through numerous visits to Italy, she exhibited at the RA from 1896. In 1901, she had a one-man exhibition at the Dowdeswell Gal-

leries under the title *Such Stuff as Dreams are Made of!* This was followed by two shows at Leighton House (1902, 1904), two more at Dowdeswell's (1905, 1909) and three at the Leicester Galleries (1911, 1915, 1920). Meanwhile in 1902 she was elected to the ROI (first woman member) and RWS. She was also making her name as a book illustrator, the resulting watercolours often forming the basis of her exhibitions. A close friend of Byam Shaw, her contemporary, she taught at his school from its foundation in 1911. The war brought a demand for memorials, and she designed more than twenty stained-glass windows 1914–40. It also curtailed the trade in lavishly illustrated books, although she worked on a few in the 1920s, including two by Dion Clayton Calthrop (see Cat. 162–3). From 1923 she suffered increasing ill-health and blindness. She contributed to the RA for the last time in 1935, and her last major work was a window in the church at Flockton in Yorkshire, dedicated June 1937.

Ref: Centenary Exhibition of works by Eleanor Fortescue-Brickdale, Ashmolean Museum, Oxford 1972–3, cat. by Gerald Taylor

144. **The Shrine** c1905–10(?)
Watercolour with bodycolour, 50 × 35 (19¾ × 13¾)
Signed *ELEANOR F BRICKDALE* (lower right) and inscribed on old label on back
Exh: RWS, Summer 1902 (20)
The mystical subject, strong verticals and horizontals, bright colours and emphasis on decorative pattern, all point to the influence of Rossetti on this attractive example. The two devotees seem to be portraits (mother and daughter or two sisters?), and the picture may have had some private significance.
MARK FREEMAN

145. **The Little Foot-Page** 1905 *ill. p131*
Oil on canvas, 90.8 × 57 (35¾ × 22½)
Signed *ELEANOR F BRICKDALE* (lower left)
Exh: Liverpool Autumn Exh. 1905 (1087); Ashmolean Museum 1972–2 (41); *Women's Works*, Liverpool 1988, cat. p21
The picture illustrates the well-known ballad theme of the peasant girl who, spurned by the knightly lover whose child she carries, dresses as a foot-page in order to follow him. This occurs in two main versions, *Childe Waters* and *Burd Helen*; for another, illustrated by Eleanor Fortescue Brickdale's close friend Byam Shaw, see Cat. 141. Ballads had inspired many Pre-Raphaelite paintings, the most obvious comparison here being *Burd Helen* (Liverpool) by the Liverpool artist W L Windus, exhibited at the RA in 1856. It might be imagined that the present picture was acquired by the Walker Art Gallery because it treated a related theme, but in fact it entered the collection first. It was bought at the Liverpool Autumn Exhibition in 1905 by Harold Rathbone, director of the Della Robbia pottery at Birkenhead, and given after he sold it in 1909.
TRUSTEES OF THE NATIONAL MUSEUMS AND GALLERIES ON MERSEYSIDE, WALKER ART GALLERY

146. **The Lover's World** c1905 *ill. p130*
Watercolour with bodycolour, 111.8 × 66 (44 × 26)
Signed *ELEANOR F BRICKDALE* (lower right)
Exh: 'Such Stuff as Dreams are Made Of!' (Second Series), Dowdeswell Galleries 1905 (20); Brighton 1980 (D10), repr cat. p108
A charming work from the second of the three exhibitions of watercolours which the artist held at the Dowdeswell Galleries, 160 New Bond Street, before the First World War. Dowdeswell's also specialised in the work of her friend Byam Shaw.
CITY OF BRISTOL MUSEUM AND ART GALLERY

147. **Guinevere** c1911
Watercolour with bodycolour, 45.5 × 26.5 (17⅞ × 10½)
Signed *EFB* (lower right)
Exh: *Water-Colours illustrating Tennyson's 'Idylls of the King' by Eleanor Fortescue-Brickdale*, Leicester Galleries October 1911 (4)
One of the artist's illustrations to Hodder and Stoughton's edition of Tennyson's *Idylls of the King* 1911 (Cat. 150). It shows the Queen when she has retired to a nunnery at Almesbury after the death of Arthur, fulfilling her vow to

> wear out in almsdeed and in prayer
> The sombre close of that voluptuous day,
> Which wrought the ruin of my lord the King.

It is interesting to compare this image with W Reynolds-Stephens' treatment of a closely related theme (Cat. 201).
BIRMINGHAM CITY MUSEUM AND ART GALLERY

148. **June is Dead** before 1915
Watercolour with bodycolour, 27.3 × 41 (10¾ × 16⅛)
Signed *EFB* (lower right)
Exh: RWS, Winter 1915 (235)
The drawing is Eleanor Fortescue-Brickdale's Diploma work for the Royal Water-Colour Society, of which she was elected an Associate in 1902 and a full member in 1920. Like E R Hughes (Cat. 49), she seems to have deliberately chosen a drawing which, because of its subject, was of limited commercial value. Nonetheless the disturbing theme, unconventional composition, and accomplished handling of the roses make this one of her most interesting works.

A similar figure occurs in the border of Byam Shaw's illustration to the poem 'In a Gondola' in *Poems of Robert Browning* published by George Bell 1897.
THE TRUSTEES OF THE ROYAL SOCIETY OF PAINTERS IN WATER-COLOURS (FROM THE DIPLOMA COLLECTION)

149. **Robert Browning, *Dramatis Personae ; and Dramatic Romances and Lyrics***
Illustrated by Eleanor Fortescue-Brickdale
London: Chatto and Windus 1909. 4to
A sequel to *Pippa Passes, and Men and Women*, which the artist had illustrated for Chatto and Windus the previous year. Byam Shaw had illustrated Browning's poems for George Bell in 1897.

The original for one of the illustrations is in the Russell-Cotes Art Gallery, Bournemouth.
THE BRITISH LIBRARY BOARD

150. **Alfred, Lord Tennyson, *The Idylls of the King***
Illustrated by Eleanor Fortescue Brickdale
London: Hodder and Stoughton 1911. 4to
The artist provided twenty-one colour plates. In addition to the example shown here (Cat. 147), there is one in the Walker Art Gallery, Liverpool (no. 9057), and several more are traceable.
ROSEMARY FARQUHARSON

151. ***The Book of Old English Songs and Ballads***
Illustrated by Eleanor Fortescue-Brickdale
London: Hodder and Stoughton 1915. 4to
These twenty-four colour illustrations to well-known ballads may be compared to Byam Shaw's similar series from Frank Sidgwick's *Legendary Ballads* (1907) and *Ballads and Lyrics of Love* (1908; see Cat. 141). Many have landscape backgrounds found at the country-houses which the artist often visited – Ablington Manor, Gloucestershire, Condover Hall, Shropshire (where Byam Shaw also painted), Newland, in the Forest of Dean (the home of her elder brother), and others.
THE BRITISH LIBRARY BOARD

Cat. 145

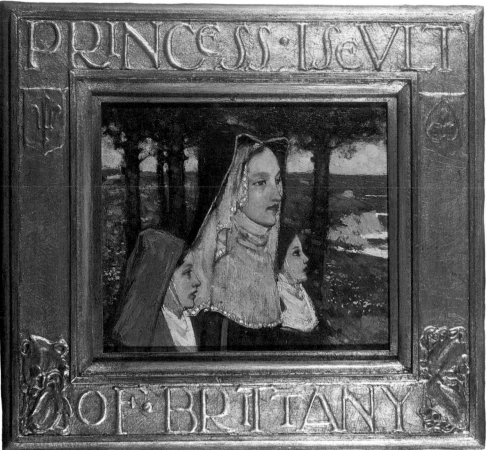

Cat. 152

HUGH WALLIS

active 1894–1922

Wallis is an obscure figure, listed by neither Bénézit nor Thieme-Becker. When he first exhibited at the RA in 1894 his address was Meadow Studios, Bushey, which suggests that he was a pupil of Herkomer, but from 1899 to 1922 (when last recorded), he was living at Altrincham, Manchester, apparently being closely involved with the Northern Art Workers' Guild (see Cat. 152). His RA exhibits include landscapes, flower-pieces and genre or subject pictures. A flower-piece dated 1922 is in the Manchester City Art Gallery.

152. **Princess Iseult of Brittany** c1904 *ill. p132*

Oil on panel, 21 × 24 (8¼ × 9½)
Inscribed *H Wallis 7 Market St* on back; the title inscribed on the original frame
Exh: Northern Art Workers' Guild, Manchester 1904
Lit: *Studio* 30 1904, p65
According to the *Studio*, the picture was one of at least three items which Wallis showed at the second Northern Art Workers' Guild exhibition, held at the Municipal School of Technology, Manchester, in 1904. These were a 'large cartoon for mural decoration', 'a charming decorative painting of two children, and one of the Princess Iseult, . . . both helped by their very suitable frames' (still on the present picture). He had also designed a 'striking poster' for the exhibition, which included works of Walter Crane, formerly Director of Design at Manchester School of Art.

Iseult of Brittany was the princess who (confusingly) Sir Tristram married, although in love with La Belle Iseult. It is possible that Wallis had a special feeling for Brittany, like so many contemporary artists.
ERIC SLACK

GERALD FENWICK METCALFE

active 1894–1923

Metcalfe was born in Landour, India, and studied art at South Kensington, St John's Wood and the RA. At St John's Wood he met Byam Shaw (also born in India), with whom he went on sketching tours in 1891–2, and in June 1893 they took Whistler's former studio at 95 Cheyne Walk, Chelsea, sharing it for four years. Like Shaw, he contributed designs to magazines (*Comic Cuts, Punch,* etc) and illustrated books. At the RA, where he began to exhibit in 1894, he showed a few subject pictures, landscapes and one relief (probably a war memorial, 1922), but he was chiefly known as a portrait painter and miniaturist (for his miniature of Byam Shaw, see Byam Shaw exh., Ashmolean Museum 1986, cat.57, repr). By 1908 he was living at Southampton, and by 1910 at Albury, near Guildford. This was still his address when he showed his last picture at the RA in 1923.

153. **Pan** 1896

Oil on canvas, 91.5 × 196.2 (36 × 77¼)
Exh: RA 1896 (185)
Lit: *The Times* 25 May 1896, p4
This beautiful picture was the first of the very few imaginative subjects Metcalfe exhibited at the RA, and is the only one known to us today. It was painted in the studio at 95 Cheyne Walk which he shared at his period with Byam Shaw, whose picture *Silent Noon* (Leighton House), exhibited 1894, offers certain points of comparison. *The Times*, reviewing the Academy exhibition of 1896, described *Pan* as 'interesting from the courage with which the artist has thrown in a splash of red drapery in the centre'.
PRIVATE COLLECTION

154. *The Poems of Coleridge*

With an introduction by Ernest Hartley Coleridge and illustrations by Gerald Metcalfe.
London: John Lane 1907. 8vo
Inscribed in ink on the fly-leaf *To my dear friend, Byam Shaw, from Gerald Metcalfe Nov 1907*
The book is illustrated throughout with line drawings, 'The Ancient Mariner' inspiring most. There is an obvious affinity with the work of Byam Shaw, to whom this copy was given, but Metcalfe tends to strike a gentler, more lyrical note. Echoes of Rossetti and Sandys are present, and also of Laurence Houseman, especially in the way swirling drapery is used to create visual effects.
JAMES BYAM SHAW, CBE, D LITT

CHARLES SIMS
1873–1928

Sims was born in Islington, the son of a costume manufacturer; as a child he became lame as the result of a fall. After an early start in business, he underwent a varied artistic training (South Kensington; Académie Julian, Paris; RA Schools) in the early 1890s, and began exhibiting at the RA in 1893. The following year he married the daughter of the landscape painter John MacWhirter, and in 1900 they took a cottage at St Laurence, Essex, where Sims began to experiment with the breezy outdoor subjects for which he is best known. From the start his work received critical attention, pictures being bought for the Luxembourg 1897 and Sydney 1902; but it was his one-man show at the Leicester Galleries in 1906 that made his name. In 1907 *An Island Festival* had a great success at the Academy and he was elected ARA (RA 1915). In 1908 *The Fountain* was bought for the Chantrey Bequest; 1910 saw him elected ARWS; and in 1912 he won gold medals at Pittsburgh and Amsterdam. Possessed of remarkable technical fluency and a restless desire to experiment, he was now evolving a mixed tempera and oil technique and moving into a 'symbolist' phase with such works as *Sweet o'the Year* (Cat. 155) and the Puvisesque *Wood Beyond the World* (1913), another Chantrey purchase. More radical still were the consciously 'primitive' *Seven Sacraments* (exh. Dowdeswell's 1917), stimulated by the war, in which his eldest son was killed. In 1918 he was appointed war artist and sent to France, a traumatic experience from which he never fully recovered. In 1920 he was appointed Keeper of the RA Schools, holding the post till 1926. During the 1920s society portraits and murals both claimed his attention, and sometimes caused controversy; his portrait of George V (1924) failed to please and was destroyed, while his contribution to the murals in St Stephen's Hall (1925–7) was severely criticised. In April 1928 he committed suicide while staying with friends in Scotland. The six 'spirituals' which he had recently completed in a semi-abstract style, apparently the product of a seriously disturbed mind, were exhibited at the RA that summer, and his book *Picture Making*, rich in insights into the theory and practice of painting, appeared 1934.

Ref: Charles Sims, *Picture Making*, with a 'critical survey' of the artist's life and work by Alan Sims 1934; *DNB*

155. 'Then Comes in the Sweet o' the Year' 1913
Tempera and oil on canvas, 96.5 × 134.5 (38 × 53)
Signed *SIMS* (lower right)
Exh: RA 1913 (81)
Lit: *Royal Academy Pictures* 1913, p112; Sims, pp82, 116
The picture was shown at the Royal Academy in 1913, together with *The Wood Beyond the World* (Tate) and *The Coming of Spring* (whereabouts unknown), all three works being attempts at symbolism in terms of figures in extensive landscapes. According to Alan Sims, '*The Sweet o' the Year*' was 'more successful' than *The Wood Beyond the World*, which was bought for the Chantrey Bequest: 'with its company of babies advancing like opening flowers across the meadow, and great, cool, early-morning sky, it claimed to be nothing more than the serenest of rural fancies'.

Sims is one of a number of artists at this period, Anning Bell, Cayley Robinson and E R Frampton being others, who liked compositions in which the accents are kept close to the frame, leaving a large empty space in the centre. In '*The Sweet o' the Year*' he seems to be pushing this idea to extremes, seeing how far he can take it without going 'over the top' and creating an uncomfortable sense of vacuity. The title is taken from a line in *The Winter's Tale*, Act IV, scene 2.
MICHAEL HOLLOWAY and DAVID FALCONER

156. Syrid and Pattatos 1915
Tempera and oil on canvas, 61 × 75 (24 × 29½)
Signed *SIMS* (lower right)
Exh: RA 1915 (125); New English Art Club Centenary Exhibition, Christie's 1986 (99)
Lit: *Royal Academy Pictures* 1915, p60; Sims, p119
The picture is one of several that Sims painted about this time on the theme of a standing figure holding up a basket of flowers against the sky. Floating scarves originally descended from the basket but were painted out. This motif appears in a smaller watercolour variant entitled *Summertime* (Christie's, 12 June 1987, lot 63) and a related sketch (Christie's, 29 July 1988, lot 260). A further sketch is in the Bury Art Gallery.

Neither Syrid nor Pattatos are found in the standard classical dictionaries, and the title may be fanciful. It appears that Sims was not above such teasing. To confuse matters further, the picture is called *Syria and Pattatos* in his book *Picture Making*, but 'Syrid' is certainly the reading in the 1915 RA catalogue.
PETER ROSE and ALBERT GALLICHAN

157. Epilogue 1922–6 ill. p133
Tempera on canvas, 29.8 × 24.5 (11¼ × 9⅝)
Signed *SIMS* (lower right)
Exh: Contemporary British Painting, Ottawa 1925; RA 1926 (457) (?)
Lit: Sims, p127 and pl.39 (?)
A comparatively late work, aptly described by Alan Sims as 'Düreresque' in conception. Dürer's engraving

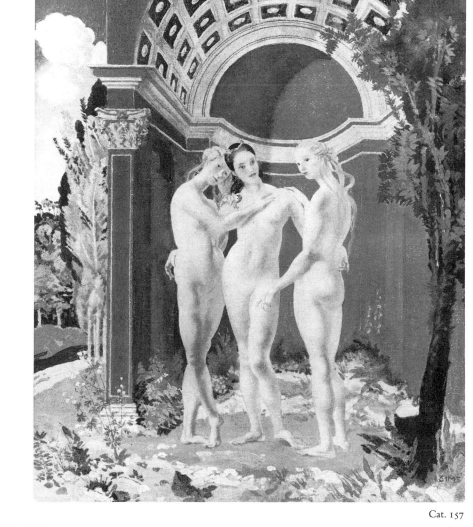

of *The Four Witches* is particularly reminiscent, and it is probably significant that Sims's design originated as a colour aquatint, exhibited at the RA in 1922 (see *Paintings, Water-Colours and Drawings from the Handley-Read Collection*, exh. FAS 1974, cat.72). Four years later he exhibited a painting of the same composition, again at the RA, but there is some doubt whether this is the present picture or a larger version. What is certain is that our picture belonged to Sir Edmund Davis, patron of Ricketts, Shannon, Dulac and many other artists of the period, appearing at his posthumous sale at Christie's, 7 July 1939, lot 89. For information on Davis, see Paul Delaney's essay above, and Simon Reynolds, 'Sir Edmund Davis, Collector and Patron of the Arts', *Apollo* June 1980, pp459–63.
CHRISTOPHER and JENNY NEWALL

158. Spring Song c1913
Watercolour over pencil, 17.1 × 22.2 (6¾ × 8¾)
Signed *SIMS* (lower right)
A sketch for the picture of this name which Sims painted in December 1913 and exhibited at the Royal Academy the following year (untraced; repr Sims, facing p82). The feeling of airiness, the 'lost and found' contours, partially dissolved in light, and the inventive handling of the paint, are all typical. In his book *Picture Making* Sims describes the techniques used for the finished picture, which was 'very quickly and easily painted'.
ERIC SLACK

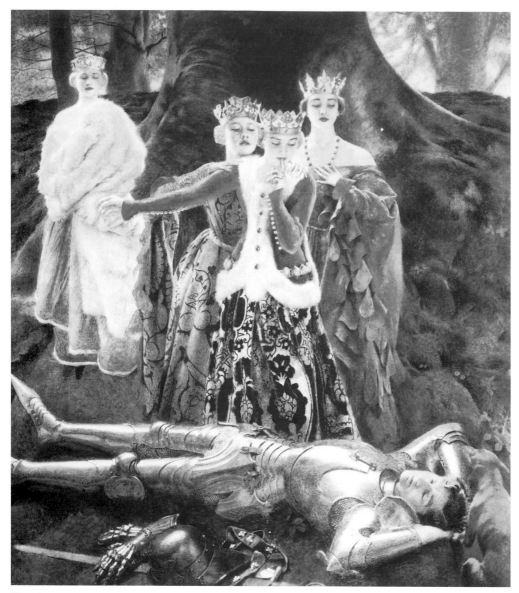

Cat. 161

FRANK CADOGAN COWPER
1877–1958

The son of Frank Cowper, a writer, he was born at Wicken, Northamptonshire, where his maternal grandfather was the rector. He studied art at the St John's Wood Art School and the RA (1897–1902), then spent six months in the studio of E A Abbey, followed by a period working in Italy. While exhibiting at the RWS, ROI, Paris Salon, etc, his main venue was the RA, where he showed regularly from 1899 until his death nearly sixty years later, becoming ARA in 1907 and RA in 1934. Throughout his life he painted subject pictures, historical, biblical and literary, although as the taste for these declined he turned increasingly to portraits, especially of young women. Having initially been influenced by the early work of the Pre-Raphaelites, he adopted a more 'Renaissance' style about 1906, laying great emphasis on the decorative effect of rich fabrics. Examples are *Vanity*, his RA Diploma work (1907), and *Lucretia Borgia Reigns in the Vatican* (Tate), bought for the Chantrey Bequest in 1914; also his contribution to the murals in the East Corridor of the Palace of Westminster

(1908–10), which are mainly Tudor in theme (see Cat. 82). His later work deteriorated and is often mawkish in mood, but he is generally regarded as one of the last exponents of the Pre-Raphaelite tradition, and as such was patronised by Evelyn Waugh. Having lived in London for most of his life, he moved to the Cotswolds after the Second World War, dying at Cirencester at the age of eighty-one.

159. St Agnes in Prison Receiving from Heaven the Shining White Garment 1905 ill. p27
Oil on canvas, 74.3 × 45.1 (29¼ × 17¾)
Signed and dated *F C COWPER 1905* (on masonry, lower right)
Exh: RA 1905 (636); Japan 1987 (59)
Venerated as a patroness of purity, St Agnes suffered martyrdom cAD 303 under the Emperor Diocletian. Having vowed to live a life of chastity, she refused the suit of a Roman youth, who had her stripped and imprisoned. In prison she was visited by an angel who brought her a robe, white as snow, to cover her nakedness, and when condemned to be burnt as a witch, she was again saved by heavenly intervention. Eventually she was despatched by the sword.

The picture is one of Cowper's most impressive works and the first of two to be bought for the Chantrey Bequest. It dates from the end of the early period when he was attempting to revive the original Pre-Raphaelite style, and in fact seems to borrow from certain specific paintings. Rossetti's *Annunciation* of 1850 (Tate) finds echoes in the subject, the relationship of the figures, the pose of the Saint and the motif of flames on the angel's feet. The realistic treatment of the straw recalls Millais' *Return of the Dove to the Ark* (Ashmolean), and there is perhaps even a hint of Madox Brown's *Take Your Son, Sir* (Tate) in the arrangement of the 'shining white garment'. For a more obvious debt to this picture, see Cat. 76.

160. The Morning of the Nativity 1908 ill. p135
Watercolour, 89 × 38 (33 × 15)
Signed and dated *F C COWPER MCMVIII* (upper centre)
In mood and colour the picture is unusually restrained for Cowper, but there are some characteristic borrowings. The pose of the Virgin and the hanging behind her suggest the influence of early Flemish paintings, while the sheep looking over the wattle hurdling were surely inspired by Millais' *Carpenter's Shop* (Tate). The picture seems to be the first of several versions. *The Nativity Morning*, an oil shown at the RA in 1916, was probably the same composition. *Our Lady of the Fruits of the Earth*, exhibited in 1917 and recently on the art market (Christie's, 24 June 1988, lot 97), certainly repeats the essential design, though details differ; it lacks the subtlety of the present picture but is richer in colour. Yet another variation is represented by a watercolour sketch in the Rose/Gallichan collection, showing the Virgin wearing a vivid blue robe and seated in a stable.
PETER ROSE and ALBERT GALLICHAN

161. The Four Queens Find Lancelot Sleeping 1954 ill. p134
Oil on canvas, 103 × 90.8 (40½ × 35¾)
Exh: RA 1954 (535); Japan 1983 (70)
Lit: *The Times* 1 May 1954, p7
The Four Queens Find Lancelot Sleeping is one of Cowper's last subject pictures. When exhibited in 1954, four years before his death, the art critic of *The Times* wrote: 'Mr F Cadogan Cowper, who must be the last Academician to have achieved the supreme distinction of having a rail put round his pictures to keep crowds at bay, shows another belated Pre-Raphaelite work'. It is indeed an astonishing case of Pre-Raphaelite survival. In subject, mood and technique it might belong to the 1900s. Only the features of the four Queens, who look like 1950s film stars, give a clue to its real date.

The subject occurs in the *Morte d'Arthur*, Book 6, ch.3. Morgan le Fay, 'Queen of the land of Gore', the Queen of Northgalis, the Queen of Eastland and the Queen of the 'Out Isles', discover Lancelot asleep beneath an apple-tree. Each wants him for her paramour, so Morgan le Fay lays him under enchantment and has him carried to her castle where he is asked to choose one of them. Faithful to Guinevere, he refuses, and eventually makes his escape. The theme had been treated by David Jones in a watercolour of 1941 (Tate) – much more 'modern' in style than the thirteen-year-later painting.

The motif of an armed knight lying full-length in the foreground also occurs in Cowper's picture *La Belle Dame Sans Merci* (private collection; repr C Wood 1981, p154), an exceptionally fine work of 1926. His RA exhibits include two other Arthurian themes, *The Damozel of the Lake* (1924; Christie's, 25 March 1988, lot 122) and *The Legend of Sir Percival* (1953).
PETER NAHUM, LONDON

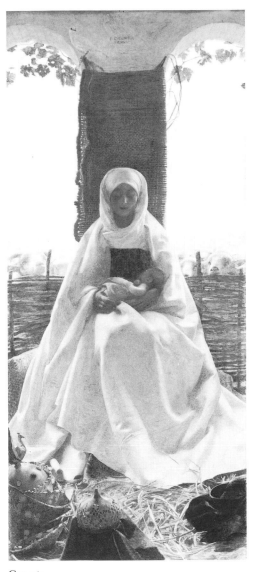

Cat. 160

DION CLAYTON CALTHROP
1878–1937

Son of the actor John Clayton (real name Calthrop) and a grandson on his mother's side of the Irish actor and dramatist Dion Boucicault. He was educated at St Paul's and studied art at St John's Wood, then at Julian's and Colarossi's in Paris. It was probably at St John's Wood that he met Byam Shaw, a close friend with a kindred interest in the stage. In the First World War he served in the RNVR (Commander 1916). A versatile artist and illustrator in early life, exhibiting at the RA 1900–3 and being co-editor of *The Idler* with Sidney Sime, he later became a prolific author of a whimsical cast of mind, writing many books on a variety of subjects from costume to the joys of fishing (some illustrated by himself, two by Eleanor Fortescue-Brickdale), and having plays produced in London and New York. From the late 1920s he lived in Dorset. *My Own Trumpet*, an autobiography, was published 1935.

Ref: *The Times* 9 Mar 1937, p14

162. **A Medieval Lady, Seated** *c*1900–5 *ill. p135*
Oil on panel, 35.2 × 22.2 (17⅞ × 8¾)
Signed *DION CLAYTON CALTHROP* (lower right)
An early work, close in style to both Byam Shaw and Frank Cadogan Cowper. Shaw used Clayton Calthrop as a model for one of his illustrations to *Ecclesiastes*, exhibited at the Dowdeswell Galleries in 1902, and Cadogan Cowper was to paint his portrait in 1915 (RA).

The idea of writing one's signature on a cartouche or label was also adopted by Byam Shaw, Cadogan Cowper and Eleanor Fortescue-Brickdale, and has sometimes caused this group to be known as the 'label school'.
PRIVATE COLLECTION

163. **Dion Clayton Calthrop, *The Guide to Fairyland***
Illustrated by the author
London: Alton Rivers 1905. 8vo
Like Cat. 162, the illustrations, drawn in pen and ink and watercolour, recall the work of Byam Shaw, though they strike their own note too. Many are humorous.
THE BRITISH LIBRARY BOARD

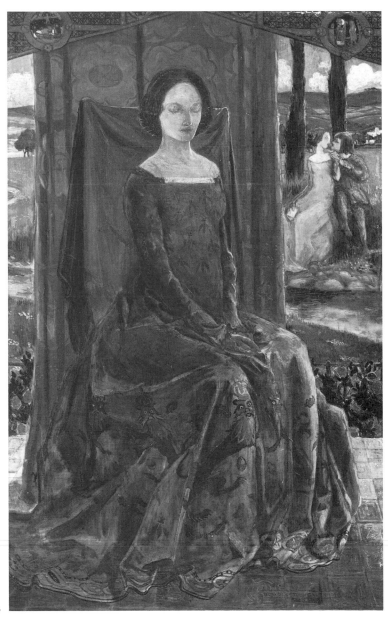

Cat. 162

Cat. 166

NATHANIEL SPARKS

1880–1957

Sparks was the son of an impoverished carpenter and violin repairer who was a cousin of Thomas Hardy. He studied at the Bristol School of Art and at the RCA under Frank Short, then worked for a while with Whistler, printing many of his Venice etchings. His own work as an etcher is uneven in quality and varied in style and subject, embracing landscape, architecture, figure compositions, portraits and copies after the Old Masters. A member of the Royal Society of Painter-Etchers, he also showed watercolours and prints at the RA (1906–37). In character he was touchy and vulnerable; his fellow etcher Malcolm Osborne was a close friend, and made a brilliantly sensitive portrait of him in 1921, but Sparks chose to quarrel with him the following year. He seems to have lived all his adult life in Battersea.

Ref: Guichard, p60; Artist as Model, exh. Garton & Cooke 1987, under cat.21

164. Christ before Caiaphas 1905

Etching, 37.5 × 47 (14¾ × 18½)
Signed and dated Nathaniel Sparks 1905 (in plate, upper right)
Sparks made his debut at the RA in 1906 with an impression of this large print. Like Cat. 165, the design

conveys something of his quirky artistic temperament, the counterpart to his personal idiosyncrasies. Particularly remarkable are the violent gesticulations of the accusers, reminiscent of some North Italian Mannerist. The two fowls at lower left no doubt refer to the denial of Peter, which is the sequel to the denunciation of Christ before Caiaphas.

Sparks etched a number of religious subjects about this time, others being The Sorrows of Job (1904), vaguely indebted to Legros, and a Rembrandtesque Descent from the Cross (1906).
THE BOARD OF TRUSTEES OF THE VICTORIA AND ALBERT MUSEUM, LONDON

165. Adam 1928–9

Line engraving in sepia, 26 × 21.3 (10¼ × 8⅜)
Inscribed in the plate To HH NS sculp (lower left) and signed Nathaniel Sparks in pencil (lower right)
The plate was engraved in memory of Henry Hardy, brother of Thomas Hardy and Sparks's second cousin; like the novelist, he died in 1928. Sparks worked in a number of styles, often reflecting his study of the Old Masters, and here he is clearly thinking of Dürer, both in terms of subject-matter and technique. The two famous engravings of The Fall of Man and The Knight, Death and the Devil were no doubt particularly influential. An impression of the print was shown at the RA in 1931.
PRIVATE COLLECTION

WILLIAM RUSSELL FLINT

1880–1969

Born in Edinburgh, the son of a commercial artist, Flint was apprenticed as a lithographic draughtsman to a firm of printers at the age of fourteen. In 1900 he moved to London, working part-time while studying art at Heatherley's, and in 1903–7 he was a staff artist with the Illustrated London News. From then on he worked freelance, soon graduating to illustrating books, notably the series of classics published by the Medici Society for the Riccardi Press (Cat. 167, 170). In 1905 he began to exhibit at the RA, becoming ARA 1924 and RA 1933; he was also closely associated with the RI (member 1910) and RWS (member 1917, President 1936–56) while holding many successful one-man shows. He is best known for his brilliantly controlled watercolours, particularly those of nudes in Mediterranean landscapes, which were widely disseminated through fine reproductions, but he is often more interesting when stretching himself in classical subjects in oils; Artemis and Cione (RA 1931; Preston) is an outstanding example. He was knighted in 1947 and a retrospective exhibition was held in the RA Diploma Galleries in 1962.

Ref: A L Baldry, 'A Romanticist Painter: W Russell Flint', Studio 60 1914, pp253–64; DNB

166. La Belle Dame Sans Merci 1908 *ill. p16*
Watercolour, 45 × 63.4 (17¾ × 25)
Signed and dated *W. RUSSELL FLINT 1908*
Exh: Liverpool Autumn Exhibition 1909 (546); Glasgow
Institute of Fine Arts 1909 (435)
An illustration to Keats's famous poem, treated by so
many Pre-Raphaelite painters and 'last romantics', this
is a particularly fine example of Russell Flint's early
watercolours with literary themes. It was bought from
the Liverpool Autumn Exh. in 1909.
TRUSTEES OF THE NATIONAL MUSEUMS AND GALLERIES ON
MERSEYSIDE, WALKER ART GALLERY

167. The Lovesick Goatherd 1913
Watercolour, 29.8 × 22.2 (11¾ × 8¾)
Signed and dated *W. Russell Flint MCMXIII* (lower
right)
Lit: *National Art-Collections Fund Review* 1988, p165, repr
One of Russell Flint's illustrations to the *Idyls of
Theocritus, Bion and Moschus*, translated by Andrew
Lang and published by the Medici Society for the
Riccardi Press 1922. A goatherd is seen trying to win
back his lover by song: 'Ah, lovely Amaryllis, why no
more, as of old, dost though glance through this cavern
after me, nor collect me, thy sweetheart, to thy side?'
The book, which appeared long after the artist had
made the drawings, belongs to the same series as the
Morte d'Arthur, Cat. 170.
TOWNELEY HALL ART GALLERY AND MUSEUM, BURNLEY
BOROUGH COUNCIL

168. Eve 1930
Etching, 18 × 26 (7⅛ × 10¼)
Signed *W Russell Flint* (lower right) and inscribed with
the title, etc below
One of two impressions in the British Museum, the
other being an earlier proof without the richly worked
background to right. According to the inscription, this
impression is on a French paper of 1753. Like Whistler
and other etchers, Flint liked to print his plates on good
old paper. As a young man he had worked for the paper
manufacturers, Dickinson's.
THE TRUSTEES OF THE BRITISH MUSEUM

169. Danae 1930
Etching, 12.5 × 17.4 (4⅞ × 6⅞)
Signed *W Russell Flint* (lower right) and inscribed with
the title, etc below
Inscriptions below the image indicate that this was the
fourth trial impression taken on 15 August 1930, on
paper dating from 1829.
THE TRUSTEES OF THE BRITISH MUSEUM

170. Sir Thomas Malory, *Morte d'Arthur*
Illustrated by W Russell Flint
London: The Medici Society for the Riccardi Press,
1910. 4to. Vols I and III of four vols
Perhaps the finest and certainly the best-known of the
series of books which Russell Flint illustrated for Philip
Lee Warner's Riccardi Press, other titles including *The
Canterbury Tales*, *The Song of Songs*, *The Idyls of
Theocritus* (see Cat. 167) and Kingsley's *Heroes*. Like
Chatto and Windus's Florence Press (see Cat. 108), the
Riccardi Press had a typeface designed by Herbert
Horne and was an attempt to bring the standards of the
private presses to the average book-buyer. Though
some may quarrel with the juxtaposition of fine
typography with plates reproducing watercolours
photographically, Flint's illustrations are remarkable,
technically brilliant and psychologically extremely
smart. Those for the *Morte d'Arthur*, which often bring
out the sexy and sadistic elements in the story, are
particularly characteristic. It is not surprising that they
won him a gold medal at the Paris Salon in 1913. Three
are in the V&A.
THE BRITISH LIBRARY BOARD

HARRY MORLEY
1881–1943
Born in Leicester, the son of a hosiery manufacturer,
Morley entered the Leicester School of Art to study
architecture in 1897. In 1901 he was awarded a
scholarship at the RCA, and in 1905 travelling
scholarships enabled him to go to Rome. During his
two-year stay the impact of Italian art led him to
abandon architecture for painting, and in 1908 he
spent six months studying at the Académie Julian,
in Paris. Returning to London, he settled in Kensing-
ton where he was to live for the rest of his life, marry-
ing Lilias Helen Swain, a skilful embroideress who
taught at the RCA, in 1911. His most interesting and
original works are his figure subjects, painted in a
monumental style reflecting the influence of the early
Italians and Cézanne, although he is probably better
known for the landscapes in the English watercolour
tradition which he made for relaxation on long family
holidays at home and abroad. He also carried out
commissioned drawings for travel books by E V
Lucas, Alfred H Hyatt and others.

Morley exhibited at the RA from 1905, having one
of his best pictures, *Apollo and Marsyas* (Cat. 171)
bought for the Chantrey Bequest in 1924 and being
elected ARA in 1936. He was also closely connected
with the RWS (Associate 1927, member 1931, Vice-
President 1937–41), and held a series of one-man
exhibitions in London galleries (1916–38). In 1923 his
long-standing interest in tempera caused him to join the
Society of Mural Decorators and Painters in
Tempera, just as his election to the Royal Society of
Painter-Etchers in 1929 reflected the importance of
print-making in his career. In 1919 he took up etching
under the guidance of Malcolm Osborne, but in 1928
he changed to line-engraving, a medium better suited
to his strong sense of form and taste for classical
themes. This development was influenced by Robert
Austin, Osborne's assistant and, like Morley, a Leices-
ter man. In 1928–9 Austin and his wife spent holidays
with the Morleys at Anticoli Corrado, a small hill-
town in the Abruzzi which furnished both artists with
subjects, and they shared an exhibition at the Leicester
City Art Gallery in 1930. During the 1930s the slump
forced Morley to accept a teaching post at the St
Martin's Schools of Art; he was also appointed to the
Faculty of Engraving at the British School in Rome
(1931), and published a series of articles on 'Figure
Painting in Oils. Theory and Practice' in *The Artist*
(September 1936–February 1937). In 1936 he joined
the Royal Society of Portrait Painters and was elected
Master of the Art Workers' Guild. In 1940 the
Morleys were bombed out of their London home and
went to live with their married daughter at Wool in
Dorset. There his last watercolours were painted and,
as an Official War Artist, he found subjects at Boving-
ton Camp and Falmouth. He returned to London in
1942, but his health, never robust, was deteriorating,
and he died on 18 September the following year.

Ref: Herbert Furst, 'Harry Morley. An Appreciation',
Apollo 1 1925, pp98–101; W Gaunt, 'The Art of Mr
Harry Morley', *Studio* 89 1925, pp123–8; Beryl Castle
and Julia Baron (the artist's daughters), *Harry Morley . . .
a biographical note*, Leicestershire Museums Publication,
no.30 1981; *Harry Morley*, exh. Julian Hartnoll 1982,
cat.; *Harry Morley*, exh. Milne and Moller 1988, cat. by
John Christian

171. Apollo and Marsyas 1924 *ill. p29*
Tempera and oil on canvas, 106.7 × 101.6 (42 × 40)
Signed and dated *Harry Morley 1924*
Exh: RA 1924 (226)
Lit: Furst, facing p100, repr
Marsyas, a brilliant performer on the flute, rashly
challenged Apollo to a trial of musical skill, on the
understanding that the loser would be flayed alive by the
winner. The Muses awarded the prize to Apollo, who
proceeded to deal with his opponent in the agreed
manner. Many artists have treated the theme, notably
Perugino in a picture in the Louvre which Morley must
have known.

Apollo and Marsyas was bought for the Chantrey
Bequest in 1924, a good choice since it is one of the
artist's most satisfactory compositions.
THE TRUSTEES OF THE TATE GALLERY

172. The Judgment of Paris 1929
Tempera and oil on canvas, 127 × 101.5 (50 × 40)
Signed *HARRY MORLEY* (lower left)
Exh: RA 1929 (401); Royal Scottish Academy 1930
A very characteristic example, obviously owing much
to the early Italians, especially Signorelli. The subject –
the famous beauty contest between Venus, Minerva and
Juno – clearly appealed to Morley, who had exhibited
a picture entitled *The Preparation for the Judgment of Paris*
at the RA in 1926. In fact, for obvious reasons, it
attracted many artists interested in the representation of
the nude. Watts and Burne-Jones had attempted it in the
1870s; Greiffenhagen had exhibited a version at the RA
in 1896; and George Spencer Watson was to do so in
1932.
PRIVATE COLLECTION

173. The Calydon Hunt 1931 *ill. p138*
Egg tempera on board, 27.3 × 38 (10¾ × 15)
Exh: *Paintings in Tempera and Water-Colours by Harry
Morley*, Beaux Arts Gallery, London 1934 (6); *Thirties*,
Hayward Gallery (Arts Council) 1979–80 (5.33)
Lit: Castle and Baron (n.p.) repr
During the 1930s Morley turned from large oil
paintings to smaller works in tempera, this being one of
a group of nine shown in a one-man exhibition in 1934.
He had used tempera as an underpainting for oils from
about 1915, but in 1923 he joined the Society of Mural
Decorators and Painters in Tempera, and met Maxwell
Armfield, Mary Sargant Florence and other exponents
of the medium; this led him to study the subject more
deeply, investigating early methods with the help of
Mrs Merrifield's translations and preparing his own
gesso panels. Also influential was the Royal Academy's
decision, taken in 1930, to accept works in egg tempera,
and no doubt it was easier to sell small works in the
financial climate of the thirties.

The picture's theme, much celebrated in antiquity, is
the hunt of the colossal wild boar which Diana sent to
ravage Calydon, a city of Aetolia, in revenge for being
neglected by King Oeneus. All the most eminent princes
of the time took part, and the boar was killed by the
King's son, Meleager.
PRIVATE COLLECTION

174. The Young Bacchus 1929
Line engraving, 17.5 × 12.5 (6⅞ × 4⅞)
Signed *Harry Morley* (below image, lower right)
Morley began to practice engraving under the guidance
of Robert Austin in 1928, and this is one of his earliest
plates. Issued in an edition of 60, published by Colnaghi
at 4 gns each, it is listed in *Fine Prints of the Year* 1930,
and reproduced in his daughter's *Biographical Note*.

An easel version in tempera was exhibited at the RA
in 1930 (exh. Julian Hartnoll 1982 (49, repr in cat.).
THE TRUSTEES OF THE BRITISH MUSEUM

Cat. 173

Cat. 178

175. The Infant Mars 1930
Line engraving, 14.8 × 10 (5⅞ × 4)
Signed *Harry Morley* (below image, lower right)
An example of the humour often present in Morley's work. There is perhaps an echo of the putti trying on the armour of Mars in Botticelli's famous painting of *Mars and Venus* in the National Gallery.
 Published by Colnaghi in an edition of 60, the print is reproduced in *Fine Prints of the Year* 1930, pl.31.
PRIVATE COLLECTION

176. Coursers 1931
Line engraving, 15 × 20.1 (5⅞ × 8)
Signed *Henry Morley* (lower right) and inscribed *7th state Jan 10/31* (lower left)
One of Morley's finest engravings, with a tremendous sense of movement and virility. Published by Colnaghi in an edition of 60, it was exhibited at the RA in 1931 and reproduced that year in *Fine Prints*, pl.33.
 This is the seventh state, of which five are in the British Museum. A related sheet of studies of greyhounds was included in Julian Hartnoll's 1982 exhibition, no.17.
THE TRUSTEES OF THE BRITISH MUSEUM

177. Bacchanal 1932
Line engraving, 17 × 15 (6¾ × 5⅞)
Signed and dated *HM 1932* in plate (lower right); signed again *Harry Morley* (below image, lower right)
For some reason this seems to be the most familiar of Morley's engravings with classical themes. An easel version, exhibited at the RA in 1938, also exists.
 The print is reproduced on the cover of Julian Hartnoll's 1982 exhibition catalogue.
THE TRUSTEES OF THE BRITISH MUSEUM

AVERIL BURLEIGH
active 1912–45, died 1949
Studied at the Brighton School of Art and lived in Brighton (7 Wilbury Crescent) until the Second World War, when she moved to Betws-y-Coed. The wife of Charles H H Burleigh (d.1956), a flower and landscape painter, she exhibited at the RA 1912–45, and was a member of the Society of Women Artists (1922), RI (1936) and RWS (1939). One-man exhibitions were held at the FAS 1925 and 1934. Her pictures embraced literary subjects, genre, landscape, portraits and still-life, and in the 1930s she worked much in tempera (cf Harry Morely, Cat. 173). She also illustrated books. Her main interest in the present context is the somewhat zany quality she brought to medieval themes.

Ref: 'Averil M Burleigh', *Studio* 58 1913, pp214–9

178. The Troubadour 1928(?) *ill. p138*
Oil on canvas, 49.5 × 54.5 (19½ × 21½)
Signed *Averil Burleigh* (lower right)
Exh: RA 1928 (889) (?)
The picture has recently been called *As You Like It*, but it corresponds to no scene in the play and it is tempting to identify it with *The Troubadour*, which the artist exhibited at the RA in 1928. In any case this date seems about right, and the title is appropriate.
 The picture provides a welcome note of humour. Not since Beardsley had anyone approached a medieval theme so tongue-in-cheek.
THE PICCADILLY GALLERY, LONDON

GEORGE OWEN WYNNE APPERLEY
1884–1960

Wynne Apperley, as he is usually known, came from a sporting and military family, his grandfather being Charles Apperley, or 'Nimrod', famous for his articles on hunting. He was educated at Uppingham and studied art under Herkomer at Bushey. In 1904 he went to Italy, the first of many European travels in search of subjects for the watercolour landscapes which were the staple of his early career. He began exhibiting at the RA in 1905 and was soon showing widely (RI, Paris Salon, etc), as well as holding annual one-man exhibitions; that at the Leicester Galleries in 1908 was particularly successful. His landscapes are bold and Sargentesque but he sometimes adopted a tighter, more Old Masterly manner, notably for an interesting group of imaginative subjects painted c1914–16 (see Cat. 179). This ambivalence of style was the subject of an exchange of letters between the artist and the critic P G Konody in the *Observer* in April 1915. In 1914, by now married with two children, he visited Spain, and two years later he settled in Granada, abandoning his family and later marrying the daughter of a local stonemason. Though he continued to paint landscapes and subject pictures, portraits of Spanish women and gypsies were henceforth the central theme of his art. Technically proficient and come-hitherish in feeling, these works proved popular. In 1918 he mounted a one-man exhibition in Madrid which was opened by the King and Queen of Spain. In 1945 he was awarded the order of Alfonso the Wise, and in 1951 elected a Distinguished Member of the Royal Academy of Fine Arts in Malaga. He died in 1960 in Tangier, where he had lived since the Spanish Civil War. In recent years, following his widow's death in 1980, he has been 'rediscovered', and several exhibitions of his work have been held.

Ref: *G O W Apperley*, Galeria Heller, Madrid 1984, cat.; *George Owen Wynne Apperley RI*, exh. by Bushey Museum Trust 1987, cat. by Grant Longman

179. **The Death of Procris** 1915 *ill. p139*
Watercolour with bodycolour, 77.5 × 133.3 (30½ × 52½)
Signed and dated *Wynne Apperley fecit 1915* (lower right)
Exh: RI 1916 (430)
Lit: R R Tatlock *A Record of the Collections in the Lady Lever Art Gallery* 1928, no.2820

This remarkable picture, one of a group of classical figure subjects that Apperley painted about 1914–16, has good claims to be his masterpiece. Eschewing the 'pin-up' approach to the nude in which he so often indulges, he rises here to true poetry and genuine emotion. The landscape itself is a considerable imaginative achievement, although possibly based on the Spanish scenery which he had seen for the first time the previous year.

Procris, daughter of Erechtheus, King of Athens, followed her husband Cephalus into the woods when he went hunting, believing that he had gone to meet his mistress. There she was accidentally wounded by him with an arrow, and died in his arms, confessing that ill-founded jealousy was the cause of her death. Apperley's picture owes much to the famous painting by Piero de Cosimo in the National Gallery, which was long thought to represent this subject. The grouping and poses of the figures, the extensive lake landscape and the little dog to the right, all go back to this source.

Like Cat. 11–12, the picture belonged to the first Viscount Leverhulme and was included in the deplorable sale of paintings and drawings from the Lady Lever Art Gallery, Port Sunlight, held at Christie's, 6 June 1958 (lot 1), when it fetched a derisory 3 guineas. Apperley had asked £200 for it in 1916. A watercolour sketch for the picture is in the same collection.
CHARLES CHOLMONDELEY

Cat. 179

DOROTHY WEBSTER HAWKSLEY
1884–1970

Born in London, the daughter of an instrument-maker and grand-daughter (on her mother's side) of a marine artist. She studied at St John's Wood and the RA Schools (Landseer scholar and life painting medallist), then taught for two years at the Women's Department of King's College, London, in Kensington, where Byam Shaw was also on the staff. She exhibited at the RA 1909–64, at provincial centres and the Paris Salon, and was a member of the RI and Society of Mural Decorators and Painters in Tempera. Her work consists mainly of subject pictures, with the occasional portrait, watercolour being her favourite medium. In the 1920s she evolved a flat schematic style that is highly personal though strongly influenced by Japanese prints and owing much to the early Italian masters and the example of Cayley Robinson; her later work tends to be more conventional (see her illustrations to the Gospel of St Luke, Eyre and Spottiswoode 1949), and at the end of her life she did large pull-out pictures for *Child Education*. For many years a close friend of Sir Sydney Cockerell, Director of the Fitzwilliam Museum 1908–37, she was one of the 'angels' who nursed him in old age at Kew. She lived all her life in London, settling after the war at 44 Redcliffe Gardens where another flat was occupied by Malcolm Osborne and his wife.

Ref: A K West, 'The Work of Miss D W Hawksley RI', *Studio* 84 1922, pp257–62; F G Mories, 'Dorothy Hawksley', *The Artist* January 1948, pp107–8

180. **The Brother of the Prodigal Son** 1924
Watercolour, 63.5 × 78.7 (25 × 31)
The picture represents the moment when the elder brother of the Prodigal Son, having worked steadily and conscientiously for his father, protests angrily at the celebrations laid on for his brother's return (St Luke, 15. 25–32). Another picture by the artist, *He Saw there a Man which Had not on a Wedding Garment*, purchased for Brighton Art Gallery in 1926, is comparable in theme and design but not so attractive in treatment.
OLDHAM ART GALLERY

181. **The End of the Day** 1925 *ill. p140*
Watercolour, 35 × 48.5 (13¾ × 19⅛)
Signed and dated *D.HAWKSLEY 1925* (lower right)
The picture is obviously influenced by Cayley Robinson, whom the artist probably knew. She certainly owned examples of his work, as did her friend Sydney Cockerell.
WILLIAMSON ART GALLERY AND MUSEUM, WIRRAL BOROUGH COUNCIL, DEPARTMENT OF LEISURE SERVICES AND TOURISM

182. **The Nativity** 1924 *ill. p140*
Watercolour with bodycolour, centre panel 102 × 53 (40⅛ × 20⅞), side panels each 102 × 23.5 (40⅛ × 9¼)
Signed and dated *D W HAWKSLEY 1924* (lower right of right panel)
Exh: RA 1924 (816); Watercolour Exh., Birmingham City Art Gallery, January 1928; *Painters in Tempera*, Kettering and Grantham 1958 (26)
Lit: The Times 12 May 1924, p19
The Times, noting that the picture had 'a place of honour' at the RA of 1924, aptly described it as 'a Botticelli conception under Chinese influence'. One might add that the way in which the figures approach through woods suggests that the artist was thinking of Van Eyck's Ghent altarpiece. She includes a self-portrait, drawing the scene, in the right side-panel, and a shepherd to the left wears a jellaba which was brought

home by her friend Sydney Cockerell from one of his visits to Wilfrid Scawen Blunt in Egypt (1900 and 1904). There are interesting changes of drawing, notably in the head of Joseph, who seems originally to have had his attention fixed on the Virgin and Child but who now looks up in surprise at the angel choir. Studies exist for

the pigeons at lower centre and left.

The artist used a similar triptych design for a watercolour entitled *Lung Ch'ing and the Beggar Maid* (National Gallery of Canada, Ottawa), exhibited at the RA in 1922.
BIRMINGHAM CITY MUSEUM AND ART GALLERY

Cat. 181

Cat. 182

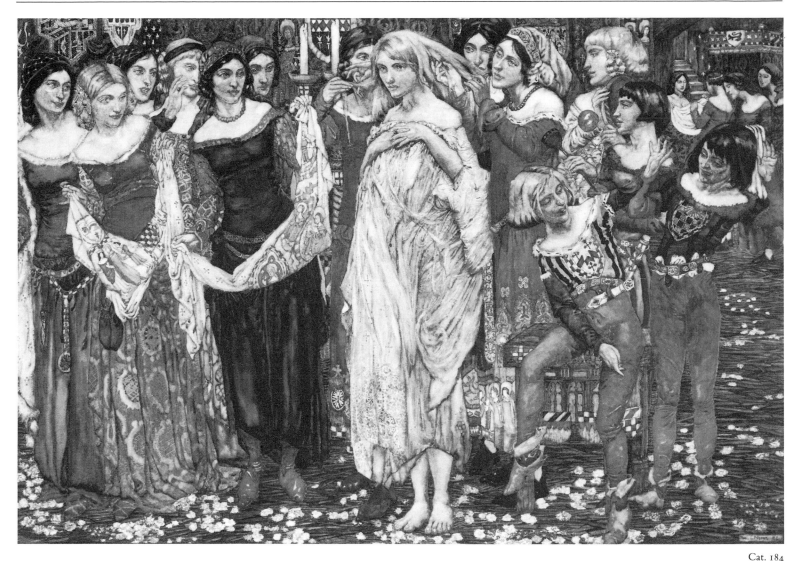

Cat. 184

NOEL LAURA NISBET

1887–1956

Of Scottish parentage, Noel was the youngest child of Hume Nisbet, artist, author and traveller, and his wife Helen, daughter of the Border sculptor, Andrew Currie. The family moved to London in 1887 and she grew up in Clapham, studying at the Clapham School of Art where she won numerous awards. In 1910 she married Harry Bush, a fellow student, and four years later they settled at 19 Queensland Avenue, a house on a new estate in Merton Park, SW19, where they were to live for the rest of their lives. Unlike Harry, who was quiet and retiring and made his name as a painter of suburban scenes, Noel was an extrovert character specialising in imaginative subjects, although she also painted portraits and flower-pieces. During the years of 1913–17 she illustrated five books of fairy tales and legends. She exhibited at the RA in 1914–38, belonged to the RI (1926) and British Watercolour Society (1945), and showed at many provincial centres. Acknowledging a debt to the Pre-Raphaelites, she worked in both oil and watercolour, though it was in the latter that she achieved her most characteristic effects.

Ref: *Harry Bush and Noel Laura Nisbet*, cat. of Studio Sale, Christie's, 28 September 1984

183. **The Procession** c1930
Watercolour, 66 × 99.5 (26 × 39⅛)
Signed *N L NISBET RI* (lower left)
One of the artist's more lyrical inventions, without too much of the wilful quirkiness, a little reminiscent of Ford Madox Brown, in which she often indulged. The form of the signature shows that the picture must have been executed after 1926, when she was elected to the Royal Institute of Watercolour Painters, and a date about 1929–30 is indicated by the processional compositon (compare *Come Lasses and Lads*, exh. RI 1930; Studio Sale, 1984, lot 132, repr in cat.).
MR AND MRS PETER THOMPSON

184. **The Dressing of the Bride** c1930–5 *ill. p141*
Watercolour, 67.3 × 99 (26½ × 39)
Signed *Noel L Nisbet RI* (lower right)
A representative example in every respect – types, costumes, colour scheme, frieze-like composition, ambiguous subject and decidedly sinister mood. There is something at once repellent yet fascinating about the artist's work, an obsessive quality that seems both out of keeping with her suburban background and a product of it.

The picture's date has not been established, but it would seem to be contemporary with Cat. 183, or possibly a little later.
JULIAN HARTNOLL

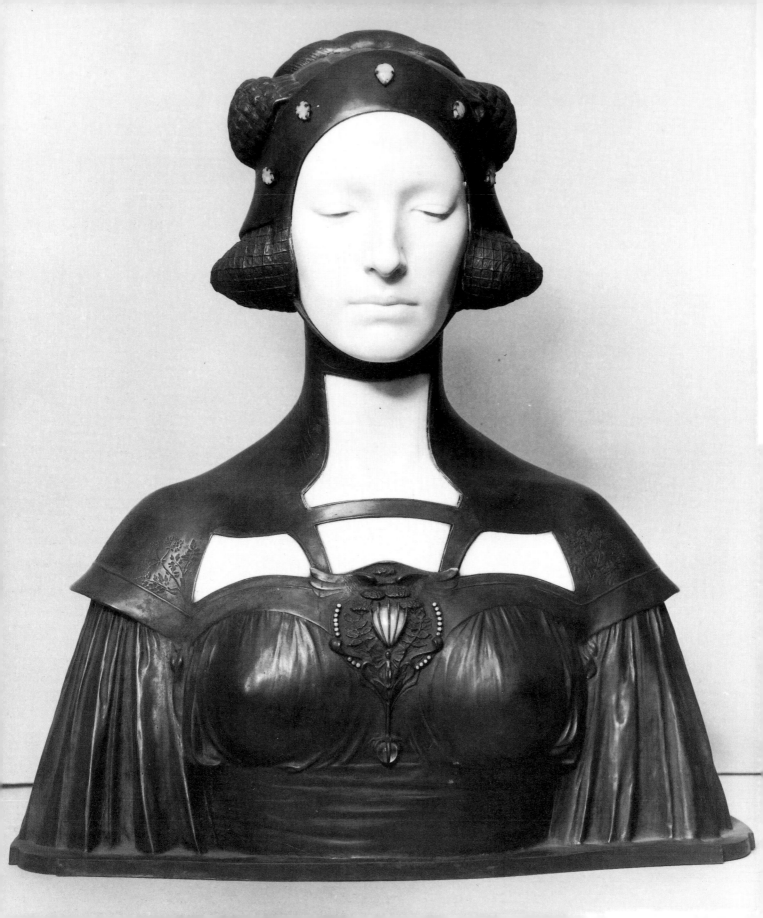

SCULPTURE

Cat. 187

THOMAS BROCK
1847–1922

Studied at the Government School of Design, Worcester, and the RA Schools (1867f). In 1866 he had become studio assistant to John Henry Foley and at the latter's death (1874) Brock completed certain of the major public monuments that had been Foley's *forte*. Brock rather took over Foley's mantle in this field – his many public statues range from Richard Baxter (1875; Kidderminster) through Robert Raikes (1880), Bartle Frere (1888 – both Thames Embankment, London) to Sir Henry Irving (1910; Charing Cross Road, London), Captain Cook (1914; The Mall, London) and at least eight public statues of Queen Victoria, including the National Memorial in London (1901–24; outside Buckingham Palace). Brock has been blamed for representing a steady, uninspired, derivative establishment competence, of no great originality or inspiration. But at his best – the London Victoria Memorial, the Black Prince (Leeds 1902) and *The Genius of Poetry* (Carlsberg Brewery, Copenhagen 1889–91 – a rare Ideal Work), Brock displays the positive virtues possible in a composite aggregation of the styles and influences of masters such as Foley, Alfred Stevens, Dalou and Gilbert, to a more than adequate degree. He became RA (1891), was knighted (1911) and a founder-member, RBS.

185. Sculpture 1902
Bronze, 39 × 35.5 × 27 (15½ × 14 × 10½)
Signed
Exh: Christchurch 1906–7; London 1908 (1331); (?) Rome 1911 (1084); FAS 1968 (20)
Lit: Birmingham 1987, no.42, p18 and repr
A study for the head of the figure of *Sculpture* at the base of Brock's Memorial to Lord Leighton in St Paul's Cathedral, London. Brock had given technical assistance to Leighton in the execution of the latter's *Athlete Struggling with a Python* (1874–7), his most important work in sculpture which some considered a major breakthrough in later 19th-century British sculpture. Leighton was also a strong force in encouraging younger sculptors both as an individual and as President of the RA between 1878 and 1896. So it is appropriate for sculpture to feature on his Memorial on a par with painting (see p61).
BIRMINGHAM CITY MUSEUM AND ART GALLERY

HARRY BATES
1850–99

Began as an architect's clerk. He became apprentice, then employee with the major firm of architectural sculptors Farmer and Brindley (1869–c1882) and trained at Lambeth School of Art (1879f) with Dalou, then the RA Schools. A stay in Paris (1883–5) and associations with Dalou and Rodin may have encouraged him to fuller modelling generally and subtler effects in relief. His mature work ranges over architectural sculpture (eg at Victoria Law Courts, Birmingham), portraiture, commemorative monuments

Opposite page: Cat. 193

(Lord Roberts 1896, Calcutta and Glasgow; Queen Victoria 1899, Dundee) and Ideal Work both freestanding and relief. Throughout there are mixed elements of idealised naturalism and classicism found (in his seniors) in Leighton and paralleled in contemporaries like Hamo Thornycroft, with whom Bates worked on the sculptural decoration of the Institute of Chartered Accountants, London 1889–93. Compare for mood, form and subject Bates's *Hector and Andromache* (1889; Manchester) with Leighton's *Wedded* (1882; Sydney), *Last Watch of Hero* (1887) and *Captive Andromache* (1888), both Manchester. Notwithstanding, Bates made of such associations a sculpted poetry all his own – his *Hounds in Leash* (1889), leaping out at the unwary visitor in an architect-designed setting at Gosford House, East Lothian, ranks as a masterpiece of the *fin-de-siècle*.

186. Mors Janua Vitae 1899 *ill. p54*; detail p60
Bronze, ivory and mother-of-pearl, height 94 (37)
Exh: RA 1899 (2050)
Lit: Beattie, pp155–6, 165, 167 repr
The subject which translates as 'Death the Gateway of Life', can be taken as representing a nude girl, Life, being taken up by the figure of Winged Death. But there are suggestions too of the more traditional Christian symbolism of the naked Soul, after death, being escorted to a new eternal life, by an angel, possibly even its own Guardian Angel. The figures are certainly poised above a miniature world complete with river and representations of St Paul's Cathedral, London and Nôtre-Dame in Paris. Around this base are found frieze figures recalling Leighton's *Daphnephoria* and Burne-Jones's trumpeting angels, these above reclining figures/mountains such as are found in G F Watts paintings like *Prometheus*, *Chaos* and *The Titans* (see p59 and Fig.19). The same title was to be used for specific mortuary objects by Alfred Gilbert (qv) – his shrine to Mrs McLoghlin, 1908 in the Royal College of Surgeons, London, and by Goscombe John (qv) for a funerary monument in Tunbridge Wells cemetery of c1919.
TRUSTEES OF THE NATIONAL MUSEUMS AND GALLERIES ON MERSEYSIDE, SUDLEY ART GALLERY

ALFRED GILBERT
1854–1934

Gilbert took to art only when thwarted of a surgeon's career. He studied at the RA Schools (1873f) and as assistant to Boehm on whose advice he went to Paris (1875–8). In Italy from 1878 to 1884, he there learned the lost-wax technique of casting bronze. Using this he sent back to London *Perseus Arming* (exh. 1882), the first of a series of major works that singled out Gilbert as the leader of his generation in sculpture. There followed *Icarus* (1884), *An Offering to Hymen* (1886) and other Ideal Works, plus public memorials to Henry Fawcett (Westminster Abbey 1885–7) and Queen Victoria (Winchester 1887). Whatever debts there may have been to the art of Gilbert's contemporaries or the past, there is in his work of all periods an almost extreme manipulation of the technical capacities of materials as well as layers of symbolism both overt and personal.

The 1890s saw no let-up: in addition to portrait

busts and public statues (*Joule*, Manchester 1890–4; *Howard*, Bedford 1894) Gilbert finished his Shaftesbury Memorial alias *Eros* (Piccadilly Circus, London 1886–93) and started the Clarence Memorial (Windsor 1892–9). Problems with the latter led to Gilbert's bankruptcy (1901) and exile in Bruges (1903f). He returned in 1926 to complete the Clarence Memorial and execute his swan-song, the Queen Alexandra Memorial (Marlborough Gate, London 1928–32).

Gilbert was member of the AWG (1888), RA (1892), Professor of Sculpture at the RA (1900) – some were subsequently suspended. He was knighted in 1932.

Ref: Richard Dorment, *Alfred Gilbert* 1985

187. St George and the Dragon, Victory Leading 1904–6; 1923 *ill. p143*
Bronze, 43.8 (h) × 31 (w) (17¼ × 12¼)
Exh: RA 1906 (1723); FAS 1968 (81); Whitechapel 1981 I (22); *Alfred Gilbert*, RA 1986 (101)
Lit: See *Alfred Gilbert* 1986, p186 for full details
Initial inspiration for this work came to Gilbert in 1904 in a dream, which may help to explain a certain surreal dimension of excitement. The idea was developed in the hope that it might be adopted as a Boer War Memorial: St George to be shown shouting out with joy, urging his horse over the dragon's corpse, with the horse prancing on its hind legs with fear, the dragon's body spread out over a pinnacled, turreted town. The memorial commission did not materialise, but Gilbert continued working on the group, modifying it and adding the figure of Victory. It was finally cast in bronze in 1923.
THE SYNDICS OF THE FITZWILLIAM MUSEUM, CAMBRIDGE

188. Cock on a Skull
? Study for the Sam Wilson Chimney-piece 1908–9
Wax on wire and split-cane framework on turned wood, height 23 (9)
Exh: (study) *Models and Designs by the late Sir Alfred Gilbert, RA*, V&A 1936 (35)
Lit: (for study) E Machell Cox, *Commemorative Catalogue of an Exhibition of Models and Designs by the late Sir Alfred Gilbert RA*, London 1936, p25, repr pl.XV; (for chimney-piece) I McAllister, *Alfred Gilbert* 1929, pp189–93; Beattie, p236, repr pls 238–40; Dorment, pp266–8
This is almost certainly a study for the Wilson chimney-piece now in Leeds City Art Gallery, properly called *A Dream of Joy during a Sleep of Sorrow*, on which Gilbert was working from 1908–13. The theme of the work as a whole was Gilbert's life and times. To the right of a

central panel (where Gilbert is represented asleep in the company of Death, Venus and chattering monkeys) a haloed figure holds a tablet on which Fame writes Gilbert's name; beside her, surmounting a skull stands a cock, symbol of the Dawn of Gilbert's fighting spirit (see Fig. 21). This group is paralleled on the left by a figure cradling a dead putto, from whose hand the Victor's wreath is slipping away; this symbolises the defeat of Gilbert's hopes. Such a context suggests a further possible symbolism of the cock and skull from the narrative of Christ's Passion, where the cock crows to signal Peter's betrayal as Christ is led out to be crucified at Golgotha, the place of the skull.

This study is shown being held by Gilbert in a portrait of him by the American painter, F P Paulus, of 1909.

LEEDS CITY ART GALLERIES

FREDERICK WILLIAM POMEROY
1856–1924
Apprenticed to a firm of architectural sculptors, he studied at Lambeth School of Art under Dalou and Frith and at the RA Schools (1880–5). He travelled to Paris where he studied with Mercié and went on to Rome. Though he exhibited statuettes and busts at the RA regularly from 1885, he was equally deeply involved with architectural and decorative sculpture, eg at Holy Trinity, Sloane Street, London; Paisley and Sheffield Town Halls; Welbeck Abbey; and the Central Criminal Court, Old Bailey, London (to name but a few). He was always aware of the decorative potential of fine-art sculpture at whatever the scale – see the sensitivity with which he handles his bronze *Perseus* figures whether over-life size or at statuette scale. He executed a number of public statues (eg Dean Hook, City Square, Leeds 1903; Monsignor Nugent, St John's Gardens, Liverpool 1906; Francis Bacon, Gray's Inn, London 1912). He was a member of the AWG (1887f; Master 1908), he exhibited with the Arts and Crafts Exhibition Society (1888f) and became RA 1917.

189. **Perseus** 1898 *ill. p144*
Bronze, height 51 (20)
Signed and dated *F W Pomeroy SC 1898*
Exh: RA 1898 (1964); Paris 1900 II, 9 (52); FAS 1902; London 1908 (1301); FAS 1968 (124); RA Bicentenary 1968 (696); Whitechapel 1981 I (11)
Lit: A L Baldry, 'The Work of F W Pomeroy' *Studio* 15 1898, p84; Spielmann, pp117, 119, repr; Read 1982, p319, repr pl.379; Beattie, pp177, 193, repr pls 178, 192
The work was first exhibited in 1898 'as a symbol of the subduing and resisting of Evil'. Baldry (op cit, p84)

called it the same year 'magnificently robust and masculine'. The full-scale (6ft 10in) original bronze is in the collection of the National Museum of Wales, Cardiff, but Pomeroy was responsible for issuing an edition of bronze reductions – a photograph exists of him with one of these (repr Beattie, pl.192). Further examples are to be found at the V&A, the Laing Art Gallery, Newcastle upon Tyne and the Ashmolean Museum, Oxford.
THE FINE ART SOCIETY

ALFRED DRURY
1856–1944
Trained at Oxford School of Art and the National Art Training School, South Kensington, studying under Dalou and Lantéri. He was in Paris 1881–5, working for Dalou, then returned to London, exhibiting at the RA from 1885, assisting Boehm and teaching briefly at Wimbledon School of Art (c1892–3). Drury's architectural sculpture has distinction (groups and figures representing The Honour of War, Victory, Justice, Truth and Fame for the War Office, Whitehall, London 1905; Inspiration, Knowledge and others on the façade of the Victoria & Albert Museum, London 1905–8; bronze pier figures on Vauxhall Bridge, London 1909). Certain Ideal Figures conceived for or placed in public contexts were at least different (*Circe* 1894, St Paul's Square, Leeds; the series *Morn* and *Even*, 1897–9 for City Square, Leeds); while the frequent examples of his *Age of Innocence* should not prejudice the appeal of his genre work. He also executed public statues and war memorials, was member of the AWG (1899) and RA (1913) but his output diminished in the 1920s and 1930s.

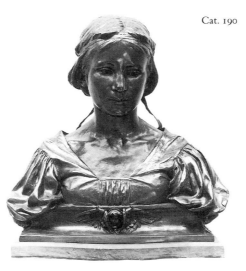

Cat. 190

190. **Griselda** 1896 *ill. p144*
Bronze, 53 × 48 × 25 (21 × 19 × 10)
Signed and dated *A. Drury 1896* (lower right)
Exh: RA 1896 (1836); Christchurch 1906–7
Lit: Spielman, pp112, 113, repr; Tate 1964, p157; Read 1982, p327
Griselda was symbol of patience in suffering in Boccaccio (*Decameron* X, 10), Petrarch (*De Obedientia ac Fide Uxoria Mythologia*) and Chaucer (*Canterbury Tales, The Clerk's Tale*) – see Cat. 194. She was a humble girl, married to a noble husband, who took her children from her and sent her back to her lowly background. But she endured patiently and without complaining and was eventually reinstated. The cherub on the base of the sculpture is symbolic of the hidden love that sustained her.
THE TRUSTEES OF THE TATE GALLERY

THOMAS STIRLING LEE
1857–1916
Trained at the RA Schools (1875–80) before going to Paris (1880–1) and Rome (1881–3). From an early date he took a close interest in the materials of sculpture, being pioneer with Havard Thomas in personally carving marble and assisting Gilbert in experiments in the lost-wax method of casting bronze. An early public success was winning the commission to execute marble relief panels on the exterior of St George's Hall, Liverpool (1882f), but these caused an outcry: one panel representing Justice (in the form of a naked young woman) in her Purity refusing to be diverted from her straight path by Wealth and Fame was judged indecent. The statuettes and reliefs Lee executed for the Adelphi Bank (also Liverpool 1892) show the extreme skills he brought to bronze casting – the relief scenes of Jonathan's Token to David, Achilles and the Body of Patroclus being almost dematerialistic. Lee also executed public statues (Bishop Gore, Birmingham 1914) and fine portrait busts (Margaret Clausen, Tate c1908; others at Bradford City Art Gallery) as well as architectural sculpture and Ideal Works. He was member of the AWG (Master 1898) and founder-member of the RBS and the NEAC.

191. **The Music of the Wind** 1907
Silver, height 66 (26)
Signed and dated *TSL SC/1907*
Exh: FAS 1968 (95); *Edwardian Reflections*, Cartwright Hall, Bradford 1975 (102)
Like the Gilbert chimney-piece (see Cat. 188 and Fig. 21) this work was commissioned direct from the artist by the Leeds industrialist and collector Sam Wilson. In both cases what resulted was an epitome of the artist's beliefs: with Lee, a finely modelled statuette in a special material, reflecting his interest (one he had shared with Gilbert from the 1880s) in the new forms and subjects of sculpture.
LEEDS CITY ART GALLERIES (SAM WILSON BEQUEST)

GEORGE FRAMPTON
1860–1928
Trained at Lambeth School of Art under W S Frith and at the RA Schools (1881f). He studied in Paris with Mercié (1888) before returning to London in 1889. From 1891 he showed a unique and remarkable series of Ideal Works – *St Christina* (shallow bronze relief, Liverpool) and *A Caprice* (mixed materials, statue) in 1891, *Mysteriarch* (tinted plaster bust 1893); *My Thoughts are My Children* (relief 1894). In these, symbolist thinking and technical experimentation merge with a formal language relating to certain types of Italian Renaissance sculpture. His practice extended to architectural sculpture (Ingram Street, Glasgow, reliefs 1896–1900; Lloyds Registry and Electra House, London, reliefs 1899–1902) as well as memorials (Queen Victoria, 1897f, for Calcutta, Leeds, St Helen's, Southport and Winnipeg; Mitchell relief, Newcastle upon Tyne 1893; Howitt relief, Nottingham 1900 2). He also executed more straightforward portrait busts, reliefs and statues, especially 1900f, though continuing with Ideal Works. He exhibited at the RA 1884f, the Arts and Crafts Exhibition Society 1893f and in Brussels, Vienna and Munich. He taught sculpture at the Slade and was joint head (with W R Lethaby) of the Central School of Arts and Crafts. He was member of the AWG (Master 1902), RA 1902, RBS founder-member and knighted in 1908.

Cat. 189

192. not in exhibition

193. **Lamia** 1899–1900 *ill. p142*
Bronze, ivory and opals, 61 × 55 (24 × 21¾)
Signed and dated *George Frampton 1899* (back) *George Frampton 1900* (side)
Exh: RA 1900 (1970); RA, Winter 1933 (602); RA Bicentenary 1968 (888); Whitechapel 1981, I (19)
Lit: *Studio* 20 1900, pp269, 270, repr; Spielmann, pp93, 94, repr; Maryon, fig.14; Read 1981, p45; Read 1982, p315; Beattie, pp160–2 and repr
On first looking into Frampton's *Lamia*, the average spectator may perhaps not appreciate the fantastic implications behind her polychrome stillness, mixing colour, magic and ultimate deadly whiteness. In Keats's poem, Lamia is part 'palpitating snake . . . of dazzling hue, vermillion spotted, golden, green and blue . . . at once some penanced lady elf/some demon's mistress, or the demon's self . . . Her head . . . serpent, but ah bitter-sweet!/She had a woman's mouth with all its pearls complete'.

Transformed through Hermes' divine agency, with colourful writhings and convulsions, she enchants and ensnares a young man. Their union is being celebrated when she is challenged by the stare of the young man's philosopher/guru:

'Begone, foul dream!' he cried, gazing again
In the bride's face, where now no azure vein
Wander'd on fair-spaced temples; no soft bloom
Misted the cheek; no passion to illume
The deep-recessed vision: – all was blight;
Lamia, no longer fair, there sat a deadly White.

Frampton has captured this moment, as philosophy triumphs over fiendish magical beauty (and imagination?). The wraith vanishes and the young man falls dead.
ROYAL ACADEMY OF ARTS, LONDON

194. **Chaucer** 1902–3
Marble, 76 × 64 × 50.5 (30 × 25 × 20)
Exh: RA 1903 (1746)
Lit: Spielmann, p93; *The Works of Art of the Corporation of London*, Cambridge 1986, p338 and repr
Commissioned to be placed in the City of London Guildhall to commemorate the 500th anniversary of the poet's death in 1400.
GUILDHALL ART GALLERY, CITY OF LONDON

195. **Madonna of the Peach Tree** 1910
Bronze
Exh: RA 1910 (1760); Rome 1911 (1119)
'Madonna of the Peach Tree' was a short story by Maurice Hewlett (1861–1923) published in 1899 in a collection entitled *Little Novels of Italy*. It tells of an old man marrying a young wife, in Verona; she becomes associated with a handsome friar which gives rise to scandal and while her husband is absent she is driven out of the city with her newborn child. No sooner has she vanished from the scene than a Madonna and Child begin a series of seemingly miraculous appearances to shepherd boys, drunks and the city's tyrant. She in turn disappears, mother and child return and the child is proved conclusively to be the old man's son. Described as perhaps the most perfect short story created by Hewlett and one of the most fascinating stories produced by his generation, the author still felt it necessary to defend the story on the ground of morality.
BRADFORD ART GALLERIES AND MUSEUMS

196. **Peter Pan** 1913
Bronze
Inscribed and signed (on base) *Dear Mr Harcourt/Little Peter Pan would be/much honoured if you would kindly accept the bronze/statuette of himself as a souvenir of his grateful/thanks for the sympathetic interest you took in securing/for*

him such a charming abode in Kensington Gardens/Yours very truly/George Frampton/March 20th 1914
Exh: RA 1911 (1960); FAS 1968 (51)
Lit: Lord E Gleichen, *London's Open-Air Statuary* 1928, p69; Read 1982, pp315, 317 and pls 375, 376
The prime version of this figure is in Kensington Gardens, London, erected in 1912 at the spot where the subject (in Sir James Barrie's story *Little White Bird* 1902) alights for his nightly visit to the gardens. The character was popularised in Barrie's play of the same name of 1904: Frampton's figure was possibly modelled on Dion Boucicault who first played the role, though there is also evidence that both character and figure relate to real models, the Llewellyn Davies brothers to whom the childless Barrie was very close.

Other full-scale versions of the work exist in Sefton Park, Liverpool, and Bowring Park, St John's, Newfoundland; Frampton also produced many at a reduced scale, reflecting the appeal of this perpetual child of magic and fairyland, who was imbued also with a certain painful nostalgia for his lost, unattainable world.
THE HON. MRS GASCOIGNE

WILLIAM GOSCOMBE JOHN
1860–1952
John had an exceptional background and training. He started work with his father, a woodcarver employed in the decorative work designed by William Burges for Cardiff Castle and Castell Coch (1874f). He then served as pupil-assistant to Burges' stonecarver Thomas Nicholls in Lambeth (1881–6) while studying at Lambeth School of Art (under Frith) and the RA Schools (1883–9). He then travelled extensively in Italy, Greece, North Africa, Spain, finally taking a studio in Paris where he was in contact with Rodin and returning to London, 1891. John's œuvre ranges widely and can incorporate drama and imagination, not just in Ideal Works but also in implicitly staider commemorative commissions. It includes portrait busts, funerary monuments and public statues, both in Wales (Cardiff, Llandaff especially) but also London (Sullivan Memorial, St Paul's Cathedral 1902, Thames Embankment 1903), Eastbourne, Liverpool (King's Regiment Memorial, 1904–8 and others), Port Sunlight, India and Baghdad. John's fine handling of modelling for bronze (eg *Boy at Play*, Tate 1895–6; gold medal, Paris 1900) is maintained at smaller scale in his medals, jewellery and insignia (many examples at the National Museum of Wales, Cardiff). He was a member of the AWG (1891), RA 1909, and knighted 1911.

Ref: F Pearson, *Goscombe John at the National Museum of Wales.* Cardiff 1979

197. **The Elf** 1898/1910
Bronze, 102 × 58.5 × 58.5 (40 × 23 × 23)
Signed *W Goscombe John*
Exh: RA 1898 (1960); RA 1899 (2047); Paris 1900 II, 9 (32); Christchurch 1906–7; London 1908 (1431); Rome 1911 (1148); FAS 1968 (90); Cardiff 1979
Lit: Spielmann, p130 and repr; RA 1939, p43, no.146; *Sir William Goscombe John RA LLD Sculpture in the National Museum of Wales*, Cardiff 1948, p9, no.2 and pl.V; F Pearson, *Goscombe John at the National Museum of Wales*, Cardiff 1979, cat. no. 51, pp13, 35 and repr, 80, 82
First exhibited in 1898 with a quotation from Victor Hugo:

C'est nous qui, visitant les gothiques églises,
Ouvrons leur nef sonore au murmure des brises;
Quand la lune du tremble argente les rameaux,

Le pâtre voit dans l'air, avec des chants mystiques,
Fôlatrer nos chœurs fantastiques
Autour du clocher des hameaux.
The nude sprite crouches on a ruined fragment of architecture; Spielmann wrote of it: 'This weird, eerie figure, quaint in feature, form, and attitude, twisted yet graceful, is a perfect embodiment of the idea at which the sculptor aimed'.

A marble version (RA 1899) is in Glasgow Art Gallery; reduced bronze versions exist at Newport (Gwent) and Merthyr Tydfil Art Galleries.
ROYAL ACADEMY OF ARTS, LONDON

198. **Merlin and Arthur** 1902 (RA)
Bronze, height 52.5 (20⅝)
Exh: RA 1902 (1618); Christchurch 1906–7; Cardiff 1979
Lit: *Sir William Goscombe John RA LLD, Sculpture in the National Museum of Wales*, Cardiff 1948, p11, no.10 and pl.XIV; F Pearson, *Goscombe John at the National Museum of Wales*, Cardiff 1979, cat. no. 59, pp38 and repr, 80
In spite of a cosmopolitan (not to say international) training and career, Goscombe John retained strong links with his Welsh, Celtic background. He was involved – with Poole (qv) and Turner (qv) among others – in the scheme to decorate Cardiff City Hall with statues of Welsh historical figures (1912f); he also executed the Hirlas Horn for the Gorsedd of Bards (1898–9; Welsh Folk Museum, St Fagan's), the Chaplet, Sword, Verge and Ring of the Prince of Wales Investiture Regalia (1911; Royal collection on loan to the National Museum of Wales, Cardiff) and many commemorative works in Wales. It was thus not unnatural for him to illustrate figures from Welsh history and mythology such as this and Cat. 197. A similar commitment is to be found in Scotland (cf Pittendrigh McGillivray, *Thenew, mother of St Kentigern*, Glasgow Art Gallery 1915) and Ireland (cf Oliver Sheppard, *The Fall of Cuchulain* 1911, General Post Office, Dublin).

The principal version of this work is in the National Museum of Wales, Cardiff; others exist in Bradford City Art Gallery and private collections.
GLYNN VIVIAN ART GALLERY, SWANSEA MUSEUM SERVICES, SWANSEA CITY COUNCIL

ARTHUR GEORGE WALKER
1861–1939
Painter, illustrator and mosaic designer in addition to his main career as sculptor. He trained at the RA Schools (1883–8). His decorative work included mosaics for the Greek Church, Bayswater; Evangelist symbols on a church in Stamford Hill (Church of the Ark of the Covenant) and two of the niche figures on the façade of the Victoria & Albert Museum. He executed war memorials at Bury St Edmunds, Derby, Hawarden and Limehouse, but his main public monument is that to Florence Nightingale in Waterloo Place, London 1915; he also executed the relief memorials to her in St Paul's Cathedral and St Thomas' Hospital. Much of Walker's œuvre consisted of portrait busts (Havelock Ellis, Ipswich Museum 1914) – some of these he executed in mixed media (Duchess of York, RA 1925, ivory and marble). But he also made Ideal groups and statuettes (*The Thorn*, Copenhagen Museum 1896), often classical but sometimes Christian. Walker was a member of the AWG (1892f – his bust of his friend Stirling Lee belongs to the Guild) and RA 1936.

199. **Christ at the Whipping Post** 1925
Ivory and marble, 58.4 × 22.9 × 17.8 (23 × 9 × 7)
Exh: RA 1925 (1413)

Lit: National Gallery, Millbank 1929, p397; Tate 1964 II, p751

Walker applied the new concerns of sculpture at the turn of the century to traditional, specifically religious works – see his emblematic symbolist evangelist figures (in bronze and stone) on the Church of the Ark of the Covenant, Stamford Hill, London of c1895 and, later, his intricately modelled *Madonna and Child* statues at Wells and Llandaff cathedrals. The present work utilises at statuette scale the full range of polychromy and mixed materials used earlier by Frampton and Reynolds-Stephens (see Cat. 192–3, 200–1). By this date though only Bayes (qv) remained a consistent poly-chromist, particularly in his ceramics and metalwork.

THE TRUSTEES OF THE TATE GALLERY

WILLIAM REYNOLDS-STEPHENS

1862–1943

Born in America of British parents, but left in early childhood. He first trained as an engineer then turned to art about 1882; he attended the RA Schools (1884–7) where he won the Landseer scholarship for sculpture and a prize for painting. A concern for art in all forms and degrees as well as experimentation with different materials and processes characterised his output, though he exhibited only sculpture at the RA after 1894. But his decorative scheme for the drawing-room at 185 Queen's Gate, London, included a vast painting, a relief frieze and ceiling cove, plus electric light-fittings, all by him, and such versatility is equally evident in his decorative work at St Mary, Great Warley, Essex (1903f). His sculpture includes letterboxes, bonbonnières, portrait busts and statues, funerary monuments and war memorials. But it was perhaps in his Ideal, fancy works that his 'passion for poetic imagery' (Hutchinson) and technical wizardry were most effectively united (eg *Castles in the Air* 1901; *Love's Coronet* 1903) – and particularly his Arthurian and historical groups. He was a member of the AWG, founder-member of the RBS (President 1921–9, gold medallist) and knighted in 1931.

Ref: G Seton Hutchinson, *The Sculptor, Sir William Reynolds-Stephens, PRBS 1862–1943. A Biographical Note.* Nottingham 1944

200. A Royal Game 1906–11

Electro-deposit copper, pewter and woods, with various metals and inlays, 241 × 233 × 99 (95 × 91¾ × 39)
Exh: London 1908 (1421); RA 1911 (1751)
Lit: NGBA 1914, p217; Maryon 1933, fig.319; Beattie, pp233, 236, repr
Described in 1914 as 'An allegory of the contest between England and Spain for the rule of the seas'.
THE TRUSTEES OF THE TATE GALLERY

201. Guinevere's Redeeming (?)1907 ill. p146

Bronze, ivory and enamels, 91.5 × 43 × 43 (36 × 17 × 17) (without plinth)
Signed *W Reynolds-Stephens*
Exh: (?) RA 1905 (1823); RA 1907 (1845); London 1908 (1459); FAS 1968 (126); Whitechapel 1981 I (23)
Lit: Beattie, pp167, 168 repr
Exhibited with a quotation from Tennyson's *Idylls of the King*:

> And so wear out in almsdeed and in prayer
> The sombre close of that voluptuous day.

Four scenarios on the base of the work reinforce the full, double-edged message, representing Guinevere's Past As Lover and As Queen, with her Redeeming By Prayer and By Giving Dole. Other versions exist: fully polychrome (dated 1905) at Warrington Museum and Art Gallery, plain bronze at the Harris Museum and Art Gallery, Preston.
NOTTINGHAM CASTLE MUSEUM AND ART GALLERY

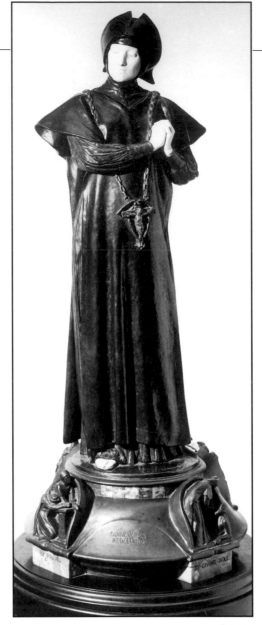

Cat. 201

ALBERT TOFT

1862–1949

Born in Birmingham of a family of Staffordshire artists in pottery and silverwork and his first experience and training was very much in applied and industrial art. He was apprenticed as modeller at Elkington's, then moved to Wedgwood's, before going on to art school at Hanley, Newcastle-under-Lyme, then finally at South Kensington (1881–3) under Lantéri. Even his earliest exhibited works (RA 1885f) were often in the more industrial medium of terracotta. On the basis of his practice as portrait sculptor he took to Ideal Works of a determinedly spiritual nature (all about Life, Fate etc) and even when he took up commemorative statuary (Queen Victoria, Leamington 1902; Nottingham 1905; Edward VII, Highgate Park, Birmingham 1913) the supporting allegories (Education and Progress, Peace, alongside Edward VII) are often the most effective part. And granted a certain spirit of Gilbert about Toft's Ideal Works, one should not be surprised that he functioned as a sort of unofficial aide to Gilbert in his troubled years. But Toft's expert control at formal modelling remained his own. He was member of the AWG (1891) and the RBS (1938). His book *Modelling and Sculpture* (1924) is useful.

202. The Spirit of Contemplation 1899–1900

Bronze, 97 × 101 × 55.9 (38 × 35¾ × 22)
Signed *Albert Toft*
Exh: RA 1901 (1694); RA 1903 (1703); St Louis 1904 (218); London 1908 (1403); Rome 1911 (1210); Whitechapel 1981 I (13)
Lit: Spielmann, pp122, 123, repr; Read 1982, pp352, 353, repr; Beattie, pp174 repr, 176
One of a series of statues of naked ladies with fancy names exhibited in the 1890s and 1900s. Standing or seated, they could be called *Love the Conqueror* (Pomeroy, qv, 1893), *Destiny* (Lucchesi 1895), *The Myrtle's Altar* (Lucchesi 1899/1900) or *Fata Morgana* (J M Swan 1900). Toft's figure is on a throne decorated with figures of Courage, Philosophy, Life and Love, no doubt the objects of the subject's contemplation.
LAING ART GALLERY, NEWCASTLE UPON TYNE (TYNE AND WEAR MUSEUMS SERVICE)

CHARLES JOHN ALLEN

1862–1956

Allen was apprentice, then workman, with the firm of architectural sculptors Farmer and Brindley (1879–89). He also studied at Lambeth School of Art, under Frith (1882f) and at the RA Schools (1887f). In 1890, the year he began exhibiting at the RA, he became chief modelling assistant to Hamo Thornycroft, until going to University College, Liverpool, in 1894 to teach sculpture and modelling at the School of Architecture and Applied Art. He moved on to Liverpool School of Art from 1905 to 1927. His early years in Liverpool were spent in association with Robert Anning Bell (especially), Herbert MacNair, RLIB Rathbone and (briefly) Augustus John. The focus of the teaching at the School was very much the practicalities of art in a decorative, applied context. Allen nonetheless executed fine-art works – *Love and the Mermaid* (RA 1895; Walker Art Gallery, Liverpool) won him deserved acclaim, even if it owes something to Boehm's *Cupid and Mermaid* of 1889–91 (Woburn Abbey). Allen's major work, the Queen Victoria Memorial in Liverpool (1902–6), combines realism ('Engineering' group) with the idealisation of Thornycroft and Stevens ('Learning' group). Allen was member of the AWG (1894f).

Ref: Mary Bennett, *The Art Sheds 1894–1905*, exh. cat. Walker Art Gallery, Liverpool 1981

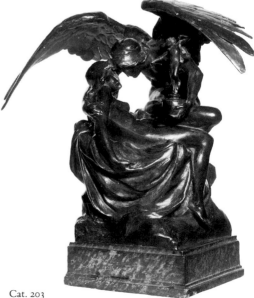

Cat. 203

203. A Dream of Love 1895 ill. p146
Bronze on marble base, 33.8 × 37 × 25 (13⅜ × 14½ × 9⅞)
Signed and dated 1895
Exh: RA 1896 (1915); Christchurch 1906–7; London
1908 (1337); Rome 1911 (1072); FAS 1968 (1); *The Art
Sheds 1894–1905*, Walker Art Gallery, Liverpool 1981 (3)
Lit: Spielmann, pp148, repr, 149; Birmingham 1987,
no.1, pp10, 11 repr
Described by Spielmann (op cit) as 'graceful in
composition and silhouette, poetic, too, and full of
pretty passages', this is one of a series of statuettes on the
subject of love which Allen exhibited between 1890 and
1908. *Love and the Mermaid* (bought by the Walker Art
Gallery, Liverpool, in 1895) was produced by Allen in
an 18 inches high version of the 46 inch original
specifically for drawing-room and chimney-piece
display.
BIRMINGHAM CITY MUSEUM AND ART GALLERY

EDGAR BERTRAM MACKENNAL
1863–1931
Born in Australia, son of a Scottish architectural
sculptor. He studied with his father and at Melbourne
School of Art before coming to London in 1882. He
briefly attended the RA Schools before proceeding
to Paris where he received advice from Rodin. In
England again in 1886 he started exhibiting at the RA
before returning to Australia to execute sculpture on
Parliament House, Melbourne. Back in Paris by 1892
and London (1894f) Mackennal continued with
architectural sculpture and Ideal Works (*Salome,
Truth, Diana* etc) but he became more involved in
public sculpture: Queen Victorias in Blackburn, Bal-
larat, Edward VIIs in London (Waterloo Place 1921),
Melbourne, Adelaide and Calcutta, plus the same
king's funerary monument at Windsor. He executed
war memorials at Highbury, Blackburn, Cliveden
and the House of Commons; his Eton College war
memorial was unusual – an advancing, life-size
entirely nude youth entitled *Here Am I*. (The work
has since been moved and sold.) One of his last great
works is *Phoebus Driving the Horses of the Sun* (1924)

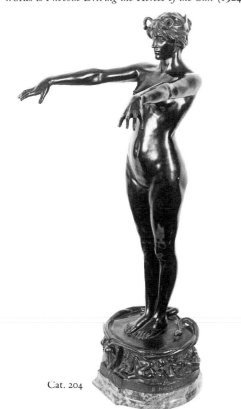

Cat. 204

on Australia House, Strand. He designed the George
V coinage, was member of the AWG (1905),
knighted 1921, RA 1922.

Ref: Noel Hutchinson, *Bertram Mackennal*. Melbourne
1973

204. Circe 1893 ill. p147
Bronze, 60.3 × 23.5 × 24.7 (23¾ × 9¼ × 9¾)
Signed *B. Mackennal*
Exh: Paris, Salon 1893 (3125, repr p269); RA 1894
(1863); Paris 1900 II, 9 (45); Christchurch 1906–7;
London 1908 (1305); Rome 1911 (1166); FAS 1968
(106); RA Bicentenary 1968 (693); Whitechapel 1981
I (10)
Lit: *Magazine of Art* 1895, pp390, 391–2; Spielmann,
pp132–3, 134, repr; *Studio* 44 1908, p266
Circe the enchantress bewitched the followers of
Odysseus and turned them into swine (see Homer's
Odyssey). 'On sending *Circe* to the Academy . . . a
surprise awaited Mr Mackennal. The plinth on which
the statue stands is decorated with a flowing series in
high relief of small nude figures in animated action and
surmounted by a coiled snake. Thus the sculptor
indicates the swine, the debased creatures who have
drunk of Circe's wine, though he was concerned in the
doing it rather with the greater value these abrupt
masses of light and shade were giving to his figure than
the allegoric significance of the forms themselves. In
Paris, however, his interpretation of the legend was
accounted to him as poetry. Not so did it appeal to the
Hanging Committee at Burlington House (ie Royal
Academy, London). They were conscious of the merits
of the work and anxious to secure its exhibition, but the
base appeared to them, to use their own words, 'as not
being in accordance with the exigencies of the
exhibition'; and courteous negotiations resulted in the
diplomatic compromise of the retention of the statue in
a place of honour, and the covering of the base from
public view with a swathing of red baize' (*Magazine of
Art*, loc cit).
Mackennal cast at least eight different versions of this
small-scale statuette; there are other examples at
Birmingham Museum and Art Gallery and the galleries
at Sydney and Adelaide.
CITY OF EDINBURGH ART CENTRE

FRANCIS DERWENT WOOD
1871–1926
Trained at Karlsruhe, South Kensington (under Lan-
téri) and the RA Schools, while also modelling for
industrial art concerns (ceramics and foundrywork)
and assisting Legros and Brock. He exhibited at the
RA from 1895. In 1897 he went briefly to Paris, then
became Modelling Master at Glasgow School of Art,
before returning to London in 1901. His Glasgow
work is revolutionarily unlocal – architectural sculp-
ture (eg at 816/8 Govan Road) equal to the best in
London, portraiture (busts of Margaret Somerville,
Lord Campbell, Christian Institute) remarkable for
modelling and character. His portraits remained
forceful (eg busts of Henry James, 1914, Boston
Public Library; Christine Sickert, RA 1925, Walker
Art Gallery, Liverpool) whereas the Machine Gun
Corps Memorial, alias *David* (Hyde Park Corner,
London 1925) represents by this date the end of the
neo-Renaissance tradition of Gilbert, Lee and
Pomeroy. Wood's later years teaching (Professor,
RCA 1918–23; RA Schools) were perhaps similarly
retardataire. He executed memorials (Queen Vic-
toria, Edward VII for India; others in Hull, Ripon
and Westerham) and some Ideal Works (eg *Atalanta*
1907–29; Manchester City Art Gallery; Chelsea
Embankment, London). He was member of the
AWG, RBS and RA from 1920.

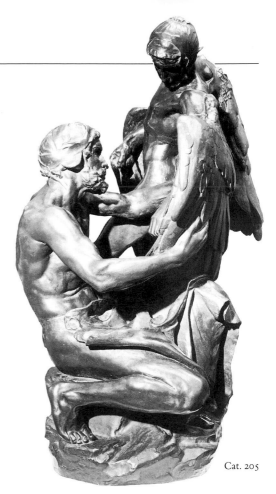

Cat. 205

205. Daedalus and Icarus 1895 ill. p147
Bronze
Lit: *Studio* 6 1896, p243, repr
A cast in bronze of Derwent Wood's winning entry for
the RA gold medal of 1895; Henry Poole (qv) had also
entered. A plaster version exists in the Russell Cotes
Museum, Bournemouth. The choice of subject for this
competition was pre-ordained, and though not always
classical, the education system for trainee sculptors had
for long been based on antiquity, owing to the sizeable
supply of originals in London (Elgin Marbles etc). This
subject had a particular point to it, though, in that it
echoes a painting of the same subject by the then
President of the RA, Lord Leighton (exh. RA 1869 now
at Buscot Park, Faringdon collection). It also harks back
to Alfred Gilbert's *Perseus Arming* (exh. 1882) and, in
title, to Gilbert's *Icarus* of 1884 (for these, see pp53, 59).
CITY OF BRISTOL MUSEUM AND ART GALLERY

GILBERT BAYES
1872–1953
Bayes was the son of a painter and etcher (A W Bayes)
and brother of the painter and illustrator Walter
Bayes. He studied at the City and Guilds School, then
at the RA Schools (1896–9), sponsored by Frampton.
He exhibited at the RA from 1889 and travelled in
France and Italy from 1899. His work embraced a
wide range of scales, functions, settings and subject-
matter – from medals and doorknockers, through
decorative reliefs for public housing schemes, public
and private fountains, war memorials, to large-scale
reliefs and statuary on public buildings (Art Gallery
of New South Wales, Sydney 1906–23; *The Queen
of Time*, alias Selfridge's Clock, Oxford Street,
London 1931). At the same time he drew from
romance, antiquity, Wagner even, for more strictly
fine-art, free-standing and relief works (*The Valkyries*
relief, RA 1898; *The Sea-King's Daughter*, various ver-
sions, RA 1913–19). He won a gold medal and

Diploma of Honour at the Paris 1925 Exhibition of Decorative Art; his frieze on the Saville Theatre, London won the RBS silver medal in 1931. He was member of the AWG (1896f; Master 1925) and President, RBS (1939–44).

206. Sigurd 1910 (RA)

Bronze and enamel on marble base, 87.5 × 94.5 × 56 (34⅞ × 37¼ × 21½) (inc. base)
Inscribed, trans. from Lombardic: *He who would win to the Heavens and be as the Gods on high/Must tremble nought at the road and the place where men-folk die*
Exh: RA 1910 (1913); Rome 1911 (1078); FAS 1968 (11); RA Bicentennial 1968 (431)
Lit: National Gallery, Millbank 1929, p8; Maryon 1933, fig.197; Tate 1964, p32
Sigurd (otherwise known as Siegfried) was the hero of William Morris's verse saga *Sigurd the Volsung* published in 1876. He is here represented 'after he has slain the dragon which guarded a mighty treasure, ridden the fire of Brynhilde, and won the helm of aweing, which he is wearing, and which was part of the treasure. He is riding the horse Greyfell and swings the dwarf-wrought sword "Wrath". His helm crest, surtout and saddle cloth bear the image of the dragon; the saddle cloth also bears in enamel the "Branstock" tree which supported his father's house and into which Odin struck the Wrath when he first gave it to the Volsung' (National Gallery, Millbank, op cit, p8). The reliefs on the base show Brynhilde with the Niblung brothers Gunnar, Hogin and Guttorm, and their mother Grimhilde, and the body of Sigurd taken to burial.

Sigurd was a central hero of Northern mythology incorporating the virtues commemorated in the inscription from Morris's saga on the work's base (see above). A secular version of such a hero for the late 19th century was symbolised in G F Watts' *Physical Energy* (Kensington Gardens of c1883–1906), to which Bayes may have been indebted. There are elements also in Bayes' equestrian sculpture of the work of Jean-Louis Gérôme (cf *Timour-Ling* 1898) which he could not have missed when he was in Paris in 1899 and 1900.

Other versions of this work exist at the Sudley Art Gallery, Liverpool and the Ashmolean Museum, Oxford.
THE TRUSTEES OF THE TATE GALLERY

207. The Lure of the Pipes of Pan (1932) ill. p148

Artificial stone, 137 × 92 (c54 × 36)
Signed
Exh: RA 1933 (1592)
Lit: Birmingham 1987, no18, pp12, 13, repr
An example of Bayes' continued vigorous classicism of the 1920s and 1930s. The basic relief style can be related to Bayes' extensive work on buildings (eg Saville Theatre frieze, Shaftesbury Avenue, London 1931; Commercial Bank of Scotland panels, Wellington Street, Glasgow 1935/36). But in twinning (so to speak) these reliefs back to back, Bayes can incorporate drama into his presentation.
BIRMINGHAM CITY MUSEUM AND ART GALLERY

HENRY POOLE

1873–1928

Poole was the son of a sculptor and trained at Lambeth School of Art under Frith (1888–91) and the RA Schools (1892–7). He also worked for Harry Bates and G F Watts. Until his mid-thirties his main concern was with architectural sculpture, eg at Rotherhithe (1897) and Deptford Town Halls and from 1900 at Cardiff City Hall. He had exhibited at the RA from 1894 but from about 1908 portrait busts and statuettes became the main part of his work. But his public statue of Edward VII at Bristol (1912) is given a fuller setting by fountains, also by Poole, and his reredos figures for the chapel of St Michael and St George, St Paul's Cathedral (1924) are obviously part of an architectural setting. His *Little Apple* group (Tate 1927) is quite emphatically 'carved' in stone, so Poole clearly brought the decorative and material concerns of his earlier years to his fine-art work. He was member of the AWG (1906) and RA 1927.

208. Young Pan 1928 ill. p148

Marble, 41 × 23 (16¼ × 9)
Signed and dated *Henry Poole, Sc., 1928*
Exh: RA 1928 (1491); Hove Art Gallery, *1927: The Exhibition of the Year* 1987
Lit: RA 1939, p61, no.80
It was an accepted convention at the RA for sculptors to present Diploma works in the form of busts – see *Joseph Henry Green* by Henry Weekes (1863) or *The*

Marchioness of Granby (Violet Duchess of Rutland) by Frampton (qv) (1902). In Poole's case he turned to the still valid mythological figure of the Great God Pan, whose continued presence in the English countryside was affirmed by Maurice Hewlett (see p61). As if to stress the subject's elemental force, the more finely finished head emerges from a much rougher-hewn marble block, a motif of execution used by Rodin in his production of marbles to emphasise the physicality of the material. Versions of Poole's *Pan* exist cast in bronze, including one in the Tate.
ROYAL ACADEMY OF ARTS, LONDON

CHARLES LEONARD HARTWELL

1873–1951

Trained at the City and Guilds School under Frith and the RA Schools (1896f). He also studied privately with Onslow Ford and Hamo Thornycroft. His exhibiting career at the RA spanned fifty years (1900–50), specialising in portraiture and genre. The latter was not always highly serious – *A Foul in the Giant's Race* (Tate 1908) involves four elephants – but *The Goatherd's Daughter* (Courtauld Institute 1929) is a serious study and won the RBS Silver Medal in 1929. Hartwell executed a few public statues (Perak; Delhi), war memorials (eg King's College School, Wimbledon; Newcastle upon Tyne) and funerary monuments (Sir W Ramsay, Westminster Abbey 1922; Hamo Thornycroft, St Paul's Cathedral 1932) but his speciality seems to have been commissioned portrait busts (Sir H Bartlett for University College, London 1922; Lord McNaghten for Lincoln's Inn 1926). He became RA in 1924.

209. The Oracle 1924 ill. p148

Marble, 32 × 19 (12½ × 7½)
Signed *Charles L Hartwell* (on back)
Exh: RA 1925 (1343)
Lit: RA 1939, no.148, p38
Hartwell's *Oracle*, like Poole's *Pan* (Cat. 208) utilises the bust form for Diploma Work and, like Poole's, uses a subject of classical derivation, rather than portrait representation.
ROYAL ACADEMY OF ARTS, LONDON

Cat. 207

Cat. 208

Cat. 209

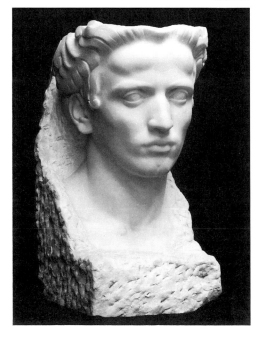

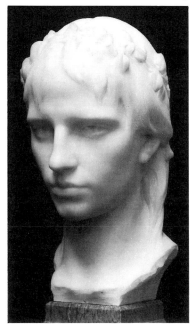

ALFRED TURNER
1874–1940

Turner was the son of the sculptor C E Halsey-Turner. He trained at Lambeth School of Art under Frith and worked for a time as assistant to Bates as well as attending the RA Schools (1895–8). In his earlier years he executed some work for decorative, architectural settings and won commissions for three statues of Queen Victoria (Delhi 1902, Tynemouth 1902 and Sheffield 1904). But his preference was for Ideal, poetic subjects along the lines of Bates and inspired more importantly by the work of the painter G F Watts (eg *Death and Innocence*, RA 1905; *Cycle of Life*, RA 1913). Turner's major public work was his South African War Memorial at Delville Wood, France (unveiled 1926) in which he took figures from antiquity, Castor and Pollux, and used them at colossal scale to symbolise the twin efforts in war of the English and Dutch races. Turner had always been a true carver, but in his later works (he exhibited at the RA up to 1937) he definitely emphasised their materiality to a greater degree (*The Hand*, Tate 1936). He was founder-member RBS (1904f), RA 1931 and taught at the Central School of Arts and Crafts (1907–34, 1937–8).

Ref: N Penny, *Alfred and Winifred Turner*, exh. cat. Ashmolean Museum, Oxford 1988

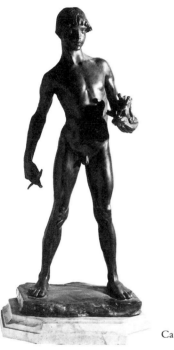

Cat. 210

210. **Dreams of Youth** (?) 1914/32 *ill. p149*
Bronze, 71 × 28.5 (28 × 11¼)
Signed *Alfred Turner*
Exh: (?) RA 1914 (2161); (?) RA 1915 (1841); RA 1932 (1520); Oxford 1988 (3)
Lit: *Alfred and Winifred Turner*, exh. cat. by Nicholas Penny, Ashmolean Museum, Oxford 1988, pp43–4
Probably the final revised version of a work Turner showed at the RA in 1914 and 1915. Inspired by G F Watts and Harry Bates (in whose studio he had worked) Turner produced works symbolic, for instance, of youth wondering at the unfolding of life. This figure carries a miniature St George and the Dragon, after Turner's 1927 design for a car mascot; this in turn may have originated in a war memorial design.
ROYAL ACADEMY OF ARTS, LONDON

Cat. 211

SYDNEY MARCH
1876–1968

March was one of a family of sculptors originating in Hull. He trained first with the sculptor Keyworth, then went to Hull School of Art (?1889f) before going on to the Royal College of Art and the RA Schools in London. In 1902 a family studio started at Goddendene, Kent, where soon twelve brothers and one sister worked together, each with a particular speciality – eg Walter supervised the technicalities of the bronze casting and the marble carving; Dudley who had trained as a goldsmith finished off the patination of his brothers' works. Sydney's main independent public works were war memorials at Omagh and Belfast, the United Empire Loyalists Memorial at Hamilton (Canada), and the equestrian statue of Lord Kitchener at Calcutta (replica at Khartoum). He executed portrait busts of the eminent and was said to be the only sculptor to whom Cecil Rhodes sat in his later days. He exhibited intermittently at the RA (1901–32).

Ref: Fred Whyler, *Goddendene and the March Family* – typescript at the Local Studies Library, London Borough of Bromley

211. **Orpheus Descending Hades** 1903 (RA)
ill. p149
Bronze, height 51 (20)
Exh: RA 1903 (1743)
Orpheus was a classical subject with added edge to it, of appeal to the age because of its magic and tragic implications. Unlike Hercules who basically wins through his Labours by being a blend of Rambo and Superman, Orpheus, through his art, does not just win over his audience but actually casts a spell over them. Reclaiming his wife Eurydice from Hades through the power of music symbolises not just the triumph over Death of art and magic, but of love also; only to assume a tragic dimension through Orpheus' failure to observe the essential condition of not looking at Eurydice until they had returned to Earth, on pain of her return to the underworld. Both Leighton and Watts had treated the theme as did the animal painter Briton Riviere (from a slightly different viewpoint), the animalier painter-sculptor J M Swan and Charles Ricketts (see Cat. 316).
THE FORBES MAGAZINE COLLECTION, NEW YORK

ERIC GILL
1882–1940

Gill was engraver and letter-designer as well as sculptor. He studied at Chichester School of Art before being apprenticed to an architect (1900–3). He began further study at the Central School of Arts and Crafts with Lethaby and Edward Johnston and took up inscription work in 1903. He began carving figure sculpture in 1910, at first possibly quite deliberately 'primitive' in style and effect. His first major sculpture work, *The Stations of the Cross* at Westminster Cathedral (1913–18) again seems almost neo-Romanesque, but this would be quite in line with Gill's identity as a very individualistic heir to the attitudes of the neo-medievalist, post Pre-Raphaelite Arts and Crafts movement. By the 1920s a certain smoother assurance was evident, especially in his favourite subjects, nude women (*Mankind*, Tate 1927–8; *Eve*, Tate 1928). But he considered himself clearly an outsider, though his employment on major schemes of public architectural sculpture (London Underground Headquarters, St James's 1928; League of Nations Palace, Geneva 1935–8) indicate the high value in which he was regarded. He was a man obsessed equally by art, sex and religion (he was converted to Roman Catholicism in 1913) and he wrote extremely ably on all three, as well as on politics and society.

Ref: *Autobiography* 1940; *Letters* (ed Walter Shewring) 1947

212. **Prospero and Ariel** 1931 *ill. p149*
Caen stone, 127 × 46 × 36 (50 × 18 × 14)
Exh: Leicester Galleries, April 1935 (175); Whitechapel 1981 I (134)
Lit: Tate 1964, pp230–1
Through the agency of Herbert Read, Gill was commissioned to execute a group to go above the main entrance of the new BBC headquarters in Portland Place, London. Gill was not happy with the subject of Prospero and Ariel, the magician and his sprite from Shakespeare's *Tempest*, which was chosen by the BBC to symbolise broadcasting. He thought the group should be taken in a spiritual manner, representing as much God the Father sending forth the Word, His Son. Gill executed three versions of the group, the present one being one third of the size of that still in Portland Place.
THE TRUSTEES OF THE TATE GALLERY

Cat. 212

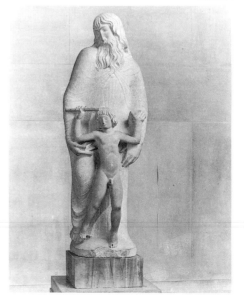

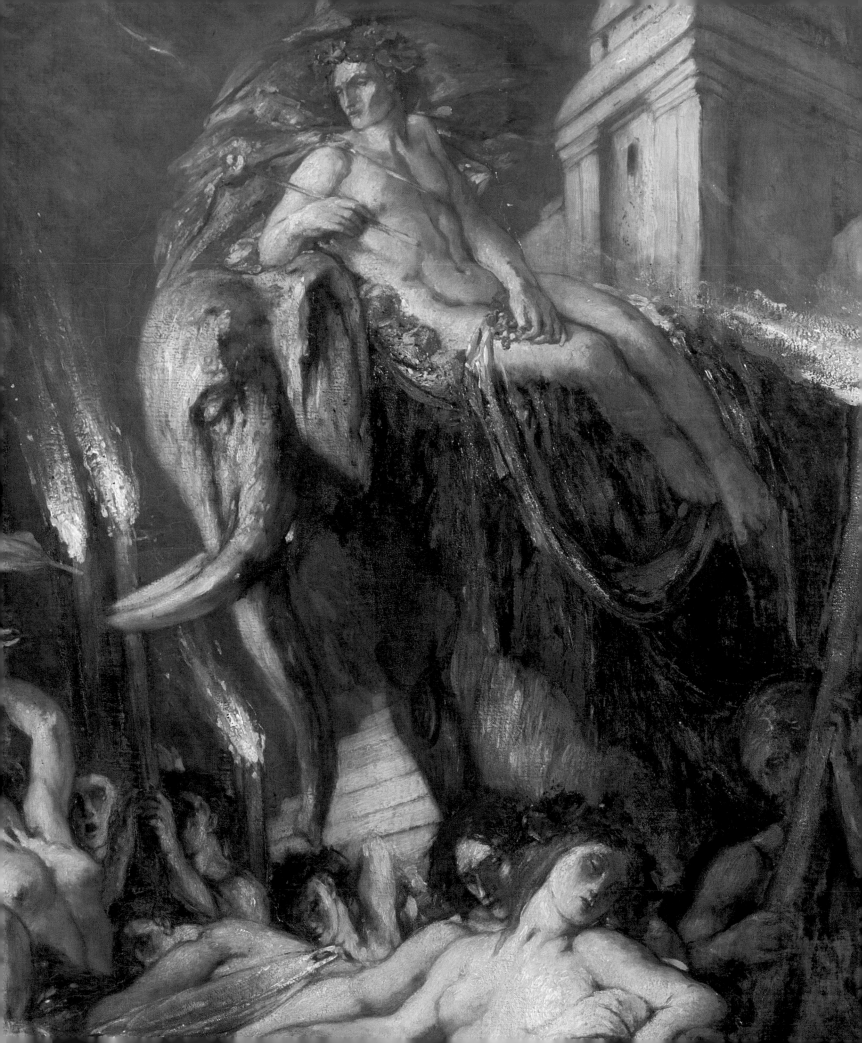

RICKETTS, SHANNON AND THEIR CIRCLE

REGINALD HALLWARD
1858–1948

Trained at the Slade and South Kensington, Hallward was deeply involved in the Arts and Crafts, designing stained glass and other church furnishings and running the Woodlands Press at Shorne, near Gravesend, c1895–1913. Here he produced books by himself and his wife Adelaide Bloxham, printing them lithographically with hand colouring in a style indebted to Blake. James Guthrie worked for him 1897–9; their vision has much in common and it would be interesting to know who influenced whom. Guthrie seems the dominant personality yet Hallward was sixteen years his senior. This close relationship is seen not only in book production but in the paintings by Hallward that have appeared on the market in recent years. He exhibited with the Arts and Crafts Exhibition Society, also at the Grosvenor, RA (intermittently 1888–1942), RBA and NEAC. In the 1880s, like so many exponents of the Arts and Crafts, he lived in Hammersmith. After the period at Shorne he seems to have divided his time between Ealing and Pembrokeshire, an area which inspired many of his later landscapes.

Ref: Reginal Hallward, exh. Christopher Wood Gallery 1984, cat. by Christopher Newall

213. **Elijah and the Ravens** c1905(?) ill. p151
Oil on canvas, 213.3 × 90.2 (84 × 23)
Exh: Christopher Wood Gallery 1984 (11, as *The Little Copse Wood*)
One of Hallward's largest works and most original conceptions. The title has recently been changed since the picture seems to show the prophet Elijah being fed by ravens after calling down a drought on Israel to punish King Ahab. An unfinished painting of the subject by Burne-Jones, worked over a stained-glass cartoon of 1874, is at Birmingham.
CHRISTOPHER WOOD

214. **Don Quixote Sets Out** c1910(?)
Oil on canvas, 110.7 × 101.6 (44 × 40)
Exh: Christopher Wood Gallery 1984 (2)
The story of Don Quixote clearly had some special appeal for Hallward, who painted at least one other picture on the theme (exh. Christopher Wood Gallery 1984, no.3, repr in cat.). Several other 'last romantics' attempted it. Heath Robinson illustrated the book in 1897, William Strang produced a set of etchings in 1902, and there are drawings by E J Sullivan and H J Ford in the V&A (E.1044–1933).
CHRISTOPHER WOOD

215. **Evening Games** before 1927
Oil on board, 24.7 × 36.8 (9¾ × 14½)
Exh: New Society of Artists 1927; Christopher Wood Gallery 1984 (13)
One of Hallward's Pembrokeshire landscapes. Note his curious technique of working in transparent glazes over

Opposite page: Detail Cat. 228

Cat. 213

a solid layer of paint, the textures of which cut across the forms.
CHRISTOPHER WOOD

216. **A Burial by Moonlight** c1930
Chalks on blue paper, 21.5 × 28 (8½ × 11)
The design seems to owe something to Blake's *Procession from Calvary*, now in the Tate Gallery. This had been in the national collection since 1884 and Hallward would doubtless have known it.
MICHAEL HOLLOWAY AND DAVID FALCONER

217. **Reginald Hallward,** *The Religion of Art*
With 'illustrative accompaniment' by the author
London: Heath Cranton 1917. 8vo
The book takes the form of a subjective meditation on the theme summed up by the words of Dostoevsky printed on the title-page: 'Beauty will save the world'. It is dedicated to the memory of the artist's daughter Priscilla, to whose 'gentle criticism' it was submitted but who had evidently died before it appeared, and has illustrations very reminiscent of James Guthrie in style.

The publishers, Heath Cranton, seem to have specialised in oddities of this kind; they were also responsible for Bernard Sleigh's *Faery Calendar* (Cat. 98) and Guthrie's *My House in the World* (1919).
SIMON REYNOLDS

WILLIAM STRANG
1859–1921

Strang was born in Dumbarton, the son of a builder, and educated at Dumbarton Academy. In 1876 he came to London and entered the Slade where he encountered Alphonse Legros, appointed Slade Professor the same year. Legros was to exercise a profound and lasting influence on his development. Under his guidance Strang took up etching, and it was in this field that he first made his name. He taught etching at the Slade 1880–1, was a founder-member of the Royal Society of Painter-Etchers 1881, and began to show etchings at the RA 1883. Many of his etchings (the catalogue lists 747 plates) were conceived as sets of illustrations – to *Pilgrim's Progress* (1885), *The Ancient Mariner* (1896), etc. Many betray the strong socialist leanings which he shared with members of the Arts and Crafts fraternity, notably C R Ashbee for whose Essex House Press he worked. He was also closely associated with Ricketts and Shannon, gaining through them a valuable understanding of Venetian and contemporary European painting. This led him to concentrate increasingly on painting from the 1890s. He showed an oil at the RA in 1892, but it was in Germany, where his etchings were well known, that he first made his mark as a painter, winning a gold medal at the Dresden International Exhibition of 1897 and showing five works at the inaugural exhibition of the Viennese Secession in 1898. In 1899 he accepted an important commission to paint a cycle of pictures on the theme of Adam and Eve for the Wolverhampton brewer, Laurence Hudson (Cat. 218). Though he continued to paint imaginative subjects, he also turned to portraiture and developed a profitable line in portrait drawings inspired by those of Holbein at Windsor. An exhibition of these was held at Van Wisselingh's Gallery in 1904 and he helped to found the National Portrait Society in 1911. Meanwhile he had been elected ARA (as an engraver, 1906) and from its inception (1898) was closely associated with the International Society, becoming Vice-President 1908 and President 1918. He also showed at the NEAC (from 1893) and held a number of one-man shows (FAS, Leicester Galleries, etc), as well as participating in an exhibition at Manchester with Ricketts, Shannon and Charles Holmes in 1909. Strang lived all his adult life in London, and was married with five children. He travelled widely in Europe and twice visited New York (1905, 1906) to execute portrait drawings. His later work shows the influence of the Post-Impressionists, particularly Gauguin, a reflection of the impact of the first Post-Impressionist exhibition at the Grafton Galleries in 1910, but also of Strang's association with younger British artists through membership of the

Society of Twelve (1904) and other bodies. He died suddenly at Bournemouth 12 April 1921, having just been elected RA. A memorial exhibition was held at the Fine Art Society later that year.

Ref: William Strang RA, exh. Sheffield, Glasgow and NPG, London 1980–1, cat. by Philip Athill

218. The Death of Eve 1900

Oil on canvas, 121.9 × 162.5 (48 × 64)
Signed and dated *W Strang 1900*
Exh: Twenty Years of British Art 1890–1910, Whitechapel 1910 (100); Sheffield, etc 1980–1 (8)
Lit: See 1980–1 exh. cat.
The painting comes from an important series of ten large canvases on the theme of Adam and Eve commissioned by the brewer and collector Laurence Hodson to form a frieze in the library at his home, Compton Hall, Wolverhampton. Hodson, who was also a patron of the Birmingham School and owned a set of Burne-Jones's San Graal tapestries (see Cat. 5), was probably introduced to Strang by C R Ashbee, whose Essex House Press he financed (see Cat. 225). The Adam and Eve series was Strang's first major commission and the only one of its kind he ever received. Completed in 1901, the paintings established his reputation and were widely seen as a landmark in modern British art when exhibited at Wolverhampton (1902) and Whitechapel (1910), arresting the attention of the Post-Impressionist generation of students and winning the admiration of Sickert. 'Here we have a modern painter setting to work on imaginative subjects in the grand, self-respecting classic manner ...', he wrote, 'I should like to see Mr Strang at the head of a great school of art'. The full significance of the paintings will no doubt only be recognised as we gain a clearer understanding of the part played by Symbolism in the development of modern British art. Philip Athill notes the influence on them of Puvis de Chavannes, and has also (since his catalogue appeared) established a link with the German Symbolist painter Hans Thoma.

Strang's friend Laurence Binyon provides a literary parallel in his narrative poem *The Death of Adam*, published 1904 but composed some years earlier. Hodson was to acquire other works by Strang, including that bizarre masterpiece *Bal Suzette* (1913; private collection).
ANNABEL AND PHILIP ATHILL

219. The Fisherman's Home c1905

Oil on canvas, 61 × 61 (24 × 24)
Signed *W Strang* (lower left)
Exh: Sheffield, etc 1980–1 (13)
As Philip Athill observes, the picture reveals 'a strong Venetian influence', the baby particularly looking as if it had strayed from an early work by Titian. Athill also stresses the influence of Puvis de Chavannes, with special reference to *The Fisherman's Family* (Chicago) of 1887. More immediate, however, is the relationship with the work of Charles Shannon, the marine subject, the square format, the high skyline, the way the figures fill the picture space, and the free brushwork, all being in his manner. Shannon himself, of course, was a fervent admirer of Puvis, and had painted a picture entitled *The Fisherman's Family*, shown in the exhibition he held with Ricketts at the Carfax Gallery in 1907.
THE VISITORS OF THE ASHMOLEAN MUSEUM, OXFORD

220. Laughter 1912 ill. p152

Oil on canvas, 120 × 120.7 (47¼ × 47½)
Exh: International Society 1912 (95); Japan 1983 (95)
Lit: Colour 1 1914, p3, repr
The picture belongs to a group of works Strang painted about this time which have been aptly described as 'large, semi-allegorical compositions' taking as their subject 'the expression of an emotion'. The best known

Cat. 220

is the astonishing *Bal Suzette* of 1913 (1980–1 exh., cat.20, repr), and with this there are further parallels: both pictures have frieze-like compositions, show a curious mingling of 'real life' and 'dressed up' characters, and may be seen as embodying the artist's 'fascination with the conflict of sensuality and Christian conscience – a conflict he felt both personally and as a characteristic of his time'. In *Laughter* this is expressed by the juxtaposition of clothed and naked figures, with the little girl on the right looking not quite as innocent as she should be.

As so often with Strang, the picture is full of references to other artists. There are echoes of the early Italians (foreground and middle distance), Holbein and the Venetians (figures), and even El Greco (sky; Strang had visited Spain in 1900). David Fraser Jenkins detects the influence of Augustus John (see essay above). Once again, as in *Bal Suzette*, these borrowings may be read as 'an expression of the struggle Strang felt between the artistic creeds with which he had grown up, and those which had made so strong a mark on him at the [recent] Post-Impressionist exhibitions at the Grafton Gallery' (all quotations from 1980–1 exh., cat.20).

The picture was illustrated in the first issue of *Colour*, a magazine launched in 1914 with the express purpose of providing good colour reproductions of modern paintings. *Bal Suzette* appeared in the following number.
VICTOR ARWAS

221. Grotesque 1897 (DS 405)

Two impressions, each etching and etched mezzotint,

20.3 × 17.5 (8 × 6⅞)
(1) inscribed *To Lady Dilke from Wm Strang*;
(2) inscribed *Wm Strang fec DS*: both inscribed *Final state (of 3) DS* and further annotated *Illustration to written description of a dream by WS. Probably etched soon after a visit to 'The Villa of Monsters', near Rome* in hand of David Strang, the artist's son (below)
Lit: Sheffield, etc 1980–1, cat.71 and p16, repr (impression in Glasgow Art Gallery)
As the inscription records, this remarkable image, the outstanding example of Strang's predilection for the macabre, was the result of a dream induced by a visit to the Villa of Monsters near Rome. Philip Athill notes the influence of Goya, Beardsley (with whom Strang collaborated on the illustrations to *Lucien's True History* 1894) and European Symbolist painting. There is perhaps a hint of Rops in the woman wearing a hat.
THE TRUSTEES OF THE BRITISH MUSEUM

222. The Cat c1897

Lithograph in black, 21.5 × 19 (8½ × 7½)
Signed *WS* in plate and *W Strang* in pencil (lower right)
The print is closely related to an etching of the same name (DS 409) dating from 1897, and is probably contemporary. Strang executed few lithographs, finding the incisiveness of etching better suited to his vision. His interest in the medium in the late 1890s was probably a response to its exploitation by Charles Shannon at this period.

The Cat is a gentler image than *Grotesque* (Cat. 221), but still decidedly sinister.
THE TRUSTEES OF THE BRITISH MUSEUM

223. The Sacrifice of Isaac

Lithograph in red, 25.3 × 28 (10 × 11)
Signed *WS* in stone and inscribed *to Campbell Dodgson from William Strang* in pencil (lower right)
Probably of about the same date as Cat. 222, though more vigorous in style. The British Museum has three impressions, all bequeathed by Campbell Dodgson, Keeper of the Department of Prints and Drawings 1912–32 and a close friend of the artist. According to a note on one of them, there were only six impressions, three in black and three in red.
THE TRUSTEES OF THE BRITISH MUSEUM

224. Folly and Lovers 1907 (DS 593)

Etching, 49 × 61 (19¼ × 24)
Signed *Wm Strang* (lower right) and inscribed *Final state (probably of 3) DS* by David Strang (lower left)
No doubt the conception owes something to the fact that Strang had illustrated Erasmus's *In Praise of Folly* for the Essex House Press in 1901, but there is no correspondence between the design and those in the book. For an interpretation of a contemporary and closely related etching (*Folly Sheltering Man and Woman*, DS 592), see 1980–1 exh., cat.77.
THE TRUSTEES OF THE BRITISH MUSEUM

225. William Strang, *A Book of Giants*

Illustrated by the author
London: The Unicorn Press 1898. 4to
Printed in a very small edition of twenty-five copies, the book tells what happens to giants who come into contact with such modern phenomena as the steam-roller, the underground, the bicycle, the torpedo, the motor car and the electric light. Boldly executed and hand-coloured in watercolour, the designs create an attractive chap-book effect and strike a characteristic note of somewhat grim humour. Philip Athill sees the influence of Lucien Pissarro and suggests that the book recommended Strang to C R Ashbee, for whose Essex House Press, founded 1898, he was soon working (see 1980–1 exh., cat.90). The chief results were a set of twelve chiaroscuro woodcuts entitled *The Doings of Death* and illustrations to an edition of Erasmus's *Praise of Folly*, both cut to Strang's designs by the Birmingham artist Bernard Sleigh and published 1901.
THE BRITISH LIBRARY BOARD

CHARLES HOLROYD

1861–1917
Born in Leeds and originally intended for a career in engineering, Holroyd entered the Slade in 1880. There he formed a close friendship with William Strang and both came heavily under the influence of Legros. Having completed his studies, he taught at the Slade 1885–9 before spending two years in Italy, gaining an intimate knowledge of the country and its art. In 1891 he married Fannie Fetherstonhaugh, another former Slade student; they returned to Italy 1894–7, then settled at Epsom (till 1903) and later Weybridge. Although he painted both subject pictures and portraits (examples of both in Tate), and exhibited at the RA (1885–1917), International Society, etc, it was as an etcher that he made his name, being elected to the Society of Painter-Etchers 1885 and showing there regularly. He was also associated with the Art Workers' Guild, serving as Master 1905. In later years administrative duties curtailed his activity as an artist. In 1897 he was appointed first Keeper of the Tate Gallery. In 1903, the year he published a monograph on Michelangelo, he was knighted; and in 1906 he succeeded Sir Edward Poynter as Director of the National Gallery. Here he made some important acquisitions (often with the help of the infant National Art-Collections Fund), but there

were also difficulties – conflicts with trustees, Suffragette attacks on pictures, and the threat of enemy action when war was declared. In 1916 he resigned on grounds of ill health, and died the following year.

Ref: DNB (essay by Campbell Dodgson); Campbell Dodgson, 'Sir Charles Holroyd's Etchings', *Print Collector's Quarterly* 10 October–December 1923, pp309–67; Campbell Dodgson, *The Etchings of William Strang and Sir Charles Holroyd*, Print Collectors' Club 1933

226. Nymphs by the Sea 1905

Silverpoint on prepared ground, 18.9 × 33 (7½ × 13)
Signed *Charles Holroyd* (lower right)
The preparatory drawing for the etching which follows (Cat. 229), in the reverse direction. Subject and treatment recall Charles Shannon, whose study of mice (Cat. 261) is in the same technique. Both artists were doubtless thinking of the early Florentine masters, who so often adopted this method of drawing.
THE TRUSTEES OF THE BRITISH MUSEUM

227. The Death of Icarus 1891 (CD 38V)

Etching, 20 × 25 (7⅞ × 9⅞)
Signed *Charles Holroyd* in pencil (lower right)
Icarus and his father Daedalus attempted to fly to escape the wrath of King Minos of Crete, but Icarus flew too close to the sun and its rays melted the wax on his wings, causing him to fall into the sea. The print is the earliest and possibly the most powerful of a series which Holroyd made on this theme, four being added in 1895 and two in 1902. Two of the 1895 etchings are reproduced in Campbell Dodgson's catalogue, pp325, 327.
 For other treatments of the theme by F Derwent Wood and E J Sullivan, see Cat. 205, 512.
THE TRUSTEES OF THE BRITISH MUSEUM

228. Prayer 1891 (CD 40 III)

Etching, 22.7 × 20 (8⅞ × 7⅞)
Signed *Charles Holroyd* in pencil (lower right)
As Campbell Dodgson observes, the background of this impressive image 'suggests the Egyptian desert, with a distant pyramid'. In its final state the print was exhibited in 1896 with the perhaps more appropriate title *Despair*.
THE TRUSTEES OF THE BRITISH MUSEUM

229. Nymphs by the Sea 1905 (CD 184 II)

Etching, 17.5 × 30 (6⅞ × 11⅞)
Signed *Charles Holroyd* in pencil (lower right) and inscribed with the title (under mount)
'*Nymphs by the Sea . . .*', wrote Campbell Dodgson, 'ranks by general consent as the finest of [Holroyd's] figure subjects in which the nude is combined with a landscape background. It was a kind of theme which both in painting and in etching he loved to essay, but his imagination did not quite carry him through when he attempted pastoral compositions in the manner of Giorgione' (*The Etchings of William Strang and Sir Charles Holroyd*, Print Collectors' Club 1933, p24). The print is reproduced in Dodgson's catalogue, p350.
THE TRUSTEES OF THE BRITISH MUSEUM

FREDERICK CAYLEY ROBINSON

1862–1927
Born at Brentford-on-Thames, the son of a stock-broker, Robinson began his artistic training at the St John's Wood Academy and entered the RA Schools in 1885. He exhibited for the first time in 1888 (ROI and RBA; member RBA 1889). Having spent much of the period 1889–91 sailing round the English coast, an experience reflected in many of his paintings (see Cat. 232), he then studied for three years at the Académie Julian, Paris. His earliest work had been

naturalistic but under the influence of Puvis de Chavannes and Burne-Jones (popular in Paris in the early 1890s) he developed a symbolist style and was actually included in Percy Bates' *English Pre-Raphaelite Painters* 1899. In 1896 he married the artist Winifred Dalley and they lived 1989–1902 in Florence, Robinson studying the Old Masters and the tempera technique. After further wanderings (Newlyn, Paris, Lamorna, Maida Vale), the artist and his family finally settled in 1914 at Lansdowne House, Holland Park, the block of studios built by Edmund Davis and already occupied by Ricketts and Shannon. The same year Robinson was appointed Professor of Figure Composition and Decoration at Glasgow School of Art, a post he held till 1924 and which required him to spend three months a year in Scotland. He had begun to exhibit at the RA in 1895 (ARA 1921) but continued to support the RBA and ROI, as well as showing at the NEAC (member 1912), RWS (member 1919), and at Glasgow and Liverpool, while holding one-man exhibitions at the Baillie (1904), Carfax (1908) and Leicester (1911) Galleries. His mature style was formed by the early 1900s. Evoking a timeless world in terms of simplified forms with firm outlines and flat, restricted tones, it revolves endlessly round a few favourite themes, a group of female figures at a table being perhaps the most characteristic. There are references to the early Italians, Puvis and Claude Lorraine, and many of the works are in tempera; he joined the Society of Painters in Tempera in 1904 and was later Honorary Secretary. Robinson made significant contributions to book illustration and theatre design, the two combining in the astonishing *Blue Bird* phenomenon (Cat. 235). He also had notable success as a muralist, the celebrated Middlesex Hospital murals of 1915–20 (Figs 24 5) being his greatest achievement in this field. He died 4 January 1927 and memorial exhibitions were held at the RA (Winter 1928) and Leicester Galleries (1929).

Ref: James Greig, 'Frederick Cayley Robinson', Old Water-Colour Society's Club, 5th Annual Vol 1928, pp61–71; MaryAnne Stevens, 'Frederick Cayley Robinson', *Connoisseur* September 1977, pp23–35; *Frederick Cayley Robinson ARA*, exh. FAS 1977, cat. by David Brown and others

230. Dawn; The Little Child Found 1907

Tempera on panel, 61 × 76.3 (24 × 30)
Signed and dated *Cayley Robinson 1907*
Exh: RA, Winter 1928 (587); NEAC Centenary Exh. Christie's 1986 (196)
It would be interesting to know more about the origin of this charming concept, a little reminiscent of the Finding of Christ in the Temple. Visually the picture owes much to Claude, being very similar in design to another work, *Souvenir of Claude Lorraine* (repr Stevens, fig.5). MaryAnne Stevens discusses this interest in Claude on the part of Cayley Robinson, which may seem surprising at first but is actually closely related to his well-recognised debt to Puvis de Chavannes. It is also paralleled by his intense awareness of other pillars of the classical tradition, including Raphael, Poussin and Guido Reni (see Cat. 235). No doubt this whole phenomenon should be seen in the context of his academic training both at the RA Schools and in Paris.
THE MARQUESS OF READING

231. Youth 1923

Tempera on panel, 46.3 × 62.2 (18¼ × 24½)
Signed and dated *Cayley Robinson 1923*
Exh: RA 1923 (34); RA, Winter 1928 (589); Centenary Exh., FAS 1976 (126); FAS 1977 (60)

Cat. 232

Lit: Stevens, pp26, 28 and fig.8
The picture is a later version of a work dated 1907 which was included in the artist's memorial exhibition at the RA in 1928 (153) and is reproduced in Greig's article, pl.XX. Greig also mentions a picture of this title at Cape Town, and the figure represents Adam in the design of *The Expulsion* which serves as the frontispiece to *The Book of Genesis* (Cat. 236).

In her article MaryAnne Stevens analyses the complex technique of the picture, Robinson's personal adaptation of the tempera process. Greig describes the early version as 'a perfect example of [the artist's] sense of formal decoration. Upright and horizontal lines, straight and curved, move with gracious rhythm in a colour scheme of wistful beauty'.
CHARLES CHOLMONDELEY

232. The Call of the Sea 1925 *ill. p154*
Oil on canvas, 89 × 122 (35 × 48)
Signed and dated *Cayley Robinson 1925*
Exh: RA 1925 (172); FAS 1969 (133); FAS 1977 (67)
Lit: *Royal Academy Illustrated* 1925, p63; Greig, p66 and col.pl.XIX (as *The Sailor's Departure*)
Greig describes the subject as follows: 'A sad-faced lad is leaving the pastoral life of his parents at sunset, it may be for ever, [while] a frail-looking ship awaits in the bay to take him into the Land of the Future'. A late work, the picture takes up the boat theme that occurs so often in Robinson's *œuvre*, first in such early realistic works as *Drifting* (1890), later in *To Pastures New* (1904), *Outward Bound* (1912; Leeds) and others (see *Connoisseur* September 1977, pp24, 27, figs 2, 3, 6). Robinson had a great feeling for the sea, but the theme also owes much to the famous *Pauvre Pêcheur* (Louvre) of Puvis de Chavannes, who had such a profound impact on his style. There are echoes – in the coast line, the reflected moon, and the group of figures on the right – of Robinson's composition *Pastoral*, of which the Tate has a fine version (1923–4); his capacity to play variations on pictorial themes is seemingly endless.

The picture belonged to Lord Blanesbrough, who was an important patron of Robinson's, as well as

owning works by Sims, Cadogan Cowper, Payne, Southall, Glyn Philpot and others.
PRIVATE COLLECTION

233. The Blue Bird about to Fly 1911
Watercolour with bodycolour, 28.4 × 50.8 (23 × 20)
Signed and dated *Cayley Robinson 1911*
Exh: *Water-Colour Drawings illustrating Maeterlinck's 'The Blue Bird' by F Cayley Robinson*, Leicester Galleries 1911 (50)
The original drawing for one of the illustrations to Maeterlinck's *Blue Bird* (Cat. 235), facing p198. A number of these drawings exist; two more are in the V&A, others in the Fitzwilliam Museum, the Leamington Spa Art Gallery, and private collections.
THE BOARD OF TRUSTEES OF THE VICTORIA AND ALBERT MUSEUM, LONDON

234. St Christopher and the Child 1918
Watercolour with bodycolour, 32 × 23.5 (12⅝ × 9¼)
Exh: RWS, Winter 1919 (94)
Lit: Stephens, p34 and fig.C
St Christopher was a giant who carried travellers over a deep river. Summoned one night by a child, he found him unexpectedly heavy, and when the child told him the reason – 'I bear the sins of the world' – he realised that he had been carrying Christ Himself.

The drawing is Cayley Robinson's Diploma work for the RWS, of which he was elected a member in 1919. Three years later, when illustrating Peggy Webling's *Saints and their Stories*, he adapted the design for the frontispiece. The legend also inspired works by C M Gere (see Cat. 94) and E R Frampton.
THE TRUSTEES OF THE ROYAL SOCIETY OF PAINTERS IN WATER-COLOURS (FROM THE DIPLOMA COLLECTION)

235. Maurice Maeterlinck, The Blue Bird. A Fairy Play in Six Acts
Translated by Alexander Texeira de Mattos. Illustrated by F Cayley Robinson
London: Methuen 1911. 4to
Maeterlinck's *Oiseau Bleu*, which has been described as

a 'transcendental pantomime' or 'philosophical *Peter Pan*', was written in 1908 and published in English by Methuen the following year. It proved an instant success and was reissued in 1911 with illustrations by Cayley Robinson. Meanwhile it had been staged, opening at the Haymarket Theatre on 8 December 1909 and being revived for the Christmas season in 1910, Robinson designing the sets and costumes (some of his designs can be seen in the bar at the Haymarket). This production also proved enormously popular, running to 402 performances and bringing rich rewards to the Haymarket's manager, Herbert Trench. Robinson's sets were described by the *Sunday Times* as a 'series of scenic pictures unrivalled in beauty and almost divine in their symphonic loveliness of colour and design'. The episode marks the climax of his career.

The illustrations to the published version, which correspond at many points with the stage settings, were greatly admired by Maeterlinck, who told Robinson that 'a charm, powerful, unexpected, and much more fairylike than the most spontaneous fantasies of the most extravagant imagination, escapes, little by little, from your pictures, purposely restrained and subdued. You have interpreted the story from within' (see Stevens, p33). Art-historically the designs are fascinating, passages being 'lifted' from many other artists, including Michelangelo, Raphael, Poussin, Guido Reni, Blake and Arnold Böcklin.

About 1915 there was talk of Graham Robertson doing illustrations to the book, which was ideally suited to his talents. However, despite his friendship with Maeterlinck, these never materialised.
OLIVIA REYNOLDS

236. The Book of Genesis
'Now printed in the Authorised version and Illustrated after Drawings by F Cayley Robinson'
London: The Medici Society for the Riccardi Press 1914. 4to
Three years later than *The Blue Bird*, and very different in theme, the book has ten colour illustrations, including some of the artist's most poetic concepts. The original of *The Death of Abel* is in the Louvre, and the frontispiece, *The Expulsion*, is related to *Youth*, shown here (Cat. 231). As in *The Blue Bird*, there are some borrowings from other artists, notably Michelangelo and Blake.

Like Anning Bell's *Mary, the Mother of Jesus* (Cat. 251) and Russell Flint's *Morte d'Arthur* (Cat. 170), the book was published by the Medici Society for Philip Lee Warner's semi-private Riccardi Press.
RUPERT REYNOLDS

ROBERT ANNING BELL
1863–1933
Bell was born in London and educated at University College School until the age of fifteen. He was then articled for two years to an uncle who was an architect before entering the RA Schools and studying under Professor Fred Brown at the Westminster School of Art. Brown himself had studied in Paris at Julian's, and no doubt influenced Bell's decision to spend a year working in Paris with the painter Aimé Morot. Returning to England, he shared a studio with the sculptor George Frampton, then spent a further period studying in Italy. During the 1890s he was deeply involved in the Arts and Crafts, being well known as an illustrator and, together with Frampton, developing a line in plaster reliefs, hand-coloured in imitation of Della Robbia plaques. In 1895 he was appointed to teach painting and drawing at the School of Architecture, University College, Liverpool. He proved an inspiring teacher, and was associated with Harold Rathbone's Della Robbia Pot-

tery at Birkenhead, supplying designs for reliefs. After four years, however, he resigned to give more time to his own work. He had exhibited at the RA since 1885. In 1888 he joined the NEAC, to which his Parisian training made him sympathetic, and in 1901 he was elected Associate of the RWS (full member 1904). He always had a preference for watercolour (see his article in praise of the medium in OWCS Annual Vol II 1925), although he painted in tempera and oil as well. In later life he carried out many designs for stained glass and mosaic; prominent examples of the latter occur over the entrance to Westminster Cathedral and in the Central Lobby of the Houses of Parliament. His mastery of so many art forms brought him numerous duties and honours. He was involved in the organisation of major Arts and Crafts exhibitions in London, Paris, Brussels and Turin (see note on Walter Crane). He was elected ARA 1914 and RA 1922, enjoyed a long association with the Art Workers' Guild (Master 1921), and remained in demand as a teacher, being Professor of Decorative Art at Glasgow School of Art (from 1911) and succeeding W R Lethaby as Professor of Design at the RCA (1918–24). His reputation also stood high in Europe; the Luxembourg bought a painting, medals were awarded him in Vienna, Milan, Barcelona, etc, and the Spanish art-historian Alejandro Riquier wrote a monograph on him (1910). Bell's second wife, Laura, was also a notable, Slade-trained artist. They lived at 28 Holland Park Road, Kensington and had a wide circle of friends. Bell died 27 Novembner 1933 and the fine Art Society held a memorial exhibition the following March.

Ref: T Martin Wood, 'Mr Anning Bell's Work as a Painter', *Studio* 49 1910, pp254–62; *The Times* 28 November 1933, p19; Mrs Steuart Erskine, 'Robert Anning Bell', Old Water-Colour Society's Club, 12th Annual Vol 1935, pp51–61

237. **Music by the Water** 1900
Watercolour, 38.7 × 54 ($15\frac{1}{4}$ × $21\frac{1}{4}$)
Signed and dated *R A Bell March 25 1900*
Exh: RWS, Summer 1904 (114)
An attractive and comparatively early example, very 'Venetian' in style. T Martin Wood's comments on the role of music in Anning Bell's work (see Cat. 238) are equally relevant here.
THE TRUSTEES OF THE TATE GALLERY

238. **The Garden of Sweet Sound (The Listeners)** 1906
Watercolour, 49.5 × 74.9 ($19\frac{1}{2}$ × $29\frac{1}{2}$)
Signed and dated *Robert Anning Bell 1906*
Exh: RWS, Summer 1906 (38)
Lit: T Martin Wood, pp257, repr, 260
The first of three works by Bell to be bought for the Chantrey Bequest, the picture appears in Tate Gallery catalogues as *The Listeners*, but was in fact exhibited in 1906 under the title *The Garden of Sweet Sound*. T Martin Wood, in his article on Bell four years later, saw it in the context of the Symbolist preoccupation with the relationship of art to music. 'In . . . *The Garden of Sweet Sound*', he wrote, 'stress is laid upon the connection between design and music, which lovers of art affectionately trace. A garden of sweet scent – that would have been impossible to paint, for it is not *to* the senses but *through* them that the appeals of art are made. In the arts the two most spiritual senses, vision and hearing . . . play into each other, so that there can be pictures painted to music, or music written to pictures . . . the attitudes of the figures in Mr Bell's picture become unattractive if by a mental effort we attempt to separate the arrangement of the design from the

associations of music.'
THE TRUSTEES OF THE TATE GALLERY

239. **Queen Hippolyta's Bath. The Amazon Guard** 1908
Watercolour, 60.4 × 99 ($23\frac{3}{4}$ × 39)
Signed and dated *Robert Anning Bell RWS 08* (lower right)
Exh: RWS, Winter 1908 (263)
Hippolyta was the Queen of the Amazons; she was given in marriage to Theseus by Hercules, whose ninth labour was to secure her girdle. The subject seems to have fascinated Anning Bell, reappearing in his picture *The Amazon Guard* (private collection), shown at the International Exhibition in Rome in 1911, and finding echoes in *The Arrow* (Cat. 242) and other related works. *Queen Hippolyta's Bath*, however, seems to be its completest expression, as well as being one of the artist's finest works.
BRADFORD ART GALLERIES AND MUSEUMS

240. **Cupid Disarmed** 1908
Watercolour, 53.3 × 75 (21 × $29\frac{1}{2}$)
Signed and dated *Robert Anning Bell 1908* (lower left)
Exh: RWS, Summer 1908 (38); Japan – British Exh. 1910
In Bell's most mellow, Venetian style. There is another unfinished version in the Tate, entitled *Her Son* (repr Mrs Steuart Erskine, pl.xx)
PETER ROSE AND ALBERT GALLICHAN

241. **'Horns of Elfland Faintly Blowing'** 1908
Oil on canvas, 34.3 × 53.3 ($13\frac{1}{2}$ × 21)
Signed and dated *R Anning Bell 08* (lower left)
Exh: New Gallery 1909 (First Portion) (39)
Lit: *The Times* 16 April 1909, p6

The picture is yet another variation by Bell on the theme of listening to music (cf Cat. 238); in this case it is given an eighteenth-century twist, the figures being vaguely Tiepolesque in conception. The title is taken from Tennyson's *Princess*:

O hark, O hear! how thin and clear,
 And thinner, clearer, farther going!
O sweet and far from cliff and scar
 The horns of Elfland faintly blowing!

The picture was shown at the last exhibition to be held at the New Gallery, which, by way of experiment, was divided into two consecutive 'portions' (Shannon's *The Mill Pond*, Cat. 253, appeared in the Second Portion). The art critic of *The Times* regarded it as 'much more successful' than another work shown by Bell, an illustration to *A Midsummer Night's Dream*; 'the listening attitudes of the three figures make a pretty pictorial motive, and the colour is bright and pleasant'.

The same passage in Tennyson was to inspire a chiaroscuro woodcut by Bernard Sleigh, dating from 1925.
PETER ROSE AND ALBERT GALLICHAN

242. **The Arrow** 1909 *ill. p155*
Watercolour, 67.3 × 73.3 ($26\frac{1}{2}$ × 29)
Signed and dated *Robert Anning Bell 09* (lower right)
Exh: RWS, Summer 1909 (76)
Lit: T Martin Wood, p254, repr
The picture is reproduced in colour at the head of Wood's article, and although he does not actually mention it, it seems to inspire some of his most telling remarks. Speaking of the artist's use of cultural cross-reference, he writes: 'We seem to see the happy maidens of Mr Anning Bell's art issuing forth into the open, with their bows and arrows in their hands, pretending to be

Cat. 242

Amazons, but not belonging to the early world, having the reflection of altar lights in their eyes, and the restraint of those who have once followed in solemn procession behind an image of the Virgin'. Since 'the gift of this age [is] its ability to revive in art remote experiences which have passed into its veins', it is 'the scholarship, not pedantic but instinctive, in Mr Bell's art which makes it so interesting'. Wood's comment on a picture very similar to ours in theme, *The Archers*, is no less relevant: it is 'of great interest because it is so expressive of Mr Bell's later mood, that of a romanticist trying to be classic . . . The romanticists at the beginning of the nineteenth century waged war upon the classics; we are as romantic as ever, but we regard the classic itself romantically.' The same could be said of many pictures in the exhibition, from Burne-Jones's *Finding of Medusa* to Harry Morley's *Judgment of Paris*.

Wood might also have made the point that *The Arrow* demonstrates Bell's tendency to take an abstract idea – shooting an arrow, listening to music (Cat. 238), winding wool (Cat. 246), etc – and use it as the basis for a picturesque composition. This is perhaps his most original characteristic as an artist.

PETER ROSE AND ALBERT GALLICHAN

243. **Going to the Hunt** 1909
Watercolour, 60 × 101 ($23\frac{5}{8}$ × $39\frac{3}{4}$)
Signed and dated October 1909
Exh: RWS, Winter 1909 (28); International Exh., Rome 1911 (382); Japan 1983 (69)
The picture is contemporary with *The Arrow* (Cat. 242) and has much in common with it, being similar tonally and in its vaguely Amazonian theme. If *The Arrow* is 'classical', however, *Going to the Hunt* would appear to be 'ancient British'. This is a note that Anning Bell strikes elsewhere, *The Alarm*, a watercolour at Liverpool, being an example.

PRIVATE COLLECTION

Cat. 244

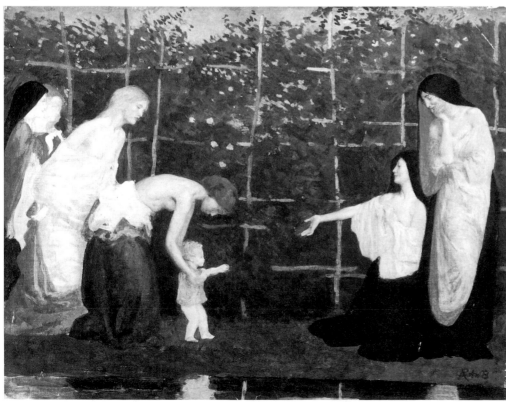

244. **Learning to Walk** c1910 *ill. p156*
Tempera on panel, 44.5 × 57.2 ($17\frac{1}{2}$ × $22\frac{1}{2}$)
Signed *RAnB* (lower right)
Exh: Memorial Exh. FAS 1934 (43)
A variation on the type of composition already explored in *Cupid Disarmed* (Cat. 240), but in the more 'Florentine' style that Bell now favoured (see Cat. 245). Childhood was a theme to which he often returned. His marriage to Laura Richard-Troncy, which seems to have taken place after 1910, was apparently childless, but there may have been children by his earlier marriage to Amy C Steele.

PETER ROSE AND ALBERT GALLICHAN

245. **The Marriage at Cana** 1911
Tempera on paper, 36.8 × 25.4 ($14\frac{1}{2}$ × 10)
Signed and dated *R An Bell 1911* (lower right)
Exh: Christie's 1986 (56)
Lit: Alice Meynell, *Mary, The Mother of Jesus* 1912, repr facing p100
This is one of the illustrations that Bell made for Mrs Meynell's *Mary, The Mother of Jesus* (Cat. 251). It demonstrates the cooler, more Florentine manner that he adopted about 1910, and may be compared with his RA Diploma picture, *The Women Going to the Sepulchre*, which is dated 1912. Both works have a characteristic colour scheme based on white, black, pink, blue and mauve – set off particularly happily here by touches of orange. The figures in *The Marriage at Cana* seem to owe someting to Masaccio, confirming the influence on this style of Florentine frescoes.

A much larger treatment of the subject by Bell, dated 1914, was on the market some years ago (Christie's, 24 October 1980, lot 53, and previous sales).

PETER ROSE AND ALBERT GALLICAHAN

246. **The Ball of Wool** (two linked designs) 1895
Plaster reliefs, coloured and gilt, each 12.7 × 31.1 (5 × $12\frac{1}{2}$)
The right-hand relief signed and dated *R An B.95* (upper right)

These and the following two items are examples of the coloured reliefs that Anning Bell developed in the late 1880s in collaboration with the sculptor, George Frampton. In an interview in the *Studio* (6 1986, p206), Frampton referred to the 'panels in fibrous plaster, gilt and coloured, which I worked out with Mr R Anning Bell, and exhibited at the Arts and Crafts, 1889'. Bell's reliefs were frequently featured in the magazine in the 1890s, and a group was included in his exhibition at the Fine Art Society in 1907.

The Ball of Wool is an early and particularly attractive example. *The Red Skein*, a watercolour exhibited by the artist at the RWS in Summer 1903, may have been a version of the design or closely related.

PETER ROSE AND ALBERT GALLICHAN

247. **Charity** 1901–7
Plaster relief, coloured and gilt, 45.7 × 24.1 ($18 × 19\frac{1}{2}$)
Inscribed *R A B Oct 01 no 6 coloured 07* (upper right)
A cast of this relief was shown in Bell's one-man exhibition at the Fine Art Society in April–May 1907, no.39. As he wrote in the catalogue, 'the reliefs can be repeated, the issue being limited to fifteen examples of each subject, worked upon, coloured and numbered by the Artist'. The present example was evidently made in October 1901 but not coloured until 1907. Where more than one cast of a relief is known, it is clear that the colour schemes often varied dramatically.

PETER ROSE AND ALBERT GALLICHAN

248. **The Fortune Teller** 1904
Plaster relief, coloured, 39.4 × 39.4 ($15\frac{1}{2}$ × $15\frac{1}{2}$)
Signed and dated *R A Bell 1904* (upper right)
A cast was shown at Bell's exhibition at the Fine Art Society in 1907, no.38.

PETER ROSE AND ALBERT GALLICHAN

249. **William Shakespeare, *The Tempest***
Illustrated by Robert Anning Bell
London: Freemantle & Co. 1901. 8vo
Bell was a prolific illustrator during the early part of his career; he decorated sixteen books in the period 1895–1907, mainly works by English poets from Shakespeare to Keble, but including also Grimm and Omar Khayyám. The designs are in a linear style inspired by Renaissance engravings, particularly the famous woodcuts illustrating Francesco Colonna's *Hypnerotomachia Poliphili*, first published by Aldus Manutius in Venice in 1499. These had also influenced Burne-Jones when he was illustrating William Morris's *Earthly Paradise* in the 1860s, and Ricketts and Shannon's designs for *Daphnis and Chloe* (Cat. 321).

THE BRITISH LIBRARY BOARD

250. ***Poems by Percy Bysshe Shelley***
Introduction by Walter Raleigh; illustrations by Robert Anning Bell
London: George Bell & Sons 1902. 8vo
Another book illustrated by Bell in his 'Hypnerotomachia' style. A fine double-page design with a frieze of mourning women, headed 'Dirges and Laments', anticipates his RA Diploma picture, *The Women Going to the Sepulchre*, of 1912.

THE BRITISH LIBRARY BOARD

251. **Alice C Thompson (Alice Meynell), *Mary, The Mother of Jesus***
Illustrated by Robert Anning Bell
London: Philip Lee Warner 1912. 4to
The book is ten years later than Cat. 249–50 and much less 'Arts-and-Crafts' in conception, being illustrated with photographic reproductions after tempera paintings by Bell. One of these, *The Marriage at Cana*, is exhibited here (Cat. 245). *The Visitation* (frontispiece) is in the Manchester City Art Gallery, and *The Adoration*

of the Shepherds was sold at Sotheby's Belgravia, 21 July 1981, lot 158. *Mary in the House of Elizabeth* is clearly an early version of the painting bought for the Chantrey Bequest in 1918.

The book is by the Roman Catholic writer Alice Meynell, using her maiden name. For other books by the same publisher, see Cat. 170, 236.

LEILA REYNOLDS

CHARLES HAZELWOOD SHANNON

1863–1937

Shannon was born at Quarrington, Lincolnshire, the son of a country parson. He attended St John's School, Leatherhead, then studied at the City and Guilds Technical Art School at Lambeth (1881–5), where he worked under Charles Roberts, wood-engraver, and met his lifelong companion, Charles Ricketts. Though usually regarded as the less dominant of the partners, he was in fact three years older than Ricketts and perhaps in some ways the stronger character. During the 1880s he supported himself by teaching at Croydon School of Art and making drawings for such magazines as Harry Quilter's *Universal Review*. In 1889 he and Ricketts founded an occasional magazine *The Dial* (ran till 1897); they also illustrated Oscar Wilde's *A House of Pomegranates* (Cat. 319), collaborated on wood-engravings illustrating *Daphnis and Chloe* (Cat. 321) and *Hero and Leander* (Cat. 323), and launched the Vale Press (1896–1904), one of the most significant private presses of the day. In 1888 Shannon had taken up lithography, and in the 1890s he produced some fifty prints and became one of the leading exponents of the medium in this country. As a painter he began to exhibit in the 1880s (Grosvenor Gallery, RBA, NEAC). Then, according to a programme agreed with Ricketts, he withdrew from exhibiting, working in private with the guidance of such books as Reynolds' *Discourses* and Eastlake's *Materials for a History of Oil Painting*. He exhibited again from the late 1890s, winning a gold medal at the Munich International Exhibition 1897, and being a founder-member of the International Society 1898 (later Vice-President). Like his lithographs, on which they are often based, his paintings divide into imaginative subjects and portraits, the chief influences on them being Titian, Watts and Puvis de Chavannes. Having been elected ARA 1911 (RA 1920), he exhibited at the Academy 1912–30. His first one-man exhibition was held at the Leicester Galleries 1907, and he also showed at the Carfax Gallery, FAS, Van Wisselingh's Gallery in London and Amsterdam, Durand-Ruel's in Paris, etc. For details of his circle and addresses, see Paul Delaney's essay above; and for his collecting activities, Joseph Darracott's exh. cat. cited below. In 1928 an important exhibition of his work was held at Barbizon House, London, and the Usher Art Gallery, Lincoln. While rehanging a picture lent to this, he fell and damaged his brain, never fully recovering his senses. Died at Kew 18 March 1937, six years after Ricketts.

Ref: 'Tis' (Herbert Furst), *Charles Shannon ARA* 1920; EBG (Eric George), *Charles Shannon* 1924; Paul Delaney, *The Lithographs of Charles Shannon* 1978; Paul Delaney, 'Charles Shannon: Master of Lithography', *Connoisseur* March 1979, p200–5; *All for Art: The Ricketts and Shannon Collection*, exh. Fitzwilliam Museum, Cambridge 1979, cat. by Joseph Darracott; *At the Sign of the Dial: Charles Hazelwood Shannon and his Circle*, exh. Lincoln, etc 1987–8, cat. by Keith Spencer and others.

252. The Bath of Venus 1898–1904 *ill. p157*
Oil on canvas, 146 × 97.8 (57½ × 38½)
Signed and dated *C H Shannon 1898–1904*
Exh: *Works by Irish Artists*, Guildhall 1904 (13, as *The Toilet of Venus*)
Lit: *Athenaeum* 11 June 1904, p759; George, pl.8
Probably the finest of Shannon's many toilet scenes, the picture was one of a group which he showed at the exhibition of *Works by Irish Artists* at the Guildhall in 1904. It had been on the easel since 1898 and may have been completed partly for this purpose. Shannon is not normally regarded as anything but English, but no doubt his name was enough to suggest that he might have been of Irish descent; the fact that his friend Sir Hugh Lane wrote the preface to the catalogue is also probably significant. At all events, his pictures, according to the *Athenaeum*, 'dominated the whole exhibition', particularly the 'ambitious' *Toilet of Venus*. This, the writer continued, was 'full of exquisite passages, with the colour and tone of things seen in the surface of old silver, with mellow notes of blue, russet and deadened greens. But it is not, perhaps, the

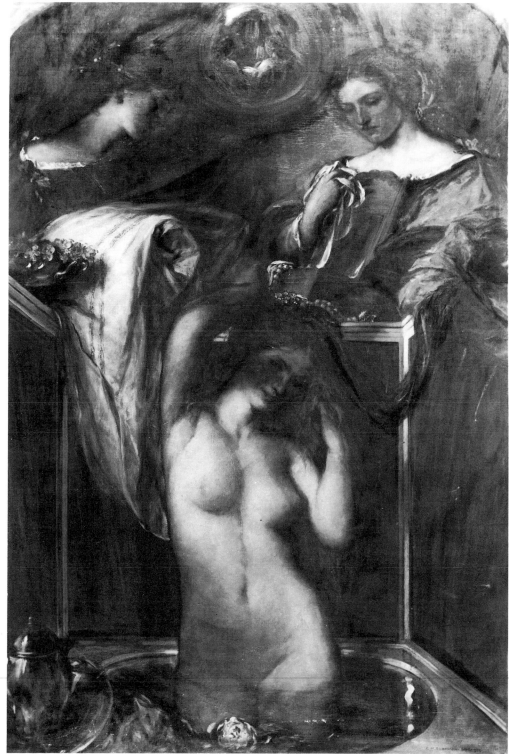

Cat. 252

complete success that at first sight makes one hope it will be. The design of the torso is admirable, but the articulation of the head and neck – perhaps for want of some definite chiaroscuro – is not clearly felt, while above, where the hands and arms of the attendants join in the knotwork of curves and lines, the intention of the design seems to have never become wholly clear. The whole composition is unusual for Mr Shannon, and suggests rather one of Mr Ricketts's woodcuts in its architectural symmetry. It is, however, not so compact as Mr Ricketts's designs generally are, and might even be improved by greater compression of the upper part.'

The complaint that Shannon's work was finer in conception than in realisation was often to be voiced, while the comments on the picture's colour suggest that, as in many of his works, the colours have darkened. This is probably because he was too free with oil glazes.

In 1904 the picture belonged to W A Pye, a friend of Ricketts and Shannon who appears in Ricketts's *Self-Portrait*, but it was subsequently acquired by Lord Northcliffe who, to Shannon's annoyance, sold it at the Red Cross benefit sale at Christie's in April 1918 (lot 894). 'The Red Cross sale has turned out splendidly', Ricketts reported to Thomas Lowinsky. 'Shannon's biggish picture, "The Bath of Venus", originally called "The Green Marble Bath", fetched £620; it was sold originally for £350' (*Self-Portrait*, p292). In fact it fetched more, £682.10.0, being bought by Sir Jeremiah Colman, head of the famous mustard firm, who also owned Cat. 47 and Cat. 112 in this exhibition.

The title, *The Green Marble Bath*, recalls Shannon's so-called 'Stone Bath' series of lithographs, dating from 1895–7. In opting for *The Bath of Venus* he was choosing a title that had already been used by Burne-Jones. Indeed Burne-Jones's picture, which dated from 1873–88, was similar compositionally, showing the naked goddess descending steps to her bath, surrounded by attendants. The picture itself is missing but is known from old photographs and a fine study at Birmingham.

THE TRUSTEES OF THE TATE GALLERY

253. **The Mill Pond** 1905
Oil on canvas, 109.2 × 103.5 (43 × 40¾)
Signed and dated *C H SHANNON 1905* (lower right)
Exh: International Society 1906 (222); *Independent Art of To-Day*, Agnew 1906 (23); New Gallery 1909 (Second Portion) (74); *Oil Paintings . . . by Charles Shannon, Charles Ricketts, William Strang. . . .* Manchester City Art Gallery 1909 (20); Lincoln 1928–9 (27)
The square format and the way the figures are crushed against the frame are typical of Shannon, as is the sometimes uncertain drawing. However, as *The Times* observed of another picture he exhibited at the New Gallery in 1909, 'Mr Shannon's distinction is that his art is native to the imaginative atmosphere, it coheres in a world of its own. So many of our able painters, when once they desert the scene before their eyes, can manage nothing but an unstable compromise between the claims of realism, decoration, and sentiment' (16 April 1909, p6).

There is a chiaroscuro lithograph of this design, dating from 1905 (D62), and some studies of male nudes in the British Museum are comparable if not related.
MANCHESTER CITY ART GALLERIES

254. **The Apple Gatherers** c1910(?)
Oil on canvas, 175 × 92 (78⅞ × 36¼)
Though of uncertain date, the picture shows very clearly Shannon's debt to Puvis de Chavannes, the subject, mural-like format, and flat, dry handling of the paint all pointing to his influence. At the same time, as so often with Shannon, the picture represents a variation on a favourite theme. *Apple-Gatherers* is the title of a lithograph of 1895 (D33), and the motif appears in at least two other lithographs, *The Romantic Landscape* (Cat. 267) and *Summer* (D8).

The picture was given to the Ashmolean in 1941 by Francis Howard (1874–1954), artist, art critic, founder of the International Society (1898) and organiser of many exhibitions. He also gave the Museum Strang's *Fisherman's Home* (Cat. 219) and presented modern British works to the Tate (including Cat. 252, 316 in this exhibition) and the Luxembourg. The American stepson of an Irish politician and newspaper proprietor, Howard was a direct descendant of Benjamin Franklin and father of the egregious Brian Howard, on whom Evelyn Waugh is said to have modelled his character 'Anthony Blanche'. It was probably his wife who upset Ricketts in 1915 by telling him of 'some youngster genius' who had described him and Shannon as 'back-numbers' (see *Self-Portrait*, p249).
THE VISITORS OF THE ASHMOLEAN MUSEUM, OXFORD

255. **Lillah McCarthy as 'The Dumb Wife'**
1917–18
Oil on canvas, 99.5 × 66 (39¼ × 26)
Signed and dated *CHARLES SHANNON 1917–18* (lower left)
Exh: RA 1918 (42); *Re-Opening Exh.*, Grosvenor Gallery 1921 (21); Lincoln 1928–9 (14)
Lit: *Royal Academy Illustrated* 1918, p113; Lillah McCarthy, *Myself and My Friends* 1933, p111, repr facing p187; Darracott, pp182–3, repr
Lillah McCarthy and her husband Harley Granville-Barker were close friends of Ricketts and Shannon, Ricketts designing many of the theatrical productions in which they were involved. Shannon's portrait shows the actress in the leading role in Anatole France's adaptation from Rabelais, *The Man who Married a Dumb Wife*, produced in New York in 1915 and at the Ambassadors Theatre, London, two years later. Ricketts designed the costume, his only contribution to the play; for his original drawing, see Stephen Calloway, *Charles Ricketts* 1979, pl.94.

In her autobiography, *Myself and My Friends*, Lillah McCarthy discussed the close rapport that existed between Ricketts and Shannon, giving as an instance the fact that Ricketts added the butterfly alighting on her head-dress in Shannon's portrait. These butterflies, together with the grey background, strike a slightly Whistlerian note, while the treatment of the drapery suggests the influence of Rubens. The friends had known and admired Whistler, taking over his house in The Vale, Chelsea, in the early 1890s. Their respect for Rubens is also well attested and they owned some superb examples of his drawings.
CHELTENHAM ART GALLERY AND MUSEUMS

256. **The Childhood of Bacchus** 1919–20 *ill. p43*
Oil on canvas, 122 × 109 (48 × 43)
Signed and dated *CHARLES SHANNON 1919–20* (lower right)
Exh: RA 1920 (185); Lincoln 1928–9 (6)
Lit: *Royal Academy Illustrated* 1920, p35; *Daily Telegraph* 1 May 1920; *The Times* 1 May 1920, p16; *Athenaeum* 7 May 1920, p611; George, pl.22
Sometimes called *The Education of Bacchus*, the picture clearly owes much to Titian, particularly the early Bacchanals which he painted for the studio of Alfonso d'Este at Ferrara. One of these, the *Bacchus and Ariadne* in the National Gallery, was believed by Ricketts to be 'the greatest picture in the world' (*Studio* 48 1910, p259), and he devoted a whole chapter to it in his monograph on Titian (1910). '*Bacchus and Ariadne*', he wrote, 'has haunted Rubens, and Vandyck and Watts; and for three more centuries it will haunt the Vandyck and the Watts of the future'. The two companion-pieces in the Prado are discussed in his book on the collection, 1903.

Shannon's source was widely recognised when his picture was exhibited in 1920. 'The design is rich', wrote the art critic of *The Times*, 'and the cupids in the air remind us pleasantly of Titian. The picture looks already

as if it had been painted long ago, but it is a very skilful modern old master, with a learning that is not mere pedantry.' '"The Childhood of Bacchus"', Sir Claude Phillips observed in the *Daily Telegraph*, 'a painted poem (*poesia*) that recalls that Shannon's earlier manner, is, in intention if not in realisation, quite Titianesque'. The point was made again in the *Athenaeum* by R H Wilenski, in a passage which, despite the sting in the tail, is a reasonable assessment of Shannon as an artist. 'A visitor passing rapidly through Gallery III', he wrote, 'might be pardoned for imagining that "The Childhood of Bacchus" had strayed from Trafalgar Square. Considered as a decoration executed in a prescribed medium, the picture is a success. The arrangement is well balanced, and sufficiently complex; the impasto is handled with intelligence, and the colour glows with Venetian splendour. When we look a little closer we note the general weakness of the drawing, the unrealised drapery, the absence of virility in the approach. But perhaps we have no right to peer too closely at this comparatively early stage in our village Titian's career. His forerunner lived and painted five score years. Mr Shannon may achieve his heart's desire in 1970 or thereabouts.' The last remark is cruelly ironic in view of the fact that Shannon's career was to be cut short in 1929, making *The Childhood of Bacchus* a fairly late work.

The picture belonged to Sir Edmund Davis (see Paul Delaney's essay and Cat. 157), appearing at his posthumous sale at Christie's 15 May 1942 (lot 145), when it fetched a mere 8 guineas. Shannon exhibited a very similar work, *The Golden Age* (private collection), at the RA in 1922.
PRIVATE COLLECTION

257. **The Wise and Foolish Virgins** 1919–20 *ill. p159*
Oil on canvas 110.8 × 177.8 (43⅝ × 70)
Signed and dated *CHARLES SHANNON 1919–20*
Exh: RA 1920 (87); Lincoln 1928–9 (19)
Lit: *Royal Academy Illustrated* 1920, p40; *Daily Telegraph* 1 May 1920; *The Times* 1 May 1920, p16; *Athenaeum* 7 May 1920, p611; George, pl.24
The subject was treated by both Ricketts and Shannon, and Shannon's picture may owe something to a scheme drawn up by Ricketts as early as 1900: '"The Wise and Foolish Virgins". Long narrow picture. They are about to cross a river from a narrow promontory; background cribbed from Pope's Palace at Avignon, reflections in water of the lit lamps and the stars, same colour as above. Twilight' (*Self-Portrait*, p29). The canvas was exhibited at the RA the same year as *The Childhood of Bacchus* (Cat. 256), but whereas the *Bacchus* received some praise, no-one had a good word to say for this fine and original conception. 'The Burne-Jones ladies seem, happily, to be dying out', wrote R H Wilenski in the *Athenaeum*, 'but they still linger, discreetly Titianised in Mr Shannon's second picture, "The Wise and Foolish Virgins"'. This was to be expected from a prophet of modernism, but the older breed of critic was no happier. Sir Claude Phillips, writing in the *Telegraph*, while admitting that 'Mr Charles Shannon is now one of the mainstays of the Royal Academy', and that 'his art, even when he fails to touch his highest level, does not lack nobility', complained that *The Wise and Foolish Virgins* had neither 'dramatic fervour' nor 'true spirituality', while suffering from 'a monotony of rhythm'. As for *The Times*, it felt that the picture was 'merely one of [the artist's] pleasant decorative arrangements; it all hangs well together, but we seem to have seen the figures and their attitudes in other pictures of his and in the pictures of other painters'.

Despite these strictures, the picture was bought by the Liverpool soap manufacturer Joseph Bibby, a successor to Leyland, Imrie, Holt and others in an earlier generation (see Cat. 46). Many preparatory drawings exist, including a group in the Usher Art Gallery,

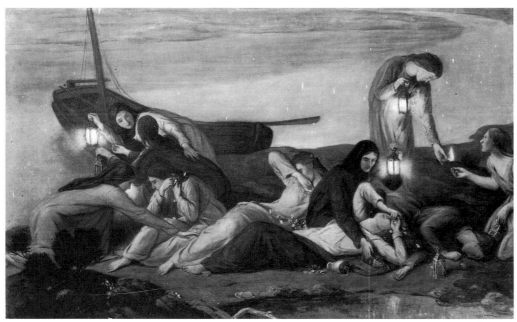

Cat. 257

Lincoln, and there is a small oil version at Coventry. Shannon also treated the subject in different compositions, one represented by a drawing in the British Museum (1962-8-9-27), another by a painting dated 1917 in the Art Gallery at Northampton. A narrow upright with violently agitated figures, this would have shown Sir Claude Phillips that Shannon was capable of endowing the theme with 'dramatic fervour'.

TRUSTEES OF THE NATIONAL MUSEUMS AND GALLERIES ON MERSEYSIDE, WALKER ART GALLERY

258. Vanity and Sanctity 1921

Oil on canvas, 104 × 113 (41 × 44½)
Signed and dated *CHARLES SHANNON 1921*
Exh: RA 1921 (65); *British Art 1890–1928*, Columbus Gallery of Fine Arts, Columbus, Ohio 1971 (94); Cambridge 1979 (A2)
Lit: *Royal Academy Illustrated* 1921, p12; *The Times* 2 May 1921, p9; George, pl.26
Shannon's RA Diploma picture, exhibited the year after he became an Academician. 'Mr Shannon's "Vanity and Sanctity" . . .', wrote the art critic of *The Times*, 'like so many of his pictures, is full of ghosts. There is the ghost of Sacred and Profane Love, the ghosts of several late Titians and of Giorgione, of Burne-Jones, and, through Burne-Jones, of the Quattro-cento; yet there is no plagiarism, for all these memories are fused in a very agreeable picture. It is the art of a painter who lives in a paradise of past masterpieces, a shadowy isle of bliss midmost the beating of the steely sea of prose and commonplace. He is not able to create a new heaven or a new earth, but he can almost persuade us that the past is the present'. It is interesting to compare this with Ricketts's description of Shannon the same year: 'He works harder than ever and seems daily more unmoved by time and life' (*Self-Portrait*, p333).

ROYAL ACADEMY OF ARTS, LONDON

259. The Birth of Venus 1923 *ill. p42*

Oil on canvas, 105.6 × 107.6 (41⅝ × 42⅜)
Signed and dated *Charles Shannon 1923* (lower left)
Exh: RA 1924 (146)
Lit: *Royal Academy Illustrated* 1924, pl.109; *The Times* 5 May 1924, p20
This beautiful late example seems to have made little impact when exhibited at the RA in 1924, *The Times* merely noting that Shannon and Ricketts (showing *Jephtha's Daughter*, Ashmolean) had 'infused their

personal qualities into the more classical kind of composition'. Nor has it received much attention since, being omitted from Eric George's monograph and apparently escaping the notice of recent Shannon enthusiasts. In fact it is something of a rediscovery.

Shannon's conception of Venus reclining as she rises from the sea is in marked contrast to famous versions by Botticelli and others, in which she appears standing. It should be seen in the context of a number of paintings and lithographs in which he explores the theme of female swimmers, *The Pursuit*, of which there is a lithograph of 1918 (D92) and a painting of 1922 (Bristol), being a good example. The putti, so obviously inspired by Titian in *The Childhood of Bacchus* (Cat. 256), are now more reminiscent of Rubens. The picture was exhibited at the same RA as Harry Morley's *Apollo and Marsyas* (Cat. 171) and Dorothy Hawksley's *Nativity* (Cat. 182).

ABERDEEN ART GALLERY AND MUSEUMS

260 Study of a Girl, Seated 1890–5(?)

Red chalk on buff paper, 20.3 × 22.9 (8 × 9)
Shannon was a prolific draughtsman, making many studies for his paintings as well as portrait drawings and independent studies; he tended to work freely in pencil or chalk, often on coloured paper in the manner of the Old Masters.

This attractive example looks back to Rossetti's studies of female figures, particularly those of Lizzie Siddal, but is also reminiscent of certain early drawings by Augustus John (cf Cat. 434). 'We dined with Rothenstein', Ricketts recorded in his journal on 5 February 1901, 'who showed us the drawings of a Slade student named John. They show, besides the influence of Rothenstein and even Shannon, the study of Rembrandt's drawings, and a quite serious evidence of ability and facility. We bought two' (*Self-Portrait*, p53).

The drawing is comparable in subject and technique to one exhibited by Peter Nahum, *Master Drawings of the Nineteenth and Twentieth Centuries* 1987, cat.61, and might be a different view of the same model made at the same sitting. However, whereas the present drawing seems to date from the early 1890s, the Nahum drawing has a date which has been read as either 1890 or 1920, and arguments for accepting the latter are advanced in the catalogue.

SIR BRINSLEY FORD, CBE, FSA

261. Studies of a Mouse before 1896

Silverpoint on prepared ground, 22.7 × 28.5 (9 × 11½)
Lit: *The Dial* 4 1896, repr
This delightful drawing was made before 1896, when it was published in Ricketts and Shannon's occasional magazine *The Dial*, and could conceivably be connected with Shannon's lithograph *The Three Sisters* of 1894 (D23), which has a mouse in the background. Whatever the case, Shannon seems to have had a fondness for mice. 'After your letter about rats', Ricketts wrote to Thomas Lowinsky in April 1918, 'Shannon went to a rat shop to buy a spotty one, and came back with two spotty Japanese mice before whom he spends hours in mute adoration; both are supposed to be of the same sex, but I expect one of them is sure to turn out a female and present us with a large family one fine morning' (*Self-Portrait*, p291)

THE TRUSTEES OF THE BRITISH MUSEUM

262. Head of a Young Girl 1898

Coloured chalks on grey paper, 24 × 21.2 (9½ × 8⅜)
Signed and dated *CHS 98* (lower right)
The drawing seems to be a portrait, either in its own right or in preparation for a painting, rather than a study for a figure subject.

THE BOARD OF TRUSTEES OF THE VICTORIA AND ALBERT MUSEUM, LONDON

263. Study of a Man Striding, seen from the back c1904(?)

Red chalk, 41 × 28.3 (16⅛ × 11⅛)
Signed *CS* (lower right)
The study does not seem to relate to a known composition by Shannon, but the pose is a little reminiscent of the two figures in *The Sower and the Reaper*, a lithograph of 1904 (D55), and the summary handling points to a similar date. The drawing probably belonged to Glyn Philpot, who met Ricketts and Shannon before the First World War and was profoundly influenced by them in the 1920s.

PRIVATE COLLECTION

264. A Woman and Two Children Bathing: Design for a Fan c1906(?)

Pen and blue ink, red chalk, blue wash and white bodycolour on grey paper, height 14 (5)
Signed *CS* (lower left)
The fan format is particularly associated with Shannon's younger contemporary Charles Conder, but Shannon himself was fond of it, clearly enjoying the compositional challenge it presented. He used it for a number of drawings as well as for a group of lithographs dating from 1906–9. Another exponent was Mary Davis, the wife of Sir Edmund Davis, who was taught painting by Shannon and greatly influenced by Conder, who decorated two rooms in her house in Lansdowne Road. The Tate Gallery has a fan-shaped watercolour on silk by her, very much in the Conder style (*Masques and Bergamasques*, no.3004).

SIR BRINSLEY FORD, CBE, FSA

265. Study of a Female Nude 1917

Red chalk, 31 × 15 (12¼ × 5⅞)
Signed and dated *C S 1917* (lower left) and inscribed *Rebirth of Arts* (lower right)
The drawing is a study for the female figure in Shannon's lithograph *The Re-Birth of the Arts* (D87), one of the twelve lithographs by various artists published by the Fine Art Society for the Ministry of Information in 1917 under the title *The Great War: Britain's Efforts and Ideals* (see Cat. 315). In the print the figure assumes a more standing position and holds an olive branch in her left hand. The drawing is unusually subtle for Shannon at this comparatively late date, when his work often suffers from coarseness of handling.

PRIVATE COLLECTION

266. Study for 'The Wise and Foolish Virgins'
1917
Black and white chalk on blue paper, 44.4 × 29.2
($17\frac{1}{2}$ × $11\frac{1}{2}$)
Inscribed with the title in the artist's hand (lower right)
A study not for the painting at Liverpool exhibited here
(Cat. 257) but for the version dated 1917 in the
Northampton Art Gallery, which shows the Foolish
Virgins – the figures seen in the drawing – mounting
stairs in an agitated manner.
SIR BRINSLEY FORD, CBE, FSA

267. The Romantic Landscape 1893 (D14)
Lithograph in black, 22.5 × 21.7 ($8\frac{7}{8}$ × $8\frac{1}{2}$)
Signed with monogram in the stone and signed *Charles
Shannon* in pencil (lower right)
Shannon took up lithography in 1888 when, apart from
Whistler, it had few exponents in England, although it
was flourishing in France. He quickly mastered the
medium and, by publishing his prints in periodicals and
three separate portfolios (1893–5), did much to bring
about a revival. In all he produced over a hundred
prints. Some of the best, unrepresented here, are
portraits of male members of his circle; the others
correspond closely to his subject paintings, which were
often based on designs originally conceived as
lithographs. Charles Ricketts produced a catalogue in
1902, and a modern catalogue by Paul Delaney was
published in 1978.
 The Romantic Landscape is an early example, a little
Samuel Palmer-like in mood and with the delicate
silvery tone so characteristic of Shannon's work in this
medium. There was an edition of thirty impressions,
and the print was published separately in *The Dial* 3
1893. Watercolour, pastel and oil versions are recorded.
THE TRUSTEES OF THE BRITISH MUSEUM

268. Atalanta 1893 (D15)
Lithograph in green, 20.4 × 16.3 (8 × $6\frac{3}{8}$)
Signed *Charles Shannon* in pencil (lower right)
With its sharp diagonal rhythms, introspective mood,
and effect of shimmering light, *Atalanta* is generally
considered to be one of Shannon's finest lithographs. An
edition of fifty impressions was issued and the print was
published separately in *The Dial* 4 1895. There were also
two oil versions entitled *A Wounded Amazon*, one
painted in 1896 (repr *The Pageant* 1897, p83), the other
exhibited at the RA in 1923.
 For the story of the virginal Atalanta, see Cat. 489.
THE TRUSTEES OF THE BRITISH MUSEUM

269. The Arming of Aphrodite 1893–4 (DIII)
Lithograph in black, 23.6 × 14.3 ($9\frac{1}{4}$ × $5\frac{5}{8}$)
This lithograph was not published or described in
Ricketts's catalogue (1902), and in fact only one
impression is known. The title is conjectural but seems
to be correct, Aphrodite being the nude figure putting
on a helmet, while one of her companions holds a lance
and another a shield which the goddess uses as a mirror.
Other pieces of armour are seen on the ground.
THE TRUSTEES OF THE BRITISH MUSEUM

270. Ministrants 1894 (D18)
Lithograph, 42.5 × 56.5 ($16\frac{3}{4}$ × $22\frac{1}{4}$)
Signed and dated *CHS 94* in the stone (lower left) and
signed *Charles Shannon* (lower right)
Exh: *At the Sign of the Dial*, Lincoln, etc 1987–8 (30)
This is by far the largest of Shannon's early lithographs
and he took great trouble in preparing it, as is shown
by a group of studies in the British Museum. In 1905
he reinterpreted the design in a colour lithograph
(*Morning*, D63), endowing the figures with more
Rubensian forms.
LINCOLNSHIRE COUNTY COUNCIL, RECREATIONAL SERVICES,
USHER GALLERY, LINCOLN

271. Sea and Breeze 1894 (D25)
Lithograph in black, 22 × 23.6 ($8\frac{5}{8}$ × $9\frac{1}{4}$)
Signed *C H Shannon del* in pencil (lower right)
One of the best of Shannon's many compositions with
figures on the sea shore, the print was issued in an
edition of fifty-five impressions published in *The
Portfolio* 2 1894. An oil version, entitled *The Summer Sea*,
was exhibited at the RA in 1919.
THE TRUSTEES OF THE BRITISH MUSEUM

272. The Wayfarers 1904 (D57)
Lithograph in dark green, 39.7 × 29.3 ($15\frac{5}{8}$ × $11\frac{1}{2}$)
Initialled in the stone and signed *C H Shannon* in pencil
(lower right)
Shannon abandoned lithography in 1897 but took it up
again in 1904, working in a bolder (some might say a
coarser) style. *The Wayfarers* is one of the most attractive
of these later prints, although, as so often with Shannon,
the effect is uneven, the haunting group of the mother
and child being better conceived than the figure of the
nude man. An edition of fifty impressions in black or
dark green was published by Colnaghi and Obach.
THE TRUSTEES OF THE BRITISH MUSEUM

273. Repose 1908
Bronze, height 25.4 (10); length 30.5 (12)
Exh: International Society 1908 (317); *Fair Women*,
International Society 1908 (7)
Shannon's only known essay in sculpture, *Repose* is
comparable to Ricketts's sculptures in scale and Rodin-
like modelling, although the figure type is unmistakably
Shannonesque. The original plaster is in the Herbert Art
Gallery, Coventry, being one of the items which
probably belonged to Ricketts and Shannon's faithful
manservant, Nicholls (see Cat.290).
PRIVATE COLLECTION

LAURENCE HOUSMAN
1865–1959

Housman was born at Perry Hall, Bromsgrove, the
son of a local solicitor; he was one of seven children,
of whom A E Housman was the oldest. His mother
died when he was six, and his father sank into penury,
placing great strain on his family. In 1882 Laurence
and his sister Clemence moved to London to study
at the City and Guilds Art School, Lambeth, where
Ricketts, Shannon and Sturge Moore were also
pupils. Clemence studied wood-engraving and was
later to engrave the work of her brother and others
(Cat. 538); Laurence, after five years at Lambeth,
went on to study at South Kensington (1887–9). By
1888 he was publishing drawings and writings in
Harry Quilter's *Universal Review*, and a commission
from Quilter to illustrate Meredith's poem *Jump to
Glory Jane* (1892) marked his debut as a book illustra-
tor. He was soon taken up by two other enterprising
publishers: Kegan Paul, who issued his selection of
writings by Blake, an important early influence on
Houseman, in 1893; and John Lane, who employed
him regularly as a book designer from that year.
Though never close personally to Ricketts, he owed
much to him as an artist, while sharing the general
enthusiasm in Ricketts's circle for Dürer and the
illustrators of the Sixties. His designs for Christina
Rossetti's *Goblin Market* (1893; Cat. 278) brought
him wider recognition as an illustrator, and from 1894
he decorated a series of books by himself (Cat. 280–1,
283) and others, including the strong-minded
Clemence. He also contributed to such famous
periodicals of the day as *The Yellow Book* and *The
Pageant* (Cat. 274). From the late 1890s he gradually
abandoned art for writing: his eyesight was deterio-

rating and writing was more profitable. He was art
critic of the *Manchester Guardian* 1895–1914 and in
1900 published (anonymously) *An Englishwoman's
Love-Letters*, a psychological study which proved
highly popular. He also launched into a career as a
playwright and began to take up feminism, pacifism
and other social causes. Indeed his early artistic work
was almost forgotten; it is not even mentioned in
Roger Fulford's life of him in the *DNB*. Never marry-
ing, he continued to live with Clemence, settling with
her at Street, Somerset, in 1924. She died in 1955 and
Laurence four years later, aged 95.

Ref: Laurence Housman, *The Unexpected Years* 1937;
Rodney Engen, *Laurence Housman* 1983

274. The Invisible Princess 1897
Pen and black ink, with touches of brown ink and white
bodycolour, 19.8 × 11.8 ($7\frac{7}{8}$ × $4\frac{5}{8}$)
Signed *LH* (lower right)
Lit: Gleeson White and C H Shannon (eds), *The Pageant*
1897, p125, repr; Engen, pp61, repr, 93
The drawing was published in *The Pageant* in 1897 as
an illustration to Housman's story 'Blind Love'. One of
his strongest and most emotionally charged designs, it
clearly, as Engen observes, betrays the influence of
Dürer, not least in the treatment of the distant
battlements. Ricketts and Reginald Savage were using
Dürer in much the same way at this period (cf Cat. 320,
334–5), and all three were taking their cue from the Pre-
Raphaelites, who had plundered Dürer for picturesque
detail and based their drawing-style on his engravings
in the 1850s and 1860s.
THE VISITORS OF THE ASHMOLEAN MUSEUM, OXFORD

275. The Burning Rose 1898
Pen and ink, 15.5 × 10 ($6\frac{1}{8}$ × 4)
Signed *LH* (lower left)
An illustration to the story 'The Bound Princess' in
Housman's third collection of fairy stories, *The Field of
Clover* 1898 (Cat. 281). Housman loved to introduce
swirling drapery, often so extravagant in form and
independent in movement that the underlying structure
of the figures is lost. This is particularly noticeable here;
indeed it takes some time to work out what is
happening.
 The version as it appears in the book, engraved by
Clemence Housman, is reproduced in Engen, p73.
PRIVATE COLLECTION

276. The Rat-Catcher's Daughter 1904 *ill. p161*
Pen and ink, 15.2 × 9.2 (6 × $3\frac{5}{8}$)
Signed *LH* (lower left)
Lit: Engen, p66, repr (enlarged)
An illustration to Housman's last collection of fairy
stories, *The Blue Moon* (Cat. 283), the drawing
exemplifies his debt to the Pre-Raphaelite illustrators of
the 1860s.
THE TRUSTEES OF THE TATE GALLERY

277. The White Doe 1904 *ill. p161*
Pen and ink, 14 × 8.3 ($5\frac{1}{2}$ × $3\frac{1}{4}$)
Signed *LH* (lower left)
Lit: Engen, p76, repr (enlarged)
Another illustration to *The Blue Moon* (Cat. 283)
THE TRUSTEES OF THE TATE GALLERY

278. Christina Rossetti, *Goblin Market*
Illustrated by Laurence Housman
London: Macmillan & Co. 1893. 8vo
The book is a landmark in Housman's career as an
illustrator. An ambitious project, inviting comparison
with D G Rossetti's original designs to the poem (1862),
it was proposed by Housman himself to Macmillan,
Christina Rossetti's publisher, and undertaken with her

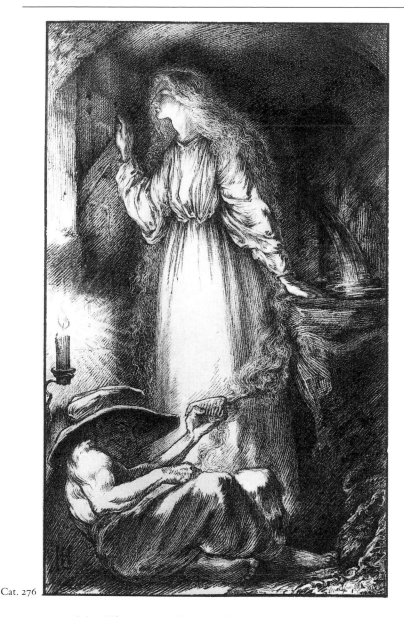

Cat. 276

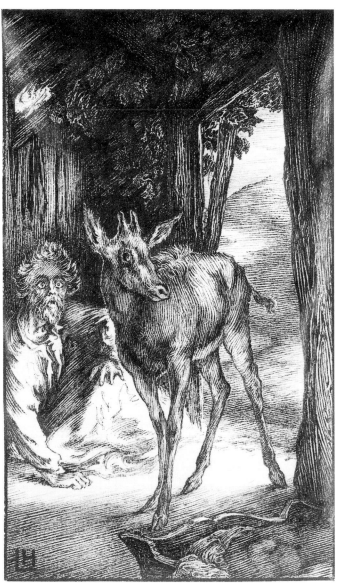

Cat. 277

express permission. When it appeared in December 1893 it met with critical acclaim and did much to establish the artist's reputation. Among those who admired it was Sir Frederic Leighton, always on the lookout for new talent. He had already commissioned drawings from Beardsley and Ricketts (Cat. 291), and now bought the book's frontispiece. Unfortunately, Christina Rossetti herself was less pleased; when asked if she liked the designs, she shook her head, saying, 'I don't think my Goblins were quite so ugly'.

THE BRITISH LIBRARY BOARD

279. Jane Barlow, *The End of Elfin-Town*
Illustrated by Laurence Housman
London: Macmillan & Co. 1894. 8vo
Pleased with *Goblin Market* (Cat. 278), Macmillan commissioned Housman to illustrate Jane Barlow's *The End of Elfin-Town* the following year. He produced six large text illustrations and eight full-page drawings, evoking a disturbing sense of reality by placing his strange elfin creatures, with their willowy limbs, pointed ears and luxuriant mops of hair, in naturalistic settings. There are echoes of Beardsley and Ricketts, but in terms both of mood and design Housman's powerful artistic personality is always in full control.

SIMON REYNOLDS

280. Laurence Housman, *Green Arras*
Illustrated by the author
London: John Lane 1896. 8vo
Housman's first published volume of poetry, *Green Arras* has five full-page illustrations and a particularly rich frontispiece and title-page. Engen describes it as a 'labour of love', pointing out that Laurence was involved as author and illustrator, his sister Clemence, to whom the book is dedicated, as engraver, and his elder brother Alfred as the critic to whom the poems had been submitted prior to publication. The book received favourable reviews, notably in the *Athenaeum* and by Gleeson White, a consistent champion of Housman's work, in the *Studio*.

SIMON REYNOLDS

281. Laurence Housman, *The Field of Clover*
Illustrated by the author
London: Kegan Paul & Co. 1898. 8vo
Between 1894 and 1904 Housman produced four volumes of fairy stories, all illustrated by himself. *The Field of Clover* was the third, and like its two predecessors (*A Farm in Fairyland* and *The House of Joy*) was published by Kegan Paul. Dedicated to his sister

Clemence – 'My Dear Wood-Engraver' – it contains five stories and ten full-page illustrations, one exhibited here (Cat. 275).

SIMON REYNOLDS

282. Percy Bysshe Shelley, *The Sensitive Plant*
Illustrated by Laurence Housman
London: Aldine House 1898. 4vo
Housman considered that his twelve full-page illustrations to this book were 'the best drawings I ever did'. The symbolism of the poem appealed to him, and the subject enabled him to explore his favourite garden settings. Remarkable for their detail and delicacy of touch, the drawings evoke a poignant image of an ideal world menaced by death and corruption.

SIMON REYNOLDS

283. Laurence Housman, *The Blue Moon*
Illustrated by the author
London: John Murray 1904. 8vo
The Blue Moon was the last of Housman's four collections of fairy stories, this time published by John Murray. For two of the original drawings, see Cat. 276–7.

SIMON REYNOLDS

CHARLES DE SOUSY RICKETTS
1866–1931

Painter, sculptor, book and theatre designer, collector, art critic and writer. Born Geneva, 2 October 1866, son of a retired naval officer who did marine paintings. Had private schooling in England and France, but largely self-educated. Attended South London Technical (now City and Guilds) Art School, where in 1882 he met his lifelong companion, Charles Shannon, and studied wood-engraving (under Charles Roberts) and life drawing. Executed pen and ink designs for reproduction in magazines such as *Woman's World*, *Universal Review*, *Atalanta*, *The Magazine of Art* and *Black and White* (1888–97); also commercial illustrations for the publishers Osgood McIlvaine and The Bodley Head. The most famous of these were for his friend Oscar Wilde, including *A House of Pomegranates* (1891), *Poems* (1892) and *The Sphinx* (1894). With Shannon founded an occasional magazine, *The Dial* (1889–97), illustrated *Daphnis and Chloe* (1893) and *Hero and Leander* (1894), and launched the Vale Press (1894–1904), for which he designed three founts and many woodcut decorations and illustrations, publishing in all about a hundred books. Took up painting and sculpture 1900. After some early lessons from Shannon, produced romantic subject paintings of a tragic and dramatic character, influenced by Gustave Moreau, Daumier and Delacroix. First appearance as a painter at Wolverhampton Industrial Exhibition 1902. First one-man show of paintings, Dutch Gallery 1906, and of sculpture, Carfax Gallery 1906. Also exhibited for many years at International Society and later at Royal Academy (1923–31; ARA 1922, RA 1928). Took up theatre design with Laurence Binyon's *Oenone* (1906) and was involved in more than forty productions, including *King Lear* (1911), Shaw's *St Joan* (1924), *Henry VIII* (1925), *The Mikado* (1926), *The Coming of Christ* (Canterbury Cathedral 1928) and *Elizabeth of England* (1931). Published *The Prado and its Masterpieces* (1903), *Titian* (1910), *Pages on Art* (1913), *Beyond the Threshold* (1929), *Recollections of Oscar Wilde* (1932), *Unrecorded Histories* (1933), the last two appearing posthumously. Member of Executive Committees of NACF, British School in Rome and International Society. Art adviser to the National Gallery of Canada 1924–31. Organised several large exhibitions, among them *A Century of Art* (1911) and the RA *Exhibition of Italian Art* (1930). Died 7 October 1931. Memorial Exhibitions at RA, London, and in Manchester (1933). With Shannon bequeathed most of his collection to the Fitzwilliam Museum, Cambridge.

Ref: C Lewis Hind, 'Charles Ricketts. A Commentary on his Activities', *Studio* 48 1910, pp259–66; Cecil Lewis (ed), *Self-Portrait: Letters and Journals of Charles Ricketts* 1939; T Sturge Moore, *Charles Ricketts RA. Sixty-Five Illustrations* 1933; Stephen Calloway, *Charles Ricketts: Subtle and Fantastic Decorator* 1979; *All for Art: The Ricketts and Shannon Collection*, exh. Fitzwilliam Museum, Cambridge 1979, cat. by Joseph Darracott; Joseph Darracott, *The World of Charles Ricketts* 1980; Michael R Barclay, *Catalogue of the Works of Charles Ricketts RA from the Collection of Gordon Bottomley*, Carlisle Museum and Art Gallery 1985; J G P Delaney, *Charles Ricketts: A Biography*, to be published by Oxford University Press 1989

284. **The Betrayal of Christ** 1904
Oil on canvas, 91.4 × 71.1 (36 × 28)
Signed *CR*
Exh: *Independent Art of To-Day*, Agnew's 1906 (33);

Whitechapel, Spring 1908 (330); *Chosen Pictures*, Grafton Galleries 1909 (105); International Exh., Rome 1911; RA, Winter 1933 (330); Orleans House 1979 (115)
Lit: *Self-Portrait*, p106; Hind, pp259, repr 262, 264; Sturge Moore, pl.VII; Calloway, pl.71; Darracott, pp59, 65, repr; Barclay, no.5

Ricketts took up painting in oils in the 1900s, after the closure of the Vale Press. Certain subjects had profound significance for him and he returned to them again and again; sometimes there is even a reflection in the work of Shannon, as in the case of his *Wise and Foolish Virgins* (Cat. 257, 266), a theme that obsessed Ricketts, as it had obsessed his hero Wilde. Although Ricketts would have said he was an unbeliever, no story moved him more than that of the Passion; Christ was for him the supreme artist, the man who remains utterly true to himself and ultimately creates beauty even out of torture and death. Again, the concept probably owed much to Wilde, and perhaps something also to Blake.

Oil painting did not come easily to Ricketts and his pictures vary considerably in quality. *The Betrayal* is one of the most successful, and it was much exhibited during his life. According to Barclay, it was painted on commission from Agnew's, who sold it to Judge William Evans, and at Evans' sale bought back by Ricketts, from whom it was acquired by Gordon Bottomley in 1924. Other sources state that Bottomley bought it at the Grosvenor Galleries the following year.
CARLISLE MUSEUM AND ART GALLERY

285. **The Descent from the Cross** c1905
Oil on canvas, 39.4 × 88.3 (15½ × 34¾)
Signed *CR* (lower left)
Exh: International Society 1905 (232); *Paintings and Bronzes by Charles Ricketts and Charles Shannon*, Carfax Gallery 1907 (1); *Oil Paintings . . . by Charles Shannon,*

Charles Ricketts, William Strang . . ., Manchester 1909 (43); International Society 1915 (31)

As already noted (Cat. 284), the figure of Christ occupied an important place in Ricketts's personal mythology, representing heroic independence of conventional values. The subject of the Deposition particularly appealed to him and he treated it many times. Other pictorial versions are in the Tate and at Bradford; a third is reproduced in Sturge Moore, pl.VI. There are also two sculptures (see Cat. 317).

Like Shannon's *Bath of Venus* (Cat. 252), the picture belonged to William Pye, who still had it in 1933. It was subsequently acquired by Cecil French, friend and champion of many 'last romantics', who bequeathed it to the William Morris Gallery in 1954.
THE WILLIAM MORRIS GALLERY, LONDON BOROUGH OF WALTHAM FOREST

286. **Don Juan and the Commander** c1905 *ill. p44*
Oil on canvas, 40.7 × 31.8 (16 × 12½)
Exh: *Chosen Pictures*, Grafton Galleries 1909 (21) (?); RA 1933 (333)
Lit: C R Cammell, *Heart of Scotland* 1956, p127

Don Juan, like Christ, was a figure of enormous importance for Ricketts. According to Sturge Moore, he regarded him as 'a kind of saint, [deriding] all attempts to justify God's way to man' and representing 'complete and mental freedom from conventions and traditions'. 'Ricketts's actions', Moore continued, 'were extremely unlike those attributed to Don Juan, but in his courageous rejection of views which did not harmonise with his experience, he was his disciple.' Mozart had illustrated this theme with divine music, Shaw and others had written interestingly, enriching it for him, and his rejection of Molière's *Le Festin de Pierre* and of my poem *A Spanish Picture* as quite unworthy

Cat. 287

of the story, also sealed its peculiar wisdom as more particularly his'. Moore might have added Byron's *Don Juan* to the list; it was, Ricketts wrote, 'the poet's passport to immortality'.

Ricketts treated the theme in numerous works; the present composition alone (an example, incidentally, of the influence on him of Daumier) is known in a second version (Sturge Moore, pl.XV) and anticipates his RA Diploma work of 1928.

The picture has an interesting provenance. It was owned by Beardsley's sister Mabel (died May 1916), then by André Raffalovich, who had befriended and patronised her brother. C R Cammell recalled seeing it in Raffalovich's dining-room about 1930 – 'a small, strangely romantic picture . . . painted with intense feeling'. Raffalovich died in February 1934, and the picture then belonged briefly to his lifelong friend Canon John Gray, who died four months later. Gray had started his career as a protégé of Oscar Wilde and a member of Ricketts and Shannon circle; his poems *Silverpoints* (1893) were published in an exquisite binding by Ricketts, he contributed to the *Dial* and was the subject of one of Shannon's finest lithographs (1896). Since then he had been received into the Roman Church, and in 1907 became parish priest of St Peter's, Edinburgh, built for him by Robert Lorimer and gradually filled with works of art by John Duncan, Frank Brangwyn, Glyn Philpot, Malcolm Drummond, and others – all with financial support of Raffalovich. Though most of these works are now regrettably dispersed, the venture remains a fascinating meeting-point for English and Scottish Symbolism, and deserves to be better known (information kindly supplied by Mr J C M Nolan).

SCOTTISH NATIONAL GALLERY OF MODERN ART, EDINBURGH

287. The Death of Don Juan c1911 ill. p162
Oil on canvas, 116.2 × 95.9 (45¾ × 37¾)
Signed *CR*
Exh: *Century of Art Exh.*, International Society 1911 (93); Cambridge 1979 (A5)
Lit: *Self-Portrait*, pp280–1, 296, 307; Denys Sutton, 'A Neglected Virtuoso: Charles Ricketts and his Achievements,' *Apollo* February 1966, pp143, repr, 146; John Christian, *Symbolists and Decadents* 1977, pl.27.
See Cat. 286. In this case there is a definite link with Mozart's *Don Giovanni*, which Ricketts had first seen at the age of six. 'The curtain . . .', he wrote, 'represents the rush of the wood instruments in the Overture'.
THE TRUSTEES OF THE TATE GALLERY

288. Bacchus in India c1913 ill. p38; detail p150
Oil on canvas, 117 × 95 (46 × 37½)
Exh: International Society 1913 (84); Cambridge 1979 (A6)
The son of Jupiter by Semele, Bacchus discovered the culture of the vine and made a progress through Asia, teaching it to the people. He spent several years in India, inculcating the orgiastic rites of the new worship. Ricketts pictures him riding on an elephant while drunken devotees lead the procession and throw themselves in his path.

One of Ricketts's most dramatic works, the picture no doubt owes something to his admiration for Titian's *Bacchus and Ariadne* in the National Gallery (see Cat. 256), although the figures in the foreground seem to betray the influence of Delacroix, another artist he greatly respected. It was not his first attempt at the theme; a picture entitled *The Triumph of Bacchus* was shown at the exhibition he shared with Shannon at the Carfax Gallery in 1907.
THE ATKINSON ART GALLERY, SOUTHPORT: METROPOLITAN BOROUGH OF SEFTON LIBRARIES AND ARTS DEPARTMENT

289. Salome, Daughter of Herodias 1925
Oil on canvas, 91.5 × 118 (36 × 46½)
Signed *CR* (lower right)
Exh: RA 1925 (167)
Lit: *Royal Academy Illustrated* 1925, p109
In this picture it is almost as if Ricketts is baiting those who dismissed him and Shannon as 'back-numbers' (see Introduction). Exhibited at the RA the same year as Maurice Greiffenhagen's *The Offerings* (Cat. 133) and Cayley Robinson's *Call of the Sea* (Cat. 232), it clearly looks back to the Symbolist world of his youth, evoking memories particularly of Gustave Moreau's famous picture *The Apparition* (Fig. 4), exhibited at the Paris Salon in 1876 and at the Grosvenor Gallery, London, the following year, and of Oscar Wilde's play *Salomé* (1894), illustrated by Beardsley. Ricketts himself had discussed the staging of this with Wilde and had designed two productions: one staged by the Literary Theatre Society in 1906, the other in Tokyo in 1919.

A sequel to the picture, *The Head of John the Baptist*, was shown at the RA in 1928, but this is more dramatic and less successful.
BRADFORD ART GALLERIES AND MUSEUMS

290. Faust and Mephistopheles 1930
Oil on canvas, 117.5 × 90 (46¼ × 35½)
Signed *CR* (lower right)
Exh: RA 1930 (218)
Lit: *Royal Academy Illustrated* 1930, p90
Faust was yet another figure with whom Ricketts identified. In 1928, two years before the picture was painted, he wrote of being faced with a 'sudden sense, like Faust, that only ashes remained of years of effort, that one was suddenly attacked from within and from without by a spiritual "Termite" who seemed to have undermined everything' (*Self-Portrait*, p407). Like his respect for Don Juan, the comparison sprang from aesthetic experience. Seeing Gounod's *Faust* was one of his earliest memories. He published an edition of Marlowe's *Dr Faustus* at the Vale Press (1903), and later made designs for a projected production by Granville-Barker at the Court Theatre, London. One of these (V&A, E 1015–1933) anticipates the present design.

The picture is one of two (the other being *Siegfried and the Magic Bird*) which Ricketts showed at the RA in 1930, the year before his death. Both were given to the Herbert Art Gallery, Coventry, in 1962 by Mr and Mrs A E Nicholls, together with a small rather indifferent version of Shannon's *Wise and Foolish Virgins* (Cat. 257) and the original plaster for his only known sculpture, *Repose* (Cat. 273). It seems likely that Mr Nicholls was a son or other relative of P Nicholls, Ricketts and Shannon's faithful manservant, who had probably been given these items at the time of Ricketts's death. Two late paintings by Ricketts, totally out of fashion, and two virtually unsaleable items by Shannon, seem just the kind of things that might have been disposed of in this way. If so, we have to thank Nicholls and his wife not only for looking after the poor witless Shannon but for preserving these interesting relics of their employers.
HERBERT ART GALLERY AND MUSEUM, COVENTRY

291. Oedipus and the Sphinx 1891 ill. p163
Pen and ink, 23.3 × 15.5 (9⅛ × 9⅛)
Signed and dated *R91*
Exh: RA 1933 (403); Carlisle 1970 (70); *Burne-Jones*, Sheffield 1971 (208); Orleans House 1979 (32); Lincoln, etc 1987–8 (57)
Lit: *The Pageant* 1896, p65, repr; Sturge Moore, pl.XXVII; C J Holmes, *Self and Partners* 1936, p164; *Self-Portrait*, p19; *Poet and Painter*, p3; Leonée and Richard Ormond, *Lord Leighton* 1975, pp117–8; Calloway, pl.14; Darracott, p72, repr; Barclay, no.1
Ricketts thought this early drawing his best and Gordon Bottomley agreed, telling the young Paul Nash to 'look

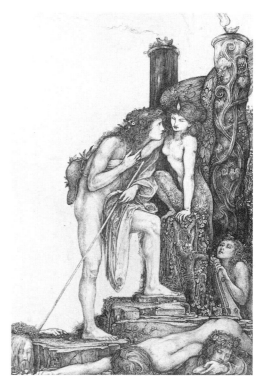

Cat. 291

how rich and full of meaning every line [of it] is'. It was commissioned by Sir Frederic Leighton, President of the Royal Academy and an enlightened talent spotter, for £5 (cf Cat. 278). Allowing Ricketts to choose the subject, he wrote, 'I'm afraid you won't care for my work, but I am interested in yours'. He was delighted with the result, telling Ricketts that the design was 'full of imagination and a weird charm – it is also, in such passages, for instance, as the wings of the Sphinx and the hair of Oedipus, a marvellous piece of penmanship'. In 1896 Ricketts bought the drawing back at Leighton's sale and published it in the *Pageant*. Bottomley tried to buy it in the 1920s, but Ricketts told him it had disappeared. By 1933, when Sturge Moore reproduced it, it belonged to William Rothenstein, and Bottomley finally acquired it from him in 1936.

The Sphinx was a monster who ravaged the neighbourhood of Thebes, devouring all who failed to answer her riddle. Oedipus gave the correct answer, causing the Sphinx to expire, and was rewarded with the hand of the widowed Queen, Jocasta, thus inadvertently marrying his own mother. The subject had been treated by Ingres and Ricketts's hero, Gustave Moreau. The drawing was made three years before the publication of *The Sphinx* by Oscar Wilde with illustrations by Ricketts (Cat. 322), but there may be some connection since Ricketts knew Wilde by 1891 and *The Sphinx* was in progress long before it was published. For a copy of the drawing by Maxwell Armfield, see Cat. 102.
CARLISLE MUSEUM AND ART GALLERY

292. The Christ c1893 ill. p164
Pen and ink on pink paper, 17.5 × 14.6 (7 × 5¾)
Exh: RA 1933 (404); Orleans House 1979 (37)
Lit: Sturge Moore, pl.XXXII; Darracott, p44, repr
One of the original drawings for Oscar Wilde's *The Sphinx*, 1894 (Cat. 322), illustrating the lines
Whose pallid burden, sick with pain, watches the
world with wearied eyes,
And weeps for every soul that dies, and weeps for
every soul in vain.

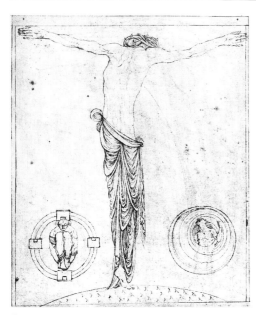

Cat. 292

For the printed page, with design and text, see Calloway, pl.39.

Three of the *Sphinx* drawings are at Manchester, all given by Albert Rutherston, brother of William Rothenstein, in 1925.

MANCHESTER CITY ART GALLERIES

293. The Autumn Muse before 1897
Three drawings, each pen and ink and white bodycolour; above 14.1 × 13.4 (5½ × 5¼), centre 8 × 7.2 (3⅛ × 2⅞), below 14 × 13.2 (5½ × 5¼)
The lower drawing signed *CR* (lower left)
Exh: RA 1933 (394)
Lit: The lower drawing: *The Pageant* 1897, repr; Calloway, pl.28
The drawings were made in preparation for an unexecuted wood-engraving, those above and centre being rough drafts while the lower drawing, on tracing paper, is a 'fair copy'. This method of working was very characteristic of Ricketts; Sturge Moore discusses it in the Introduction to his monograph.

The drawings belonged to Campbell Dodgson, Keeper of the Department of Prints and Drawings at the British Museum 1912–32.

THE TRUSTEES OF THE BRITISH MUSEUM

294. Illuminated Page from 'Hero and Leander' 1894–9
Watercolour with bodycolour and gold paint, page size 19.7 × 12.7 (7¾ × 5)
Exh: Arts and Crafts Exh. Soc., 6th Exh. 1899 (Case N,9); Cambridge 1979 (A7); Orleans House 1979 (31)
Lit: Calloway, p57, pl.53
The illumination is worked on a printed page of the Vale Press *Hero and Leander* (Cat. 323), the painted image differing from the woodcut beneath, which shows Hermes and the three Fates. This was a private experiment by Ricketts, who probably had hopes of getting someone to commission an illuminated copy of the book.

Having been exhibited in 1899 at the 6th Arts and Crafts Exhibition, the painting was lost sight of, although Cecil French tried more than once to buy it from Ricketts. After Ricketts's death it was found by Sturge Moore among some Vale Press papers. French eventually acquired it when it appeared at a sale at

Sotheby's about 1938, together with some Oscar Wilde letters, and subsequently gave it to the British Museum.

THE TRUSTEES OF THE BRITISH MUSEUM

295. St Francis and the Wolf before 1899
Two drawings, each pen and ink and white bodycolour on tracing paper, 12 × 9.7 (4¾ × 3⅞) and 14.3 × 10 (5⅝ × 4)
Exh: RA 1933 (390)
Probably a design for a wood-engraving, like Cat. 293, and certainly in the same technique, one drawing being a 'fair copy' of the other. They belonged to Robert Steele, a distinguished student of medieval literature who edited two books for the Vale Press and may conceivably have been related to Amy C Steele, Anning Bell's first wife. There was formerly a letter on the back from Ricketts to Steele, as follows: 'Here is the long promised drawing, much of it is not bad. The wolf however as you will see has obviously been drawn [done?] from description'. Steele used the design as the frontispiece to his edition of *The Mirror of Perfection* 1903.

THE TRUSTEES OF THE BRITISH MUSEUM

296. Study of a Male Nude c1905(?)
Pencil, 13 × 38 (5⅛ × 15)
A fine and significant drawing, epitomising the influence of Delacroix on Ricketts and the homo-erotic impulse behind his work. The subject had clearly moved him to make an unusually free and authoritative visual statement.

THE BOARD OF TRUSTEES OF THE VICTORIA AND ALBERT MUSEUM, LONDON

297. Album of Drawings
Fifty-seven pages, 40 × 28 (15¾ × 11), with drawings in pen and ink, watercolour and bodycolour, some on tracing paper
Inscribed on the front by Ricketts *Scrawls and Scraps for Sphinx, Poems in Prose, Omar, Imitation of Christ C Ricketts*; some of the drawings annotated by Gordon Bottomley
Lit: Barclay, no.48
This is one of five albums in which Ricketts gathered miscellaneous drawings and sketches in the last two years of his life. It was bought by his friend and admirer Gordon Bottomly at the sale of Shannon's estate at Sotheby's, 9 June 1938, and bequeathed by him to his executor, Claude Colleer Abbott. In 1971 Abbott in turn bequeathed it to Carlisle, where it rejoined the rest of the Bottomley collection. Three of the other albums are in the British Museum; the fourth, containing theatrical designs, was sold in 1979, broken up and dispersed.

CARLISLE MUSEUM AND ART GALLERY

298. Stage Design for 'Agamemnon' 1909
Watercolour with bodycolour over black chalk, the outline incised 32.7 × 44.7 (12⅞ × 17⅞)
Inscribed *Agamemnon* (lower centre)
A severely classical design for an unstaged production of the tragedy by Aeschylus. It dates from early in Ricketts's career as a designer for the stage, which began with a number of semi-professional productions but really took wing with Herbert Trench's *King Lear* at the Haymarket in 1909.

THE BOARD OF TRUSTEES OF THE VICTORIA AND ALBERT MUSEUM, LONDON

299. Stage Design for 'The Eumenides' c1919
Black chalk, red ink, and watercolour with bodycolour on grey-green paper, 41.9 × 57.2 (16½ × 22½)
Inscribed *The Eumenides* (lower centre) and signed on the back
Exh: International Theatre Exhibition, V&A 1922 (113)

Lit: Sturge Moore, pl.LIX; Calloway, pl.80
Aptly described by Calloway as one of Ricketts's 'most splendidly hieratic conceptions', the drawing seems, like Cat. 298, to be for a production of a tragedy by Aeschylus that never materialised. It exemplifies Ricketts's passion for making dramatic use of curtains in his stage sets, while the figures betray his admiration for Gustave Moreau. Like Delacroix, another hero, he saw no discrepancy between romanticism and classic art; after all, who more than the Greek tragedians had expressed those 'emotions of awe, melancholy and compassion' which he recognised as the hallmarks of his own work?

THE BOARD OF TRUSTEES OF THE VICTORIA AND ALBERT MUSEUM, LONDON

300. Costume Design for 'Judith' 1919
Watercolour, 37.6 × 30.2 (14¾ × 11⅞)
Inscribed (twice) with the title above
Lit: Calloway, pl.81
Ricketts's design for the costume worn by Lillah McCarthy (see Cat. 255) in Arnold Bennett's play *Judith*, produced at the Kingsway Theatre, London, in April 1919. Though the costume was made and a photograph exists showing the actress wearing it (Calloway, pl.82), it was banned by the censor and a more 'decent' version had to be substituted. 'I am heart-broken', Ricketts wrote to Binyon, 'that you should have seen *Judith* after the Lord Chamberlain had forbidden my dress in Act II. Lillah's bare torso, covered with bands and straps of jewels, emerging from the fish-tail skirt, the jewelled leg also bare, would have enchanted Gustave Moreau; she looked like a Kwannon or Astarte' (*Self-Portrait*, p315. For a fuller account of the play, which was not a success, see Lillah McCarthy, *Myself and Friends* 1933, pp228–31).

Ricketts had a reputation for 'daring' theatrical designs; as early as 1907 Granville-Barker had hesitated to use him for a production of Euripides' *Medea*, preferring the 'safer' Cayley Robinson. He designed two plays on the theme of Judith, the other, staged 1916, being by Sturge Moore, and the subject also occurs in his painting.

DERBY ART GALLERY

301. Costume Design 1919
Watercolour, 44.5 × 26.7 (17½ × 10½)
Inscribed by the artist *To A Drinkwater from C R Ricketts June 1919*
The production for which this attractive design was made has not been identified, but it was probably given to A E Drinkwater, father of the poet and playwright John Drinkwater and himself an actor-manager, associated with Ricketts's friend Lillah McCarthy. Because the drawing was given away in Ricketts's lifetime, it escaped the dispersal of his stage designs to museums by the NACF after his death in 1931, entering the collection at Bedford in recent times.

THE TRUSTEES OF THE CECIL HIGGINS ART GALLERY, BEDFORD

302. Stage Design for 'Parsifal' c1921
Watercolour with bodycolour, 29.6 × 41.2 (11⅝ × 16¼)
A design for Wagner's *Parsifal* (Act 3, Scene 1), showing landscape near the Castle of the Grail, with Gurnemanz's hut in the foreground. This and the following two items belong to a large group of stage and costume designs for Wagner's operas, commissioned from Ricketts c1920 by the tenor Melchior for the Bayreuth Festival, but never used. Comparable settings for *Parsifal* are at Southport and Nottingham.

THE SYNDICS OF THE FITZWILLIAM MUSEUM, CAMBRIDGE

303. **Costume Design for 'Parsifal'** c1921
Watercolour over black chalk, 31.7 × 43.2 (12½ × 17)
Exh: Probably RA 1933 (349); Cambridge 1979 (A16)
Lit: Sturge Moore, pl.LVI; Darracott, p192, repr
One of Ricketts's best-known and most splendid
costume designs.
THE TRUSTEES OF THE BRITISH MUSEUM

304. **Stage Design for 'Götterdämmerung'** c1921
Watercolour with bodycolour, 30.8 × 42.5 (12⅛ × 16¾)
See Cat. 302. The Keep at Chilham Castle, Kent, given
to Ricketts and Shannon by their patron Sir Edmund
Davis as a country retreat, provided the inspiration for
a number of these Wagnerian sets. 'It will be charming
and romantic', Ricketts wrote when they were settling
in in 1921, 'the tower by moonlight with tree shadows
cast across it looks like an ideal setting for *Tristan* . . .
The park and gardens are superb . . . there are dead trees
which make me think of the *Ring*. One of these is a
veritable dragon, a first-rate Fafner, which I shall put
upon the stage' (*Self-Portrait*, p337).
SUNDERLAND MUSEUM AND ART GALLERY (TYNE AND WEAR
MUSEUMS SERVICE)

305. **St Joan and her Voices** 1924 *ill. p166*
Watercolour with bodycolour, 46.3 × 60.6 (18¼ × 23⅞)
Inscribed with Latin texts on scrolls, and *stencil flowers*
in pencil (lower centre)
Lit: George Bernard Shaw, *St Joan* (de luxe ed) 1924,
p177, repr; Barclay, no.14
A study for a drop curtain in Bernard Shaw's play
St Joan, produced at the New Theatre, London, by the
author and Lewis Casson, March 1924, with Sybil
Thorndike in the leading role. Ricketts designed the
entire production, one of his most lavish and possibly
the climax of his career as a stage designer. There was
a series of drop curtains, the drawing for another is in
the Fitzwilliam Museum, Cambridge (repr Calloway,
pl.91).

In a letter to Sydney Cockerell now in the British
Museum (MS 52746, p128) Ricketts wrote that he was
using Paul de Limbourg and Van Eyck as sources for his
design ('an intelligent blend'), and asked for advice in
how to translate into Latin 'I sleep but my heart
waketh', the text inscribed above the figure of France
asleep at lower left. As the Latin version he suggests in
the letter ('Ego dormo sed cor me vigilat') differs from
that in the drawing ('Dormio sed vigilat cor meum'),
Cockerell, or some other pundit in Cambridge,
presumably put him right.

The drawing belonged to Gordon Bottomley who,
according to a note in the Carlisle Museum archive,
tried to buy it in the autumn of 1924. Ricketts, however,
refused to sell it, 'saying that he had not decided whether
it should survive or not'. He eventually gave it to
Bottomley at Easter 1930, 'while Shannon was lying
deranged and mortally ill'.
CARLISLE MUSEUM AND ART GALLERY

306. **The Annunciation** 1924
Pen and ink and watercolour, 5,8 × 17.7 (2¼ × 7)
Lit: Michael Barclay, 'The Scenic Designs of Charles
Ricketts', *Apollo* 121 March 1985, p185, fig.3
A study for the decoration of a *cassone* used in the
Epilogue of Bernard Shaw's play *St Joan* (see Cat. 305).
The *cassone* stood in a corner of King Charles's
bedroom, and the drawing shows the care that Ricketts
took over every detail of the production. He even went
so far as to illuminate the pages of St Joan's missal,
although the book was never opened on stage.
MICHAEL RICHARD BARCLAY

307. **Stage Design for 'Henry VIII'** 1925
Black chalk, black wash and white bodycolour,
31.7 × 42.5 (12½ × 16¾)

A design, with figures indicated, for the trial scene in
Shakespeare's *Henry VIII* (Act 2, Scene 4). The play was
produced by Lewis Casson at the Empire Theatre,
London, on 23 December 1925, with Sybil Thorndike
as Katharine of Aragon. Darracott (pp174–5) reproduces
a photograph of the scene on stage and Ricketts's
detailed study for the stained-glass window. This
presented Esther and Ahasuerus – an obvious reference
to the 'actual' scene below – and seems to have been
based on postcards of the windows in the Chapel at
King's College, Cambridge, sent to him by Sydney
Cockerell.
THE BOARD OF TRUSTEES OF THE VICTORIA AND ALBERT
MUSEUM, LONDON

308. **Design for a Backcloth for 'Henry VIII'**
1925
Watercolour with bodycolour, 48.5 × 56 (19⅛ × 22)
Lit: 'On Producing Shakespeare. An Interview with Mr
Lewis Casson', *Drama* IV January 1926, repr p91
This handsome drawing was made for the baptism scene
in the last Act of *Henry VIII* (see Cat. 307), but not used
in the actual production. Intended to represent a fresco
symbolising the triumph of Protestantism, with the
King trampling on the Papal insignia in the main
lunette, it is clearly influenced by Holbein. Writing
about the project to Sydney Cockerell in October 1925,
Ricketts announced that he 'intended putting Holbein
on the stage', and reported that he had visited Hampton
Court in search of detail. The production was also to
feature 'tapestries . . . in the most roly-poly Romano-
van-Orley style' (*Self-Portrait*, pp351–2).
THE BOARD OF TRUSTEES OF THE VICTORIA AND ALBERT
MUSEUM, LONDON

309. **Stage Design for 'Montezuma'** c1925
Watercolour with bodycolour, 29 × 42.5 (11½ × 16¾)
Like Christ and Don Juan (Cat. 284–7), the figure of
Montezuma, the last emperor of Mexico, who
immolated his people and himself when his country was
invaded by the Spanish in 1520, exercised a powerful
hold over Ricketts's imagination. He treated the theme
in several paintings (one at Manchester; for another,
formerly in the collection of Edmund Davis, see
Callowway, p25, pl.I), and in the early 1920s
encouraged his young friend Cecil Lewis to write a
tragedy on the subject. For this he produced some of his
finest designs, though the play was never staged. The
present example is a setting for the Throne Room of the
Palace.
MANCHESTER CITY ART GALLERIES

310. **Stage Design for 'Montezuma'** c1925
Watercolour with bodycolour, 30.2 × 43.3 (11⅞ × 17 1/16)
Lit: Calloway, p26, pl.II; Darracott, p150, repr
A design for the Epilogue of Cecil Lewis's *Montezuma*
(see Cat. 309).
THE BOARD OF TRUSTEES OF THE VICTORIA AND ALBERT
MUSEUM, LONDON

311. **Costume Design for 'Montezuma'** c1925
Watercolour with bodycolour and gold paint,
45.7 × 30.5 (18 × 12)
Exh: Cambridge 1979 (A15)
Lit: Sturge Moore, frontispiece; Darracott, p167, repr
One of Ricketts's most spectacular costume designs, for
the hero of Cecil Lewis's tragedy (see Cat. 309). A
comparable but not quite so arresting design is in the
V&A (see Calloway, p27, pl.III), and two more are at
Manchester.
THE TRUSTEES OF THE BRITISH MUSEUM

312. **Stage Design for 'The Bride of Dionysus'**
1929
Watercolour with bodycolour, 46.8 × 57.8 (18⅜ × 22¾)
The drawing is believed to be a design for Donald
Tovey's opera *The Bride of Dionysus*, staged in
Edinburgh in 1929, although another version at Carlisle
has been identified as for Act 1 of Wagner's *Tristan and
Isolde* (Barclay, no.13). Ricketts was working on the
Bride of Dionysus designs at the time of Shannon's
accident in January 1929, and threw himself into the
project with added zeal in an attempt to shut out the
horror of reality.
SUNDERLAND MUSEUM AND ART GALLERY (TYNE AND WEAR
MUSEUMS SERVICE)

313. **Darius Rising from the Tomb** 1906–7
Lithograph in black, 61.6 × 43.8 (24¼ × 17¼)
Exh: Orleans House 1979 (88)
Lit: Barclay, no.16
In contrast to Shannon, to whom lithography seems to
have come naturally, Ricketts found the medium
extremely difficult. Nonetheless, he executed a few
prints of considerable power. The present image was
used as a poster for *The Persians* by Aeschylus, produced
by Lewis Casson at Terry's Theatre, London, on
23 March 1907 for the Literary Theatre Society. As
Stephen Calloway observes, it seems to owe something
to Odilon Redon in subject and treatment. Impressions
were also taken on khaki-coloured paper, both versions
being in the Bottomley collection at Carlisle.
CARLISLE MUSEUM AND ART GALLERY

314. **Poster for 'The Dynasts'** 1914
Lithograph in black, 61.2 × 47 (24⅛ × 18½)
Signed with initials in the stone and *Charles Ricketts*
below (lower left); also by Thomas Hardy (lower right)
Lit: Barclay, no.15
Like Cat. 313, the lithograph was used as a poster, in this
case to advertise Thomas Hardy's epic drama about the
Napoleonic wars, *The Dynasts*, produced by
H Granville-Barker at the Kingsway Theatre, London,
25 November 1914. The sets were by Norman
Wilkinson (see Cat. 108).
CARLISLE MUSEUM AND ART GALLERY

315. **Italia Redenta** 1917
Lithograph in blue, yellow and green, 68 × 42.5
(26¾ × 16¾)
Signed *CR* in the stone (lower right)
Ricketts's contribution to a set of twelve lithographs
published under the title *The Great War: Britain's Efforts
and Ideals* in 1917. Two hundred proofs were printed by
the Avenue Press and issued by the Fine Art Society for
the Ministry of Information. The other artists involved
were Frank Brangwyn, George Clausen, Edmund
Dulac, Maurice Greiffenhagen, Ernest Jackson,
Augustus John, Gerald Moira, William Nicholson,
William Rothenstein, Charles Shannon and E J Sullivan.
See also Cat. 265, 344 and 364.
THE TRUSTEES OF THE BRITISH MUSEUM

316. **Orpheus and Euridice** 1905–7
Bronze, height 33.7 (13¼)
Signed *CR*
Ricketts was attracted to sculpture in the 1900s, showing
a group of twelve bronzes at the Carfax Gallery in 1906,
and a further group of eight in the exhibition he held
with Shannon at the same gallery the following year.
Although his work in this medium owes something to
Alfred Stevens, the main influence was Rodin, 'the sight
of [whose] things', he wrote in 1900, 'stirred up curious
old wishes of mine to do sculpture' (*Self-Portrait*, p49).
He met Rodin at the Davises in 1903 and backed him
as President of the International Society when Whistler
retired that year.

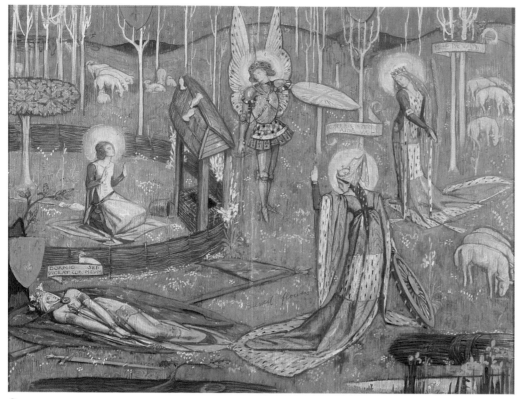

Cat. 305

Casts of *Orpheus and Euridice* were included in the Carfax exhibition of 1907 and shown at the International Society in 1907, 1911 and 1914. This one was given to the Tate by Francis Howard (see Cat. 254).
THE TRUSTEES OF THE TATE GALLERY

317. The Deposition c1908
Painted plaster, height 40 (15¾)
Signed *CR* on the base
This little-known example of Ricketts's sculpture treats one of his favourite subjects; there is a smaller sculpture on the same theme, and see Cat. 285. The present version is a remarkable instance of his capacity to see sculpture 'in the round', each viewpoint revealing some new and arresting combination of figures. As the sculptor Henry Poole observed, 'whatever may be said about that fellow's anatomy, no matter from where you look at his statuettes you see a telling silhouette, and it is only great masterpieces that rival him in that'.

The piece was given by Ricketts to Henning Nyberg, who acted as his assistant in his last years and accompanied him to Italy in 1931. It remained in the possession of Nyberg's widow until her death in 1979.

The bronze version was exhibited at the International Society in 1908, and a cast was included in the exhibition *British Sculpture 1850–1914*, FAS 1968 (129).
PRIVATE COLLECTION

318. Paolo and Francesca c1909
Bronze, height 32 (12⅝), length 53 (20⅞)
Exh: FAS 1968 (136); Cambridge 1979 (A14)
One of the most emotionally charged and Rodinesque of all Ricketts's sculptures, exhibited at the International Society in 1909. Like Cat. 34 and 103, this cast belonged to Charles and Lavinia Handley-Read.
THE SYNDICS OF THE FITZWILLIAM MUSEUM, CAMBRIDGE

319. Oscar Wilde, *A House of Pomegranates*
Designed and decorated by Charles Ricketts and Charles Shannon

London: Osgood McIlvaine 1891. 8vo
Ricketts's earliest essays in book design resulted from commissions from his friend Oscar Wilde; he designed all Wilde's books with the exception of *Salomé*, which was done by Beardsley. *A House of Pomegranates* was the most important of four published in 1891. Ricketts was responsible for the overall design, binding, title-page and many other decorations; Shannon for four full-page plates, reproduced by a new and imperfect process which caused them to fade to near invisibility. The cover was severely criticised in a review in *The Speaker*, provoking Wilde's celebrated reply: 'There are only two people in the world whom it is absolutely necessary that the cover should please. One is Mr Ricketts, who designed it, the other is myself, whose book it binds. We both admire it immensely!'
MICHAEL RICHARD BARCLAY

320. John Leicester Warren, Lord de Tabley, *Poems Dramatic and Lyrical*
Illustrated by Charles Ricketts
London: Elkin Mathews and John Lane 1893. 8vo
The firm of Osgood McIlvaine which published *A House of Pomegranates* (Cat. 319) folded in 1892, and Ricketts's next commissions came from the enterprising partnership of Elkin Mathews and John Lane (The Bodley Head), which was responsible for so much of the best literature and book design of the 1890s. The five illustrations to Lord de Tabley's *Poems* show Ricketts in his most Pre-Raphaelite vein, looking back to Rossetti's intensely medieval illustrations to the Moxon *Tennyson* (1857), and thinking too of Dürer, who had been a profound influence on Rossetti at that time. Gordon Bottomley described the design of *Nimrod*, which is perhaps the best, as 'one of the most tremendous things that any one has ever done' (*Poet and Painter*, p9). One of the original drawings is in the British Museum.
SIMON REYNOLDS

321. Longus, *Daphnis and Chloe*
Illustrated by Charles Ricketts and Charles Shannon

London: Elkin Mathews and John Lane 1893. 4to
Daphnis and Chloe, a story by the late classical author Longus in a Jacobean version 'done into English by George Thornley, Gent', shows Ricketts moving towards the idea of founding his own press. Though still a commercial venture, the book was scrupulously designed by Ricketts, and he and Shannon designed and engraved on wood thirty-seven illustrations and over a hundred initials. The engraving alone took them eleven months. The chief influence on the concept was the famous first edition of the *Hypnerotomachia Poliphili*, published by Aldus Manutius in Venice in 1499.
SIMON REYNOLDS

322. Christopher Marlowe and George Chapman, *Hero and Leander*
Illustrated by Charles Ricketts and Charles Shannon
London: Elkin Mathews and John Lane 1894. 8vo
The success of *Daphnis and Chloe* (Cat. 321), which sold out quickly, encouraged Ricketts and Shannon to produce another volume along similar lines. Though only a year later, the designs for *Hero and Leander* are markedly more spare and sophisticated.
SIMON REYNOLDS

323. Oscar Wilde, *The Sphinx*
Designed and illustrated by Charles Ricketts
London: Elkin Mathews and John Lane 1894. 4to
The Sphinx is often described as Ricketts's finest book. He had full control of every aspect of the design which, as Stephen Calloway observes, 'mirrors precisely the exotic and perverse qualities of Wilde's poem'. Ricketts himself believed that the illustrations were his best and most lyrical, although Wilde disagreed, telling him that 'you have seen them through your intellect, not your temperament'. Today the book is not only greatly admired but extremely rare; it did not sell well and a large proportion of the unsold stock was destroyed in a fire at the printers, the Ballantyne Press, in 1899.

For one of the original drawings, see Cat. 292.
THE BRITISH LIBRARY BOARD

324. Michael Drayton, *Niphidia and the Muses Elizium*
Designed and decorated by Charles Ricketts
London: Hacon and Ricketts 1896. 8vo
Ricketts finally launched the Vale Press in 1896 (see Paul Delaney's essay above), and this book was published the same year. Edited by John Gray (see Cat. 286), it has a splendid pictorial frontispiece with a figure of Oberon, king of the fairies, together with a rich 'honeysuckle' border and twelve initials.
PRIVATE COLLECTION

325. *The Early Poems of John Milton*
With decorations by Charles Ricketts
London: Hacon and Ricketts 1896. 8vo
SIMON REYNOLDS

326. *The King's Quair*
Two designs by Charles Ricketts, reproduced in *The Dial* no.4 1896
These two magnificent drawings, in Ricketts's most mannered style, illustrate a poem by King James I of Scotland which, some thirty years earlier, had been the subject of a series of wall-paintings by the Pre-Raphaelite painter William Bell Scott. The original drawings, made before 1896 when they were reproduced in *The Dial*, belonged to Laurence Hudson of Wolverhampton (see Cat. 218) and are now in a private collection in America. There is a contemporary drawing of the subject by J E Southall in *The Quest* V 1896.

Ricketts published an edition of the poem at the Vale Press in 1903; it was one of two books edited for him by Robert Steele (see Cat. 295), the other being the

poems of Chatterton (1898). However, the book did not contain these drawings.

MICHAEL RICHARD BARCLAY

327. **Michael Field** *The World at Auction*
Decorated by Charles Ricketts
London: Hacon and Ricketts 1898. 4to
One of four plays by Michael Field published by Ricketts at the Vale Press, the opening page decorated with Renaissance motifs to suit the imagery of the drama. For Michael Field, pseudonym of the two poets Katherine Bradley and her niece Edith Cooper, see Paul Delaney's essay above.

PRIVATE COLLECTION

328. **William Blake**, *Poetical Sketches*
Decorated by Charles Ricketts
London: Hacon and Ricketts 1899. 8vo

PRIVATE COLLECTION

329. *Rubáiyát of Omar Khayyám*
Decorated by Charles Ricketts
London: Hacon and Ricketts 1901. 8vo
Sturge Moore reproduces this beautiful frontispiece (pl.XLVIII), the original drawing for which is at Carlisle (Barclay no.37).

THE BRITISH LIBRARY BOARD

330. **Lucius Apuleius**, *De Cupidinis et Psyches Amoribus*
Designed and decorated by Charles Ricketts
London: Hacon and Ricketts 1901. 4to
Ricketts published both Latin and English versions of the story of Cupid and Psyche, the Latin version, shown here, having five illustrations designed and cut by him. One of the original drawings, *Psyche in the House*, which had already been published in *The Pageant* in 1896 and was adapted for reproduction in the book, is at Carlisle (Barclay, no.2).

The subject of Cupid and Psyche had also preoccupied Burne-Jones when he was working on an illustrated edition of William Morris's *Earthly Paradise* in the 1860s.

PRIVATE COLLECTION

331. *The Parables chosen out of the Gospels . . .*
Designed and illustrated by Charles Ricketts
London: Hacon and Ricketts 1903. 8vo
A fairly late product of the Vale Press, which closed in 1904, the *Parables* has ten illustrations by Ricketts in a more naturalistic style than he had adopted hitherto. Significantly, he was to reinterpret several of them in oil paintings.

The scheme invites comparison with Millais' famous illustrations to the Parables, published 1864, which would of course have been familiar to Ricketts.

PRIVATE COLLECTION

332. **Jean Paul Raymond (ie Charles Ricketts)**, *Beyond the Threshold*
Illustrated by Charles Ricketts
London: Curwen Press 1929. 8vo
In the last years of his life, following Shannon's tragic accident, Ricketts returned to two early activities, book production and authorship. *Beyond the Threshold* was the first of two collections of 'decadent' stories, the second, *Unrecorded Histories*, appearing posthumously in 1933. Very much in the manner of Wilde, they reflect Ricketts's increasing devotion to the memory of his friend, also expressed in two late sets of illustrations to Wilde's *The Sphinx* and *Poems in Prose* and in his *Recollections of Oscar Wilde*, published 1932. Both *Beyond the Threshold* and the *Recollections* were anonymous, Ricketts pretending that he was translating the French of Jean Paul Raymond.

For these late illustrations Ricketts evolved a new style of great sophistication. The five for *Beyond the Threshold* are at Carlisle (see Barclay, 32–6, and Calloway, pl.97–8). They include *The Head of Orpheus*, another treatment of the subject discussed under Cat. 110.

SIMON REYNOLDS

GEORGE SAUTER
1866–1937
Born at Rattenbach, Bavaria, of peasant stock, Sauter studied at the Munich Academy, then seems to have worked with Lenbach. He travelled widely in Holland, Belgium, France and Italy, but in 1894 settled in London, marrying Lilian Galsworthy, sister of John Galsworthy, who used them as models for the hero and heroine of his novel *Villa Rubein* (1900). They lived at 1 Holland Park Avenue and had a son, Rudolf (1895–1977), who also became an artist. Though mainly known for his portraits (sitters including Max Müller, Karl Blind, Hans Richter, Prince Pierre Troubetzkoy and the Archduke Joseph of Austria), Sauter painted landscapes and symbolist themes. He was closely associated with the International Society, serving on the Council for many years and exhibiting regularly. Ricketts's friend Count Antonio Cippico wrote an article on his work. In 1915 he was interned and in January 1917 was repatriated to Germany, an event which ruined his marriage and left him permanently embittered. Nonetheless his entry in *Who Was Who* shows that he received many honours and other forms of official recognition.

Ref: The Count de Soissons, 'George Sauter', *The Artist* 30 1901, pp169–80

333. **Memories of Love** 1911
Oil on canvas, 68.6 × 55.8 (27 × 22)
Signed and dated *G Sauter 1911* (upper right)
One of a group of paintings by Sauter in the collection of the Leeds industrialist Sam Wilson, of which at least two others – *The Leeds Picture* and *The Dispute* (also 1911) – have the same kind of delicate symbolism. There seems to be a world to discover here, no doubt familiar

to some but insufficiently researched for the purpose of this catalogue. Sam Wilson's collection, which was left to the Leeds City Art Gallery in 1925 and contains, among many interesting things, major examples of Brangwyn and an astonishing chimney-piece by Alfred Gilbert, is also represented in the exhibition by Cat. 188 and 191.

LEEDS CITY ART GALLERIES

REGINALD SAVAGE
active 1886–1933
Painter, illustrator and wood-engraver, Savage was a member of Ricketts's circle in the 1890s, contributing to *The Dial* and *The Pageant*. He was also closely associated with C R Ashbee's Essex House Press. He exhibited at the RA (1887), New Gallery, RBA, ROI and RI, and illustrated, amongst others, *Pilgrim's Progress* (1899), *A Book of Romantic Ballads* (1901), Milton's *Comus* (1902), Herrick's *Hesperides* (1903) and Thomas Hood's *Miss Kilmansegg* (1904). Walter Crane praised his 'weird designs', and C R Ashbee said of him: 'He has in his work that feeling of tapestry and stained glass without colour which the woodcut designer is ever searching for; he has also a very subtle and delicate sense of humour'. However, according to Charles Holmes, he 'could not remain content with the meagre rewards which attend original design and scrupulous workmanship. To Ricketts's regret, he drifted off to make a living as an illustrator in a manner less exacting and much better paid' (*Self and Partners* 1936, p165). By 1910 he was teaching at Camberwell School of Art, where David Jones was among his pupils; there are a number of references to 'old Solly' in Jones's 'self-portrait', *Dai Greatcoat* 1980. In 1933 he completed Ricketts's rough design for the binding of his posthumously-published *Unrecorded Histories*, so his severance from the Ricketts circle cannot have been quite as complete as Holmes implies.

334. **Sidonia and Otto von Bork on the Waterway to Stettin** 1896 *ill.* p167
Pen and ink, 14 × 19 (5½ × 7½)
Signed with monogram

Cat. 334

Lit: C H Shannon and J W Gleeson White (eds), *The Pageant* 1896, p125, repr

One of Savage's finest drawings, illustrating an incident in Wilhelm Meinhold's *Sidonia von Bork, die Klosterhexe* (1847). This blood-curdling gothic romance, written in the form of a contemporary chronicle, purports to trace the career of a girl of noble Pomeranian family who, after a life of relentless crime, was burnt as a witch at Stettin in 1620. In 1849 a translation by Lady Wilde was published in England; this was passionately admired by Rossetti, Burne-Jones and their circle – a devotion expressed most vividly in Burne-Jones's watercolours of *Sidonia* and *Clara von Bork*, painted in 1860 (Tate).

Savage's drawing reflects a resurgence of interest in Meinhold around the turn of the century. In 1893 William Morris reprinted *Sidonia* at the Kelmscott Press, and in 1895 David Nutt brought out a new edition of Meinhold's other romance, *The Amber Witch*, with an introduction by Joseph Jacobs (see Cat. 495) and illustrations by Burne-Jones's son, Philip. In 1896 Burne-Jones's own early watercolours were exhibited as part of the Leathart Collection at the Goupil Gallery, and bought by Graham Robertson. Within the orbit of Ricketts and Shannon we have Savage's drawing, which was published in *The Pageant* in 1896 with an article on Meinhold by Frederick York Powell, while Ricketts reissued *The Amber Witch* at the Vale Press in 1903. For further aspects of the Meinhold phenomenon, see Cat. 372, 376.

It is hardly surprising that Savage's drawing is heavily indebted stylistically to the early pen drawings of Rossetti and Burne-Jones, as well as to *their* great source of inspiration, Dürer's engravings. In this it corresponds closely to Ricketts's designs for Lord de Tabley's *Poems* of 1893 (Cat. 320).

SIMON HOUFE

335. Behemoth c1892 ill. p168

Wood-engraving, 30 × 21.7 (11⅞ × 8½)
Signed (monogram) in the print (lower right) and signed *Reginald Savage* below (lower right)
The print was used as the frontispiece to the second number of *The Dial* 1892, and is another example of the wood-engraving revival in the early Ricketts circle;

Cat. 335

indeed Sturge Moore's *Death of the Dragon*, reproduced in *The Dial* 4 1896, forms something of a sequel. Like Cat. 334, the image is clearly indebted to Dürer, his famous engraving of a rhinoceros being especially relevant. This was recognised by Charles Holmes, who recalled seeing *Behemoth* about the time it was published. 'Its power', he wrote, 'and its surprising comprehension of Dürer, excited my keen admiration' (*Self and Partners*, p141).

Impressions in both black and green are known. This one was given to the Ashmolean in memory of Ricketts by T E Lowinsky in 1932.

VISITORS OF THE ASHMOLEAN MUSEUM, OXFORD

THOMAS STURGE MOORE
1870–1944

Born at Hastings, the son of a doctor and the brother of the Cambridge philosopher G E Moore. Educated at Dulwich College and studied art at Lambeth School of Art with Ricketts and Shannon, who remained close friends for life; indeed he was Ricketts's literary executor and devoted much energy to ensuring that he was remembered after his death. As an artist Moore played an important part in the revival of creative wood-engraving, specialising in small, intense designs owing much to Blake, Calvert and the German 'Little Masters'. These were published in *The Dial* and *The Pageant* and by the Vale, Eragny, Unicorn and Essex House Presses. He exhibited regularly with the Society of Twelve (founded 1904) and, although his main work as a wood-engraver was done before the First World War, helped to found the Society of Wood-Engravers 1920. Many of his designs are related to his literary works, for he was also active as a poet, translator, playwright, essayist and critic; while there are obvious links between his art and the studies he published of Altdorfer, Dürer, Correggio and Blake (1900–10). W B Yeats was a close friend, Moore designing many of his bookplates, book-covers, etc.

Ref: *The Private Library*, Second Series, Vol 4: 1, Spring 1971, mainly devoted to Moore; *Thomas Sturge Moore*, Clare Warrack and Geoffrey Perkins, sale cat. 1979

336. Miscellaneous Designs 1895–1902

Five wood-engravings in black, yellow and grey, various sizes
The four smaller designs signed *TSM*
The large design, which dates from 1900 and is based on an engraving by Giulio Campagnola, is the device of the Unicorn Press, which published a number of literary works by Moore. Laurence Binyon was its moving spirit. Other designs come from *Metamorphoses of Pan and Other Original Woodcuts*, a portfolio published by the Vale Press 1895; *Some Fruits of Solitude* by William Penn, Essex House Press 1901; and the Eragny Press edition of Perrault's *Histoire de Peau d'Ane* 1902.

THE TRUSTEES OF THE BRITISH MUSEUM

337. The Centaur and The Bacchante 1897–8

Six wood-engravings in black and green, approx. 6.5 × 9.5 (2⅝ × 3¾) and larger
Two signed *TSM*
Illustrations to *The Centaur and The Bacchante*, translated from the French of Maurice de Guérin by T Sturge Moore and published by the Vale Press 1899.

THE TRUSTEES OF THE BRITISH MUSEUM

338. Siegfried c1901

Six wood-engravings in grey, brown, ochre and green, each approx. 6 × 9.5 (2⅜ × 3¾)
Six illustrations to Moore's version of the Siegfried-Brynhild saga, based on those of Morris and Wagner

and entitled *The Unknown Known*. This was not published until 1939, but the engravings were completed by 1901 when these impressions were given to the British Museum. They were shown at the first exhibition of the Society of Twelve in 1904.

The subject of one of Moore's designs, *Siegfried and the Bird*, was later treated in a painting by Ricketts (see Cat. 290).

THE TRUSTEES OF THE BRITISH MUSEUM

339. Miscellaneous Designs c1901–8

Four wood-engravings in black, various sizes
All signed *TSM*
The designs include *Theseus with the Body of Phaedra*, an illustration to Sturge Moore's tragedy *Aphrodite against Artemis* (1901), exhibited 1908; *The Young Man Fleeing from the Captors of Christ*, a design inspired by Correggio, c1906; and *The Centaur's First Love*, first version, before 1908.

THE TRUSTEES OF THE BRITISH MUSEUM

WILLIAM SHACKLETON
1872–1933

The son of a Bradford paper manufacturer, Shackleton was educated at the local Grammar School and Technical College before winning a scholarship to the Royal College of Art, South Kensington, in 1893. In 1896 a British Institute Scholarship enabled him to pursue his studies in Paris (Julian's) and Italy, where he acquired a deep love for the Old Masters, particularly Leonardo and Giorgione. His favourites among modern masters were Turner, whose influence on him is marked, and Watts, whom he knew. After returning from Italy he settled in London, but spent periods painting in Sussex, where he was closely associated with Edward Stott; near Boulogne, where he painted *The Mackerel Nets* (1913; Tate); and, after the war, at Malham, in the West Riding, where he acquired a cottage near an ancestral farm beneath Gordale Scar. This dramatic scenery inspired many of his later works. In 1901 he began to exhibit at the NEAC, becoming a member in 1909 and continuing to show there regularly until his death; he also had one-man exhibitions at the Goupil Gallery (1910), Leicester Galleries (1922) and Barbizon House (1927). The salient features of his style are what he called a 'conscientious symbolism', an unusual fondness for pink and yellow colour schemes, and a grainy surface as if he mixed his colours with sand. Many of his lesser works and studies for paintings are in oils on paper.

Ref: Cats of Bradford Spring Exhibitions 1917–18; Richard Church, 'The Art of William Shackleton', *Studio* 83 1922, pp17–22; Cat. of Memorial Exh., Bradford 1933; *The Times* 12 January 1933, p14

340. A Nude Man Seated by a Lake c1910 (?)

Oil on board, 24 × 31.7 (9½ × 12½)
Exh: Possibly Memorial Exh., Cartwright Hall, Bradford 1933
A particularly sensitive example of Shackleton's work, the picture may have been in his memorial exhibition at Bradford in 1933, which included works entitled *A Woodland Pool* (70), *The Pool* (94) and *The Bathing Pool: Sunrise* (96). The dating is conjectural.

PRIVATE COLLECTION

341. Line of Life 1915 ill. p169

Oil on canvas, 95.2 × 101.6 (37½ × 40)
Signed and dated *Wm Shackleton 15*
Shackleton divided his pictures into 'imaginative' and 'naturalistic' subjects, and presumably this scene of palmistry falls into the second category. A strong element of symbolism is clearly present, however, as in all his work. The effect is a little reminiscent of George

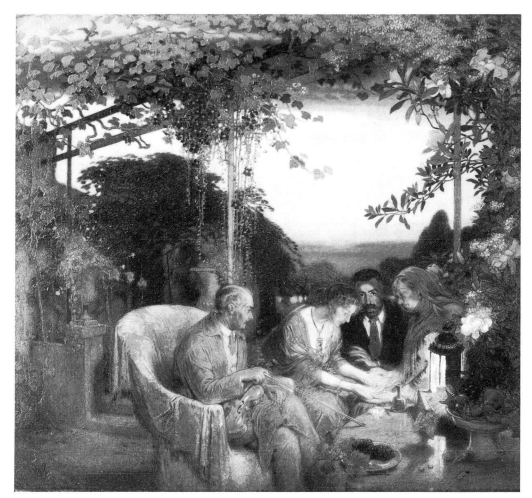

Cat. 341

Warner Allen's *Picnic at Wittenham* (Cat. 484), painted some thirty years later, but this must be fortuitous. The picture seems to have been a favourite of the artist's since he left it to the Tate on his death in 1933.

TRUSTEES OF THE TATE GALLERY

342. The Polar Star 1920

Oil on canvas, 103 × 76 (40½ × 30)
Signed and dated *Wm Shackleton 20* (lower left)
Exh: Memorial Exh., Cartwright Hall, Bradford 1933 (32); Christie's 1986 (229)
The picture was bought for the artist's native Bradford in 1922 and embodies some of the chief characteristics of his style – his symbolist approach, his submission to the influence of Turner, and the grainy quality of his paint. The figures are a little reminiscent of Shannon.

BRADFORD ART GALLERIES AND MUSEUMS

343. The City of Golden Gates

Oil on canvas, 127 × 120.5 (50 × 47½)
Exh: Memorial Exh., Cartwright Hall, Bradford 1933 (33); *Christianity in Art*, Preston 1938; Shackleton Exh., Bradford 1979
Lit: Church, p21, repr
Shackleton is seen here at his most extravagant. The concept and design suggest the influence of Gustave Moreau, although the picture is probably one of those inspired by Malham Cove in the West Riding, near which Shackleton had a country retreat after the First World War. For another example, *The Nymph of Malham Cove* (Towneley Hall Art Gallery, Burnley), see the catalogue of the Brighton Museum's *Fairies* exhibition 1980, p125.

The picture is among the many that Shackleton's widow gave to northern museums after his death, thus ensuring that his work is well represented in public collections but not common on the market.

HARRIS MUSEUM AND ART GALLERY, PRESTON

FRANCIS ERNEST JACKSON

1872–1945

Born at Lockwood, Huddersfield, the son of a news-agent, Jackson was apprenticed to a lithographer in Leeds before going to Paris about 1893 to study at Julian's and the Beaux-Arts. His masters included Bouguereau and Laurens, and he knew Monet. By 1900 he had settled in London and begun to specialise in lithography, helping to found *The Neolith* (1907) and the Senefelder Club (1910). This led to a fruitful relationship with Frank Pick, head of the London Underground, for whom he organised two series of posters by various artists. He also taught lithography at the Central School, Camberwell, Chelsea and elsewhere. Jackson in fact was a born teacher, being appointed Professor of Drawing at the RA Schools in 1921 and taking over the direction of the Byam Shaw School four years later. He exhibited at the RA, NEAC, Paris Salon, etc; was Secretary of the Tempera Society (from 1922) and Master of the Art Workers' Guild (1928); and was elected ARA in 1944, shortly before his death. This occurred in Oxford 11 March 1945 as the result of a road accident.

Ref: J G P Delaney, 'F Ernest Jackson, Draughtsman and Lithographer', *Apollo* May 1987, p338–43

344. United Defence against Aggression (England and France, 1914) 1917

Colour lithograph, 63.5 × 43.8 (25 × 17¼)
From the same series as Cat. 315 and 364. The series was produced under Jackson's direction; see Delaney, p341.

THE TRUSTEES OF THE BRITISH MUSEUM

EDWARD HENRY GORDON CRAIG

1872–1966

Born at Stevenage, the illegitimate son of Ellen Terry and the architect William Godwin. Began his career as an actor, mainly with Irving at the Lyceum, but gave this up in 1897 and began to propagate his radical views on the theatre. In 1905 he moved to Berlin and thereafter rarely returned to England, settling in 1907 in Florence where he ran a theatre magazine, *The Mask*, till 1929. Though married since 1893, he enjoyed a long-standing relationship with Elena Meo, daughter of the artist and artist's model Gaetano Meo, as well as affairs with Isadora Duncan and many others. Though often considered impractical, his ideas on staging were eagerly sought and he mounted productions for Eleanora Duse in Florence, Constantin Stanislavsky in Moscow, etc. A *Macbeth* for Beerbohm Tree, however, failed to materialise. His most influential book was *On the Art of the Theatre* (1911). After the First World War, which caused his theatre school in Florence to close, he settled in Rapallo, publishing studies of Irving and Ellen Terry in the early 1930s. The Second World War found him in Paris, where he was interned during the Occupation. In later years he lived in Venice, publishing his memoirs 1957 and being made Companion of Honour 1958.

345. 'Hamlet': Design for Stage Set 1907

Etching, 16.5 × 10.5 (6½ × 4⅛)
Signed and dated 1907
One of many designs for stage sets presented by the artist to the V&A in 1922, showing the vast megalithic forms and dramatic shafts of light so characteristic of his vision. Craig's reputation as a pioneer of stage designs stands higher than that of Ricketts, but though he theorised more, he actually did far less. In 1903 Ricketts described Craig's ideas as 'intelligent but diffuse'. Eight years later he wrote to Sydney Cockerell: 'Should you have time – and I strongly advise you to find it – go and see the Craig Exhibition at the Leicester Gallery. It is well worth while. His designs are more "abstract" in character than mine, and in a sense more whimsical or inconsequent, but not always. The sketches are feeble in execution, they exaggerate also the possibilities of height and space obtainable in any London theatre. He does not realise that a figure is practically one-third of the height of the opening, therefore much of the element of surprise and originality might evaporate under execution. Nevertheless, one experiences an agreeable sense of novelty, a sense of an imaginative atmosphere which I have noticed only in my work upon the stage, and it is something like a disaster that his Macbeth setting was never realised' (*Self-Portrait*, pp166–7).

As Ricketts acknowledged, the similarities between him and Craig as stage designers are ultimately more significant than the differences. Not only did both artists have the ability to create an 'imaginative atmosphere'; Ricketts's passion for dramatic sweeps of curtaining to lend grandeur to his designs (see Cat. 299) is not far removed from Craig's devotion to soaring megaliths.

THE BOARD OF TRUSTEES OF THE VICTORIA AND ALBERT MUSEUM, LONDON

346. Design for Stage Set c1907

Etching, approx. 16.5 × 10 (6½ × 4)
From the same series as Cat. 345.

347. **Design for Stage Set** c1907
Etching, approx. 16.5 × 10 (6½ × 4)
From the same series as Cat. 345.

JAMES JOSHUA GUTHRIE
1874–1952

Born in Glasgow, the son of a metal merchant, Guthrie studied in the evenings at Heatherley's and with the British Museum Students' Group while working for the family firm in London. Having been Reginald Hallward's assistant for two years, he founded his own press, the Pear Tree Press, at Gravesend in 1899, moving to South Harting 1901 and Flansham 1906. A magazine, *The Elf*, which he wrote and illustrated himself, was issued 1899–1903 and again 1905–10. Fiercely independent, he could turn his hand to painting, illustration, bookplate design, etching, printing, writing and poetry. Colin Franklin stresses that in his approach to book-design his master was Blake rather than William Morris, observing that Flansham, where he spent most of his life, is not far from Felpham, where Blake lived for three years, and that he may have identified with him. If so, there is a close parallel here with H J Stock (see above); indeed Guthrie published a collection of bookplates by Stock in 1920. The possibility of a relationship between Guthrie and Louis Davis (see Cat. 352) is also interesting in this context. Guthrie was a close friend of Edward Thomas and associated with Laurence Housman, Eleanor Farjeon and Gordon Bottomley, whose *Frescoes from Buried Temples* (Cat. 355) is the *chef-d'œuvre* of the Pear Tree Press.

Ref: *The Private Library*, Second Series, Vol 9 : 1, Spring 1976, devoted to Guthrie, with essays by Colin Franklin, etc, and a checklist of his books

348. **The Forest** 1907
Pen and ink and white bodycolour, 19.7 × 13 (7¾ × 5⅛)
Signed with monogram and dated *07* (lower left). The artist's address and date November 1907 inscribed on the back
In May 1912 Gordon Bottomley described Guthrie's method of drawing to Paul Nash as follows: 'I wish I could tell you how he gets that rich crumbly quality. Probably only the Lord knows. So far as I have seen he takes a piece of granulated cardboard and washes it over with a few brushfuls of a thin mixture of plaster of Paris. Then he digs into that with a pen and Indian ink. Then he puts on a film of Chinese white. (Paris, India, China, what riches all at once!) Then, he says, he shaves it. At this point, it is usually heavenly; but he has the arrogance to think he can improve it, so he practically does it over again – and worse – on the top of the original. I have his worst drawing: it is $\frac{1}{16}$″ thick with Chinese white, and underneath that Chinese white is buried a drawing of heartbreaking loveliness' (*Poet and Painter*, p35).
The drawing was published in the second series of *The Elf* (Cat. 354), facing p8.
PRIVATE COLLECTION

349. **Clouds** c1907
Etching, 17.7 × 14.6 (7 × 5¾)
Signed (monogram) in plate (lower left) and signed *James Guthrie* in pencil (lower right). The title inscribed on the back in the artist's hand
A characteristic image, showing what Paul Nash, in a letter to Gordon Bottomley, called 'the curly wiggliness' of the artist's trees. Bottomly replied: 'I think you hit on a point about the curly trees; but every man worth anything has some such singularity of vision which seems strange to everyone else until they get used to it. And Guthrie has a serenity of intense vision in his best things, a sense of romance and mystery and wonder, which makes me happy to look over his curly trees and to look beyond his turbid technique' (*Poet and Painter*, pp34–5).
The etching was published in *The Elf*, second series, facing p22.
THE TRUSTEES OF THE BRITISH MUSEUM

350. **Romance** 1907
Intaglio print, 21.3 × 14 (8⅜ × 5½)
Signed (monogram) and dated 1907 in the plate (lower right); the title printed lower left
Romance was published in the second series of *The Elf* (facing p38) and is an example of the intaglio prints that Guthrie used in book production, made photographically from his original drawings. Despite his reservations about Guthrie's 'wiggly' trees (see Cat. 349), the young Paul Nash may well have been influenced by images of this kind.
THE TRUSTEES OF THE BRITISH MUSEUM

351. **Symphony** c1908
Etching, 18.2 × 14.5 (7⅛ × 5¾)
Signed (monogram) in plate (lower right), signed *James Guthrie* in pencil (lower right) and inscribed with title on back
Yet another image from the second series of *The Elf* (Cat. 354), *Symphony* is reminiscent of a Pre-Raphaelite wood-engraving of the 1860s. Guthrie seldom put much emphasis on human emotion, preferring to strike a balance between figures and landscape in the Samuel Palmer manner, although the dramatic design *Grief* (*The Elf*, second series, facing p26) is another example.
The title of the print is a mystery, nor is it altogether clear what is happening. Despite the heavily barred window, the figures do not seem to be in a prison since a door stands open at the top of the flight of stairs.
THE TRUSTEES OF THE BRITISH MUSEUM

352. **The Children in the Wood** c1905–10
Intaglio print, 11.1 × 8.7 (4⅜ × 3¼)
Inscribed on the back by the artist *Engraver's proof of frontispiece for Dollie Radford's In Summer Time*
There seems to be no book by Dollie Radford called *In Summertime*, so possibly the project was abandoned. In any case it is interesting to find that Guthrie, like Louis Davis, was associated with this author. Indeed there is something reminiscent of Davis's innocent fairy-tale world in Guthrie's group of children. They may well have known one another, their mutual interest in Blake being a bond between them.
The Children in the Wood is the title Guthrie himself gave to another impression; see Ian Hodgkins, *Illustrated Books 1890–1914*, Catalogue 35, nd, no.311.
THE TRUSTEES OF THE BRITISH MUSEUM

353. **Gordon Bottomley, *The Riding to Lithend***
Illustrated by James Guthrie
Pear Tree Press, Flansham 1909. 8vo
Guthrie published two plays by Bottomley, *Midsummer Eve* (1905) and *The Riding to Lithend*. The latter, which is Icelandic in theme and dedicated to Edward Thomas, a close friend of both author and publisher, contains five illustrations – described by Colin Franklin as 'marvellous examples of Guthrie's etchings printed at his hand press' – and decorations hand-coloured in watercolour and gold. The original drawing for the frontispiece is in the V&A, which acquired it only a year after the book was published.

For an illustration to the play by Paul Nash, see Cat. 445.
PRIVATE COLLECTION

354. *The Elf. A Magazine of Drawings and Writings*
Written and illustrated by James Guthrie
Pear Tree Press, Harting 1912. The title-page dated 1905. 4to
The collected edition of Guthrie's magazine *The Elf*, second series. The twenty-six 'drawings' include three illustrations to Poe's 'Ullalume', bookplates, and four designs exhibited here (Cat. 348–51). Among the 'writings' are articles on 'The Making of Books', 'The Future of Art', and the poetry of Walt Whitman and W H Davies; also a number of poems, including one on a picture by Reginald Hallward.
SIMON REYNOLDS

355. *Frescoes from Buried Temples*
A Portfolio of Drawings by James Guthrie with Poems by Gordon Bottomley
Pear Tree Press, Flansham 1928. Folio
The masterpiece of Guthrie's Pear Tree Press, described by Colin Franklin as 'among the three or four monumental achievements of private presses in the twentieth century; and, by its originality in concept and content, the highest'. The Prospectus gives a good idea of its scope and the range of techniques employed. 'In this Portfolio are embodied many definite and personal departures from the familiar method by which books are put together, and it is not on the lines of productions where pictures and text are in simple and immediate conjunction with each other . . . the designs and poems are not so much complementary to each other as separate variations upon epical or elemental themes concerned with the beginnings of our planet and our race and looking to that past for some intimations of the future of both. The pictorial Inventions, handled by the artist in an arbitrary spirit and without realism, are drawn with regard to the exceptional and varied methods employed at his press – surface and intaglio printing, singly and in combination, monochrome and colour, being used for the beauty and enrichment of these large pages. The Poems are lettered in a fine script and printed from intaglio plates; and the whole work in consequence claims attention as an adventure in book-production such as has not (with the exception of Blake's noble experiments) been made since moveable types and the trade of printing destroyed the art in which the page was made in one piece and the craftsman was an individual artist.'
The reference to Blake is significant, he being the main influence on the printing techniques and layout of the pages. The text was written by Helen Hinkley and there was an edition of 55 copies, each hand-printed by Guthrie and signed by himself and Bottomley on the last page. Two of the original drawings are in the Bottomley collection at Carlisle.
THE BRITISH LIBRARY BOARD

CLINTON BALMER
active 1900–22

Balmer was probably born in Liverpool and certainly studied there under Augustus John, who was art instructor at the University 1901–2. By 1904 he had painted a lunette in Toxteth Branch Free Library, Liverpool (*Studio* 30, p67). In 1900 he met Gordon Bottomley, who commissioned him to illustrate his collection of poems, *The Gate of Smaragdus*, published 1904. These designs are his best-known work, although Bottomley told Paul Nash that 'they do not show [him] at his strongest, for he is essentially a painter and colourist'. Bottomley also owned a number of his paintings (Carlisle), but these are rather disap-

pointing essays in the Shannon style. 'Some years' before 1911 he settled in New York, where, according to Bottomley, he was 'not able to do the kind of work he does best' (*Poet and Painter*, p22). Bottomley was still corresponding with him in 1917 and dedicated a poem to him in 1922.

356. Three Illustrations to 'The Gate of Smaragdus' c1904 *ill. p171*
Pen and ink and white bodycolour, 16.8 (6⅝) diam, 13.2 × 18.6 (15¼ × 7¾), 14.6 × 21.3 (5¼ × 8⅜)
Exh: two from the set, Carlisle 1970 (99)
See Cat. 357. The drawings illustrate 'The Last of Helen', 'A Song of Apple-Gathering' and 'The Stealing of Dionysos'. When Paul Nash criticised the drawings in 1911, Bottomley wrote in their defence: 'I think you have diagnosed their faults more completely than their merits. Seven years ago Ricketts and Shannon said of them "They contain a sense of beauty not usual in the present day"; and W B Yeats praised them . . . One reason why they seem worse than they are is that they are drawn in the art-school convention of ten years ago; and nothing looks staler than a convention of a fashion that has just gone out. But look behind the sometimes vacant drawing and you will find a subtler rhythm, much fine and really expressive composition, and an often original invention' (*Poet and Painter*, p22).
CARLISLE MUSEUM AND ART GALLERY

Cat. 356

357. Gordon Bottomley, *The Gate of Smaragdus*
'Decorated by Clinton Balmer'
London: At the Sign of the Unicorn 1904. 4to
Inscribed on the flyleaf by the author *To Christopher and Penelope Wheeler with much regard; from Gordon Bottomley, The Sheiling, Silverdale: Christmas 1926*
This early collection of poems was produced under the author's supervision by a local printer at Ulverston and published 'At the Sign of the Unicorn', being transferred almost immediately to Elkin Mathews. Later described by Bottomley as 'that green, green book', it is intensely 'aesthetic' and shows the influence of Ricketts and Shannon at every turn. Following the example of Ricketts, the poems are printed in small capitals. One of the poems, *The White Watch*, is inspired by a Shannon lithograph, and the nine illustrations by Balmer are also very Shannonesque. Other indications of Bottomley's taste are poems on Gustave Moreau's painting *L'Apparition* (Fig. 4) and a work by Conder, and a dramatic fragment entitled 'A Vision of Giorgione'.
PRIVATE COLLECTION

EDMUND DULAC
1882–1953
Born at Toulouse, Dulac studied law at the local university but gave this up to enter the Académie Julian in Paris. A confirmed Anglophile, he emigrated to England in 1904, and in 1905 began to make his name as an illustrator with a series of designs for J M Dent's new edition of the Brontë sisters' novels. Two years later he illustrated *Stories from the Arabian Nights*, retold by Laurence Housman, as a Christmas Gift Book for Hodder and Stoughton, a firm with which he was to work for many years. In 1912 he became a British citizen, and from about this time belonged to the circle of Edmund and Mary Davis, thus encountering Ricketts and Shannon and W B Yeats, who was to be one of his closest friends. Until c1914 he worked in a 'naturalistic' style with a strong blue tonality, illustrating Shakespeare's *The Tempest*, *The Rubáiyát of Omar Khayyám*, *Stories from Hans Andersen*, Poe's *The Bells* and others in this idiom. Thereafter the influence of Persian manuscripts and Far Eastern art became marked in his work. During the 1920s he diversified, painting portraits, designing for the stage, and venturing into interior decoration, as well as embarking on a long association with the Hearst magazine *American Weekly*. Much of his later work has an Art Deco flavour. During the war he designed bank notes and postage stamps for the Free French, and one of his last commissions was to commemorate the Coronation of Queen Elizabeth II.

Ref: Colin White, *Edmund Dulac* 1976

358. Illustration to 'The Tempest' 1908
Watercolour, 33.5 × 25.3 (13¼ × 10)
Signed and dated 1908 and inscribed *Antonio: 'Here lies your brother and no better than the earth he lies upon'* (Act 2, scene 1)
Dulac did forty illustrations to an edition of *The Tempest* published by Hodder and Stoughton in 1908, one of a series of Shakespeare plays, each illustrated by a different artist. Colin White devotes a long passage to these 'beautifully observed scenes' and compares them with Heath Robinson's designs to the companion edition of *Twelfth Night*.
THE TRUSTEES OF THE CECIL HIGGINS ART GALLERY, BEDFORD

Cat. 368

359. Poster for 'Macbeth' 1911
Chalk and watercolour, 84.1 × 62.9 (33⅛ × 24¾)
Signed and dated *Edmund Dulac 1911* (lower right) and inscribed *Shakespeare's MACBETH His Majesty's Theatre* (below)
Lit: White, pp41, 49–50, pl.34
Dulac's largest drawing, a poster advertising Granville Barker's production of *Macbeth* at His Majesty's Theatre in 1911. For a poster by Ricketts advertising a later production by Barker, see Cat. 314.
THE TRUSTEES OF THE BRITISH MUSEUM

360. The Princess Badoura 1913
Watercolour with bodycolour, 28.7 × 23.7 (11¼ × 9⅜)
Signed and dated *Edmund Dulac 13* (lower left)
Exh: Fantastic Illustration (87)
Lit: White pp61, 71, repr
The original drawing for the frontispiece to *Princess Badoura. A Tale from the Arabian Nights*, retold by Laurence Housman and published by Hodder and Stoughton, 1913. As Colin White observes, the drawing marks a radical departure for Dulac, showing him adopting an Eastern emphasis on flat pattern in place of the Western conception of space to which he had previously adhered. In his later work this emphasis was usually to be expressed in terms of a 'Persian' or 'Mughal' style; here Chinese and Japanese influence prevails.
 Princess Badoura was the second collaboration between Dulac and Housman, who had already worked on *Stories from the Arabian Nights* in 1907.
THE TRUSTEES OF THE BRITISH MUSEUM

361. The Princess Burns the Ephrite to Death 1914
Watercolour with bodycolour, 31.5 × 25.2 (12⅜ × 9⅞)
Signed *Edmund Dulac* (lower left)
Exh: Fantastic Illustration (88)
Lit: Peppin, p137
An illustration to yet another selection from the *Arabian Nights – Sinbad the Sailor and Other Stories from the Arabian Nights*, published by Hodder and Stoughton, 1914. The book reflects Dulac's growing enthusiasm for Persian miniatures and the impact of a Mediterranean cruise with Edmund Davis and his wife in the autumn of 1913, which had given him first-hand experience of the colour and exoticism of Eastern life.
THE TRUSTEES OF THE BRITISH MUSEUM

Cat. 362

362. The Ice Maiden 1915 ill. p172

Watercolour with bodycolour, 30.5 × 25.4 (12 × 10)
Signed and dated *Edmund Dulac 15* (lower left)
Exh: *Fantastic Illustration* 1979 (89); Dulac exh.,
Sheffield, etc 1983 (27)
Lit: White, pp76, 121, repr
One of six illustrations that Dulac contributed to *The
Dreamer of Dreams* by Queen Marie of Roumania,
published by Hodder and Stoughton 1915. 'Everything
about her was white, glistening and shining; so shining
that the human eye could hardly bear the radiance. Her
long white hair hung about her; a circle of glow-worms
surrounded her forehead. . . . On either side marched
one of the great bears like two guardians.'

The book was popular, partly because the author was
related to the British Royal Family and because
Roumania had just entered the war on the side of the
Allies, and the publishers issued another book by Queen
Marie, *The Stealers of Light*, in 1916, Dulac again being
the illustrator.
THE ROYAL PAVILION, ART GALLERY AND MUSEUMS,
BRIGHTON

363. Assemblage of Fairytale and Nursery Rhyme Characters

Watercolour with bodycolour, 34.2 × 25.5 (13½ × 10)
Signed *Edmund Dulac* (lower left)
Exh: *Fantastic Illustration* (90); Brighton 1980 (D37)
The date of this delightful drawing is uncertain, and it
was apparently never published.
THE TRUSTEES OF THE BRITISH MUSEUM

364. Poland: A Nation 1917

Colour lithograph, 69.5 × 44.5 (27⅜ × 17½)
Signed and dated *Edmund Dulac 1917* (in the stone, upper
right)
Lit: White, pp124, image repr, 203
From the same series as Cat. 315 and 344.
THE TRUSTEES OF THE BRITISH MUSEUM

365. The Rubáiyát of Omar Khayyám

Illustrated by Edmund Dulac
Hodder and Stoughton 1909. 4to
The *Rubáiyát* was the Gift Book issued by Hodder and
Stoughton in 1909, an appropriate choice since this was
the centenary of the birth of Edward Fitzgerald, the
poem's best-known translator. Dulac provided twenty
plates, praised by Colin White for their ability to

conjure up 'the heady scent of incense' and their insight
into the character of Omar. In addition to the trade
edition there was a de luxe limited edition of 750 copies,
bound in vellum and numbered and signed by Dulac.
DRUSILLA AND COLIN WHITE

366. High Ross Williamson, *Gods and Mortals in Love*

Illustrated by Edmund Dulac
London: Country Life 1936. 4to
An example of Dulac's Art Deco style, the book has
eleven colour plates illustrating tales retold from Ovid.
They had first appeared in 1931 as covers for the
magazine *American Weekly*, with which Dulac was
associated 1924–51. In a brief preface, he wrote: 'A book
with coloured pictures and an illustrated book are not
quite the same thing. . . . This is presented as a book
with coloured pictures.'
PRIVATE COLLECTION

GLYN PHILPOT

1884–1937

Painter of portraits and of genre, religious, mytho-
logical and allegorical subjects, and sculptor. Born 5
October 1884, son of a surveyor. From 1900 studied
under Philip Connard and Thomas McKeggie at
South London Technical (now City and Guilds) Art
School, Lambeth, where he won a two-year scholar-
ship, and in 1905 at the Académie Julian, Paris, under
Jean Paul Laurens. Early book illustrations and paint-
ings influenced by Charles Ricketts. Won first prize
for book illustration in National Competition for
Schools of Art, 1903 (Cat. 371–2). After visits to Spain
in 1906–10, strong influence of Velazquez in his paint-
ing. Worked in traditional method of under-painting
and glazes, and acquired a technical dexterity compar-
able to Sargent's. Exhibited at RA 1904, 1917–37
(ARA 1915, RA 1923, the youngest artist ever elec-
ted); also at International Society 1909–24 (member
1912), National Portrait Society (founder-member
1911), etc. First one-man show, Baillie Gallery 1910;
others were to follow at Grosvenor, Leicester and
Redfern Galleries (1923, 1934, 1937). Won first prize
Carnegie International Competition, Pittsburgh
1913, and visited America, returning 1921 for portrait
commissions. Enlisted in army 1914, invalided out
1917; commissioned to do naval portraits for Imperial
War Museum 1918. Painted King Fouad of Egypt
(for £3,000 and fares) 1923; and mural for St
Stephen's Hall, Westminster 1927. Experiments in
sculpture date back to 1910, but first came to public
notice as a sculptor 1923. Did twelve sculptures, many
of black male models, who also appear in his painting
from 1912. Member of Jury, Carnegie International
Competition, Pittsburgh 1924 and 1930; on the latter
occasion was influenced by work of Picasso to adopt
a more 'modern' style of painting, which led to a drop
in demand for his work. President of Guild of
Catholic Artists 1929 (had converted to Catholicism
1905). Visit to Berlin 1931, which had profound effect
on his imagination and inspired a new range of sub-
jects. Made regular visits to France (where he lived
for long periods) and Italy all his adult life and in the
1930s to North Africa. Trustee of the Tate Gallery
1927–34 and 1935–7. One-man exhibition Venice
Biennale 1930. Asked to withdraw *The Great Pan*
(later destroyed) from the Royal Academy 1933. Did
many watercolours in south of France 1936–7. Died
London 16 December 1937. Memorial Exhibition,
Tate Gallery 1938.

Ref: A C Sewter, *Glyn Philpot 1884–1937* 1951; *Glyn
Philpot*, exh. National Portrait Gallery, London 1984–5,

cat. by Robin Gibson; *Glyn Philpot: the Bronzes*, exh.
Leighton House, London 1986, cat. by David Hickman

367. Melampus and the Centaur 1919

Oil on canvas, 120.7 × 205.5 (47½ × 80⅝)
Signed and dated *Glyn Philpot 1919* (lower right)
Exh: International Society 1919 (51); *Paintings and
Sculpture by Glyn Philpot RA*, Grosvenor Galleries 1923
(17); NPG 1984–5 (22)
Lit: *Studio* 78 1919, p161, repr; Sewter, pl.33
Melampus, a native of Argos, who was celebrated in
antiquity as a physician, is seen learning the medical
properties of herbs from the centaur, Chiron. Painted
late in 1919, when the artist was at the height of his
career, the picture was one of the stars of his one-man
exhibition at the Grosvenor Galleries in 1923, reviewers
even making comparisons with Michelangelo. It is
certainly one of the most successful of his mature
mythological works. Robin Gibson, observing that the
desert setting looks back to Leighton as much as it
anticipates Dali, describes it as 'a nostalgic vision of a
golden age, seen with tremendous clarity and
imagination. The figure painting is one of the most
virtuoso efforts of Philpot's career.

In addition to its intrinsic merits, *Melampus* is
important as a key example of the impact of Ricketts
on Philpot's mature work. Philpot had been influenced
by Ricketts as a student (Cat. 372), and had met him
shortly before the First World War; but it was only in
the post-war period that the friendship flourished. In
1923 Philpot took over Ricketts and Shannon's flat in
Lansdowne House, and the two older artists tended to
see Philpot and his friend Vivian Forbes as their
successors. In *Melampus*, the intimacy is reflected
particularly in the choice of subject. Ricketts himself
treated centaur themes, and, as Gibson reminds us, he
and Shannon owned Piero di Cosimo's *Fight between the
Lapiths and the Centaurs* (National Gallery), which
would have been familiar to Philpot. It is perhaps worth
adding that Delacroix, an artist much admired by
Ricketts, had painted the subject of Chiron educating
Achilles. However, when all is said on the subject of
Philpot's debt to Ricketts (and indeed to Shannon), his
fundamental independence is the impression which
remains. While taking what he needed from Ricketts,
he was never swamped by his powerful personality; and
of course his drawing and technique, from an academic
point of view, were infinitely superior.
GLASGOW ART GALLERY AND MUSEUM

368. Repose on the Flight into Egypt 1922 ill. p171

Oil on canvas, 75 × 115.5 (29½ × 45½)
Exh: *Paintings and Sculpture by Glyn Philpot RA*,
Grosvenor Galleries 1923 (35); Tate Gallery 1938 (9)
Lit: Sewter, pl.2; Gibson, pp22, 24
Repose on the Flight into Egypt was painted in Florence,
where Philpot rented a studio for some months in the
summer of 1922. Robin Gibson describes it as a
'decorative, but rather uneasy, religious allegory . . .
presumably inspired by the confrontation of pagan and
Christian civilisation in Italy'. Uneasy or not, the picture
betrays an admirable ability on Philpot's part to re-think
a familiar theme in startlingly original terms. Like
Melampus (Cat. 367), it shows the influence of Ricketts;
the centaur theme re-occurs, and the sphinx, with its
curious crouching attitude, has stepped straight out of
one of his illustrations to *The Sphinx* by Oscar Wilde
(Cat. 323). The desert setting, like the background of
Melampus, may reflect a visit by Philpot to North
Africa (he was certainly in Egypt in 1923 and visited the
area regularly in the 1930s), or it may owe something to his
knowledge of Spain, which he had revisited in 1919.
PRIVATE COLLECTION

369. Penelope 1923
Oil on canvas, 134.4 × 91.5 (53 × 36)
Exh: RA 1923 (170); Tate Gallery 1938 (41); NPG
1984–5 (33)
Lit: *Royal Academy Illustrated* 1923, p33; Sewter, pl.3
The picture makes a fascinating comparison with earlier
treatments of the theme by J R Spencer Stanhope
(Cat. 1) and J W Waterhouse (Cat. 114). As Robin
Gibson observes, 'using the classical legend as a prop on
which to hang a compact and marvellously elegant
figure composition, Philpot creates a serene but tense
parable with powerful undertones of repressed
sexuality'. Besides the versions of Stanhope and
Waterhouse, the picture seems intensely sophisticated,
playing with an idea that they simply accept; yet this
approach, paradoxically, proves ultimately more
convincing, at least to modern taste.

The model for the three suitors seems to be the same
young man who posed for Melampus (see Cat. 367),
while Philpot's sister Daisy probably modelled for
Penelope.

ROBIN DUFF OF MELDRUM, MBE

370. The Threefold Epiphany 1929
Oil on canvas, 131 × 156 (51½ × 61½)
Inscribed on three cartouches: *HODIE IN JORDANEA
JOHANE CHRISTUS BAPTIZARI VOLUIT* (left);
*HODIE STELLA MAGOS DUXIT AD
PRAESEPIUM* (centre); *HODIE VINUM EX AQUA
FACTUM EST AD NUPTIAS* (right)
Exh: RA 1929 (50)
Lit: *The Times* 6 May 1929, p21; Gibson, p25, repr
One of Philpot's most idiosyncratic conceptions, the
picture belongs to a group of religious works which he
painted around 1929 and seem to be connected with his
election as President of the newly constituted Guild of
Catholic Artists and Craftsmen, formed that year to
celebrate the centenary of Catholic emancipation.
Another was a large *St Michael* (private collection; repr
Gibson, p26), painted for Father John Gray's church at
Morningside, Edinburgh (see Cat. 286). *The Threefold
Epiphany* combines in one composition the Baptism of
Christ, the advent of the Magi, and the Marriage of
Cana. To paint such a concept in 1929 was no doubt
attempting the impossible, although it was typical of the
'last romantics' to attempt it at all. Inevitably, perhaps,
Philpot calls the Old Masters to aid; the figures are
vaguely early Flemish, the landscape decidedly German,
while the man undressing to the left recalls Piero della
Francesca's *Baptism* in the National Gallery. None of this
saved the picture from criticism when exhibited at the
RA. The art critic of *The Times*, for instance, disliked
the way in which the figures were shown 'heraldic
fashion against an atmospheric landscape, with the effect
of a stage pageant before old-fashioned scenery',
although he concluded, somewhat quaintly, that 'with
its decorative particularity and illustrative interest, "The
Threefold Epiphany" is a good sort of picture for an
Englishman to paint'.

For a picture by Harry Morley shown at the same
RA, see Cat. 172.

PRIVATE COLLECTION

371. The Ancient Mariner c1900–3
Pen and ink, over black chalk, with watercolour,
22.8 × 19.7 (9 × 7¾)
Exh: National Competition of Schools of Art, South
Kensington 1903; NPG 1984–5 (72)
Lit: 'The National Competition', *Studio* 29 1903,
pp264–5, repr
An illustration to the opening lines of Coleridge's
poem:
It is an Ancient Mariner,
And he stoppeth one of three.
This and the following drawing were executed when

Philpot was a student at the Lambeth School of Art. In
1903 they were entered for the National Competition
for Schools of Art, where they won first prize for book
illustrations and were highly praised in a review in the
Studio for their 'poetic atmosphere, . . . rare dignity and
subtlety of feeling'. They clearly betray Pre-Raphaelite
influence, while showing a characteristic interest in the
male figure and anticipating the romantic subject
pictures that Philpot was to paint in the 1920s. *The
Ancient Mariner* also inspired a set of twelve etchings by
William Strang (1896), and illustrations by Gerald
Metcalfe 1907 (Cat. 154) and Harry Clarke 1913–15.

THE VISITORS OF THE ASHMOLEAN MUSEUM, OXFORD

372. Sidonia von Bork c1901–3
Pen and black ink, with brown wash, over pencil,
22.5 × 18.7 (8⅞ × 7⅜)
Exh: National Competition of Schools of Art, South
Kensington 1903; NPG 1984–5 (73)
Lit: As for Cat. 371
Even more than Cat. 371, this drawing places Philpot
in the Pre-Raphaelite tradition. Wilhelm Meinhold's
blood-curdling gothic romance *Sidonia the Sorceress* had
won the ardent admiration of Rossetti and his followers
in the late 1850s, and their enthusiasm was taken up by
Ricketts and Shannon around the turn of the century,
Ricketts reprinting another book by Meinhold in 1903,
the very year that Philpot's drawing was exhibited (see
Cat. 334). It is no accident that Ricketts and Shannon
had been distinguished pupils at the Lambeth School of
Art, where Philpot was studying; indeed a group of
early graphic designs by Philpot betray the strong
influence of Ricketts's Vale Press books (see NPG exh.,
cat.127–32).

THE VISITORS OF THE ASHMOLEAN MUSEUM, OXFORD

373. Mask: The Dead Faun c1920
Bronze, height 25.4 (10)
Exh: NPG 1984–5 (120; giving previous exhibitions)
Lit: Sewter, pl.120
Robin Gibson rightly describes this as one of Philpot's
'most sensuous creations' – so sensuous indeed that the
last thing the head appears is 'dead'. He also points out
that the artist 'resists any inclination to give classical
allusions to his faun'. No doubt many 'last romantics'
would have succumbed to this temptation; yet even
Philpot's choice of title is significant.

The model was George Bridgman, the good-looking
'affable layabout' who so often appears in Philpot's
work in the 1920s.

PRIVATE COLLECTION

VIVIAN FORBES
1891–1937
Forbes began his career as a businessman in Egypt.
Shortly before the First World War he met Glyn
Philpot, who encouraged him to become an artist,
teaching him and sending him to study first at the
Chelsea Polytechnic and later in France. During the
1920s Forbes exhibited at the RA and elsewhere and
Philpot helped him to obtain commissions, including
one of the St Stephen's Hall murals (1927), a scheme
to which Philpot himself contributed, and a wall-
painting for the Viceroy's House, New Delhi (1930).
In the 1930s he spent more time abroad and tended
to specialise in small, semi-mystical watercolours of
the type represented here (Cat. 375). An unstable
character, professionally and emotionally dependent
on Philpot, he returned to England for his mentor's
funeral in December 1937 and committed suicide the
following day.

374. The Pointing Child c1930 (?)
Oil on canvas, 24 × 32 (9½ × 12⅝)

Signed *Vivian Forbes* (lower right)
The subject of this enigmatic little picture is obscure; in
an extensive landscape a child seems to be pointing
something out to a much older figure, who is only
partially seen on the left. If there was an original title,
it is now lost, and the present one is an invention.

PRIVATE COLLECTION

375. Ariadne on Naxos 1937
Pen and watercolour, 38.5 × 31 (15¼ × 12¼)
Signed and dated *VF 1937* (lower right)
A fine example of the imaginative compositions in pen
and colour wash on coarse-grained paper that Forbes
produced in the 1930s. It shows Ariadne abandoned by
Theseus on the island of Naxos, and is a little
reminiscent of Blake in its fiery tones. A note on the
back records that it was painted at Cannes in January
1937, less than a year before the artist's death.

PRIVATE COLLECTION

THOMAS ESMOND LOWINSKY
1892–1947
Born in London and educated at Eton and Trinity
College, Cambridge, Lowinsky studied at the Slade
1912–14. During the First World War he served with
the Scots Guards in France and Germany; Ricketts
corresponded with him at this period (see his *Self-
Portrait* for letters), and he was one of Ricketts's
executors. He exhibited at the NEAC (member 1926)
and elsewhere, and had his first one-man exhibition
at the Leicester Galleries 1926. Three paintings by him
are in the Tate, one a Chantrey purchase (1939). As
an illustrator he was closely associated with the
private presses of the Twenties, illustrating authors
as varied as Plutarch, Milton, Voltaire and the Sitwells
in a characteristic style – cold, often rather sinister,
with heavily hatched shading. Douglas Percy Bliss
described his work as 'Pre-Raphaelite in its elabora-
tion of detail, in its angular and somewhat grotesque
types, and its bestowal of equal attention upon every
inch of the surface'.

376. William Meinhold, *Sidonia the Sorceress*
Translated by Lady Wilde, illustrated by Thomas
Lowinsky
London: Ernest Benn for the Julian Editions 1926. 4to
The book may be seen as the last stage in a long tradition
of interest in Meinhold's gruesome romance, going back
to its discovery by Rossetti and his followers in the 1850s
(see Cat. 334). The mannered and rather unattractive
illustrations clearly owe much to German sixteenth-
century engravings. There is an original drawing for
one of them (p355) in the British Museum.

PRIVATE COLLECTION

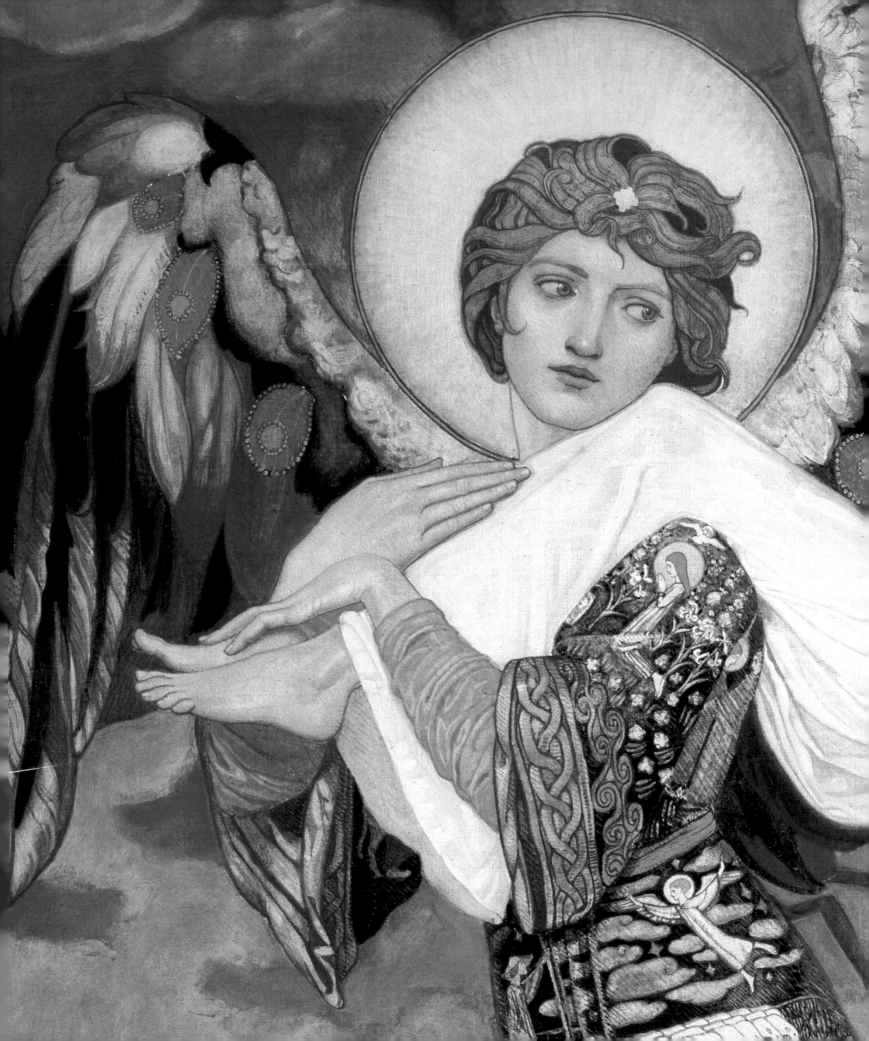

THOMAS MILLIE DOW

1848–1919

Born at Dysart, Fife, the son of the Town Clerk, Dow was destined for a career in law but abandoned his apprenticeship in Edinburgh to study art in Paris, enrolling at the Ecole des Beaux-Arts under Gérôme some time before the spring of 1879 and later working in the atelier of Carolus-Duran and at Julian's. In the early 1880s he was painting at Grès with John Lavery, Alexander Roche and William Stott of Oldham, a close friend and important influence on his style and choice of subject-matter. In 1883–4 he was in America, where he visited the artist Abbot Thayer, whom he had known in Paris, and painted the Hudson River. He exhibited regularly at the Glasgow Institute from 1880 and lived in Glasgow until 1895, contributing a 'decorative fresco' to the International Exhibition of 1886. In London he exhibited at the Grosvenor Gallery, NEAC, etc. In 1895 he moved to St Ives, Cornwall, where he died.

Ref: Norman Garstin, 'The Work of T Millie Dow, *Studio* 10 1897, pp144–52

377. **Eve** (a triptych) 1897–8
Oil on canvas, centre panel, 141 × 114.3 (55½ × 45); side panels 140.5 × 51.5 (55½ × 20¼)
Signed *TDM*
Exh: Royal Glasgow Institute 1898; Munich Secession 1899; International Society, London 1904 (192); Spring exh., Leeds 1905 (585); Société Nationale des Beaux-Arts, Paris 1906 (410); Liverpool Autumn Exh. 1906 (811)
Lit: Garstin, p144, repr; *Magazine of Art* 1898, p334; *Art Journal* 1898, p128; J L Caw, *Scottish Painting* 1908, p409; D & F Irwin, *Scottish Painters at Home & Abroad* 1975, p391
The centre panel was reproduced in the *Studio* in 1897 in an unfinished condition. The following year it was exhibited at Glasgow in a more advanced state and with the addition of the wings, representing good and evil angels respectively sorrowing and exulting over the Fall of Man. The centre panel, still further elaborated but again minus the wings, was exhibited at Liverpool in 1906, and acquired by the Walker Art Gallery for £300. Only in 1987 were the wings finally purchased, thus restoring the triptych to its full symbolist glory.
TRUSTEES OF THE NATIONAL MUSEUMS AND GALLERIES ON MERSEYSIDE, WALKER ART GALLERY

378. **Sirens of the North**
Oil on canvas, 107.3 × 152.4 (42¼ × 49)
Signed *TMD* (lower right)
Exh: The Glasgow School of Painting, FAS 1970 (4)
Lit: Hardie, p79
Hardie describes the picture as 'a faintly comic treatment of the theme of the *femme fatale* dear to the Symbolists of the nineties, where woman often appears as sphinx, harpy, or as here, as mermaid, representing a threat to men, as the hesitant oarsman who approaches in his eminently sinkable skiff seems to be fully aware'. Nonetheless it is perhaps more successful than *The Herald of Winter*, Dow's other large symbolist work in the Dundee Art Gallery.
DUNDEE ART GALLERIES AND MUSEUMS

Opposite page: Detail Cat. 392

PHOEBE ANNA TRAQUAIR (née MOSS)

1852–1936

Phoebe Traquair was astonishingly versatile, excelling as mural painter, illuminator, calligrapher, embroiderer, enameller and watercolourist. She was born and brought up in Dublin and studied at Dublin School of Art. In 1872 she married and settled in Edinburgh where she became deeply involved in the Edinburgh Arts and Crafts movement and, like John Duncan and others, was a protégé of Patrick Geddes. As an embroiderer and illuminator she contributed to Arts and Crafts exhibitions in London, Dublin, Paris and America. In 1892 she became a member of the Guild of Women Binders. Her four-part needlework screen, based on Walter Pater's *Denys l'Auxerrois* and symbolising the spiritual life of man (1895–1902), is in the National Gallery of Scotland. For her work as a muralist, see Lindsay Errington's essay above.

379. **The Virgin and Child with Angels**
(a triptych)
Oil on panel, centre panel 22.3 × 18.2 (8¾ × 7⅛); wings 22.3 × 9.3 (8¾ × 3⅝)
Signed and dated on the outside *PT 1900*
One of a number of works which the artist bequeathed to the National Gallery of Scotland in 1936, another being Cat. 382.
NATIONAL GALLERIES OF SCOTLAND

380. **Reception** c1900
Oil on panel, arched at top, 25.1 × 16.7 (9⅝ × 6⅝)
Exh: Carlisle 1970 (57)
One of three examples of Phoebe Traquair's work in the Gordon Bottomley collection at Carlisle.
CARLISLE MUSEUM AND ART GALLERY

381. **Meeting in Paradise** c1900 (?)
Watercolour with bodycolour, 9.8 × 14.1 (3⅞ × 5½)
Exh: Carlisle 1970 (55)
CARLISLE MUSEUM AND ART GALLERY

382. **Illuminated Manuscript of Elizabeth Barrett Browning's 'Sonnets from the Portuguese', Nos 2 and 38** No.2 1894, No.38 1896
ill. p50
Mixed media on vellum, 18.9 × 15.5 (7½ × 6⅛) and 18.7 × 15.7 (7⅜ × 6¼)
Both signed with monogram
NATIONAL GALLERIES OF SCOTLAND

383. **Illuminated Manuscript of D G Rossetti's 'House of Life'** 1898–1902
Ink, watercolour and gold leaf on vellum, 68 leaves, bound by the Doves Press in blue calf, tooled and gilded, 19.1 × 15.7 (7½ × 6¼)
Signed (monogram) and dated on most of the pages
Exh: Arts and Crafts Exhibition Society 1903 (319)
Lit: *Art Journal* 1900, p144; *Studio* 34 1905, p342
TRUSTEES OF THE NATIONAL LIBRARY OF SCOTLAND

384. **Illuminated Manuscript of Dante's 'Vita Nuova'**
1899–1902
Ink, watercolour and gold leaf on vellum, 43 leaves,

bound by Sangorski and Sutcliffe in morocco, tooled and gilded, 19.2 × 15.2 (7½ × 6)
Signed in monogram and variously dated
Like Cat. 383, the choice of subject reflects the artist's Pre-Raphaelite affiliations, and perhaps the fact that Dante was one of the great heroes of Ruskin, who lent her illuminated manuscripts to study in the late 1880s. The manuscript has descended to the present owner from the famous collector and connoisseur, Lord Carmichael of Stirling, for whom it was executed. It contains portraits of Lord and Lady Carmichael.
SIR MICHAEL CULME-SEYMOUR

ALEXANDER IGNATIUS ROCHE

1861–1921

Born in Glasgow, Roche trained as an architect and studied at the Glasgow School of Art. At the end of 1881 he went to Paris where he studied at Julian's under Boulanger and Lefebvre, and later at the Ecole des Beaux-Arts under Gérôme. In the early 1880s, together with Lavery, Millie Dow and others, he painted at Grès-sur-Loing, and by 1885 he was attending the winter classes of W Y Macgregor in his Glasgow studio, an important forum for the development of the Glasgow style. He exhibited at the Glasgow Institute in 1885 and at the Edinburgh International Exhibition of 1886; also with the NEAC (1889–91), at the Grosvenor Gallery, and in 1890 in Munich. In 1892 he won an Hon. Mention at the Paris Salon and a prize for work shown in the USA, where he spent some time carrying out portrait commissions. He was in fact mainly a portraitist, although he also painted many landscapes (Italy, France, Iona, etc) and in 1899 was commissioned to decorate the Banqueting Hall in the City Chambers in Glasgow. He was elected ARSA in 1892 and RSA in 1900. In 1897 he moved to Edinburgh. Paralysis deprived him of the use of his right hand in 1908, but he taught himself to paint with his left.

385. **Good King Wenceslas** 1887
Oil on canvas, 45.8 × 76.2 (18 × 30)
Signed *A ROCHE* (lower left)
Exh: NEAC 1890; The Glasgow Boys, Scottish Arts Council 1968 (104); Christie's 1986 (50)
Lit: Hardie, p79 and pl.64; Billcliffe 1985, p204 and pl.181
This attractive and important picture, almost the only work by the artist to survive from the late 1880s, is a highly original attempt to treat a religious subject in naturalistic terms. Roger Billcliffe, pointing out that, but for the medieval dress of the figures and the King's halo, we might be looking at a scene of modern life, compares it to Bastien-Lepage's *Joan of Arc*. Yet there is a sense of unreality even about the landscape, due to the introduction of vertical saplings in the foreground plane, which divide the composition at suitable intervals. This treatment of foliage was to become one of the hallmarks of the Glasgow style.

It is interesting to compare the picture with A J Gaskin's much more formalised treatment of the same theme (Cat. 78). Jessie M King illustrated the subject in book form in 1919.
PRIVATE COLLECTION

EDWARD ATKINSON HORNEL
1864–1933

Born in Bacchus, Australia, but brought up in Kirk-cudbright, Hornel studied in Edinburgh at the Trustees' Academy 1880–3 and at the Antwerp Academy under Verlat 1883–5. It is possible he met James Ensor in Belgium; certainly in 1893 he contributed to the exhibition of the Groupe des XX, of which Ensor was a founder. He returned to Kirkcudbright in 1885 and in the same year met George Henry, with whom he formed an important artistic relationship (see Lindsay Errington's essay above). He occasionally rented a studio in Glasgow and in 1885 was attending the winter classes of W Y Macgregor. He completed mural paintings at the International Exhibition and elsewhere in Glasgow in 1888. In 1890 Hornel and Henry's *The Druids* (Fig. 10) was shown at the Glasgow Institute and the Grosvenor Gallery. In 1893, together with Henry, he visited Japan, financed initially by the Glasgow art dealer Alexander Reid and, in later months, by William Burrell. Reid showed his Japanese work in Glasgow in 1895, 1901 and 1903 at exhibitions which were praised by the critics and financially successful. He was elected to the NEAC 1891 (resigned 1892) and in 1901 he was elected to the RSA, but declined the honour. His work was shown widely, including Venice, Vienna, St Petersburg and the USA. He made a second visit to the Far East in 1907.

Cat. 386

386. The Brownie of Blednoch 1889
Oil on canvas, 61 × 45.7 (24 × 18)
Signed and dated *E A Hornel 89* (lower left)
Lit: Billcliffe 1985, pp238 repr, 239–40
The picture was painted only a year before the famous *Druids* (Fig. 10), and likewise expresses Hornel's preoccupation with Celtic lore, nourished by his knowledge of the rich local culture and folk tales of Kirkcudbright and the surrounding Galloway hills. The goat appears as a symbol of fertility in several of his pictures of the late 1880s; here, however, it is seen as an evil spirit, surrounded by sheep, witches and skulls.

William Strang did a set of seven etchings on this theme in 1884.

GLASGOW ART GALLERY AND MUSEUM

MARGARET MACDONALD
1864–1933

Born in Newcastle-under-Lyme. Studied at Glasgow School of Art where she met Charles Rennie Mackintosh (c1893), marrying him in 1900. Together with Mackintosh, her sister, Frances, and Charles's friend Herbert MacNair (who married Frances in 1899), formed the group known as 'The Four', who worked in close association and were pioneers of the so-called Glasgow Style. Her watercolours were influential in Mackintosh's own creative development, and she collaborated with him on many of his decorative and architectural projects. Her early work (c1893–7) belongs to what came to be known as the 'Spook School' of Celtic expression. All four artists were heavily influenced by Aubrey Beardsley and Jan Toorop, whose work *The Three Brides* is considered to be of primary significance in the development of the Glasgow Style. After her marriage Margaret Macdonald's work changed and she began to concentrate on decorative gesso panels, such as those executed for the Willow Tearooms (1904) and the Wandorfer Music Salon in Vienna. In 1914 she and Charles settled in England, living in Chelsea 1916–23, and then at Port Vendres in the French Pyrenees (1923–7). No drawings have come to light from these later years.

Ref: Roger Billcliffe, *Mackintosh Watercolours* 1978; *Margaret Macdonald Mackintosh*, cat. of exh. Hunterian Art Gallery, Glasgow 1983–4

387. The Mysterious Garden 1911 *ill. p178*
Watercolour and ink on vellum, 48.3 × 45.7 (19 × 18)
Signed and dated *MARGARET MACDONALD MACKINTOSH 1911* (lower right)
Exh: RSW Glasgow 1911 (96) and 1912 (240); Memorial Exh., McLellan Galleries, Glasgow 1933 (75); Mackintosh Exh., Edinburgh 1968 (94)
Lit: Billcliffe 1978, p47, no.XV, p104, repr
This and the following item are examples of the large watercolours which the artist began to exhibit after 1910, inspiring C R Mackintosh to turn to watercolour painting as a full-time occupation. As Billcliffe observes, however, 'while his subject matter remained firmly based on nature, Margaret retained her interest in obscure legend and myth or the stories of Maeterlinck'.
PRIVATE COLLECTION

388. The Pool of Silence 1913
Watercolour and ink, 75.8 × 63.5 (30 × 25)
Signed and dated *MARGARET MACDONALD MACKINTOSH 1913* (lower left)
Exh: RSW Glasgow 1913 (125) and 1914 (135); Memorial Exh., McLellan Galleries, Glasgow 1933 (132); Mackintosh Exh., Edinburgh 1968 (95)
Lit: Billcliffe 1978, p47, no.XVI, p105, repr
See Cat. 387.
PRIVATE COLLECTION

DAVID GAULD
1866–1936

A designer of stained glass as well as a painter of landscapes, portraits and symbolist subjects, Gauld was born in Glasgow and worked as an apprentice lithographer while studying part-time at the Glasgow School of Art 1882–5. Charles Rennie Mackintosh was a fellow pupil and remained a close friend, designing him a suite of bedroom furniture when he married in 1893. He first exhibited publicly at the Paisley Art Institute in 1885, and in 1887 took a job as an illustrator on the *Glasgow Weekly Citizen*. By 1888 he was involved in the design of stained glass, and the effect of this, together with the influence of the Pre-Raphaelites, is clearly seen in two remarkable

pictures painted in 1889, *Music* (private collection) and *St Agnes* (Cat. 389). This line, however, was not developed; in the 1890s – when he exhibited at the Grosvenor Gallery and the Vienna Secession – he turned to more conventional landscapes, painting in 1896 at Grès, where Roche, Millie Dow and others had painted twelve years before. His most important work in stained glass was a series of windows for St Andrew's Scottish Church in Buenos Aires, made by the Glasgow firm of Guthrie and Wells in the 1900s. In later life he became a producer of popular images of cattle. Was elected ARSA 1918, RSA 1924.

389. St Agnes 1889
Oil on canvas, 61 × 35.5 (24 × 14)
Signed *DAVID GAULD* (lower right)
Exh: Glaspalast, Munich 1890 (?); *Glasgow School of Painting*, FAS 1970 (6); *Post-Impressionism* RA 1979–80 (292)
Lit: Hardie, p81, pl.108; Billcliffe 1985, pp265–7, pl.233
St Agnes and the contemporary *Music* (Billcliffe, pl.232) are unique in Gauld's work and indeed in the history of the Glasgow School, being even more radical experiments in symbolism than the slightly later works of Hornel and Henry (Fig. 10–11). They clearly owe much to Gauld's involvement with stained glass while betraying the influence of Rossetti and Burne-Jones, whose work was often exhibited at the Glasgow Institute in the 1880s. In turn they probably influenced the mystical watercolours that Gauld's friend C R Mackintosh was to begin painting in 1892 (see Cat. 401).
ANDREW MCINTOSH PATRICK

JOHN DUNCAN
1866–1945

Duncan was born in Dundee, the son of a cattle dealer, and was studying at the Dundee School of Art by the age of eleven. After three years in London doing 'hack work' for publishers, he continued his studies in Antwerp and Dusseldorf and spent a winter in Rome, where he developed an ardent admiration for Michelangelo. He was to become a member of the Dundee Graphic Arts Association, and in 1898–9 shared a studio with the young George Dutch Davidson (Cat. 413–16) whom he greatly influenced. However from 1892 he was mainly based in Edinburgh where he was closely associated with Patrick Geddes, biologist, town planner and prophet of the Celtic Revival. Geddes' offered him the post of Director of his new art school and Duncan sought to express Geddes' ideas in a number of mural projects, notably a series of six panels illustrating scenes from Celtic history in the common room of University Hall in Ramsay Lodge. He was also involved with Geddes' influential magazine, *The Evergreen* (see Lindsay Errington's article above). In 1899 he embarked on a tour of America with Geddes. In 1900 he lectured at the International Assembly of the Paris Exposition, and the same year became Associate Professor of Art at the Chicago University, holding the post for two years. On returning to Scotland, he made his home in Edinburgh, where his studio in Torphichen St and later St Bernard's Crescent became a centre for a lively group of artists and intellectuals, including Geddes, Mrs Kennedy Fraser, Father John Gray (see Cat. 286), Lady Margaret Sackville, and such younger talents as Eric Robertson, Cecile Walton and Joyce Cary. One of his associates, the novelist Mary Agnes Hamilton, described him in her novel *Yes* (1914) as 'accumulating unsaleable works which pleased him but not the buyers'. In fact he received many commissions for altarpieces, church murals and stained glass, and was elected ARSA in 1910 and RSA

in 1923. He was a great experimenter with techniques and much of his work is in tempera. His subject-matter remained rooted in the Celtic Revival and the Pre-Raphaelite tradition, but he also painted 'straight' landscapes in Iona and elsewhere, and took a keen interest in the development of modern art. Many regarded him as a mystic, and he confessed to hearing 'fairy music' while he painted. This rather fay quality led him into trouble when he fell in love with and married a girl who believed she had discovered the Holy Grail in a well at Glastonbury; the marriage was not a success and his wife eventually left him, taking herself and her two daughters to South Africa.

Ref: John Duncan. A Scottish Symbolist, exh. Bourne Fine Art, Edinburgh 1983, cat. by Martin Forrest; *John Duncan*, exh., Edinburgh Art Centre and Dundee Art Gallery 1986, cat. by John Kemplay

390. The Riders of the Sidhe 1911 *ill. p51*
Tempera on canvas, 114.3 × 175.2 (45 × 69)
Signed and dated *John Duncan 1911* (lower left)
Exh: RSA 1911 (129); British Association Exh., Dundee 1912 (410); Edinburgh 1986 (4)
The riders carry symbols of their faith and power, said to be based on Celtic tradition but probably invented by Duncan himself. The leading rider (to the left) holds the symbol of intelligence, the tree of life and of the knowledge of good and evil; the second holds the cup of abundance and healing, the third, the sword of the will on its active side, and the last, the crystal of the will on its passive side. For further explanation, see Lindsay Errington's essay above. A smaller version and preparatory drawings are recorded.
DUNDEE ART GALLERIES AND MUSEUMS

391. Tristan and Isolde 1912
Tempera on canvas, 76.6 × 76.6 (30⅛ × 30⅛)
Signed and dated *John Duncan 1912* (lower right)
Exh: RSA 1912 (251); Edinburgh 1986 (5)
The famous Arthurian subject; Tristan has been sent to Ireland to conduct Iseult to Cornwall, where she is to marry his uncle, King Mark; but on the voyage they unwittingly drink the love-potion intended for Mark, and fall passionately in love. The theme has been treated by Rossetti and his circle in a set of stained-glass cartoons; by Matthew Arnold and Swinburne in poetry; and of course by Wagner. Duncan, in one of his most satisfactory works, gives it an appropriately Celtic emphasis by the rich embroidery on Tristan's dress and other details.
CITY OF EDINBURGH ART CENTRE

392. St Bride 1913 *ill. p46; detail p174*
Tempera on canvas, 120.7 × 143.5 (48½ × 57½)
Signed and dated *John Duncan MCMXIII* (lower left)
Exh: Edinburgh 1986 (6)
One of Duncan's most arresting and characteristic works. For the subject and close relationships with the writings of Fiona Macleod, see Lindsay Errington's essay above.
NATIONAL GALLERIES OF SCOTLAND

393. The Adoration of the Magi 1915
Tempera on board, 66 × 122 (26 × 48)
Signed and dated 1915
Exh: RSA 1915 (372); Bourne Fine Art 1983 (50)
The composition is already adumbrated in the embroidered decoration on the dress of the angel on the left in *St Bride* (Cat. 392). The abstract use of colour in the rocks on the left, a little reminiscent of Redon, is remarkable.
BOURNE FINE ART

394. Jorinda and Joringel in the Witch's Wood 1909
Oil on board, 63.5 × 89 (23 × 35)
Signed and dated *1909* (lower right)
Exh: RSA 1910 (167); Liverpool Autumn Exh. 1910 (1081); Scottish National Exh., Glasgow 1911; *Art and Artists at the Grafton* Grafton Galleries, London 1913; Bourne Fine Art 1983 (49)
Due to the exigencies of catalogue-making, this item is out of sequence; it is in fact the earliest work by Duncan in the exhibition. It illustrates Grimm's fairy tale of the same name, which tells how two lovers wander into a wood where a witch turns the girl, Jorinda, into a nightingale and carries her off to her castle. Eventually Joringel rescues her with the aid of a magic flower.
The subject was also treated by Mark Symons in a picture exhibited at the RA in 1929.
PRIVATE COLLECTION

395. Ivory, Apes and Peacocks 1923
Oil on canvas, 101.5 × 152.5 (40 × 60)
Signed *DUNCAN* (lower right)
Duncan's Diploma work for the Royal Scottish Academy, of which he became a full member in 1923. The subject is the visit of the Queen of Sheba to Solomon (I Kings. 10), although in fact the title is taken from the description of Solomon's navy of Tharshish, which 'once in three years came . . . bringing gold, and silver, ivory and apes, and peacocks'. The phrase was also used as the title of a book by 'Israfel', published by the Unicorn Press 1899 with a binding by Paul Woodroffe.
A smaller version, begun in 1909 and completed 1920, is in the Glasgow Art Gallery, and preparatory drawings are known.
ROYAL SCOTTISH ACADEMY

396. Phlegethon
Oil on canvas, 41 × 61.4 (16⅛ × 24¼)
Signed *John Duncan* (lower left)
Exh: Edinburgh 1986 (15)
Phlegathon, the river of fire, is one of the five rivers of the underworld.
ABERDEEN ART GALLERY AND MUSEUMS

397. Deirdre of the Sorrows *ill. p53*
Black chalk, 86 × 70.5 (34½ × 28)
Exh: Bourne Fine Art 1983 (3); Edinburgh 1986 (24)
One of the most famous figures in Irish legend, Deirdre is seen sorrowing for the death of her beloved Naoise and his brothers. Having delivered a pathetic elegy known as Deirdre's Lament, she kills herself.
NATIONAL GALLERIES OF SCOTLAND

398. Cuchulainn
Pencil, 38.1 × 27.8 (15 × 11)
Inscribed *CUCHULAINN I CARE NOT THOUGH I LAST BUT A DAY IF MY NAME AND FAME ARE A POWER FOR EVER*
Exh: Bourne Fine Art 1983 (10); Edinburgh 1986 (30)
The great hero of Irish legend, who performed so many mighty deeds in his short life of twenty-seven years.
NATIONAL GALLERIES OF SCOTLAND

GEORGE WILLIAM RUSSELL
1867–1935
Russell, who adopted the pseudonym 'AE', a contraction of the word 'aeon', was born in Lurgan and educated in Dublin, where he lived until 1932. He is probably better known as a poet and journalist than as a painter. Encouraged by Yeats, he published his first volume of mystical verse, *Homeward*, in 1894. His poetic drama *Deirdre* was performed in 1902 at the Abbey Theatre, which he helped to found. He edited *The Irish Homestead*, a journal devoted to Irish culture

1905–23, and subsequently *The Irish Statesman*, a literary and political journal which supported the Free State. Meanwhile he continued to publish poetry, including *The Divine Vision* (1904), *Gods of War* (1915), *The Interpreters* (1922), *Midsummer Eve* (1928), *The Avatars*, a fantasy of the future (1933) and *The House of the Titans*, an ambitious work based on Celtic mythology (1934). During his last years he lived in Bournemouth, where he died and is buried.

Ref: H Summerfield, *That Myriad-Minded Man* 1975

399. A Spirit or Sidhe in a Landscape c1900–5
ill. p177
Oil on board, 25 × 19 (9⅞ × 7½)
Russell's paintings tend to be variations on a theme, and this is a characteristic example. It belongs to a group of three pictures acquired by the National Gallery of Ireland in 1973, all showing spirits in landscapes and painted about the same time.
THE NATIONAL GALLERY OF IRELAND

400. The Winged Horse c1900–5
Oil on panel, 30.5 × 45.7 (12 × 18)
A slightly Redon-like concept, acquired by Hugh Lane for his Museum of Modern Art in Dublin.
THE HUGH LANE MUNICIPAL GALLERY OF MODERN ART, DUBLIN

Cat. 399

CHARLES RENNIE MACKINTOSH
1868–1928
Born in Glasgow, the son of a police superintendent, Mackintosh is the most famous of the Glasgow Style designers and has become something of a cult figure of international importance. He studied at the Glasgow School of Art while being apprenticed to the architect John Hutchinson, transferring to the firm of Honeyman and Keppie in 1889. In 1891 a travelling scholarship enabled him to visit Italy, France and Belgium, and in 1892 he began to paint a series of mystical watercolours. Meanwhile his furniture designs were establishing a repertoire of forms which became the hallmarks of the Glasgow Style and his reputation as an architect was confirmed

387

by his famous designs for Glasgow School of Art (1897–1909). In 1900 he married Margaret Mac-Donald, who collaborated with him closely and encouraged his painting. Although his work was highly acclaimed abroad, Glasgow proved increasingly restrictive, and in 1914 he left to concentrate on painting in watercolours. He lived in Chelsea until 1923 and thereafter in France.

Ref: *Charles Rennie Mackintosh*, Centenary Exh., Edinburgh, etc 1968, cat. by Andrew McLaren Young; Roger Billcliffe, *Mackintosh Watercolours* 1978

401. **The Harvest Moon** 1892
Watercolour, 35.2 × 27.6 ($13\frac{7}{8} × 10\frac{7}{8}$)
Signed and dated *CHAS R McINTOSH H 1892* (lower right) and inscribed on reverse *THE HARVEST MOON CHAS R MACKINTOSH 1893 TO JOHN KEPPIE OCTOBER 1894*
Exh: RGI 1894 (864); Edinburgh, etc 1968 (53)
Lit: Billcliffe 1978, p11; p27, no.37; p58, repr
The first of a series of mystical drawings which Mackintosh began to make in 1892, *The Harvest Moon* was given two years later to John Keppie, a partner in the firm of Glasgow architects Honeyman and Keppie for which the artist was working. Billcliffe analyses it at length and discusses its significance.
GLASGOW SCHOOL OF ART

402. **The Tree of Influence** 1895 *ill. p178*
Watercolour, 31.8 × 23.2 ($12\frac{1}{2} × 9\frac{1}{8}$)
Inscribed *THE TREE OF INFLUENCE THE TREE OF IMPORTANCE THE SUN OF COWARDICE.*

CHARLES RENNIE MACKINTOSH – JANUARY 1895 (right vertically)
Lit: Billcliffe 1978, p12; p29, no.45; p69, repr
'The attribution of abstract concepts to natural forms was not unusual in the Symbolist movement', writes

Cat. 402

Billcliffe in discussing this drawing and Cat. 403, 'but rarely were the forms stylised to the degree seen here. Mackintosh's meaning in these drawings has eluded all commentators'.

The drawings were formerly in the collection of Katherine Cameron, whose work is represented below.
GLASGOW SCHOOL OF ART

403. **The Tree of Personal Effort** 1895
Watercolour, 32.2 × 23.6 ($12\frac{3}{4} × 9\frac{1}{4}$)
Inscribed *THE TREE OF PERSONAL EFFORT THE SUN OF INDIFFERENCE CHARLES RENNIE MACKINTOSH JANUARY 1895* (right vertically)
Exh: Edinburgh etc 1968 (72)
Lit: Billcliffe 1978, p12; p29, no.44; p68, repr
See Cat. 402.
GLASGOW SCHOOL OF ART

ROBERT BURNS
1869–1941
Born in Edinburgh, the son of a landscape photographer, Burns studied at the Glasgow School of Art in the 1880s, C R Mackintosh being a fellow pupil. In 1889 he went to London to work under Fred Brown at Westminster, then proceeded to Paris where he entered the Académie Delecluse and studied Japanese and Venetian art, both of which were to influence him profoundly. Returning to Edinburgh in 1892, he became deeply involved in the decorative arts and, like John Duncan, Phoebe Traquair and others, was associated with Patrick Geddes (see Lindsay Errington's essay above and Cat. 404–5). He also painted easel pictures of a symbolist nature, exhibiting at the Glasgow Institute, RSA, International Society, Vienna Secession, etc. He was elected President of the Society of Scottish Artists 1901, ARSA 1902, and appointed first head of Drawing and Painting at Edinburgh College of Art 1908. However he was always a difficult and rebellious character, and by 1920 had broken both with the Academy and the School of Art. He now turned increasingly to watercolour, painting landscapes in Morocco 1921 (exh. Leicester Galleries, London), and returned to his early interest in applied art, decorating Crawford's restaurant in Edinburgh; this enormous task, involving many talents, was completed 1927. In 1929 he suffered the first of a series of strokes, but remained prolific, mainly as an illustrator, until his death.

Ref: *Robert Burns Limner*, exh. FAS 1976, cat. by Paul Stirton; *Robert Burns*, exh. Bourne Fine Arts 1983, cat. by Martin Forrest; forthcoming monograph by Martin Forrest

404. **Odysseus** c1912
Red chalk on brown paper, 35 × 19.3 ($13\frac{3}{4} × 7\frac{5}{8}$)
Signed with initials
This and the following item reflect Burns's relationship with Patrick Geddes, being costume designs for the *Masque of Learning*, an enormous pageant of the history of civilisation involving over nine hundred actors, singers and musicians, which Geddes presented in Edinburgh and London in 1912–13. For a fuller account of this and other pageants relating to the Celtic Revival (and photo), see Elizabeth S Cumming, *Arts and Crafts in Edinburgh 1880–1930* 1985, pp10–11.
M A FORREST

405. **Dancer** c1912
Black chalk on brown paper, 33.3 × 19.3 ($13\frac{1}{8} × 7\frac{5}{8}$)
Signed with initials
See Cat. 404.
M A FORREST

406. **The Ballad of** *The Twa Corbies* (two pairs of illustrations) 1929
Monochrome wash on vellum, 29.2 × 19 (11½ × 7½)
Exh: FAS 1976 (4–5)
Four of eight designs for this ballad in the National Gallery of Scotland, of which pen and ink versions were published in *Scots Ballads* 1939 (Cat. 409). The ballad recounts the grim conversation of two crows, who plan to make their dinner from the corpse of a dead knight.
NATIONAL GALLERIES OF SCOTLAND

407. **The Border Widow's Lament** c1937
Ink and watercolour, two sheets framed together, each 30.7 × 20 (12⅛ × 7⅞)
Exh: FAS 1976 (19); Bourne Fine Art 1983 (52)
One of the pen and ink outline drawings which Burns began to make in 1936 when preparing his ballad designs for publication (see Cat. 409).
M A FORREST

408. **The Twa Sisters** c1937
Watercolour, two sheets framed together, each 30.8 × 20.6 (12⅛ × 8⅛)
Exh: FAS 1976 (16); Bourne Fine Art 1983 (53)
A colour study for Cat. 409.
M A FORREST

409. *Scots Ballads by Robert Burns, Limner*
Edited and illustrated by Robert Burns London: Seeley Service & Co. 1939. Folio
Burns inherited his interest in ballads from his father, and began to make designs for an illustrated edition in the 1890s. The project was postponed until 1929 when, having suffered a stroke and been confined to bed, he took up the designs again, treating them first in watercolour and gold on vellum, and in 1936 reinterpreting them as black and white drawings suitable for reproduction.
M A FORREST

FRANCES MACNAIR (née Macdonald)
1874–1921
Frances Macdonald, like her sister Margaret, Charles Rennie Mackintosh and Herbert MacNair (whom she married in 1899), belonged to the group known as 'The Four' which pioneered the Glasgow Style. She trained at Glasgow School of Art, where she met MacNair. Her work and development has much in common with those of her sister, although her figures tend to be more emaciated and anguished. Like Margaret's, her work is characterised by an interest in symbolism, mythology and fairy subjects. By 1900 she had moved to Liverpool, where MacNair was Instructor in Design at the School of Architecture and

Applied Art, but they returned to Glasgow in 1908. MacNair had little success as a watercolourist and life for the couple was difficult. Such late works as *Man makes the beads of life but women thread them* and *Tis a long path which wanders to desire* are no doubt a reflection of this.

Ref: Roger Billcliffe, *Mackintosh Watercolours* 1978

410. **The Sleeping Princess** c1909–15 ill. p179
Watercolour and gold on vellum, 12.7 × 44.5 (5 × 17½)
Signed FRANCES MACDONALD MACNAIR (lower left)
Lit: Billcliffe 1978, p47, no.XIV
PRIVATE COLLECTION

411. **A Paradox** c1910 (?)
Watercolour, 35.5 × 45 (14 × 17¾)
Signed *Frances MacNair* (lower left) and inscribed on the back with the title, the artist's address (6 Florentine Terrace, Hillhead, Glasgow), and the original price (£20)
Exh: Japan 1983 (34)
VICTOR ARWAS

WILLIAM ORPEN
1878–1931
Born at Stillorgan, Co Dublin, the son of a lawyer, he studied at the Dublin Metropolitan School of Art from the age of eleven until he enrolled at the Slade in 1897. While there he became an accomplished draughtsman and won the Composition Prize in 1899. On leaving he set up a teaching studio in Chelsea with Augustus John but also worked in Ireland where from 1902–1914 he taught part-time at the Dublin School of Art and became involved with the Irish cultural renaissance. Exhibited at the NEAC from 1899 (member 1900), at the RA from 1908 (ARA 1910, RA 1919) and was a founder-member of the National Portrait Society 1911. While enjoying great success as a portrait painter, being regarded as Sargent's successor, he also exhibited nudes and landscapes. In 1916 he joined the Army and in 1917 went to France as an Official War Artist. Knighted in 1918. During the 1920s he kept studios in both Paris and London. His war reminiscences, *An Onlooker in France 1917–1919*, were published 1921.

412. **The Holy Well** 1916 ill. p74
Tempera on canvas, 234 × 186 (92 × 73.5)
Signed *Orpen*
Exh: NEAC 1916 (22); RA 1933 (68); *William Orpen Centenary Exhibition*, National Gallery of Ireland, Dublin 1978 (99)

Lit: P G Konody and S Dark, *William Orpen Artist and Man* 1932, p37, repr
As James White pointed out in the catalogue of the Orpen Centenary Exhibition in 1978, the picture is one of two painted by the artist about this time in which he satirised Celtic themes and employed a medium which currently intrigued him, tempera. The other painting, *Western Wedding* 1914, is now in Japan. *The Holy Well*, which probably reflects Synge's play *The Well of the Saints*, shows the naked figures of ancient pagan Ireland being made to drink from the well and transformed into Arran islanders against a background of Celtic crosses and beehive dwellings of the sixth and seventh centuries AD. Orpen's artist friend Sean Keating provided him with the sketches of Arran and local costumes he needed for the composition, and Keating himself is seen standing on the wall cynically surveying the scene of pagan renewal. The picture is also discussed by David Fraser Jenkins in his essay above.
THE NATIONAL GALLERY OF IRELAND

GEORGE DUTCH DAVIDSON
1879–1901
Born at Goole, in Yorkshire, of Scottish parents, this short-lived Dundee artist left school in 1895, intending to become an engineer. However in the spring of 1896 he contracted influenza, which left him an invalid until his death. In 1897, although he had shown no previous interest in drawing, he began to study art at Dundee High School. About the same time he met John Duncan, sharing his studio 1898–9. Duncan influenced him profoundly, warning him against realism, although his work at this period also shows the impact of Art Nouveau, Celtic and Persian ornament, and Munch. In September 1899 Davidson and his mother left Dundee for a ten-month stay in London, where he steeped himself in the museums; then went on to Antwerp and Italy, visiting Florence, Ravenna and Venice before returning to Scotland in August 1900. He died five months later, still aged only twenty-one.

Ref: George Dutch Davidson, *Memorial Volume*, Dundee Graphic Arts Association 1902; William Hardie, 'The Hills of Dream Revisited: George Dutch Davidson', *Scottish Arts Review* XII 4, pp18–23; reprinted with appendices 1973

413. **The Hills of Dream** 1899
Watercolour with bodycolour, 43.2 × 68.6 (17 × 27)
Signed and dated *G Dutch Davidson 1899* (lower left)
Exh: Dundee Graphic Arts Association 1900 (86) and 1901 (159)
Lit: *Memorial Volume* 1902, pp6–7, pl.4; *Magazine of Art* 1904, p328; Hardie, p87

Cat. 410

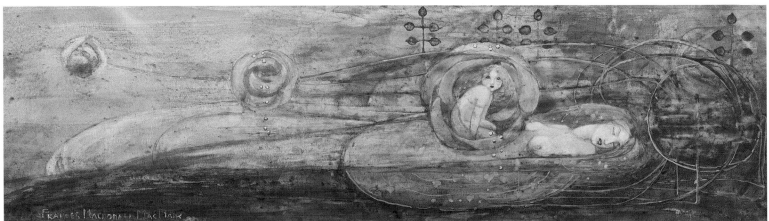

Executed in Antwerp in 1899, this remarkable drawing illustrates a quatrain from a book of the same name by Fiona Macleod:

> And a strange Song I have heard
> By a shadowy Stream
> And the Singing of a snow-white Bird
> By the Hills of Dream.

Nothing could be further from 'the deep pit of Realism' which Davidson was so anxious to avoid.

DUNDEE ART GALLERIES AND MUSEUMS

414. The Tomb 1899–1900
Pen and ink, 24.1 × 29.8 (9½ × 11¾)
Exh: Memorial Exh., Dundee 1901 (probably 153)
Lit: *Memorial Volume* 1902, pl.7; Hardie, p87 and pl.100
An illustration to the *Rubáiyát of Omar Khayyám*, this drawing, like Cat. 413, was done in Antwerp. However, as Hardie remarks, it shows 'a technical advance on . . . *The Hills of Dream* [and] is something of a *tour de force* in its complex refinement'.

DUNDEE ART GALLERIES AND MUSEUMS

415. Orpheus 1900
Pencil, 19.7 × 22.9 (7¾ × 9)
Exh: Memorial Exh., Dundee 1901 (149)
Lit: *Memorial Volume* 1902, p11, pl.12
Dated 1900 in the *Memorial Volume*.

DUNDEE ART GALLERIES AND MUSEUMS

416. Ullalume 1900 ill. p52
Pen and ink with black wash and white bodycolour, 23.2 × 29.9 (9⅛ × 11½)
Exh: Memorial Exh., Dundee 1901 (163)
Lit: *Memorial Volume* 1902, pl.10; Hardie, p88
This design inspired by Edgar Allan Poe was executed during the last five months of the artist's life, when he had returned from his travels in Italy. There are clear reflections of his recent experience of quattrocento painting and the Tuscan landscape, while technically the drawing is more refined than anything he had achieved before.

DUNDEE ART GALLERIES AND MUSEUMS

ERIC HAROLD MACBETH ROBERTSON
1887–1941

Born in Dumfries, Robertson moved to Edinburgh at the turn of the century, at first studying architecture, later turning to painting. He was inspired by the Pre-Raphaelites, Gustave Moreau and John Duncan, whose studio he frequented. Although regarded as brilliant, his art and life-style were considered decadent. Much against her parents wishes, he married Cecile Walton, daughter of the Scottish artist E A Walton, in 1914. Two years earlier, he had helped to found the Edinburgh Group, which held two exhibitions before the First World War, during which he served in the Ambulance Service in France. Returning to Edinburgh in 1919, his career flourished in a lively intellectual circle which also included the composers Cecil Gray and Peter Warlock and the writers Clifford Bax and Olaf Stapledon. His work, though still seen as subversive, had many admirers, and he evolved a new, more 'Vorticist', style which he called 'expressionism'. However, his marriage had long been in trouble, and Cecile Walton left him in 1923. He moved to Liverpool, hoping to establish a portrait practice, and when this plan failed, turned to commercial art. He remarried in 1927. In the late 1930s he contracted tuberculosis, from which he died in Cheshire in 1941.

Ref: *The Edinburgh Group*, exh. City Art Centre, Edinburgh and Glasgow Art Gallery 1983, cat. by John Kemplay; *Eric Robertson*, exh. Piccadilly Gallery, London 1987, cat. by John Kemplay

417. The Sea Horse 1912
Oil on canvas, 68.5 × 76.2 (27 × 30)
Signed on the stretcher
Exh: Society of Scottish Artists, Edinburgh 1912; Piccadilly Gallery 1987 (1)
Lit: *The Scots Pictorial* 36 1920, p420, repr
An early symbolist work, not far in style from John Duncan. According to the Piccadilly Gallery catalogue, the artist 'may have had in mind the legend of the Water Horse of Poll Nan Craobhan'.

MR AND MRS JOHN KEMPLAY

418. Spring 1913
Oil on canvas, 68.5 × 75 (27 × 29½)
Signed *ERIC ROBERTSON*
Exh: Edinburgh Group 1913; *The Edinburgh Group* 1983 (28)
Robertson was fond of this almost Munch-like type of composition, in which the head and shoulders of a figure are set against a landscape background to evoke a particular mood. Another, more austere, example, dating from 1919, was exhibited at the Piccadilly Gallery 1987–8 (5).

PRIVATE COLLECTION

419. Lilith 1909
Pencil, 73.6 × 67.3 (29 × 26)
Signed and dated *ERIC ROBERTSON DECEMBER 1909* (lower right)
Exh: Piccadilly Gallery 1987 (11)
A magnificent example of the type of drawing that gave Robertson a reputation for being a dangerous immoralist, and eventually cost him the friendship of his hero, John Duncan. The title is taken from Rossetti's sonnet of the same name, Lilith being 'Adam's first wife, . . . the witch he loved before the gift of Eve'. The band across her bosom has been seen as a reference to bondage, although this and the pose are also reminiscent of Michelangelo. The peacocks seem to look back to the Aesthetic Movement, while the throne is astonishingly like a piece of furniture by C R Mackintosh. The model was almost certainly Sarah Adamson, whose sister, Mary Agnes Hamilton, wrote the novel *Yes* (1914), based on the early lives of Eric Robertson and Cecile Walton.

THE PICCADILLY GALLERY, LONDON

420. Head Study of Anne Paterson 1913
Pencil, 33 × 29.2 (13 × 11½)
Signed and dated *Eric Robertson 1913* (lower right) and inscribed *Anne Paterson* (lower left)
The drawing owes an obvious debt to Rossetti and Burne-Jones.

CHARLES CHOLMONDELEY

HARRY CLARKE
1889–1931

The most exotic of all the hot-house flowers in the exhibition, Clarke was born in Dublin, the son of a 'church decorator'. He left school when his mother died in 1903 and entered his father's stained glass studios, meanwhile studying at the Metropolitan School of Art, where he won numerous prizes. In 1913 he was commissioned to illustrate his first book, Hans Andersen's *Fairy Tales*, and a travelling scholarship enabled him to study stained glass in France. His reputation as a stained-glass designer was established with the windows executed for Honan Chapel, Cork (1915–17), and in 1919 Thomas Bodkin, a consistent champion of his work, published an important article on him in the *Studio*. In 1921, on the death of his father, he took over the family business; meanwhile his glass, which was widely exhibited, had gained an international reputation, and his illustrations were

acclaimed. Elected ARHA 1924 (on Fiscal Committee with Yeats), RHA 1925. In 1925 an exhibition of his illustrations was held at the St George's Gallery, London, and a large exhibition in his own studio was opened by the President of the Irish Free State. This marked the climax of his career. From now on overwork began to take an increasing toll on his health. In 1929 tuberculosis was diagnosed and he left for Switzerland, dying there two years later.

Ref: *Harry Clarke*, exh. Trinity College, Dublin 1979, cat. by Nicola Gordon Bowe; *The Stained Glass of Harry Clarke*, exh. FAS 1988, cat.

421. Faust and Margaret c1925
Watercolour, 32.8 × 23.5 (12⅞ × 9¼)
Exh: Dublin 1979 (103)
An unfinished and unpublished illustration for Goethe's *Faust*, issued by George Harrap in 1925 with eight colour plates and many text decorations by Clarke. The book is described by Nicola Gordon Bowe as the artist's 'graphic masterpiece'.

DONALD DEAN

422. The Countess Cathleen c1928
Watercolour, 43 × 29 (17 × 11½)
Exh: FAS 1988 (52)
A preliminary study for the W B Yeats panel of the so-called Geneva Window. The window was commissioned by the Irish Free State in 1925 in the International Labour Office of the League of Nations in Geneva, each panel representing a work by a distinguished Irish author. It was completed shortly before Clarke's death but rejected on the grounds that some of the authors were unsuitable.

THE FINE ART SOCIETY

423. Edgar Alan Poe, *Tales of Mystery and Imagination*
Illustrated by Harry Clarke
London: George Harrap 1919. 4to
Clarke's second published book. He had long wanted to illustrate Poe, an artist perfectly attuned to his type of imagination, and sought the commission from Harraps. The resulting drawings, all in black and white, show him at his most extravagant. 'Never before', wrote M C Salaman in the *Studio*, 'have these marvellous tales been visually interpreted with such flesh-creeping, brain haunting, illusion of horror, terror and the unspeakable.' The book was a great success.

SIMON HOUFE

424. *The Year's at the Spring. An Anthology of Recent Poetry*
Compiled by Lettice d'Oyly Walters. Illustrated by Harry Clarke
London: George Harrap 1920. 4to
After the record sales of the Poe (Cat. 423), Harraps offered Clarke the contract for this book. He accepted in January 1920 and completed the illustrations in June.

DRUSILLA AND COLIN WHITE

CECILE WALTON
1891–1956

Born in Glasgow, the daughter of the landscape and portrait painter E A Walton, who moved to London in the 1890s, settling in Cheyne Walk. She was something of a child prodigy and from the start was surrounded by the artists of her father's circle, who included James Guthrie, John Lavery, Arthur Melville, James Pryde, George Sauter, and Whistler. Unlike most of these, however, she was drawn to literary subjects, a taste she shared with her friend Jessie M King. When her father returned to Edinburgh on becoming President of the RSA, she became

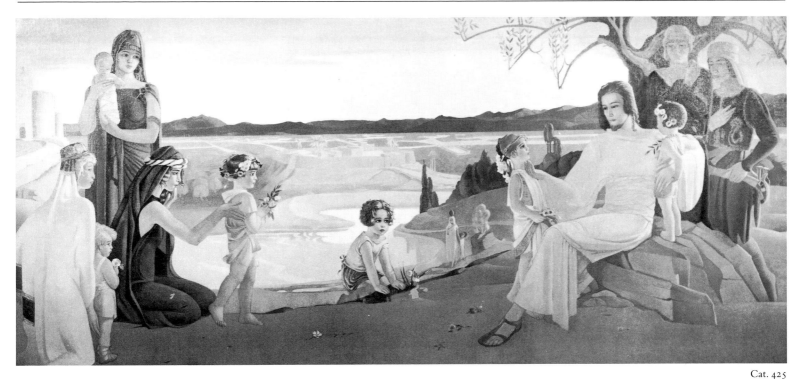

Cat. 425

friendly with John Duncan, the chief influence on her work. In 1908 she spent a year studying in Paris, and her parents also sent her to Florence, hoping to end the romance between herself and Eric Robertson. In 1914, however, she married Robertson, by whom she had two children. Having exhibited with the Edinburgh Group in 1913, she spent the war years, when Robertson was abroad, in Bedford Park. She reached the peak of her career in the early 1920s, never fully recovering from the break-up of her marriage in 1923. About 1930 she was in Cambridge, working for Tyrone Guthrie at the Festival Theatre, and on returning to Edinburgh in 1933 she became organiser of the BBC Scottish Children's Hour. A second marriage, to a producer, also failed. Later she settled at Kirkcudbright, making painting trips to North Africa in the early 1950s.

Ref: *The Edinburgh Group*, exh. City Art Centre, Edinburgh and Glasgow Art Gallery 1983, cat. by John Kemplay

425. Suffer Little Children To Come Unto Me
c1925) (?) ill. p187
Oil on canvas, 152.5 × 335 (60 × 132)
Exh: *The Edinburgh Group*, City Art Centre, Edinburgh and Glasgow Art Gallery 1983 (87)
The picture was painted as a mural for the Children's Village at Humbie, East Lothian. For another treatment of the same theme, very similar in purpose, see Cat. 460.
THE PICCADILLY GALLERY, LONDON

426. To Trick the Basilisk c1918
Watercolour, 22.9 × 22.9 (9 × 9)
Signed *Cecile Walton*
Exh: Edinburgh Group 1920
One of the original drawings for *Polish Fairy Tales* (Cat. 428), of which a number survive (see *The Edinburgh Group*, exh. 1983, nos 70–83). The designs, twenty in all, were much admired when shown in the Edinburgh Group exhibition in 1920. 'Nothing more convincing of [the artist's] genius could possibly be desired by her numerous admirers in Scotland', wrote Frederic

Quinton in the *National Outlook*.
MR AND MRS JOHN KEMPLAY

427. Hans Christian Andersen, *Fairy Tales*
Translated by H Oscar Sommer, illustrated by Cecile Walton
London and Edinburgh: T C and E C Jack 1911. 8vo
Hans Andersen engaged the attention of a number of 'last romantics', others who illustrated him including A J Gaskin, Maxwell Armfield, Edmund Dulac, W Heath Robinson, Arthur Rackham and Harry Clarke. Cecile Walton's delicate watercolour designs, done at the age of nineteen, were commissioned by the Edinburgh publishers, T C and E C Jack. They tended to specialise in women artists, also employing Katherine Cameron (Cat. 529–30), Jessie M King (Cat. 534) and Minnie Spooner (Cat. 540–1), although Paul Woodroffe worked for them regularly and Byam Shaw and E J Sullivan swam briefly into their net.
ROSEMARY FARQUHARSON

428. A J Glinski, *Polish Fairy Tales*
Translated by Maude Ashurst Biggs, illustrated by Cecile Walton
London: John Lane 1920. 4to
Nine years later than the Hans Andersen (Cat. 427) and more forceful in style, the designs for this book were executed towards the end of the First World War, when the artist was living with her parents in Bedford Park. They represent her masterpiece as a book illustrator.
THE BRITISH LIBRARY BOARD

ANCELL STRONACH
born 1901, still active 1938
A painter of murals, portraits and figure subjects, Stronach was born in Dundee and went to Glasgow School of Art, gaining a Diploma in 1920 and a travelling scholarship. Remembered as 'an elegant, immaculately dressed man who wore a grey morning suit and spats, much in the style of Whistler', he himself became Professor of Mural Painting at the Art School; he also worked on the Empire Exhibition

held in Glasgow 1938. He exhibited at the RSA (Associate 1934), the RA (1927–31), in the provinces and widely abroad.

429. The Other Wise Man 1927
Oil on canvas, 127.6 × 102.9 (51¼ × 41½)
Signed and dated *Ancell Stronach 1927* (lower right)
Exh: RSA 1928 (90); Palace of Arts Empire Exh., Glasgow 1938
Painted when the artist was twenty-six, the picture clearly shows the influence of Maurice Greiffenhagen, with whom he would have come into contact at the Glasgow School of Art. Cat. 133, Greiffenhagen's own treatment of the Nativity story, painted two years before Stronach's makes a telling comparison.
CITY OF EDINBURGH ART CENTRE

SLADE SCHOOL SYMBOLISTS

AMBROSE McEVOY
1878–1927

Mainly known as a portrait painter, particularly of women, McEvoy was born in Wiltshire and, encouraged as a boy by Whistler, entered the Slade at the age of fifteen. He became friendly with Augustus John and worked extensively with him, and in Dieppe with Sickert. He exhibited at the NEAC from 1900 (member 1902), had a one-man exhibition at the Carfax Gallery 1907, and also exhibited at the Grosvenor, Grafton and Leicester Galleries. Founder-member of the National Portrait Society 1911, member of the International Society (1913), ARA 1924, ARWS 1926. During the First World War he was attached to the Royal Naval Division and painted a number of official military and naval portraits, now in the Imperial War Museum. In 1920 he visited New York and exhibited there at the Duveen Galleries.

430. The Seasons c1904
Oil on canvas, 43.8 × 50 (17¼ × 19¾)
Signed *McEvoy* (lower right)
Although best known for his portraits, McEvoy executed a number of subject pictures early in his career. These, however, are mainly taken from modern life; *The Seasons* is unusual in its wholehearted symbolism.
THE LEICESTERSHIRE MUSEUM AND ART GALLERY, LEICESTER

431. Mary Magdalene Annointing Christ's Feet
c1900
Watercolour, 31.8 × 42.5 (12½ × 16¾)
Inscribed on reverse *Early drawing for . . .*
Exh: McEvoy exh., Morley College 1975
BRADFORD ART GALLERIES AND MUSEUMS

AUGUSTUS JOHN
1878–1961

A versatile talent, he painted portraits, figure compositions and landscapes, and was noted as a brilliant draughtsman and etcher. Born in Wales, the younger brother of Gwen John, he entered the Slade on a scholarship in 1894 and was a contemporary of Orpen, with whom he organised the running of the Chelsea Art School 1903–7. He exhibited at the NEAC from 1899 and in the same year held a successful one-man show at the Carfax Gallery, where much of his work was shown until he was elected ARA in 1921. In 1901 he married and lived in Liverpool, where he taught at the art school affiliated to the University. Though based in England, he made regular painting trips to Paris and Provence, and visited the USA (1923) and Jamaica (1937). Famous for his bohemian life-style and promiscuity, he led a nomadic existence 1911–19 in Dorset, Wales and Ireland, where he worked with Innes and Derwent Lees. He was briefly associated with the Camden Town and Bloomsbury artists, and became Official War Artist with the Canadian Forces during the First World War. RA 1928, resigned 1938, re-elected 1940; member of the London Group 1940–61. Awarded the OM 1942.

Opposite page: Detail Cat. 452

Cat. 433

Ref: Michael Holroyd, *Augustus John* 1975; *Augustus John: Studies for Compositions*, exh. National Museum of Wales, Cardiff 1978, cat. by David Fraser Jenkins

432. Bathers c1910
Black chalk, 137 × 183 (54 × 72)
For commentary on this cartoon, see David Fraser Jenkins' article above.
E S CAZALET

433. Walpurgis Night 1900 *ill. p183*
Pen and wash, 34.9 × 48.3 (13¾ × 19)
Exh: Cardiff 1978 (12)
Related to a large painting of Faust and Mephistopheles witnessing a witches' coven on the Brocken, which John began to paint in 1900 but never exhibited.
THE TRUSTEES OF THE TATE GALLERY

434. Hark, Hark, the Lark! 1903
Pencil, 38.4 × 25.4 (15⅛ × 10)
Signed *John* (lower left)
Exh: *Paintings, Pastels, Drawings and Etchings by Augustus E John . . .*, Carfax Gallery 1903; Cardiff 1978 (22)
A study from life, or perhaps a combination of two life studies, this drawing is described in the Cardiff catalogue as being 'in a fine Ingres manner'. However the poses and psychology of the figures, both here and in two closely related drawings (Cardiff exh., nos 23–4), surely look back to Rossetti. Presumably these were the sort of drawings that Laurence Binyon had in mind when, writing in the *Saturday Review* in 1907, he described John as belonging to the Pre-Raphaelite tradition (see David Fraser Jenkins' essay above). The influence of Shannon should also be considered;
see Cat. 260.
MANCHESTER CITY ART GALLERIES

435. Group with a Girl Going to a Boat 1907
Pencil on paper, 37.5 × 50.2 (14¾ × 19¾)
Inscribed *To Lady Gregory from Augustus John 1907* (lower right)
Exh: Cardiff 1978 (70)
One of John's most Puvis-like conceptions, the drawing was given to Lady Gregory, with whom John stayed in Ireland in September 1907. She had commissioned him to make an etched portrait of W B Yeats, who was also staying in the house.
NATIONAL MUSEUM OF WALES, CARDIFF

HENRY LAMB
1883–1960

Lamb was born in Adelaide, Australia, but brought up in Manchester and educated at Manchester Grammar School. He studied medicine at Manchester University until 1904, then decided to become an artist, visiting Italy in 1904 and attending John's and Orpen's Chelsea School in 1906 and the Atelier 'La Palette' in Paris under J E Blanche 1907–8. He worked in France, particularly Brittany, in the summers of 1910–11 and in Ireland 1912–13. Exhibited at the NEAC 1909–14, the London Group 1913, and associated with the Camden Town and Bloomsbury Groups. Stanley Spencer, in particular, was for some years a friend and exerted an influence on his work. He served in both World Wars and was awarded the MC during the first. First one-man exhibition 1922. Exhibited at the RA from 1921, becoming ARA in 1940 and RA in 1949. Enjoyed great success as portrait painter in the 1930s. Trustee of the National Portrait Gallery 1942–60 and the Tate Gallery 1944–51.

Cat. 436

Cat. 437

Ref: *Henry Lamb*, exh., Manchester City Art Gallery 1984, cat. by Sandra Martin

436. Fisherfolk, Gola Island 1913 *ill. p184*
Oil on canvas, 82.1 × 102.6 (33 × 41½)
Exh: NEAC (S) 1914 (166) as *Islanders, Donegal* (?)
Lit: Manchester 1984 (30)
In 1913 Lamb made his second trip to Donegal in Ireland, where the previous year he had sailed round the island of Gola, describing it in a letter to Lady Ottoline Morrell as 'a half-loved, half-dreaded little exile'. On both occasions he sketched the fishermen and women who are brought together in this picture, widely regarded as one of his most successful works. It would have been completed in his Hampstead studio, and in both the composition and the handling of the figures was almost certainly influenced by Stanley Spencer, for whom Lamb had a great admiration. In a letter to Lytton Strachey in 1914, he called the painting his 'Gola Sonata'.
PRIVATE COLLECTION

JOHN S CURRIE
c1884–1914
The son of an Irish builder and railway contractor, Currie was born in Chesterton, Newcastle-under-Lyme, although the date is uncertain. Encouraged by Arnold Bennett, he studied c1903 at the Newcastle and Hanley Schools of Art, where he won National and British Institution Scholarships. He worked for a time as a ceramic artist, and became Master of Life Painting at Bristol Art School, a post he held at the time of his marriage in 1907. He subsequently moved to London, and in 1910 studied part-time at the Slade and became friendly with Augustus John and Mark Gertler. He left his wife in 1911 and a year later was working in Newlyn, Cornwall. Exhibited with the NEAC from 1912, becoming a member 1914. In the same year he shot both himself and his mistress, Dolly Henry, in Hampstead.

437. King David Refusing the Shunammite Woman 1913 *ill. p184*
Oil on board, 55.5 × 74 (22 × 29½)
Exh: Grosvenor Gallery 1913; Bradford Jubilee Exhibition 1930 (250); *Some Unusual By-Ways in British Art*, Piccadilly Gallery 1980 (28); *John Currie*, Stoke-on-Trent City Museum and Art Gallery 1980 (32)
Executed only a year before the artist's suicide, the picture illustrates 1 Kings 1. 1–4, which tells how Abishag, a young Shunammite virgin, was brought to the aged King David, 'but the king knew her not'. Currie was never entirely satisfied with it and even after it was bought in 1913 by Sir Edward Marsh, wished to make changes. It also brought to an end the friendship between Currie and Epstein, who believed that the figure of Abishag was borrowed from his 1907 'Strand' figure *Maternity*. Currie maintained that the figure was modelled on his girlfriend Dolly Henry, and inspired by the antique. Whatever the case, the picture clearly reflects Currie's relationship with Gertler, who, as a Jew, was powerfully attracted to Old Testament themes (cf Cat. 455).
THE PICCADILLY GALLERY, LONDON

DERWENT LEES
1885–1931
Born in Melbourne, Australia, Lees lost his right foot in a riding accident while a young man. He was educated at Melbourne University and in Paris, and in 1905 came to London, where he studied at the Slade under Brown and Tonks. He taught drawing at the Slade 1908–18, and was closely associated with Augustus John and J D Innes 1911–14. He exhibited

with the NEAC (member 1911) and was a member of the Friday Club 1911–16. Also exhibited at the Goupil and Chenil Galleries, holding a one-man exhibition at the latter 1914. From c1919 he suffered from an incurable mental disease which made him unable to work, and spent the last thirteen years of his life in hospital. Died in London March 1931.

438. A Woodland Idyll
Oil on Panel, 50.9 × 39.5 (20 × 15⅝)
MANCHESTER CITY ART GALLERIES

MARK SYMONS
1886–1935
Born in Hampstead but brought up in Sussex, Symons was the son of an artist, William Christian Symons, and the cousin of Arthur Symons, editor of the *Savoy*. The family was staunchly Roman Catholic, and William Symons had done decorative work in Westminster Cathedral; Whistler, Sargent and Brabazon were family friends. Mark studied at the Slade 1905–9, winning a two-year scholarship 1906–7. On leaving he decided that he wanted to become a priest or enter a monastery. Ill health caused him to postpone a decision, but he prayed incessantly, made numerous retreats, and worked for the Catholic Evidence Guild 1918–24. Meanwhile he continued to paint sporadically, exhibiting at the RA 1913, 1914 and 1920. Suddenly in 1924, while visiting the presbytery at Caversham, he met a Miss Constance Gerber and they were married that December. For the last ten years of his life Symons painted hard and produced a considerable body of work. He now exhibited regularly at the RA, although the bizarre religious symbolism of such pictures as *Were You there when they Crucified My Lord* (1930) was often a cause of controversy. During this period he lived in the Reading area (Caversham and Wokingham), and a memorial exhibition was held at Reading in 1935.

Ref: Stephanie Wines, *Mark Symons* 1937; *Mark Symons*, exh. Reading Museum and Art Gallery 1979, cat. by Eric Stanford

439. Incipe Parve Puer, Risu Cognoscere Matrem (Begin Little Child to Know Your Mother with a Smile) c1925–7 *ill. p185*
Oil on Canvas, 57.5 × 90 (22⅝ × 35½)
Possibly, but by no means certainly, the earliest of the religious paintings by Symons exhibited here.
PRIVATE COLLECTION

440. Sedes Sapientiae
Oil on canvas, 73 × 41 (28¾ × 16⅛)
Exh: RA 1927 (555); Reading 1979 (61)
Lit: Wines, pp32–4, repr
The picture was painted early in the ten-year period at the end of Symons' life when most of his important work was executed, and was one of three that he exhibited at the RA in 1927. There they attracted the attention of Glyn Philpot, a fellow Roman Catholic, who, though he had never met Symons, wrote to express his admiration: 'Their beauty of invention and clarity of rendering gave me very great pleasure; and their spiritual sweetness gave me something more than pleasure, for which I feel I must thank you'. *Sedes Sapientiae* was bought by the Abbot of Downside Abbey for £75.
WORTH SCHOOL

441. Ave Maria 1929 *ill. p30; detail p198*
Oil on canvas, 123 × 66 (48½ × 26)
Exh: RA 1929 (434); Reading 1979 (65)
A very representative example, combining the intense

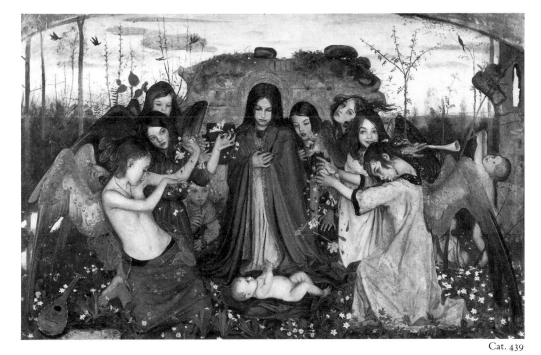
Cat. 439

spirituality of the artist's vision, his interest in fairy themes, his uncompromising linear clarity, and a characteristic feeling for detail. The model for the Virgin was his wife Constance, who appears in the same role in Cat. 440.
READING MUSEUM AND ART GALLERY

442. A Fairy Tale c1935
Oil on canvas, 88 × 88 (34⅝ × 34⅝)
Exh: RA, 1935 (785); Reading 1979 (28); Brighton 1980 (D90)
One of Symons' many treatments of fairy themes, this is presumably a late work since it was exhibited at the Royal Academy the year he died.
NEWPORT MUSEUM AND ART GALLERY, GWENT

PAUL NASH
1889–1946
Landscape painter in oil and watercolour, book illustrator, decorative artist and writer. He left St Paul's School with no formal qualifications and studied first at Chelsea Polytechnic, then at the Bolt Court LCC technical school, and finally at the Slade 1910–11. In 1910 he began a long correspondence with the poet Gordon Bottomley. He held his first one-man exhibition at the Carfax Gallery 1912, which led Roger Fry to invite him to join the Omega Workshops. Married Margaret Odeh, a suffragette, 1914. Member of the Friday Club 1913, the London Group 1914, NEAC 1919. Served with the Artists' Rifles 1914–17 and was appointed Official War Artist as a result of his exhibition at the Goupil Gallery 1917. He first went to Paris in 1922, thereafter visiting France regularly and with Burra in 1930. As well as making significant contributions to book illustration, Nash supplemented his income by writing art criticism. In 1933 he helped to form *Unit One*, together with Moore, Hepworth and others. He was on the Committee of the International Surrealist Exhibition in London 1936, exhibiting there and at the major Surrealist shows in Tokyo 1937, Amsterdam 1938 and Paris 1938. In 1940 he was appointed Official War Artist to the Air Ministry, and the war inspired some of his finest later works. His health was poor from 1933, and he died of pneumonia July 1941.

Ref: *Paul Nash*, exh. Tate Gallery 1975, cat. by Andrew Causey; Andrew Causey, *Paul Nash*, 1980

443. The Sleeping Beauty 1910 *ill. p185*
Watercolour, 18 × 5.9 (8¼ × 6¼)
Signed in monogram *PN* (lower right) and inscribed *Till he find the quiet chamber far apart*
Exh. Carlisle 1970 (118)
Lit: *Poet and Painter*, pp18–20, 247
Executed in his most Pre-Raphaelite vein, the drawing was one of a number that Nash sent to Gordon Bottomley in April 1911. Bottomley, in replying, wrote: 'Perhaps most of all we like the feeling in the little "Sleeping Beauty" picture; it is very delightful, and the colour . . . is full of originality and richness'. Nash hastened to give it to him, disparaging it as 'the veriest sketch-club "done-in-a-hurry" thing and the drawing's vile'.
CARLISLE MUSEUM AND ART GALLERY

Cat. 443

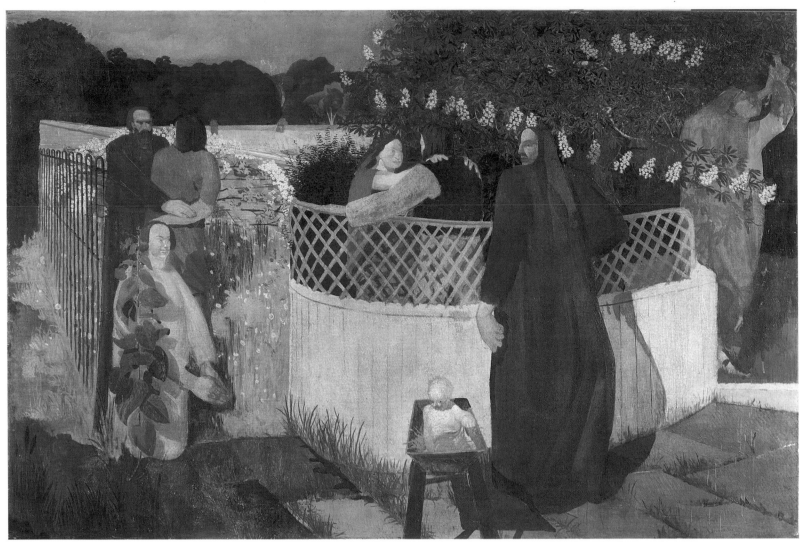

Cat. 451

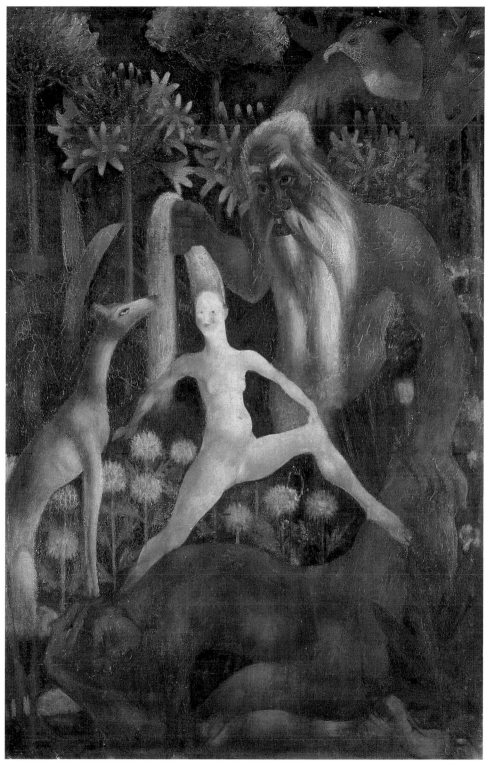

Cat. 455

444. The Combat 1910
Pencil, ink and wash, 35.5 × 26.7 (14 × 10½)
Signed with monogram (lower left)
Exh: Oxford Arts Club 1931 (11); Tate 1975 (1)
Lit: *Poet and Painter*, pp4–5; Margot Eates, *Paul Nash*
1948, p50; Paul Nash, *Outline* 1949, p64, repr
Executed before April 1910, when it is mentioned in the
Nash-Bottomley correspondence, the drawing was
originally accompanied by a poem by Nash (quoted in
Tate catalogue). It is sometimes called *Angel and Devil*.
THE BOARD OF TRUSTEES OF THE VICTORIA AND ALBERT
MUSEUM, LONDON

445. Hallgerd Refuses her Hair to Gunnar 1911
Pencil, 40 × 24.5 (15¾ × 9⅝)
Signed with monogram (lower left)
Exh: *British Art to 1930*, Durham Light Industrial
Museum 1975
Lit: *Poet and Painter*, pp17, 19, 20
The drawing is inspired by Gordon Bottomley's play
The Riding to Lithend (Cat. 353). 'Both for dramatic and
pictorial composition', Bottomley wrote to Nash in
April 1911, 'your "Lithend" drawing is by far the
biggest and most complete thing you have shown me
yet. Your idea of Rannveig took me by surprise with
its fineness; the grouping of the girls is beautiful; and
Hallgerd is the real thing and no mistake'. Nash begged
him to keep it, saying he would 'try another later on'.
CARLISLE MUSEUM AND ART GALLERY

446. Barbara in the Garden c1911
Pen and ink and watercolour, 36.1 × 48.9 (14¼ × 19¼)
Signed *Paul Nash*
Exh: Carlisle 1970 (119)
Lit: *Poet and Painter*, p234
Like Cat. 443, 445 and 447, the drawing belonged to
Gordon Bottomley, who in 1941 called it by the
Tennysonian title *The Rosebud Girls in the Garden*.
CARLISLE MUSEUM AND ART GALLERY

447. Under the Hill 1912
Pen and wash, 39.5 × 32.3 (15½ × 12¾)
Signed with monogram (lower right)
Exh: *Drawings by Paul Nash*, Carfax Gallery 1912 (16);
Carlisle 1970 (120); Tate 1975 (12)
Lit: *Poet and Painter*, pl.VI
Drawn near the Thames close to Wittenham, when
Nash was staying with relatives at Sinodun in
September 1912. The title, while obviously appropriate,
may owe something to Beardsley's choice of this name
for his version of the Tannhäuser legend (see Cat. 62).
CARLISLE MUSEUM AND ART GALLERY

DAVID BOMBERG
1890–1957
Bomberg was born in Birmingham but moved with
his family to the East End of London in 1895. He was
apprenticed to a lithographer 1905–8, and attended
evening classes at the City and Guilds Institute and
at the Westminster School under Sickert 1908–10.
From 1911 to 1913 he studied at the Slade, and c1913
visited Paris where he met Picasso, Modigliani and
Derain. Joining the London Group the same year, he
showed with them intermittently throughout his life.
In 1914 he had his first one-man exhibition at the
Chenil Galleries in Chelsea, and in 1915 showed at the
Vorticist Exhibition, although he considered him-
self to have no formal connection with the move-
ment. The same year he enlisted in the Royal
Engineers, later transferring to the Eighteenth Kings'
Royal Rifles. He lived in Palestine 1923–7, in Spain
1934–5, and also visited Morocco and the Greek
Islands (1930), Russia (1933) and Cyprus (1948). Dur-
ing the Second World War he worked briefly as an
Official War Artist and began teaching. He formed

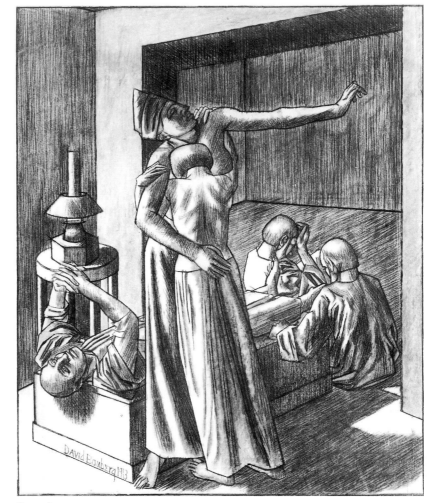

Cat. 448

the Borough Group with his students, including
Auerbach and Kossoff, in 1947, and the Borough Bot-
tega Group in 1953. His last years from 1954 were
spent largely in Spain.

Ref: Richard Cork, *David Bomberg* 1987; *David Bomberg*,
exh. Tate Gallery 1988, cat. by Richard Cork

448. Family Bereavement 1913 *ill. p188*
Pencil and charcoal, 56 × 47 (22 × 18½)
Signed and dated *David Bomberg 1913* (lower left)
Exh: Tate Gallery 1988 (25)
Lit: Cork, pp37–8, fig.37
This and the following two drawings clearly refer to the
death of Bomberg's mother, to whom he was very
close, in October 1912. All three are conceived in terms
of the starkly formalised idiom that the artist was now
exploring, although Cat. 448 is by far the most finished
and representational. It was greatly admired by
Augustus John, who described it to the American
collector John Quinn as 'extremely good and dramatic
. . ., very simplified and severe. I'd like you to have it'.
FISCHER FINE ART, LONDON

449. Family Bereavement 1913
Watercolour, 56 × 48.2 (22 × 19)
Exh: Tate 1988 (26)
Lit: Cork, p38
See Cat. 448. Although the three drawings vary
dramatically in finish, it is not clear which version was
executed first. Cat. 449–50 could be in the nature of
preliminary sketches for Cat. 448, or distillations from
it.
MR AND MRS GEOFFREY CHIN

450. Family Bereavement 1913
Charcoal and conté, 54.5 × 46.2 (21½ × 18¼)
Exh: Tate 1988 (27)
Lit: Cork, pp37–8, fig. 38
See Cat. 448–9.
MR AND MRS GEOFFREY CHIN

STANLEY SPENCER
1891–1959
One of the most individual talents in the whole of
British art, Spencer was born and brought up in
Cookham, where he spent most of his life. After a
scanty early education, he trained at the Maidenhead
Technical Institute before entering the Slade for four
years in 1908; Gertler, Bomberg and Paul Nash were
fellow pupils. In 1912 he showed at the second Post-
Impressionist Exhibition, organised by Roger Fry.
During the First World War he served as an orderly
in the Royal Army Medical Corps and as an Infantry-
man in Macedonia, gaining experiences which were
used in his murals for the Burghclere Memorial
Chapel, completed 1932. He exhibited at the NEAC
from 1912 (member 1919–27) and was elected ARA
in 1932, although the rejection of two of his paintings
three years later led to his resignation. During the
Second World War he was commissioned by the War
Artists' Advisory Committee to paint dockland sub-
jects in Glasgow. He was re-elected ARA and RA in
1950, and knighted in 1958.

Ref: *Stanley Spencer RA*, exh. RA 1980, cat.

451. The Nativity 1912 *ill. p186*
Oil on panel, 102.9 × 152.4 (40½ × 60)
Exh: RA 1980 (10)
Painted while Spencer was a student at the Slade, *The Nativity* was submitted for the summer composition prize in 1912, this being the set subject. The picture was much acclaimed at the time, and awarded the Nettleship prize for figure painting. It is generally considered to be indebted to Piero della Francesca's *Nativity* in the National Gallery.
SLADE SCHOOL OF FINE ART, UNIVERSITY COLLEGE LONDON

452. Zacharias and Elizabeth 1914 *ill. p70; detail p182*
Oil on canvas, 152.4 × 152.4 (60 × 60)
Exh: NEAC 1920 (12); RA 1980 (21)
Undoubtedly the finest of the early paintings in which Spencer combined a strong sense of place, the influence of early Italian art, and a Pre-Raphaelite intensity of feeling and respect for detail. It illustrates St Luke's Gospel, ch. 1, and shows Zacharias, while sacrificing at an altar, hearing the message of the angel that his wife, Elizabeth, will bear a child; the angel is off-stage, represented only by a shaft of light. Zacharias appears again, with Elizabeth, in the background, as does Elizabeth a second time, alone – a narrative method no doubt owing as much to the early Italians as do the Giottesque figures. The setting is a view from a back window of 'Wistaria Cottage', Cookham, looking towards Cliveden Woods, where Spencer was allowed to paint by the owner, Jack Hatch the coalman. 'I wanted to absorb and finally express the atmosphere and meaning the place had for me . . .', Spencer wrote in 1937, 'It was to be a painting characterising and exactly expressing the life I was, at the time, living and seeing about me'.
PRIVATE COLLECTION

453. Joachim among the Shepherds 1912
Pen, pencil and wash, 40.6 × 37.1 (16 × 14⅝)
Signed and dated *S Spencer 1912*
Exh: NEAC, Winter 1912 (5); *British Painting since Whistler*, National Gallery 1940 (326); RA 1980 (11)
A detailed study for an oil painting, executed shortly after the artist left the Slade. Like so many of Spencer's works, the concept is related to a particular place, in this case a 'single-file' path which he often took in Cookham, although he also recorded that it was influenced by Ruskin's book on Giotto's frescoes in the Arena Chapel in Padua, published 1853. The fact that this had also inspired the Pre-Raphaelites fifty years before lends colour to Gordon Bottomley's statement that Spencer was one of the 'only true heirs of the Pre-Raphaelites' (see Introduction).
THE TRUSTEES OF THE TATE GALLERY

WILLIAM ROBERTS
1895–1980
Born in Hackney, Roberts was apprenticed to an advertising firm as a commercial artist while attending evening classes at St Martin's School of Art. In 1910 he won a scholarship to the Slade, where he proved a brilliant student; he was later to marry the sister of another student, Jacob Kramer. Having worked briefly with Roger Fry at the Omega Workshops and exhibited at the NEAC for the first time in 1913, he joined the Vorticists and participated in the Vorticist Exhibition of 1915. He was also a member of the London Group. In 1916 he joined the Royal Field Artillery, and was an Official War Artist 1917–18. In 1920 he took part in the Group X Exhibition, and had his first one-man exhibition at the Chenil Gallery in 1923. From 1925 he taught part-time at the Central School of Arts and Crafts. He showed

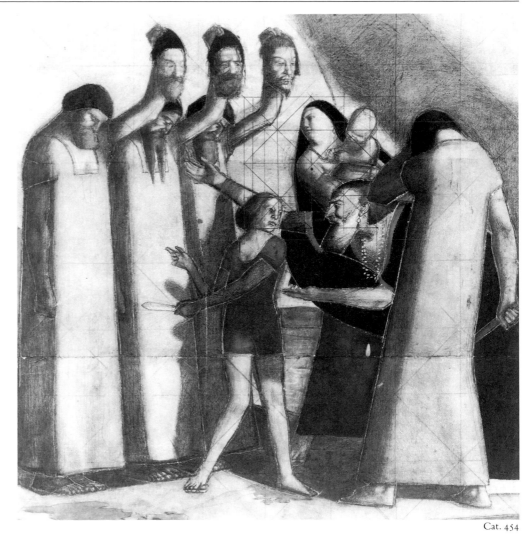

Cat. 454

continuously at the RA from 1952, being elected ARA in 1958 and an RA in 1966.

454. Unidentified Subject c1913 *ill. p189*
Pencil and watercolour, ruled diagonally for transfer, the outlines pricked and incised, 59.7 × 59.7 (23½ × 23½)
The drawing dates from the time when Roberts was at the Slade and is possibly the result of a student competition. The subject has not been identified but seems to be biblical, the figure leaning forward to the right looking rather like an Assyrian or Babylonian king. Although the drawing shows abundant evidence that it was made in preparation for a painting, no trace of this has been found. It was formerly in the collection of Sir Ralph Richardson, to whom its dramatic character no doubt appealed.
LORD AND LADY IRVINE

MARK GERTLER
1891–1939
Born in Spitalfields, the son of Polish-Jewish immigrants, Gertler attended art classes at Regent Street Polytechnic before entering the Slade in 1908. There he won a scholarship and several prizes, and met Roberts, Paul Nash, Spencer and Dora Carrington, with whom he conducted a long and unhappy affair. Later he frequented the Bloomsbury circle, often staying with Lady Ottoline Morrell at Garsington Manor. He was a member of the NEAC 1912–14 and the London Group 1915. In 1919 he visited Paris, and

1920 contracted tuberculosis, thereafter visiting the South of France regularly for health reasons. During the 1920s he was commercially successful, but radical changes in his work in the 1930s, prompted by his visits to France, lost him popularity. His exhibition at the Leicester Galleries in 1934 was a failure. In 1931 he began teaching at the Westminster Technical Institute. A sufferer from depression throughout his life, he committed suicide in 1939.

Ref: John Woodeson, *Mark Gertler* 1972

455. The Creation of Eve 1914 *ill. p187*
Oil on canvas, 90 × 60 (35.4 × 23.6)
Exh: The London Group, November 1915; *Mark Gertler*, The Minories, Colchester 1971 (11)
Lit: John Woodeson, *Mark Gertler* 1972, pp184–6, 190 repr
A painting of which Gertler was particularly proud, *The Creation of Eve* was received with outrage when exhibited with the London Group in 1915. Sir Claude Phillips wrote in the *Daily Telegraph* that it was 'a deliberate piece of eccentricity, which does not greatly amuse or interest us'. Another critic referred to its 'Hunnish indecency', and Gertler noted how 'some people in a rage stuck a label on the belly of my poor little Eve with "made in Germany" on it'. However, all this brought Gertler to the attention of Roger Fry and Clive Bell, and many art lovers leapt to his defence, Lady Ottoline Morrell declaring the picture 'quite beautiful' and Sickert praising him as a 'master painter'.
PRIVATE COLLECTION

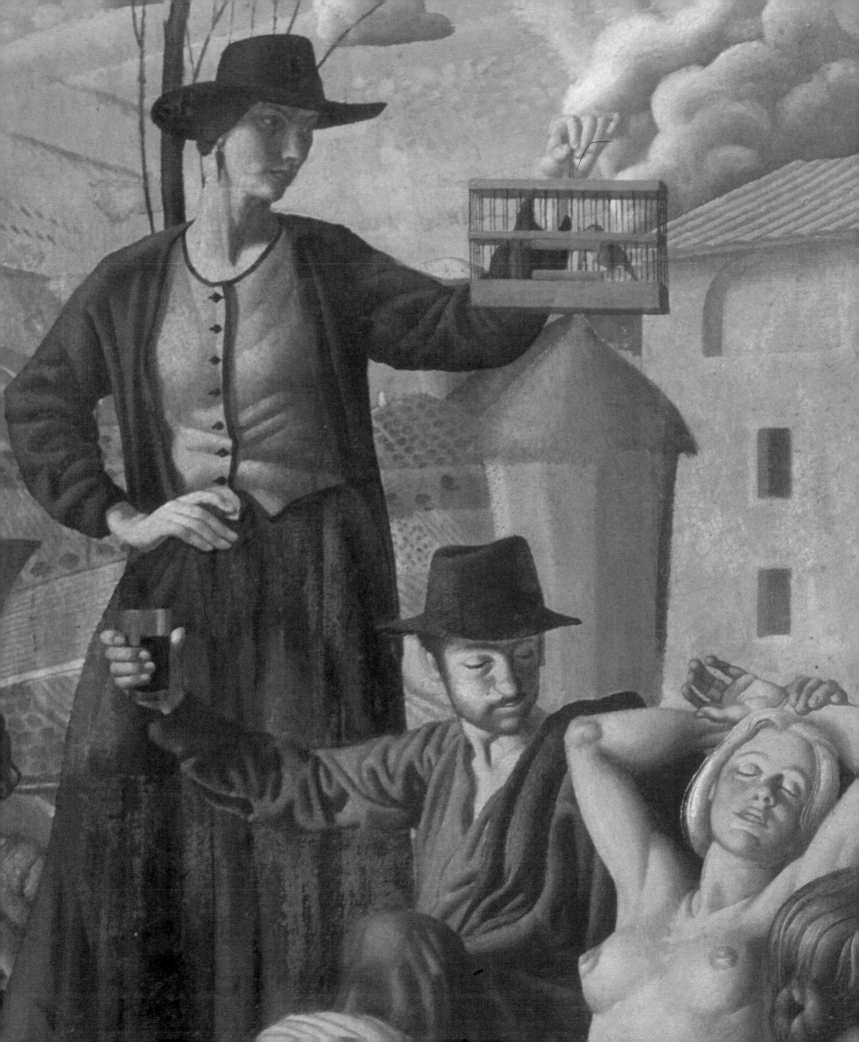

ROME SCHOLARS, MURALISTS AND OTHERS

GEORGE CLAUSEN

1852–1944

Born in London, the son of a painter of Danish descent, Clausen studied at the RCA 1873–5. He then worked for several years as assistant to Edwin Long, visited Belgium and Holland, and in 1883 studied briefly in Paris at the Académie Julian under Bouguereau. His early work is profoundly influenced by Bastien-Lepage, with that of Millet later becoming dominant. He exhibited at the RA 1876–1943 and in 1886 was a founder-member of the NEAC, although he ceased to exhibit there when elected ARA in 1895. Also exhibited at the Grosvenor Gallery, RI (member 1886) and RWS (member 1898), and held one-man exhibitions. On his marriage in 1881 he moved to Berkshire and later to Essex, choosing themes from these surroundings for his paintings. He was a popular Professor of Painting at the RA Schools 1904–6, and was elected RA in 1908. Following the First World War he painted a major canvas for the Ministry of Information, *In the Gun Factory at Woolwich Arsenal 1918*. He was knighted in 1927 after the successful completion of his mural in St Stephen's Hall at the age of seventy-five (Cat. 457–9). This, and the fact that he was one of the original members of the Faculty of Painting for the British School in Rome (1912), qualifies him to head this section.

Ref: *Sir George Clausen RA*, exh. Bradford, RA, Bristol and Newcastle 1980, cat. by Kenneth McConkey

456. Composition Sketch for 'Spring' 1918–19

Watercolour over charcoal, squared for transfer, 27.2 × 37.7 ($10\frac{3}{4}$ × $14\frac{7}{8}$)
Exh: Bradford, RA, etc 1980 (131)
Clausen was moved to paint on a monumental scale before the First World War, and found certain opportunities to do so in war commissions. This drawing is for one of four symbolical representations of the Seasons which he was asked to paint for the hall at High Royd, Honley, near Huddersfield, in June 1918 and completed the following year.
ROYAL ACADEMY OF ARTS, LONDON

457. Composition Sketch for 'The English People' 1925–7

Watercolour with bodycolour, 32.7 × 47.5 ($12\frac{7}{8}$ × $18\frac{3}{4}$)
Exh: Bradford, RA, etc 1980 (134)
A preliminary sketch for Clausen's contribution to the murals in St Stephen's Hall in the Palace of Westminster. Some fifteen years later than the decoration of the East Corridor (see Cat. 82), the scheme consisted of eight murals, each 10 × $14\frac{1}{2}$ ft, representing *The Building of Britain*. Clausen was by far the oldest of the artists involved – the others being William Rothenstein, Charles Sims, Glyn Philpot, Vivian Forbes, Thomas Monnington, A K Lawrence and Colin Gill – some of whom had only recently been students at the British School in Rome. The commission was given in August 1925, and the eight scenes, painted on canvas attached to the walls, were installed by June 1927.

Opposite page: Detail Cat. 462

Clausen's painting, entitled in full *The English People, in spite of persecution for heresy, persist in gathering secretly to read aloud Wycliffe's English Bible*, was generally considered the best; and he received a knighthood the day the series was unveiled.
The sketch differs considerably from the final painting, where the disposition of the figures is changed and the sky-line is lower.
ROYAL ACADEMY OF ARTS, LONDON

458. Figure study for 'The English People' 1925–7

Pencil, squared for transfer, 47.5 × 32 ($18\frac{3}{4}$ × $12\frac{5}{8}$)
Inscribed *long* (lower left) and *head too big* (upper right)
Exh: Bradford, RA, etc 1980 (135)
A study, evidently from life, for the man standing to the left in the St Stephens' Hall mural, squared for transfer to the full-scale cartoon. The written memoranda were heeded; in the painting the man's head is much smaller in relation to his body.
ROYAL ACADEMY OF ARTS, LONDON

459. Figure study for 'The English People' 1925–7

Pencil, 46 × 29 ($18\frac{1}{8}$ × $11\frac{3}{8}$)
Exh: Bradford, RA, etc 1980 (136)
For the female figure in the centre of the mural. She appears in a different pose in the preliminary composition sketch, Cat. 457.
ROYAL ACADEMY OF ARTS, LONDON

MARY SARGANT FLORENCE (née Sargant)

1857–1954

The daughter of a barrister, Mary Sargant was born in London and studied in Paris under Luc-Olivier Merson and at the Slade under Legros. Her brother was the sculptor F W Sargant. In 1888 she married Henry Smyth Florence, a musician. Although she worked in watercolour and tempera, her speciality was true fresco; she undertook murals in this exacting technique at the Old School, Oakham, Rutland c1909–14, at Bourneville School near Birmingham 1912–14, and at her own house, 'Lord's Wood', near Marlow, Bucks. A member of the NEAC and the Society of Mural Decorators, she exhibited occasionally at the RA and had several works in the exhibition of Decorative Art at Burlington House in 1923. Her book *Colour Co-Ordination* was published 1940. Died aged ninety-seven.

Ref: *The Times* 16 December 1954, p10

460. Suffer Little Children to Come unto Me 1913

Charcoal and watercolour with bodycolour, 122.6 × 228.6 ($48\frac{1}{4}$ × 90)
Exh: NEAC 1914 (188); RA 1933 (733)
One of two cartoons in the Tate for the artist's frescoes at Bourneville Junior School, Birmingham (see Alan Powers' article above). It is interesting to compare the design with Cat. 425 – the same subject, by another woman artist, treated on a similar scale and intended for children.
THE TRUSTEES OF THE TATE GALLERY

LEON UNDERWOOD

born 1890

Sculptor, painter, wood-engraver, etcher and writer, Underwood was born in London and studied at the Regent Street Polytechnic 1907–10, the RCA 1910–13 and, after war service, at the Slade 1919–20. Founder-member of the Seven and Five Society 1919. Won a premium in the Rome Prize competition 1920 (the first prize going to Winifred Knights), but refused to go to Rome. Started his own school in Hammersmith 1921 and had the first of many one-man exhibitions at the Chenil Galleries 1922. Between 1911 and 1931 he travelled extensively, including Russia 1913, Italy 1925, Mexico 1928, studying Mayan and Aztec sculpture, and Spain, where he studied cave paintings. In 1931 he re-opened his art school and founded the magazine *The Island*, to which Moore and Nevison contributed. Served in Civil Defence Camouflage 1939–42. In 1945 he visited West Africa and subsequently wrote several books on African art.

Ref: Christopher Neve, *Leon Underwood* 1974

461. Peasantry 1922

Oil on canvas, 122 × 244 (48 × 86)
Exh: Pittsburgh International (New York, St Louis, Philadelphia) 1924
Lit: Neve, pp69–71, 73 repr
Painted at Ashurst, Kent, in the summer of 1922, the picture is compared by Neve to 'John's large Romany pictures – there is very much the sense of picturesque figures on a landscape stage for no apparent reason'. He also associates it with 'the Georgian poets' celebration of the Weald, and in particular . . . Edmund Blunden's poetry'. The figure on the far left, holding a fishing-rod, is a self-portrait.
BOURNE FINE ART

COLIN GILL

1892–1940

Colin Gill, who was born at Bexley Heath and was Eric Gill's cousin, studied at the Slade and was the first winner of the Rome Scholarship in 1913. He returned to England for military service in 1915, completing his studies after the war. He exhibited at the RA from 1924 and at the NEAC from 1914 (member 1926). From 1922 to 1925 he was instructor in composition at the RCA. He painted one of the murals in St Stephen's Hall, Westminster, 1925–7 (see Cat. 457), and decorations in the Bank of England, Essex County Hall, Chelmsford, Northampton Town Hall, etc. In 1939 he went to South Africa to carry out a commission in the Magistrates' Court, Johannesburg, but died there in 1940 before the work was finished.

462. Allegory 1920–21 *ill. p194; detail p190*

Oil on canvas, 117 × 228 (46 × 90)
Signed and dated 1921
Exh: Grosvenor Gallery, Summer 1922 (111); *International Exh Summer of Modern Decorative and Industrial Art*, Paris 1925

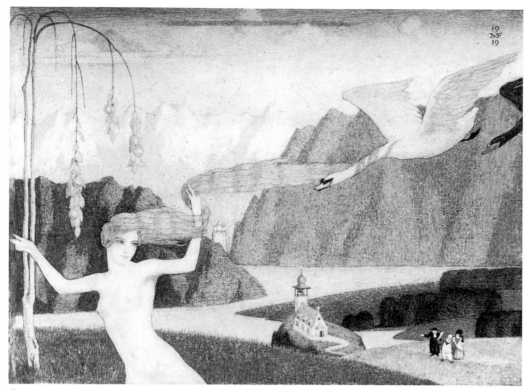

Cat. 463

Lit: *Studio* 84 1922, p282, repr; *British Artists in Italy 1920–1980*, exh. Canterbury College of Art 1985, cat. p17; Powers 1986, p512

Allegory (also called *L'Allegro*) was painted after the First World War, when Gill resumed his studies at the British School in Rome, and was well received and widely exhibited at the time. As Alan Powers observed in the catalogue of the 1985 exhibition at Canterbury, 'the influence of two Slade School heroes, Augustus John and Stanley Spencer, now seems obvious, but with its sharp colours and contours, it is a work of great individuality which justified the aims and methods of the Scholarship'. Winifred Knights (Cat. 466) was the model for the girl with the bird-cage.
THE BRITISH SCHOOL AT ROME

MEREDITH FRAMPTON
1894–1984

Born in London, the only son of the sculptor Sir George Frampton RA (Cat. 193–6), he studied at St John's Wood before entering the RA Schools in 1912. In 1915 he was elected a member of the Art Workers' Guild, being proposed by his father and George Clausen. During the First World War he joined the Artists' Rifles, and after the war worked in a studio in St John's Wood until he moved to Wiltshire in the 1940s. He exhibited at the RA from 1920 (ARA 1934, RA 1942). His work consists mainly of portraits, although he also specialised in still life, his style being marked by its vivid focus and slightly Surrealist flavour. Although he enjoyed considerable success in the inter-war years, failing eyesight caused him to stop painting in 1945, and his work was neglected until the Tate Gallery exhibition in 1982.

Ref: *Meredith Frampton*, exh. Tate Gallery 1982, cat. by Richard Morphet

463. **Nude with Flying Swans**
1919 ill. p192
Tempera on panel, 18 × 24.1 (7 × 9½)

Dated 1919
Apparently a rare venture for the artist into imaginative subject-matter. Normally he achieves a sense of unreality by a kind of hyper-realism.
THE TRUSTEES OF THE TATE GALLERY

ROBERT SARGENT AUSTIN
1895–1973

Born in Leicester, Austin studied at Leicester School of Art and at the RCA under Frank Short. He served in the Artillery 1916–19, then returned to the RCA 1919–22. He won the Rome Scholarship for engraving in 1922. Though mainly known as an engraver, he was also a fine watercolourist, his work reflecting his interest in Dürer and the other Old Masters. Elected ARA 1921, RE 1928, ARWS 1930, RWS 1934, ARA 1939 and RA 1949. Tutor of Engraving at the RCA 1927–44 and Professor in the Department of Graphic Design 1948–55. He was a friend of Harry Morley (Cat. 171–7) and their engravings have much in common, although Austin's show none of the warmth and humour that characterise Morley's.

464. **The Flight into Egypt** 1925 (CD 61 III and IV)
Engraving, two impressions, each 16.5 × 26 (6½ × 10¼)
The upper impression signed *RSA* in plate, the lower signed and dated *Robert Austin 1925* (below)
The third and fourth states of this engraving, the third showing the shape of the donkey cut out and drawn in on another piece of paper below. It is interesting to compare the image with Cat. 472, executed two years earlier.
THE TRUSTEES OF THE BRITISH MUSEUM

GEOFFREY RHOADES
born 1898

Painter, book illustrator and stage designer, Rhoades was born in London and studied at Clapham Art School under L C Nightingale in 1916 and at the Slade under Tonks 1919–23. He taught art part-time at the Working Men's College, London, 1928–36 and at Bishop's Stortford College 1930–45, while in the 1950s he was assistant at the Ruskin School, Oxford. Had a one-man exhibition at Wye College, Ashford,

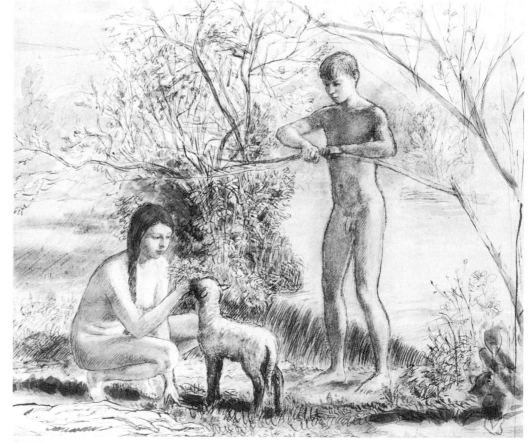

Cat. 465

Kent in 1956. Many of his stage designs are in the V&A.

465. Daphnis and Chloe *ill. p192*
Pen and grey wash, 34.1 × 406 (13½ × 16)
Exh: Carlisle 1971 (94)
This and Cat. 472 are examples of the drawings with imaginative figure subjects bought for Carlisle by Sir William Rothenstein in the 1930s (see Alan Powers' essay above)
CARLISLE MUSEUM AND ART GALLERY

WINIFRED MARGARET KNIGHTS
1899–1947
Born in London, she studied at the Slade 1915–19 under Tonks and Brown, winning the Slade Scholarship and in 1919 the Rome Scholarship in painting. In Rome 1920–24 and in 1924 married Thomas Monnington, whom she met a the Rome School. After returning to England she worked for D Y Cameron at the Courtauld Institute. Although she never exhibited at the NEAC, she was elected a member in 1929, resigning two years later. Exhibited at the Imperial Gallery 1927–31 and carried out commissions for the Slade School of Art, Canterbury Cathedral, and Wellington Cathedral, New Zealand.

466. The Deluge 1919–20 *ill. p195*
Oil on canvas, 152.4 × 183 (60 × 72)
Exh: *British Artists in Italy*, Canterbury College of Art 1985 (3)
The artist's winning entry for the Rome Scholarship, painted at the age of twenty. As Alan Powers notes, it 'balances academic values with a completely modern treatment, including the most streamlined sort of Ark'.
 The cartoon for the picture was sold at Christie's, 14 October 1987, lot 129.
JONATHAN CLARK LTD

EDWARD IRVINE HALLIDAY
1902–1966
Born and educated in Liverpool, Halliday began his art training at the local School of Art; he then studied for a year at the Académie Colarossi in Paris before entering the RCA in 1923. In 1925 he won the Rome Scholarship and in the next three years studied in Italy and travelled in Greece, the Balkans and North Africa. After returning to England, he worked on decorative schemes in London, Liverpool and elsewhere, including a set of three panels in the Library of the Athenaeum, Liverpool, representing episodes from the mythology of Athena (completed 1930). He exhibited at the RA (from 1929), the Paris Salon, the Liverpool Autumn exhibitions, etc, and was later best known for his portraits, his sitters including Princess Elizabeth and the Duke of Edinburgh (1949), Pandit Nehru (1954) and Sir Malcolm Sargent (1966).

467. The Conversion of Lydia of Thyatira 1927
Oil on canvas, 106.7 × 150 (42 × 59)
Inscribed in Greek *Halliday made this 'Agalma'* (work of art) *and dedicated it to Benjamin Johson* (lower centre)
Lit: Powers 1986, p514
The painting shows St Paul, accompanied by Silas, converting Lydia, 'a seller of purple, of the city of Thyatira', at Phillipi (Acts. 16. 13–15). It was commissioned by Sir Benjamin Johnson, head of the Merseyside firm of Johnson Brothers and a leading figure in local public life, its subject being chosen because Lydia, as a seller of dyes, was regarded as the patron of dyers, and dyeing was then Johnson's main business. It dates from the same period (1927–30) as the 'Athena' panels painted by Halliday for the Library of the Athenaeum, Liverpool, and is in the same cool, classical style. No doubt the setting owes much to his travels in Greece when he was a Rome Scholar.
JOHNSON BROTHERS (CLEANERS) LIMITED

WALTER THOMAS MONNINGTON
1902–1976
Monnington was born in London, the son of a barrister, and studied under Tonks at the Slade (1918–23) where he won the Rome Scholarship in 1923. In 1924 he married the painter Winifred Knights, also a Rome Scholar. On returning to England he maintained his association with the Slade, becoming a member of the Faculty of Painting, of which he was chairman 1949–67. He also taught at the RCA, the Academy Schools and Camberwell School of Art. In 1925–7 he executed a mural in St Stephen's Hall, Westminster (see Cat. 457), and another at the Bank of England in 1931. He first exhibited at the RA in 1931, was elected ARA the same year and RA in 1938 at the age of thirty-six. During the Second World War he was an Official War Artist on active service with the RAF. His most important post-war public work was a vast mural in the new Council House, Bristol (1956). Elected PRA 1966 and knighted the following year.

Ref: *Sir Thomas Monnington PRA*, memorial exh., RA 1977, cat. by Judy Egerton

468. Allegory 1924–6 *ill. p66*
Tempera on canvas, 125.7 × 276.8 (49½ × 109)
Exh: *Autumn Exh.*, Brighton 1927 (16); *Re-opening Exh.*, Liverpool 1933 (192); *Contemporary Art Society Exh.*, Bath 1938 (26); RA 1977 (12)
This was Monnington's major work as a Rome Scholar and is generally considered his masterpiece. He began studies for it in May 1924, the landscapes being based on scenery at Piediluco, where he and Winifred Knights, who were married that year, spent an idyllic summer. Monnington described the painting as having its origin in the story of the Garden of Eden, but suggested also that it reflected his love for Winifred, who appears variously in the picture, as does Monnington himself. The cartoon, completed by the end of 1924, was admired by Ricketts and Shannon when they visited Rome that autumn, and the painting was begun in March 1925 and completed in London the following year. The medium is pure egg tempera. Before it was finished H S Ede had bought it for the Contemporary Art Society, which presented it to the Tate in 1939.
THE TRUSTEES OF THE TATE GALLERY

WILLIAM EVAN CHARLES MORGAN
1903–after 1935
An engraver who deserves to be better known and more fully researched, Morgan studied at the Slade and won the Rome Scholarship in Engraving (instituted 1921) in 1924. He exhibited at the RA 1928–35, showing line engravings, an etching and a watercolour; drypoints and woodcuts are also recorded. Central to his œuvre are the line engravings, of which about twelve are known. They include Italian landscapes, animal and bird studies, and a self-portrait (1930), but the most significant are a group of imaginative figure subjects featuring solidly constructed nudes. In both these figure compositions and his Italian landscapes, Morgan is often reminiscent of Harry Morley, and there was probably a connection even though Morley was not appointed to the Faculty of Engraving at the British School until 1931, by which time Morgan would have left. They might have met at Anticoli Corrado, a small hill-town in the Abruzzi very popular with Rome Scholars; it was the subject of a landscape by Morgan in 1927, while Morley and Robert Austin spent the summers there 1928–9. They were also both associated with the Beaux Arts Gallery in London; Morgan used it as a postal address and Morley held exhibitions there in 1927 and 1934. The date of Morgan's death, if indeed he is not still living, does not seem to have been established. His last address as an RA exhibitor was in Argyll.

469. The Source 1927
Line engraving, 30 × 16.2 (11⅞ × 6⅜)
Signed in the plate (lower left) and signed and dated *William E C Morgan 1927* (below, lower right)
One of Morgan's earliest plates, executed at the age of twenty-four during his last year as a Rome Scholar, and exhibited on his first appearance at the RA in 1928. In view of his training at the Slade and the British School, it is hardly surprising that he has chosen a subject closely associated with Ingres.
 Morgan's monumental figure style is typical of the Rome Scholars, who looked particularly to Piero della Francesca for inspiration. However, in Morgan's case the crucial influence was probably Signorelli. It is significant that in 1926 he executed two engravings of Orvieto, where Signorelli painted his masterpiece, the frescoes in the Cathedral.
THE TRUSTEES OF THE BRITISH MUSEUM

470. Nymphs Bathing 1928
Line engraving, 20 × 28 (7⅞ × 11)
Inscribed *Nymphs Bathing 70/83* (lower left) and signed and dated *William E C Morgan 1928* (lower right)
Exhibited at the RA in 1930, the print shows Morgan's style at its hardest and most metallic. An edition of 83 impressions was published at 6gns each.
THE TRUSTEES OF THE BRITISH MUSEUM

471. Perseus 1929
Line engraving, 22 × 20.7 (8⅝ × 8⅛)
Inscribed *Perseus 61/70* (lower left) and signed and dated *William E C Morgan 1929* (lower right)
Described by Guichard as the artist's 'masterpiece', the engraving was exhibited at the RA in 1929 and reproduced in *Fine Prints* that year, pl.29. An edition of 70 impressions was issued at 5gns each.
 The rabbits and salamanders in the foreground, while clearly owing something to Dürer, reflect the feeling for animal life that emerges so strongly in other prints by Morgan, for example the *Young Love Birds* of 1929 (repr Guichard, pl.48). It is amusing to note how one of the serpentine locks on Medusa's decapitated head has been utilised in the cause of modesty.
THE TRUSTEES OF THE BRITISH MUSEUM

LIONEL ELLIS
born 1903
Born at Plymouth, the son of a dockyard mechanic, Ellis studied at Plymouth School of Art 1918–22 and at the RCA under William Rothenstein 1922–4. In 1926 he visited Paris, Florence and Rome on a scholarship. As well as being a painter, sculptor and wood-engraver, he illustrated three books (Herrick, Theocritus, Catullus) for the Fanfrolico Press in the late 1920s. Taught at Wimbledon School of Art 1937–68 and exhibited at RA, NEAC, etc. FRSA 1951. Lived as a recluse on retirement.

472. The Flight into Egypt 1923
Pen and wash, 21.2 × 24.9 (8⅜ × 9⅞)
Inscribed *The Flight. Lionel Ellis 23/7/23*
Exh: Carlisle 1971 (75)
See Cat. 465.
CARLISLE MUSEUM AND ART GALLERY

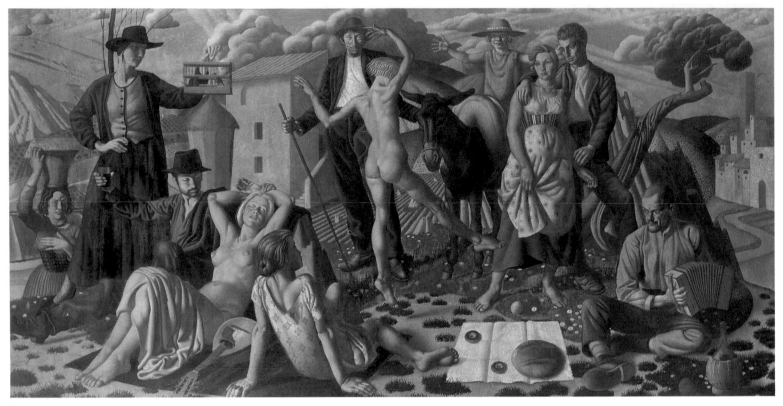

Cat. 462

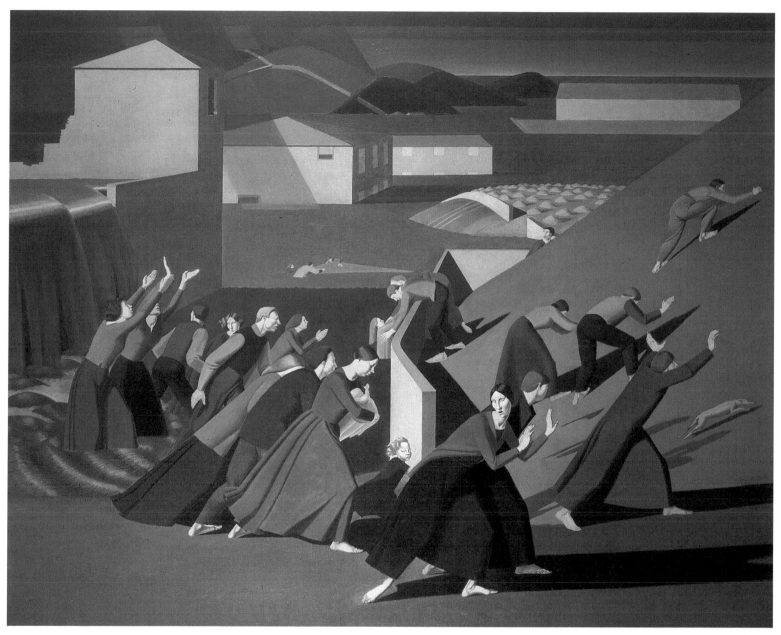

Cat. 466

Cat. 475

Cat. 477

CHARLES MAHONEY

1903–1968

Born in Lambeth, the son of an engineer, his real Christian name being Cyril. He won scholarships first to Beckenham School of Art, where he studied under Percy Jowett, then to the RCA (1922–6), where he encountered William Rothenstein, who did much to direct his career. Soon after leaving the RCA, he returned there to teach (1928–53), and about the same time embarked on a series of mural projects. A painting above the stage at Morley College (*The Pleasures of Life*; destroyed in the war) was followed in the mid 1930s by the murals at the Brockley School, Lewisham (Cat. 475–8), and finally by those in the Chapel at Campion Hall, Oxford, commissioned 1941 and never quite completed (Cat. 479–81). While his murals are his greatest achievement, he also painted easel pictures and was a prolific and accomplished draughtsman, many of his paintings and drawings reflecting his passion for gardening at his home at Wrotham in Kent. He taught at the Byam Shaw School 1954–63 and at the RA Schools 1961–8. Member NEAC 1950, ARA 1961, RA 1968. In later years his health declined; he ceased painting in 1965 but continued to draw till his death.

Ref: John Rothenstein, *Charles Mahoney*, a 'tribute' coinciding with the memorial exh., Parkin Gallery, London and Ashmolean Museum, Oxford 1975

Cat. 474

473. The Expulsion from the Garden of Eden
1936
Oil on canvas, 91.4 × 76.2 (36 × 30)
Probably the most complete expression of an idea that haunted Mahoney for years; see Cat. 482. The picture was given to the Tate by the Contemporary Art Society in 1942.
THE TRUSTEES OF THE TATE GALLERY

474. Autumn 1947–53 ill. p196
Oil on board, 215.5 × 124 (84¾ × 48¾)
Exh: Memorial exh., Ashmolean Museum, Oxford 1975; *Exhibition Road*, RCA 1988 (65, as *Figures in a Garden*)
ELIZABETH BULKELEY (THE ARTIST'S DAUGHTER)

475. Fortune and the Boy c1933 ill. p196
Pencil, pen and grey wash, squared for transfer, 53.3 × 33 (21 × 13)
Cat. 475–8 are studies for Mahoney's murals at Brockley School, painted by Mahoney and Evelyn Dunbar in the 1930s with subjects from Aesop's Fables; see Alan Powers' essay above and *Country Life* 30 April 1987, pp120–1.
ELIZABETH BULKELEY (THE ARTIST'S DAUGHTER)

476. Joy and Sorrow 1934
Oil on paper, 57.2 × 39.4 (22½ × 15½)
See Cat. 475.
ELIZABETH BULKELEY (THE ARTIST'S DAUGHTER)

477. Joy and Sorrow c1933 ill. p196
Pencil, pen and grey wash, 53.3 × 33 (21 × 13)
See Cat. 475.
ELIZABETH BULKELEY (THE ARTIST'S DAUGHTER)

478. The Rose and the Butterfly 1933
Oil on paper, 25 × 25 (9⅞ × 9⅞)
Signed and dated *Cyril Mahoney 1933*
P J WESTON, CMG

479. The Coronation of the Virgin (Spring)
c1942
Oil on paper, arched top, 45 × 29.8 (17¾ × 11¾)
This and Cat. 480–1 are studies for Mahoney's last series of murals, painted in the Lady Chapel at Campion Hall, Oxford 1941–52. Sir John Rothenstein in his 1975 'tribute' to the artist describes the circumstances of the

commission and some of the problems involved, which led Mahoney to abandon the project before it was quite complete.
ELIZABETH BULKELEY (THE ARTIST'S DAUGHTER)

480. The Adoration of the Shepherds (Winter)
c1942
Oil on paper, arched top, 45 × 29.8 (17¾ × 11¾)
Like Cat. 479, a study for one of the large (6 × 9ft) panels in the Lady Chapel at Campion Hall, Oxford. The finished mural, which differs in several respects from the study, is reproduced in Sir John Rothenstein's *British Art Since 1900* 1962, pl.60.
ELIZABETH BULKELEY (THE ARTIST'S DAUGHTER)

481. The Marriage of the Virgin c1942
Oil on paper, 29.2 × 29.2 (11½ × 11½)
A study for one of the smaller (approx. 3 × 3ft) murals at Campion Hall, Oxford (see Cat. 479). In detail and composition the paintings owe much to early Italian example. The most notable case is *Our Lady of Mercy (Autumn)*, which is clearly inspired by Piero della Francesca's altarpiece at Borgo San Sepolcro, but the man breaking a stick in the foreground of *The Marriage of the Virgin* recalls Raphael's painting of the same subject in the Brera, Milan, where this motif is prominent.
ELIZABETH BULKELEY (THE ARTIST'S DAUGHTER)

482. Study for 'The Expulsion from Eden'
Pen and wash, 48.3 × 32.4 (19 × 12¾)
Signed *CM*
Exh: Memorial Exh., Parkin Gallery, London, and Ashmolean Museum, Oxford 1975
One of many drawings in which Mahoney reinterpreted this subject, a good deal later than Cat. 473.
SIR BRINSLEY FORD, CBE, FSA

IAN GRANT
born 1904
Mainly known as a portrait and landscape painter, Grant studied at Glasgow School of Art 1922–26, in Paris 1927 and at the RCA 1927–30. He exhibited at the RA, RBA, RSA, NEAC and in the provinces, and is represented in several public collections. Also worked as an art historian. Lived in Stockport, Cheshire for some years.

483. Figures by a Lake 1929 ill. p197
Oil on canvas, 119.4 × 211 (47 × 83)
The picture won second prize in the Rome Scholarship competition 1929. Very Puvis-like in feeling, it was one of a number of 'Rome School' items sold at Christie's, 14 October 1987.
ANTHONY MOULD LTD

GEORGE WARNER ALLEN
1916–1988
Born in Paris, son of the writer and wine expert Herbert Warner Allen. Educated Lancing College (1930–3) and Byam Shaw School of Art (1933–9), where he studied under F Ernest Jackson (Cat. 344); after the war he taught at the Byam Shaw himself. He was deeply influenced by his older fellow student, Brian Thomas, and by Charles Ricketts's writings on art. His work consists mainly of mythological and religious subjects, often large in scale and latterly in brilliant colours, painted in a mixed oil and tempera technique such as he believed was used by the great Venetian painters. Worked in the Directorate of Camouflage at Leamington Spa 1940–5. Large successful one-man shows at Walker's Galleries, New Bond Street 1952 and Reading Art Gallery 1953. Among his early patrons were T S Eliot, Sir John Betjeman and Earl Baldwin. After an eight-year period when circumstances made it difficult to paint, he began work again in 1962, leading an isolated existence and selling virtually no work for twenty-five years. He only re-emerged in the 1980s when a group of young enthusiasts discovered his work and brought it to wider attention. In 1973 he was received into the Roman Catholic Church. Died at Oxford 31 July 1988

Ref: Sydney R Jones, 'George Warner Allen', *Studio* 143 1952, p76–9; *Daily Telegraph* 4 August 1988; *The Times* 5 August 1988; *Independent* 12 August 1988

484. Picnic at Wittenham 1948
Oil and tempera on panel, 122 × 122 (48 × 48)
Signed with monogram (lower right)
Exh: Walker's Galleries, London 1952 (31); Reading Art Gallery 1953 (4)
Lit: Jones, p78, repr
The landscape of Long Wittenham, near the artist's home, the pastoral poetry of Matthew Arnold and George Meredith, and the early bacchanals of Titian and Poussin – all seem to find a point of contact in this idyllic scene, in which modern life and classical myth are subtly blended. Painted only three years after the end of the Second World War, the picture contains an unmistakable hint of menace, and in fact forms a pendant to the more overtly disturbing *Et in Arcadia Ego* which was included in the exhibition *A Paradise Lost*, held at the Barbican in 1987 (356). Technically it exemplifies the artist's method of building up forms and colours by glazing over a tempera underpainting.
PRIVATE COLLECTION

485. Christ with Martha and Mary 1949 ill. p26
Oil and tempera on panel, 79 × 70 (31 × 27½)
Signed with monogram and dated 1949 (lower left)
Exh: Walker's Galleries, London 1952 (28); Reading Art Gallery 1953 (8)
Lit: Jones, p76, repr
One of the artist's finest early works, imbued with the deep religious feeling that was to lead him into the Roman Catholic Church many years later. There seem to be echoes of Titian and Dürer in the half-length figure of Christ engaged in animated conversation with the two women.
PRIVATE COLLECTION

Cat. 483

IN FAIRYLAND

EMMA FLORENCE HARRISON
active 1877–1925

Working in London and an RA exhibitor 1887–91, Florence Harrison (as she is always known) is chiefly remembered for the type of book shown here, illustrated in an attractive late Pre-Raphaelite style especially indebted to Rossetti. She also illustrated books of verse by herself. According to Peppin and Micklethwait, her later work, published by Dent, is more conventional.

486. Christina Rossetti, *Poems*
Illustrated by Florence Harrison
London and Glasgow: Blackie & Son Ltd 1910. 4to
ROSEMARY FARQUHARSON

487. William Morris, *Early Poems*
Illustrated by Florence Harrison
London and Glasgow: Blackie & Son Ltd 1914. 4to
A sequel to Cat. 486 and to an edition of Tennyson's *Guinevere and Other Poems* (1912), all issued by Blackie's in the same format.
THE BRITISH LIBRARY BOARD

JOHN DIXON BATTEN
1860–1932

Born at Plymouth, the son of a QC, Batten went to Trinity College, Cambridge, and entered the Inner Temple in 1884. However, he soon abandoned law for art, studying at the Slade under Legros and exhibiting at the RA (1891–1922), the Grosvenor and New Galleries and with the Arts and Crafts Exhibition Society, etc. He is chiefly remembered for his illustrations to the books of fairy tales edited by Joseph Jacobs and published by David Nutt in the 1890s; for his colour-woodcuts in the Japanese style; and as one of the leading exponents of the tempera and fresco revival. He was a founder-member of the Society of Painters in Tempera (1901), its Secretary for twenty years, and Hon. Secretary of the Art Workers' Guild 1903–8. Lived in London, latterly at Kew.

Ref: *The Times* 12 August 1932, p12

488. Beauty and the Beast 1904
Tempera on canvas, 66 × 77.5 (26 × 30½)
Inscribed *painted in tempera by John D Batten March 1904* (on back of frame)
Exh: *Painters in Tempera*, Kettering 1958 (24)
Lit: John D Batten, 'The Practice of Tempera Painting', *Studio* 84 1922, p299, repr
One of Batten's most elaborate and beautiful early paintings in tempera, though where it was first exhibited has not been established. The *Athenaeum*, reviewing the first exhibition of the Society of Painters in Tempera, held at the Carfax Gallery in 1905, described Batten as 'the most accomplished of all the artists', but complained of his 'rhetorical and sophisticated mood', even comparing particular images to Carlo Dolci and 'a heroine of the old Lyceum'. This seems extraordinary in relation to *Atalanta's Race* (Cat.

Opposite page: Detail Cat. 441

489), but there is perhaps something rather 'rhetorical' about *Beauty and the Beast*.

The picture was retouched by Joseph Southall, the Birmingham exponent of tempera, on its acquisition in 1936.
BIRMINGHAM CITY MUSEUM AND ART GALLERY

489. Atalanta's Race c1905
Tempera and gold leaf on gesso, partly raised, on wood, 25.5 × 61.5 (24¼ × 10)
Signed *JDB* (lower left)
Exh: Tempera Exh., Carfax Gallery 1905 (12); *Viva Victoria*, Roy Miles 1980 (22); *Romantic and Symbolist Paintings and Drawings*, Charles Cholmondeley 1987 (7)
Lit: Aymer Vallance, 'The Tempera Exhibition at the Carfax Gallery', *Studio* 35 1905, p295, repr; J D Batten, 'The Practice of Tempera Painting', *Studio* 84 1922 p301, repr
Atalanta, daughter of King Schoeneus of Scyros, insisted that she would only marry a man who beat her in a race, those who failed being condemned to die. Many of her suitors perished, but Milanion, by dropping golden apples which she was unable to resist picking up, succeeded in outrunning her. The subject was treated by William Morris in his *Earthly Paradise*, and by Edward Poynter in a picture executed for Lord Wharncliffe in the 1870s.

In August 1922 Batten painted a fresco fragment with a detail of the two principal figures for the exhibition of Mural Decorative Art held at the Royal Academy the following January. Now in the V&A (P.17–1923), this is illustrated in his article on fresco painting in the *Architects' Journal* 25 April 1923, p719.
PRIVATE COLLECTION

490. John and the Swan-Maiden c1895
Pen and ink, 30.5 × 21.5 (12 × 8½)
Inscribed *East o' the Sun & West o' the Moon* (below)
Lit: Houfe, p228, repr
An illustration to 'The Land East of the Sun and West of the Moon' in William Morris's *Earthly Paradise*. Research has yet to establish if it was published, but it is very similar to the drawings Batten made for Joseph Jacobs' compilations of legends and fairy tales published by David Nutt in the 1890s (see Cat. 495–6).

Like Cat. 91, the drawing belonged to George Howard, Earl of Carlisle. Howard patronised both Batten and H J Ford, whose careers and styles are in many ways very similar.
SIMON HOUFE

491. Hasan Rejoins his Wife c1896
Pen and black ink, corrected with white bodycolour, 20 × 15.8 (7⅞ × 6¼)
The original drawing for an illustration to the story 'Hasan of Bassorah' in *The Book of Wonder Voyages*, edited by Joseph Jacobs for David Nutt 1896.
THE BOARD OF TRUSTEES OF THE VICTORIA AND ALBERT MUSEUM, LONDON

492. Eve and the Serpent 1895
Colour-woodcut, 13.7 × 28.3 (5⅜ × 11⅛)
This and Cat. 493–4 are examples of the colour-woodcuts that Batten and Frank Morley Fletcher

produced in the 1890s, using multiple blocks in the Japanese manner to achieve richness and subtlety. *Eve and the Serpent*, which was printed from six separate blocks, is the most complex. A number of preliminary drawings, 'colour separations' and trial proofs are in the V&A and British Museum.

A M Hind refers to this experiment in reviving the Japanese method in his *Introduction to the History of Woodcut* (1935).
THE TRUSTEES OF THE BRITISH MUSEUM

493. The Harpies 1896
Colour-woodcut, 30.4 × 15 (12 × 5⅞)
Signed *John D Batten* (lower left) and *Morley Fletcher* (lower right); inscribed *No 6* (lower left)
The design exists in two versions, impressions of each being in the V&A and British Museum. The prettier, 'pink' version, shown here, was designed by Batten and cut on wood by Morley Fletcher in 1896. The other, in which rust tones predominate, was printed in 1920, Batten cutting a new block for the king's robe.
THE TRUSTEES OF THE BRITISH MUSEUM

494. Apples and Admirals c1900
Colour-woodcut, 20.7 × 24.7 (8⅛ × 9¾)
Signed *John D Batten* (lower left) and inscribed *No 4* (lower right)
Not all Batten's colour-woodcuts have literary themes; there is also one of a tiger, and his wife Mary Emmeline Batten produced some attractive flower designs in this technique (impressions in British Museum).
THE TRUSTEES OF THE BRITISH MUSEUM

495. Joseph Jacobs (ed), *Celtic Fairy Tales*
Illustrated by J D Batten
London: David Nutt 1892. 8vo
As an advertisement in *The Quest* stated in 1894, David Nutt, who had offices in the Strand, 'made a speciality of publishing works relating to Celtic Myth, Legend and Romance', while aiming to attract 'lovers of Black and White Art.' His chief allies in these twin objectives were the Jewish writer Joseph Jacobs, who knew Burne-Jones and had been a tutor to the children of Sir George Lewis, the famous solicitor, and J D Batten. Between them the three were responsible for a long series of books of fairy tales and legends in the 1890s. This is one of the earliest, to be followed by *More Celtic Fairy Tales* in 1894.
UNIVERSITY OF READING LIBRARY

496. Joseph Jacobs (ed), *More English Fairy Tales*
Illustrated by J D Batten
London: David Nutt 1894. 8vo
See Cat. 495. A sequal to *English Fairy Tales*, produced by the same team in 1890.
UNIVERSITY OF READING LIBRARY

HENRY JUSTICE FORD
1880–1941

Born in London, where he spent most of his life, Ford was educated at Repton and acquired a First Class degree in classics at Cambridge before entering the Slade to study under Legros; he also attended Herkomer's art school at Bushey. He was an exact

contemporary of J D Batten, whom he must have known at the Slade if not at Cambridge, and their styles have much in common. Though quite a prolific painter, exhibiting at the RA 1892–1930, Ford is mainly known as an illustrator, particularly of the numerous books of legends and fairy stories which Andrew Lang and his wife Leonora edited for Longmans from 1899. He knew Burne-Jones, whose influence on him is apparent, and, like Batten again, was one of the artists patronised by George Howard, Earl of Carlisle. An exhibition of his watercolours was held at the FAS in 1895. In later life he lost his reason; there are references to this in Kerrison Preston (ed), *Letters from Graham Robertson* 1953.

497. A Fantastic Bird Carrying a Ball of Myrrh and Followed by other Birds c1905

Pen and ink, 21.5 × 21.1 (8½ × 8¼)
Signed *H J FORD* (lower left)
Lit: Houfe, p307, repr
Though very much in the style of Ford's designs for Andrew Lang's coloured Fairy Books (Cat. 498–9), the drawing has not so far been identified with a published illustration.
THE BOARD OF TRUSTEES OF THE VICTORIA AND ALBERT MUSEUM, LONDON

498. Andrew Lang (ed), *The Violet Fairy Book*

Illustrated by H J Ford
London: Longmans, Green & Co. 1901. 8vo
One of the eleven coloured Fairy Books which are the most famous product of the long collaboration between Longmans, Andrew Lang and Ford; the first, the *Blue Fairy Book*, appeared in 1889, the last, the *Lilac Fairy Book*, in 1910.
 A watercolour for one of the plates in the *Violet Fairy Book* – *The Tontlawald* – was sold at Christie's, 15 May 1984, lot 175, as by Eleonor Fortescue-Brickdale.
PRIVATE COLLECTION

499. Andrew Lang (ed), *The Green Fairy Book*

Illustrated by H J Ford
London: Longmans, Green & Co. 1902. 8vo
Belonging with same series as Cat. 498, but a year later. Ford excelled at dragons of the type seen in the frontispiece.
THE BRITISH LIBRARY BOARD

500. Andrew Lang, *Tales of Troy and Greece*

Illustrated by H J Ford
London: Longmans, Green & Co. 1907. 8vo
Dedicated to H Rider Haggard, the book contains some of Ford's best black and white illustrations.
THE BRITISH LIBRARY BOARD

ANONYMOUS (English)

501. Vanity c1890

Watercolour with bodycolour, 21 × 14.5 (8¼ × 5¾)
Signed *RMB*(?) (on shield, above)
This charming and beautifully painted little picture seems to be English and to date from about 1890. The signature, however, is hard to decipher, nor does a particular hand suggest itself, although so accomplished an artist must surely have produced other work.
ROBIN DE BEAUMONT

ARTHUR RACKHAM

1867–1939

Born in Lewisham and educated at the City of London School, Rackham entered the Westminster Fire Insurance Office as a clerk in 1885 while attending evening classes at Lambeth School of Art. Among his fellow students were Ricketts, Shannon and Sturge Moore. In 1892 he became a staff artist on the *West-minster Budget*, and he worked as a pictorial journalist for some years while making his name as a book illustrator, one of his earliest successes being *The Ingoldsby Legends* (1898). Many influences contributed to his famous style, from Cruikshank, Doyle, Beardsley and E J Sullivan to Dürer and Japanese prints, although it was always based on close observation of nature. With the publication of *Rip Van Winkle* (1905) and *Peter Pan in Kensington Gardens* (1906), his reputation was assured, and these triumphs were followed by a seemingly endless flow of colour-plate volumes, rivalled only by those of Dulac in popularity. He exhibited widely, notably at the RWS (Associate 1902, member 1908, Vice-President 1910) but also at the RA (1888–1933), RBA, RI, ROI, RSA, etc, as well as holding a series of successful one-man shows at the Leicester Galleries. He was active in the affairs of the Art Workers' Guild (Master 1919), and enjoyed a considerable reputation abroad, being awarded gold medals in Milan (1906), Barcelona and Paris (1912), and later visiting America (1927) and Denmark (1931), where he made studies for illustrations to Hans Andersen. Despite failing health, he completed his last set of designs, for *The Wind in the Willows*, shortly before his death.

Ref: Derek Hudson, *Arthur Rackham: His Life and Art* 1960; *Arthur Rackham*, exh. Sheffield, etc 1979, cat. by James Hamilton; forthcoming monograph by James Hamilton

502. The Prince and the Dwarf 1896

Pen and ink and watercolour, 21 × 15.2 (8¼ × 6)
Signed and dated 1896
Exh: *The Illustrators*, Chris Beetles, October 1988 (163)
An original drawing for *Grimm's Fairy Tales*, published by Constable 1909. It illustrates the story 'The Water of Life', and was made long before publication.
PRIVATE COLLECTION

503. The Little Oriental Rug 1905

Pen and ink and watercolour, 39.3 × 28.5 (15½ × 11¼)
Signed *Arthur Rackham* (lower right)
Exh: Sheffield, etc 1979 (25)
An illustration to the story of this name published in the *Pall Mall Magazine*, December 1905.
BRADFORD ART GALLERIES AND MUSEUMS

504. Hermia in the Wood 1908

Pen and ink and watercolour, 27 × 24.3 (10⅞ × 9⅝)
Signed and dated *Arthur Rackham 08* (lower left)
Exh: *Water-Colour Drawings illustrating Shakespeare's Comedy 'A Midsummer-Night's Dream' by Arthur Rackham RWS*, Leicester Galleries, October–November 1908 (39); Sheffield, etc 1979 (35)
One of Rackham's most beautiful drawings, illustrating Act 3, scene 2 of *A Midsummer-Night's Dream* in the Heinemann edition of 1908 (Cat. 508). Hermia is seen in despair at the temporary desertion of Lysander:
 Never so weary, never so in woe,
 Bedabbled with the dew, and torn with briers,
 I can no further crawl, no further go.
The drawing had two interesting former owners: the colonial administrator, Sir Frank Swettenham (immortalised by Sargent) and Dr Eric Millar, Keeper of Manuscripts at the British Museum. Millar, who also owned Cat. 359–61 and Cat. 363, left his collection to the BM in 1967.
THE TRUSTEES OF THE BRITISH MUSEUM

505. Brambles, with Soldiers (?) Entangled 1907

Pen and ink over pencil, 30.3 × 20.2 (12 × 8)
Signed and dated *Arthur Rackham 07* (lower right)
This unfinished and powerful drawing tells us much about Rackham's vision, the brambles assuming a life of their own in a manner wholly characteristic but seldom so freely expressed in his published illustrations. The subject is a little ambiguous, but a clutching hand certainly appears to left, and figures with helmets and swords can be discerned in the central area of pencil-work. Possibly there is a vague reminiscence of the first of Burne-Jones's *Briar Rose* paintings, in which a group of sleeping knights is seen entangled in the briar wood.
THE BOARD OF TRUSTEES OF THE VICTORIA AND ALBERT MUSEUM, LONDON

506. The Pied Piper of Hamelin c1934

Pen and ink and watercolour, 21.6 × 14 (8½ × 5½)
Signed *A Rackham* (lower left)
The frontispiece to George Harrap's edition of Browning's poem, published in 1934, five years before Rackham's death. The four colour plates and black and white drawings he contributed are slightly freer in style than his early work, though still very characteristic.
CHRIS BEETLES LTD

507. J M Barrie, *Peter Pan in Kensington Gardens*

Illustrated by Arthur Rackham
London: Hodder and Stoughton 1906. 4to
One of Rackham's most popular and remarkable books, full of the anthropomorphic images at which he excelled.
THE BRITISH LIBRARY BOARD

508. William Shakespeare, *A Midsummer-Night's Dream*

Illustrated by Arthur Rackham
London: William Heinemann 1908. 4to
The first of three editions of the play that Rackham illustrated, others following in 1928 and 1939. The text was ideally suited to his genius and in this early edition he is at his best, whimsical one moment, sombre and disturbing the next. For one of the original drawings, see Cat. 504.
THE BRITISH LIBRARY BOARD

509. Richard Wagner, *The Rhinegold and the Valkyrie*

Translated by Margaret Armour. Illustrated by Arthur Rackham
London: William Heinemann 1910. 4to
Rackham illustrated the whole of Wagner's *Ring*, these designs being issued in 1910 and those for *Siegfried and The Twilight of the Gods* the following year. The subject-matter was something of a new departure for him and the designs were a success, winning him a gold medal in Paris in 1912. However, he did not pursue this line, soon returning to lighter themes.
CHRIS BEETLES LTD

510. John Milton, *Comus*

Illustrated by Arthur Rackham
London: William Heinemann 1921. 4to
Yet another book done for Heinemann, ten or more years later than Cat. 508–9 but showing no signs of decline.
THE BRITISH LIBRARY BOARD

EDMUND JOSEPH SULLIVAN

1869–1933

Born in London and studied art at Hastings under his father, Michael Sullivan. At the age of twenty, joined the staff of the *Graphic* as an illustrator, later working for the *Daily Graphic*, *Punch*, *Pall Mall Budget*, etc. Though a prolific magazine illustrator, he was equally well known for his books, making his name with editions of Carlyle's *Sartor Resartus* (1898), Tennyson's *Dream of Fair Women* (1901), *The Rubáiyát of Omar Khayyám* (1913) and others. Commanding a brilliant pen-and-ink technique, he had a wide influence on

other artists (including Rackham); he taught illustration at Goldsmith's College and in 1921 published a textbook, *The Art of Illustration*. He was also active as a painter, etcher and lithographer, exhibiting at the RA, RSA, RE, RWS (Associate 1913, member 1929) and International Society, of which he was on the Council. Joined the Art Workers' Guild 1911 and Master 1931, two years before his death.

511. A Skeleton amid Roses c1900 *ill. p201*

Pen and ink, 22 × 16 (5⅝ × 6¼)
Signed Edmund J Sullivan
Lit: 'Modern Pen Drawings', *Studio*, Special Winter Number 1900–1, p29, repr
An illustration to Omar Khayyám but drawn long before the edition illustrated by Sullivan, published 1913. The concept is very characteristic, striking a similar note to Cat. 513. Sullivan's work abounds in images of time, mortality and decay.
ROBIN DE BEAUMONT

Cat. 511

511A. An Archer Drawing his Bow in a Wood
1909 (?)
Pen and ink over black chalk, 29.5 × 20.6 (11⅝ × 8⅛)
Signed and dated *EDMUND J SULLIVAN 09* (?)
(lower right)
Presumably for an unidentified illustration. The date is hard to read and could be 1900.
THE TRUSTEES OF THE BRITISH MUSEUM

512. The Fall of Icarus 1886 (?)
Lithograph in black, 54.3 × 38.1 (21¾ × 15)
Signed and dated in the plate *EDMUND J SULLIVAN 86* (?) (lower left)
An impressive and (if the date is read correctly) very early work; the subject evokes comparison with Charles Holroyd's etchings on the same theme (see Cat. 227).
THE TRUSTEES OF THE BRITISH MUSEUM

513. Melancholy c1910 (?)
Etching, 22.5 × 17.5 (8⅞ × 6⅞)
Signed *Edmund J Sullivan* (lower right) and inscribed below *Melancholy*. *"She dwells with Beauty, Beauty that must die"* (Keats)
One of the most 'symbolist' of Sullivan's etchings,

inspired by Keats's 'Ode to Melancholy'. Sullivan illustrated Keats in 1910 and the print may be contemporary.
THE TRUSTEES OF THE BRITISH MUSEUM

514. La Motte Fouqué, *Sintram and his Companions*
Translated by A C Farquharson. Illustrated by E J Sullivan
London: Methuen 1908. 8vo
Fouqué's story had been inspired by Dürer's engraving *The Knight, Death and the Devil* (reproduced as the book's frontispiece), and Sullivan takes up this theme with relish, developing Dürer's imagery in many of his own designs. Fouqué had been enormously admired by Burne-Jones and Morris as undergraduates in the 1850s, and continued to have an appeal; his other well-known story, *Undine*, was illustrated by Harold Nelson in 1901 and by Rackham in 1909.
THE BRITISH LIBRARY BOARD

CYRIL R GOLDIE
1872–1942
Drawings and etchings by this little-known artist are in the V&A and the British Museum, all given by his widow on his death in 1942. Many are classical landscapes peopled by arcadian figures, clearly betraying a deep knowledge of the Old Masters. Guichard describes Goldie as 'this elusive artist of the 1920s', but in fact his style was formed long before since as early as 1901 he designed a cover for *The Artist* adapted from Botticelli's *Minerva and the Centaur* in the Uffizi. Goldie's talent may be modest but his work suggests that he was a true eccentric, going his own way impervious to fashion.

515. A Group of Figures in a Wooded Landscape
c1920 (?)
Pencil and watercolour, 28 × 38 (11 × 15)
The drawing is possibly an allegory of the artist and his family, Goldie himself being the bearded man sitting writing on the left, and his wife the foremost woman in the centre.
THE BOARD OF TRUSTEES OF THE VICTORIA AND ALBERT MUSEUM, LONDON

516. Rocky Landscapes with a Centaur and a Deserted Building c1920 (?)
Pencil and watercolour, 30.2 × 43.2 (11⅞ × 17)
The strongest of the group of drawings by Goldie in the British Museum, although they include several comparable images.
THE TRUSTEES OF THE BRITISH MUSEUM

517. Lost Sheep 1917
Etching, 20 × 25 (7⅞ × 9⅞)
Signed and dated *Cyril Goldie 1917* (lower right) and inscribed *Lost Sheep* (lower left)
Lit: V&A impression repr Guichaud, pl.26
Perhaps the best of Goldie's known etchings, with characteristic echoes not only of quattrocento painting but of Claude and Gaspard Dughet.
THE TRUSTEES OF THE BRITISH MUSEUM

WILLIAM HEATH ROBINSON
1872–1944
Born in London and trained at Islington School of Art and the RA Schools. Attaining little success as a landscape painter, he followed the example of his father Thomas Robinson and his two elder brothers, Thomas and Charles, and turned to illustration. Open to many influences, including Beardsley, Gilbert, Crane, Sime, Rackham and Japanese prints, he developed a versatile approach able to encompass the

horrors of Rabelais no less than the poetry of *A Midsummer-Night's Dream*. Meanwhile he was a frequent contributor to *The Sketch*, *The Bystander* and other periodicals, making his name as an inventor of comic characters and absurd machines. In 1934 he designed a home full of such gadgets for the Ideal Home Exhibition. Also designed for the stage and in 1930, like Dulac and Greiffenhagen, was involved in the decoration of the liner *Empress of Britain*. The RA held a memorial exhibition 1945.

Ref: W. Heath Robinson, exh. Chris Beetles Ltd 1987, cat. by Geoffrey Beare

518. 'And Treacherously Murthered Abece'
c1904
Pen and ink, black wash and some white bodycolour, 59.6 × 47 (23½ × 18½)
Signed *W HEATH ROBINSON* (lower left) and inscribed with title
Exh: Chris Beetles Ltd 1987 (30)
This and Cat. 519, 520 are among the long series of illustrations made by Heath Robinson for an edition of the complete works of Rabelais, published in two volumes by Grant Richards in 1904. The drawings are one of the greatest achievements of his early career as an illustrator; as Geoffrey Beare observes, 'the reader is transported to a bleak landscape peopled by grotesque peasants and priests whose lives are dominated by fear and superstition and who can find relief only in drunkenness and debauchery'. Beare suggests the influence of Breughel, the grotesque heads of Leonardo, and the gargoyles and choir-stall carvings of English medieval churches.
 This drawing illustrates Vol 2, Book 3, ch. XLIV.
CHRIS BEETLES LTD

519. 'When my Lords the Devils had a Minde to Recreate Themselves upon the Water' c1904
Pen and ink, black wash and some white bodycolour, 59.6 × 47 (23½ × 18½)
Signed *W HEATH ROBINSON* (lower left) and inscribed with title
Exh: Chris Beetles Ltd 1987 (98)
See Cat. 518. An illustration to Vol 1, Book 2, ch. XXX, epitomising the dark satanic element in Rabelais and the brilliant use of texture and tonal contrast displayed throughout the drawings.
CHRIS BEETLES LTD

520. 'The Eldest Child was a Daughter, whose Name was Vine' c1904
Pen and ink, 59.4 × 47 (23⅜ × 18½)
Signed *W HEATH ROBINSON* (lower centre) and inscribed with title
Exh: Chris Beetles Ltd 1987 (35)
See Cat. 518. One of the more light-hearted drawings, illustrating Vol 2 Book 3, ch. LI. The mood of Rabelais' text, though sombre, gives Heath Robinson plenty of scope to express his robust humour.
CHRIS BEETLES LTD

521. 'Isn't It Wonderful!' before 1910
Pen and watercolour, 35.5 × 24.8 (14 × 9¾)
Signed *W. HEATH ROBINSON* (lower right)
Exh: Chris Beetles Ltd 1987 (113)
Lit: *The Graphic* 25 June 1910, pxx, repr
One of Heath Robinson's most remarkable drawings, combining the comic element for which he is best known with a gentle lyricism in the figure of the little girl among the sunflowers.
CHRIS BEETLES LTD

522. William Shakespeare, *A Midsummer-Night's Dream*
Illustrated by W Heath Robinson
London: Constable & Co. 1914. 4to
Published when the artist was forty-one and at the height of his powers, this book is generally regarded as his finest achievement as an illustrator. In his autobiography Heath Robinson wrote: 'The old Greek stories of the wedding of Theseus and Hippolyta, of Pyramus and Thisbe and of life in ancient Athens as seen through English eyes, bewitched me. All of these and their strangely harmonious combination with everything that was lovely, and humorous too, in our English countryside, filled me with enchantment. I was ambitious to try to express something of this in my drawings and make them a record of this, the most wonderful moonlight night in fantasy.'
CHRIS BEETLES LTD

ANNIE FRENCH
1872–1965
Born in Glasgow, the daughter of a metallurgist, she studied at the Glasgow School of Art under Francis Newbery and Jean Delville, the Belgian Symbolist painter who taught at Glasgow c1898–1902. In 1909 she took over Jessie M King's teaching post in the School's department of Design, holding it until 1914 when she married the artist George Woolliscroft Rhead (1854–1920) and settled in London. Chiefly known in her day as a designer of greetings cards, she exhibited her watercolours regularly at the Royal Glasgow Institute from 1904 and the RA from 1909; also in Liverpool, Paris and Canada. Her style is one of extreme intricacy and delicacy of touch. Philippe Jullian called her a 'lace-maker', and Diana Johnson describes her figures as 'spirits composed of cobwebs rather than creatures of flesh and blood'.

523. The Sleepless Daisy c1907
Pen and watercolour on vellum, 20.3 × 22.9 (8 × 9)
Signed *ANNIE FRENCH* (lower right)
Exh: Liverpool Autumn Exh. 1907 (1541); *Women's Works*, Liverpool 1988, cat. p58
This and Cat. 524 were among four drawings which the artist showed at the Liverpool Autumn Exhibition in 1907, *The Sleepless Daisy* being bought at this time for the Walker Art Gallery.
TRUSTEES OF THE NATIONAL MUSEUMS AND GALLERIES ON MERSEYSIDE, WALKER ART GALLERY

524. Little Gods Protect Me c1907
Pen and watercolour, 24.1 × 31.1 (9½ × 12¼)
Signed *ANNIE FRENCH* (lower right)
Exh: Liverpool Autumn Exh. 1907 (1575); RGI 1908 (634); Belgian Artists Relief Fund, RSA 1915 (18)
PRIVATE COLLECTION

525. The Daisy Chain before 1916
Pen and ink (on vellum?), 18.1 × 37.1 (7⅛ × 14⅝)
Signed *ANNIE FRENCH* (lower left)
The drawing was presented to the V&A in 1916 by Arthur Edward Anderson (1870–1938), who gave generously not only to the V&A but to the Tate, Fitzwilliam, Ashmolean, Whitworth Art Gallery, Manchester, etc. He may be seen as a counterbalance to Cecil French (see Introduction and Cat. 109), for although he liked the 'last romantics', having a particular preference for Simeon Solomon and Shannon, he also donated works by Epstein, Gaudier Brzeska, Gertler and Henry Moore. See Michael Clarke's essay in the cat. of the exh. *French Nineteenth Century Drawings*, Whitworth Art Gallery 1981.
THE BOARD OF TRUSTEES OF THE VICTORIA AND ALBERT MUSEUM, LONDON

526. Tristram and Iseult c1916
Pen and watercolour, 22.9 × 35.6 (9 × 14)
Signed *ANNIE FRENCH* (lower right)
Exh: RGI 1916 (531); RA 1916 (1525) (?)
PRIVATE COLLECTION

527. The Lady under Enchantment after 1914 (?)
Pen and ink and watercolour, 30.5 × 50.2 (11⅞ × 19¾)
Signed *AF* (lower left) and inscribed *Annie French London, Lady under Enchantment* on the back
Exh: RA 1917 (800) (?)
Probably the picture entitled *The Enchanted Ladye* exhibited at the RA in 1917.
LAING ART GALLERY, NEWCASTLE UPON TYNE (TYNE AND WEAR MUSEUMS SERVICE)

528. A Garden Piece
Pen and watercolour with bodycolour, 27.3 × 20.3 (10¾ × 8)
Signed *ANNIE FRENCH* (lower right)
PRIVATE COLLECTION

KATHERINE CAMERON
1874–1965
The younger sister of D Y Cameron, she was born in Glasgow and studied there at the School of Art and at Colarossi's in Paris. Married the artist Arthur Kay in 1928. Her greatest love was painting and etching flowers; illustration took second place, although in the early 1900s she was a prolific illustrator of children's books for the Edinburgh publishers T C & E C Jack, specialising in fairy stories and romantic texts (*Stories of King Arthur's Knights* 1905; *Celtic Tales* 1910, etc) in their 'Told to the Children' series. She contributed to the *Yellow Book* in 1897. Her graphic work shows the influence of the Glasgow School and Japanese prints. Elected RSW (1897) and ARE (1920).

529. Louey Chisholm, *In Fairyland*
Illustrated by Katherine Cameron
London and Edinburgh: T C & E C Jack 1904. 8vo
See Cat. 530.
ROSEMARY FARQUHARSON

530. Louey Chisholm, *The Enchanted Land*
Illustrated by Katherine Cameron
London and Edinburgh: T C & E C Jack 1906. 4to
This and Cat. 529 are examples of the artist's work for Jacks – attractive, but seldom as inspired as her flower studies. Louey Chisholm, who 'retold' so many of the stories illustrated by Kate Cameron and Jacks' other 'regular', Minnie Spooner, was the wife of T C Jack.
ROSEMARY FARQUHARSON

JESSIE MARION KING
1875–1949
Scottish by birth, she studied at Glasgow School of Art and at the RCA, later visiting France and Italy on a travelling scholarship and being particularly attracted to the art of the early Renaissance. She was also influenced by the Pre-Raphaelites and by Charles Rennie Mackintosh and his circle, although she developed a highly individual style of her own. She worked as a muralist and as designer of fabrics, jewellery, ceramics, book-covers, etc, as well as illustrating numerous books, some written by herself. Exhibited at the International Exhibition of Decorative Art at Turin 1902 (gold medal for book design), and taught at the Glasgow School of Art 1902–9. Went to Paris 1911 and ran the Shealing Atelier for for Fine Art with her husband E A Taylor. Returned to Scotland 1913 and later settled at Kircudbright.

Ref: *Jessie M King and E A Taylor*, cat. of Sotheby's sale,

Glasgow, 21 June 1977; forthcoming monograph by Colin White

531. The Flower Fairy in the Magic Garret 1903
Pen and ink, 22.2 × 16.2 (8¾ × 6⅜)
Signed with monogram *JMK* (lower right) and inscribed *THE FLOWER FAIRY IN THE MAGIC GARRET* (below)
Exh: Brighton 1980 (D58)
An illustration to M H Spielmann's *The Magic Giant in Littledom Castle and Other Tales* 1903.
SUNDERLAND MUSEUM AND ART GALLERY (TYNE AND WEAR MUSEUMS SERVICE)

532. The White Lady c1903
Pen and ink, heightened with silver, on vellum, 24.6 × 14.2 (9¾ × 5½)
Signed with monogram
An unidentified illustration, apparently not far in date from Cat. 531.
THE TRUSTEES OF THE CECIL HIGGINS ART GALLERY, BEDFORD

533. Sleeping Beauty and the Prince c1928
Pen and watercolour on vellum, 32 × 47 (12⅝ × 18½)
Signed *Jessie M King* (lower right)
Exh: *Fantastic Illustration* (125)
A beautiful example of the artist's later style, apparently not published in a book. As Diana Johnson observes, 'the lively yet delicate touches of colour and the angular rendering of forms create a more staccato rhythm than the fluid lines of her earlier work in the Art Nouveau style'.
DRUSILLA AND COLIN WHITE

534. William Morris, *The Defence of Guenevere and Other Poems*
Illustrated by Jessie M King
London: John Lane 1904. 8vo
Like her illustrations to Sebastian Evans' *High History of the Holy Graal*, published by J M Dent 1903, *The Defence of Guenevere* exemplifies the artist's early style, seen here also in two original drawings (Cat. 531–2). It is interesting to compare the book with Florence Harrison's treatment of the same subject a decade later (Cat. 487).
ROBIN DE BEAUMONT

535. Edmund Spencer, *Poems*
Illustrated by Florence Harrison
London and Edinburgh: T C & E C Jack 1906. 16o
One of a series of miniature volumes of works by English poets, to which E J Sullivan and others also contributed. The book has a preface by W B Yeats.
DRUSILLA AND COLIN WHITE

PAUL WOODROFFE
1875–1954
Born in India of Roman Catholic parents, his father being a judge in the Madras Civil Service. Educated at Stoneyhurst and in 1893 entered the Slade. His first illustrated book, *Ye Booke of Nursery Rhymes*, published 1895. About the same time he met Laurence and Clemence Housman, who were to play a large part in his career (see Cat. 537–8). In the late 1890s he became a pupil of the Arts and Crafts stained-glass artist Christopher Whall, and in 1904 he established a stained-glass workshop at Chipping Campden, not far from C R Ashbee's Guild of Handicraft, with which he worked in close co-operation. His most important stained glass was a series of fifteen windows for St Patrick's Cathedral, New York, finally completed 1934. Meanwhile he had continued active as a book designer and illustrator, working (among

others) for Ashbee's Essex House Press and the Edinburgh publishers T C & E C Jack. He exhibited at the RA, Arts and Crafts Exhibition Society, NEAC, and at the Cotswold and Baillie Galleries; and was a member of the Art Workers' Guild from 1901. Last recorded work a window of 1945. Retired with his wife to Mayfield, Sussex, early 1950s, and died at Eastbourne.

Ref: *Paul Woodroffe*, exh. William Morris Gallery, Walthamstow 1982–3, cat. by Peter Cormack

536. *The Little Flowers of St Francis of Assisi*
London: The Art Book Co. 1899. 8vo
Exh: William Morris Gallery 1982–3 (14)
The book has two companion volumes, *The Confessions of St Augustine* 1900, and *The Little Flowers of St Benet* 1901
PETER CORMACK

537. *Of Aucassin and Nicolette*
Translated from the Old French by Laurence Housman.
Illustrated by Paul Woodroffe
London: John Murray 1902. 8vo
These highly intricate designs, admirably engraved on wood by Clemence Housman (see Cat. 536), betray the influence of Laurence Housman (the book's translator) and of the 1860s illustrators who so influenced Housman himself.
UNIVERSITY OF READING LIBRARY

538. **A Volume of Wood-Engravings by Clemence Housman**
The volume is exhibited here in connection with Paul Woodroffe, but contains engravings by Clemence Housman after a number of other artists – her brother Laurence, Reginald Savage, James Guthrie, F L Griggs and William Strang. The Woodroffes show him both

in his neo-1860s vein (*Aucassin and Nicolette*) and in his more 'Arts and Crafts' style.
THE TRUSTEES OF THE BRITISH MUSEUM

HENRY MATTHEW BROCK
1875–1960
Brock was born and lived all his life in Cambridge, being one of a well-known family of Cambridge artists and the younger brother of the illustrator Charles Edmund Brock (1870–1938). Indeed Henry Matthew, who studied at the Cambridge School of Art, worked closely with Charles Edmund and their styles are very similar. He had a flair for capturing action, and tended to specialise in boys' stories and authors like Scott, Dickens, Thackeray, R L Stephenson and Baroness Orczy, remaining popular from the 1890s until he gave up working due to failing eyesight in 1950. Elected RI 1906. Married his cousin, a sister of the artist Fred Pegram, 1912.

Ref: C M Kelly, *The Brocks. A Family of Cambridge Artists and Illustrators* 1975

539. **Beverley Nichols (ed), *A Book of Old Ballads***
Illustrated by H M Brock
London: Hutchinson 1934. 4to
A handsome and, in terms of subject, slightly unusual example of Brock's work, the book offers interesting late interpretations of such ballads as 'Fair Rosamond', 'King Cophetua', 'Child Waters' and 'Barbara Allen's Cruelty', which had long been exercising the minds of the 'last romantics'. Parallels by Burne-Jones, J W Waterhouse, Maurice Greiffenhagen, Robert Burns, Byam Shaw, Eleanor Fortescue-Brickdale and others are not hard to find, even within the context of this exhibition.
PRIVATE COLLECTION

MINNIE DIBDIN SPOONER (née Davison)
active 1893–1927
Illustrator of children's books, portrait painter and etcher. Married to the artist C S Spooner. Exhibited RA (1919–27), New Gallery, Liverpool, Royal Hibernian Society, etc. Member of Royal Miniature Society 1901, and closely associated with the Edinburgh publishers T C & E C Jack. Living at Chiswick in the 1920s.

540. **Louey Chisholm, *The Golden Staircase***
Illustrated by M Dibdin Spooner
London and Edinburgh: T C & E C Jack 1906. 4to
See Cat. 541.
ROSEMARY FARQUHARSON

541. **Amy Steedman, *Our Island Saints***
London and Edinburgh: T C & E C Jack 1912. 4to
Two of the books that Minnie Spooner illustrated for Jacks, both good examples of her gentle and appealing style. Amy Steedman and her brother, the Rev. C M Steedman, were prolific authors of children's books, again closely connected with Jacks. Amy Steedman was also a painter.
ROSEMARY FARQUHARSON

OSWALD COULDREY
c1885–c1955/60
An obscure figure, unknown to reference books, Couldrey was probably born in the 1880s. He served in the First World War and lived for many years at Abingdon, Berkshire, where he is remembered as a local 'character' – a big man, very deaf (probably as a result of shell-shock), wearing horn-rimmed spectacles, corduroy shorts and sandals. He seems to have been mainly a topographical draughtsman; a number of street scenes by him hang on the staircase of Abingdon Town Hall, and he exhibited a watercolour, *Net-*

Cat. 548

houses at Hastings, at the RA in 1950. However, he also painted imaginative subjects, sometimes showing the influence of Blake. He is included here as an interesting example of the romantic tradition continuing at a semi-amateur level.

Ref: Information from Richard Jefferies

542. **The Return of Persephone** c1920
Watercolour with bodycolour, 21.5 × 28 (8½ × 11)
Signed *O COULDREY*
Persephone, the daughter of Ceres by Jupiter, was carried off by Pluto, king of the infernal regions. However, at her mother's insistence, Jupiter ruled that she should only spend six months with Pluto, returning to earth for the rest of the year.

The watercolour was once in the possession of John Masefield.
R H JEFFERIES

VERNON HILL
1886–1972
Born in Halifax, where he was apprenticed to a trade lithographer at thirteen and at eighteen became a student teacher at night classes for mill hands. By 1907 he was working with the poster artist John Hassall. Active as an illustrator, etcher and sculptor, he held his first one-man exhibition at the Leicester Galleries in 1924. His most important illustrations are for Stephen Phillips' *The New Inferno* (1911) and Richard Chope's *Ballads Weird and Wonderful* (1912), both published by John Lane. Blake was a dominant influence on his early graphic work, which later became more Art Deco in feeling. As a sculptor he is best known for his long association with Sir Edward Maufe on Guildford Cathedral, which lasted intermittently 1932–56. A large collection of his prints and drawings is in the Southampton Art Gallery.

543. **Night** 1912–13
Signed with monogram in plate and *Vernon Hill* in pencil (lower right)
Etching, 16 × 15.6 (6¼ × 6⅛)
This is perhaps the best of a group of three early etchings by Hill, the others representing *Dawn* and *Day*. Closely related in style as well as in subject, they date from 1912–13 and are clearly inspired by Blake, *Day* being a figure with outstretched arms reminiscent of his famous image *Glad Day*. In this they are comparable to Hill's illustrations to *The New Inferno* by Stephen Phillips, published 1911.

All three etchings were given to the V&A as early as 1914, and there are further impressions at Southampton.
THE BOARD OF TRUSTEES OF THE VICTORIA AND ALBERT MUSEUM, LONDON

544. **The Spirit that Destroyed Rheims** 1915
Etching, 22.7 × 15 (9 × 5⅞)
Signed *Vernon Hill* in pencil (lower right) and inscribed with the title (lower left)
A comment on the severe damage sustained by Rheims Cathedral from shellfire during the First World War. Six impressions are at Southampton, one being dated 1915.
THE TRUSTEES OF THE BRITISH MUSEUM

545. **Evening** 1916
Etching, 10 × 22.5 (4 × 8⅞)
Signed *Vernon Hill* in pencil (lower right) and inscribed with the title (lower left)
According to inscriptions on other impressions of this sensitive image at Southampton, it dates from 1916 and was also called *Dusk* or *Nightfall* by the artist.
THE TRUSTEES OF THE BRITISH MUSEUM

546. **Richard Chope,** *Ballads Weird and Wonderful*
Illustrated by Vernon Hill
London and New York: John Lane 1912. 4to
Chope in his Preface stresses that his selection of ballads eschews 'hackneyed themes of love and romance' to concentrate on 'the bizarre, the whimsical, the extraordinary', and Hill's twenty-five carefully finished pencil drawings fully play up to this intention. Although Chope rightly notes the influence on them of Blake and Flaxman, individual images show that Hill was a keen student of the Pre-Raphaelites, borrowing motifs from Holman Hunt, D G Rossetti and Ford Madox Brown.
SIMON REYNOLDS

MARGARET WINIFRED TARRANT
1888–1959
Born in Battersea, the daughter of the artist Percy Tarrant, she studied at Clapham School of Art and at Heatherley's. She began her career as an illustrator in 1908 with an edition of Kingsley's *Water Babies* for J M Dent, and subsequently worked for Ward Lock and Harraps before establishing a close relationship with the Medici Society in 1920. Her religious paintings, fairy subjects and flower studies all proved enormously popular. In 1934 her parents died and the following year she visited Palestine. Moved about this time to Peaslake, Surrey, but died in Cornwall.

Ref: John Gurney, *Margaret Tarrant and her Pictures* 1982

547. **Do You Believe in Fairies?** 1922
Watercolour, 29.2 × 24.8 (11½ × 9¾)
Signed *Margaret W Tarrant* (lower right)
Lit: Gurney, p5, repr
Published by the Medici Society in 1922, the same year as Sir Arthur Conan Doyle's *The Coming of the Fairies* and about the same time as Bernard Sleigh's books on fairy themes (see Cat. 98).
PRIVATE COLLECTION

548. **All Things Wise and Wonderful** 1925 ill. p203
Watercolour, 53.3 × 66 (21 × 26)
Signed *Margaret W Tarrant* (centre panel, lower right)
Lit: Gurney, p8, repr
First published by the Medici Society in 1925, this is the quintessential image associated with the 'Children's Corners' so popular in churches in the 1920s and 1930s. It is said that during the Depression some art shops were able to keep going on sales of the reproduction. The text is taken from Mrs Alexander's well-known hymn.
PRIVATE COLLECTION

549. **Little Hands Outstretched to Bless** c1925
Watercolour, 21.3 × 15.2 (8⅜ × 6)
Signed *MWT*
PRIVATE COLLECTION

CICELY MARY BARKER
1895–1973
Born in Croydon, she studied part-time at the local School of Art, but was largely self-taught. She became one of the most accomplished and well-loved children's illustrators of her day, many of her designs accompanying her own verses. Best known are the 'Flower Fairy' books, in which enchanting children masquerade in picturesque botanical costumes. These, like most of her books, were done for the Glasgow publishers, Blackie's, and have recently enjoyed a revival of popularity. She also designed Christmas cards for the Girls' Friendly Society, and at least one stained-glass window (St Andrew's Church, Croydon), One of her pictures was bought by Queen

Mary. Lived most of her life in Sussex and was a close friend of Margaret Tarrant, whose work is in many ways similar.

550. **Cicely Mary Barker,** *Flower Fairies of the Autumn*
Illustrated by the author
London and Glasgow: Blackie & Son 1926. 16o
The best and last of three 'seasonal' Flower Fairy books which the artist published 1923–6. There seems to have been no volume for Winter, although Flower Fairies of other kinds re-emerged in the 1930s and 1940s (see Cat. 553).
PRIVATE COLLECTION

551. *Rhymes Old and New*
Collected and illustrated by Cicely Mary Barker
London and Glasgow: Blackie & Son 1933. 8vo
The 'rhymes' include such period-pieces as 'A Fairy Went a-Marketing' by Rose Fyleman and 'Eddi's Service' by Kipling.
THE BRITISH LIBRARY BOARD

552. *The Little Picture Hymn Book*
Illustrated by Cicely Mary Barker
London and Glasgow: Blackie & Son 1933. 16o
The book is as redolent of a 'Children's Corner' as Margaret Tarrant's *All Things Wise and Wonderful*, Cat. 548.
THE BRITISH LIBRARY BOARD

553. **Cicely Mary Barker,** *A Flower Fairy Alphabet*
Illustated by the author
London and Glasgow: Blackie & Son 1934. 16o
A later re-working of the 'Flower Fairy' theme, to which the artist was still returning in 1950.
THE BRITISH LIBRARY BOARD

554. **Two Christmas Cards**
Examples of the Christmas cards designed by the artist for the Girls' Friendly Society in the 1930s.
PRIVATE COLLECTION

DAPHNE CONSTANCE ALLEN
1899–after 1934
Daughter of Hugh Allen and possibly related to Ruskin's publisher George Allen, who published some precocious watercolours by her in 1912 under the title *A Child's Vision*; a sequel to this Ruskinian concept, *The Birth of the Opal. A Child's Fancies*, appeared the following year. Educated at Streatham College for Girls and still living at Streatham 1934, she exhibited at the Dudley Gallery and elsewhere, illustrated further books, and had designs published by the Medici Society, in the *Illustrated London News*, etc. Painted war memorials and designed stained-glass window at Scotby Church, Cumberland.

Ref: *Who's Who in Art*, 1934 ed, p7

555. **The Beechwood** c1927
Watercolour, 34.3 × 25.4 (13½ × 10)
Signed *DAPHNE ALLEN*
Exh: The Deanery, St Paul's 1927
R H JEFFERIES

556. **Calling the Seagulls**
Watercolour, 36.8 × 47 (14½ × 18½)
VICTOR ARWAS

557. **April Magic**
Watercolour, 29 × 22.8 (11½ × 9)
Signed (lower right)
PRIVATE COLLECTION

Abbreviations

Barclay
Michael Richard Barclay, *Catalogue of the Works of Charles Ricketts RA from the Collection of Gordon Bottomley*, Carlisle Museum and Art Gallery 1985

Bate
Percy Bate, *The English Pre-Raphaelite Painters, their Associates and Successors*, 4th ed 1910

Beattie
Susan Beattie, *The New Sculpture* 1983

Billcliffe 1985
Roger Billcliffe, *The Glasgow Boys* 1985

Birmingham 1986–7
Masterly Art: The Birmingham Municipal School of Art 1884–1920, exh. Birmingham City Art Gallery 1986–7 (no catalogue)

Birmingham 1987
Sculpture in Birmingham Museum and Art Gallery, A Summary Catalogue by Evelyn Silber, Birmingham 1987

Brighton 1980
Fairies, exh. Brighton Museum 1980. Catalogue by Stella Beddoe and others

By Hammer and Hand
Alan Crawford (ed), *By Hammer and Hand. The Arts and Crafts Movement in Birmingham*, Birmingham City Museum and Art Gallery 1984

Cardiff 1979
Exhibition of works by Goscombe John, National Museum of Wales, Cardiff 1979

Carlisle 1970
Gordon Bottomley. Poet and Collector, exh. Carlisle Museum and Art Gallery 1970. Catalogue by D R Perriam

Carlisle 1971
William Rothenstein. A Unique Collection, exh. Carlisle Museum and Art Gallery 1971. Catalogue by D R Perriam

Christchurch 1906–7
New Zealand International Exhibition, Christchurch, New Zealand 1906–7

Christie's 1986
The New English Art Club Centenary Exhibition, exh. Christie's, London 1986. Catalogue by Francis Farmar

Dorment
Richard Dorment, *Alfred Gilbert*, New Haven and London 1985

Fantastic Illustration
Fantastic Illustration and Design in Britain, 1850–1930, exh. Museum of Art, Rhode Island School of Design, and Cooper-Hewitt Museum 1979. Catalogue by Diana L Johnson

FAS
Fine Art Society

FAS 1968
British Sculpture 1850–1914, exh. Fine Art Society 1968

FAS 1969
The Earthly Paradise, exh. Fine Art Society 1969. Catalogue by Charlotte Gere

Alfred Gilbert
Alfred Gilbert, exh. Royal Academy of Arts, London 1986

Hardie
William Hardie, *Scottish Painting 1837–1939* 1976

Japan 1983
International Symbolist Exhibition, Japan 1983, organised by Victor Arwas, London, Barry Friedman, New York, and Piccadilly Gallery, London

Japan 1985
The Pre-Raphaelites and their Times, exh. circulated in Japan 1985 by the Tokyo Shimbun. Catalogue by John Christian

Japan 1987
Burne-Jones and his Followers, exh. circulated in Japan by the Tokyo Shimbun 1987. Catalogue by John Christian

Jullian
Philippe Jullian, *Dreamers of Decadence* 1971

Lincoln 1928–9
Paintings and Drawings by Charles Shannon RA, exh. Usher Art Gallery, Lincoln 1928–9

London 1908
London Franco-British Exhibition 1908 – Fine Art Section (numbering refers to the official *Souvenir of the Fine Art Section*, compiled by Sir Isidore Spielmann 1908)

Maryon
Herbert Maryon, *Modern Sculpture Its Methods and Ideals* 1933

National Gallery, Millbank 1929
National Gallery, Millbank Catalogue British School 1929

NEAC
New English Art Club

Newcastle 1972
Albert Moore and his Contemporaries, exh. Laing Art Gallery, Newcastle upon Tyne 1972. Catalogue by Richard Green

NGBA 1914
National Gallery, British Art: Catalogue with Descriptions, Historical Notes and Lives of Deceased Artists 1914

Poet and Painter
Claude Colleer Abbott and Anthony Bertram (eds), *Poet and Painter. Being the Correspondence between Gordon Bottomley and Paul Nash 1910–1946* 1955

Powers 1986
Alan Powers, 'Honesty of Purpose. Painters at the British School at Rome', *Country Life* 27 February 1986, pp512–14

Preston
Kerrison Preston (ed), *Letters from Graham Robertson* 1953

RA
Royal Academy of Arts, London

RA 1933
Commemorative Exhibition of Works by Late Members, Royal Academy, Winter 1933

RA 1939
Catalogue of the Diploma & Gibson Galleries, Royal Academy of Arts, London 1939

RBA
Royal Society of British Artists

RBSA
Royal Birmingham Society of Artists

RCA
Royal College of Art

RE
Royal Society of Painter-Etchers and Engravers

Read 1981
Benedict Read, 'Classical and Decorative Sculpture' in *British Sculpture in the Twentieth Century* (S Nairne and N Serota eds), Whitechapel Art Gallery 1981

Read 1982
Benedict Read, *Victorian Sculpture* 1982

RGI
Royal Glasgow Institute

RI
Royal Institute of Painters in Watercolours

ROI
Royal Institute of Oil Painters

Rome 1911
International Fine Arts Exhibition, Rome 1911 (numbering refers to the *Souvenir of the British Section*, compiled by Sir Isidore Spielmann 1911)

RSA
Royal Scottish Academy

RSW
Royal Scottish Society for Painters in Watercolour, Glasgow

RWS
Royal Society of Painters in Water-Colours

St Louis 1904
St Louis International Exhibition 1904 (numbering refers to the official *Commemorative Album of The British Section*, compiled by Sir Isidore Spielmann 1904)

Spielmann
Marion H Spielmann, *British Sculpture and Sculptors of To-Day* 1901

Tate 1964
M Chamot, D Farr and M Butlin, *Tate Gallery Catalogue: The modern British paintings, drawings and sculpture* (2 vols) 1964

Whitechapel 1981 I
British Sculpture in the Twentieth Century Part 1: Image and Form 1901–1950, exh. leaflet, Whitechapel Gallery 1981

C Wood 1981
Christopher Wood, *The Pre-Raphaelites* 1981

C Wood 1983
Christopher Wood, *Olympian Dreamers* 1983

List of artists

List of Lenders

England

The Abbot and Community of Ampleforth Abbey Cat. 133

Victor Arwas Cat. 69, 220, 411, 556

Annabel and Philip Athill Cat. 218

Michael Richard Barclay Cat. 306, 319, 326

The Trustees of the Cecil Higgins Art Gallery, Bedford Cat. 11–12, 301, 358, 532

Chris Beetles Ltd Cat. 506, 518–22

Williamson Art Gallery and Museum, Wirral Borough Council, Department of Leisure Services and Tourism [Birkenhead] Cat. 181

Birmingham City Museum and Art Gallery Cat. 49, 71, 74, 82, 147, 182, 185, 203, 207, 488

Bourne Fine Art Cat. 393, 461

Bradford Art Galleries and Museums Cat. 64, 135, 195, 239, 289, 342, 431, 503

The Royal Pavilion, Art Gallery and Museums, Brighton Cat. 362

City of Bristol Museum and Art Gallery Cat. 146, 205

The British Library Board Cat. 39, 59, 61–2, 78–9, 98, 149, 151, 163, 170, 225, 249–50, 278, 323, 329, 355, 428, 487, 499–500, 507–8, 510, 514, 551–3

The Trustees of the British Museum Cat. 37, 80, 94, 97, 118–19, 168–9, 174, 176–7, 221–4, 226–9, 261, 267–9, 271–2, 293–5, 303, 311, 315, 336–9, 344, 349–52, 359–61, 362–4, 464, 469–71, 492–4, 511A–13, 516–17, 538, 544–5

The British School at Rome Cat. 462

Elizabeth Bulkeley (the artist's daughter) Cat. 474–7, 479–81

Towneley Hall Art Gallery and Museums, Burnley Borough Council Cat. 68, 167

James Byam Shaw CBE, D Litt Cat. 139–40, 143, 154

Nicholas Byam Shaw Cat. 142

The Syndics of the Fitzwilliam Museum, Cambridge Cat. 187, 302, 318

Carlisle Museum and Art Gallery Cat. 56–7, 284, 291, 297, 305, 313–14, 356, 380–1, 443, 445–7, 465, 472

E S Cazalet Cat. 432

Cheltenham Art Gallery and Museums Cat. 84, 100, 255

Mr and Mrs Geoffrey Chin Cat. 449–50

Charles Cholmondeley Cat. 22, 81, 179, 231, 420

Sir George Christie Cat. 3

Jonathan Clark Ltd Cat. 466

Peter Cormack Cat. 536

Herbert Art Gallery and Museum, Coventry Cat. 290

Sir Michael Culme-Seymour Cat. 384

Donald Dean Cat. 421

Robin de Beaumont Cat. 25, 501, 511

The Trustees of the De Morgan Foundation Cat. 1, 44, 50

Derby Art Gallery Cat. 300

Robin Duff of Meldrum, MBE Cat. 369

The Governors of Dulwich Picture Gallery Cat. 42

Falmouth Art Gallery (Falmouth Town Council) Cat. 70

Rosemary Farquharson Cat. 150, 427, 486, 529–30, 540–1

The Fine Art Society Cat. 76, 189, 422

Fischer Fine Art, London Cat. 448

Fiona Forbes Cat. 131

Sir Brinsley Ford CBE, FSA Cat. 260, 264, 266, 482

R D Franklin Cat. 129

The Honorable Mrs Gascoigne Cat. 196

John Gere Cat. 92–3, 99

Bennie Gray Cat. 46–7, 63

Guildhall Art Gallery, City of London Cat. 194

Hammersmith and Fulham Archives Cat. 13–18

London Borough of Hammersmith and Fulham (Cecil French Bequest) Cat. 109

Julian Hartnoll Cat. 184

Eric Holder Cat. 128

Michael Holloway and David Falconer Cat. 155, 216

Graham Horton Cat. 95

Simon Houfe Cat. 334, 423, 490

Ferens Art Gallery (Hull City Museums and Art Galleries) Cat. 136

Lord and Lady Irvine Cat. 454

R H Jefferies Cat. 542, 555

Johnson Brothers (Cleaners) Limited Cat. 467

Henry Keswick Cat. 121

Kettering Museum and Art Gallery Cat. 123–4

Leeds City Art Galleries Cat. 127, 188, 333

Leeds City Art Galleries (Sam Wilson Bequest) Cat. 191

The Leicestershire Museum and Art Gallery, Leicestershire Cat. 430

Leighton House Museum, Royal Borough of Kensington and Chelsea Cat. 117

David Lemon Cat. 120

Lincolnshire County Council, Recreational Services, Usher Gallery, Lincoln Cat. 270

Trustees of the National Museums and Galleries on Merseyside, Sudley Art Gallery [Liverpool] Cat. 45, 186

Trustees of the National Museums and Galleries on Merseyside, Walker Art Gallery [Liverpool] Cat. 90, 111, 145, 166, 257, 377, 523

Andrew McIntosh Patrick Cat. 389

Deirdre MacLellan Cat. 122

Manchester City Art Galleries Cat. 253, 292, 309, 434, 438

Roy Miles Fine Paintings Cat. 36

The William Morris Gallery, London Borough of Waltham Forest Cat. 285

Rachel Moss Cat. 58

Anthony Mould Ltd Cat. 483

Peter Nahum, London Cat. 161

Christopher and Jenny Newall Cat. 157

Laing Art Gallery, Newcastle upon Tyne (Tyne and Wear Museums Service) Cat. 202, 527

Nottingham Castle Museum and Art Gallery Cat. 201

Oldham Art Gallery Cat. 180

The Visitor of the Ashmolean Museum, Oxford Cat. 27, 96, 141, 219, 254, 274, 335, 371–2

The Piccadilly Gallery, London Cat. 21, 23–4, 66, 178, 419, 425, 437

Pre-Raphaelite Inc. (by courtesy of Julian Hartnoll) Cat. 29–30, 113, 138

Harris Museum and Art Gallery, Preston Cat. 115, 343

R Price Cat. 101

Pyms Gallery, London Cat. 125

Reading Museum and Art Gallery Cat. 441

The Marquess of Reading Cat. 230

University of Reading Library Cat. 495–6, 537

John Redman Cat. 83

Beata Reynolds Cat. 19

Leila Reynolds Cat. 251

Olivia Reynolds Cat. 235

Rupert Reynolds Cat. 236

Simon Reynolds Cat. 89, 217, 279–83, 320–2, 325, 332, 354, 546

Peter Rose and Albert Gallichan Cat. 53, 156, 160, 240–2, 244–7

Royal Academy of Arts, London Cat. 193, 197, 208–10, 258, 456–9

The Trustees of the Royal Society of Painters in Water-Colours (from the Diploma Collection) Cat. 38, 48, 148, 234

Eric Slack Cat. 152, 158

Slade School of Fine Art, University College London Cat. 451

The Atkinson Art Gallery, Southport: Metropolitan Borough of Sefton Libraries and Arts Department Cat. 288

Sunderland Museum and Art Gallery (Tyne and Wear Museums Service) Cat. 304, 312, 531

The Trustees of the Tate Gallery Cat. 4, 10, 72, 103, 159, 171, 190, 199–200, 206, 212, 237–8, 252, 276–7, 287, 316, 341, 433, 453, 460, 463, 468, 473

Mr and Mrs Peter Thompson Cat. 183

Joscelyne V Charlewood Turner Cat. 77

The Board of Trustees of the Victoria and Albert Museum, London Cat. 60, 67, 164, 233, 262, 296, 298–9, 307–8, 310, 345–7, 444, 491, 497, 505, 515, 525, 543

P J Weston, CMG Cat. 478

Drusilla and Colin White Cat. 365, 424, 533

William Wiltshire Cat. 32

Christopher Wood Cat. 52, 213–15

Wolverhampton Art Gallery Collection Cat. 137

Worth School Cat. 440

National Railway Museum, York Cat. 134

Wales

National Museums of Wales, Cardiff Cat. 435

Newport Museum and Art Gallery, Gwent Cat. 442

Glynn Vivian Art Gallery, Swansea Museum Services, Swansea City Council Cat. 198

Scotland

Aberdeen Art Gallery and Museums Cat. 114, 259, 396

Dundee Art Galleries and Museums Cat. 35, 378, 390, 413–16

City of Edinburgh Art Centre Cat. 204, 391, 429

National Galleries of Scotland [Edinburgh] Cat. 379, 382, 392, 397–8, 406

Royal Scottish Academy [Edinburgh] Cat. 395

Scottish National Gallery of Modern Art, Edinburgh Cat. 286

Trustees of the National Library of Scotland [Edinburgh] Cat. 383

M A Forrest Cat. 404–5, 407–9

Glasgow Art Gallery and Museum Cat. 132, 367, 386

Glasgow School of Art Cat. 401–3

Mr and Mrs John Kemplay Cat. 417, 426

The Republic of Ireland

The Hugh Lane Municipal Gallery of Art, Dublin Cat. 400

The National Gallery of Ireland [Dublin] Cat. 399, 412

The United States of America

Delaware Art Museum, Samuel and Mary R Bancroft Memorial Cat. 9, 43

The FORBES Magazine Collection, New York Cat. 116, 211

Yale Center for British Art, Paul Mellon Collection Cat. 26

Hong Kong

Mark Freeman Cat. 144

Acknowledgements

Barbican Art Gallery and John Christian would like to extend our warmest and most sincere thanks to all the lenders to the exhibition, as listed, and to those who wish to remain anonymous. Also to the many people who have generously given their knowledge, advice and assistance over the past three years. We would particularly like to thank the following.

John Abbott
Victor Arwas
Philip Athill
Ruth Atkins
Ivan Bailey
Michael Barclay
Martin Beisly
Stella Beddoe
Chris Beetles
Mary Bennett
John Bennington
Roger Billcliffe
Patrick Bourne
Christabel Briggs
Ruth Bubb
Elizabeth Bulkeley
Richard Burns
Stephen Bush
James Byam Shaw
Stephen Calloway
Lindsay Campbell
Beryl Castle
Krzysztof Cieszkowski
Paul Chipchase
Charles Cholmondeley
Jonathan Clark
R Aquilla Clarke
Andrew Clayton-Payne
Peter Cormack
Robin Chrichton
Gabriel Cross
Elizabeth Cumming
Jane Cunningham
Ashted Dastor
Peter Day
Robin de Beaumont
Ian Dejardin
Anne de Lara
Kate Dinn
Richard Dorment
Christopher Drake
Frances Dunkels
Lord Dunluce
Simon Edsor
Rowland Elzea
Rosemary Farquharson
Sir Brinsley Ford
Martin Forrest
Stephen Forshaw
Terry Friedman
Albert Gallichan
John and Charlotte Gere
Francis Gilfoil
Norah Gillow
Catherine Gordon
Nicola Gordon Bowe
Halina Graham
Bennie Gray
Irving Grose
Paul Gumn
James Hamilton
Laura Hamilton
Julian Hartnoll
Alan and Mary Hobart
James Holloway
Christine Hopper
Juliet Horsley
Simon Houfe

Charles Howell
David Hughes
Francina Irwin
Haidee Jackson
James James-Crook
Richard Jefferies
Stephen Jones
Amanda Kavanagh
John and Anne Kemplay
Caroline Krzeskinska
Lionel Lambourne
Antoinette Le Normand Romain
Alison Ledward
Christopher London
Jeremy Maas
Rupert Maas
Andrew McIntosh Patrick
Margaret Mackay
Barry Marks
Rodney Merrington
Roy Miles
Chris and Juliet Moller
Hilary Morgan
Edward Morris
Rachel Moss
Jim Moyse
Jane Munro
Peter Nahum
Christopher Newall
Teresa Newman
J C M Nolan
David Penn
Godfrey and Eve Pilkington
Eugene Press
John Quentin
Janice Reading
Simon Reynolds
Judith Robinson
Peter Rose
Una Rota
Terence and Dolores Rowe
John Sheeran
Peyton Skipwith
Erick Slack
Gregory Smith
Hazel Smith
Richard Southgate Michael Spender
Eric Stanford
Andrew Stewart
Simon Taylor
Peter and Jackie Thompson
Julian Treuherz
Jane Vickers
Ethna Waldron
Neil Walker
Robert Walker
Philip Ward-Jackson
Ray Watkinson
Adam White
Bridget White
Colin White
Jon Whiteley
Stephen Wildman
Heather Wilson
Christopher Wood
Leslie Woodbridge
Clara Young

Photographic acknowledgements

Barbican Art Gallery would like to thank all lenders for their co-operation in the production of photographs and for kindly allowing us to reproduce their works. The Witt Library, at the Courtauld Institute of Art, have also kindly supplied a number of photographs for the catalogue. We would further like to acknowledge and thank the photographers listed below for their particular efforts on our behalf.

A C Cooper
Prudence Cuming Associates
John Goodman, Poole Museum Service
Jonathan Morris Ebbs
Richard Littlewood
Ray Matthews, Middlesex Hospital
Antonia Reeve
Terry Rice
Miki Slingsby
Rodney Todd-White
Reg Wilcox, Minster Photographic